Paris:
Capital of
the Arts
1900-1968

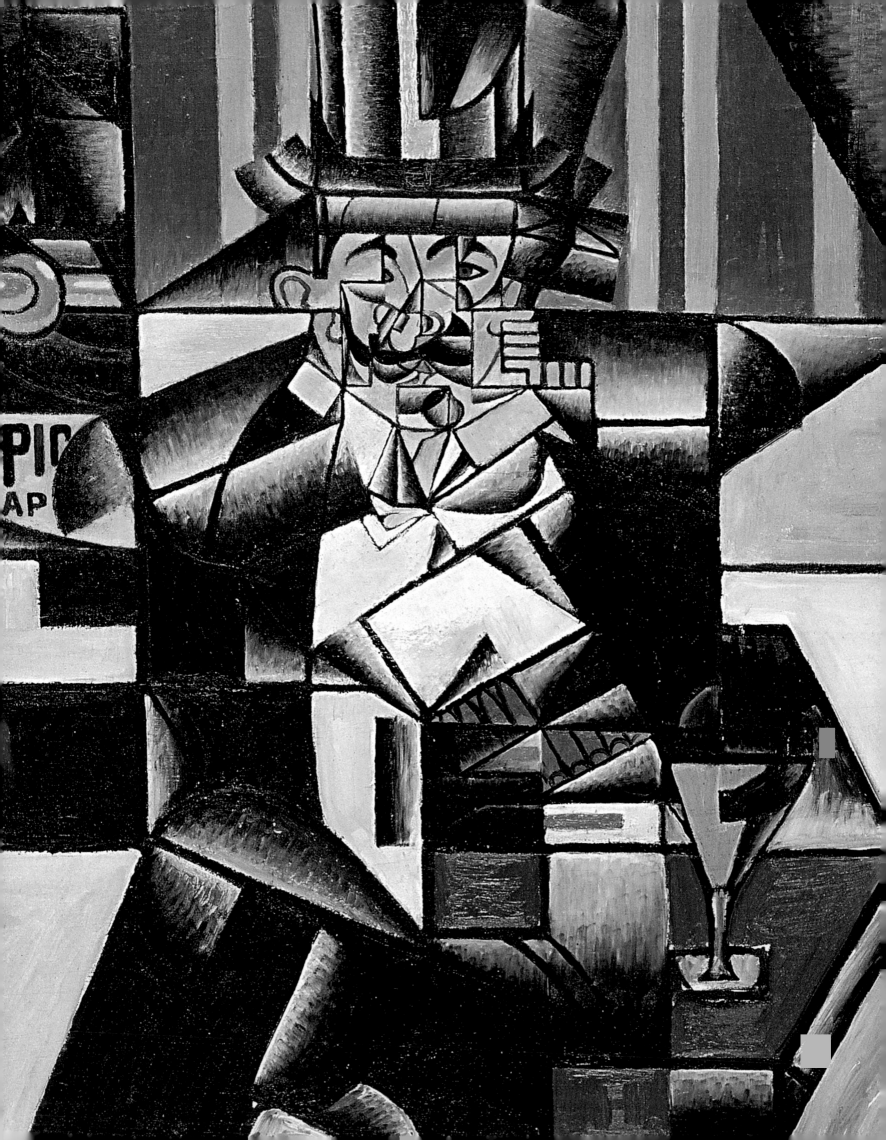

Royal Academy of Arts

Sarah Wilson

Eric de Chassey
Gladys Fabre
Simonetta Fraquelli
Nicholas Hewitt
Katarzyna Murawska-Muthesius
Kenneth Silver

Capital of
the Arts
1900-1968
PARIS

This exhibition is under the patronage
of Madame Georges Pompidou

Exhibition Curators
Ann Dumas
Gladys Fabre
Norman Rosenthal
Sarah Wilson

First published on the occasion of the exhibition
Paris: Capital of the Arts 1900–1968
Royal Academy of Arts, London, 26 January – 19 April 2002
Guggenheim Museum, Bilbao, 21 May – 3 September 2002

Sponsored by

 Merrill Lynch

The Royal Academy of Arts is grateful to Her Majesty's
Government for agreeing to indemnify this exhibition
under the National Heritage Act 1980, and to Resource,
The Council for Museums, Archives and Libraries, for
its help in arranging the indemnity.

British Library Cataloguing-in-Publication Data

A catalogue record for this book is available
from the British Library

ISBN 0-900-94697-0 (paperback)

ISBN 0-900-94698-9 (hardback)
Distributed outside the United States and
Canada by Thames & Hudson Ltd, London

ISBN 0-8109-6639-5 (hardback)
Distributed in the United States and Canada
by Harry N. Abrams, Inc., New York

Editorial Note
Unless otherwise stated, measurements are given in
centimetres, height before width, and, for sculpture,
before depth.

Illustrations: p. 2, cat. 31 (detail); p. 6, cat. 258 (detail);
pp. 10–11, cat. 29 (detail); pp. 26–27, *Looking Towards
Sacré-Coeur, Montmartre*, c. 1900; pp. 54–55, cat. 2 (detail);
pp. 104–05, *La Coupole, Montparnasse*; pp. 128–29, cat. 63
(detail); pp. 158–59, cat. 83 (detail); pp. 234–35, *Picasso in
His Studio on the Rue des Grands-Augustins*, 1938; pp. 262–63,
cat. 213 (detail); pp. 328–29, *Cellar on Rue de la Huchette*,
c. 1960; pp. 352–53, cat. 241 (detail); pp. 396–97, cat. 274
(detail); pp. 406–07, *Boulevard Saint-Germain, Latin Quarter*,
6 May 1968 (detail).

Exhibition Consultant
Simonetta Fraquelli

Exhibition Organisation
Susan Thompson
with
Miranda Bennion
Annie Starkey

Photographic and Copyright Coordination
Miranda Bennion
Roberta Stansfield

Catalogue
Royal Academy Publications
David Breuer
Peter Hinton
Alexandra MacGilp
Fiona McHardy
Peter Sawbridge
Nick Tite

Translation
From the French
Caroline Beamish: Fabre (pp. 40–53)

Design
Esterson Lackersteen

Picture Research
Julia Harris-Voss, with Celia Dearing

Production
Robert Marcuson, in association with
Textile & Art Publications

Colour Origination
Field Print & Graphics Ltd
in association with Robert Marcuson

Printing
Graphicom, Italy

President's Foreword

The Royal Academy is renowned for celebrating not only the genius of art and artists, but also the 'genius of place' – something that attracts talented people to a particular city, where ideas and practices evolve via the exchange of creative energies within a community of artists and intellectuals. Venice, Rome, New York and London have all been addressed directly and indirectly in exhibitions here in recent decades, but only now have we taken up the greatest challenge of all. The subject of an exhibition, 'L'Ecole de Paris 1900–1950', held at Burlington House over fifty years ago, Paris is the city that artists particularly love and have been drawn to, both for its history and its sense of modernity, a city that for the best part of two centuries was the leading centre of art and style. Members of the Royal Academy past – Frederic, Lord Leighton – and present – John Craxton, Eduardo Paolozzi, David Hockney and R. B. Kitaj – have spent significant periods in Paris, absorbing its atmosphere and contributing to its art life. I spent a formative year of my life in Paris between 1953 and 1954 when I met artists such as Georges Vantongerloo, who set me on the path that I was eventually to follow as a practising sculptor. Like many visitors, I fell in love with Paris. In the words of Josephine Baker's famous song: 'J'ai deux amours, mon pays et Paris'.

This exhibition was first conceived some years ago during discussions between Sarah Wilson of the Courtauld Institute of Art and Norman Rosenthal, the Academy's Exhibitions Secretary. Exhibitions devoted to the twentieth-century art of other countries – Germany, Britain, Italy and America – have been held here in recent years, and the idea was to formulate an exhibition about art in France during the same century. It soon became clear that this was a practical impossibility and that an exhibition covering the twentieth century would have to be international in scope. And so the idea of Paris as a magnet for twentieth-century artists evolved. A starting date of 1900 was immediately agreed, but only after much debate was 1968 chosen as a conclusion, the date when Paris, it can be reasonably argued, ceased largely to consider itself as the only major centre of artistic innovation.

The work of 173 artists is represented in this exhibition. That number could easily have been doubled. Some – Picasso, Matisse, Chagall, Modigliani, Klein, Tinguely – are internationally renowned; others are less well known, yet all contribute to the extraordinary narrative of Paris as a capital of the arts.

After its showing at the Royal Academy the exhibition will travel to Bilbao. It is a great pleasure to be working once again with our colleagues at the Guggenheim Museums in Bilbao and New York, who have lent major works from their collections.

We are indebted to Thomas Krens, Director, and Lisa Dennison, Deputy Director and Chief Curator, of the Solomon R. Guggenheim Museum, New York, and to Juan Ignacio Vidarte, Director, Petra Joos, Director of Museum Activities, and Daniel Vega, Associate Director for Planning and Organisation, of the Guggenheim Museum, Bilbao. The exhibition has been a major feat of organisation, masterminded by Ann Dumas of the Royal Academy and Gladys Fabre, former curator at the Musée d'Art Moderne de la Ville de Paris, as well as Simonetta Fraquelli, working alongside Sarah Wilson and Norman Rosenthal. We are indebted to all those who have contributed to the catalogue. To mark the important development of photography as an art form in Paris, the Royal Academy is simultaneously publishing *Paris Pictured* by Julian Stallabrass, which deals with many of the great photographers of this period.

We are particularly grateful to our sponsors Merrill Lynch for their extraordinarily generous support of this exhibition. Without them in these difficult times it would have been almost impossible to proceed with this project. Every visitor to this show owes them a genuine debt of gratitude. We also thank BBC Radio 3 who are broadcasting a number of programmes covering some of the historical, philosophical, literary, musical and artistic issues that arise from a consideration of different aspects of this exhibition.

We are delighted that Madame Georges Pompidou has agreed to be the patron of 'Paris: Capital of the Arts 1900–1968'. She has for so long been an enthusiastic supporter of art and culture in general and in Paris in particular, and her blessing does us great honour. His Excellency the French Ambassador, Monsieur Daniel Bernard, and Monsieur Xavier North, Cultural Counsellor and Director of the Institut Français in London, which is also holding a number of complementary events, have given us invaluable assistance throughout. As always, we are immensely grateful to our lenders, both public and private. The exhibition is full of loans from French collections, of course, but there are many from collectors in other parts of the world. Although it would be invidious to single out particular lenders, we owe a great debt to the Musée National d'Art Moderne, the Centre Georges Pompidou, in Paris and its director, Monsieur Alfred Pacquement, for his generosity, advice and encouragement. We also thank Madame Suzanne Pagé, Director of the Musée National de l'Art Moderne de la Ville de Paris, for her support.

To everyone who has made this exhibition possible, the Royal Academy of Arts extends its heartfelt thanks.

Professor Phillip King CBE
President, Royal Academy of Arts

Sponsor's Preface

Merrill Lynch is proud to sponsor 'Paris: Capital of the Arts 1900–1968', an exhibition that celebrates the work of the many great artists who gathered in Paris, and the art movements that came to life there over nearly seven decades. This project gives us the opportunity to join once again with the Royal Academy of Arts and to show our support for the vibrant cultural community that thrives in London today.

As a company, we recognise the value of investing in the preservation and development of cultural and educational resources around the globe. To that end, we partner with many of the world's leading not-for-profit cultural organisations to provide greater public access to innovative cultural programming and encourage a broad perspective and dialogue on contemporary issues.

We congratulate the Royal Academy on this engaging exhibition and its ongoing commitment to creative, dynamic and thought-provoking programming.

David H. Komansky
Chairman and Chief Executive Officer, Merrill Lynch

E. Stanley O'Neal
President and Chief Operating Officer, Merrill Lynch

Acknowledgements

The curators of the exhibition would particularly like to thank the artists represented for their advice and help during its realisation. The invaluable assistance afforded by individual lenders and the directors and staff of lending institutions is gratefully acknowledged. Thanks are also due to all of the following people: Daniel Abadie; Katya Ahrens; Eduardo Alaminos López; Jean Albou; Susanna Allen; Jean-Paul Ameline; Irina Antonova; Petrine Archer Straw; Marta Arroyo; Paolo Baldacci; Jacques Beauffet; Agnès de la Beaumelle; Christoph Becker; Lucy Belloli; Laurence Bertrand-Dorléac; Ernst Beyeler; Galerie M. Bochum; Caterina Bon; Juan Manuel Bonet; Maria Luisa Borras; Ivor Braka; Emily Braun; Emmanuel Bréon; Christian Briend; Francis Briest; Andreja Brulc; Richard Calvocoressi; Olivier Camu; Mary Carin; Isabel Carlisle; Jacques Cartier; Lucia Cassol; Clarenza Catullo Bernard Ceysson; Philippe Chabert; Mark Clark; Emmanuel Clavé; Michèle Cone; Pieter Coray; Ronald Cordover; Dan Cowap; Mr D'Afflitto; Susan Davidson; Nanne Dekking; James Demetrion; Lisa Dennison; Bernard Derderian; Bernard Derosier; Misia Dewasne; Françoise Dios; François Ditesheim; Ginette Dufrêne; Dominique Dupuis Labbé; Denise Durand-Ruel; Bernd Dütting; Gregory Eades; David Elliott; Patrick Elliot; Nathalie Ergino; Carla Esperanza; Gerard Faggionato; Mannfred Fath; Serge Fauchereau; Evelyne Ferlay; Eric Fernie; Michael Findlay; Marcel Fleiss; Valerie Fletcher; Isabel Fontaine; Jean Fournier; Rudi Fuchs; Laurent Gervereau; Daniel Gervis; Claude Ghez; Arnold Glimcher; Kristina Gmurzynska; Romy Golan; Heide Grape-Albers; Jacqueline Grassi; Olivier Grassi; Christopher Green; Karsten Greve; Françoise Guiter; Wolfgang Günther; Margit Hahnloser; Richard Hamilton; Anne d'Harnoncourt; Barbara Haskell; Michael Hass; Ivor Heal; Jacqueline Hélion; Allis Helleland; Charlie Herscovici; Ann Hindry; Isabel Horovitz; Marwan Hoss; Lucy Hunt; Pontus Hulten; Geurt Imanse; Joe Jacobs; Jean-François Jaeger; Hans Jannsen; William Jeffett; Petra Joos; David and Tanya Josefowitz; Paul and Ellen Josefowitz; Pauline Karpidas; Paul Kasmin; Samy Kinge; Christian Klemm; Josy Kraft; Maya Kramer; Sophie Krebs; Thomas Krens; Ulrich Krempel; Jan Krugier; Geneviève Lagardère; Claude Lamouille; Marc Larock; Pierre Larock; Denise Laurens; Quentin Laurens; Sylvain Lecombre; Marie José Lefort; Tom Leighton; Serge Lemoine; Katie Lemon; Jeremy Lewison; Jacques L'Hoir; William S. Lieberman; Tomás Llorens; Adrian Locke; Olivier Lorquin; Glenn Lowry; Anne Luyckx; Adrien Maeght; Isabelle Maeght; Gino di Maggio; Guido Magnaguagno; Maria Rosa Malet; Daniel Malingue; Madeleine Malraux; Daniel Marchesseau; Anna Maris; Franck Marliot; T. Marshall Rousseau; Claudine Martin; Michel Maso; Jacqueline Matisse Monier; Brigitte Maurice-Chabard; Emeline Max; Maureen McCormack; Marilyn McCully; Duncan McGuigan; Dany McNutt; Mr and Mrs Werner Merzbacher; François Meyer; François Michaud; Andrew Middleton; Lucy Mitchell-Innes; Jean Gabriel Mitterand; Daniel Mocquay; Herbert Molderings; Jean-Paul Morel; José Mugrabi; Jacqueline Munck; Helly Nahmad; Pierre and Marianne Nahon; Peter Nathan; Alicia Navarro; Esty Neuman; Xavier North; Annick Notter; Alfred Pacquement; Suzanne Pagé; Amanda Paulley; Edmund Peel; Carlos Perez; Gilbert Perlein; Christian Perrazone; Tom Phillips; Claude Picasso; Paloma Picasso; Annette Pioud; Vincent Pomarède; Isabelle Poncet; Jane Poutney; Jean-Louis Prat; Michael Raeburn; Gianluca Ranzi; Gérard Regnier; Denise René; Jennifer Richenberg; Duncan Robinson; Phyllis Rosenzweig; Cora Rosevear; Margit Rowell; Jann Runnquist; Howard Rutkowsky; Philip Rylands; Marianne Sarkari; Philippe Sauve; Alain Sayag; Alain Schaer; Didier Schulmann; Sabina Schulz; Didier Semin; Nicholas Serota; Natalie Seroussi; George T. M. Shackelford; Jasper Sharp; Annie Shaw; Marjorie Shiers; Kenneth E. Silver; Adrien Sina; Werner Spies; Marie-Brunette Spire; Françoise de Staël; Julian Stallabrass; MaryAnne Stevens; Kate Storey; Anne Strauss; Michel Strauss; Dominique Szymusiak; Alain Tarica; Hillary Taylor; Keith Taylor; Michael Taylor; Catherine Thieck; Léo Thieck; Samir Traboulsi; Evelyne Trehin; Lucien Treillard; Cecilia Treves; Patrice Trigano; Ben van Beneden; Paul van Calster; Willem van Krimpen; Kirk Varnedoe; Sylvie Vautier; Daniel Vega; Germain Viatte; Dina Vierny; Leslie Waddington; Kenneth Wayne; Rosemarie Weber; Claude Weill; Corinne Wellesley; Michael Werner; Sarah Whitfield; Anne Winton; Renos Xippas; and Kazuhito Yoshii.

Sarah Wilson would like to acknowledge the assistance of the Arts and Humanities Research Board and the support of the Modern Department at the Courtauld Institute of Art, University of London

Sarah Wilson

Introduction

Montmartre, Montparnasse, Saint-Germain-des-Prés and the Latin Quarter: these Parisian places, linked to particular moments of twentieth-century painting and sculpture, are rich with their own political and artistic histories. Traces of this narrative still linger to be discovered in Paris's streets, now overlaid by the vibrant contemporary art world, with its different focuses and locations of activity.

The nineteenth-century poet Charles Baudelaire wrote extensively about the *flâneur*, the dandy who strolls through the modernised Paris revealed by Baron Haussmann's broad boulevards and shopping arcades. In the 1930s, the German writer Walter Benjamin, exiled in the city, began his ambitious archival project linked to the birth and death of Paris's arcades, which resulted in the huge literary collage 'Paris, Capital of the Nineteenth Century', a work he was forced to leave incomplete as he fled Nazi persecution.[1] The expanding and fascinating literature on the *flâneur,* or the female *flâneuse,* generally orientated towards nineteenth-century Parisians or Parisiennes,[2] ignores those who came to Paris to stay and work or to live permanently, and fails to state that every visitor, every artist – Chagall from Russia, Maria Elena Vieira da Silva from Portugal, Zao Wou-Ki from China, or Soto from Venezuela – arrived with an already-formed dream of the city.[3] They discovered its past and present by walking the streets, as *flâneurs* or *flâneuses* with a perspective not distanced through the *fin-de-siècle* viewpoint of Baudelaire's French dandy – or the chaperoned young Frenchwoman – but instead with a feeling of belonging and not belonging to Paris central to the city's cosmopolitan status.

Himself a *flâneur*, Benjamin specifically selected literary fragments relating to the 'dream city': 'Rattier evokes a dream Paris, which he calls "the false Paris" as distinguished from the real one: "the purer Paris...the truer Paris...the Paris that doesn't exist"'.[4] The 'Paris that doesn't exist' gave rise to myriad versions of the city, whether conceived from behind the Iron Curtain (see Katarzyna Murawska-Muthesius's essay, pp. 250–61), seen from Hollywood (Vincente Minelli's *An American in Paris* starring 'artist' Gene Kelly was shown in the city in 1953), or recollected by William Burroughs in the context of 1960s Fluxus happenings at the American Center in the Boulevard Raspail. As Burroughs said, 'Dreams are a biological necessity, for individuals and for whole cultures as well. And artists are the dreamers for our world – they are, in some sense, the most powerful members of society because their dreams will come to life in a thousand ways in a thousand places. But even dreams require conduits and connections, to bring them to reality in the minds of people all over the world.'[5]

Paris, 'Capital of the Nineteenth Century', artistic and intellectual epicentre of the world at the 1900 Exposition Universelle, reigned supreme until the Second World War destroyed the Europe of the 1920s and 1930s. In 'Paris: Capital of the Arts', by opting for the illumination offered by a greater time-span, 1900–1968 – the 'longue durée'[6] – we take up the challenge, demonstrating Paris's role as a centre of outstanding artistic and intellectual achievement after 1945, and to the very threshold of the period of doubt and

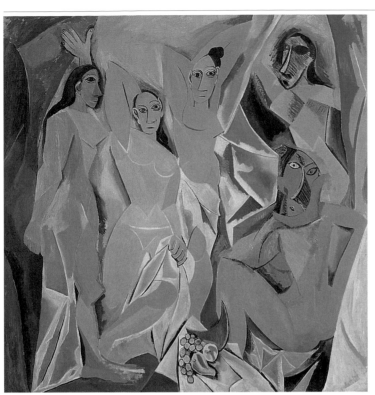

Figure 1

reassessment that occurred at the end of the twentieth century and is now characterised as 'postmodernism'.

Although conceived as a sequence of dramatic spectacles, with a visual, narrative or atmospheric coherence, 'Paris: Capital of the Arts' also loosely follows a conceptual division into parts which represent significant shifts, not only in the historical art world but in the city's 'legendary topography', from Montmartre (birthplace of *Les Demoiselles d'Avignon* [fig. 1] and Picasso's Cubism [fig. 3]) to Montparnasse, from Saint-Germain-des-Prés to the Latin Quarter. Significantly the phrase 'legendary topography' was devised by the Durkheimian sociologist Maurice Halbwachs, another victim of the Nazi Holocaust.[7] Although the break between the worlds of Paris before and after 1945 cannot be demonstrated through works of art alone, the effects of the catastrophe are registered: emblematically so, in the case of the pre-war Surrealist Giacometti, for example, whose postwar emaciated bronzes of the human figure were compared by Sartre to the 'fleshless martyrs of Buchenwald'.[8]

Following Halbwachs, the theorisation of 'lieux de mémoire' (places of memory) has generated a magisterial study of Paris's historic sites, monuments, songs, flags and local lore.[9] Not only do the legendary Montmartre, Montparnasse, Saint-Germain-des-Prés and Latin Quarter qualify as 'lieux de mémoire', but paintings by Picasso or Dubuffet, or sculptures by Lipchitz or Giacometti, are also sites of concentrated memory – as, with increasing distance, is modernism itself. 'Farewell to an Idea' was the title recently chosen by the art historian T. J. Clark for a publication on just this subject in which he defined modernism as turning away from the 'worship of ancestors and past authorities, to the pursuit of a projected future of goods, pleasures, freedoms, forms of control over nature, or infinities of information' but saw the modernist past as already a 'ruin'.[10] In contradistinction to Clark's valedictory pessimism, the energy, creativity and vision contained in works of art themselves, can, surely, communicate across time; in the same way, the reconstructive project of the historian, even working with fragments, is worthwhile.

It has recently become fashionable, to 'abolish history' in major museum displays which seek to construct provocative juxtapositions of works of art across time and space.[11] 'Paris: Capital of the Arts' aims, instead, to be provocative *within* the co-ordinates of history; to demonstrate, for example, how an erotic nude, a high-society portrait, a geometric abstract painting of the 'school of Mondrian' or a Surrealist dreamscape are all part of the Parisian narrative of the 1920s and 1930s. Many group exhibitions focus on a cluster of works made in a particular period, while monographic exhibitions show 'a life through the work'. With its longer time-span, 'Paris: Capital of the Arts' shows the abrupt changes in manner and material that demonstrate an artist's response to the climate of the times. Familiar aspects of Picasso's stylistic evolution from 1901 to 1945 are seen here, as are, for instance, the abrupt changes in the work of César, from 1950s welded iron sculptures (cats 210, 211), to his readymade crushed car – Marie-Laure de Noailles' white Sunbeam of 1961 (cat. 251).

2 Jean Bazaine's stained-glass window depicting
Baptism at the Church of Saint-Séverin, Paris, 1966

3 Pablo Picasso, *Portrait of Ambroise Vollard*, 1910
Oil on canvas, 92 × 65 cm
Pushkin Museum. Moscow

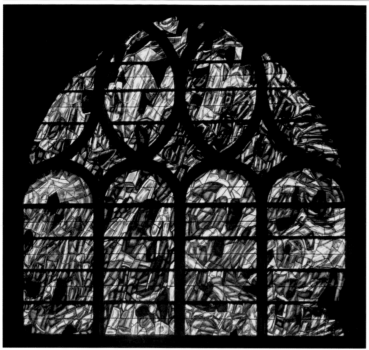

Figure 2

The paintings and sculptures displayed in 'Paris: Capital of
the Arts', inevitably linked to all the 'isms' of the time,[12] formed
part of a continuum of creativity involving many other art forms:
take Matisse's engagement with poetry, literature and the *beau
livre,* music, costume and stage design, dance, ceramics, tapestry,
stained glass and architecture, for example, or Fernand
Léger's writings on popular culture, the dance hall, and his
work with film.[13] Artists less well-known outside France such
as Jean Bazaine have worked in various media on collaborative
projects, too: Bazaine's flame-like stained-glass window series
(fig. 2), created from 1964–69 for the flamboyant gothic interior
of the Church of Saint-Séverin, familiar to every stroller in the
Saint-Michel quartier, is a prime example,[14] while Pierre
Buraglio's restored Saint-Symphorien chapel within the
church of Saint-Germain-des-Prés itself (1992) is a well-kept
secret.[15]

Finally a word on Parisiennes: Suzanne Valadon and Marie
Laurencin in Montmartre, Tamara de Lempicka, Sonia Delaunay,
Sophie Täuber-Arp and Paule Vézelay in Montparnasse,
Germaine Richier and Maria Elena Vieira da Silva in
Saint-Germain-des-Prés, Alina Szapocznikow from Poland,
Ruth Francken from Prague, and Niki de Saint Phalle,
flying between Paris, New York and Los Angeles in the 1960s.
Many strong female artists are represented in what was patently,
still, a man's art world. The personalities and professionalism
of famous models such as Assia Granatouroff should be
mentioned here,[16] as should the dedication and flair of gallerists
such as Berthe Weill, Katia Granoff, Jeanne Bucher, Lydia Conti,
Iris Clert, Denise René and Dina Vierny (once a model herself
for the sculptor Aristide Maillol).[17] The Narrative Figuration
movement of the 1960s and early 1970s, and the initially Nice-
based Supports-Surfaces movement, prominent just after 1968,[18]

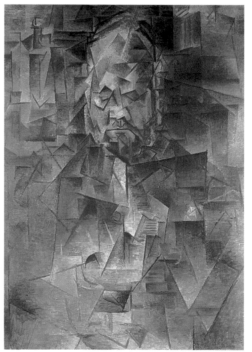

Figure 3

4 Giorgio de Chirico, *Portrait of Guillaume Apollinaire*, 1914
Oil on canvas, 81.5 × 65 cm
Musée National d'Art Moderne, Centre Georges
Pompidou, Paris

Figure 4

were perhaps the last viable instances of the all-male avant-garde grouping, based (as was its original blueprint, Marinetti's misogynistic pre-First World War Futurist movement) on a political model, with manifestos, journals, printed tracts and so on. Group photographs from 1900 to 1968, extending to today's invitation cards from the exclusively male stable of the Galerie Louis Carré, confirm this analysis. While Sophie Täuber-Arp and Maria Elena Vieira da Silva acquired a new stature and authority via their inclusion in the recent exhibition 'Inside the Visible'[19] far more research is required to give a fuller picture of women artists, their working practices and their role within the art world in Paris to 1968.[20] The case of the artist Marie Raymond (Yves Klein's mother), whose social receptions and role on the jury of the Salon des Indépendants were important, is perhaps exemplary here.[21]

Montmartre and Paris before 1914

On a hill with a superb view of the city, Montmartre, already hallowed by Corot, by Van Gogh and by Renoir, by one Spanish artist, Pablo Picasso, and one Frenchman, Georges Braque, would shatter traditional perspectival frameworks of Western art and reject the atmospheric, coloured city visions of the Impressionists. The new painting, Cubism, transformed Manet's nineteenth-century drinking parlours and theatre bars into something approaching a turn-of-the-century *vanitas*: a violin, a bottle of Suze, a fragment of the day's newspaper were all that was necessary to create a poem to a bohemian present. The original 'Wild Men of Paris',[22] the Fauves, whose work is normally associated with Paris's suburbs or the beaches of L'Estaque and Collioure in the South, frequented Montmartre cabarets such as the Rat Mort; Derain's seated dancer (cat. 3) shows the extraordinary liberation of colour and free handling inaugurated by the movement. Polish in origin, the poet Guillaume Apollinaire (see fig. 4), the most inquisitive and brilliant art critic of the time, provides the link between the Fauves and the Cubists, working in a 'medievalist' mode with the Fauves Derain and Raoul Dufy, playing Cubist 'poetics' with Picasso, or promoting the new movements in art with his book *Les Peintres cubistes: meditations esthétiques* (1913).[23] In his book, he baptised the fusion of Cubist dissolving space with the spectral and planetary colours of Robert and Sonia Delaunay as 'Orphism'. The proximity of the literary world to the art of the Cubists and Orphists is magnificently symbolised by Albert Gleizes's *Portrait of the Editor Figuière* (1913; cat. 32) in which titles literally jump off the book spines behind the sitter.[24] While Natalia Goncharova's dynamic vision of electric light (cat. 43) brings her close to the Orphists as well as to the Italian Futurists (who stormed Paris in 1912, depicting light and speed as 'lines of force'), we should recall that her work signals another world, one of music, drama and oriental spectacle: that of the Ballets Russes.

The pastoral set of Diaghilev's ballet *L'Après-midi d'un faune* (1912), danced by Nijinsky to music by Claude Debussy, was anticipated by the nymphs and pipe-playing satyrs in the 'Golden age' pastoral setting of *Le Bonheur de vivre* (1905–06)

5 Henri Matisse, *Le Bonheur de vivre*, 1905–06
Oil on canvas, 174 × 238.1 cm
The Barnes Foundation, Merion, Pennsylvania

6 Henri Matisse, *The Painter in His Studio,
Quai Saint-Michel*, 1916
Oil on canvas, 146.5 × 97 cm
Musée National d'Art Moderne, Centre
Georges Pompidou, Paris

by Henri Matisse (fig. 5). The rapid transformation in Matisse's work to more primitive, naked, dancing red figures on a divided blue and green ground in *Music* and *Dance II* (both 1910) captures a very similar spirit to Igor Stravinsky's ballet *The Rite of Spring*, a work so new and discordant that it caused a riot in the Théâtre des Champs-Elysées in 1913. With so long a time-span and so wide a range, however, 'Paris: Capital of the Arts' may be conceived as a series of powerful installations, with dramatically varied atmospheres, each closely linked to the city. Thus depictions of the classical past, of Orientalist visions, of Provençal landscapes or Mediterranean beach scenes have been avoided, so that – while it is not always possible with completely abstract work – a sense of Paris, of the city itself, prevails. Almost without exception, works in this exhibition were made in Paris (fig. 6). Thus Matisse, who left for the South of France definitively in 1917, is absent after this date. (Kenneth Silver's essay, pp. 118–27, indicates the importance of the Mediterranean world for Parisian artists.) The invisibility of Marcel Duchamp, who exhibited his *Nude Descending a Staircase* in New York's Armory show in 1913 (fig. 7) and moved to America in 1915, is perhaps more fitting, in that, unlike Matisse, he was not an 'exhibiting presence' in Paris for decades, but rather a forgotten, subsequently legendary absence. He returns as the father of two opposing groups of artists in the 1960s: the Nouveaux Réalistes whose work appropriated 'readymade' objects (Duchamp's invention), and, conversely, the Narrative Figuration artists, whose great 'realist' polyptych of Duchamp's life, death and funeral reclaimed, with a vengeance, the right to paint (cat. 280). It was Duchamp who reinvented the Mona Lisa as a twentieth-century icon, adding and subtracting moustaches and epithets as the fancy took him (cat. 50). In the 1960s she became not only a Louvre 'readymade' for the Nouveau Réaliste artist Daniel Spoerri, but also a symbol of France when she flew the Atlantic to Washington with the Cultural Minister André Malraux in January 1963. President de Gaulle's angry withdrawal from NATO in June, however, invited retaliation. American art dealers in New York followed the lead of politicians and diplomats, with

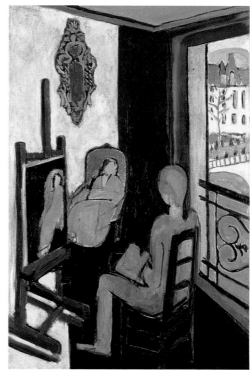

Figure 6

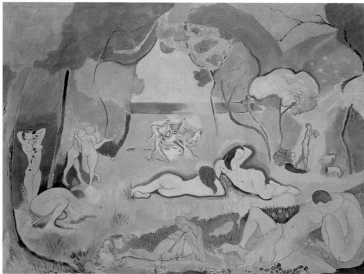

Figure 5

7 Marcel Duchamp, *Nude Descending
a Staircase, no. 2*, 1912
Oil on canvas, 146 × 89 cm
Philadelphia Museum of Art: The Louise and Walter
Arensberg Collection

8 Jean Fautrier, *L'Homme ouvert (The Autopsy)*, c. 1928
Oil on canvas, 116 × 73 cm
Granville Collection, Musée des Beaux-Arts, Dijon

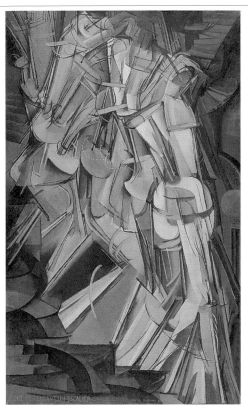

Figure 7

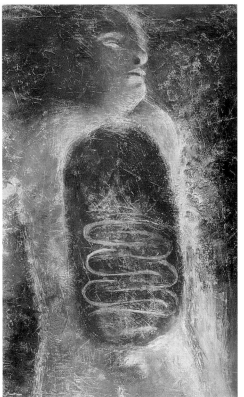

Figure 8

the inevitable consequences for the French art market. Since time immemorial, art has been associated not only with places, styles and personal prestige, but with political power.

Montparnasse and Paris of the 1920s and 1930s

Duchamp may have decided that painting was an obsolete activity well before the First World War, but within the Ecole des Beaux-Arts, and in private studios such as the Académie Julian or the Académie de la Grande-Chaumière, studios set up by modernists such as Matisse or Fernand Léger, studios in La Ruche (the Montparnasse 'beehive'), or in individual artists' spaces, painting continued.[25] Nudes of the 1920s and 1930s – ranging from the decorative and provocative Foujita (cat. 115) to the sombre figures (cat. 135) of Jean Fautrier (whom Marcel Zahar called 'the most tragic painter of our epoch' in 1930) – demonstrate not only the powerful eroticism of the brothel environment, at its most elaborate in luxury establishments like the Sphinx,[26] or as embodied by Kiki de Montparnasse (cat. 74), but also the ritual dimension of a confrontation between sexuality and the sacred at its most impersonal. Rare still-lifes by Fautrier and Chaïm Soutine reveal evident links between animality and death: relationships with Rembrandt – Fautrier's magnificent black boar series and *L'Homme Ouvert (The Autopsy)*, c. 1928; fig. 8 – and Chardin signal the continuous pull within French modernism back, again, to the Louvre. The poverty and self-deprivation of painters such as Soutine, exiles from their countries, their families and their religious milieux, should not be forgotten. Nor should the fact that Paris, a beacon of freedom and liberal tradition, welcomed huge communities fleeing political and religious persecution, together with hosts of economic refugees. Their presence in the metropolis in the 1920s as members of the workforce underlined the fact that France, beneath her glittering veneer, was mourning the loss of a generation of young men in the First World War. Emile-Antoine Bourdelle's great bronze *La France*, a warrior-like Pallas Athene standing triumphantly on the steps of the new Palais de Tokyo in 1937, had indeed been originally conceived as a memorial to the 1914–18 war dead of Montauban.[27]

With the jazz-age Paris of the 1920s and 1930s, we confront a simultaneity of modernist styles, ranging from the neo-plasticist severity of Mondrian and his school, to the post-Cubist violence in primary colours of Picasso's *Painter and Model, Paris* (1928; cat. 83) and the provocative silhouettes of Fernand Léger and Picabia. Picabia's *La Feuille de vigne (The Fig Leaf)* (1922; cat. 57), already perversely insulting about painting, the Louvre, and the French tradition, parodies Ingres's *Oedipus and the Sphinx* (1808), the prudishness of the nude as a genre (genitalia are of course invisible on Picabia's black silhouette) and Ingres's own dictum that 'drawing is the probity of art', with 'dessin français' (French drawing) written in childlike capitals on the painting. Parody invokes paradox, however: Picabia depends on Ingres for his subject, and his work's monumental scale and careful execution – albeit in shiny Ripolin house-paint – betray his aspirations. His constant sense of competition with Duchamp

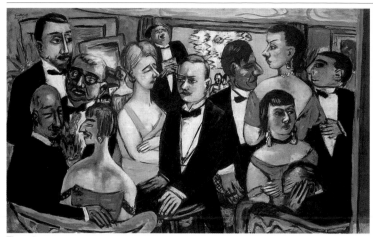

Figure 9

or Picasso was always in conflict with his ironic and insouciant persona as a millionaire Don Juan.[28] An analysis of the deeper meaning of the conflicting styles of 'high art' and of the 'left' and 'right' of the avant-garde during this period, and the relationship with Art Deco – interior design, furniture, fashion, jewellery – is sorely missing in conventional art history, whose classifications sideline the 'decorative' arts, functioning on monographic or style-based models and coping with contradictions at best via the device of dialectic: Cubism and its 'enemies', geometric abstraction 'against' Surrealism, post-Cubism or realism.[29] Alternatively, recent gender-based analyses of the 1920s and 1930s focus too obsessively on Duchamp, Man Ray and 'excluded' rediscoveries such as the lesbian Surrealist photographer Claude Cahun or women Surrealist painters. Even the most recent and sophisticated examinations of Brancusi's play on gender, in works such as the shiny, phallic *Princess X* (1915–16; fig. 10), exclude the stylised world of lacquer and veneer, sharkskin and crushed velvet, brittle conversation, high camp and ostentatious wealth that constituted the Art Deco world.[30] The portrait of the high-society poetess Anna de Noailles by Kees van Dongen (cat. 69), Max Beckmann's evocations of dinner-jacketed *soirées* (fig. 9), Tamara de Lempicka's outrageous lesbian *amazone* in riding gear (cat. 66), even Picasso's soulful and realist portrait of Olga (cat. 67) all provide a glimpse of the world which framed jazz-age avant-garde abstractions – and indeed emphasise the continuing function of portraiture within such an avant-garde context.

Dada objects, and the circus Surrealism of Miró or Alexander Calder, were also part of this world: the patron Marie-Laure de Noailles would have been more likely to encounter a spike-toothed iron (*Cadeau*, 1921–70; cat. 60) or a wrapped sewing machine by Man Ray (*The Enigma of Isidore Ducasse*, 1923; cat. 61) than their utilitarian counterparts below stairs. In the 'purism' of Ozenfant and Le Corbusier (Charles-Edouard Jeanneret), the silhouettes of shiny cocktail shaker and soda siphon replace Montmartre's bottle of Suze or Spanish Anise whose intrusive labels had figured in Cubist painting and collage.

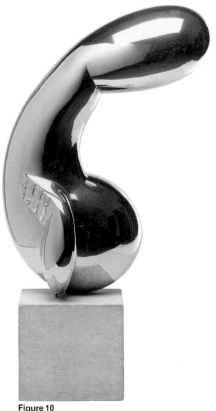

Figure 10

11 Max Ernst, *The Angel of the Hearth and Home*, 1937
Oil on canvas, 112.5 × 144 cm
Private collection

In the later 1930s, however, we enter a theatre of nightmare. The 'hand-made dream paintings' by Salvador Dalí and René Magritte had already put unmentionable sexual fantasies onto canvas, far more disturbingly than the 'automatic' Surrealist experiments of the earlier 1920s such as André Masson's poured sand paintings. The *cafard après la fête*[31] (the depression after the party) signalled in 1929 by the Wall Street crash in New York and the collapse of the European art market; but the rise of fascism gave Surrealists such as the German artist Max Ernst an altogether greater sense of anxiety and urgency: his visions of devouring monsters (fig. 11), bodies floating in space, even of the monuments of Paris such as the Porte Saint-Denis in ruins within a desolate night landscape were prophetic metaphors of horror to come. Indeed in Ernst's case, as in that of many other artists, such as Jacques Lipchitz or Marc Chagall, the ruin of the Parisian dream signalled another exile. The Jewish 'Ecole de Paris' was liquidated; many faced deportation and certain death.

Saint-Germain-des-Prés: occupation and reconstruction

The Hungarian photographer Brassaï recalled his conversations with Picasso in the Paris of the Occupation years, when the dark church spire stood like a sentinel over the blacked-out square of Saint-Germain-des-Prés.[32] The Flore and Deux-Magots cafés sheltered the writers of the 'existentialist' script of the post-1945 period, notably the philosopher Jean-Paul Sartre. The period of waiting and mourning under Nazi Occupation is demonstrated by works in *vanitas* mode by Picasso and Braque (cats 159–61); in Braque's case, especially, the sense of repentance for the 'wild years', *les années folles*, seems palpable. The self-portraits of Francis Gruber or Bernard Buffet (cats 157, 158) expressed a return to 'reality' which was echoed by painters such as Jean Hélion who had been a cosmopolitan abstract artist in the 1930s (cat. 101). Hélion's war experiences shattered his faith in 'formalist' solutions for art: he returned from geometric arrangements of lines and colours to the nude, the studio, the bare table, the loaf of bread. Thus we have the paradigmatic

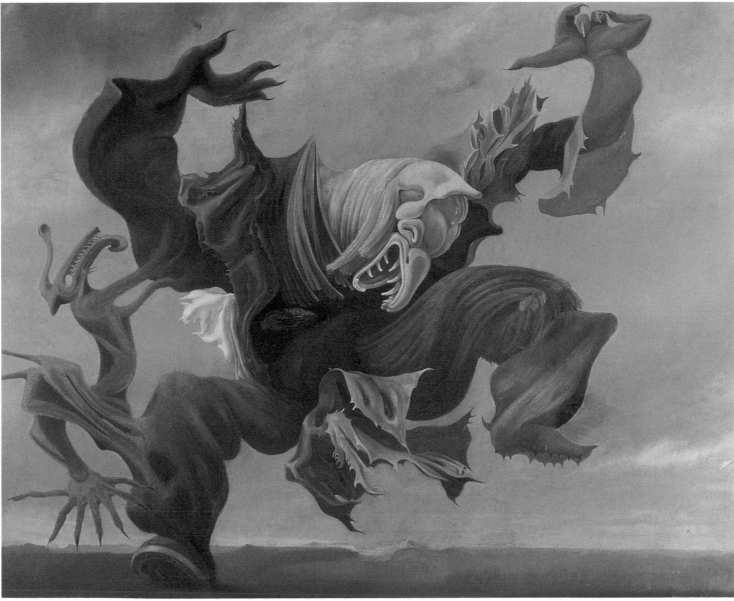

Figure 11

12 Alberto Giacometti with Samuel Beckett and the tree
used in *Waiting for Godot*, at the Théâtre de l'Odéon,
Paris, 1961

instance of two generations in stylistic contradiction with one
another in a living present: hosts of younger abstract artists were
streaming into Paris to be welcomed at the Salon des Réalités
Nouvelles at this time.[33]

A different kind of art – called 'art autre' by the critic Michel
Tapié – also challenged realism during the 1940s. The heavily
impasted works of Jean Fautrier and Jean Dubuffet were a shock
for a select audience in 1945 to 1947. Fautrier's *Hostages* (cats
163–64) were both highly aestheticised and palpably gouged
and defaced with scars; exhibited during the *épuration* or purge
period of vicious reprisal killings all over France, their meaning
was not merely retrospective. Dubuffet's splattered and
graffitied bodies and landscapes counter the disturbing
combination of the erotic and tragic in Fautrier with a black,
anarchist humour and derision (cat. 172). The dimension of
the 'absurd' so important to existentialist philosophy is often
missing in the critical reception of postwar Giacometti: his *Tall
Figure* (1947; cat. 175) – the 'scream' of the 1940s – contains
that necessary element of the ridiculous that would reappear
in the writings of Samuel Beckett; Giacometti created the set for
Waiting for Godot at the Théâtre de l'Odéon in 1961 (fig. 12).

When Surrealism re-emerged in postwar Paris, at the
wealthy Galerie Maeght, it was hardly a Saint-Germain-des-Prés
phenomenon: painters such as Roberto Matta returned briefly
to Paris from America at this time (cat. 187). The Surrealist leader
André Breton's American sojourn was a source of constant
reproach from a younger generation of artists who had lived
through Europe's war inside or outside France, such as the Cobra
group which included artists from COpenhagen, BRussels and
Amsterdam. The former Surrealist writer Louis Aragon now
directed the French Communist Party's two-tier arts policy:
a socialist realism devoted to workers' struggles which was
deeply opposed to Surrealist frivolity, combined, when
expedient, with exhibitions and appearances at functions by
Party members Picasso or Léger or prestigious poets such as
Paul Eluard – like Aragon, a former Surrealist who was
convinced that Breton had been left behind by events. While
postwar Surrealism had a 'black-magic' emphasis, particularly
in the paintings of the Romanian Victor Brauner (cat. 190), a more
disturbing *rapprochement* was taking place between Surrealism
and what the artist Jean Dubuffet would call 'Art Brut' and the
medical establishment 'psychopathological' art, created by
schizophrenics and other 'outsiders'. The conjunction of the
great Surrealist show of 1947 with exhibitions of works by two
'mad' artists, William Blake and Vincent van Gogh, provided
the background – this time in Saint-Germain-des-Prés itself –
against which Antonin Artaud (see fig. 13), returning from years
of asylum incarceration, explored the limits of both body and
psyche in a performance at the Vieux-Colombier theatre. His
words were published constantly through the 1950s, 1960s and
1970s in experimental artistic and literary reviews; distributed
and broadcast, they would participate in the Parisian cacophony
of May 1968.

Against these extremes, and in the tradition of the measure
of 'Braque le patron' (Braque the boss), as the literary editor

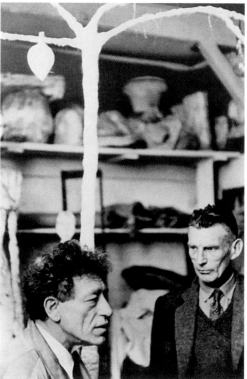

Figure 12

13 Jean Dubuffet, *Portrait of Artaud*, 1947
Oil on canvas, 128.9 × 94.6 cm
Morton J. Neumann Collection, New York

Figure 13

Jean Paulhan called him,[34] the new school of Paris flourished.[35] It combined figures from the patriotic, and often Catholic, Occupation group 'Young Painters of the French Tradition', such as Jean Bazaine, Maurice Estève and Charles Lapicque, whose bright, luminous canvases were influenced by older artists such as Pierre Bonnard, with Nicolas de Staël, who painted heavier, thickly impastoed structures. Trained in Brussels, de Staël was Russian in origin. His work hovered between abstraction and, eventually, a figuration perceptible in bold slabs of paint that contained memories of Chardin, Courbet and Eugène Boudin in tender reds, browns and pale blues and of Manet in audacious blacks. A new *japonisme* enters this painterly grouping in the work of artists such as Hans Hartung (cat. 202). Zao Wou-Ki was able to translate dimensions of his past training in classical Chinese landscape painting into the turbulent, formless swirls of what was now loosely called the Informel (cat. 206).

As the 1950s progressed, the heavily impastoed works of the immediate postwar period gave way to a brighter and more spiritual mood, even in the powerful works of Pierre Soulages, a painter normally associated with a very dark palette. The sense of light, liquidity and evanescence in works by Sam Francis (cat. 218), the *étoilement* – or starburst cracks of white – that show through the once-folded canvases of Simon Hantaï (cat. 222), signal a move away from the mud and *matière* of painting and the abject, victimised bodies of Dubuffet or Fautrier. The rejection of industrially produced paint in favour of pure pigment, the gold and the blue of Yves Klein (cat. 219) – who simultaneously implies weightlessness and flight by 'resurrecting' vertically the body imprints he has made (with nude 'female paintbrushes' working on the flat) – has its visual counterpart in sculpture too. Both Germaine Richier, who worked for the church, and whose Provençal bats became gold, angelic figures (cat. 192), and Niki de Saint Phalle, whose 'political' gold altarpiece mocks the ecclesiastical establishment (cat. 250), demonstrate the power of contemporary Catholicism in their art.

Quartier Latin: Paris in the 1960s

Two opposing movements bring us into the 1960s: geometric abstraction and Nouveau Réalisme. Geometric abstract art flourished from 1945 onwards, returning directly to the point reached by the last Salons of the 1930s before the interruptions of war and occupation. Indeed the veteran painter František Kupka (see cat. 41), who broke through to pure abstraction at the Salon d'Automne of 1912, sat on the committee of the Salon des Réalités Nouvelles through the 1950s. The dynamism of geometric, 'Op' and then kinetic art is demonstrated in this period: its 'historicist' dimension is revealed by Jean Tinguely's 'Meta-Malevich' series (1954; cat. 228) which parodies Kasimir Malevich, the Russian painter of the original 1915 'tabula-rasa' black square on white ground. Jesús Rafaël Soto's red *Penetrable Curtain* (cat. 242) cuts off this movement from the 'Paris of the Street' of the 1960s.

The work of the 'affichistes', artists who roamed the streets tearing posters off walls to exhibit them in art galleries, responds to the Algerian War (1954–62) as well as to the 'events of May'.

14 Georges Mathieu painting *The Battle of Hakata*,
Tokyo, 1957

15 *Eryximaque*, Biennale de Paris, 1965
Conception and body-painting by Myriam Bat-Yosef,
with improvised dance by Teresa Trujillo to sound
poetry by François Dufrêne

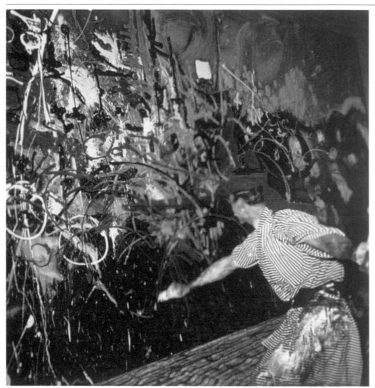

Figure 14

Niki de Saint Phalle's astonishing *Tirs* – shoot-out paintings
in which the canvas (body) literally bursts with paint (blood)
when aerosols of concealed paint are exploded by bullets –
provided a commentary on Franco-American relations, war,
the Church, and the condition of women in the 1960s (she was
in America during May '68). Art had already begun to move
towards performance, in Georges Mathieu's swashbuckling
public painting-performances (fig. 14), Yves Klein's 'female
paintbrushes' (fig. 16) and Niki de Saint Phalle's *Tirs* (cat. 247)
long before Jean-Jacques Lebel brought the American-style
'happening' to Paris; and interdisciplinary performance art
became increasingly significant (fig. 15). Christo's wrapped
motorcycle (1963; cat. 255), Arman's burnt armchair (1965;
cat. 253) – thrown, we imagine, by an *enragé* into the street –
create an atmosphere that reflects the anger and passion of
a period in which artists contributed to a mayhem that almost
brought down the government.

Revolution, intellectual, artistic or political, has always
been a constant in French art, as the philosopher Gilles Deleuze
understood. Despite the sense of crisis and the violence of May
1968, he would paradoxically claim 'there's no revolutionary
but a joyful one, no politically or aesthetically revolutionary
painting without joy'.[36] The live, political meanings of works
of art become lost or banished from amnesiac museums; they
must be restored, their revolutionary joy recaptured.

Why do we end the exhibition in 1968? In 1965, Georges
Mathieu exhibited the hugely confident canvas *Paris: Capital
of the Arts* (fig. 18) in riposte to the American challenge at the
1964 Venice Biennale, new dealer strategies and the animated
Paris–New York debates of the mid-1960s. Paris's violent

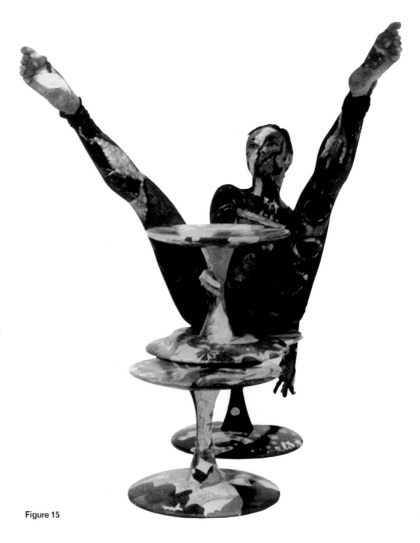

Figure 15

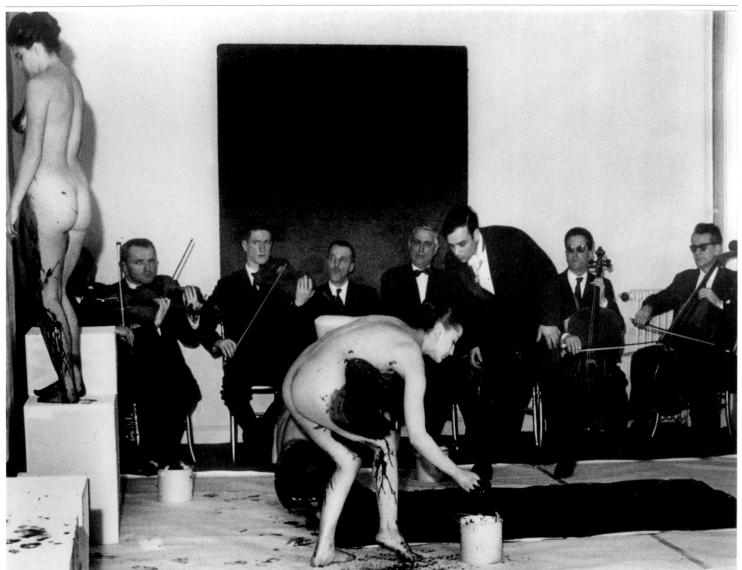

Figure 16

implosion of 1968 marked a caesura in the artistic life of the city itself, profoundly impacting upon its institutions and collective psyche. The 'après-mai' was melancholic, for artists, philosophers, politicians alike. Moreover, significant metamorphoses in the art world were taking place, such as Harald Szeemann's 1969 exhibition 'When Attitudes Become Form' in Berne. The decision of European curators such as Szeemann, and Pontus Hulten in Stockholm, to look away from Paris was significant.[37] Szeemann's 1972 Documenta exhibition in Kassel and its relationship to France's milestone retrospective 'Douze Ans d'art contemporain' (1960–72) could also have been taken as a *terminus ad quem*, but 1972 is a far less eloquent date in the public imagination.[38] This is despite the passionate continuation of French art debates in the 1970s, during the period of France's greatest theoretical prowess, and the active engagement with the visual arts not only of writers and critics but of philosophers such as Roland Barthes, Jean-François Lyotard, Michel Foucault, Julia Kristeva and Jacques Derrida.[39]

Paris–New York debates should be framed, moreover, within a comprehensive vision of the geopolitics of the art world which reflect France's historical alliances and continuing spheres of influence in broader, global terms. The key issues of Franco-Soviet relations from 1920 onwards should be considered, as should France's political, economic and cultural investments in Francophone Europe, the French-speaking Eastern European countries and her own colonies, as well as Canada (all countries involved imported the Beaux-Arts model from Paris).[40] Besides France's participations in the Venice and São Paulo Biennales, the Kassel Documenta and Montreal's 'Expo '67' (fig. 17) during the post-1945 period, recent analyses of Paris-based activities confirm these broader axes: the Paris–Poland axis of the 1950s and after; the Paris–Milan–Tokyo axis for the Informel ('informale'/ 'anformeru'), subsequently modified by neo-Dada and political figuration; Yves Klein's links with Japan, Italy and the German Zero Group; the gallerist Denise René's Latin-American strategies; or the 'revolutionary' visual arts axes

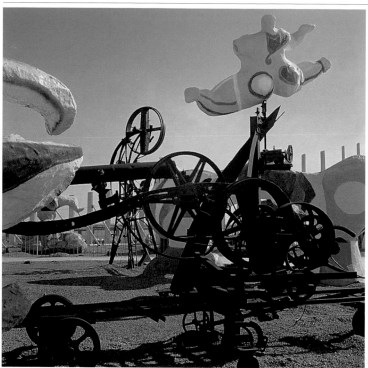

Figure 17

set up with Castro's Cuba or Mao's China.[41] On a micro-level, cultural discoveries, important friendships, shared readings, politics, passions and visual experiments mapped out each artist's individual destiny.[42]

Even before May 1968, the melancholic, self-reflexive blue *Murder* paintings of Jacques Monory (cat. 278), which would so attract Lyotard, posited a 'painting after painting' as a possible response to the problem of art in an era of art's vanishing logic.[43] Likewise Jean Tinguely, who challenged modernist absolutism with a neo-Dada humour, ends our exhibition with *Miramar* (1961; cat. 246), his dangling *Ballet of the Poor* – an absurd, Beckettian finale for the great tradition of sculpture.[44]

These postwar years and the issues they raised – not least those of the place for art in a period of reconstruction, colonial wars and revolution – formed the lived terrain of the future theorists of postmodernism. Yet there is a logic of development from Mallarmé, Picasso, Duchamp, Joyce and Benjamin before 1939 – magnificent *œuvres* by theoreticians of absence, of the fragment – to Artaud and Derrida as thinkers for our times. Paris's outstanding contribution to philosophy, literature, art and the humanist disciplines has shaped the twentieth century and our heritage. The twenty-first century will pose a new challenge.[45]

Figure 18

1 See Benjamin 1991; and Benjamin 1999.

2 The most stimulating essays in Tester's collection *The Flâneur* (Zygmunt Bauman's 'Desert Spectacular' and Stefan Morawski's 'The Hopeless Game of Flânerie', in Tester 1994, pp. 138–57 and 181–97) go beyond the nineteenth-century paradigm.

3 Ory 1994B, p. 361, quotes Alper and Bloch-Morhange 1980, who record the views of Paris of artistic immigrants of the 1950s and 1960s: the 'Mecca of the arts' and the 'city of light'.

4 Paul-Ernest de Rattier, *Paris n'existe pas*, 1857, pp. 137–38, in Benjamin 1999, p. 99.

5 Burroughs in Delanoë 1994, pp. 8–9.

6 The 'longue durée' was introduced as a concept in 1958: see Braudel 1958; and Ross 1995, pp. 188–90.

7 Halbwach's *Topographie légendaire des évangiles en Terre Sainte. Etude de mémoire collective* (1941), an investigation of the post-facto 'invention' of the Holy Land published just prior to his deportation, is particularly poignant in view of the remapping of Europe which was proceeding via concentration and extermination camps at the time. The subsequent metonymic use of the name 'Auschwitz' became a 'legendary' and inadequate substitute for the Holocaust within collective memory.

8 '…les martyrs décharnés de Buchenwald'; see Sartre 1948, quoted from 1992 edition, p. 303.

9 See Nora 1984; Nora 1986; and Nora 1992.

10 See Clark 1999, pp. 7, 2.

11 This is true of Tate Modern in London and the Museum of Modern Art, New York, in contrast to the new rooms of post-1945 art at the Musée National d'Art Moderne, Centre Georges Pompidou, Paris.

12 It is important to indicate here the joint publication Arp and El Lissitzky 1925.

13 Beyond the extensive monographical literature on Matisse and Léger and their writings one should indicate the important essays on the interrelationship between painting and cinema through the century in Marseilles 1989.

14 Bazaine's *Notes sur la peinture d'aujourd'hui* (1948) were re-edited in 1953, 1960, 1966 and 1990; and translated into Danish, Swedish, Turkish and Spanish, into German by the poet Paul Celan, and into Japanese, all before 1953. He illustrated works by poets such as André Frenaud, Jean Tardieu and Eugène Guillevic; made stained glass for projects all over Europe; designed several tapestries; and created sets and costumes for plays from the 1930s to the 1980s. Ceramic projects have included a wall for the Unesco Building (1960) and the mosaic *Wings and Flames* for the Cluny Métro station (1985–87). See Paris 1990.

15 For Buraglio's Chapelle de Saint-Symphorien, in many ways a homage to Matisse, see Armogathe 1993; Gibson 1995; and Linder 2000, pp. 202–10.

16 Assia Granatouroff (1911–1982), born in Ukraine, posed for the painters Derain, Kisling, Gromaire and Valadon, the sculptors Chana Orloff and Despiau, and photographers including Ergy Landau, Dora Maar, Roger Schalk and Emmanuel Sougez. See Mont-de-Marsan 1993. For Assia and Dina Vierny, see Wilson 2001.

17 See Granoff 1981; and Clert 1978. For Jeanne Bucher see Strasbourg 1994, and for Denise René, Paris 2001B and Gran Canaria 2001.

18 For Supports-Surfaces, see Paris 1998.

19 Boston 1996.

20 See Perry and Wilson 1997; reprinted in Gaze 2001.

21 See Guilbaut 1996, p. 329: 'That one of the most gifted painters of the period, Marie Raymond, was symbolically obliterated by Klein's female paintbrushes should give psychoanalytic art historians pause, given that Raymond was in fact Klein's mother.' (Guilbaut writes unaware of the exhibition held in Nice in 1993, thanks to work of the Yves Klein archive.) For a more pertinent comparison with the *femmes-pinceaux*, see the work of Myriam Bat-Yosef (fig. 15).

22 Burgess 1910, one of the first American newspaper accounts of contemporary developments in Paris, translated 'fauve' with the 'wild men' epithet.

23 See Apollinaire 1909; Apollinaire 1911; Apollinaire 1913B; Paris 1991B; and Paris 1993. Apollinaire's collaborations with André Derain for *L'Enchanteur pourrissant* (1909) and with Raoul Dufy for *Le Bestiaire ou Cortège d'Orphée* (1911), in which Apollinaire's medievalist and early Renaissance verse tropes are illustrated with stylistically complementary woodcuts, demonstrate a bibliophile and historicist countercurrent within early modernism, together with an interest in early European reproductive techniques which is underplayed in almost all art-historical accounts.

24 Figuière edited Gleizes and Metzinger's pioneering *Du 'Cubisme'* in 1912; Henri-Martin Barzun's *L'Ere du drame* in 1912; and Apollinaire's *Les Peintres cubistes: méditations esthétiques* in 1913.

25 Although many of these Ateliers continued – the Académie Charpentier still flourishes within the Académie de la Grande Chaumière complex – apparently, no equivalent for the twentieth century exists to John Milner's extensive *The Studios of Paris: The Capital of Art in the Late Nineteenth Century* (Milner 1988). Successful artists such as Lipchitz moved from Montparnasse to expensive modernist studios in the Boulogne suburbs of Paris by the later 1920s (see Culot and Foucart 1992) while municipal building programmes created new artists' quarters in suburban Montrouge in the 1930s, for example. Le Magnen and Valabrègue 1998 describe artists' studios still flourishing in La Ruche, the Cité Fleurie and Montmartre; the takeover of old artisans' studios; and the appropriation of new studio space such as the 'frigos' owned by the SNCF (French Railways). The 'red' suburbs Villejuif and Malakoff continue to be popular for groups and individual artists' studios.

26 For the centrality of brothels to the Parisian social and political fabric see 'Madame Sphinx' (alias Lemestre 1974); and Adler 1990.

27 For immigration to Paris see Kaspi and Marès 1989; Frank 1992; Ory 1994B; and for war memorials and memory, Sherman 1999.

28 See Hélène Seckel's essay on Picabia's Don Juanism in Paris 1976, pp. 35–39.

29 See Green 1987; and Green 2000 (surely definitive, although with very little on Art Deco). Michèle Cone's analysis of 1940s furniture, 'Wartime Gilt', shows the potential for the incorporation of the decorative arts into a serious period analysis (Cone 1999).

30 See Chave 1993; Jones 1994; and New York 1997, for example, following Chadwick 1985, Whitney Chadwick's classic, and entirely 'separatist', feminist analysis of women Surrealists.

31 Beyond the immediate depression, the Alsatian critic's Adolph Basler's *Le Cafard après la fête* (Basler 1929) introduced to France a pessimism based on Oswald Spengler's *Decline of the West* (1918–22) written prior to, but published in the wake of, the First World War.

32 See Brassaï 1964.

33 Hélion had been the adviser in New York for A. E. Gallatin's collection of geometric abstract art. *They Shall Not Have Me* (Hélion 1943) relates his war experiences. This generational issue is quite distinct from the ideological confrontations between abstraction and socialist realism within the Cold War Parisian art scene.

34 See Paulhan 1946.

35 For an extensive analysis of foreign artists in Paris after 1945 and the vicissitudes of the 'Ecole de Paris' label, see Bertrand-Dorléac 1994. For the 'School of Paris' versus the 'Ecole de Paris' label as interpreted outside France, see Barker 1993; and Wilson 1999.

36 'Il n'y a de révolutionnaire que joyeux, et de peinture esthétiquement et politiquement révolutionnaire que joyeuse.' Gilles Deleuze, 'Le Froid et le chaud' ('Cold and Heat'), 1973, on the painter Gérard Fromanger, in Deleuze, Foucault and Rifkin 1999, p. 77.

37 See Bonn 1996; Semin and Ewig 2000, incorporating Szeemann 2000; and Tesdorpf 2001. Meetings were held in Paris in November 1968 with the artists Agam, Sarkis and Buren. Discussions on Paris as the possible first venue of 'When Attitudes Become Form. Live in Your Head. (Works, Concepts, Processes, Situations, Information)' took place between Pierre Gaudibert, Director of ARC (Animation Recherche Confrontation), Musée de la Ville de Paris, and Blaise Gauthier and Gemain Viatte of the CNAC (Centre National de l'Art Contemporain). The publicity requirements of the capitalist American tobacco sponsors, Philip Morris, were, it is speculated, unthinkable in the post-May '68 climate. The extremely influential show, which incorporated the alternative aesthetics of Arturo Schwarz's Milan show 'Towards a Cold Poetic Image' (1967) and the Kassel Documenta of 1968 (arte povera, conceptualism, minimalism), opened in April 1969 in Berne and toured to London and Krefeld. Alain Jacquet, Sarkis and Klein were the only French artists represented.

38 Compare Kassel 1955 with Kassel 1972; and see Clair 1972; and Paris 1972.

39 See for example Paris 1986B; Lyotard 1998; and Deleuze, Foucault and Rifkin 1999. The gallerist Aimé Maeght's magnificent lithographed series *Derrière le Miroir* (December 1946–June 1982), which brought artists together with poets, writers and philosophers such as Jean Genet and Sartre before 1960, continued, with Bachelard, Foucault and Derrida, and writers such as Italo Calvino, Paul Auster and Alain Robbe-Grillet through the 1970s. See Tours 1986B. All these conjunctions symbolised far wider discourses. Julia Kristeva prefaced an Alain Kirili exhibition in 1985.

40 See Ory 1994B. The Association Française d'Action Artistique (AFAA, founded in 1922) has had a crucial organisational and budgetary role in translating the 'diplomatic and geographic imperatives of the Quai d'Orsay' (Piniau and Tio Bellido 1998, p. 127). For the diplomatic voyages of the Popular Front arts minister Jean Zay, see Piniau and Tio Bellido 1998, p. 51; for the focus on geopolitical alignments from 1932, see p. 65; for the extension from Europe and the United States to Latin America, and subsequently to Eastern Europe and the Soviet Union after 1954, and post-colonial imperatives in francophone Africa, see pp. 82–93; for the succession of Venice Biennale prizes, 1948–60, versus the perils of eclecticism, see pp. 96–97; and for France's official universalist project versus self-examination and crisis, see p. 151. The AFAA has always been responsible for France's Venice Biennale exhibitions; see Venice 1990.

41 See Piene and Mach 1973; Lyons 1992B; Dorroh 1998; Groom 1998; Scoppetone 1998; and the Paris-based presence in the international art chronology, 1960–90, in Paris 1993B, pp. 201–63.

42 See as an exemplary instance Reut-Arman 2000, for Arman's friends, acquaintances, connections and souvenirs (with Arman's photographs).

43 See Lyotard 1998 (with texts on Monory of 1972 and 1981).

44 Tinguely's sculpture/décor *Miramar*, popularly named *Ballet of the Poor* (1961; cat. 246), was created for the interior of the exhibition 'Rorelse I Konsten', the Stockholm Moderna Museet version of the Amsterdam Stedelijk Museum's 'Bewogen, bewegen' (which involved many of Denise René's artists). Robert Rauschenberg performed a 'dance-happening' at the opening, which was attended by Agam, Calder, Duchamp, Niki de Saint Phalle, Spoerri and others. See Venice 1987, p. 97. Tinguely's *Miramar* stands for a host of Paris-based commissions for Opéra sets by Léonor Fini (1965), by Tinguely himself and Niki de Saint Phalle (1966: *Eloge de la folie*, danced by Nureyev and Fontaine), by Martial Raysse (1967), and by Max Ernst (1968). See de Bonneville 1983.

45 The Paris-based writer Juan Goytisolo poses the question 'Paris, Capital of the Twenty-First Century?' (1990) in terms of alternative options: a greater internationalism and a richly polyphonic cultural mixing versus an introspective European 'heritage' culture. See Goytisolo 1997, especially pp. 141–44.

1

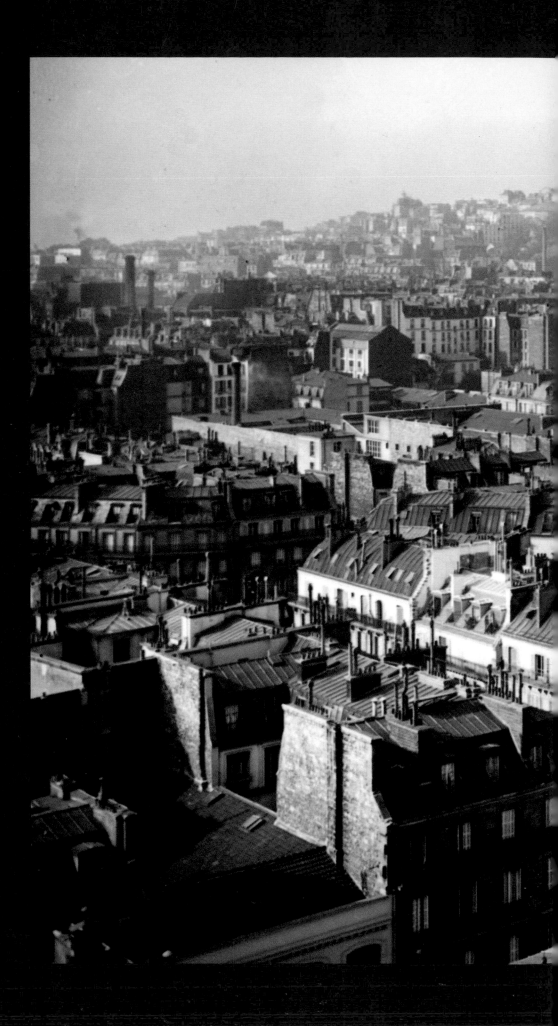

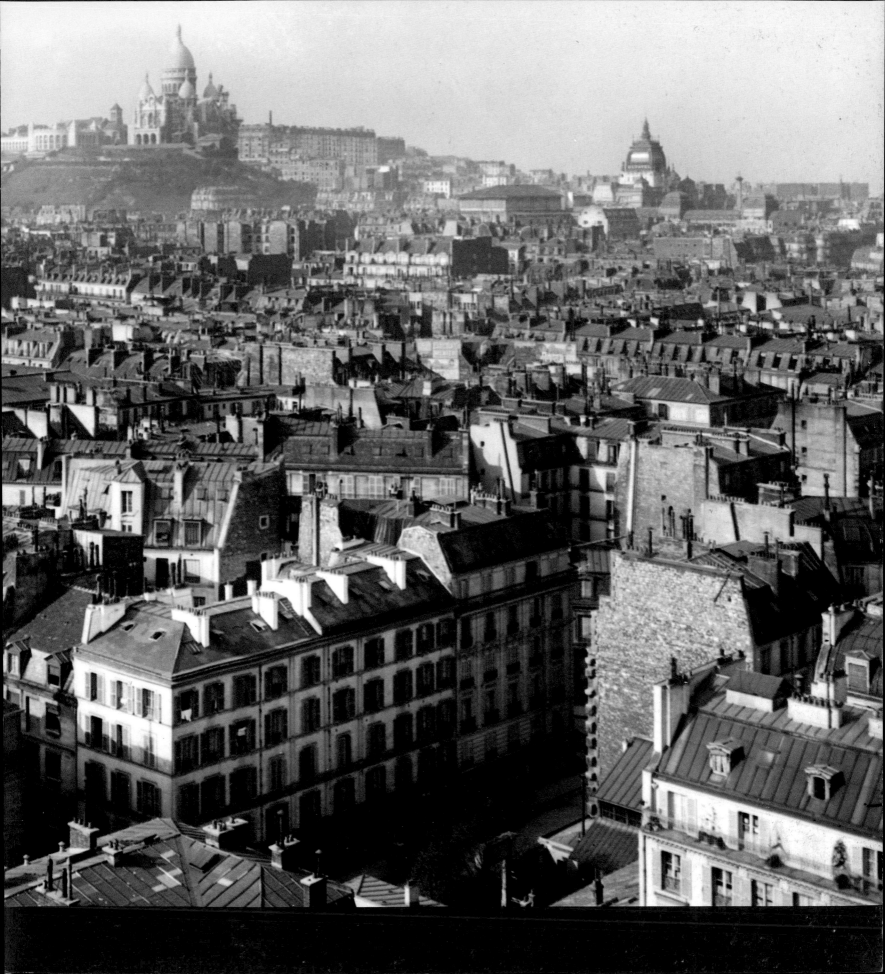

Nicholas Hewitt

Montmartre: Artistic Revolution

The landscape of pleasure

The 'most important pictorial revolution since the Renaissance',[1] ushered in by *Les Demoiselles d'Avignon* (1907), did not happen by chance in Picasso's studio in the Bateau-Lavoir. Drawing upon the immediate experiments of the Fauves, the discovery of African art, and the 'primitivism' of 'Douanier' Rousseau, it was also intimately dependant upon the recent cultural history of Montmartre, an area which became, from the 1880s to the outbreak of the First World War, a major international centre of the avant-garde.

The origins of Montmartre's prominence as a centre for Parisian pleasure go back far into the Ancien Régime, when the Butte de Montmartre was an attractive village outside the city, and the area below the hill a district famous for its taverns and prostitutes. The crucial event in its development, however, was the construction in 1784 of the Mur des Fermiers Généraux which encircled the capital and maintained high taxation, particularly on wine, inside Paris, leaving the districts outside lightly taxed. The effect of this was to create a pleasure-zone around the city along the lines of the wall, with thriving clusters of dance-halls and taverns at the crossing-points, the 'barrières'.[2] Montmartre gained a huge impetus from the wall, which ran on the line of the future 'Boulevards Extérieurs' of Rochechouart, La Chapelle and Clichy, with 'barrières' at what were to become the Place Pigalle, the Place Blanche and the Place de Clichy. With the annexation in 1861 of the outlying districts, the whole of Montmartre was absorbed by the city, and saw its role as a centre of entertainment enhanced by improved communications and street-lighting.[3]

The 'événement' in the creation of modern Montmartre was the opening in December 1881 of the first artistic cabaret, Le Chat Noir (fig. 20), on the Boulevard Rochechouart.[4] Initially, Le Chat Noir was merely a venue for bohemians at which poets and singers could perform their latest works. Very rapidly, however, Rodolphe Salis transformed his cabaret into a centre of modern entertainment, with recitations, songs, music and elaborate shadow-plays designed by the cartoonist Caran d'Ache. The key to the success of Le Chat Noir and other similar establishments such as Le Divan Japonais, Le Rat Mort and Aristide Bruant's Le Mirliton was that they continued to nurture bohemian and artistic groups, such as the Incohérents who organised seven exhibitions between August 1882 and the spring of 1893,[5] while at the same time attracting a commercial clientele from the Parisian bourgeoisie.

The key to the cabarets, and the element which provides a link with the avant-garde of the 1900s, was 'fumisterie': elaborate practical jokes, wrapped in fantasy and dazzling wordplay. The cabarets were dominated by humorists, of whom the most important was Alphonse Allais, effectively the inventor of a new form of French humour, derived from that of Mark Twain and English nonsense stories, which cultivated the Absurd and Black Humour.[6] It is no coincidence, therefore, that Allais, who features in the Surrealist leader André Breton's *Anthologie de l'humour noir* (1938), rubbed shoulders in Le Chat Noir with avant-garde figures such as the composer Erik Satie and the playwright Alfred Jarry, whose *Ubu* cycle (fig. 19) also presents iconoclasm, absurdity and fantasy. Another characteristic which links the cabaret humorists with the avant-garde of the 1900s is a fascination with machines and technological innovation: many were seriously interested in scientific inventions (the 'chansonnier' Charles Cros patented the phonograph months before Edison) but they also subverted science by taking invention to absurd extremes.

The work of the Montmartre humorists was intimately connected with the rise, following the press law of 1881, of weekly publications such as *Le Rire*, *Le Sourire*, *La Vie parisienne*, *Le Frou-Frou* and the more radical

Figure 19

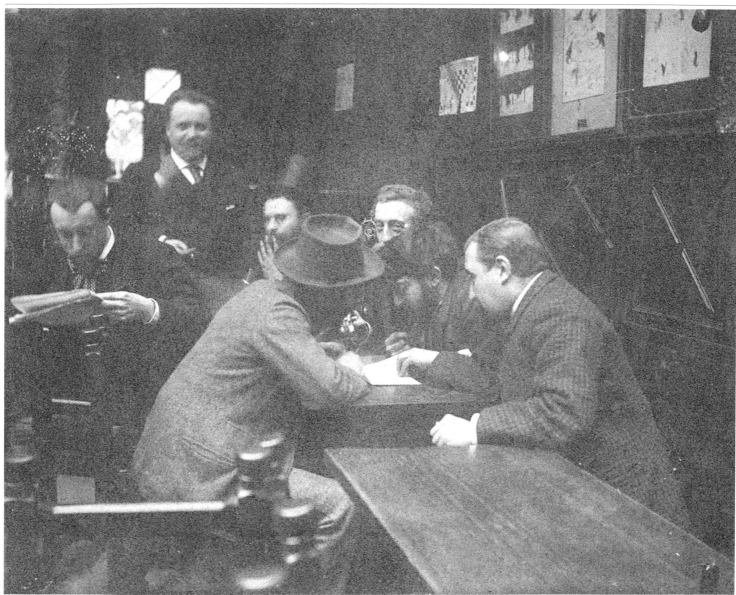

Figure 20

L'*Assiette au beurre*. In addition, most Montmartre cabarets produced their own journals, such as *Le Chat Noir* or *Le Mirliton*, which served as outlets for their humorists and 'chansonniers' but also publicised the various establishments and Montmartre generally to a national and international audience: not for nothing did provincial or foreign artists and bohemians head automatically for Montmartre when they came to Paris. Weekly publications were a particularly important interface between avant-garde artists and mainstream, even popular, culture: Picasso contributed to *Le Frou-Frou*, and Marcel Duchamp to *Le Rire* and *Le Courrier français*, while *L'Assiette au beurre*, with its radical libertarian stance, attracted work from František Kupka, Juan

Gris, Marcoussis, Kees van Dongen and Galanis.[7]

In Montmartre, the phenomenon of the artistic cabarets was accompanied by an expansion of mass popular entertainment. Dance-halls proliferated along the Mur and at the 'barrières', as well as on the Butte, and operated with increasing sophistication. On the Butte, the Moulin de la Galette evolved from a simple dance-hall dispensing wine and cakes ('galettes') into an establishment with gas lighting, professional dancers and a weekly programme of activities which effectively segregated the clientele of local regular visitors, depicted by Renoir in his painting of 1876, from 'le Tout-Paris'.[8] On the Boulevard Rochechouart, L'Elysée-Montmartre was always more associated with

crime and prostitution. It had considerable success as the venue for the 'fêtes costumées' organised by Jules Roques on behalf of Pastilles Géraudel, culminating in the notorious first 'Bal des Quat'z'Arts' in 1892.

With their professional dancers, the Montmartre dance-halls had already begun to employ forms of entertainment exploited by their rivals the music-halls, which would eventually drive them out of business. The earliest music-hall was the Folies-Bergère, founded in 1869, which introduced circus attractions, such as trapeze artists, and ballets copied from the London Alhambra.[9] In 1886, the Folies-Bergère adopted the format of the 'revue à grand spectacle' which it has cultivated ever since. The real revolution, however, came in 1889, with the opening

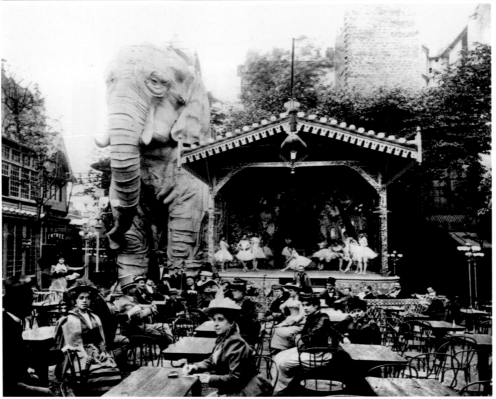

Figure 21

of the Moulin-Rouge (fig. 21). Designed
by Willette, this music-hall is a powerful
example of a persistent strain of inherent
inauthenticity or kitsch in Montmartre
culture: it was never a real windmill. The
Moulin-Rouge comprised a garden with a
stage, on which Yvette Guilbert, who had
begun her career with Salis at Le Chat Noir,
became a major star, and, inside, a dance-hall,
with a promenade from which clients could
observe the dancers or watch side-shows.

The popularity of the music-hall at the end
of the nineteeth century was matched by the
equal enthusiasm in Paris for the circus, which
had virtually a cult following by the end of the
century. Montmartre housed one of the three
circuses in Paris, the Cirque Fernando (later
called the Cirque Médrano)[10] which became
a regular subject for artists from Degas and
Seurat to Toulouse-Lautrec and the Cubists.
One reason for the popularity of the circus
among artists was the fact that the Cirque
Fernando/Médrano, holding a mere 2,500
spectators, was relatively small-scale (unlike
its American equivalents), and was thus able
to create 'an intimacy and a rapport between
performers and audience'.[11] The same could
not be said of the Hippodrome, on the corner
of the Place de Clichy, which specialised in
lavish spectacles, such as riding displays,

its own circus, pantomimes, chariot races and
epic performances like *Vercingétorix*.[12] Even
this, however, could not satisfy the public's
taste for novelty for long, and in 1907 the
Hippodrome was turned into the largest
cinema in Paris, the Gaumont-Palace.

Like the origins of the Moulin-Rouge itself,
a considerable measure of inauthenticity
existed in the 'packaging' of Montmartre
as a pleasure-centre. In one respect at least,
however, Montmartre lived up to its
reputation, and that concerned the availability
of easy sex. The area had a long history of
prostitution, reinforced by the development
of 'brasseries à femmes', of which Manet's
Le Bar aux Folies-Bergère (1882) is an example.
The arrival of the dance-halls and music-
halls expanded the market for prostitution,
which was also massively increased by the
Exhibitions of 1889 and 1900. At the same
time, improvements in transport and
communications and the introduction of
electric street lighting and gas and electric
interior lighting combined to create not
merely the 'Ville Lumière' but also the
international image of 'Paris by Night', with
its connotations of permanently available,
illicit pleasure.

One of the features of the redevelopment
of Paris under Baron Haussmann had been the

22 The Cabaret des Assassins, later Le Lapin Agile, 4 Rue des Saules, Montmartre, c. 1900

23 Pablo Picasso, *At the Lapin Agile*, 1905
Oil on canvas, 99 × 100.3 cm
The Metropolitan Museum of Art, New York:
The Walter H. and Leonore Annenberg Collection.
Partial Gift of Walter H. and Leonore Annenberg, 1992

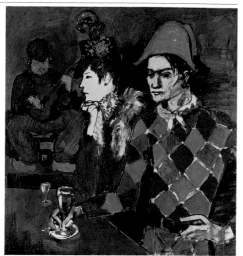

Figure 23

expansion of the city to the north, accompanied by a similar displacement of artistic activity. The new apartment buildings in the Ninth and Eighteenth Arrondissements provided artists' studios on their top floors.[13] In addition, in Montmartre, as in Montparnasse, older artisanal buildings existed which could be colonised by artists for studios: the Bateau-Lavoir, for example, inhabited by Picasso, Max Jacob, van Dongen, Juan Gris and other avant-garde artists and writers, was a former piano factory built in 1860. At the same time, the growth of cafés and restaurants which benefited from gas and then electric lighting to stay open for long hours was conducive to the rise of artistic communities. The change was dramatic: most of the Impressionists, for example, lived in Montmartre and used the Café Guerbois and later La Nouvelle Athènes as their headquarters. This artistic colony was reinforced by the establishment of the Rue Laffitte as a major centre for art dealers such as Bernheim Jeune, Wildenstein and Durand-Ruel.[14] They were joined at the turn of the century by Ambroise Vollard and Berthe Weill, who helped to launch the Fauves and Cubists.

By the time Picasso moved into the Bateau-Lavoir in 1904, Montmartre had all the prerequisites for a flourishing international bohemia: inexpensive accommodation and studio space, not yet excessively affected by the expansion of the city or mass-tourism; cheap cafés, restaurants and a night-life conducive both to bohemian conviviality and artistic inspiration; and an established artistic community comprising musicians like Erik Satie, writers from the Symbolist and Naturalist traditions, as well as from the avant-garde, and painters from both the Impressionist and Nabi schools. At the same time, the area offered a pleasing marginality between bourgeois affluence and working-class radicalism, together with all the trappings of modern mass culture. Small wonder, therefore, that Montmartre should have become a magnet for French and non-French writers and artists, and, by the turn of the century, a major international crucible of the European avant-garde.

1900s bohemia

The centre of 1900s bohemia in Montmartre was the tavern in the Rue des Saules known as Le Lapin Agile (fig. 22), which was named after the caricaturist and former Communard André Gill, who had painted the inn-sign.[15]

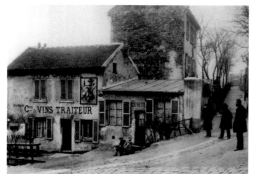

Figure 22

After a succession of owners, the inn was taken over by Aristide Bruant, who employed as manager a former fishmonger, Frédéric Gérard, known as Frédé, who had formally run a Montmartre bar called Le Zut.[16] Under Frédé's management, 'from 1900 to about 1910, this unremarkable pub was a real magnet for artists of the Butte, a sort of cultural institution for bohemians'.[17] The format of the entertainment was similar to that of Montmartre's other bohemian venues, with poets and singers performing their own work. The young writer Francis Carco, newly arrived from the South, performed songs by Félix Mayol, while, for the avant-garde, 'absurd stories and pre-Dada songs by Jules Depaquit had no less success'.[18] The main room was decorated with a huge plaster Christ by the sculptor L. J. Wasley, and by paintings donated by clients: one by Suzanne Valadon, three Utrillos and notably Picasso's *At the Lapin Agile* (1905; fig. 23). The clientele was mixed: young apprentice painters ('rapins'); avant-garde artists and their more traditional or commercial colleagues, like Francisque Poulbot, the creator of Montmartre's caricatural street-urchins; and writers like the avant-garde poets André Salmon and Max Jacob and the future realist novelists Pierre Mac Orlan, Roland Dorgelès and Francis Carco. This artistic community lived in uneasy proximity to Zo d'Axa's anarchists from *Le Libertaire* and, more seriously, criminals who came up from the working-class districts to the east: in 1911, Frédé's stepson Victor was murdered behind the bar.

Nor were these the only tensions: within the bohemian community itself considerable

antagonism existed between the avant-garde artists known disparagingly as the 'bande à Picasso' and the traditionalists, headed by Dorgelès, who perpetrated the famous 'Boronali' hoax in 1910 (fig. 24). With the help of André Warnod, Dorgelès tied a paintbrush to the tail of Frédé's donkey, Aliboron. The resulting canvas, *Sunset over the Adriatic*, was exhibited to general respect at the Salon des Indépendants under the name 'Boronali', an alleged member of the 'Excessivist' School. This was an important instance of Montmartre 'fumisterie', a side-swipe at both Cubists and Futurists, and, incidentally, an early example of both Montmartre's traditionalism and xenophobia. In fact, a powerful strain of Montmartre realism and whimsicality coexisted with the avant-garde and, on the Butte at least, outlived it. Théophile-Alexandre Steinlen, Willette and Poulbot were successful artists who achieved considerable commercial popularity. In particular, Montmartre traditionalists championed Utrillo, whose 'White Period' paintings of Montmartre street scenes helped to 'fix' a certain image of the Butte as surely as Toulouse-Lautrec fixed Lower Montmartre as a pleasure-centre. Significantly, Utrillo's paintings of this period (cat. 20) were based on postcards and photographs, not the locations themselves, both because Utrillo feared the mockery of the Montmartre street-children and also because his mother, that quintessential Montmartre figure, the model and painter Suzanne Valadon (see cat. 19; fig. 25), was often obliged to lock him inside.

Montmartre avant-gardes

In 1900 when Picasso first arrived in Paris from Barcelona he gravitated quickly to Montmartre. During this and the subsequent visits he made before finally settling there in 1904 he plunged himself into Montmartre's bohemian world, with its circuses, cabarets and *café-concerts*. In Picasso's hands these familiar images acquired an added expressionism and heightened palette, derived partly from Van Gogh, in such lurid scenes of Montmartre night-life as *Le Divan japonais* (cat. 2) or *Le Moulin de la Galette* (fig. 26) which suggest stronger affinities with the menacing ambience of Kirchner's Berlin nocturnes than the halcyon innocence of Renoir's Impressionist view of the famous music-hall. These vivid vignettes of Montmartre life caught the eye of the enterprising dealer Ambroise Vollard who had arrived from the Ile de la Réunion a few years before. His offer of a one-man show in his little gallery on the Rue Laffitte spurred Picasso to produce a series of quickly brushed oils mostly painted on cardboard.

These Parisian subjects soon gave way to the more timeless figures of his famously pathos-soaked Blue Period. Although the majority of Picasso's Blue Period pictures were painted in Barcelona, a series of his images of prostitutes from the St Lazare hospital near Montmartre which date from 1901 are painted in the same distinctive style. But the mood soon shifted to the elegiac *tristesse* that pervades the scenes of graceful acrobats and melancholy harlequins who were a regular

Figure 25

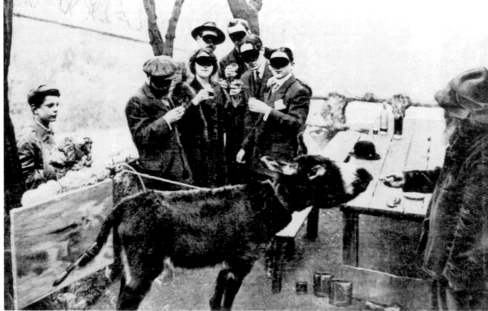

Figure 24

26 Pablo Picasso, *Le Moulin de la Galette*, 1900
Oil on canvas, 88.2 × 115.5 cm
Solomon R. Guggenheim Museum, New York:
Thannhauser Collection. Gift of Justin K.
Thannhauser, 1978

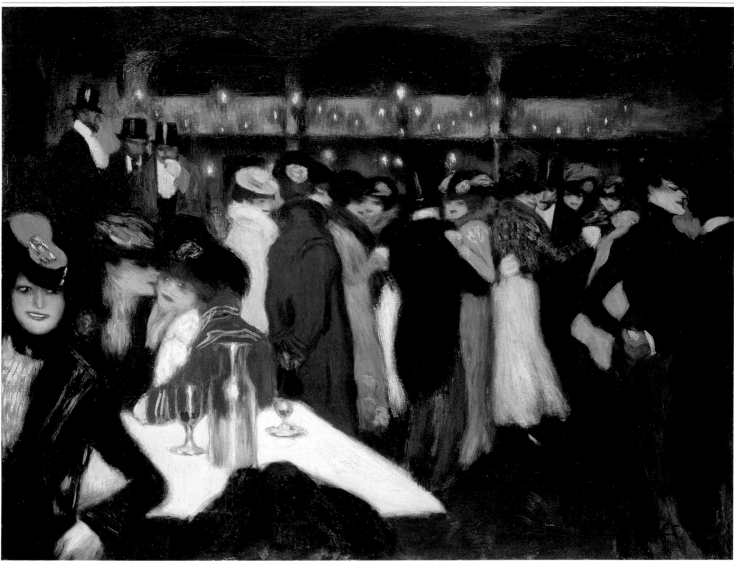

Figure 26

feature of the outdoor fairs performed on the *terrain vague* of Montmartre.

A few years later at the Salon d'Automne of 1905, Matisse's *Woman with a Hat* and works by a group of his followers caused a sensation with the unshackled aggression of their brush strokes and the violence of their colours that were sometimes, at least in Vlaminck's case, squeezed directly from the tube.[19] The critic Louis Vauxcelles was sufficiently provoked to compare them to wild beasts – 'fauves' – and the name stuck.[20] The leaders of the Fauve group, Derain and Vlaminck, pursued their experiments not in Paris but in Chatou a few miles out along the Seine. There they made postcard views of an uneventful suburb pulsate with the dazzling, fiery light of more southern climes. This search for incandescent luminosity lured them to the Mediterranean itself where, inspired by Matisse's *Luxe, calme*

et volupté (fig. 58), painted in St Tropez in 1904, they recaptured Golden Age subject matter in landscapes painted on the Côte d'Azur. The following year Derain painted at L'Estaque and in 1907 Braque was at La Ciotat. Several of these artists however, including Derain, had studios in Montmartre and would sometimes harness their new and vibrant style of painting to such typical local subjects as the dancers at the Rat Mort cabaret (cat. 3).

Although short-lived, Fauvism was remarkably international in its range. A number of foreign artists who gravitated towards Paris were seduced not just by the sheer physicality of the works produced by the 'wild men of Paris', but also by their liberation from academic tradition. Auguste Chabaud, the Czech František Kupka and the Dutchman Kees van Dongen each shared a search for the kind of visual innocence to be

found in children's or folk art. Although van Dongen is associated with Fauvism he touches only on its periphery. He was not primarily concerned with landscape but with the world of popular entertainment – the Cirque Médrano, the *café-concerts* – and by decorative nudes and portraits. His striking portrait of Fernande Olivier (cat. 5), Picasso's mistress during these years, is one of the rare occasions she posed semi-nude, probably in Picasso's absence. In his portrait of Daniel-Henry Kahnweiler, the young German art dealer who was soon to become the pioneering champion of Picasso's and Braque's Cubist paintings, van Dongen reduces his subject to a simplified iconic mask in bold black against a blood-red ground (cat. 11). Indeed, red and black became almost a hallmark in the vivid interiors and nudes painted by Auguste Chabaud (cats 7, 8) during this period; the two

colours were something of a fashion among Montmartre painters generally. They are also much in evidence in the palette employed by the Englishman Walter Sickert in *Théâtre de Montmartre* (cat. 10).

The quest for an innocent vision would account later on for the enthusiasm of Picasso and his friends for the 'naive' paintings of 'Douanier' Rousseau. A famous banquet was given in his honour in Picasso's studio in 1908.[21] Picasso's great friends the critic and poet Guillaume Apollinaire and his companion the painter Marie Laurencin are frozen in the still formality of a nineteenth-century photograph in Rousseau's double portrait *The Poet and His Muse*.

During 1906 and 1907, sequestered in the chaos of his Bateau-Lavoir studio, Picasso was engaged in a far more profound experiment that was infinitely more radical and far-reaching in its implications than anything attained by the Fauves: *Les Demoiselles d'Avignon* (fig. 1) completed in 1907, has become a landmark in the history of modern art. The still undiminished rawness and the immediacy of the painting's impact belie its lengthy and reflective genesis.[22] Numerous preparatory studies in which Picasso works through different configurations of the figures and their poses (cats 16–18) reveal the rich diversity of his sources. Ancient Iberian art, stone carving and above all African masks (an epiphany for him when he first visited the Musée Ethnographique du Trocadéro in 1906) equipped the artist with a new primitivising energy. The retrospective exhibition devoted to the work of Cézanne in the Salon d'Automne of 1907 had a profound effect on Picasso and many of his contemporaries. The impact not only of the willed awkwardness of Cézanne's figures,[23] especially the late bathers, but also his distinctive means of fusing multiple viewpoints in his scrutiny of a single object is felt in *Les Demoiselles* and, a few years later, in the first Cubist paintings created by Picasso and Braque.

When Picasso finally 'unveiled' his modern masterpiece, his literary friends André Salmon and Max Jacob were dumbstruck. Braque, hesitant at first, soon joined Picasso on his great artistic adventure into Cubism. 'Roped together like mountaineers', the two went on to form a completely new language for painting. Taking Cézanne's simultaneous viewpoints as their

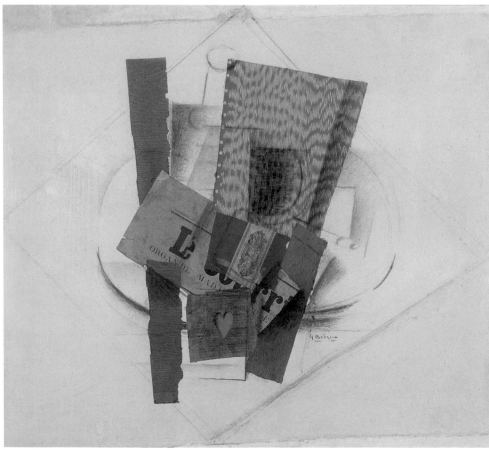

Figure 27

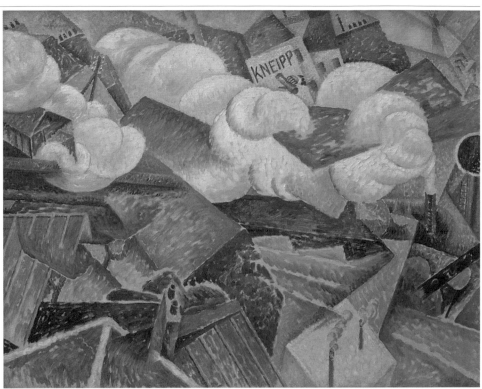

Figure 29

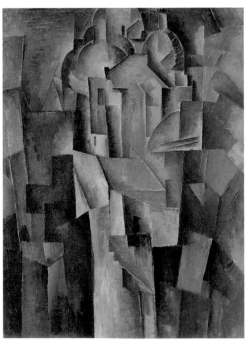

Figure 28

starting point they produced shimmering and hermetic compositions in muted but subtle browns, greens and ochres. These works of the so-called Analytical Cubist phase of 1910–12 suggest an allusive and shifting world that is both spiritual and intellectual. Their pictorial language, as has often been noted, has affinities with the evocative poetry of Mallarmé.[24]

After the first phase of austere Cubist experiment, Picasso and Braque broke the boundaries of the arcane and self-referential world they had created and began to enrich their pictorial vocabulary with references to, and soon physical fragments of, the world around them, drawing especially on the popular entertainments of Montmartre.[25] In 1911, for the first time, Picasso added words to a painting: 'Ma Jolie' (the refrain from a popular music-hall song).[26] Such references were soon expanded to include sheet music, snippets of advertising slogans and all kinds of detritus and ephemera that floated into the dense and increasingly decorative fabric of these Cubist compositions, creating a collaged universe of pasted materials (fig. 27). Syllables from truncated brand labels or newspaper clippings became the springboards for puns and wordplays that echo the subversive wit of the music-hall.[27] As we will see, Apollinaire, who became one of the Cubists' chief

apologists, used typography in a brilliant and erratic way that is a counterpart to the Cubists' wordplay.

Outside Le Chat Noir was a sign reading: 'Passant, sois moderne!'. Modernity was a central theme of Montmartre culture from the 1880s until the First World War. Avant-garde artists and writers in the 1900s were acutely conscious of living in a new century and they celebrated all aspects of the modern world with enthusiasm. The changing skyline of Paris, resisted and derided by traditionalists, was warmly welcomed by the avant-garde. The Eiffel Tower made frequent appearances, especially in Delaunay's work (cats 27, 30), while Braque's *Montmartre with the Sacré-Coeur* (1910; fig. 28) features the still unfinished and widely despised basilica. At the same time, the avant-garde shared with the cabaret humorists an interest in new technology, particularly in its relationship to speed. The Futurists celebrated the railways (fig. 29) and especially the motor-car and aeroplane, themes also pursued by the Cubists: in Delaunay's *L'Equipe de Cardiff* (1913; fig. 30), Blériot's biplane flies over the Eiffel Tower, advertising hoardings for the great wheel, and Welsh rugby players, those other symbols of modernity. Significantly, Picasso, fully conscious of the pioneering role he shared with Braque as an *inventor* of

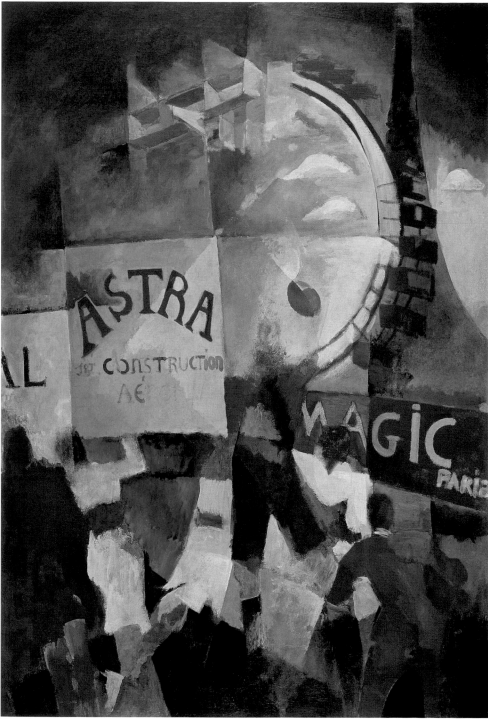

Figure 30

a new art, frequently addressed him as 'Mon cher Vilbure' [*sic*]: a homage to the Wright brothers,[28] but also an assertion of the painter as artisan and engineer, linked to the use of workmen's raw materials in the collages.

While continuing to be fascinated by nineteenth-century forms of popular entertainment such as the circus and the music-hall, members of the twentieth-century avant-garde embraced new forms of mass culture, such as the cinema and sport. The rugby players in Delaunay's *L'Equipe de Cardiff* are less the product of eyewitness observation than the reflection of a poster or a newspaper photograph: they remind us not only that the avant-garde was more interested in the artefacts of modern mass culture than in the activities *per se*, but that these artefacts had themselves become part of the twentieth-

31 Blaise Cendrars and Sonia Delaunay, *La Prose du Transsibérien et de la petite Jehanne de France* (unfolded overview), 1913
Watercolour and relief print on paper support, 195.6 × 35.6 cm
Musée Zadkine Collection

Figure 31

century cityscape. As Kirk Varnedoe and Adam Gopnik comment in their evocation of a turn-of-the-century artist returning from the Louvre to his studio: 'Beside, beneath and behind him in that stroll, in the apparently trivial and marginal things taken for granted along his path – in the cheap reproductions he brushed past on his way out of the museum, in the brightly coloured commercial posters along the boulevard and in the shop windows of the department stores, in the newspapers and cartoon journals of the morning, stacked up in kiosks along the quai, and even in the mean scrawlings on the walls of the darkened side streets – was an alphabet for art's new language. There, in germ, lay another telling power of the coming age – modern urban culture…'.[29] This new language offered the incorporation of allusions to posters and hoardings, Métro tickets, wine-bottle labels and newspapers in avant-garde painting, and, in poetry, to celebrations of journalism and advertising as the new culture.[30] In Cubist painting, Braque and Picasso rapidly moved from the use of newspapers as 'accessories',[31] to the incorporation, in Avignon in the summer of 1912, of decorators' materials, such as 'faux-bois' wallpaper, and, finally, newspaper cuttings. Juan Gris was also working towards the same conclusion, so that, by the time Braque departed for the war in 1914, all three artists had produced a large number of 'papiers collés' 'that seemingly rerouted the printed ephemera of the café table and the city streets into the studio and onto the easel'.[32] Similarly, advertising and window displays, which effectively isolated familiar objects in unfamiliar circumstances, informed the later experiments of Marcel Duchamp, Francis Picabia and the Dadaists, as they looked back to the humorists of the 1890s. The incorporation of the ephemera of mass culture into the visual arts was reflected in literature, too, as is demonstrated by the massive popularity of science fiction and crime-writing among the avant-gardists. Apollinaire and his circle particularly admired the *Fantômas* series, perhaps because it served as an engaging metaphor of the subversion operating deep within bourgeois Parisian society. Similarly, composers like Satie borrowed the rhythms and harmonies of popular music, which was now available to a mass audience through the advent of the gramophone.

One of the most remarkable features of the Parisian and especially the Montmartre avant-garde of the pre-war period is the close association that existed between painters, sculptors and writers. Figures such as Apollinaire in his review *Soirées de Paris*, Salmon in *Montjoie!*, Pierre Reverdy in *Nord-Sud* and Pierre Albert-Birot in the Left-Bank review *Sic* acted not only as impresarios and publicists for the avant-garde but also illustrated its principles in their own work.[33] In fact, one of the best introductions to the practice of Cubism and Simultaneism is through the work of the poets, for whom 'concision and visual appearance are essential concerns'.[34] Apollinaire, in his collection *Alcools*, dispenses with punctuation and in his poem 'Zone' provides a 'Simultaneist' evocation of modern Paris, including the city's mass-cultural artefacts and various allusions to aviation and 'art nègre'. In the later *Calligrammes*, originally entitled 'Moi aussi je suis peintre', he moves, through the exploitation of modern typographical possibilities, from the lyricism of *Alcools* to a 'plastic poetry' which regresses towards the state in which individual letters must be constantly reinterpreted to provide both a syntactical meaning and a visual image. Similar experiments were undertaken by Reverdy in his *Poèmes en prose* (1915) and his novel *Le Voleur de Talan*, and by Max Jacob in *Le Cornet à dés* (1917). Not only do the authors of these prose poems reflect the attempts of painters to capture simultaneous action and various points of view on one surface, but they also use typography both to create the poem as a visual image in its own right and to destroy any primacy of point of view. Reverdy, for example, places a number of blocks of print on the page which may be read in any order[35] and Albert-Birot experiments with the typography of modern advertising to produce 'poèmes-affiches'.[36] Possibly the most significant example of collaboration between poets and artists was the 'Simultaneist' *La Prose du Transsibérien et de la petite Jehanne de France* (1913; fig. 31) by Blaise Cendrars, 'a poem over six feet in length, which was printed in letters of different colours and sizes on an abstract coloured background designed by Sonia Delaunay'.[37] Writers could be important patrons as well as influential critics: Gertrude Stein was as important to the development of the French avant-garde in this respect as the art dealer Daniel-Henry Kahnweiler or the collector Wilhelm Uhde.

Apollinaire was also responsible for coining the term 'Orphic' Cubism. In the work

of Robert Delaunay, its foremost practitioner, kaleidoscopes in faceted colour of such icons of modern Paris as *Tour Eiffel aux arbres* (cat. 27) or the *Fenêtres* paintings (cat. 28) incorporate contemporary philosophical notions about the passage of time, or simultaneity, a concept also espoused by the Italian Futurists.[38] Cubism in its later more colourful and decorative form embraced French as well as many foreign adherents. The Spaniard Juan Gris (who like Picasso and Braque lived in Montmartre), his compatriot Maria Blanchard, the Czech František Kupka and the Mexican Diego Rivera as well as the French Cubists Gleizes and Metzinger, joint authors of the influential *Du 'Cubisme'* (1912), all contributed to a more accessible form of Cubism that won favour at the Salon.

From 'lieu de plaisir' to 'lieu de mémoire'

Although Montmartre possessed all the social, professional and economic prerequisites for a successful bohemia it was never entirely alone; its activities were mirrored by what was happening on the opposite bank of the Seine. Members of the Montmartre avant-garde were never isolated from their colleagues on the Left Bank: Cubism, like Fauvism, was not an exclusive preserve of Montmartre and considerable artistic interaction took place across the city.[39] In time, however, the Montmartre avant-garde began to be depleted by defections to other districts of Paris; some figures abandoned the capital altogether. The outbreak of war itself took most French nationals to the Front and broke up what remained of an already declining bohemia. Montmartre was the victim of its own success: urban renovation, the increase in tourism following the rise of the music-halls, the completion of the Sacré-Coeur, and increased gentrification with consequent rises in prices drove out many of the original members of 1900s bohemia. Paradoxically, the First World War, hailed by the Futurists and Apollinaire as the apotheosis of Modernism, sounded the death-knell of the Montmartre avant-garde. It is ironic that the Métro line, the Nord-Sud of 1910 (celebrated, incidentally, in the title of Reverdy's review), which linked Montmartre with Montparnasse, was open, artistically at least, only to one-way traffic.

After the war, Montmartre culture was very different. The Sacré-Coeur, finally consecrated in 1919, now dominated the Parisian skyline and completed the role of Montmartre as both tourist centre and visual icon. As Maurice Agulhon has commented, the Sacré-Coeur, along with 'the Eiffel Tower, the Arc de Triomphe (and) Notre-Dame…all but monopolise the market for trinkets, for great monuments reduced to the size of paperweights. This quartet is noteworthy for the way in which it combines the attractions of the unusual (the Eiffel Tower, obviously, but also the Sacré-Coeur, owing to its height, its whiteness and its distinctive style) with reassuring values of religion and patriotism.'[40]

The basilica, subject of countless popular commercial paintings and prints, symbolised the transition of Montmartre from a locus of vibrant artistic activity to a 'lieu de mémoire', forever turning back towards the increasingly idealised past of the Belle Epoque. Despite some pockets of continuing avant-garde activity, notably the Surrealists in the Café Cyrano, much of the artistic production of Montmartre in the interwar years reverted to traditional forms of realism and caricature. Writing in particular, both fiction and non-fiction, concentrated to an unusual extent on the evocation of the pre-war period. Montmartre became quite literally a 'lieu de mémoires', a place of memoirs, as well as a place of memory, with seemingly every participant in the bohemia of the Belle Epoque determined to relive the past. These memoirs, often in fictional form, tend to follow the same pattern and adopt similar themes: the dramatic role of the First World War in the destruction of pre-war bohemia, coupled with an idealised, nostalgic vision of the Belle Epoque and a deep distrust of the present.

As such, Montmartre culture during the interwar years, increasingly beleaguered on the Butte, tends to portray itself as the last bastion of traditional French values in an increasingly unpalatable world. Montmartre is celebrated as a village, with its one remaining vineyard, a representative of 'la France profonde' in the midst of the modern cosmopolitan capital. Where once the avant-garde had celebrated the birth of the Ecole de Paris and the triumph of modernity, Montmartre culture tended to resurrect some of the least acceptable features of the cabarets of the 1890s, notably their xenophobia and nationalism. As such, it demarcates itself vigorously from the cosmopolitanism of Montparnasse, and its earlier anarchism takes on definably right-wing characteristics. In other words, the celebration of pre-war bohemianism has both aesthetic and political connotations during the interwar years and

under the Occupation. While modernist novelists like Louis-Ferdinand Céline or Marcel Aymé are able to revitalise the fictional portrayal of Montmartre, they certainly cannot escape its political conservatism. The nostalgic evocation of pre-war Montmartre in Céline's *Féerie pour une autre fois* (1952–54), with the inclusion incidentally of Rodolphe and Mimi from *La Bohème*, is narrated from a Danish prison cell in which the narrator awaits extradition to France on charges of collaboration.

1 '…la révolution picturale la plus importante depuis la Renaissance'; Gleizes and Metzinger 1912, p. 21.
2 It was, incidentally, as a municipal customs official at one of these Parisian 'octrois' that 'Douanier' Rousseau was employed.
3 For a detailed study of the growth of Montmartre as a pleasure-centre see Chevalier 1980.
4 See Chevalier 1980, chapter 2.
5 See Cate 1996, p. 40.
6 See Carrière 1963, pp. 12–13: 'Tout ce que nous appelons aujourd'hui l'humour noir, l'absurde, l'insolite, l'impossible, le délire, tout a été découvert et méticuleusement exploité entre 1880 et 1910.'
7 See Fauchereau 2001, p. 170.
8 Barreyre 1959, p. 64.
9 See Whiting 1999, p. 23.
10 See Cate 1991, p. 39; and Barreyre 1959, p. 70.
11 Cate 1991, p. 39.
12 See Guide 1900, p. 469.
13 See Buisson and Parisot 1996, p. 24.
14 See Béthencourt-Devaux 1972, p. 101.
15 The sign depicts a rabbit dressed in a green frock-coat and the red sash of a Communard emerging in a sprightly fashion from a saucepan: a transposed self-portrait by Gill, who had served on the Artists' Commission of the Commune, but had managed to jump out of the frying pan. The name of the tavern testifies to Montmartre's love of puns, the 'Lapin Agile' being variously interpreted as the 'Lapin A. Gill', 'Lapin à Gill' and even 'Là peint A. Gill'. Some accounts have Gill as one-time proprietor of Le Lapin Agile, but the most authoritative biography has him merely as a frequent customer. See Fontaine 1927.
16 See Crespelle 1978, pp. 155 and 159.
17 '…de 1900 à 1910 environ, ce médiocre bouchon fut pour les artistes de la Butte un authentique pôle d'attraction, une sorte de maison de la culture de la bohème'; Crespelle 1978, p. 150.
18 '…les histoires absurdes et les chansons pré-dadaïstes de Jules Depaquit n'avaient pas moins de succès'; Crespelle 1978, pp. 151–52.
19 The principal members of the Fauve group were, apart from Matisse, André Derain and Maurice Vlaminck. Other artists who formed part of the group included Henri Manguin, Charles Camoin, Albert Marquet, Jean Puy, Emile-Othon Friesz, Raoul Dufy and Georges Braque.
20 Gil Blas, 17 October 1905, n.p.
21 For an example of the affection in which Rousseau was held by the Cubists, see Apollinaire 1914. Delaunay's La Ville de Paris also contains an affectionate homage to the 'Douanier': a reproduction of the prow of the boat in Rousseau's Moi-même: portrait-paysage (1890). Although he lived in Plaisance, Rousseau was connected to the Montmartre avant-garde through his friendship with the playwright Alfred Jarry.
22 The exhibition 'Les Demoiselles d'Avignon' (Paris 1988C) presented some 450 items relating to the painting, including many unpublished studies and sketchbooks. The forthcoming anthology of essays devoted exclusively to Les Demoiselles d'Avignon – Green 2001 – will also explore the work's evolution in depth.
23 The Cézanne retrospective held in the Salon d'Automne that opened on 1 October 1907 contained fifty-six works of all periods including two of the three late bather compositions (National Gallery, London; Philadelphia Museum of Art). These works had the most profound impact on Picasso and also Derain.
24 Krauss 1998, pp. 35–36.
25 See Weiss 1990.
26 Picasso's mistress Fernande Olivier spoke of his passion for risqué music-hall songs; see Weiss 1990, p. 86.
27 See Weiss 1990, p. 83.
28 See Cooper 1970, p. 39.
29 New York 1991, p. 15.
30 See 'Zone', in Apollinaire 1966, pp. 7–14.
31 New York 1991, p. 23.
32 New York 1991, p. 23.
33 It is interesting that the avant-garde poets of Montmartre – Apollinaire, Reverdy and Max Jacob – all converted to Catholicism, a creed which they saw, possibly in the wake of the modernising Pope Leo XIII, as by no means incompatible with the avant-garde; indeed, the faith seemed its very epitome. It is also worth bearing in mind that, according to Braque and the dealer Kahnweiler, Apollinaire and Salmon were 'entirely lacking in artistic discernment' ('totalement dépourvus de discernement artistique'), making up for their lack of knowledge with their enthusiasm, and privileging innovation above all. It was this, for Crespelle, which made them blind, for example, to the importance of Utrillo. See Crespelle 1978, p. 90.
34 '…la concision et l'aspect visuel seront des soucis essentiels'; Fauchereau 1982, p. 173.
35 Fauchereau 1982, p. 173.
36 Fauchereau 1982, p. 181.
37 Golding 1968, p. 37.
38 Simultaneity, the flow of consciousness and the passage of time, was rooted in the theories of the popular philosopher Henri Bergson.
39 Gleizes and his colleagues, for example, met regularly with Paul Fort and the Symbolist circle at the Closerie des Lilas café.
40 Agulhon 1998, p. 524.

Gladys Fabre

Paris: The Arts and the 'Internationale de l'esprit'

In his memoirs, the Russian Symbolist Andreï Biély paints a word picture of the French capital: 'Paris does not hold the eye: it is not a composition; it is a battle of compositions. If you say "I am in Paris" you are saying "I am nowhere"; it is just an expression. Here everyone lives in one of several Parises, and you could spend your life in the space that separates them, flying underground from *quartier* to *quartier* in the Métro, beneath *quartiers* that are of no interest to you, beneath people's feet, beneath towers, churches, unfamiliar theatres…Dubonnet was my first encounter in Paris; my relative Alexandre Benois my first encounter with a person. This caused sudden geographical confusion: is this Paris or Petersburg?'[1]

The expression 'battle of compositions' could also be used to describe the political and cultural environment of Paris. It employs the same dialectic of universality and singularity, from the global 'nowhere' to the local 'here and now', which causes 'sudden geographical confusion', with the attendant problematic disintegration of distinguishing landmarks (such as gender, race, religion or culture) via institutionalised citizenship and modernity. As a contrast to universalism, a form of pacifist internationalism emerges which acknowledges the foreigner as universal man, but also recognises his otherness, his difference. In an effort to avoid war, it promotes improved knowledge of other cultures and cultural exchanges. By rejecting on principle the notion of one culture's superiority to another, these pacifists, like Marxists, are often caught out by their desire simultaneously to defend one or more transnationalisms based on identity: Mediterranean, Celtic, Jewish or even 'proletarian'. By exposing the interaction which existed between the visual arts and the different facets of idealism, I will attempt to demonstrate the important role played

by this 'Internationale de l'esprit', as the internationalism of left-wing intellectuals was known.

Part I: The ferment of ideals, and the 'mission civilisatrice' of the arts and literature before the First World War

The beginning of the twentieth century witnessed the emergence of a young generation of painters, poets and writers who shared a common set of political views which had been coloured by the Dreyfus Affair, socialism and the legacy of Symbolism. The Dreyfus Affair resulted in a crisis of conscience from which subsequent notions of justice, human dignity and identity all drew strength. By favouring the development of styles of art designed to promote unity between human beings and nations, beyond frontiers, socialism vouchsafed a future bathed in the sunlight of universal brotherhood. Symbolism focused on the links between the spiritual and the material, insisting on the need to express 'the idea in a form perceptible to the senses' by using 'correspondences' between forms, colours and rhythms. On these foundations were built a polyphonic, simultaneist literary modernism, Futurism and the Cubism of Passy, Puteaux or Courbevoie.[2]

The Abbaye de Créteil and its circle

Against this background the group established at the Abbaye de Créteil emerged; its members personified the 'Internationale de l'esprit', which constituted its first network of artistic contacts.[3]

The phalanx (fig. 33), founded by the writers Charles Vildrac, René Arcos, Georges Duhamel, Alexandre Mercereau, Henri Martin (known as Barzun), the painter Albert Gleizes and the typographer Lucien Linard, planned to live by the manual labour of printing and by organising artistic events. This newly created 'independent Villa Medici' – a reference to the French cultural centre in Rome to which artists and writers were invited after a rigorous selection process – was intended to protect its members from ideological or commercial compromise. The experiment in communal living at Créteil lasted from December 1906 to January 1908; the publishing enterprise continued in Paris until the group joined forces with Editions Figuière in 1910. Visitors, whether French or from abroad, were delighted to find their dreams realised at the Abbaye: Fourierism,

49, RUE LAFFITTE, 49 (au premier)
(SALLES DE "LA FRANÇAISE")

2ᵉ EXPOSITION DES PEINTRES & SCULPTEURS

UMBERTO BRUNELLESCHI — HENRI DOUCET — T. ESSAIAN
ALBERT GLEIZES — E. de KROUGLICOFF — MAURICE ROBIN
ORY ROBIN — LOUIS TRIQUIGNEAUX
NAOUM ARONSON — BRANCUSI — MAURICE DROUARD
de SCZEPKOWSKI — GEO PRINTEMPS

de

"L'Abbaye"

Groupe d'Art

INVITATION

de 10 heures à 6 heures,
(Dimanche y compris)

DU 15 JANVIER AU 8 FÉVRIER

Figure 32

32 The invitation to an exhibition mounted by the Abbaye Circle of artists, January 1908

33 Members of the Abbaye Circle, *c*. 1907, showing (front row, from left to right) Charles Vildrac, René Arcos, Albert Gleizes, Barzun, Alexandre Mercereau and (back row, from left to right) *Georges* Duhamel, B. Mahn and d'Otémar

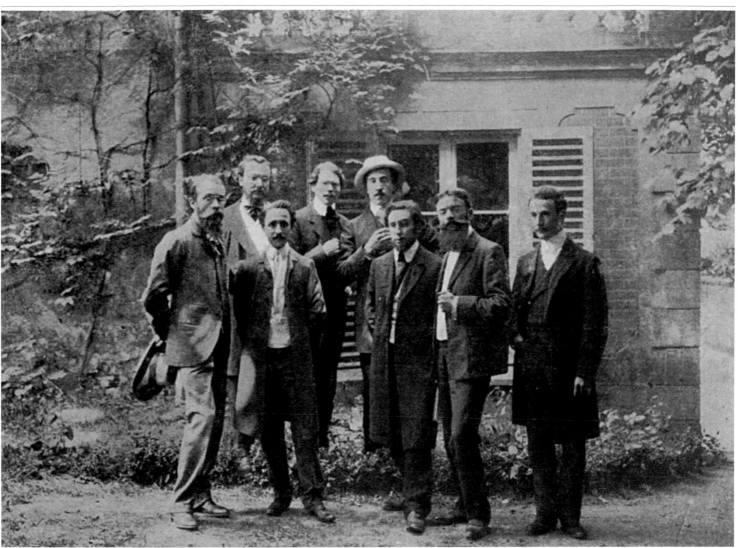

Figure 33

a secular 'monastery', and the adaptation of William Morris's precepts of 'artist, craftsman and poet'.[4]

The Abbaye attracted worldwide publicity by arranging exhibitions (fig. 32), poetry evenings, concerts with Albert Doyen, publications by its founders Arcos, Barzun, Duhamel, Mercereau and Vildrac and its members Paul Adam, Jules Romains, Mescislas Golberg, Pierre-Jean Jouve, Robert de Montesquiou, Roger Allard and Valentine de Saint-Point. The support of Gustave Kahn, René Ghil, Anatole France, Apollinaire, Théo Varlet, Ricciotto Canudo and F. T. Marinetti guaranteed literary success. After 1910, the founders of the Abbaye took up a variety of important positions in literature and the arts. As the individual reputation of each of its members grew, however, solidarity grew more tenuous. At the beginning of 1912, the Abbaye split into two distinct factions, the

'unanimists' and the 'dramaticists'. In his *La Vie unanime* (1908), Jules Romains set out to explain 'the soul of human groups and the universe as perceived by collectivities'. The book's international success prompted its author to promote himself to the leadership of a 'unanimist school'; he was joined in this by Duhamel, Vildrac, Arcos and occasionally Jouve, Paul Castiaux, Georges Chennevière, André Spire and Jean-Richard Bloch, a cousin of Max Jacob. Although the visual arts themselves were not the object of a theoretical regeneration by the unanimists, individual adherents manifested an interest. Vildrac and Marseille opened a gallery in the latter half of 1910 where they exhibited works by Gleizes, Auguste Herbin and Raoul Dufy. Castiaux lent his support to the art of Henri Le Fauconnier in *Les Bandeaux d'or*. Jean-Richard Bloch, director of the review *L'Effort*,[5] with the collaboration of Léon Balzagette, Marcel

Martinet, Spire, Vildrac and Gaston Thiesson, published articles on Cézanne; criticised the art criticism of Louis Vauxcelles, André Salmon and Guillaume Apollinaire; raised the question (at this early date) of 'proletarian' art; and published essays by Giovanni Papini, Ardengo Soffici, Herwarth Walden and Roger Fry.

The dramaticists, the other faction from the former Abbaye, consisted of Mercereau, Gleizes and Barzun, reinforced by the art critics and writers Roger Allard, Jacques Nayral (Gleizes's brother-in-law), Apollinaire, Canudo, Olivier Hourcade and the Cubists of Puteaux, Passy and Courbevoie who exhibited for the first time as a group in Salle 41 of the Salon des Indépendants (1911) and then in the exhibition of the Section d'Or at the Galerie Bernheim (1912). The dramaticists were at pains to promote all the arts as the expression of a future which was in the

process of being constructed. Unlike Marinetti, they aimed to create a synthesis between tradition and modernism; but, like the Futurists, they were determined that each discipline – literature, painting, sculpture, architecture, music and film – should be at once the expression of a social ideal and its driving force. The review *Poème et Drame, anthologie internationale de la poétique des arts et des idées modernes* (1912–14), the gatherings of Les Amis de Passy and the books on literature and the arts published by Editions Figuière[6] were all attempts to unite the arts and literature worldwide, on the crest of the tidal wave of enthusiasm for modernism. 'L'Antitradition futuriste', the manifesto published in 1913 by Apollinaire in *Lacerba*, carries this enthusiasm to the limits of poetic expression.

Alexandre Mercereau: ambassador of the arts and literature

Mercereau was to be the linchpin of internationalism in the arts and literature. From January 1906 to March 1907 he lived in Moscow where he was part of the literary team (headed by Henri Tastevin) attached to the review *La Toison d'or*. In 1909 he took over the presidency of the literary section of the Salon d'Automne and, in this capacity, invited the leading supporters of internationalism, present and future, to the poetry evenings he held in October 1910 and 1911.[7]

In 1910 he became co-director of Paul Fort's review *Vers et Prose*. From this time on, Mercereau was regarded as one of the leading authorities on young writers. Foreign publications requested articles from him or published essays about him,[8] and in return, he introduced foreign writers to the French,[9] assisting in the publication of *Les Soirées de Paris* (Apollinaire), *Poème et Drame* (Barzun), *La Vie des lettres* (Nicolas Beauduin) and *Montjoie!* (Canudo). In a letter of thanks to Mercereau for information he had given to F. S. Flint during the editing of his book *Contemporary French Poetry* (1912), Barzun writes: 'In short, having read it, I realise how much I owe you for the information you provided, and for the various assertions made about me in the chapter on the Abbaye. You really are the indispensable hub of our generation, and you are also the most loyal and devoted friend.'[10]

At the same time, Mercereau assisted artists to gain entry to the Salon d'Automne, and organised a succession of exhibitions. In

February 1908 a letter from Henri Tastevin informed him that Nikolai Ryabushinsky, the Russian painter, collector and patron of the review *La Toison d'or*, wanted him to assemble some work by French artists for an exhibition to be held in Moscow in April or May, followed in 1909 by a second exhibition devoted mainly to the Fauves. Ryabushinsky and the Russian collectors Sergei Shchukin and Ivan Morosov bought work by Georges Rouault, Camille Claudel, Emile-Antoine Bourdelle, Félix Vallotton, Louis Valtat, Vuillard, van Dongen and Van Gogh at these exhibitions to complete their collections, which already contained paintings by Picasso, Matisse, Gauguin, Cézanne, Derain, Degas and Renoir. A few months later the Russian sculptor Vladimir Izdebsky asked Mercereau to organise an international exhibition which would travel to Odessa, Kiev, St Petersburg and Riga from December 1909 to July 1910.[11] Mercereau also selected the French entry for the first (1910–11) and second (1912) 'Knave of Diamonds' exhibitions, and organised 'One Hundred Years of French Painting, 1812–1912' at the French Institute in St Petersburg (1912). He curated an exhibition on Cubism at the Dalmau Gallery in Barcelona (1912) and one on modern art held at the Manès Society of Prague (1914). The work of the Czech Cubists of the Manès group[12] was hung alongside examples of avant-garde painting from Paris (fig. 35).[13]

Ambition apart, this strategy of mutual promotion represented a response to the urgent need to build a new world of peace and humanist values. In 1912 Mercereau joined the society 'For greater understanding, and for Franco-German intellectual *rapprochement*' which was presided over by John Grand-Carteret and Henri Guilbeaux.[14] In 1913 Mercereau was one of the French delegates to the Congress of Ghent and, in August, he formed a committee to champion

Figure 34

35 A page from the review *Ziata Praha* (*Prague Life*), XXXI, 13 March 1914, showing *Pelotaris* by Félix Toben, *Naiad* by Constantin Brancusi and *Portrait of a Woman in a Boat* by Jean Metzinger included in the exhibition held at the Manès Society of Prague (1914)

roztroušeně, nesoustavně, pro čtenáře nedosti infor- velmocí v těchto dnech nastoupil cestu do svého no- Číslo toto vydáno dne 13. března 1914.

VÝSTAVA SPOLKU VÝTVARNÝCH UMĚLCŮ „MANES" V PRAZE: „MODERNÍ UMĚNÍ"

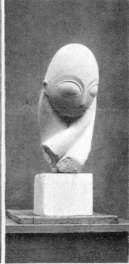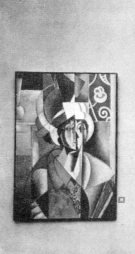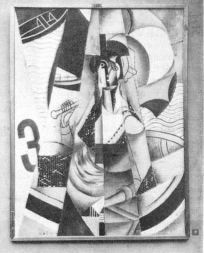

TOBEN FÉLIX: PELOTARIS BRANCUSI CONST.: NAJADA METZINGER JEAN: PORTRÉT ŽENY — V ČLUNU

„ZLATÁ PRAHA" vychází v číslech každý pátek, v sešitech jednou za 14 dní. Celý náklad tištěn je na čtvrt roku 5 K, poštou 5 K 75 h, na půl roku 10 K, poštou 11 K 50 h. na celý rok 20 K. poštou 23 K. Do každých 14 dní v sešitech jakožto románová příloha. Připlácí se na ni: čtvrtletně 1 K. půlletně 2 K. ročně 4 K.

Figure 35

a project entitled 'Alliance internationale: les Grandes Conférences'; its members were Romain Rolland, Laurent Tailhade, Paul Adam, Emile Verhaeren, J. H. Rosny, Stefan Zweig, René Ghil, Eugène Figuière, Gustave Kahn and Paul Fort (fig. 34). The society's aim was to assist universal culture and the march of progress by organising conferences, exhibitions and scientific missions all over the world, and by publishing a bulletin in five or six languages. 'Although realisable one day, this remains only a dream at the moment; it may however represent the basis of the establishment of the United States of Europe as well as of a vast world federation in which each nation will have its place and each individual a voice.'[15]

It fell to Henri Tastevin to organise the first (and only) conferences held, in Moscow and St Petersburg, with lectures by Verhaeren, Marinetti[16] and Fort, and with the financial support of Princess Eudoxia Lossev and the patronage of Count Alexis Tolstoy.[17] Although the Abbaye had distanced itself from Marinetti after the press scandal caused by *Le Roi Bombance* and the 'Foundation and Manifesto of Futurism' published on the front page of *Le Figaro* on 20 February 1909, Mercereau continued to enjoy friendly relations with him. He was also very close to other key Italian Futurists.[18] No great

supporter of Futurism before the war because of his relationship with Gleizes and the Cubists, during the 1920s Mercereau devoted several evenings to Futurist literature, painting and music in the Café Caméléon (1923–27), the favourite meeting place of his 'university' in Montparnasse.[19]

The Ballets Russes and fashionable internationalism

The Grandes Conférences in Moscow competed with the activities of the Moscow Arts Circle, the Alliance, and the Aesthetic Society, of which the Symbolist poets, the painters of the Blue Rose and of the World of Art (Mir Iskusstva, 1898–1904) were members. *Mir Iskusstva*, the glossy review named after the movement founded by the painters Alexandre Benois, Filofosov, Léon Bakst (born Rosenberg), the musician Walter Nouvel and Sergei Diaghilev, sponsored exhibitions and helped to inform the Russians about European art and literature. When publication ceased, Diaghilev organised a 'Retrospective of Russian Painting' in Paris at the Salon d'Automne and a concert at the Grand Palais (1906). In 1909 the success enjoyed by Russian music in Paris encouraged him to present the Ballets Russes in Paris. By combining the talents of the greatest composers, choreographers, dancers,

librettists and painters, he succeeded in producing a stunning spectacle.[20] At the outset his productions were post-Symbolist and avant-garde: *Le Coq d'or* (1914) had scenery and costumes designed by the Russian artist Natalia Goncharova who, just before the declaration of war, had exhibited her Rayonist paintings at the Galerie Paul Guillaume. In 1917 Picasso's dazzling contribution to the ballet *Parade* reintroduced modernism to Diaghilev's productions, where it was sustained until 1929.

Although the ballets of Loïe Fuller, Isadora Duncan, Valentine de Saint-Point, the Russian ballets of Diaghilev (1909–29) and the Swedish ballet of Rolf de Maré (1920–24) participated fully in the internationalism of Paris by bringing about a revolution in the arts, their success was also due to the powerful xenophilism of the upper middle classes and of the enlightened aristocracy, which comprised large numbers of French 'Israelites'. The role played by Gabriel Astruc is typical in this respect. The son of the great rabbi Aristide Astruc, and the founder, with Crémieux, of the Alliance Israélite, he became a music publisher and organised concerts of the music of leading contemporary composers,[21] having no hesitation meanwhile in extolling black American music and the fashionable

'cakewalk'. Astruc produced Diaghilev's first performances at the Opéra, at Le Châtelet, and then at the Théâtre des Champs-Elysées (1913). Astruc himself caused this theatre to be built with international financial assistance.[22] In order to ensure the success of the events he sponsored, he founded, with the Comtesse de Greffulhe, a very smart international committee for patronage of the arts whose membership brought together crowned heads and successful French and foreign financiers.[23]

The activities of Gabriel Astruc, known as the 'Astruckisches Musikhaus', were frowned upon by reactionaries and anti-Semites. At the opening of the Théâtre des Champs-Elysées, which boasted architecture by the Perret brothers, interior decoration by Maurice Denis, Henri Lebasque and Jacqueline Marval, and bas-reliefs by Emile-Antoine Bourdelle, paradoxically 'the words "Munich" and "German neo-Greek" could be heard; soon after his financial ruin, caused by the exorbitant cost of the Ballets Russes, thugs from the Action Française could be heard in the streets yelling "Krachastruc!"'[24]

The awakening of the Jewish consciousness

The international reaction to anti-Semitism and the Dreyfus Affair was manifested in a heightened awareness of human rights and the assertion of Jewishness and Zionism. Six months after the arrest of Captain Dreyfus, Theodor Herzl published in Paris the first version of *L'Etat juif* (1896), the book most directly connected with the founding of Zionism. At the same time French supporters of Dreyfus, both Jewish and non-Jewish, brought the intolerable plight of the Jews in Eastern Europe into the public eye. Beginning in 1894, Charles Péguy's *Les Cahiers de la Quinzaine* published articles by Bernard Lazare which denounced first the Dreyfus trial and then the pogroms. In 1912 a protest by writers, artists, teachers and magistrates took place against the massacres in Kiev on 25 March 1911.[25] After the war, an Appel à l'Humanité against the massacres in Kishinev, Pinsk and Vilna mobilised intellectuals again.[26]

In France the Jewish community was divided into three distinct camps: the first, the Zionists, wanted to build a state in Palestine which would combine modernity with secular Judaism. The second, a minority, claimed a double identity – they were French and Jewish, the latter with a capital J, as André Spire wrote, proclaiming his pride in belonging to a people possessed of such a history, religion and diaspora culture. The third, the majority, consisted of the 'French Israelites' (as they called themselves at the time). These last remained firmly attached to the idea of French republican assimilation; they opposed Zionism and the awakening of the Jewish consciousness which they feared would stir up anti-Semitism. Zionism, on the other hand, imparted an immense feeling of hope to Jews abroad, as well as to the many Jewish émigrés in Paris, including Chagall, Marek Szwarc, Chana Orloff, Jacques Lipchitz and Adolphe Feder; as a result, socialist intellectuals who proclaimed their Jewishness, as did Spire, Gustave Kahn, Julien Benda, Henri Hertz, Edmond Fleg, or Jean-Richard Bloch, became the mouthpiece of the movement. 'You ask me why I love these pariahs,' André Spire wrote above one of his first Jewish poems, 'the only proletariat in which I still have faith.'[27] To this political and cultural atmosphere were due the creation of the Université Populaire Juive (in the Rue de Faubourg Saint-Antoine) and the birth of a Jewish literature. Key publications included André Spire's *Poèmes juifs* (1908) and *Quelques juifs* (1913); *La Danse devant l'Arche* (1912) by Henri Franck; *Ecoute Israël* (1913) by Edmond Fleg; and *Levy* (1912) and *Et compagnie* (1917) by Jean-Richard Bloch. The Yiddish review *Mahmadim*, published in 1912–13 by La Ruche, was the brainchild of a group of émigré artists from Russia and Poland: Yoysef Tchaikov, Leo Koenig, Yitzhak Lichtenstein, Marek Szwarc and Henri Epstein. The five or six numbers to which it ran were the first attempt at combining modernity with Jewish modes of expression. The example of *Mahmadim* was transported to Poland by Marek Szwarc, Yankl Adler and Moyshe Broderzon who set up the review *Yung Yiddish* (1919); in Soviet Russia Tchaikov was campaigning for Jewish Constructivism.

Modernism in art, cosmopolitanism in Paris and internationalism

The presence of such large numbers of foreign artists transformed the art scene in Paris by increasing the gap which existed between official art and independent art (as presented at, respectively, the Salon d'Automne and the Salon des Indépendants), a distinction which had first been drawn by the Impressionists and the Fauves. Foreigners came to Paris to escape political exclusion and the pogroms against the Jews, but also because of the myth

surrounding the artistic capital, the high quality of life there and the observance of human rights in France. They were to contribute enormously to the emergence in France of avant-garde art, which is perhaps less French than Parisian, and therefore international. The distortions and simplifications of the primitivism of Derain were matched by those of Picasso, Brancusi, Modigliani and Ossip Zadkine, while the Cubism of Braque and Picasso was followed by that of Gleizes, Metzinger, Léger, De La Fresnaye, Henri Laurens, the brothers Villon and the foreigners Juan Gris, Marcoussis, Henri Hayden, Exter, Baranoff-Rossiné, Alfred Reth, Diego Rivera, Lipchitz, Joseph Csaky and Chagall. The Orphism of Robert Delaunay was echoed in the art of Sonia Terk-Delaunay and the synchronism of the Americans Patrick Henry Bruce, MacDonald Wright and Morgan Russell. The abstraction ushered in by Kupka also attracted these Americans, as well as Picabia, Léger and Mondrian. This melting pot of artistic styles, with their fascinatingly motley ancestry, was viewed by the public, official institutions and conservatives in general as a chaos which threatened to destroy all national and traditional artistic frames of reference.

In Parisian salons, galleries and newspapers, nationalist critics who favoured 'good taste and moderation', mediocre and jealous artists, xenophobes and anti-Semites were all alarmed at the growing presence of foreign artists, the majority of them Jews from Eastern Europe: innovation was allied to foreignness. Avant-garde art, alien to tradition and particularly to the academic tradition, was denounced as the responsibility of the Other: of immigrants living in France, of the international art market (allegedly run by Jews), or of Russian, German and American collectors. Such nationalism reached its irrational climax during the First World War, when Cubism was spelt with a 'K' and was considered to be 'Boche' art. Paradoxically, however, apart from the very restricted participation of Bolz and Freundlich, none of the Germans resident in Paris practised it. Before the war, modernists and internationalists had hailed the seething mix of cultures in Paris as one of France's major glories. The patchwork of the Parisian artistic scene was a metaphor for the European (or even global) social federalism for which they yearned. When war came, this position was no longer tenable. At the Front, or when they sought refuge abroad, modernists and internationalists had great difficulty in opposing nationalist propaganda and a 'return to order'. It was not until hostilities ended that a specific strategy was adopted, greatly assisted by Léonce Rosenberg's gallery and bulletin *L'Effort moderne* and the review *L'Esprit nouveau*, which was edited by Le Corbusier and Amadée Ozenfant. This strategy linked modernity closely with French tradition: the tradition of classicism in the broadest sense, embracing the spirit of construction and harmonious contrast, allied to the tradition of assimilating foreigners. As will become clear, this argument had the major disadvantage of making very difficult the recognition of any formal originality expressing a radical 'difference' of culture, ideology or experience.

Part II: The political radicalisation of ideals: literature and the arts in the service of their internationalisation

The First World War shook people's faith; if not their faith in mankind, at least their faith in the idealists' ability to create a better world. Neither pacifism nor international socialism had been able to prevent war. The civilising mission of literature and the arts had failed and many considered that avant-gardism had played an important role in this. In order to implement the Balfour Declaration (1917) in favour of a Jewish national homeland in Palestine, French Zionism had to mobilise. In short, the 'return to order' in all spheres had to be organised in a different way. Ideals had to be redefined and their promulgation to society reorganised; these were the most pressing tasks of the immediate postwar period.

Zionism and its offshoots

After the death of Herzl, the Zionist Federation of France, which had been founded in 1901, was led by Max Nordau, a doctor and art historian and the author of *Entartung* (*Degeneracy*; 1892); born in Hungary, he later became an honorary member of the Salon d'Automne. André Spire, a poet and writer as well as being a lawyer and member of the Conseil d'Etat, did not join the Zionist Federation until 1917. In the same year he founded the League of Friends of Zionism.[28] On 15 June 1919 in *Palestine nouvelle*, the League's journal, Spire took issue with the notion that 'there is no Jewish beauty, or Jewish art', a debate that was to be taken up with passion by art critics after 1925.[29]

The emergence of this controversy coincided with the mounting xenophobia and anti-Semitism which followed the increasing success of the School of Paris,[30] to which the rising value on the international market of the work of Modigliani, Chaïm Soutine, Kisling, Jules Pascin and Chagall bore witness. In order to counteract such controversy and disparagement, Jewish values were being promoted in a more organised fashion by the Jewish minority. In 1922, in the Rue de Lancry, Yiddish revolutionaries founded the Kulture-Liga, an association and cultural centre which aimed 'to provide a corner for Jewish culture'. Also in 1922 the review *Ménorah* first appeared (1922–33); this was modelled on *L'Illustration* and was directed from 1923 by Gustave Kahn.[31] Its objectives were announced in the first issue: 'to bring together the Israelites of France with Israelites abroad. To fill the vacuum which exists among reactionaries between Jewish civilisation and other forms of human civilisation. Free of racial and religious prejudice, our motto will be: "Above political parties".' The space devoted to the arts made much of the participation of Jewish artists of all nationalities in the various Salons in Paris, and carried news items about art in Palestine. The review's taste in art was eclectic (it contained illustrations by Chana Orloff, Lipchitz and Kisling), though a definite predilection for Expressionism was evident, as featured in works by Alicia Halicka, Max Band, Mané-Katz and Issachar Ryback. In 1922 a shipment of *objets d'art* for the future Jewish Museum in Jerusalem was organised jointly by *Ménorah* and the Friends of Zionism.[32] In 1928 the review sponsored a large retrospective exhibition of modern Jewish art.[33]

Other initiatives drew this international community closer together. In 1923 the poet Oser Warsawski, who had left Warsaw for Paris, published the second issue of the Yiddish review *Khaliastra* (*The Gang*), with illustrations by Chagall. In the same year the 'Société des amis de la culture juive' was set up, with as members Marek Szwarc, Chagall, the Russian poet Constantin Balmont and the composer Darius Milhaud. The society organised an exhibition, with Gustave Kahn as director, of the work of Michel Kikoïne, Isaac Dobrinsky, Halicka, Isaac Païles, Sigmund Menkès, Szwarc, Mané-Katz, Miestchaninoff, Frenkel and Fotinsky, while L'Amicale des Israélites Saloniciens presented works by Mané-Katz, Nathan Spiegel Menkès,

Othon Coubine and Feder at the town hall of the Thirteenth Arrondissement. With Madame Gustave Kahn and the police commissioner/collector Léon Zamaron as joint presidents, the 'Aide amicale aux artistes' ('AAAA') began organising the famous balls in the Bullier dance hall in 1923.[34] At the Café Caméléon, Mercereau devoted one of his Tuesday poetry sessions to Jewish poetry in French: the work of Henri Franck, André Spire, Edmond Fleg, Albert Cohen and Georges Cattaui was recited. In 1928 the Israël Zangwill Committee, presided over in France by André Spire, launched a prize aimed at encouraging the 'first steps of a Jewish scholar, writer or artist'. The vice-president was the illustrious Yiddish poet Schalom Asch, who had supported Kisling and the review *Mahmadim* before the war. Members of the committee included the writers Gustave Kahn, Joseph Milbauer, Fleg, Joseph Kessel, Victor Basch and Jean-Richard Bloch and the painters, sculptors or musicians Chagall, Adolphe Feder, Kisling, Mela Muter, Chana Orloff, Marek Szwarc, Maxa Nordau (the daughter of Max Nordau) and Darius Milhaud. Also in 1928 the collection of monographs 'Les Artistes juifs' was published by Les Editions du Triangle, financed by Michel Kireliovitch, the Polish Jewish mathematician and physicist. Usually published in French, but occasionally in Yiddish or English, these made the work of Modigliani, Pascin, Kisling, Kars, Léopold Gottlieb, Eugène Zak, Soutine and many others familiar to a wider public. They were mainly edited by well-known Jewish critics, such as Waldemar George, Vauxcelles, Florent Fels, Emile Szittya or Adolphe Basler.

Finally, two exhibitions were held in Zurich on the occasion of the Zionist Congress of 1929: 'Les Artistes juifs de Paris', selected by J. Pougatz of the Galerie Billiet,[35] and 'Jüdischer Künstler unserer Zeit', at the Salon Henri Brendlé. The preface to Brendlé's catalogue, edited by Waldemar George, made an ambiguous apology for Jewish genius, vaunting its internationalism and its revolutionary capacity to undermine the foundations of Western culture – as demonstrated by the anti-classicism of Chagall and Lipchitz, or Soutine's *nervotisme*. 'This art is undoubtedly one of the greatest conquests of the Messianic tradition,' George concluded, '…the ferment of revolution, viewed as an end in itself, a life principle, a factor of perpetual movement, this double-faced art…It is the art

Figure 36

of impassioned pilgrims, of knights errant, nomadic prophets, destroyers, great agitators – it is the conscience of the century.' Jacques Biélinky wrote a critique of George's argument in *L'Univers israélite*, ending his review as follows: 'Who would have thought that in Zurich, just as the correspondents of Soviet newspapers were being expelled from the chamber where the Zionist Congress was being held, the virus of world revolution would squeeze in under a different door, via the two exhibitions of the work of Jewish artists?'[36]

Communism and its 'fellow-travellers': the periodicals **Clarté** and **Monde**

The Russian revolution of 1917 threw political theory into confusion, and, as Barbusse observed, 'the figure of Lenin appeared as a kind of Messiah'.[37] This 'dawn of a new era' was led by intellectuals – Lenin, Grigori Ovseyevich Zinoviev, Trotsky and Anatoly Lunacharsky – who were familiar figures to the Montparnasse circle. They could be encountered, before and during the war, in the studio of Diego Rivera, at La Ruche, at the Cantine of Marie Vassilief or, in Zurich, at the Dadaist Cabaret Voltaire. In 1922 the International Congress of Revolutionary Artists in Düsseldorf counted a large number of European idealists among its membership.[38] It was from this international melting pot of the arts that the French communist press and its subsidiaries drew the strength and originality of their artistic and literary content. The Belgian printmaker Franz Masereel was certainly the favourite of the pacifist periodicals and books published in Switzerland, where Henri Guilbeaux, Romain Rolland, Yvan Goll and Stefan Zweig had taken refuge, joined there after the war by Vildrac, René Arcos and Duhamel. From 1916 to 1919 Masereel (fig. 36) produced illustrations for the reviews *Tablettes* and *Demain*, and the newspaper *La Feuille*; with Arcos, he founded a publishing house, Les Editions du Sablier. Masereel moved to Paris in 1922 and frequented pacifist and unanimist circles and the Clarté group. Also in 1922, Rolland founded the pacifist review *Europe* and Jean Maxe published in Switzerland *L'Abbaye et le bolchevisme culturel*, the unanimists' retrieval of their ideology, which was immediately denounced by Mercereau. Nevertheless Mercereau's books, and the books of the unanimists and communist 'fellow-travellers', were prominently

displayed at an exhibition entitled 'Revolutionary Art of the West' held in Moscow in 1926.

French intellectuals of the extreme left at first tried to ignore the fundamental divergences which existed between the socialist idealists and pacifists and the communists, embodied in their split and the resulting foundation of the Parti Communiste Français at the Congress of Tours in December 1920. The socialists and pacifists were attached to peace and to independent ideas, whereas the more pragmatic communists considered war a means of achieving social justice. For better or worse, they managed to put up with the Party's ideological shifts, which were stage-managed by Moscow. Barbusse, who had become an icon after the appearance of his novel *Le Feu* (1917), stood midway politically between Rolland and Lenin; he continued to hope that reason, social justice and the republican idea would triumph over class warfare. In 1919 he launched the magazine *Clarté* (1919–27), whose political and literary content reflected his own personal contradictions, his misunderstandings with the French communist party and the internal battles between his collaborators on the magazine: Maurice Parijanine, Victor Serge, Paul Vaillant-Couturier, Balzagette, Jean Bernier and Marcel Fourier. Unlike the self-censorship and jockeying for control which went on in the political and literary sections, the articles on the plastic arts reveal glimpses of an underlying humanist idealism which was still flourishing. The choice of works reproduced was eclectic, ranging from the contained miserablism of Mela Muter to the trenchant Expressionism of Käthe Kollwitz, Masereel or George Grosz[39] and of Chagall, Kisling, Feder, Serge Fotinsky, Théophile-Alexandre Steinlen, Friesz, van Dongen and Foujita, to the avant-garde with Léger, Gleizes, André Lhote, Jean Lurçat, Picasso, the Japanese Seidzi Togo, the American Gerald Murphy, the Russians Zadkine, Orloff, Jean Lébédeff and the Hungarian Bela Uitz. The quality of the reviews of the Salons, the articles on Picasso by Roger Fry,[40] on Abel Gance's *La Roue* by Léon Moussinac, and on *L'Art et la société bourgeoise* by Grosz, betray a rare open-mindedness towards German art and the avant-garde movements.

Militancy was not abandoned, however. In 1921 André Gybol hailed the artistic policy of the USSR most succinctly: 'It is a strange paradox. All about us an extraordinary feat

Figure 37

Figure 38

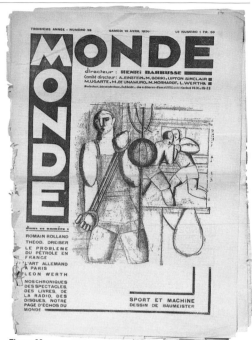
Figure 39

has been accomplished. Paris, which is now nothing more than the centre of the imperialist, reactionary world, Paris the modern Coblenz, is nevertheless home to the most audacious artists of the age. An enormous movement has taken place here too. And the French are unaware of it!…In Moscow two museums of foreign art, which should really be called museums of French art, were opened during the early days of the Revolution. The Morosov and Shchukin collections should suffice to illustrate the so-called barbarism of the people we term the Mujiks of Moscow. What Louvre in France, what Luxembourg, can bear comparison with these collections? And how will the people of France ever become familiar with the work of today if the geriatric officials and the troglodytes from the Beaux-Arts prohibit canvases representing modern tendencies from being hung on the walls of our museums?'[41]

In 1925 art criticism became more radical.[42] Bela Uitz, a Constructivist painter, castigated naturalism or any modern work which referred to the past (Foujita's references to Botticelli, for example) as petit bourgeois, and all the individualist '-isms' as bourgeois, or, in other words, grand-bourgeois élitist: Expressionism, Cubism and Cubo-Futurism. Although he referred to 'collective proletarian art' he was incapable of defining it. In fact, communist, revolutionary and populist writers were to argue about what proletarian

literature ought to be until the end of the 1930s. Bela Uitz's observations coincided with the 'demolition' of the literary highlights of the so-called bourgeois past, for example the works of Maurice Barrès and Anatole France, at the hands of *Clarté* and Surrealism. In addition, they took a stand together in favour of Stalin's new cultural orientation and against the position adopted by Trotsky. In 1923, Trotsky declared: 'Not only is there no proletarian culture, but there is no reason to feel sorry about this; the proletariat has taken power precisely in order to put a permanent end to its relationship with class culture and to open the way to human culture.'[43] From November 1925 to 1927 Pierre Naville tried to oust Barbusse from the editorship of *Clarté* by siding with the Surrealists Louis Aragon, Robert Desnos, Breton and Eluard. His collaboration was soon censured by Moscow: 'For the moment there is little "clarity" in the review,' commented Lunacharsky sardonically.[44] This first political disagreement of the Surrealist revolution was followed, after the Kharkov Congress in 1931, by the division of the Surrealists into two conflicting camps: the first, led by Breton, sided with the Trotskyists and the second, led by Aragon, with the Stalinists.

Barbusse, well aware of the potentially disastrous effects of this internal wrangling, tried to reunite the Left (apart from the Surrealists who had labelled him dishonest) by launching *Monde* in June 1928. In a letter

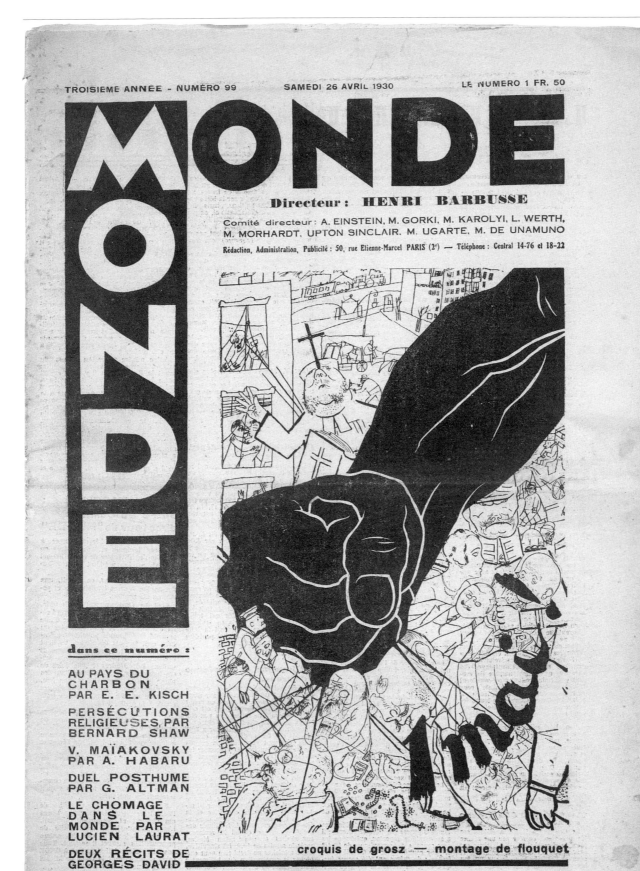

Figure 40

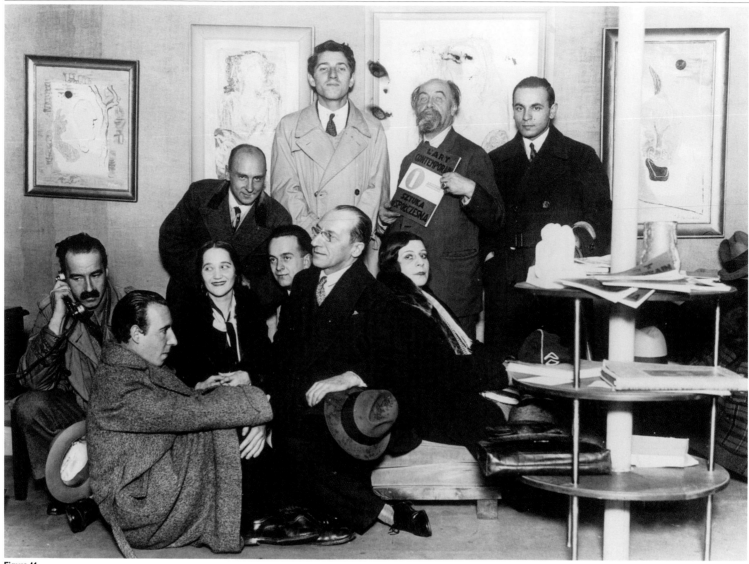

Figure 41

dated 2 February 1927 he wrote to Henri Poulaille, who had inspired the project, '*Monde* will aim to disseminate great human principles in the current international chaos, and to take up arms against the reactionary mindset and reactionary propaganda. This publication could become an important forum – intellectually, artistically, morally and socially.' In fact, Barbusse received financial support from Lunacharsky, plus his tacit agreement that the weekly magazine should be a platform for views that were independent (or ostensibly so, at least) from those of the Party. Barbusse was able to preserve relative editorial freedom until the end of 1931, and his editorial board consisted mainly of non-communists.[45] *Monde*, intellectually and artistically of a high calibre, was noted for its geographical range, the scope of its articles and its determination to give priority to artists

themselves (figs 37–40).[46] It was copiously illustrated with rayogrammes by Maurice Tabard and László Moholy-Nagy, political photo-montages, paintings and sculptures.[47] *Monde* gave pride of place to engraving, probably because of the medium's revolutionary history and its powerful visual impact. The periodical published a series of wood- and linocuts by Expressionist, realist and modernist exponents of international social art,[48] plus illustrations by the progressive group of Cologne (Seiwert,[49] Peter Alma and Hélios Gomez).

In 1931, under the auspices of Moscow, a radical change came over *Monde*. The amount of space given to the visual arts diminished and what remained was devoted to the figurative art of Steinlen, Vallotton, Maximilien Luce and Robert Lotiron. At this time the 'Internationale de l'esprit' began to

collapse. The first generation of communist writers, almost all excluded or expelled from the Party, joined the leftist opposition with their idealist 'fellow-travellers' and the group led by Breton.

Internationalism in Parisian avant-garde periodicals at the end of the 1920s

As the migration of avant-garde artists to Paris speeded up, a few small, internationalist publications produced by left-wing artists took over in a minor way from *L'Esprit nouveau* (1920–25). Their circulation was small and their lifespan often short. In Lille, Donce-Brisy and Charles Rochat, with the collaboration of Théo Varlet (who was still close to the Abbaye Circle) and the painter Félix Del Marle, launched the monthly magazine *Vouloir* (1924–27), which promoted leftist literature, the abstract art of Kupka,

Del Marle, Marcel Lempereur-Haut, Mondrian, van Doesburg and Georges Vantongerloo, and Russian proletarian art. In 1928 a Franco-Lithuanian review, *Muba*, appeared.[50] The Belgian Michel Seuphor also published *Les Documents internationaux de l'esprit nouveau* (1927) with Prampolini and Paul Dermé, before setting up (with Joaquín Torres-García) the periodical and group Cercle et Carré (1930) which brought together all the avant-garde trends around abstraction, as had the 1925 exhibition entitled 'L'Art d'aujourd'hui', organised by Victor Yanaga Poznański, a Polish pupil of Gleizes. Finally, Wanda Khodossievitch-Grabowska (the future Nadia Léger),[51] who had followed Malevich's course in Russia and the courses of Léger and Ozenfant at the Académie Moderne, joined forces with the Polish poet Jan Brzekowski in the publication of a Franco-Polish review, *L'Art contemporain* (fig. 41).[52] The work of Marcoussis, Léger, Arp, Miró, Ernst, Malevich, van Doesburg and Vantongerloo appeared abundantly in the publication, plus reproductions of work by the 'a.r.' group of Łódź, which consisted of the painters Stazewski, Władysław Strzemiński, the sculptor Katarzyna Kobro and the poets Jan Brzekowski and Julian Przyboś (fig. 42).

At this time, the 'a.r.' group decided to create a collection of modern art in the industrial city of Łódź (fig. 43). Brzekowski, Wanda Khodossievitch-Grabowska, Seuphor and Henryk Stazewski collected gifts of works from the contributors to *L'Art contemporain* and from the groups Cercle et Carré, Art Concret (1930) and Abstraction-Création (1931–36);[53] to these were added donations made to Strzemiński and Kobro by Polish avant-garde artists. By this means a spectacular collection of 111 pieces was made,[54] a tribute to the influence of Paris and also to that 'Internationale de l'esprit' which had persisted throughout the first three decades of the twentieth century. In 1932 the preface to the catalogue endorsed this: 'Thus the international collection of modern art of Łódź is a collective and social act. The goal which motivated its instigators and its producers, as well as all the artists who offered their paintings, was to bring nations closer together by this most precious of possessions, works of art.'[55]

Conclusion

In France the 'Internationale' of the mind and the arts managed to modernise itself,

Figure 42

continuing to promote the French universalist tradition of open arms and open minds; it continued also to encourage exchanges of views and a familiarity with foreign art and literature. Paris served as an international foil for the arts. As Gertrude Stein wrote, Paris was 'the place you had to be'. The American sculptor John Storrs endorsed this when he explained that he lived in Paris in order to be able to sell to the USA. In return, the presence of so many foreigners strengthened France's cultural influence. This mutual promotion could however result in parochialism and a lack of awareness of the world outside; all enthusiasm for the wider world would be consumed as innermost thoughts fastened on Montmartre and Montparnasse as their microcosm, or on the inner self as the main field for research. In his autobiographical novel *Les Transplantés* (1913) the Italian writer Canudo advises emigré artists to 'find themselves in a country of their choosing', claiming that Paris was the most likely place for such a transformation to take place.

In fact there is no doubt that the predominant '-ism' in France, common to Cubists, Dadaists, Surrealists and independent artists alike, was fierce *individualism*. It comes as no surprise therefore to learn that geometrical abstraction and non-figurative art, which sought to transcend individualism by an impersonal mode of execution, an expression of a universal order (cosmic or scientific), an adaptation to architecture or to the creation of a common style, enjoyed scant success in France and were principally practised by artists from abroad. Like Russian Constructivism, non-figurative art was generally the expression of a social, progressive ideal; it was accepted on grounds of eclecticism and internationalism, but rejected as élitist radicalism, incomprehensible to the masses. The 'Internationale de l'esprit' was trapped in its defence of the avant-gardes and of the art of foreigners for two main reasons: firstly, revolutionary expression was by no means a proletarian art and vice versa; secondly, the emphasis on differences of identity (proletarian, Jewish or others) was antithetical to assimilation and non-federalist internationalism of the sort which would render man uniform, as exemplified by the architecture of the Bauhaus and its offshoots. The radical thoroughness of Mondrian, the elegance of Foujita, the cruelty of Zadkine's first sculptures, the exaggerated

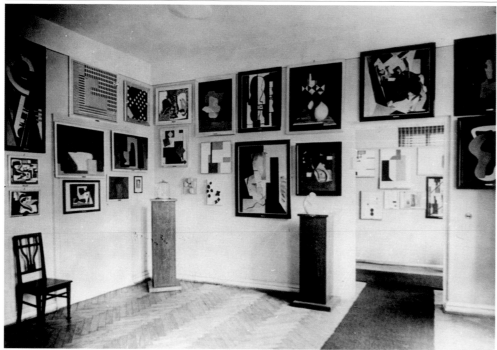

Figure 43

Expressionism of Soutine, the nostalgia inherent in the art of Modigliani, Eugène Zak or Kisling, and the formal and iconographic multiculturalism of Chagall were appreciated by virtue of their difference by a handful of critics, who, with some preconceived ideas, viewed them as examples of northern puritanism, oriental refinement, Jewish pathos, the experience of exile or of the wandering artist dreaming of other lands wherever he might be. It is, however, true to say that singularity was diminished by the pre-eminence accorded to French influences or radically condemned by the conservatives.

At the end of the 1920s, the success of the School of Paris precipitated its repudiation by some early supporters who were alarmed by the sharp increase in competitors and by the emergence of a fashion described as a stylistic Esperanto. In 1928 the Belgian critic André de Ridder published the following critical assessment of the Parisian scene: 'As far as creativity is concerned, the danger resides in facility…We are witnessing a generalised lowering of standards, as well as over-production. Paris, with its cafés…distracts the artist from his work. We are in danger of witnessing – in Paris as elsewhere – a highly individual art, which aims at universality, but which is in reality cosmopolitan or *métèque*; an art of uniformity, neutrality, banality; a derivative art based on imitation…Powerful, beautiful Paris, with

your coterie of lucid writers and inventive painters, your scientific laboratories; Paris the fashion paradise – provided that you are not transformed into a Babel with all its confusion!'[56]

History was to gainsay these predictions. The collapse of the stock market in 1929 affected the arts badly. Artists could no longer afford to live in Paris and moved to the countryside or returned to their home country. A few, gripped by anxiety, like Pascin or Bruce, took their own lives. The prevailing Stalinism marginalised the 'Internationale de l'esprit', now either in opposition or suffering from the demolition of its original ideals. Henceforward the babel of shattered hopes focused on 'the Real', grasped by some, planned by others: another source of confusion.[57] To Carl Einstein's dictum 'Rien ne va plus. Enough of your empty cocktails of the absolute',[58] Surrealism responded by putting itself at the service of the revolution; abstract or non-figurative art took the name of Concrete art; and Léger supported New Realism while a small number of independent artists turned to social realism. Hitler's accession to power in 1933 provoked a first wave of emigration among Jews, socialists and German communists to the USSR, France, Holland and Great Britain; during the Second World War there was a second international exodus, this time to othe United States of America.

1 Andreï Biély, *Entre deux révolutions*, 1934, in Biély 2000, p. 64.
2 These were the three Parisian suburbs inhabited by the three Villon brothers (Jacques Villon, Raymond Duchamp-Villon and Marcel Duchamp), Barzun and Gleizes; the painters would meet periodically in one of these.
3 On the Abbaye, see Fabre 2001.
4 Montefiore 1907.
5 *L'Effort* was published in Poitiers from 1911; by 1912 it was entitled *L'Effort libre*.
6 Mercereau edited the literary volumes, and Apollinaire the series 'Tous les arts' in which *Du 'Cubisme'* by Albert Gleizes and Jean Metzinger (1912), *Les Peintres cubistes* by Apollinaire and *Henri Rousseau* by Wilhelm Uhde were published.
7 These included Apollinaire, Marinetti, Kahn, Canudo, Henri Barbusse, Spire, Joseph Billiet, Emile Verhaeren, Frantz Jourdain, Han Ryner, Constantin Balmont, Valère Brussov, Biély and Alexandre Blok, among others.
8 These included, among many others, Marinetti's *Poesia*; Papini and Soffici's *Lacerba*; the Russian *Viessy*, *Apollon* and *Russkaya Mouise*; the Czech *Moderni Revue*, *Ceska Kultura* and *Prehleb*; and the Brazilian *O Paiz*.
9 He published, as editor, Gustave Lanson's *Anthologie des poètes nouveaux* and the *Anthologie des lyriques allemands contemporains depuis Nietzsche* by Henri Guilbeaux (1914), and, under his own name, a critical encyclopedia, *La Littérature et les idées nouvelles* (1912).
10 From a letter dated 18 August 1912 in the Archives Mercereau. On 30 September 1913, Barzun paid homage to Flint during the tenth 'Dîner des artistes de Passy' by giving a lecture entitled 'La Jeune Poésie anglaise et la "libre Abbaye" of *Poetry and Drama*'.
11 This contained 763 paintings by artists including Bonnard, Matisse, Albert Marquet, Rouault, Vuillard, Vlaminck, Henri Rousseau, Gleizes, Le Fauconnier, Braque, Metzinger, Giacomo Balla, Laurencin, Mikhail Larionov, Natalya Goncharova, Alexei Jawlensky, Kandinsky and Alexandra Exter, among others.
12 See Fabre 1997B.
13 Those exhibiting included R. Delaunay, Duchamp-Villon, Dufy, Roger de La Fresnaye, Othon Friesz, Gleizes, Tobeen, Villon, André Lhote, Marchand, Metzinger, Luc-Albert Moreau, Archipenko, Alice Bailly, Bohr, Patrick Henry Bruce, Julio González, Mondrian, Rivera, Otto and Adya van Rees, Stern, Moïse Kisling, Louis Marcoussis, Marie Vassilief, Zawadowski and Brancusi.
14 Other members of this society 'Pour mieux se connaître, œuvre de rapprochement intellectuel franco-allemand' included Elie Halévy, Paul Langevin, Victor Margueritte, Gabriel Astruc and Frantz Jourdain.
15 From a letter announcing the project in the Archives Mercereau.
16 See Khardjiev 1982. Tastevin had prepared for Marinetti's arrival with a lecture (13 December 1913) on 'Le Futurisme comme esthétique et rapport au monde', for which Mercereau had sent him documentation. In addition Tastevin's aunt was the proprietor of the French bookshop in Moscow where *Du 'Cubisme'* and the other books published by Editions Figuière were sold.
17 Lack of funds restricted the project and the war interrupted it. Laurent Tailhade, Albert Gleizes and Romain Rolland also went to Russia. The lectures were held in December 1913 (Verhaeren), January–February 1914 (Marinetti) and March (Fort).
18 His acquaintances included Umberto Boccioni, Giovanni Papini, Ardengo Soffici, Giuseppe Ungaretti, Carlo Carrà, Luigi Russolo and Gino Severini, who married the daughter of Paul Fort in 1913.
19 The Café Caméléon was situated at 146 Boulevard Montparnasse from 1921 until 1923, and then at 241 Boulevard Raspail until 1927. From 1922 Mercereau organised more than 1,200 meetings there, presented as follows: 'foreign literature on Mondays, poetry on Tuesdays, local literature on Wednesdays, modern music on Thursdays, theatre and other matters on Saturdays (occultism, psychoanalysis…) and art on Sundays'.
20 He presented the composers Erik Satie, Igor Stravinsky, Nikolai Rimsky-Korsakov and Claude Debussy; the choreographers Mikhail Fokine and Léonide Massine; the dancers Tamara Karsavina and Vaslav Nijinsky; the librettist Cocteau; and the painters Bakst, Benois, Nicholas Roerich, Larionov and Goncharova.
21 These included Richard Strauss, Camille Saint-Saëns, Gabriel Fauré, Debussy, Richard Wagner, Johan Halvorsen, Modest Mussorgsky and Stravinsky.
22 Financial assistance came from Pierre Laffitte, Isaac and Moïse de Camondo, Deutsche de La Meurthe, Henri de Rothschild, Otto H. Kahn and William K. Vanderbilt, among others.
23 Members of the committee included Queen Elisabeth of the Belgians, the Crown Princess of Romania, Louis-Ferdinand of Bavaria, the Duke of Camastra, the Grand-Duchess Wladimir, Otto H. Kahn, William K. Vanderbilt, James Stillman and Pierpont Morgan. Astruc 1929, p. 274.

24 Astruc 1929, p. 284.
25 Its signatories included, among others, Anatole France; Paul Langevin; Alfred Vallette of the *Mercure de France*; Frantz Jourdain, President of the Salon d'Automne; Paul Signac, President of the Salon des Indépendants; Alfred Roll, President of the Société Nationale des Beaux-Arts; and Professors Gabriel Séailles and Charles Seignobos.
26 This time those involved included Henri Barbusse, Georges Duhamel, Elie Faure and Victor Margueritte.
27 The poems were published with the title *Verset* by the *Mercure de France* in 1908, then reprinted with the title *Poèmes juifs* in enlarged editions by Kundig in Geneva in 1919 and by Albin Michel in Paris in 1962. On Spire see Spire 1997, pp. 45–56.
28 His co-founders were Seignobos and Séailles (who taught philosophy at the Sorbonne), the poets Gustave Kahn, Henri Hertz, Edmond Fleg, the doctor Léon Zadoc, Jules Isaac, Armand Bernard and Baruch Hagani, the director of Jewish periodicals.
29 Those who supported assimilation included Louis Vauxcelles, Adolphe Basler and Florent Fels; the Zionists or supporters of 'Jewishness' were Marek Szwarc, Waldemar George, Jacques Biélinky and Joseph Milbauer; the anti-Semites and nationalists included Camille Mauclair and F. R. Vanderpyl. Wilhelm Uhde was a xenophile. These opinions were expressed in the art columns of the *Mercure de France*, the *Univers Israélite* and the *Nouvelle Aurore*, and in the books *Picasso et la tradition française* (1928) by Wilhelm Uhde, *La Peinture religion nouvelle* (1926) and *Le Cafard après la fête* (1929) by Adolphe Basler, and *La Farce de l'art vivant* (1929) and *Les Métèques contre l'art français* (1930) by Camille Mauclair. The behaviour of Waldemar George was complex, some might say dangerously equivocal, in 1930–36. It is interpreted by Romy Golan as an outburst of xenophobia or anti-Semitism in Golan 1995B, pp. 152–54 and 206. My interpretation is less cut and dried. During the 1920s, George supported an internationalism based on difference, but he considered this to have failed by 1930 when the hoped-for mutual enrichment had degenerated into a 'volapuk', an aesthetic homogenisation which contaminated national identifying characteristics. During this dramatic change of view, represented by what then became the School of Paris, he made a chauvinist right turn and then became a fervent admirer of Italian fascism. See George 1931, George 1936 and Fabre 2000. My interpretation has the merit of not contradicting the fact that Jewish artists continued to request his opinions even after the Second World War.
30 A name, invented by André Warnod in 1925, to define the art of foreigners living in Paris as well as the whole ensemble of modern art, French and foreign. It is a term as vague as it is journalistic. See Gee 2000; Silver 2000; and Fabre 2000.
31 Kahn's fellow contributors were Georges Cattaui, Fleg, Hagani, Hertz, Roger Lévy, Aimé Paillère, Spire and Tchenoff, among others.
32 They elicited gifts from Alexandre Altman, Jules Adler, Mela Muter, Maxa Nordau and Henri Valensi.
33 This exhibition displayed work by Henri Valensi and Marcelle Cahn, Pascin, Max Liebermann, Georges Kars, Georges Kohn, Abraham Weinbaum, Modigliani, Pissarro and many other artists.
34 The honorary committee and list of patrons included Gustave Kahn, André Spire, Frantz Jourdain, Paul Signac, Marcel Sembat, Rachilde, Alfred Vallette, Léonce Bénédite, Paul Husson and Géo Charles.
35 Founded in 1922 by Joseph Billiet, a writer belonging to the Abbaye Circle, and reopened by Pierre Vorms, a defender of social realism in the 1930s.
36 Biélinky 1929, p. 593.
37 Caute 1967, p. 78.
38 Romain Rolland, Han Ryner, Edouard Dujardin, Marcel Sauvage, Tristan Rémy and Henri Poulaille, with at their side Kandinsky and representatives of the arts in Italy (Enrico Prampolini), Hungary (the Ma Group with László Kassak and László Moholy-Nagy), Germany (the November Gruppe and the Expressionists, and the Kommune with Freundlich, Franz Seiwert and Raoul Hausmann), Belgium (the Groupe Lumière), Eastern European Jewry (Henryk Berlewi, Jankel Adler and Marek Szwarc) and the International Union of Neo-Plastic Constructivists (Van Doesburg, Hans Richter, El Lissitzky, Karel Maes and Max Buchartz).
39 Masereel and Grosz exhibited in 1924 and 1925 at the Galerie Joseph Billiet.
40 *Clarté*, 22, June 1922.
41 *Clarté*, 2, December 1921.
42 Bela Uitz's articles 'A propos de Chagall et de Foujita' (*Clarté*, 72, March 1925); 'Le Cimetière des indépendants' (*Clarté*, 74,

May 1925); and 'Vers un art prolétarien' (*Clarté*, 75, June 1925) are good examples. A former contributor to the review *MA*, Uitz was a member of the Hungarian section of the French Communist Party who exhibited at this time in the *Clarté* offices.
43 Trotsky 1923 and *Clarté*, 47, November 1923.
44 Morel 1985, p. 101.
45 The editorial board consisted of Albert Einstein, Maxim Gorky, M. Morhardt, Léon Balzagette, M. Ugarte, Miguel de Unamuno, Upton Sinclair and Léon Werth. Poulaille wrote the record reviews; Paul Dermé, founder of *L'Esprit nouveau*, wrote about scientific innovations; Georges Altman about film; Tristan Rémy about the circus; and the Belgian avant-garde painter Pierre-Louis Flouquet, a member of the 7 Arts group and of the future Abstraction-Création movement, was in charge of articles about art.
46 Many articles testify to this: 'L'Art polonais moderne' (*Monde*, 74, 2 November 1929), 'La Peinture allemande à Paris' (*Monde*, 98, 19 April 1930) and 'L'Art et la photo' (*Monde*, 123, 11 October 1930) by Flouquet; 'L'Architecture nouvelle en Hollande' (*Monde*, 108, 28 June 1930) by Theo van Doesburg; 'L'Architecture nouvelle en Italie' (*Monde*, 85, 18 January 1930) by Alberto Sartoris; 'La Crise du Bauhaus' (*Monde*, 116, 23 August 1930) by Hannes Meyer; 'L'Art au Brésil' (*Monde*, 83, 4 January 1930) by Géo Charles; 'L'Art en danger' (*Monde*, 84, 11 January 1930) by George Grosz; and 'La Fin de la peinture' (*Monde*, 107, 21 June 1930) by Elie Faure.
47 The work of Léger, Kandinsky, Willi Baumeister, Picasso, Matisse, Derain, Chagall, Emiliano di Cavalcanti, Louis Lozowick, Klyment Redko, Bourdelle, Lipchitz and Zadkine, among others, was featured.
48 These included artists such as Masereel, Josef Cantré, Käthe Kollwitz, Grosz, Carl Hofer, William Gropper, Marcel Gromaire, Dovgal, Aleksandr Deïneka, G. Aguirre, Diego Rivera and E. Negrete.
49 Seiwert had been acquainted with Freundlich, Tristan Rémy and Poulaille since the Düsseldorf Congress; he made a number of trips to France after 1926. His international review *A bis Z* (1929–33) contained articles on Herbin, Brancusi, Freundlich, Ozenfant and Picasso.
50 Lasting for two issues, this was edited by Juozas Tysliava, with the participation of A. Binkis, Cocteau, Deltheil, Paul Dermé, Vicente Huidobro, Bruno Jasienski, Kailas, Kurcijs, Kairiukstis, Lipchitz, Malevich, Mitsitch, Mondrian, J. J. P. Oud, Polianski, Aleksander Rafalowski, Rimydis, Russolo, Michel Seuphor, Henryck Stazewski, Suta, Vantongerloo, Visnapuu and Ilarie Voronca.
51 Wanda Khodossievitch married the Polish painter Stanislas Grabowski in 1922 and followed him to Paris. She took part in group exhibitions at the Galerie d'Art Contemporain (1926), the Galerie Aubier (1927), the Galerie Sacre du Printemps (1927), the Franco-Polish exhibition at the Galerie Bonaparte (1929) and at Cercle et Carré (1930).
52 Waldemar George, Przybos, Piper, Jalu Kurek, Max Jacob, Seuphor and Tzara all wrote for this review, which lasted for three issues, from 1929–30.
53 A group whose membership included almost the whole of Art Concret (founded in 1930 by Theo van Doesburg, Hélion, Otto G. Carlsund, Leon Tutundjián and Wantz) and Cercle et Carré; it was enlarged to include English, Italian and American abstract painters. Herbin, who became its president, was a member of the Communist Party after the Congress of Tours (1920). See Fabre 1990.
54 The collection contained work by Arp, Léger, Ozenfant, Baumeister, Prampolini, Schwitters, Sophie Täuber, Joaquín Torres-García, Vantongerloo, van Doesburg, Gleizes, Hélion, Herbin, Stanislaw Ignacy Witkiewicz, Karol Hiller, Mieczyslaw Szczuka, Kobro, Strzemiński and Wladyslaw Strzemiński and Teresa Zarnower, as well as works by Mondrian, Calder, Picasso and Gorin which disappeared during the war. These losses seems less grievous if you consider that in 1945 an exhibition entitled 'Entartete und judische Kunst' was planned at the Łódź Museum, after which the whole collection was to have been destroyed. The Germans did not have time to execute their plan.
55 In Łódź 1971, p. 8.
56 De Ridder 1928.
57 Fabre 1997.
58 Einstein 1929.

Hermenegildo Anglada Camarasa
The White Peacock, 1904
Oil on board, 78.5 × 99.5 cm
Carmen Thyssen-Bornemisza Collection

1

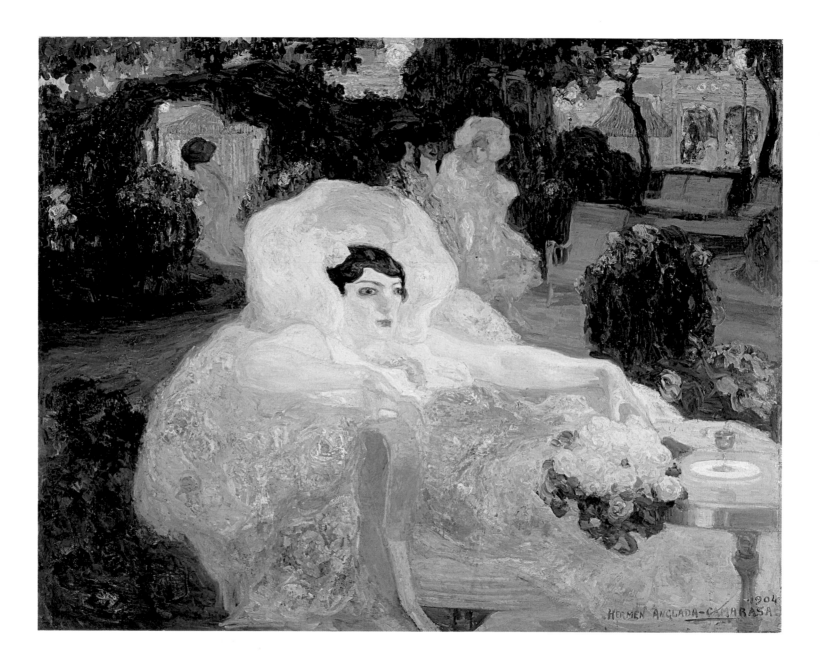

Pablo Picasso
Le Divan japonais, 1901
Oil on board laid down on panel,
69.85 × 53.34 cm
Mugrabi Collection

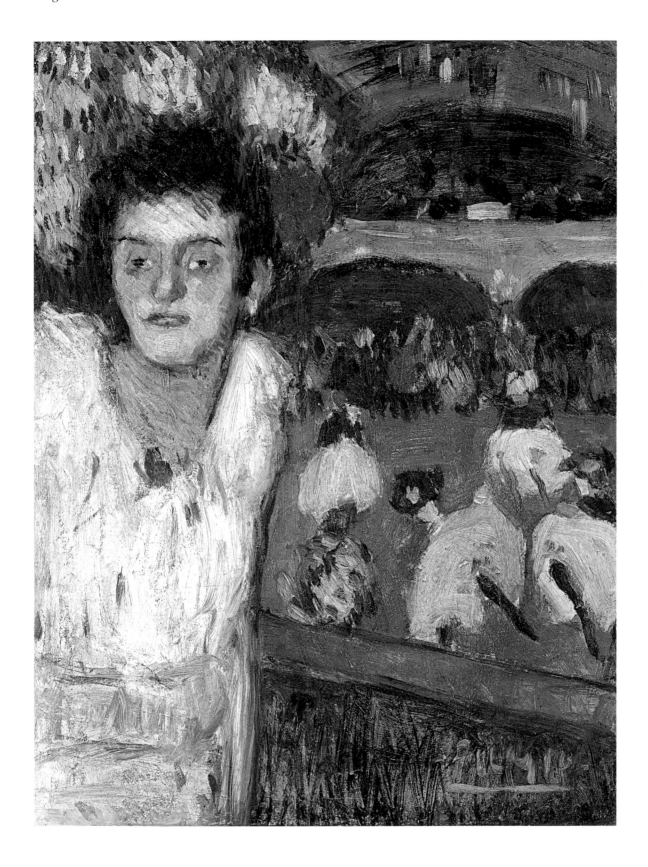

André Derain
Woman in a Chemise, 1906
Oil on canvas, 100 × 81 cm
Statens Museum for Kunst, Copenhagen

3

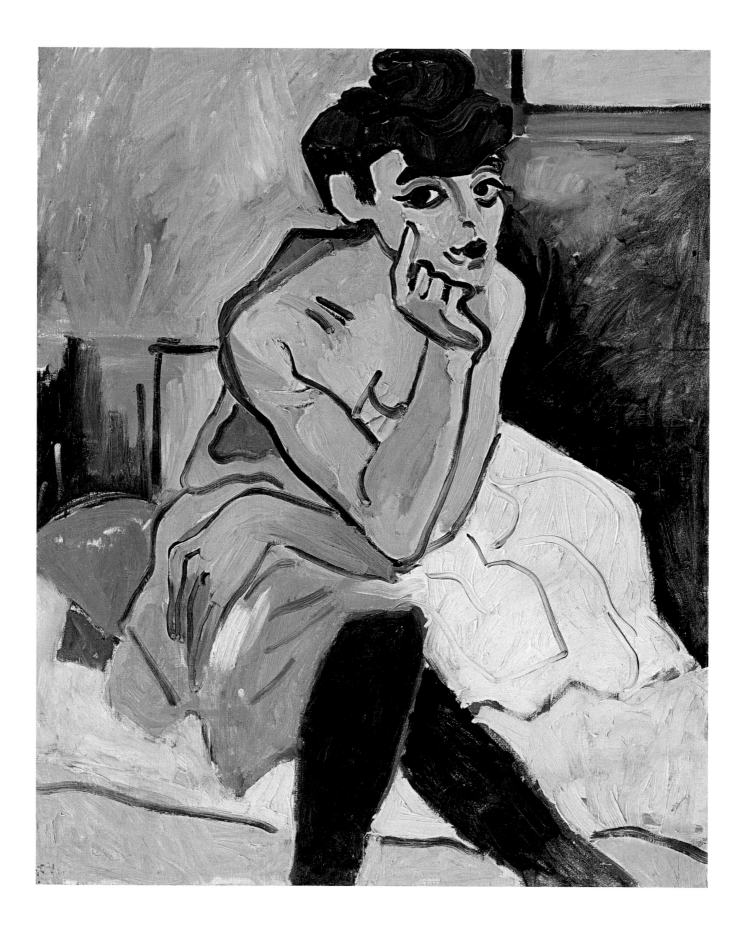

Maurice de Vlaminck

Dancer at the 'Rat Mort', 1905–06
Oil on board, 62.2 × 25.4 cm
Joseph Hackmey

4

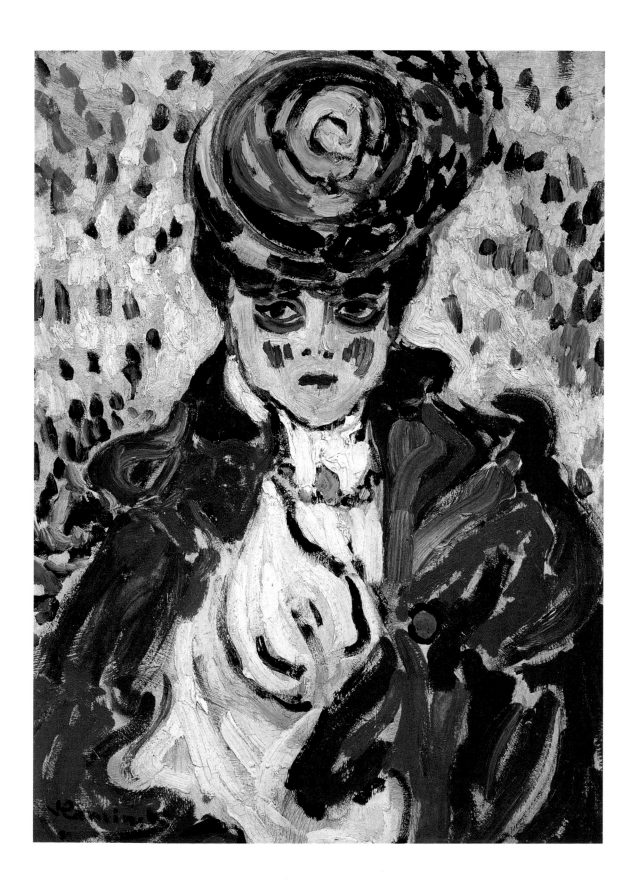

Kees van Dongen
Portrait of Fernande, 1905
Oil on canvas, 100 × 81 cm
Private collection

5

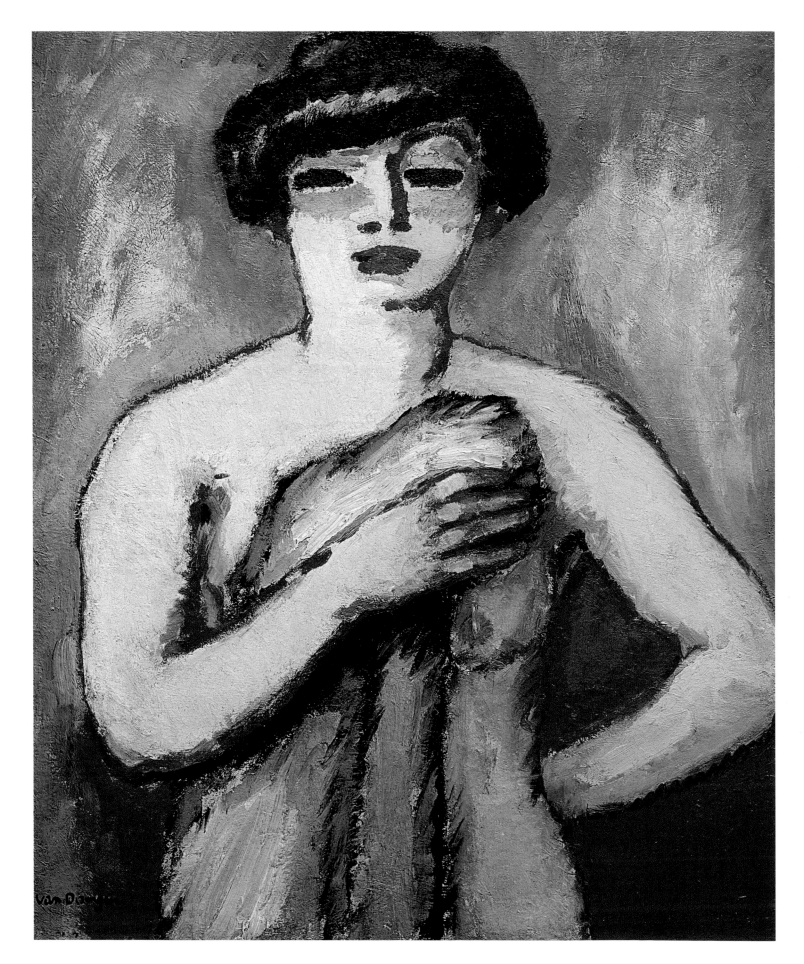

Henri Matisse
Carmelina, 1903–04
Oil on canvas 81.3 × 59 cm
Museum of Fine Arts, Boston,
Tomkins Collection

6

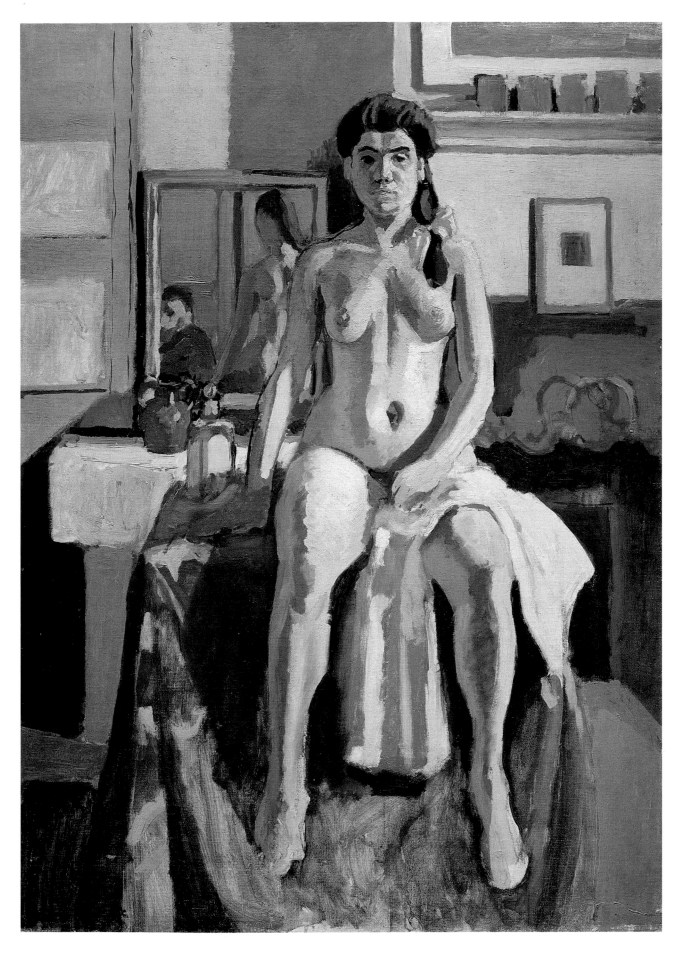

Auguste Chabaud
Hotel Corridor, 1907–08
Oil on cardboard, 105 × 76 cm
Städelsches Kunstinstitut und Städtische
Galerie, Frankfurt am Main

7

Auguste Chabaud
Au Salon, 1907
Oil on hardboard, 108 × 76 cm
Petit Palais, Musée d'Art Moderne, Geneva

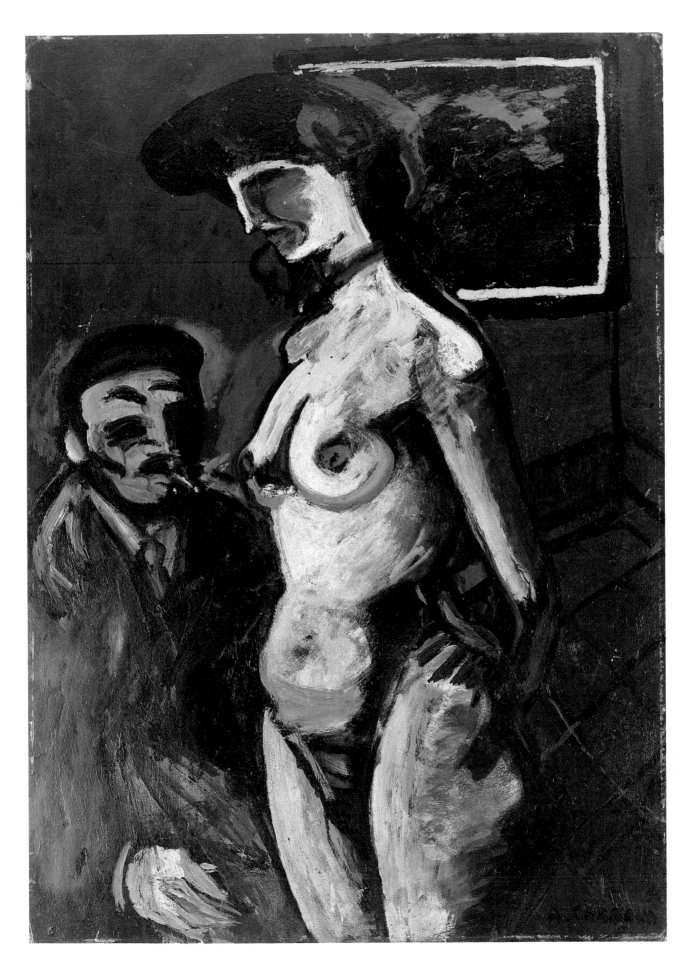

Edouard Vuillard
Le Boulevard des Batignolles, c. 1910
Oil on paper, 78 × 96 cm
Niedersächsisches Landesmuseum, Hanover

9

Walter Sickert

Théâtre de Montmartre, 1906
Oil on canvas, 50.8 × 61.6 cm
King's College, Cambridge (Keynes Collection).
On loan to The Fitzwilliam Museum, Cambridge

10

Kees van Dongen
Daniel-Henry Kahnweiler, 1907
Oil on canvas, 65 × 54 cm
Petit Palais, Musée d'Art Moderne, Geneva

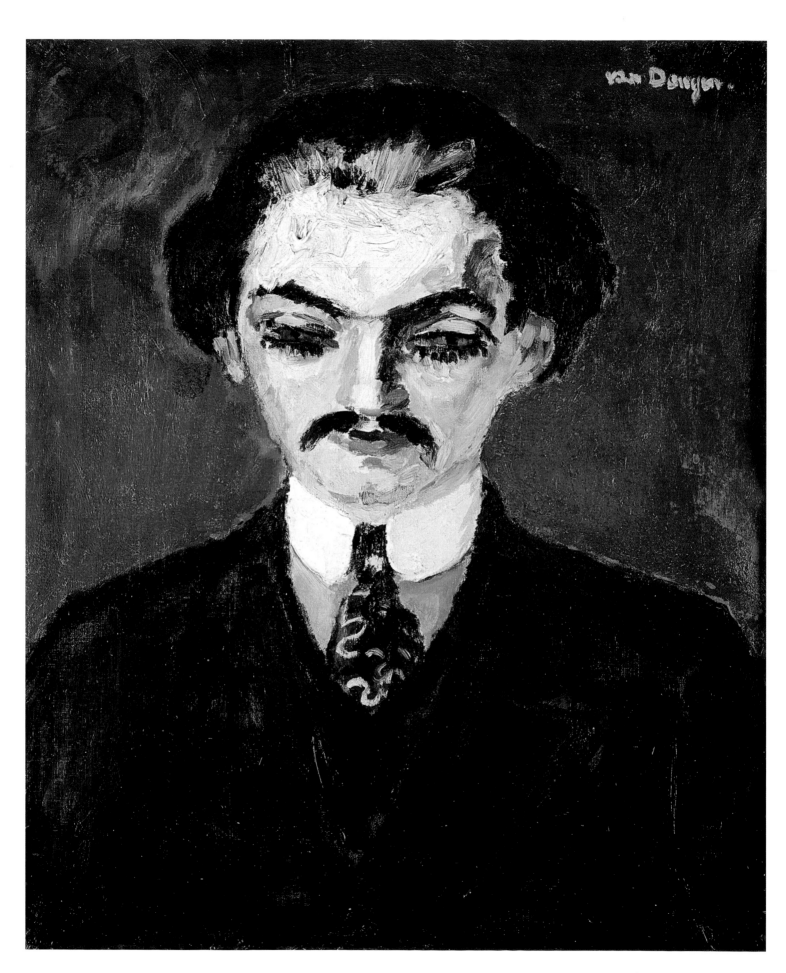

12

Georges Rouault
Clown with Rose, 1908
Gouache and watercolour on paper laid down
on canvas, 100 × 65 cm
Private collection

Pablo Picasso
The Fool, 1905
Bronze, 41.5 × 36.5 × 22 cm
Musée d'Art Moderne de la Ville de Paris

14

Henri Matisse
Two Women, 1907–08
Bronze, 46.6 × 25.6 × 19.9 cm
Hirshhorn Museum and Sculpture Garden,
Smithsonian Institution, Washington DC.
Gift of Joseph H. Hirshhorn, 1966

15

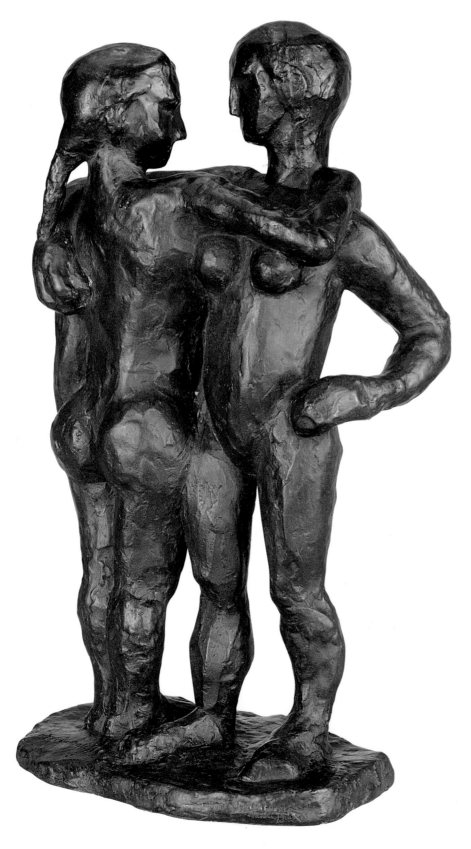

Henri Matisse
Two Women, 1907–08
Bronze, 46.6 × 25.6 × 19.9 cm
Hirshhorn Museum and Sculpture Garden,
Smithsonian Institution, Washington DC.
Gift of Joseph H. Hirshhorn, 1966

Pablo Picasso
Study for *Les Demoiselles d'Avignon*, 1907
Oil on canvas, 54 × 41 cm
Moderna Museet, Stockholm

16

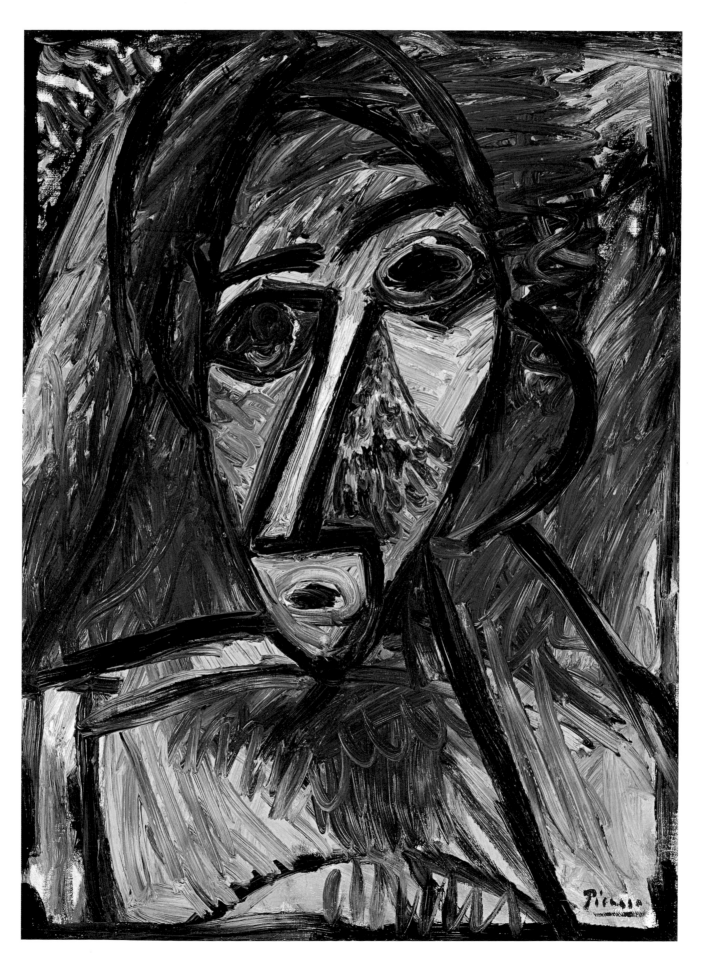

Pablo Picasso
Study for *Les Demoiselles d'Avignon*, 1907
Oil on cardboard, 53.5 × 36.2 cm
Musée Picasso, Paris

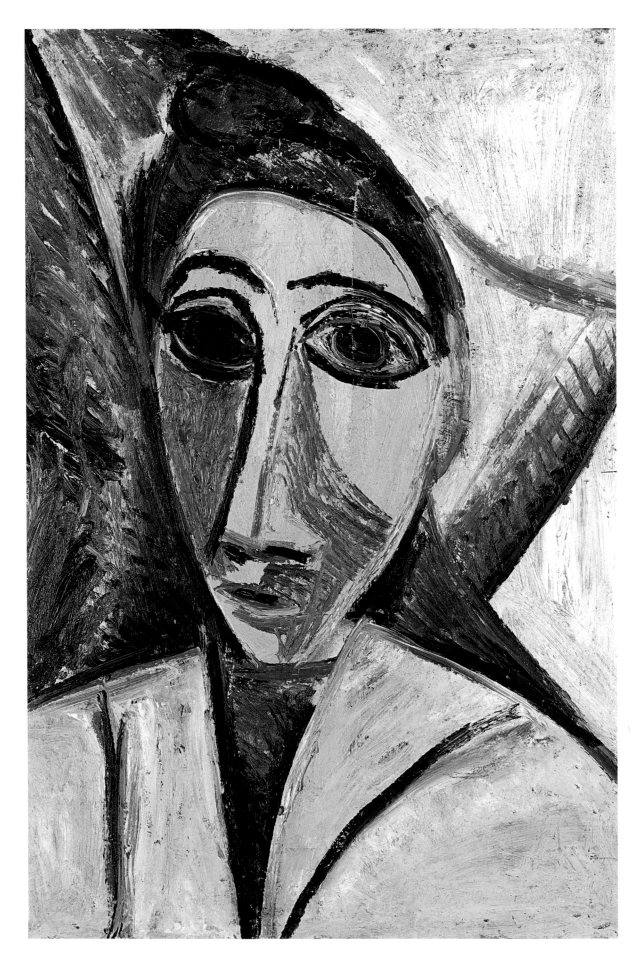

Pablo Picasso
Study for *Les Demoiselles d'Avignon*, 1907
Oil on canvas, 93 × 43 cm
Civico Museo d'Arte Contemporanea, Milan

18

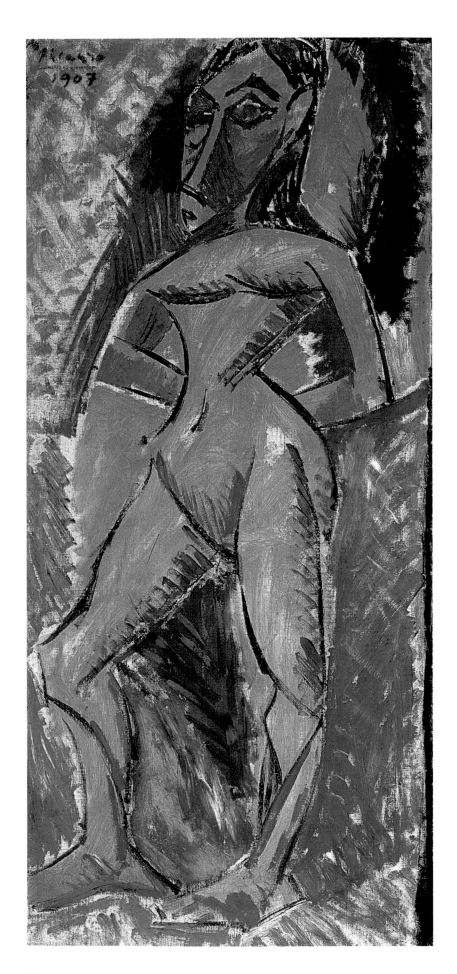

Suzanne Valadon
The Fortune Teller, 1912
Oil on canvas, 130 × 163 cm
Petit Palais, Musée d'Art Moderne, Geneva

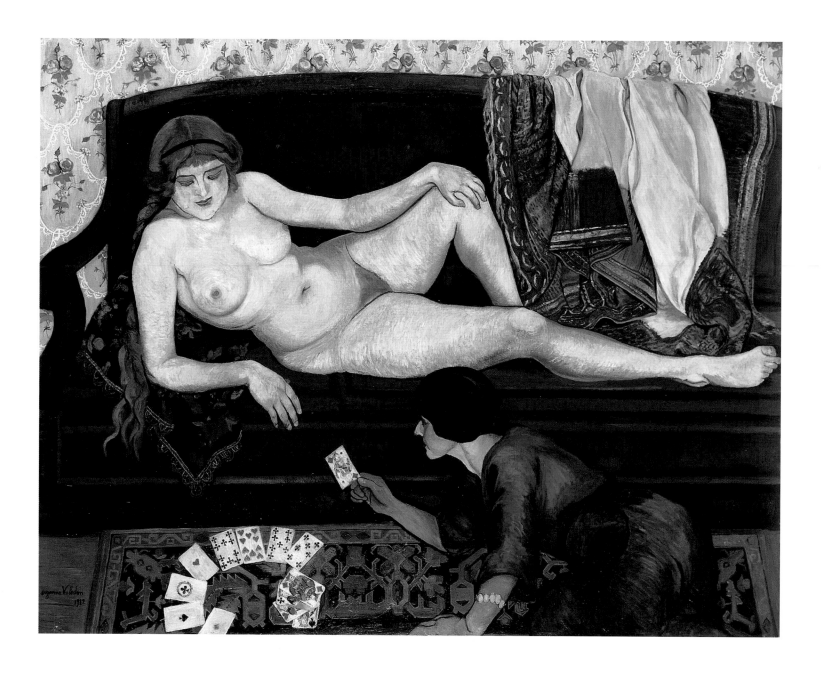

Maurice Utrillo
L'Impasse Cottin, 1910–11
Oil on cardboard, 62 × 46 cm
Musée National d'Art Moderne,
Centre Georges Pompidou, Paris

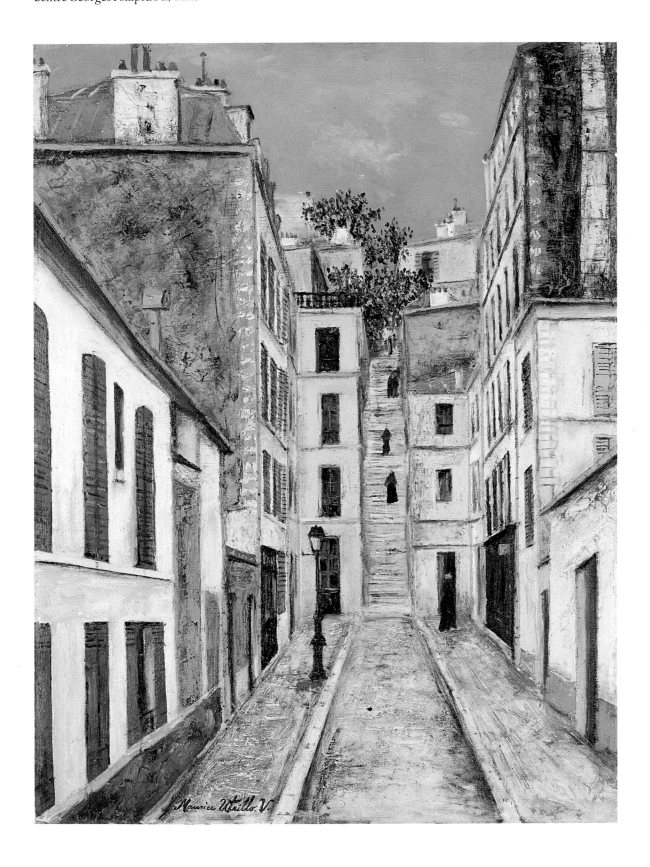

Marie Laurencin
Apollinaire and His Friends, 1909
Oil on canvas, 130 × 194 cm
Musée National d'Art Moderne,
Centre Georges Pompidou, Paris

Pablo Picasso
Sacré-Coeur, 1910
Oil on canvas, 92.5×65 cm
Musée Picasso, Paris

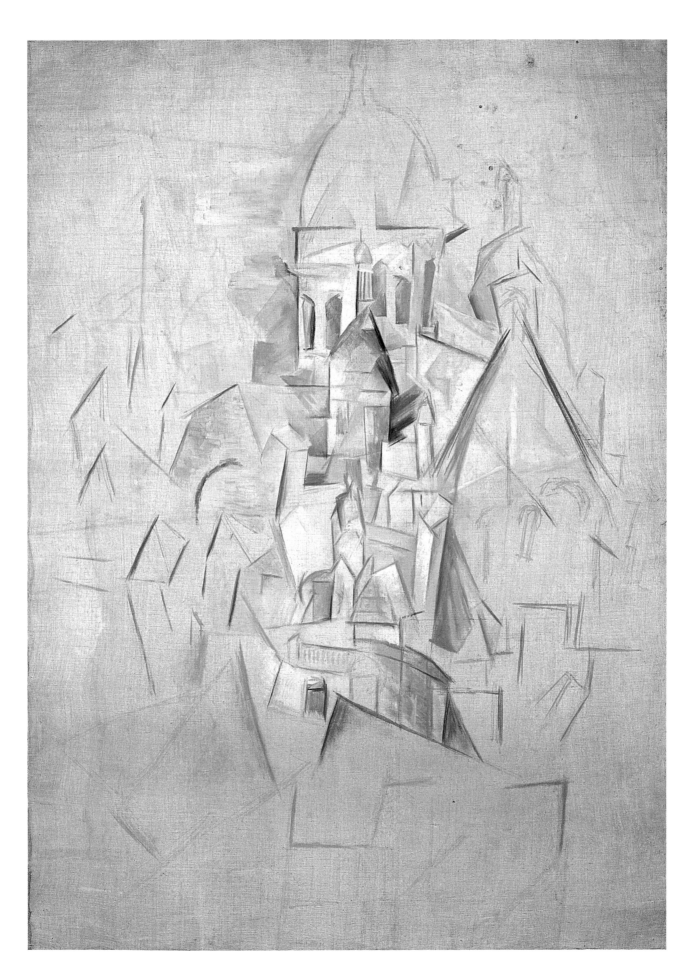

Georges Braque
Still-life with Violin, 1913
Oil and charcoal on canvas, 65.4 × 92.1 cm
Mugrabi Collection

23

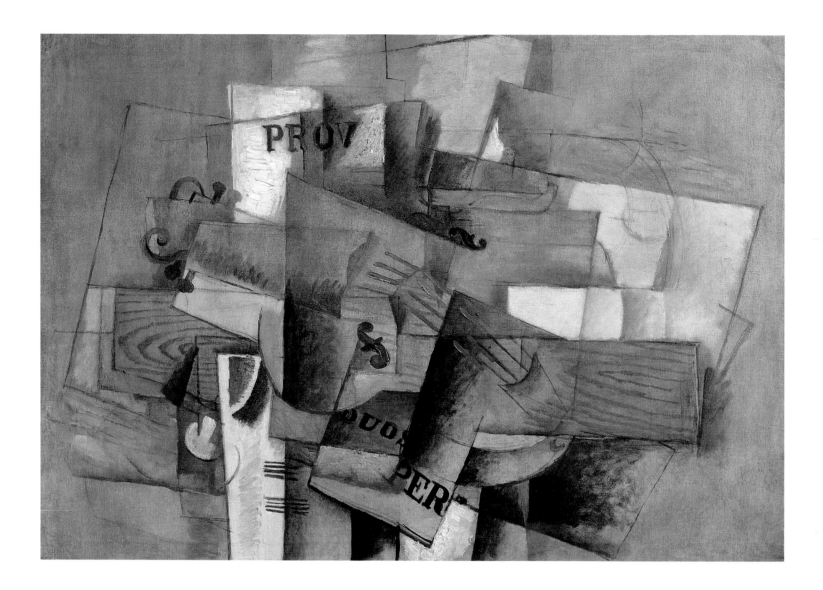

Georges Braque
Cards and Dice, 1914
Oil on canvas, 35.5 × 44 cm (oval)
Courtesy Helly Nahmad Gallery, London

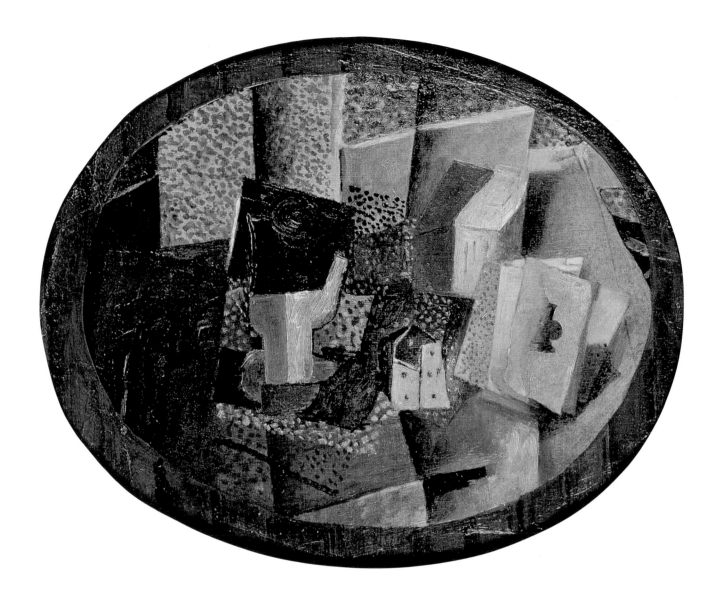

Robert Delaunay
La Ville, 1911
Oil on canvas, 145 × 111.9 cm
Solomon R. Guggenheim Museum, New York.
Gift of Solomon R. Guggenheim, 1938

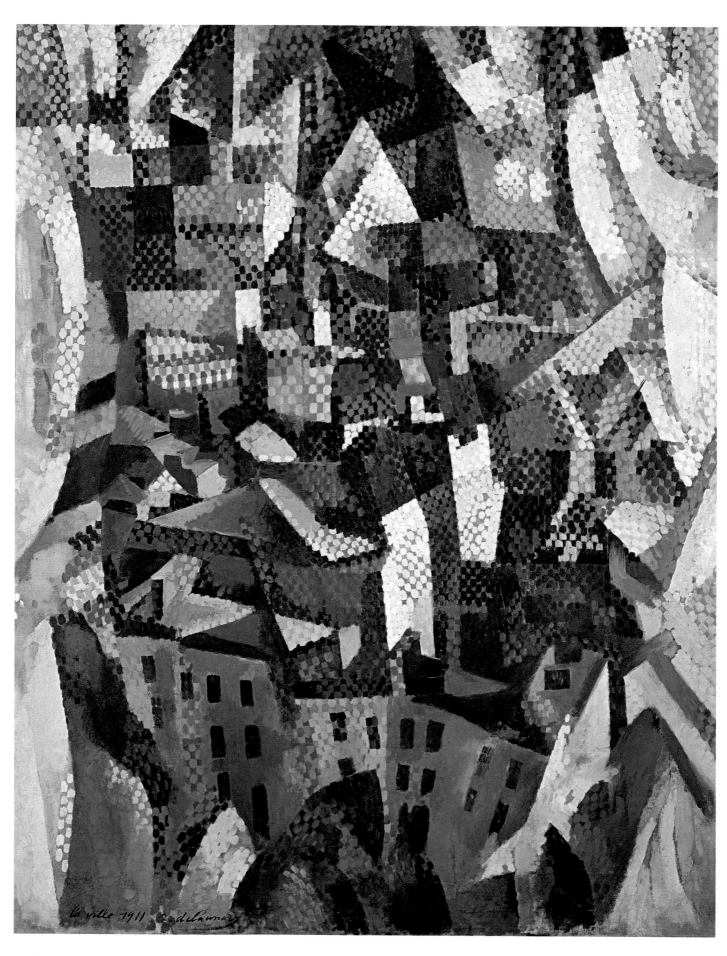

Pablo Picasso
Woman with a Mandolin
(Madame Léoni Seated), 1911
Oil on canvas, 100 × 81 cm
Marina Picasso Collection. Courtesy Galerie Jan
Krugier, Ditesheim & Cie, Geneva

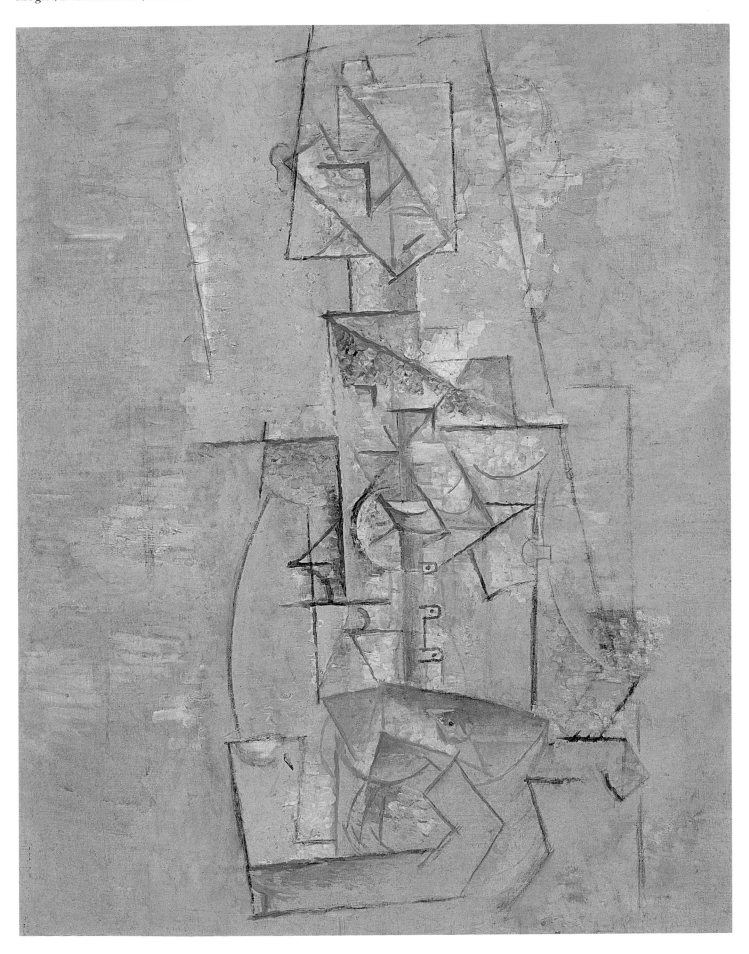

27

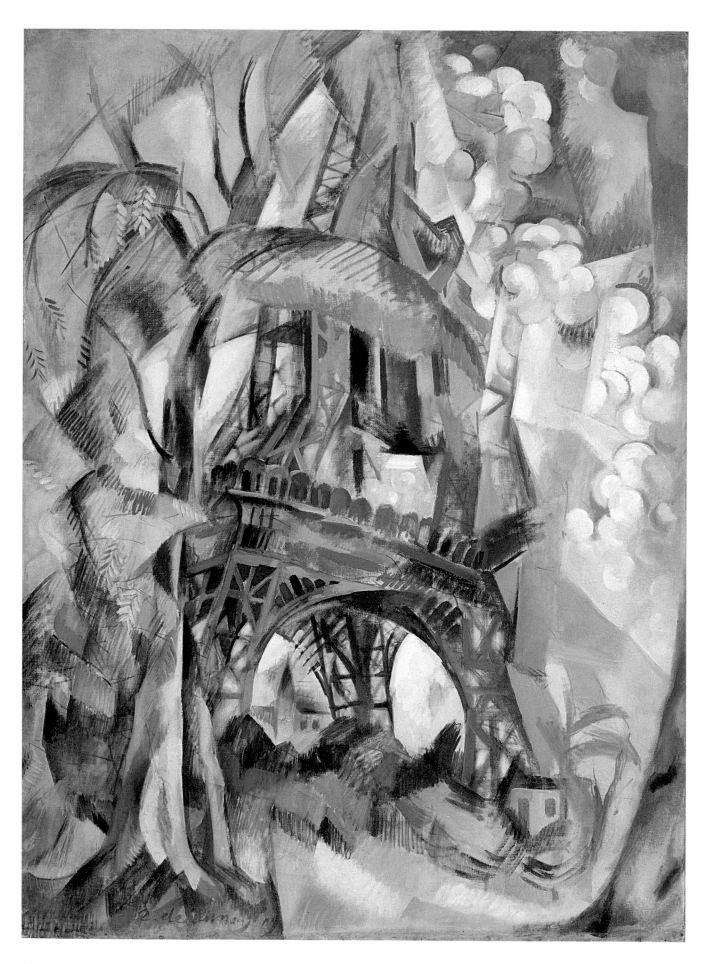

Robert Delaunay

La Fenêtre sur la ville no. 3, 1911–12
Oil on canvas, 113.5 × 130.7 cm
Solomon R. Guggenheim Museum, New York

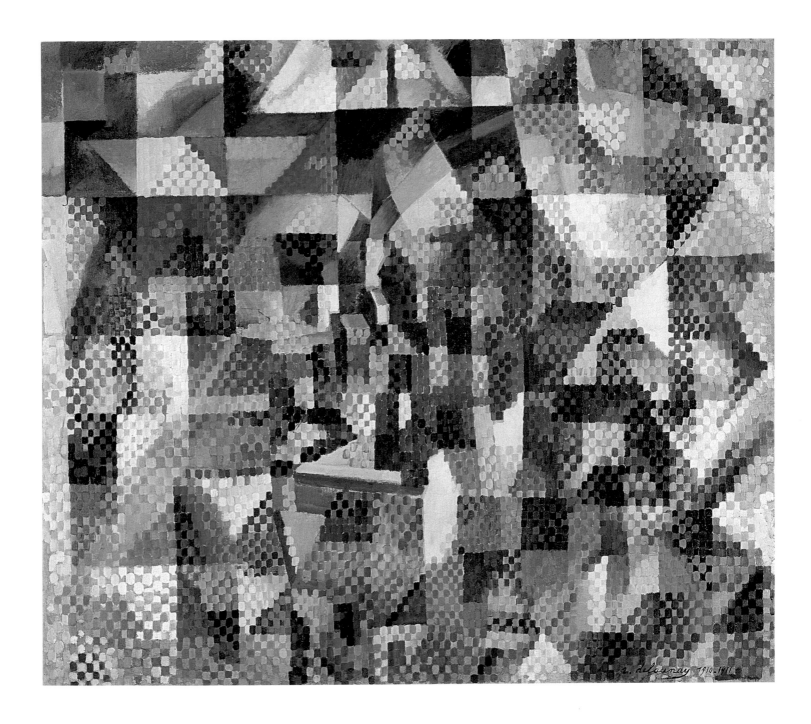

Gino Severini
The Nord–Sud (Speed and Sound), 1912
Oil on canvas, 49 × 64 cm
Pinacoteca di Brera, Milan. Emilio and Maria
Jesi donation

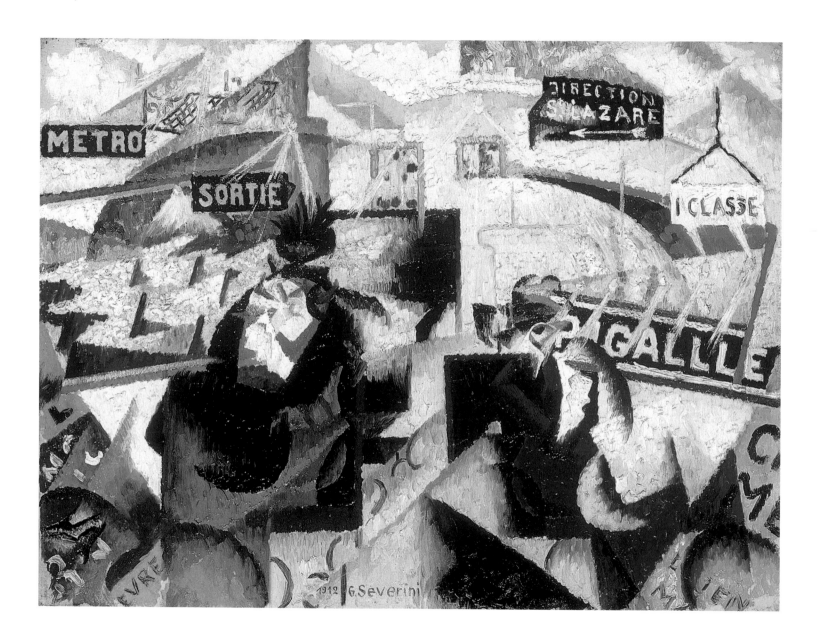

Robert Delaunay
Tour Eiffel, 1911
Oil on canvas, 202 × 138.4 cm
Solomon R. Guggenheim Museum, New York.
Gift of Solomon R. Guggenheim, 1937

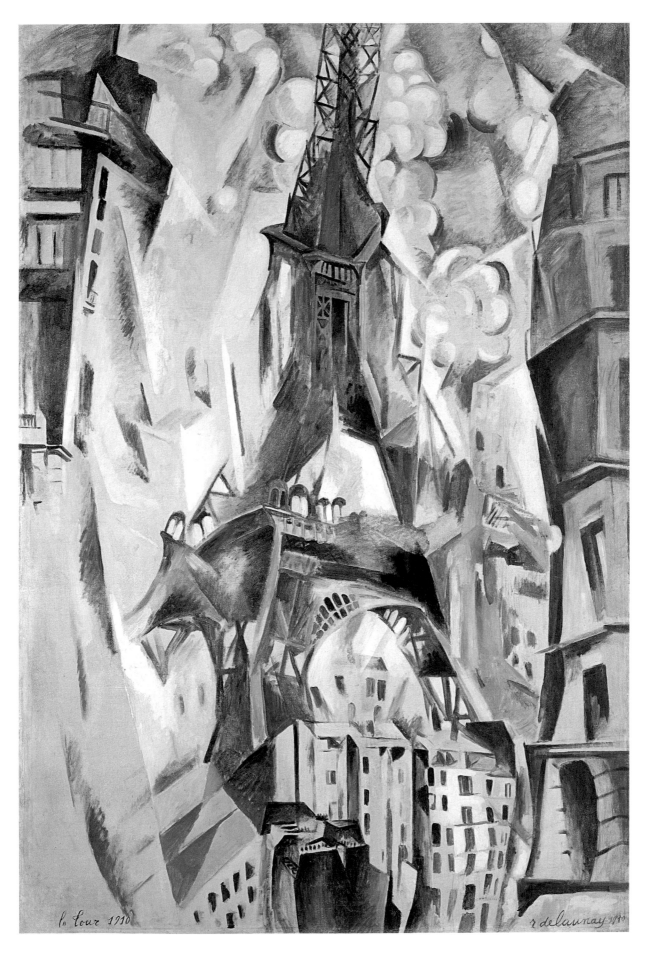

Juan Gris
Man in a Café, 1912
Oil on canvas, 128.2 × 88 cm
Philadelphia Museum of Art: The Louise and
Walter Arensberg Collection, 1950

31

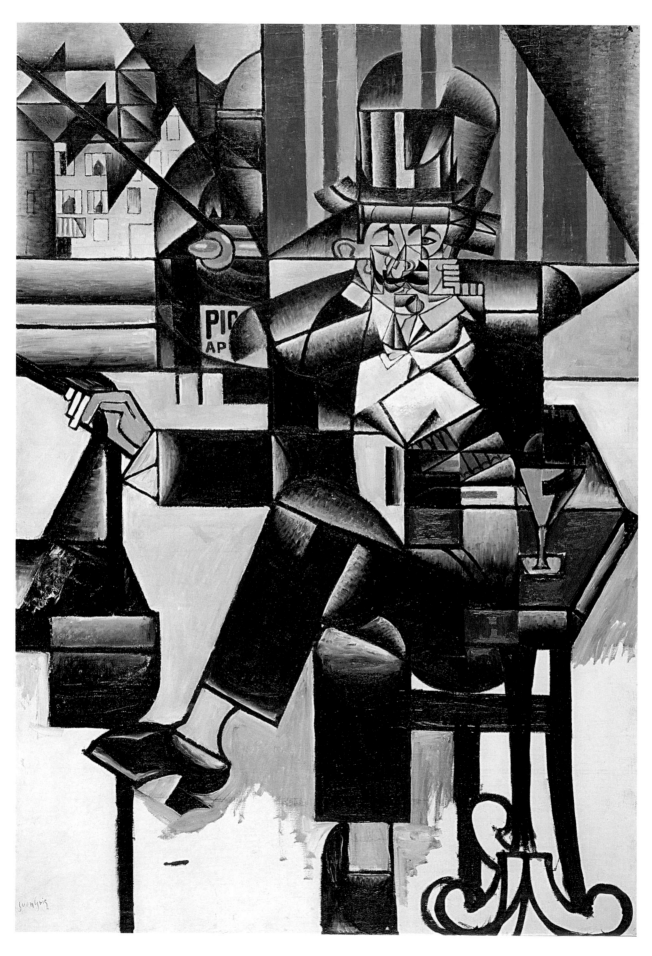

Albert Gleizes
Portrait of the Editor Figuière, 1913
Oil on canvas, 143 × 102 cm
Musée des Beaux-Arts, Lyons

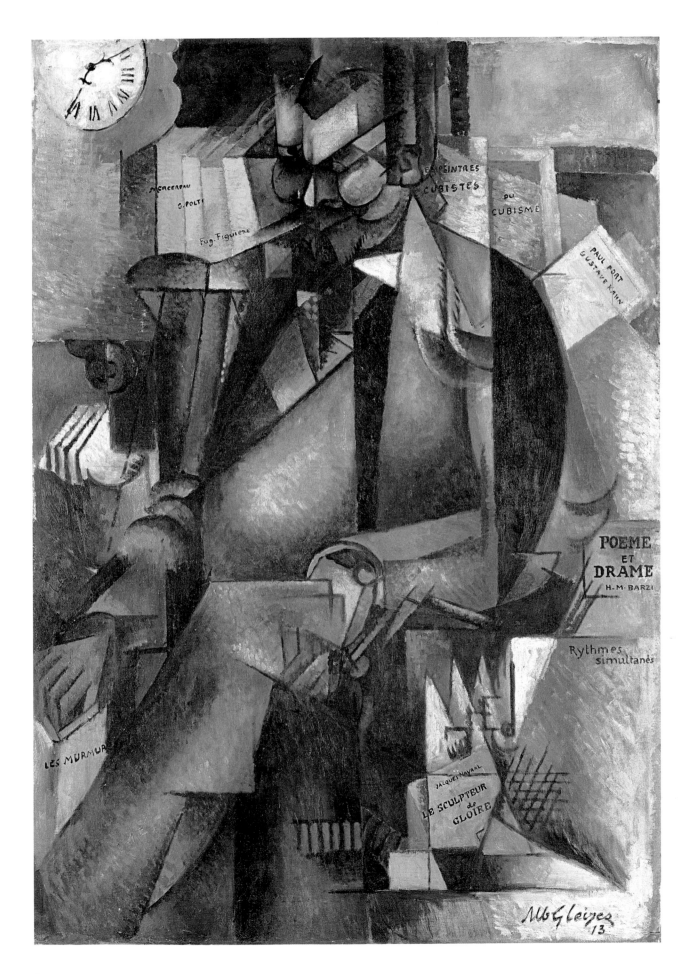

Fernand Léger
Nude Model in Studio, 1912–13
Oil on burlap, 127.8 × 95.7 cm
Solomon R. Guggenheim Museum, New York

33

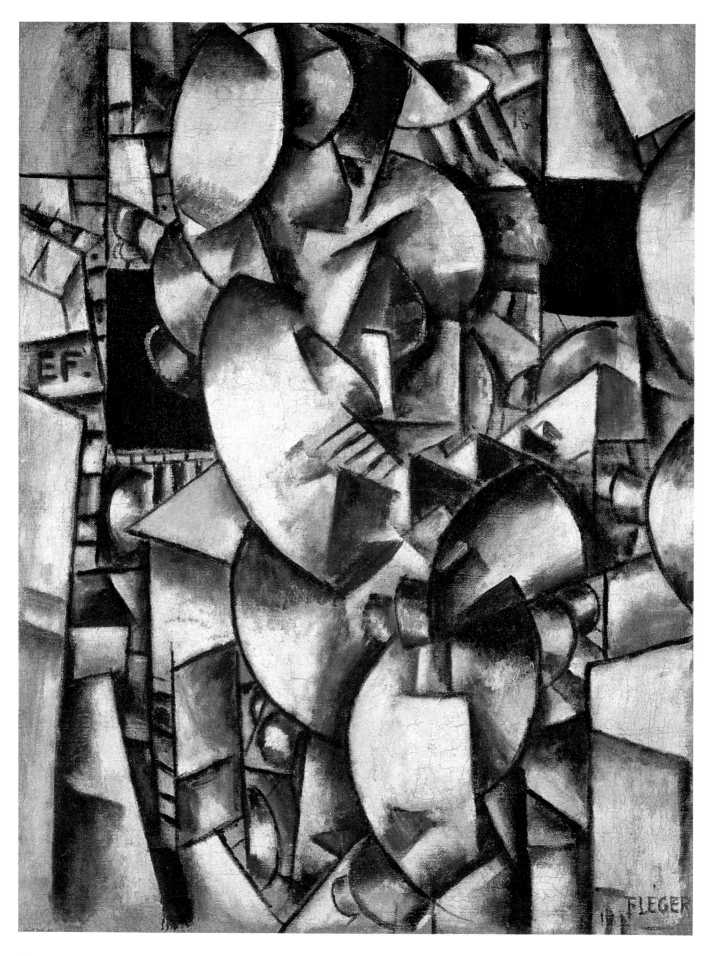

Marc Chagall
Paris Through the Window, 1913
Oil on canvas, 135.8 × 141.4 cm
Solomon R. Guggenheim Museum, New York.
Gift of Solomon R. Guggenheim, 1937

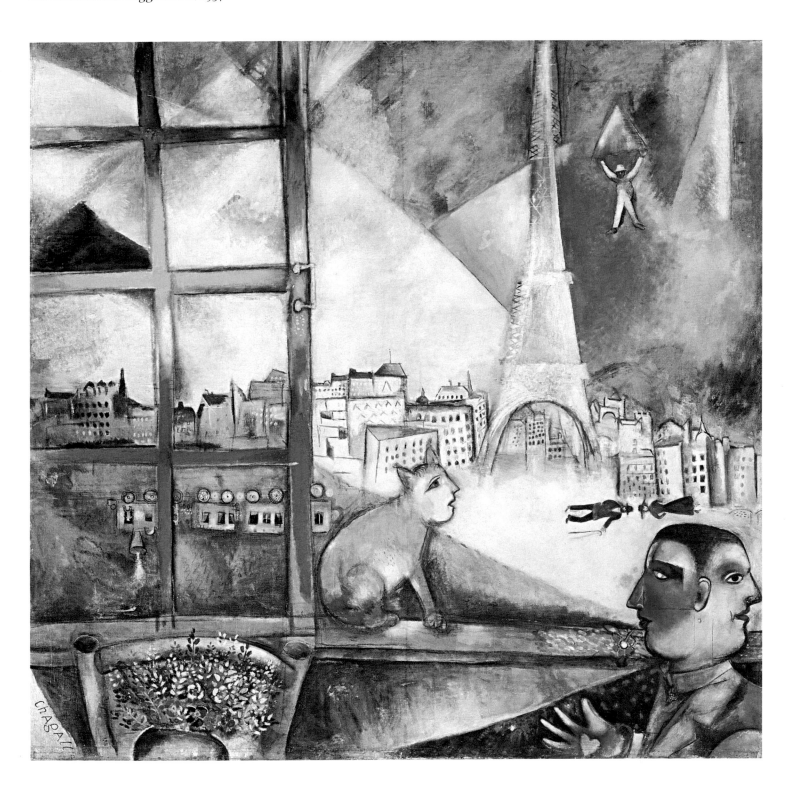

35

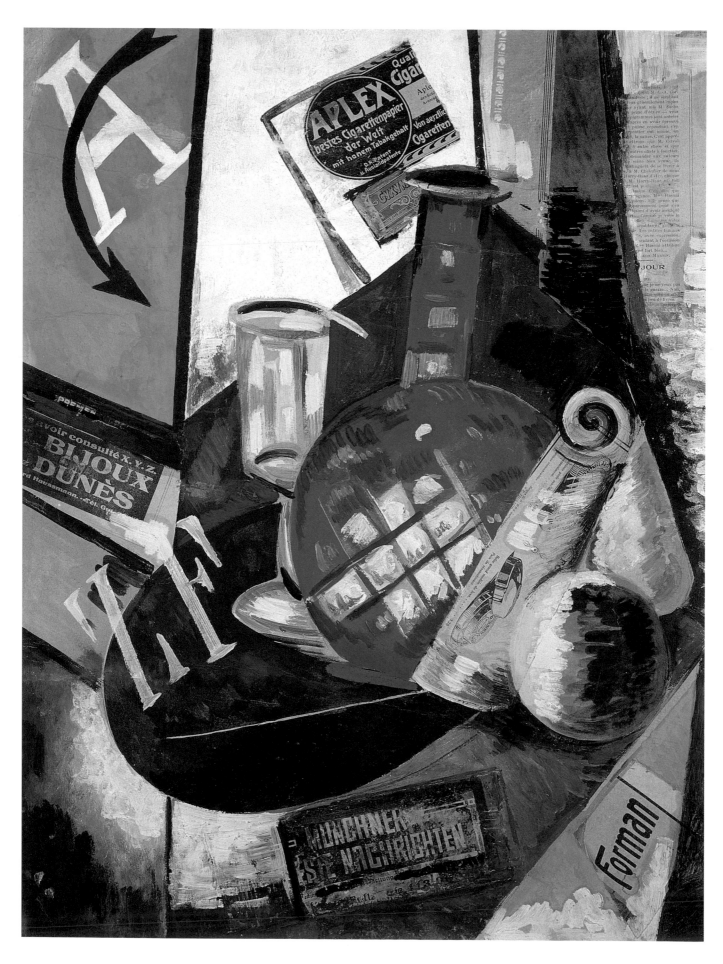

Juan Gris
The Smoker, 1913
Oil on canvas, 73 × 54 cm
Museo Thyssen-Bornemisza, Madrid

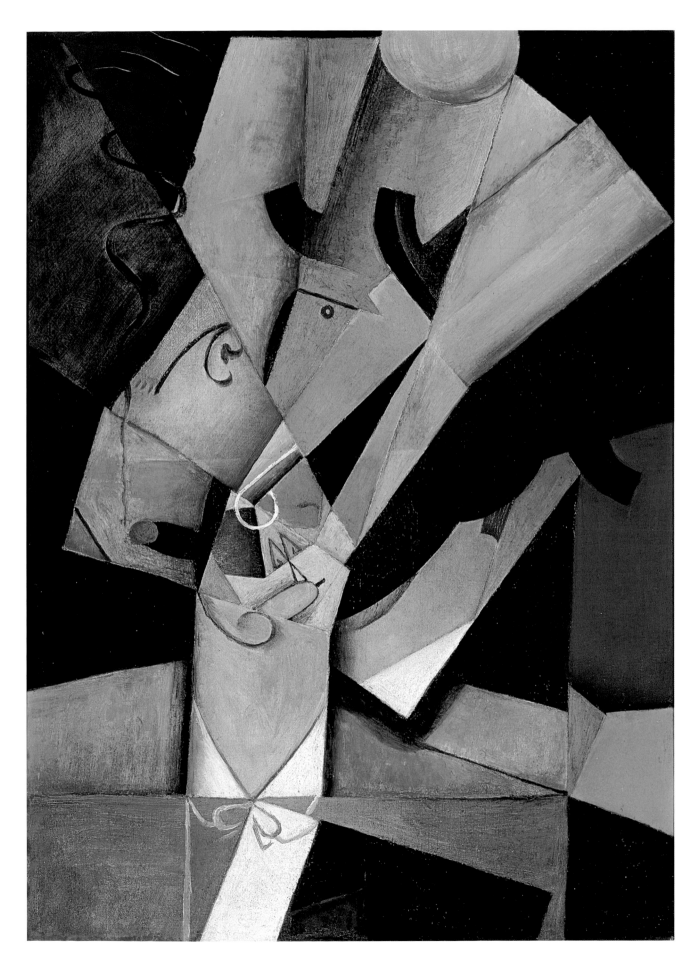

Juan Gris
The Smoker, 1913
Oil on canvas, 73 × 54 cm
Museo Thyssen-Bornemisza, Madrid

Sonia Delaunay-Terk
Dubonnet, 1914
Watercolour on canvas, 61 × 76 cm
Museo Nacional Centro de Arte Reina Sofía,
Madrid

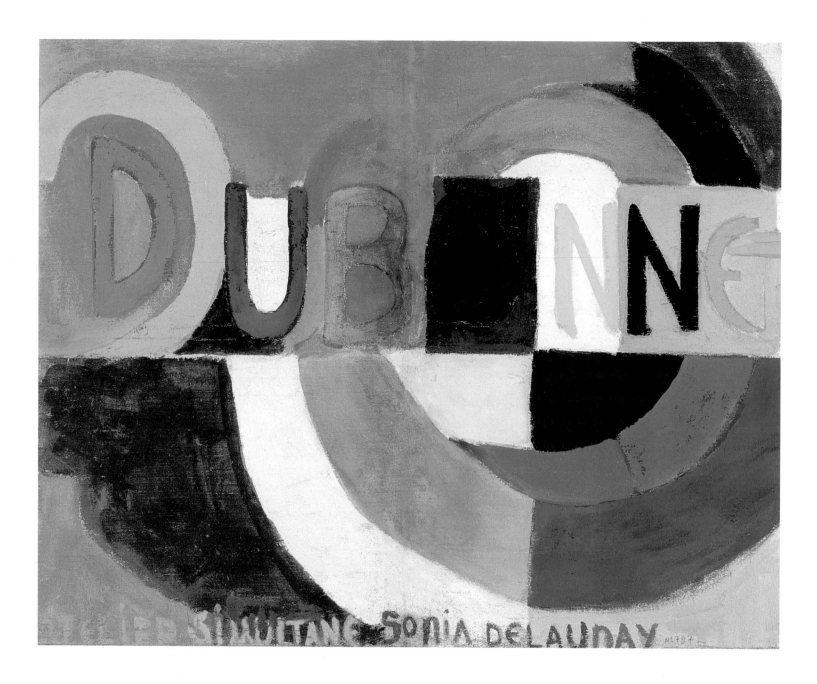

Diego Rivera
Portrait of Martín Luis Guzmán, 1915
Oil on canvas, 72.3 × 59.3 cm
Fundación Televisa Collection, Mexico City

38

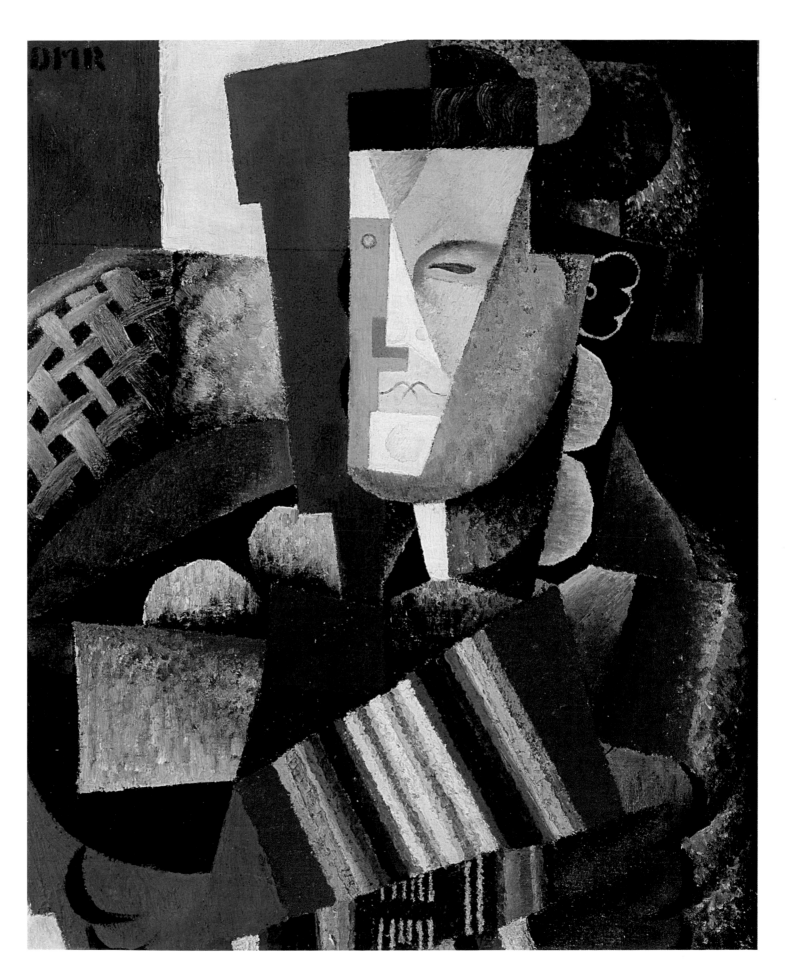

Diego Rivera
Portrait of Martín Luis Guzmán, 1915

Morgan Russell
Four-part Synchromy, no. 7, 1914–15
Oil on canvas, 40 × 29.2 cm
Whitney Museum of American Art, New York.
Gift of the artist in memory of Gertrude V.
Whitney

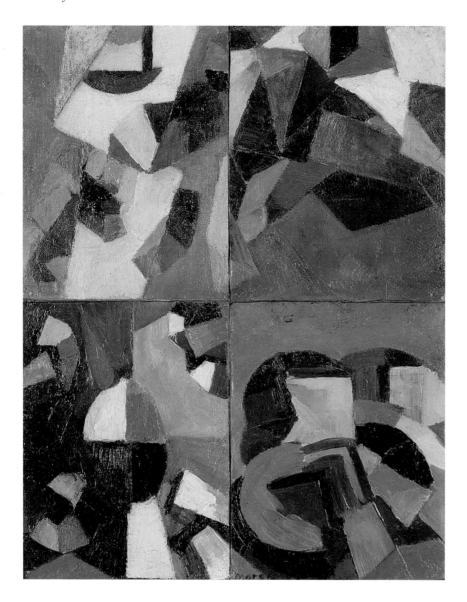

Sonia Delaunay-Terk
Le Bal Bullier, 1913
Oil on canvas, 97 × 132 cm
Kunsthalle Bielefeld

František Kupka

The First Step, 1909
Oil on canvas, 83.2 × 129.6 cm
The Museum of Modern Art, New York,
Hillman Periodicals Fund, 1956

41

Francis Picabia
Physical Culture, 1913
Oil on canvas, 89.5 × 117 cm
Philadelphia Museum of Art: The Louise
and Walter Arensberg Collection, 1950

42

Natalia Goncharova
Electric Lamp, 1913
Oil on canvas, 105 × 81.5 cm
Musée National d'Art Moderne, Centre Georges
Pompidou, Paris. Gift of the Société des Amis
du Musée National d'Art Moderne, Paris, 1966

43

Marcel Duchamp
Bicycle Wheel, 1913
Readymade, $126.7 \times 64.1 \times 32$ cm
Hessisches Landesmuseum, Darmstadt

44

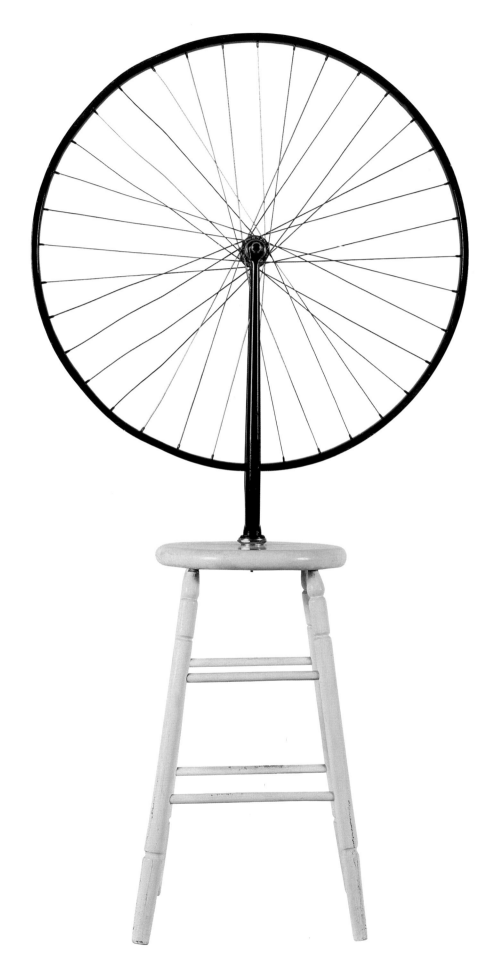

Jacques Lipchitz
Pierrot with a Clarinet, 1919
Bronze, 75.5 × 25 × 26 cm
Private collection, Switzerland

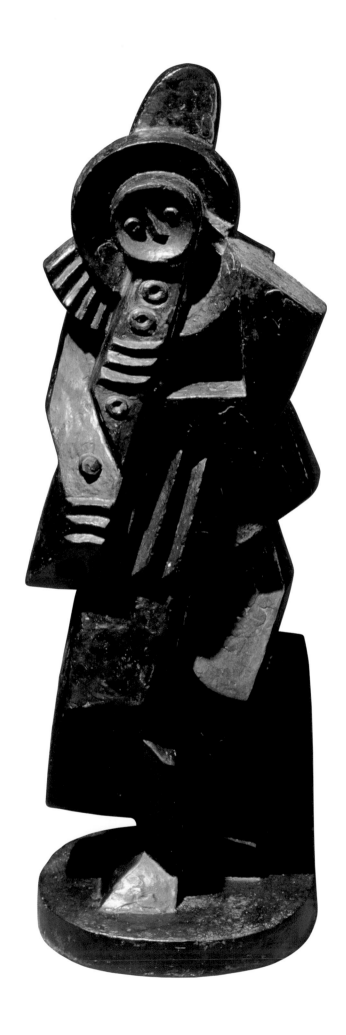

Maria Blanchard
Cubist Composition, c. 1917
Oil on canvas, 57 × 54 cm
Zorrilla de Lequerica Collection, Bilbao

46

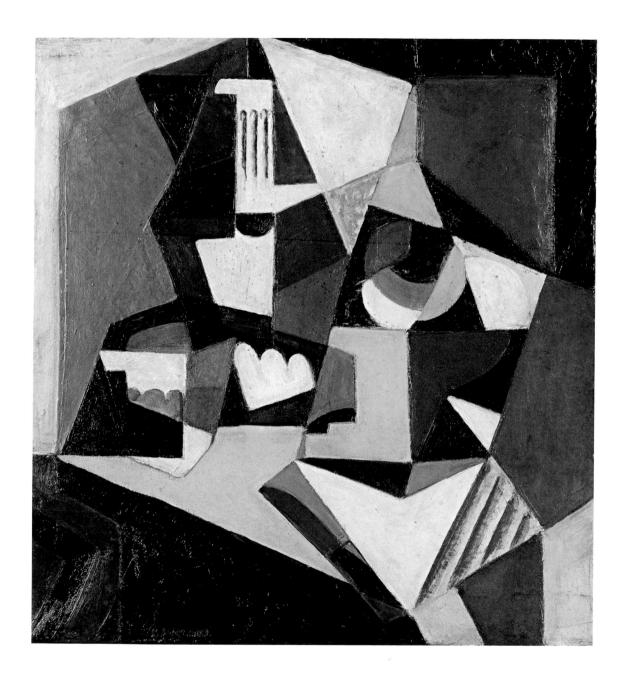

Raymond Duchamp-Villon
Large Horse, 1914 (cast 1961)
Bronze, 100 × 98.7 × 66 cm
Tate. Purchased 1978

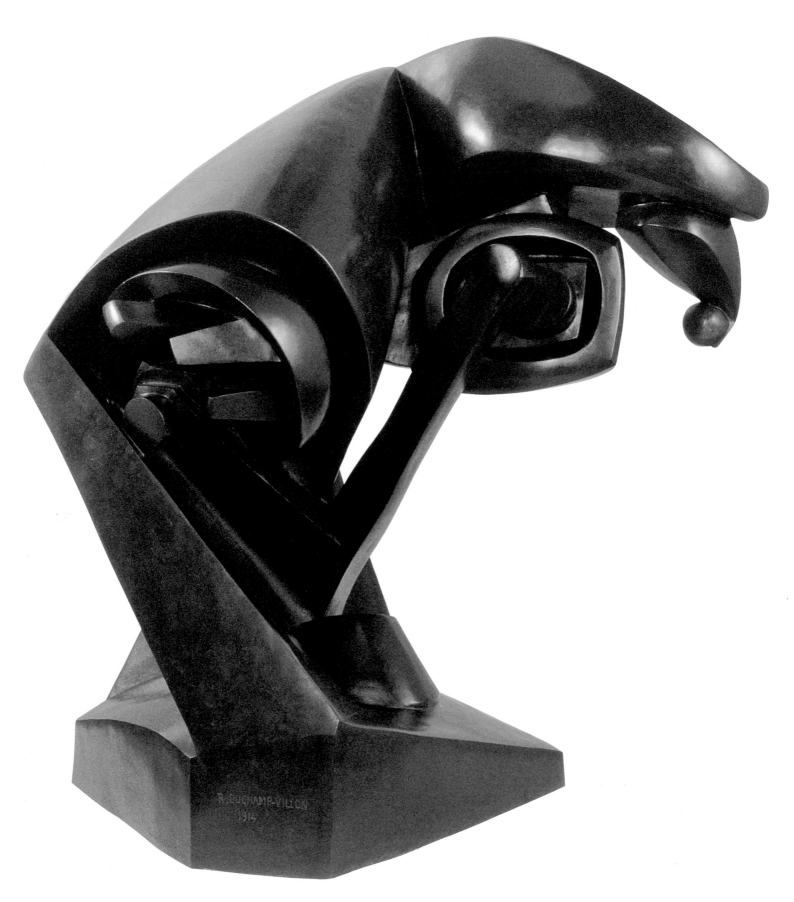

Gino Severini
Dancer no. 5, c. 1913–16
Oil on canvas, 93.3 × 74 cm
Pallant House Gallery, Chichester
(Kearley Bequest), through the National
Art Collections Fund, 1989

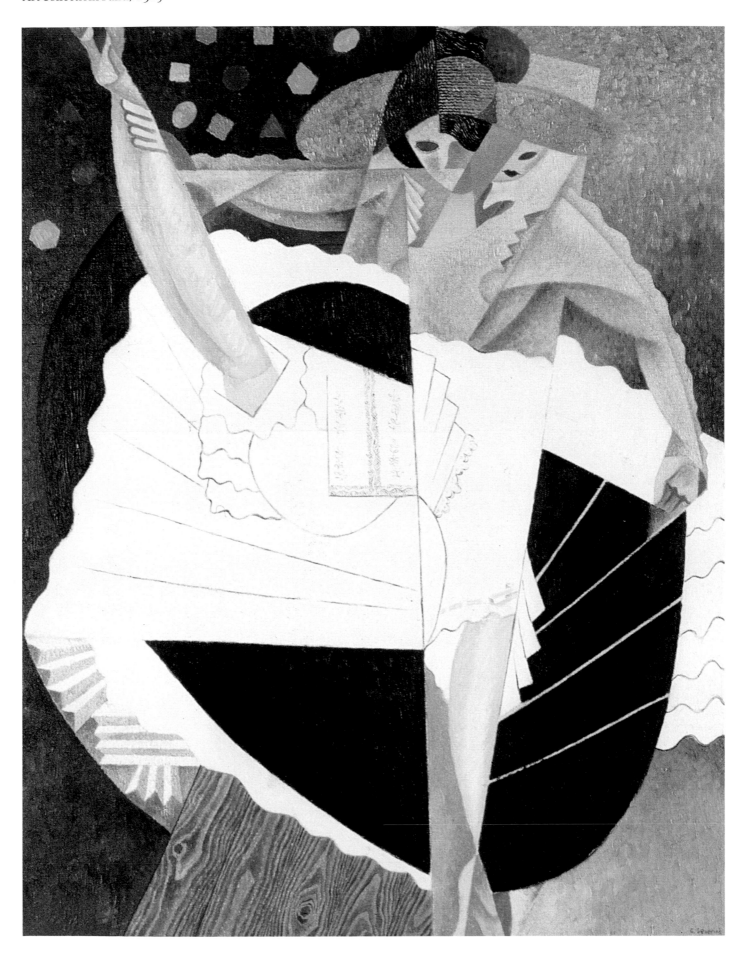

2

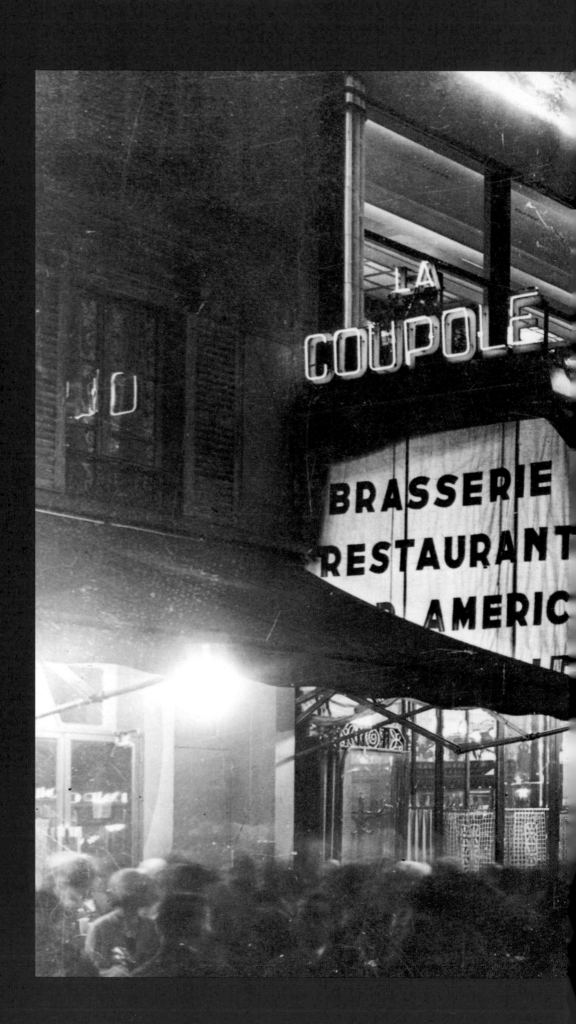

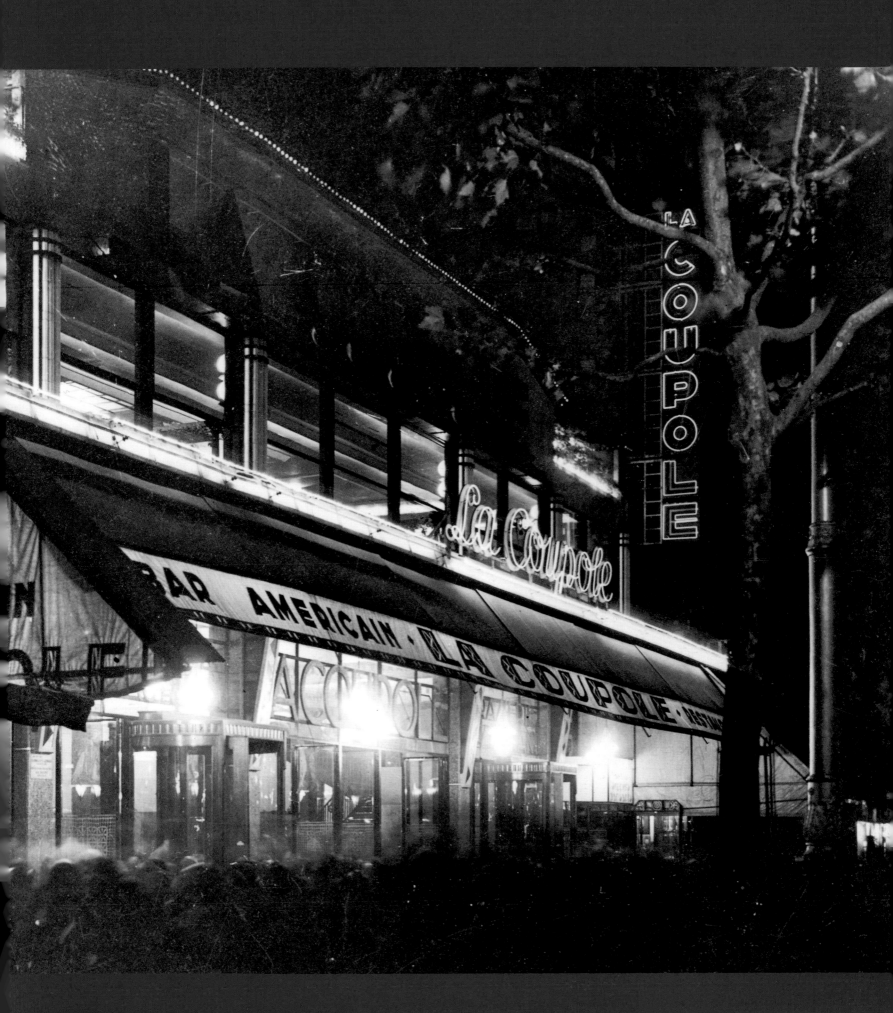

Montparnasse and the Right Bank: Myth and Reality

Simonetta Fraquelli

Hemingway famously referred to Paris as 'a moveable feast', a mythical city ungraspable in its richness and variety.[1] Paris in the interwar period was the hedonistic capital of Europe, an artistic crossroads and a testing ground of unparalleled vitality, the goal of artists in search of freedom and inspiration. Although artists, writers, musicians and dancers were drawn to the city for various reasons, none doubted its mythical status. Paris embodied a dream. Diverse interpretations of that dream were offered by three large-scale exhibitions held in the city between the wars: the Exposition Internationale des Arts Décoratifs et Industriels Modernes (1925) presented a glamorous vision, the Exposition Coloniale (1931) a fantastic colonial world and the Exposition Internationale des Arts et des Techniques dans la Vie Moderne (1937) a surreal spectacle of political power.

The Exposition Internationale des Arts Décoratifs et Industriels Modernes, held from April to November 1925 (fig. 44), had been planned before the First World War as a means of establishing France's supremacy in the decorative arts, especially over Germany. Art and industry were to collaborate in improving the quality and design of everyday objects. But after the war this emphasis changed. Staged primarily as a demonstration of France's economic recovery, the exhibition used the city of Paris, or an illusion of it, to promote French luxury goods and modern French design.[2]

A 'city within a city', with pavilions, palaces and shops, the Exposition presented Paris as a dream-like spectacle. Everything was contrived to envelop the visitor in a fantasy world. Lavish lighting effects along the Seine turned the city into a veritable *ville lumière*, complete with fountains; the window displays of shops on the Pont Alexandre III dazzled onlookers; and fashion shows, dance spectacles and other events brought together the worlds of fashion, art and performance. This *tableau vivant*, its theatricality intensified by its ephemerality, was a vast marketing ploy, 'selling' a seductive view of Paris as the centre of opulence and glamour. With the real city acting as a backdrop, the Exposition presented a vision of Paris as 'a woman's city', a world centre of fashion and shopping, thus redefining the French capital as the ultimate modern city.[3]

Alongside the effervescent modernity of the 'woman's city', the Exposition offered another 'reality', that of the French countryside. Indeed, the official model for postwar reconstruction presented at the Exposition was not some modernist master-plan, but the Pavillon du Village Français and the pavilions of the French regions.[4] Built in vernacular styles, these no doubt appealed to visitors who had recently left the countryside to live in the capital, not to mention those members of the French intelligentsia who, in the spirit of the postwar 'call to order', advocated a return to traditional, rural values.

The Exposition was laid out along the banks of the Seine between the Grand Palais and the Esplanade des Invalides – a central site similar to those used for the world fairs held in the city in the nineteenth century. Although the location was controversial – some lamented a missed opportunity to build urgently needed housing and schools there – the frivolous, élitist nature of an exhibition which pandered to bourgeois aspirations attracted the most severe criticism. The critic Waldemar George, for instance, berated the exhibition for being retardataire. He praised only a handful of pavilions for embodying a 'truly' modern spirit, most notably the Constructivist architect Konstantin Melnikov's Russian pavilion, which contained furniture designed by Alexander Rodchenko, and Le Corbusier's Pavillon de l'Esprit Nouveau (fig. 45).[5]

The élitism of the Exposition angered Le Corbusier, who violently rejected the 'feminine', commodity-based modernity it promoted.[6] In his pavilion, erected on the periphery of the exhibition site without an official grant, he emphasised the merits of mass production and standardisation, displaying his belief that only judicious urban planning could bring order and efficiency to the physical environment and to daily life itself. His 'machine à habiter' (machine for living), conceived as a single residential unit within his vision of a Contemporary City for Three Million, was intended to provide a 'democratic' architecture for the masses.[7] Thus Le Corbusier engaged with the realities of modern society, its problems and aspirations, in an Exposition that catered for a single class: the ever-growing, increasingly consumerist and socially ambitious bourgeoisie.

Le Corbusier's pavilion, unlike most spaces at the Exposition, included easel paintings, with examples by Juan Gris, Fernand Léger and Amedée Ozenfant. Eager to maintain an emphasis on design, the organisers had banned works of painting and sculpture

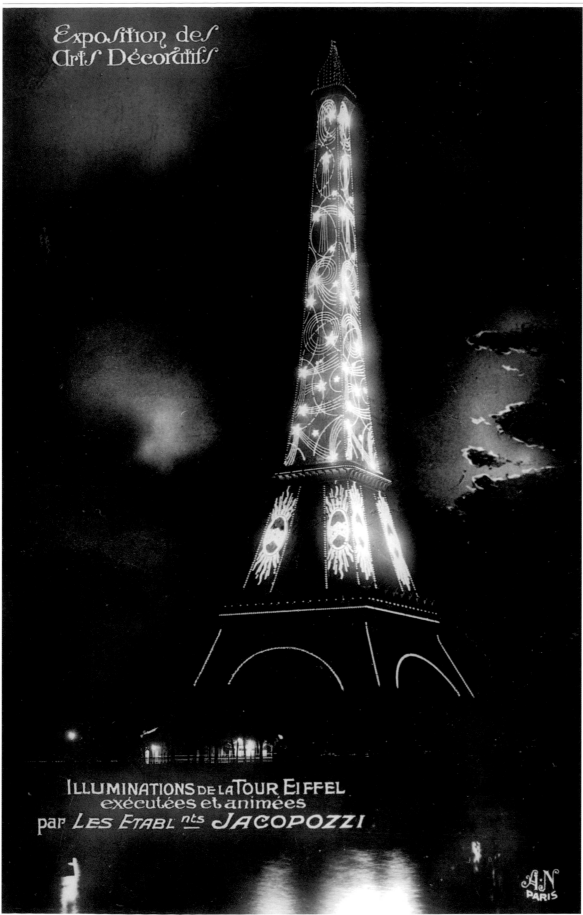

Figure 44

Figure 46

unless they formed part of a coherent decorative ensemble. Moreover, many artists who identified with the avant-garde found the commercial orientation of the Exposition distasteful and did not participate, despite the fact that they were beginning to profit from the very system they criticised, as witnessed by the growth of the art market at this time. The other paintings and sculptures that were included might be described as Art Deco (a phrase not used in English by art historians until the late 1960s). Though they have used this term to describe furniture or other items of applied art, art historians have been reluctant to apply it to works of fine art within the modernist canon. No doubt one reason is that Art Deco is difficult to characterise in stylistic terms, for it is an amalgam of the traditional and the modern. Sometimes described as a form of 'tamed' Cubism, Art Deco painting also harks back to Symbolist illustration, the folk and oriental styles of the Ballets Russes, the clear precision of Purism and the Futurists' celebration of the machine. Yet Art Deco's close links with the market its more conservative aspirations have prevented it from being admitted unreservedly into the modernist canon. Unlike other art movements generally considered avant-garde, Art Deco is not marked by a critical stance. Its exponents did not seek to distance themselves from their times; rather, they wholeheartedly embraced the 'traditionalist' *Zeitgeist*.

The characteristic Art Deco combination of lightweight modernity with elements of tradition undoubtedly appealed to the middle classes, described by Edward Lucie-Smith as 'on the one hand, obsessed with fashion, on the other, imbued with a rather nervous conservatism'.[8] By and large, Art Deco painting was aimed at the same audience as that targeted by the 1925 Exposition, and indeed many women painters adopted the style to ensure their success. The best-known of these is Tamara de Lempicka, a Polish-Russian émigré whose much sought-after portraits and nudes celebrated the high society of the 1920s and 1930s (fig. 46). The heightened realism of her portraits, influenced by the Italian old masters and the work of their Novecento compatriots, gives them a distinctive aloofness and sensuality. The Duchesse de la Salle (cat. 66), for instance, a notorious 'amazon' (a contemporary name for a lesbian), is represented in male riding gear, emphasising her androgynous character. Although Art Deco painting is predominantly figurative, its elegance and slickness can be detected occasionally in avant-garde abstract painting and sculpture of the period. Clearly influenced by the Neo-Plasticism of his friend and compatriot Piet Mondrian, César Domela's elegant geometric abstraction is close to Art Deco. Even the pure, 'primitive' forms of Constantin Brancusi's highly polished sculptures do not contradict the Art Deco

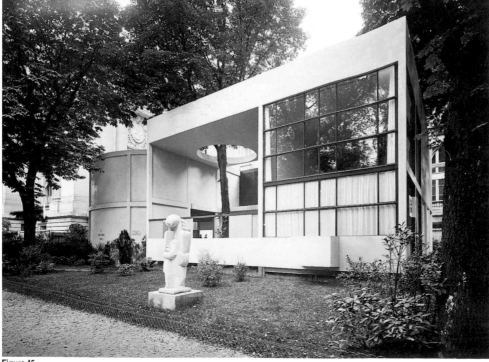

Figure 45

aesthetic. Indeed, despite living in Paris as a self-styled Romanian peasant, Brancusi fraternised in the 1920s with wealthy American expatriates there and sold most of his work to them.[9]

The Exposition acquainted a wider public with African art. One section of the exhibition was devoted to La Crosière Noire of 1925, the second in a series of expeditions across Africa to be sponsored by the French car manufacturer André Citroën (who also organised spectacular advertising for his company, whose name he emblazoned in neon on the Eiffel Tower). Numerous posters and a film celebrating the expedition were shown at the Exposition to great acclaim alongside furnishings and artefacts collected *en route*, and indeed the period between 1925 and the Exposition Coloniale of 1931 represents the climax of the French obsession with all things black.[10] Referred to as *négrophilie*,[11] this craze did not distinguish clearly between African culture (in the form of artefacts from the colonies) and black-American culture (i.e. jazz and dance from the USA), but tended to conflate them as the 'primitive' or 'exotic' component of the modernist aesthetic. Whereas early modernist artists, most notably Picasso, had hitched the forms of 'primitive' sculpture to their innovative cart, in the 1920s the Parisian avant-garde and other *négrophiles*, including the Anglo-American shipping heiress Nancy Cunard, saw an appreciation

of black culture as, on the one hand, a means of regenerating a 'civilised' European culture that had spawned war and destruction and, on the other, as a vehicle for rebelling against bourgeois norms, as a way to shock.

Another event in 1925 focused attention on black culture: La Revue Nègre. Performed in the prestigious Théâtre des Champs-Elysées, which had been home to the Ballets Russes before the war, this combination of a traditional music-hall revue with the first all-black cast to be seen in Paris took the city by storm, not least on account of the sensational 'Dansc sauvage' performed by the young American dancer Josephine Baker (fig. 47). Rolf de Maré, the theatre's manager and formerly producer of the progressive Ballet Suedois, timed the opening of the Revue to coincide with the Exposition so that he might capitalise on the popularity of black exhibits there. The Revue's success rested largely on its pandering to Parisian expectations. The marrying of jazz rhythms to the raw sensuality of Baker's dancing, for instance, corresponded with the European stereotype of Africans as savage, exotic people of unrestrained sensuality.[12]

Identified closely with modernity, black culture invaded many areas of modern life – fashion, dance, music, furniture, magazines and film – but contemporary painting and sculpture only rarely featured black people. Although many artists of the period sought

Figure 47

out Baker as model and muse, Le Corbusier, Picasso and Tsuguharu Foujita among them, she appears hardly at all in their work. Notable exceptions are the early wire-framed sculptures of the American artist Alexander Calder.

La Revue Nègre was invited to perform at the closing night of the exhibition, 7 November 1925. That same month another major artistic event took place in Paris: the opening, at the Galerie Pierre, of the first Surrealist group exhibition.[13] Featuring works by Hans Arp, Max Ernst, Giorgio de Chirico, André Masson, Joan Miró, Man Ray and Pierre Roy, it included paintings by Picasso, who was abandoning his eminently saleable neoclassical style of the early 1920s. The *Manifeste du Surréalisme*, published in 1924, had launched the movement, which was less nihilistic and more overtly revolutionary in spirit than its predecessor, Dada. Its main apologist, André Breton, defined Surrealism as 'pure psychic automatism, by which an attempt is made to express, either verbally, in writing or in any other manner, the true functioning of thought, in the absence of all control by the reason, excluding any aesthetic or moral preoccupation'.[14] Reinterpreting Freudian dream symbolism, which was much in vogue in Paris at the time, and focusing on sexuality, the Surrealists sought to accentuate difference. By flouting expectations and embracing the enigmatic, they attempted to reinvent values for a postwar society. Their violent escapades and inscrutable images were intended to shock a bourgeoisie which, they felt, was being lulled into complacency by promises of a stable order based on reason. The Surrealist motto 'épater les bourgeois' contrasts starkly with the aims of the Exposition, with its emphasis on commerce and women, its regional nostalgia and Le Corbusier's vision of purity and order. Accordingly, an image such as Ernst's *Paris-Rêve* of 1924–25 (fig. 48) is anything but precise and regular. This dream vision of the city, more hallucination than utopia, was created by a random, instinctual process – Breton's 'automatism' – to which the artist surrendered himself. Similarly, the Surrealist writers Breton and Louis Aragon surrendered the protagonists of their novels *Nadja* and *Paris Peasant* to the city itself, allowing anything to happen to them as they wandered about aimlessly. Adopting the role of a *naïf*, or peasant, Aragon celebrated the enigmatic spaces of Paris, its arcades and out-of-the-way

corners, where, he claimed, 'modern mythology' dwelled before being destroyed by city planning. As Walter Benjamin wrote of the Surrealists in 1929: 'At the centre of this world of things stands the most dreamed-of of their objects, the city of Paris itself.'[15]

Surrealism's writers and thinkers – Aragon, Breton, Paul Eluard and Philippe Soupault – were French, whereas many of its artists came from abroad: Max Ernst and Hans Bellmer from Germany; Joan Miró, Luis Buñuel and Salvador Dalí from Spain; and René Magritte from Belgium. To avoid the '*tout Paris* scene' of Montparnasse, Breton and his followers had originally gathered at the Café Certa in the Passage de l'Opéra or at Le Cyrano in the Place Blanche on the Right Bank, close to Breton's home in Montmartre. But by 1925 an alternative centre of Surrealism had established itself in the Rue Blomet in Montparnasse (near the fashionable jazz-dance venue Le Bal Nègre), where Masson and Miró had adjoining studios.

Montparnasse has been one of the most compelling of Parisian locations, both in its heyday and for subsequent generations. By 1910 the picturesque, village-like district of Montmartre, Montparnasse's predecessor as home to the city's artistic community, had become expensive and overrun with tourists. Henceforth, aspiring artists arriving in the French capital settled in Montparnasse, which by the early 1920s had become the cultural hub of the city, cosmopolitan, bohemian and chic all at once, and teeming with artists from all over the world.[16] Access to Montparnasse, which Apollinaire had described as 'a haven of freedom and beautiful simplicity',[17] had improved in 1910, when it was linked to Montmartre by the Nord–Sud Métro line. Gino Severini celebrated the new line in his Futurist paintings (cat. 29) and Pierre Reverdy's avant-garde periodical of the war years was named after it.

For artists leaving their native surroundings, the attraction of Paris lay in the city's perceived freedom and tolerance, in its numerous free academies and its museums. In search of cheap and hospitable places to live and work, they would go to the *cités*, the artistic colonies, of Montparnasse.[18] The most famous of these, La Ruche (the beehive) in the Passage Dantzig, had had its heyday before the war, and yet continued to typify the Montparnasse ethos in the 1920s. The extreme conditions of life in its studios, which were small, cold and often dirty, were offset by the

Figure 48

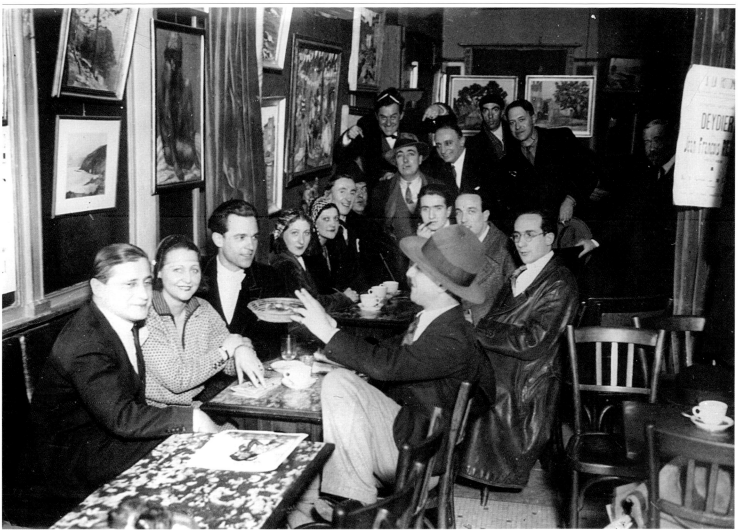

Figure 49

peppercorn rent and the convivial environment. Many artists who lived in La Ruche were Jews from Eastern Europe,[19] but one resident, the Italian Ardengo Soffici, later recalled that it attracted every conceivable nationality and type of artist: 'Frenchmen, Scandinavians, Russians, Englishmen, Americans, German sculptors and musicians, Italian modellers, engravers, fakers of Gothic sculpture, assorted adventurers from the Balkans, South America and the Middle East.'[20]

In 1934 Marcel Duchamp wrote: 'Montparnasse was the first really international colony of artists we ever had. Because of its internationalism it was superior to Montmartre, Greenwich Village or Chelsea [and] the colourful but non-productive characters of Montparnasse often contributed greatly to the success of the creative group. Liquor is an important factor in stimulating the exchange of ideas between artists.'[21]

Until the mid-nineteenth century, as Montparnasse lay just beyond the tax collectors' wall, alcohol consumed there was not subject to duty. This encouraged drinking establishments to open, creating a 'lieu de plaisir' that retained its reputation after the removal of the wall in 1860.[22] Indeed, Montparnasse began to attract increasing numbers of cafés, dance-halls and restaurants.[23] The informal life of the *quartier*'s cafés (fig. 49) engendered its unique atmosphere, contributing enormously to the artistic ferment of Montparnasse.

Unlike traditional salons, which were usually run by the wealthy and accessible only by invitation, the cafés of Montparnasse, especially those on the intersection of the Carrefour Vavin (now the Place Pablo Picasso), provided a more democratic environment for the exchange of ideas. In establishments such as Le Dôme, La Rotonde, La Coupole and Le Select artists mingled with poets, musicians,

writers, tradesmen, workers, the *demi-monde* and, as never before, with the affluent Parisians of the Right Bank who came to this bohemian *quartier* in search of entertainment and thrills.[24] The cafés offered artists warmth, both social and physical, and formed a welcome antidote to the often abject poverty of their studios. Cafés were also an environment in which work could be shown and deals made, initiating or even circumventing relationships between galleries and the public. Some proprietors, such as Victor Libion of La Rotonde, would accept works of art in lieu of payment; critics would discover new talent; dealers would scout for potential clients; and collectors would look for artists to paint their portraits. As a result, many established dealers – Henry Bing, Jeanne Bucher, Paul Guillaume, Pierre Loeb and Leopold Zborowski among them – came to support foreign artists working in Paris.[25]

50 Tsuguharu Foujita, *Reclining Nude with Toile de Jouy*, 1922
Oil on canvas, 130 × 195 cm
Musée d'Art Moderne de la Ville de Paris

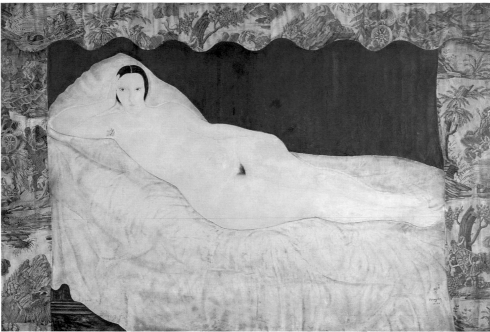

Figure 50

On the famous *terraces* artists searched for models. The most celebrated of these was Alice Prin, alias Kiki. This fun-loving, gregarious model and *muse extraordinaire* came to personify the permissive society of Montparnasse in the 1920s. She posed for several artists, including Moïse Kisling, Jules Pascin and Foujita, whose rapturously received *Reclining Nude with Toile de Jouy* (fig. 50) featured Kiki in the pose of Manet's Olympia. In 1928 Pablo Gargallo sculpted her head as an Art Deco artefact: a hollowed-out bronze of incisive lines, the pointed ends of her bobbed hair resting against the cheekbones. Man Ray immortalised Kiki in such photographs as *Ingres' Violin: The Artist's Hobby Horse* (fig. 51) and in his Surrealist film *L'Etoile de Mer*. She was passionately devoted to him and lived with him from 1924 to 1926, but nevertheless slept with whomever she pleased and was friendly with everyone. From 1923, she entertained clients and friends with her legendary charms and *canaille* songs full of *double entendres* at the newly established Jockey Club, Paris's first nightclub, which was designed as a cowboy saloon and much frequented by Americans. In 1929, at the age of 28, Kiki published her memoirs, with Hemingway writing the foreword to the English edition. The sexual mores they embodied scandalised readers and made their author famous the world over.

The majority of images of Kiki are nudes, in which she is the traditional object of the male gaze. In this, artists did not differ greatly from the organisers of the 1925 Exposition, who presented women in terms of the bourgeois domestic ideal, as both commodity and consumer. Although the experience of war and the need for women to enter the workforce was contributing gradually to their emancipation, it would be another twenty years before women in France were enfranchised politically and artistically.

Many of those who had lived at La Ruche early in their careers, including Brancusi, Alexander Archipenko, Marc Chagall, Jacques Lipchitz, Chaïm Soutine, Ossip Zadkine and, although he died in 1920, that archetypal *peintre maudit* of Montparnasse, Amedeo Modigliani, later achieved fame as exponents of the 'Ecole de Paris'. As coined by the critic André Warnod in 1925, the term referred to foreign artists working in Paris and, more precisely, in Montparnasse after the war.[26] It did not denote a specific artistic style, and later came to be seen as the opposite of the 'Ecole Française', which consisted of native French artists such as André Derain, Othon Friesz, Dunoyer de Segonzac, Maurice Vlaminck and others. With the notable exceptions of Brancusi, Mondrian and the Surrealists, most artists living in Montparnasse in the 1920s, especially the Jewish ones, did not aspire to highly avant-garde practices. Rather, they produced what Kenneth Silver has called 'modernism without the "sting"' – work that, while imbued with

modernist tendencies, was basically
traditional. Welcomed in France in the 1920s,
artists of the Ecole de Paris sometimes came
under attack as anti-Semitism and xenophobia
grew in the 1930s.[27]

The work of Ecole de Paris artists is far
from homogeneous. It ranges from the
anguished, old master-inspired expressionism
of Soutine, a Lithuanian who, despite
acquiring wealth in 1923 through the
patronage of the American Albert Barnes,
remained fundamentally an outsider, to the
linear grace of Foujita, who combined aspects
of his native Japanese art with contemporary
European styles. It encompasses the poetical
fantasy world of Chagall, with its mixture of
Jewish, Russian and biblical imagery, and the
bold primitivism of Modigliani's sculptures
and the attenuated Italianate forms of his
sensual nudes and languid portraits. With
the exception of landscapes and still-lifes by
Chagall and Soutine, portraits and nudes are
the subjects most frequently encountered in
the Ecole de Paris. Portraiture was also the
preferred genre of Art Deco painters,
doubtless because of its profitability. Given
the sexual freedom that reigned in
Montparnasse, it is not surprising that the
market for nudes was buoyant. Pascin's
erotically charged brothel scenes with their
pallid colours differ greatly from the sugary
classicism of Kisling's nudes, but both are
symptomatic of a hedonistic lifestyle marked
by conspicuous consumption.

One of the most striking aspects of Paris in
the 1920s is the extent to which it 'belonged'
to the Americans, before the Wall Street Crash
forced many of them to return home in 1929.
At a time when American influence, in the
shape of Taylorist industrial management,
new technologies and the film industry, was
making itself felt in France, Paris offered a
haven to Americans and black Americans
seeking to escape the puritanism, censorship
and intolerance, not to mention the
prohibition, back home.[28] A favourable
exchange rate made life in Paris affordable for
even the least well-off Americans.[29] Artists,
photographers, musicians, dancers, writers,
collectors, dealers, rich heiresses – all came to
the hub of the creative world, to be inspired
or, in the case of the black Americans, to
inspire. We owe some of the most vivid
accounts of Paris in the 1920s and 1930s to
Americans, to writers like Hemingway and
Henry Miller and to photographers such as
Man Ray, Berenice Abbott and Florence Henri.

The dominance of Gertrude Stein,
doyenne of the pre-war avant-garde, was
waning in the 1920s, though her home in the
Rue Fleurus in Montparnasse remained a
frequent port of call for American writers and
artists. A far less visible, though more
influential, American in 1920s Paris was
Sylvia Beach. She owned a lending library and
bookshop called Shakespeare and Company at
12 Rue de l'Odéon, a gathering place for
British and American expatriate writers as
well as for French authors pursuing an interest
in America. She later recalled: 'When I opened
my bookshop in 1919, I could hardly foresee
that the censorship rife in the American
publishing world would lead many American
writers to Shakespeare and Company, all those
pilgrims who crossed the Atlantic and
colonised the Left Bank in Paris.'[30] In 1922
Beach published James Joyce's *Ulysses* when
no British or American publisher would
accept it. Hemingway, Stein, André Gide,
Jules Romains and later Simone de Beauvoir
subscribed to her library.

If the 1925 Exposition had been staged
to revive France's flagging postwar economy
and in a spirit of rivalry with Germany, the
Exposition Coloniale of 1931 was an attempt
to restore the French economy in the depths
of the Depression.[31] The colonies, which
provided France with a plentiful supply of
vital raw materials, with a preferential, ready-
made market for its products and with
desperately needed manpower, offered an
expedient diversion from the problems at
home.[32] The Exposition, held from September
1931 to February 1932 under the slogan
'A tour of the world in a day', was designed
to celebrate the 'humane' achievements of
colonialism and its future. Billed as a united
demonstration by the world's colonial powers
of their 'civilising' mission towards their
territories, the Exposition was in fact a brazen
justification for France's own colonial
campaigns. The 'empires' of other
participating nations, among them America,
Italy, Belgium, Denmark and the Netherlands,
were tiny in comparison to that of France.
Germany was excluded, and Britain, the only
other truly imperial power, refused to take
part.[33]

As a propaganda exercise, the Exposition
was a resounding success. Over 30,000,000
tickets were sold, making it the most
successful international exhibition since the
enormous Exposition Universelle of 1900.
For visitors, whether from Paris, the French

Figure 51

52 The reconstruction of the Temple of Angkor Wat at the 1931 Exposition Coloniale, which was later sold to a film company in order to be burned down

53 The Surrealists' counter-colonial exhibition, 'La Vérité sur les colonies'

regions or abroad, the experience must have been like escaping to another world – a fictional world dominated by France. Each colonial pavilion was constructed in the respective vernacular style, with date and palm trees and specially transported tribesmen giving an aura of authenticity to the proceedings. In contrast, the Palais de la Section Métropolitaine and other pavilions representing the *métropole* (i.e. France) were built in a monumental, 'modern' Art Deco style – the 'civilising' style, as it were. By mounting the Exposition in the poor eastern suburbs of Paris, next to the Bois de Vincennes, in a district traditionally associated with prostitution and marginal trades, the organisers attempted to 'colonise' and regenerate this urban area. Despite the Métro extension linking Vincennes to the centre of town, the domineering 'metropolitan' pavilions segregated the Exposition from the city, echoing the disjunction between 'superior' Mother France and her subjugated territories. Along with the heterogeneous quality of the pavilions themselves, this reinforced France's already ambiguous relationship with her colonies, in which discontent and nationalism were growing. The organisers thus failed in their aim of presenting a united greater France – called, significantly, 'France d'outre-mer' (overseas France) rather than the French Empire.

Despite their very different positions towards colonialism, few intellectuals of the Left or Right objected to the 'civilising' ethos of the Exposition. The Surrealists were a notable exception. They distributed *Ne visitez pas l'Exposition Coloniale*, a pamphlet calling on people to boycott the event, and *Premier Bilan de l'Exposition Coloniale*, which attacked the violence at the heart of French colonialism and the destruction of the oppressed peoples' art (fig. 52).[34] With the clandestine backing of the Communist Party, the Surrealists mounted a counter-demonstration, entitled 'La Verité sur les colonies', in the reconstruction of the Russian Pavilion from the 1925 Exposition on the Avenue Mathurin-Moreau (fig. 53). By juxtaposing non-Western sculptures with what they termed 'European fetishes', cheap devotional figurines bought in the Rue Saint-Sulpice, they intended to undermine what Patricia Morton has referred to as 'the cultural hierarchies that informed Western stereotypes of primitive art and its "degeneracy"'.[35]

The Surrealists' fascination with non-Western cultures did not begin with the Exposition Coloniale: among the first to collect African sculpture, they were avid fans of jazz music and keen ethnographers.[36] The Surrealists' interest in these cultures – a kind of positive discrimination – reinforced the 'primitive', intuitive and mystical qualities

Figure 53

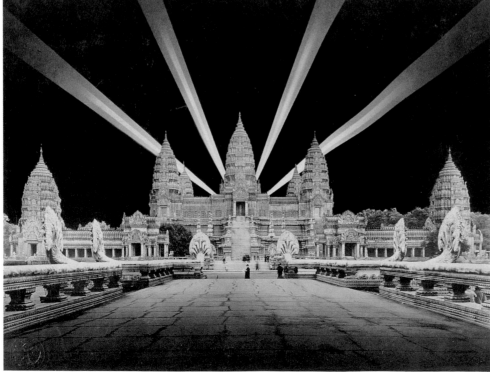

Figure 52

54 The cover of the official guide to the 1937 Exposition

55 The Exposition Internationale des Arts et des Techniques dans la Vie Moderne (1937) looking towards the Palais de Chaillot

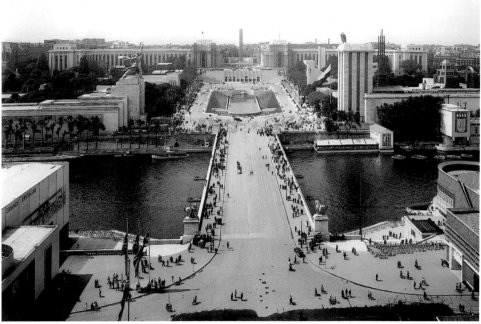

Figure 55

Figure 54

of the art of those cultures; tellingly, 'La Verité sur les colonies' did not juxtapose African and Oceanic sculpture with European 'high' art, but with kitsch. Non-Western cultures appealed to the Surrealists as representing the 'other', rather as dreams presented another, more 'real' way of interpreting the world. Yet ultimately, for them highly ambiguous values were attached to the manifestations of these cultures, which served primarily as alternatives to the repression and *ennui* of Western society. Ironically, the exotic dream world espoused by the Surrealists was not so very dissimilar to that presented at the Exposition.[37]

Plans to hold another world fair in Paris were already being discussed in 1932, the year the Exposition Coloniale closed. These eventually resulted in the Exposition Internationale des Arts et des Techniques dans la Vie Moderne, which opened in May 1937. Once again, the centre of Paris was turned into a massive spectacle, bedazzling the visitor with fountains and outdoor lighting effects that, among other things, transformed the Seine into a river of gold. Held at a time of intense anxiety as the world stood on the brink of catastrophe, the Exposition aimed to celebrate every form of human accomplishment, to 'shore up Europe's faith in civilisation', and, of course, to boost France's stagnant economy. France was the first to benefit, using large numbers of the country's unemployed to construct the

buildings, even if a series of strikes prevented several pavilions from being completed on time.[38] More importantly, Paris was again to become the centre of the world, after the dark years of the Depression had reduced the flow of tourists to the French capital to a trickle.

Forty-two nations participated, each represented by an elaborate pavilion. The vast site (fig. 55), centred on the Eiffel Tower, stretched from the Invalides on the south bank to the Trocadéro on the north. Prominent participants were the dictatorships of Germany, Italy and the Soviet Union. Although the host country did not have a national pavilion as such, the buildings representing France and France d'outre-mer occupied the greater part of the site: 53 pavilions devoted to French industry and trade (including palaces displaying the most recent scientific discoveries), eleven colonial pavilions and seventeen regional ones. Over 800 painters, sculptors and representatives of the applied arts decorated these buildings, with furnishings including Raoul Dufy's enormous mural on the history of electricity for the Pavilion of Electricity and Light and Robert Delaunay's huge abstract decorative panels for the Pavilion of Air. Painting and sculpture avowedly lay at the heart of the visual-arts displays, yet in practice they risked being overshadowed by the more recent, more obviously communicative media of film, photography and advertising. Léger's

56 Pablo Picasso, *Guernica*, 1937
Oil on canvas, 349.3 × 776 cm
Museo Nacional Centro de Arte Reina Sofía, Madrid

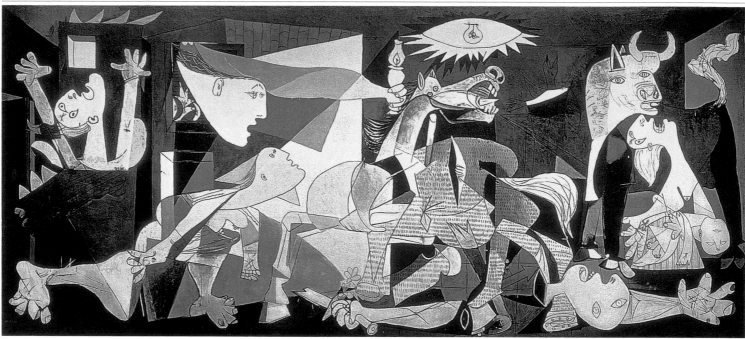

Figure 56

photomurals for the Agriculture Pavilion, which united aspects of city and country life, was a potent representative of these innovations.

The omnipresence of France at the Exposition suggested that all activity emanated from that country and, more specifically, from its capital. The image on the official guide to the fair (fig. 54) was a globe that had stopped spinning the moment France appeared; France herself did not appear, but the image of the ship above – derived from the city seal of Paris – and the tricolour ribbon around the globe reinforced the idea of France encompassing the entire world and welcoming the participating nations to her capital.[39] Paris was thus presented as the global centre of knowledge and power. Seen in this light, the positioning of the Peace Column at a point where it overlooked the national pavilions amounted to a desperate attempt to reassure visitors of France's ability to maintain peace between the belligerent nations of Europe.[40] In fact, the layout of the Exposition made it perfectly clear where the real power lay: the pavilions of Germany and the Soviet Union, each a soaring, vertical structure, confronted one another dramatically in the Trocadéro Gardens.

The commercial emphasis of the Exposition meant that displays devoted to the visual arts were shown elsewhere. Two refurbished museums had been installed in the Palais de Chaillot, the Musée

des Monuments Français and the Musée de l'Homme, and two major art exhibitions were mounted. Strictly speaking, these were not part of the fair, though in them the spirit of France and of Paris could best be recognised. Housed in the newly constructed Palais de Tokyo, 'Chefs-d'œuvre de l'art français' surveyed nearly two millennia of art in France, from Roman artefacts to Impressionists and Post-Impressionists, dwelling on areas where the mastery of French artists was unquestioned. The second exhibition, 'Maîtres de l'art indépendant', organised by the city of Paris and held in the Petit Palais, celebrated the cosmopolitan breadth of art produced in Paris between 1895 and 1937. Works were arranged neither chronologically, nor in accordance with their creators' ethnic origins or group affiliations. Including only a few foreign artists – most notably Picasso, represented by 31 works[41] – the exhibition seemed to suggest that artists' various styles had been miraculously 'transformed' into French art. 'For Paris,' as the exhibition's organiser stated, 'it is a tradition to receive, with a great liberality, the most audacious tendencies in French art.'[42] Yet the exhibition was conceived not as a survey of art in Paris but as a series of one-artist shows.[43] Moreover, it ignored entire areas of artistic expression, such as Surrealism and non-figurative art.[44]

Contrasting starkly with the bombastic hype of the Exposition, the Spanish Pavilion

offered visitors a shocking reminder of the real world: Picasso's allegory of war and murder, *Guernica* (fig. 56), painted in reaction to the bombing by Franco and his Nazi allies of the small eponymous Basque town on 26 April 1937, during the Spanish Civil War. This lone injection of reality into the dream world of the Exposition stood as a grim omen for the future of Paris.

Although France had been victorious in the First World War, the experience had left the nation devastated both physically and psychologically. In the ensuing twenty years the country lurched from postwar euphoria to pre-war angst, from an uncertain peace to unprecedented cataclysm. Harsh economic realities and the constant threat from neighbouring Germany – as world power, as coloniser, as innovator in the visual arts – threatened both France's cultural hegemony and her territories. Against this background, the three fairs of 1925, 1931 and 1937 attempted to construct a mythical narrative of French cultural identity with Paris as the hub of the world. While the fairs revelled in fantasy and attempted to fabricate a continuation of past glory, artists responded to the realities of contemporary life, with its conflict between progress and tradition, between town and country, between France and abroad, and between liberal republicanism and authoritarianism whether of the Left or the Right.[45]

1 He used the phrase as the title of his semi-fictional memoirs, published in 1964, in which he recalled his time in Paris as a young writer in the early 1920s.

2 Franco-Teutonic relations were such that, although they billed the Exposition as international, the organisers did not invite Germany to participate. The Bauhaus style was thus not represented. The USA declined to take part on the grounds that it had no modern design, while Britain's contribution was small and inconsequential owing to the high tariffs imposed on foreign participants. See Green 2000, pp. 5–9. My discussion of the Exposition is indebted to Gronberg 1998.

3 See Gronberg 1998, pp. 1–19.

4 See Golan 1991.

5 George 1925.

6 Le Corbusier 1925, p. 87: 'Today decorative objects flood the shelves of department stores; they sell cheaply to shop girls.' For those of Le Corbusier's persuasion, a taste for luxury and decoration was considered 'backward' and feminine; machine production was viewed as 'progressive' and masculine. See Fer, Batchelor and Wood 1993, p. 155. Despite his rejection of craftsmanship and expensive materials, Le Corbusier's attitude to the decorative arts was ambiguous. See Troy 1991, pp. 159–227.

7 In the Pavillon de l'Esprit Nouveau Le Corbusier also exhibited his scheme for the rebuilding of Paris, his Plan Voisin. Le Corbusier's architectural theories were derived largely from Purism, the painting style and philosophy he had developed after the First World War with the painter Amedée Ozenfant. Advocating an art of purity and simplicity that they held to be in tune with the machine age, the Purists painted cool, clear, flat images, often still-lifes, whose diagrammatic precision made them resemble idealised cityscapes. They expounded their ideas in a book, La Peinture moderne, and a journal, L'Esprit nouveau, published from 1920 to 1925. For Purism, see London 1970 and Silver 1977.

8 See Lucie-Smith 1990 and Claridge 1999.

9 See Temkin 1995.

10 The growing interest in African culture was also fuelled by the recent refurbishment of the city's ethnographic museum, the Musée de l'Homme.

11 See Clifford 1989; Blake 1999; and Archer-Straw 2000.

12 Léger is often credited with the idea of staging the show, but in 1923 Maré's ballet company had already staged the African-inspired ballet La Création du monde, based on Blaise Cendrars's Anthologie nègre and with music by Darius Milhaud.

13 An exhibition of Miró's painting had been held in the gallery in June of that year.

14 André Breton, Manifeste du Surréalisme, October 1924, quoted in Breton 1969.

15 Walter Benjamin, 'Surrealism: The Last Snapshot of the European Intelligentsia', in Benjamin 1999B, p. 211.

16 Montparnasse straddles the Sixth, Fourteenth and Fifteenth Arrondissements. Reasons for its popularity are explained in Hewitt 1996. For a survey of Montparnasse in our period, see Crespelle 1976 and Bougault 1997.

17 Apollinaire 1991.

18 The influx of artists into Montparnasse prompted the building of studios alongside conventional housing. When these filled an entire lot they were referred to as cités. See Klüver and Martin 1989, p. 18.

19 For an in-depth discussion of Jewish artists in Paris, see Romy Golan and Kenneth Silver's New York 1985, pp. 12–60 and 80–88.

20 Soffici 1954.

21 Quoted in Charters 1934, p. 295.

22 Hewitt 1996, p. 31.

23 'The French State, with its respect for artists and understanding of the attraction they exert, allowed Montparnasse to develop into a "free zone" with less police surveillance and greater acceptance of unconventional behaviour and lifestyles than would have been allowed in other areas of Paris.' Klüver and Martin 1989, p. 11.

24 By the 1920s Le Dôme, originally frequented by Germans and Austrians, had become the haunt of the American literary colony, which congregated in its back room for bouts of heavy drinking. Since 1911 La Rotonde had been run by Victor Libion, who made it a haven for painters, poets and writers of all nationalities. La Coupole, which opened with a great fanfare in 1927, had columns painted by Léger and others and quickly became the hang-out of American expatriates, including Josephine Baker. Le Select, established in 1924, was the first café to stay open all night. See Klüver and Martin 1989, pp. 69–79.

25 Several artists supported in this way – for example the sculptors Jacques Lipchitz and Oscar Miestchaninoff – achieved prosperity and moved to the Paris suburbs, where they commissioned well-known architects to build them 'International Style' houses. For a survey of the art market in Paris in the 1920s, see Gee 1981.

26 See Warnod 1925, published in October of that year. Recent scholarship on the Ecole de Paris can be found in Paris 2000, pp. 398–99. Although large numbers of foreign artists had come to Paris before the war, the influx increased in the 1920s for political reasons. Many Russians were forced to flee their country as a result of continued pogroms against Jews, the Bolshevik Revolution and the expulsion of 'white' Russians. The growth and eventual triumph of Nazism in Germany during the 1920s and 1930s led Jewish artists to flee to Paris in great numbers. See Golan 1995B, p. 137.

27 See Silver 1985, pp. 50–57, and Golan 1995B, pp. 138–41.

28 Homosexuality, for example, was not a legal offence in France. See Wiser 1983, p. 111. For Americans in Paris in the 1920s, see Allan 1977; Fitch 1983; and Reynolds 1999.

29 'In Paris then, you could live very well on almost nothing and by skipping meals occasionally and never buying any new clothes, you could save and have luxuries.' Hemingway 1964, p. 77.

30 Beach 1956. See also Monnier 1976.

31 The Exposition Coloniale, too, had been planned before the First World War, originally being scheduled to take place in 1916. See Morton 2000, pp. 71–72.

32 For French colonialism, see Golan 1995B, pp. 105–06 and Morton 2000.

33 Britain had held its own colonial exhibition at Wembley in 1924. See Morton 2000, p. 322.

34 The latter was written after the Dutch pavilion, containing unique objects from the Dutch colonies in Southeast Asia, had been destroyed by fire, and after it became known that the vast reconstruction of the Temple of Angkor Wat, centrepiece of the entire Exposition, had been sold to a film-making firm in order to be burned down. See Morton 2000, p. 101.

35 See Morton 2000, p. 103.

36 In the 1920s they frequented the fashionable bars of Montparnasse in which jazz was played, such as Le Jockey and Le Jungle, and the black clubs of Montmartre, most notably Bricktop's (Ada Smith's) famous haunt, the transgressive ambience of which particularly appealed to them. See Blake 1999, p. 113. Michel Leiris, author of L'Age d'homme, was an especially avid ethnographer. By 1931 he had left the official group and was collaborating with Georges Bataille and other dissident Surrealists on the mainly ethnographic magazine Documents.

37 See Berkeley 1990.

38 For a detailed discussion of the 1937 Exposition, see Wilson 1992.

39 For the guide and the Exposition logos, see Herbert 1998, p. 19.

40 The Peace Column was erected in the court formed by the recently remodelled wings of the neoclassical Palais de Chaillot.

41 Matisse, for example, was represented by 61 paintings. See Green 2000, p. 12.

42 Raymond Escholier, quoted in Herbert 1998, p. 100.

43 The state exhibition 'Origines et développement de l'art international indépendant', held at the Jeu de Paume the same year, was smaller but more inclusive, presenting a sequence of movements driven by French artists and foreign artists in France. See Herbert 1998, p. 190, and Green 2000, pp. 12–13.

44 For the history of abstract painting in France between the wars, see Münster 1978, and Green 2000, pp. 32–34.

45 For the complex history of antagonism and rapprochement between the Left and Right in France, see Sternhell 1983.

Kenneth E. Silver

At One Remove: Parisian Modernists on the Côte d'Azur

A postcard from the edge

From the Côte d'Azur, in July 1919, Pablo Picasso sent a postcard of the Hôtel Continental et des Bains, St Raphaël, to 'Monsieur Jean Cocteau, 10 R. d'Anjou, PARIS' (fig. 57). Instead of writing anything to his friend in the area designated for 'Correspondance' on the postcard's reverse, Picasso made a little ink and watercolour sketch of his hotel room. Against a shaded wall, with the curtains pushed back, Picasso depicts the windows of his room flung open, traces of reflected mauve and blue light filling the glass panes; a filigree iron balustrade extends across the width of the aperture, beyond which he paints a deep-blue sea and a pale-blue sky, and what appears to be an aeroplane in flight overhead. No words are necessary, nor could they convey the splendour outside his window, Picasso seems to tell Cocteau: just look at what I can see without even leaving my room! This light-filled opening onto the vast Mediterranean, this framed, stage-like image of sea and sky on the card's left, is the wordless counter-image to Paris, the postcard's destination, at the right.

For early twentieth-century modernists, the idyllic Côte d'Azur was the prime refuge from the urban intensity of the capital. France's southeastern Mediterranean coast – what the English-speaking world usually refers to as the Riviera – was both the most thoroughly different place to which an artist might escape from Paris with relative ease, and the most familiar of artistic colonies. If spectacular scenery, exotic foliage, mostly very good weather, and a long, overnight train ride from Paris all conspired to assure artists that they had indeed left home, the presence on the coast of so many others like themselves meant that the studio life of Paris could be maintained, at least to a certain extent, *au littoral*. This was important, since most artists continue to work while on vacation. To be in a new environment and yet to be able to keep one's creative juices flowing is the formula for productive escape, as opposed to counter-productive distraction.

The groundwork for the artistic colonisation of the Côte d'Azur was accomplished by the painters of three successive Parisian movements: Impressionism, Neo-Impressionism and Fauvism. First, Monet and Renoir toured the coast together for two weeks in 1883, stopping at Marseilles, Hyères, St Raphaël, Monte Carlo, Menton, and a few Italian towns. Monet

returned five years later and spent four months working in Antibes, bringing thirty-nine brilliantly coloured paintings nearly to completion (a group of these were exhibited at the Galerie Boussod-Valadon in Paris to much critical notice hardly a month after his return). In 1892, Paul Signac, Seurat's most prominent follower and a highly visible Parisian art-world *animateur*, sailed his boat to St Tropez, where he eventually bought a house and became the centre of a Neo-Impressionist group in the area which included Henri-Edmond Cross, Théo van Rysselberghe and Jeanne Selmersheim-Desgrange, among others.[1]

But it was Henri Matisse – Signac's guest at St Tropez in the summer of 1904 – who would become the single most important Parisian transplant to the French Riviera, the modern artist whose name is synonymous with the Côte d'Azur. Testing the waters of his host's method, Matisse created a Fauve version of Signac's divisionism: *Luxe, calme et volupté* (fig. 58), its title taken from the refrain of Charles Baudelaire's poem, 'L'Invitation au voyage'. With its almost lurid palette of over-saturated colour, its exaggerated, individual paint strokes, and a curious mix of the pastoral and the urban – in which timeless nudes at the seashore are juxtaposed with a fully clothed, modern picnicker – Matisse's picture both extended and reconceived the Golden Age paradigm that had been experiencing a French revival in the late nineteenth century, most notably in the neo-Arcadian art of Puvis de Chavannes. Indeed, despite the painting's obvious debt to Signac's method, its more important reference points are the art of Puvis and Paul Gauguin. If the colouristic freedom, supercharged linearity and quirky specificity in *Luxe, calme et volupté* make Matisse the undisputed victor in a pictorial struggle with Puvis – whose innovative but ultimately generic pale-toned murals allowed him to become the unofficial artist of the Third Republic – the outcome of the battle waged here with Gauguin is less certain. As had his great touristic predecessor, Matisse evokes the pungency of an exotic locale by means of non-naturalistic colour and assertive line. But the result is so clearly a hybrid, even a pastiche, of earlier strategies that the integrity of Gauguin's escapist dream is never fully attained by Matisse. Still, the combination of gorgeous setting, vigorous application of paint, and highly charged sexuality (a result of the bodily contortions of his nudes and

Figure 57

their naked difference from the overdressed interloper) established a new standard for images of escape.

It took only another decade and a half for the Riviera to become a second home to the Parisian avant-garde. By the 1920s modern artists visiting from Paris and elsewhere could be found at work in almost every town from Marseilles to Menton, with recognised 'art colonies' established at Cassis, St Tropez, Cagnes and Villefranche. Henceforth, it would be neither Gauguin's real-life Polynesia nor the Cubists' imagined Africa, but France's own Côte d'Azur which would function as the key Parisian signifier of 'elsewhere'.

The place of myth

Raoul Dufy, who would spend many seasons working in Nice, Vence and many other locations on the Riviera, considered *Luxe, calme et volupté* a turning point, not just in Matisse's career, but in his own. 'At the sight of this picture I understood the *raison d'être* of painting,' he said. 'Impressionist realism

lost its charm for me as I beheld this miracle of creative imagination at play, in colour and drawing.'[2] For Picasso too, after his first trip to St Raphaël, the imaginative rather than the realist Côte d'Azur took hold (he returned to the coast numerous times in succeeding years: in 1920 to Juan-les-Pins, in 1923 to Cap d'Antibes, and in 1924, 1925 and 1926 again to Juan-les-Pins). Much later, while living in Cannes, he told an interviewer, 'It's strange, in Paris I never draw fauns, centaurs or mythical creatures…They always seem to live in these parts.'[3] Unlike the paintings made at resorts on the Channel coast by the Impressionists half a century earlier, with their images of contemporary Parisian tourists at leisure, Picasso's Riviera art of the 1920s is populated by a mythic, Mediterranean race of bathing nymphs, rampant centaurs and music-making Arcadian shepherds, re-imagined by a man who had been born at Málaga, on the southern Spanish shoreline of that same, mythic sea.

His most important example of this revivified classicism on the Côte d'Azur is

The Pipes of Pan, a picture painted in Antibes in the summer of 1923 (fig. 59). In contrast to similar, neoclassical figure paintings created in the north – at Fontainebleau, in 1921, for example – Picasso has found real-life embodiments of the Antique ideal in the south: his protagonists were apparently inspired, at least in part, by the young fishermen of the port town, which itself dated back to ancient Greek times, when it was called Antipolis. A large picture of two serious-looking, monumental figures, *The Pipes of Pan* is Picasso's attempt to revivify, to make intense and palpable again, a Mediterranean typology which stretches back in French art from Puvis de Chavannes, Ingres and Poussin to its Greco-Roman origins. If Paris, the birthplace of Cubism, was modernity itself, a site of change, contingency and invention from scratch, then Antibes, for Picasso, was its opposite, a place in which the past, or a myth of the past, still shaped the present. What had begun at St Raphaël as a quasi-documentary record of his hotel-room

58 Henri Matisse, *Luxe, calme et volupté*, 1904
Oil on canvas, 98.5 × 118.5 cm
Musée d'Orsay, Paris

window – a picture of the first thing at hand, as it were – has developed, in four years, into a full-blown Mediterranean idyll. Significantly, the composition has hardly changed at all: the windows which were flung open so that they formed a perspectival spatial container in 1919 have become the stucco or stone walls at left and right (these were probably inspired by the battlements of Vauban's seventeenth-century fort on the water at Antibes, or by those of the Grimaldi castle there, which would become the Musée Picasso in 1949). St Raphaël's sea and sky, with a sharply drawn horizon, persist as well, in more or less exactly the same place (although the modern balustrade and aeroplane have disappeared).

Into this pre-established, theatricalised template, Picasso introduces at Antibes what had been conspicuously missing at St Raphaël: a human presence, the young artist-labourer playing the shepherd's pipe and his older companion, who are as solidly constructed as the generic architecture which frames them. They look familiar, of course, since they descend from a worthy lineage in the history of art: the standing figure is a refashioned Greek *kouros* and his seated companion is a shepherd, lifted from the Golden Age images of Poussin and Puvis.[4] The tricks of pictorial illusionism, developed over centuries in the West, are ostentatiously revived by the artist (who counts on our recognition of his previous, antithetical role as Cubism's inventor to give piquancy to this revival). What's more, unlike some of his other Arcadian forays, this one – like his *Woman in White* of the same year – is conceived without a trace of irony: we sense *gravitas* here, not parody, in a fishing-port-turned-beach-resort, of all places. Yet, despite the rather flat feet of his protagonists, there is nothing cloddish about Picasso's neoclassicism. The intensity of the colour (a brilliant recollection of Cézanne's earth-and-sky Provençal palette), the colossal scale of his figures pushed up close to the picture plane, and the elemental quality of the setting are all self-consciously 'virile' (his answer, as it were, to the wan classicism of Puvis). And, although the old-fashioned shepherd's pipe is unquestionably an historicising attribute, his figures are individualised and modern: although both are of dark complexion, the younger one's hair is a mass of waves while the older one's is cropped short, outlining the contour of his skull; and both wear modern swimming trunks, just the sort of baggy shorts that were starting to be worn as an alternative to the kind which entirely covered the male chest. On a Côte d'Azur stage set, then – by way of his powers

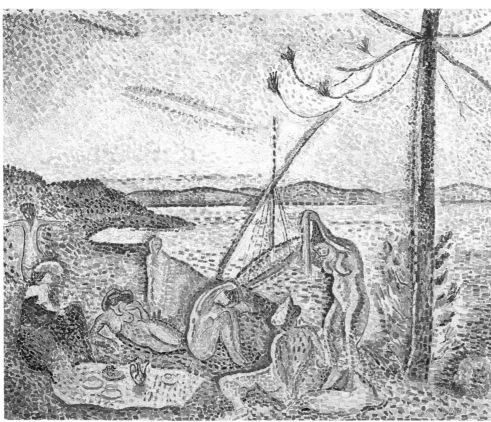

Figure 58

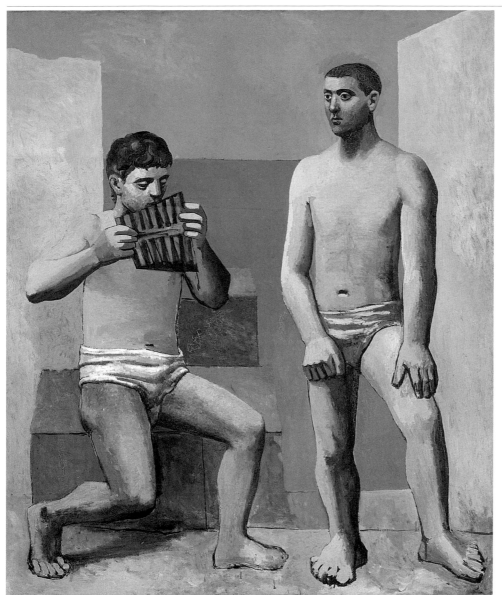

Figure 59

as a medium – Picasso's protagonists enact the drama of *longue durée*, the seamless connection of the present to the distant past.

Orientalism and disorientation

It was perhaps inevitable that the traditional, Renaissance idea of the picture as a window (in which the canvas is read as a transparent plane, through which a three-dimensional world is glimpsed), as opposed to the Cubist idea of the picture as a non-illusionistic, self-referential *Ding an sich*, would reassert itself in a place where 'views', from hotel rooms and rented digs, were endemic. Parisian artists were outsiders on the coast, touristic interlopers whose first apprehension of the place was framed by the windows, and the security, of their temporary lodgings. Indeed, it is hardly an accident that the early nineteenth-century, Romantic theme of the open window coincides with the advent of modern tourism, when nomads began to travel in large numbers in search of enlightenment and pleasure (Thomas Cook began organising tours to British seaside resorts in 1845).[5] When Matisse returned to the Riviera in the winter of 1917–18, almost a decade and a half after his sojourn in St Tropez with Signac, his open window at the Hôtel Beau-Rivage, on Nice's Promenade des Anglais, became his predominant subject. Picasso probably got the idea for his hotel-room window postcard from Matisse, a number of whose Nice paintings were shown at the Galerie Bernheim-Jeune in Paris in May 1919 just before Picasso left for St Raphaël. For Matisse, too, the framed view from his hotel room would lead to a reinvestment in illusionism, just as this step back from the modernist precipice was the corollary of a renewed appreciation of the theatrical: 'Do you remember the light through the shutters?' he later asked a friend in reference to his first hotel rooms in Nice. 'It came from below as if from theatre footlights. Everything was fake, absurd, amazing, delicious.'[6]

But if the make-believe suggested to Picasso by the Riviera took him back all the way to Greece and Rome (and probably, as well, to his own Mediterranean childhood), Matisse's train of thought entailed a far less arduous journey, travelling back only as far as the orientalism of the French Romantics of the previous century. For the man born and brought up in the cold, muddy North, the South, by the 1920s, didn't mean shepherds and nymphs – he'd already travelled that

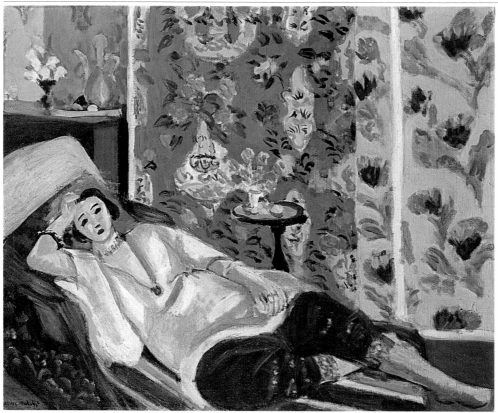

Figure 60

route, between 1905 and 1910 – but North African and Islamic culture. Of course, Matisse had already been *there* too, not only in reality (to Algeria in 1906 and Morocco in 1911–12), but in his art, when the oriental carpet and the Persian miniature, with their brilliantly coloured flatness and their arabesques, had inspired some of his greatest works in the pre-war years. Now, for almost an entire decade on the Côte d'Azur, Matisse would recollect the Middle East at one remove, and become the kind of 'orientalist' which he had never been (his picture structure of the pre-war years had been too deeply marked by his Islamic, pictorial 'conversion' for that). It was not the real countries on the other side of the Mediterranean from which he would now draw sustenance, nor from their art and decoration, nor even from his own, earlier radical innovations, but from the harem images of Ingres, Delacroix, Chassériau and Renoir.

It was as if the artifice of the Côte d'Azur, and Nice in particular, demanded a suitably touristic response from Matisse – not the vitalism of native Moroccan culture, but the dreamy *décontraction* of his French predecessors. 'Nice, a fairy-tale city of carnivals, pageantry, battles of flowers, azure,

plaster, gold...No Italian comic-opera set could more fittingly haunt the waking sleep of poets than this theatre of illusions,' Cocteau had written,[7] and this might equally serve as a description of Matisse's hotel-room theatre of illusions (fig. 60). It is not only that Matisse wants us to recognise the artistic precedents for these works; or that he insists on the make-believe of his countless, posing models, whether dressed up as odalisques or in contemporary attire; or that the decor is a cobbled-together *mise-en-scène* of French and foreign bibelots, whose setting in a hotel room or apartment, rather than a typical artist's studio, is left undisguised. It is, rather, that Matisse's one great subject in Nice – whatever the particularities of a given painting – is artifice itself, be it 'assuming' a pose or 'arranging' a still-life. The pictures are always theatrical, in that they are so emphatically contrivances, but never in the narrative sense. The Nice *œuvre* of the 1920s has only one story to tell, and it is undramatic in the extreme: a confectioner, with the *luxe* of abundant time on his hands, with attractive models at his disposal, and equipped with a collection of vases, decorated screens and patterned fabrics, has seen fit to organise his materials in preparation for creating the

61 Kees van Dongen, *Self-portrait as King Neptune*, 1922
Oil on canvas, 170 × 120 cm
Musée National d'Art Moderne, Centre Georges
Pompidou, Paris

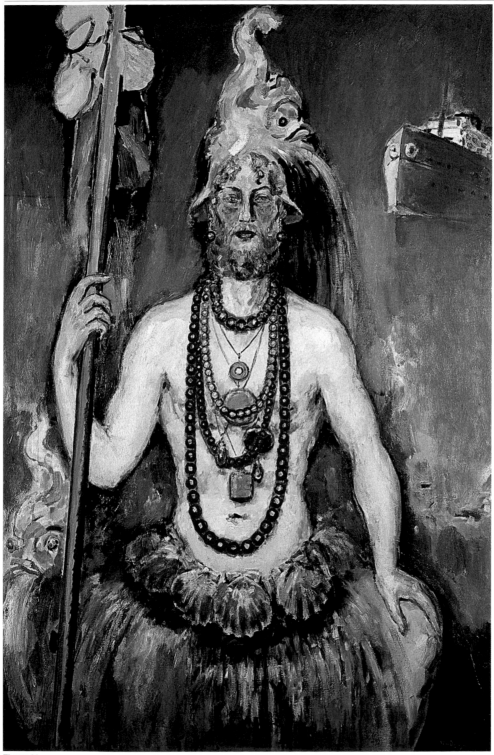

Figure 61

painted representation at which we now gaze.
There is no allegory, no symbolism, no moral
to be drawn, except one: that this seemingly
frivolous filling of time is a thing worth doing.
The sensual languor of these paintings
conveys the special, attenuated time-frame
of the long-term visitor, as well as the tourist's
way of looking: curious, slightly distanced,
disinterested. Like tourism itself, Matisse's
hot-house aesthetic in Nice is an exercise in
carefully circumscribed, specular mobility.
In stark contrast to Paris, where the intensity
of urban life demanded an ever-changing,
strategic relationship to the world, the Riviera
made no such demands. When an interviewer
asked him why he kept returning to the coast
to work, Matisse said: 'Because in order to
paint my pictures I need to remain for several
days in the same state of mind, and I do not
find this in any atmosphere but that of the
Côte d'Azur…The northern lands, Paris in
particular…offer too unstable an atmosphere
for work as I understand it.'[8]

If the harem is Matisse's model for insular,
private delectation on the coast, his extrovert,
former Fauve colleague Kees van Dongen,
in his *Self-portrait as King Neptune* (fig. 61),
returns us to the Riviera out of doors, in a
disguise that is mythic, public and tribal.
Van Dongen started sojourning in Cannes in
the early 1920s and soon became the reigning
modern artist of that high-society enclave.
He may well be dressed up here for one of the
town's many costume parties or for Mardi
Gras; as the cruise ship in the painting's upper-
right-hand corner indicates, he shows himself
seated at the water's edge. As frankly artificed
as any of Matisse's odalisques, van Dongen's
self-styling is a hotchpotch of primitivist
reference, an amalgam of the myriad fantasies
which a Côte d'Azur tourist might summon
up on the road to leisure-time regression. This
Roman deity of the watery depths sports a
dolphin on his headdress (and there is another
dauphin as well at the lower left); his trident,
though, looks like some kind of decorated
'native' spear, just as his grass-skirt,
cockleshell belt and multiple necklaces –
strings of beads and pendants – locate his get-
up somewhere between Africa and the South
Seas. And do we not also sense here something
demonic, as if holiday-time hedonism would
be less than compelling without the waft of
sin? Van Dongen presents himself as king
of the Côte d'Azur *imaginaire,* his body a
fantastic mapping of the Riviera's disorienting
geography, in which the chic swimming club

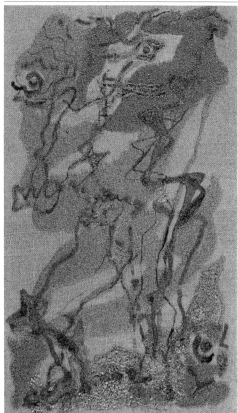

62 André Masson, *Painting (Figure)*, 1926–27
Oil and sand on canvas, 46.1 × 26.9 cm
The Museum of Modern Art, New York.
Gift of William Rubin

Figure 62

at Cannes was called 'Palm Beach', the fashionable neighbourhood in the nearby hills 'La Californie', a cliff near Beaulieu 'La Petite Afrique' and one of St Tropez's sandy beaches 'Tahiti'. If by the interwar years France's southeast coast had become the prime escapist zone for well-heeled visitors from Paris, New York and Rio de Janeiro, so the notion of 'getting away' – as a kind of escape *en abîme* – was thematised by its entrepreneurs as well as its more enterprising artists.

Beached

Whereas, for Monet and Signac in the late nineteenth century, the Riviera had been a significant location for the renewal of landscape painting, by the 1920s the coast had become a setting for artistic fantasy – arcadian, oriental and primitive – rather than a subject in its own right. To a certain extent this shift was indicative of the Riviera's rampant development. As the pace of residential and commercial construction accelerated, and as tourism in general on the coast increased at a sometimes alarming rate, nature was pushed ever further into the background, its role being gradually reduced to one that was ancillary to the social life being enacted before it. Yet, as the roads became ever more

congested and the pine, mimosa and eucalyptus on the hills gave way to villas and hotels, the Côte d'Azur's beaches came into their own. In the early 1920s the preferred season on the Riviera began to shift from winter to summer and daytime activity moved to *la plage*: exercising on the sand, swimming, sunbathing and picnicking. The water's sandy edge became the new locus for the diurnal performance of hedonistic ritual, a place where the evolutionary paradigm could be turned back on itself.

The thirty-year-old Surrealist André Masson, an inveterate beachgoer, devised his celebrated 'sand paintings' while staying on the coast at Sanary, near Toulon, during a ten-month stay from May 1926 to March 1927. Searching for a way to paint, as opposed to merely drawing, in the psychically 'automatic' way practised by the Breton circle, Masson discovered that a combination of oil paint, glue and sand – employed, among other ways, in a free-fall application that anticipates Jackson Pollock's drip technique – could yield complex and richly textured images. Moreover, by using sand of differing consistencies, Masson could create hybrid creatures, as in *Painting (Figure)* of 1926–27 (fig. 62), in which landscape and figure merge in a kind of ecstatic gestalt but the individual, superimposed planes of rough canvas and sand – alternately 'filling in' and breaking free of the linear armature – maintain their integrity. Unlike Picasso, with his classical preconceptions, or Matisse, with his Romantic ones, Masson arrived on the Riviera with the minimum of art-historical baggage. Analogous to Surrealism's exhortation to narrow the gap between conscious behaviour and subconscious drives, Masson's sand paintings propose a new, more intimate connection between landscape and figure, an experiential rather than an abstract one. The haptic aspect of Masson's sand paintings, their relief-like appeal to the spectator's sense of touch, is the pictorial corollary of the visceral, Côte d'Azur beach experience of exposed flesh in unexpected, intimate contact with nature.[9]

Masson's literal incorporation of the Riviera into his work apparently impressed Picasso enough to give it a try himself, three years later. At Juan-les-Pins, in the summer of 1930, Picasso made a series of constructions which directly challenged the younger artist's sand-encrusted canvases. As if in defiance of Masson's pictures, Picasso turned his canvases around, choosing to work instead on their

63 Pablo Picasso, *Composition with Glove*, August 1930
Construction with sand and found objects,
27 × 35.5 × 8 cm
Musée Picasso, Paris

Figure 63

backs, the wooden stretchers functioning as both containing edges and frames (fig. 63). In them, he arranged found objects (many from the beach: a glove or a toy boat, bits of seaweed, nails, cardboard and rope), before pouring glue over the assemblage and immersing the whole in sand. The result is a group of wholly textural, monochromatic works which go beyond the enriched pictorialism of Masson's series to suggest something darker and deeper, a kind of burial in the sand, or a mummification, reminiscent of the casts of Pompeii's unfortunate residents at the moment of Vesuvius's eruption in AD 79.

Graveyard and launching pad

'I wanted to crown my achievement like a pharaoh painting his sarcophagus,' Jean Cocteau said of his decoration of the tiny Chapelle Saint-Pierre, completed in 1957, on the edge of the port in Villefranche.[10] Along with the two other postwar, artist-designed chapels on the Côte d'Azur – Matisse's Chapel of the Rosary, at Vence (1947–51; fig. 64) and Picasso's Temple of Peace, at Vallauris (1952) – Cocteau's chapel marks the final stage, by now in the kingdom of Thanatos, of the Parisian avant-garde's love affair with the Riviera. By the 1950s, the coast had become a kind of retirement community for modern masters. Not only Matisse and Picasso, but also Cocteau, Chagall, Ozenfant and Le Corbusier, among others, spent all or many of their final years on the coast (and several are buried there as well). There were numerous reasons for this, apart from the obvious fact that the easy life of a resort community is congenial to those for whom survival itself has become a problem.

For one thing, the Parisian masters and their admirers found it easier to prepare for enduring fame on the coast than in the capital: without red tape and excessive property prices, one could, almost by fiat, create a museum, as happened in 1949, at Antibes, when the Musée Picasso was inaugurated (it took decades for the same thing to happen in Paris). But other factors, including the value which the presence of famous names conferred on the coast's postwar efforts to revive tourism, as well as the Riviera's skill at opulent display and clever publicity, meant that the decline and fall of the avant-garde could be more judiciously managed in the vacation land of the Côte d'Azur than in the distracted, youth-oriented capital. After the inauguration of the three chapels, numerous other permanent installations followed on the coast:

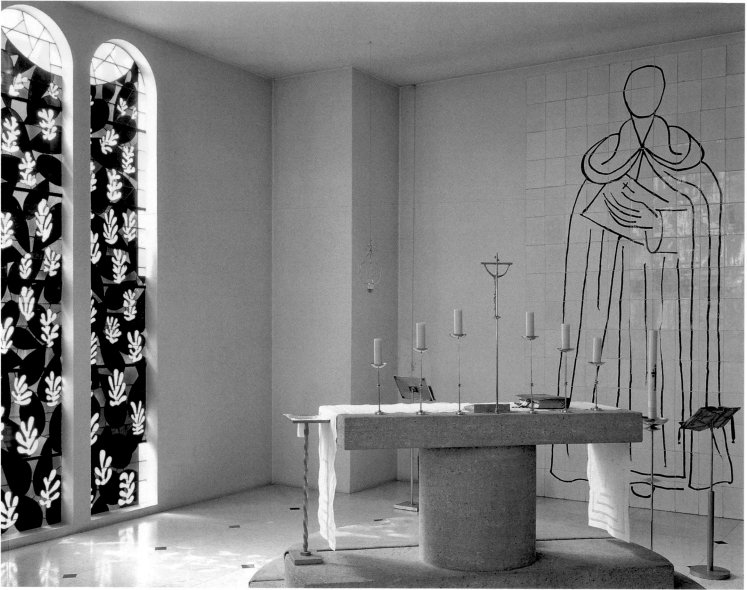

Figure 64

Cocteau decorated wedding chapels for the town halls of Menton and St-Jean-Cap-Ferrat and an amphitheatre for a student retreat at Cap d'Ail; and Chagall fashioned mosaic murals for the baptistery of Vence Cathedral, for Nice's law school, and for the Fondation Maeght, which opened in Saint-Paul-de-Vence in 1964 and also incorporated mosaic and ceramic work by Braque, Léger and Miró. A series of monographic museums followed the foundation of the Picasso museum at Antibes: in 1960, at Biot, the Musée National Fernand Léger opened, five years after the artist's death; in 1963, the Musée Matisse received its first visitors in the Cimiez neighbourhood of Nice, close to where the artist had lived for many years (and near where he had been buried nine years earlier);

and, in 1973, in Nice, while the artist was still alive and well, the Musée National Message Biblique Marc Chagall was founded.

But if the Riviera rather than Paris became the Elysian Fields of modernism, it was also there, rather than in the capital, that the most important French, postwar avant-garde movement, 'le nouveau réalisme', came into being. This was unprecedented: the Côte d'Azur had been host to major and minor artists for decades, but they had almost all been outsiders – tourists – mostly from Paris. The coast had been a place where Impressionists, Pointillists, Fauves, Cubists, Dadas, Surrealists and abstract artists went to work and play; it had never been a place where movements were *born*. All that changed in the late 1950s and early 1960s, when a group

of locals, usually referred to as the 'Ecole de Nice' – including Yves Klein, Arman (Fernandez), Martial Raysse, Robert Malaval and Ben (Vautier) – began to work in a variety of iconoclastic modes.

These young Azuréens, who had come of age with Picasso, Matisse, Cocteau and Chagall as neighbours, and in a place that treated its modern artists as royalty, had both a strong sense of modernist privilege and a demystified sense of artistic celebrity. And they were well aware of the uniqueness of their situation, of having an opportunity to turn the tables on nearly a century of artistic 'colonialism' on the coast. 'Although we're always on vacation, we of the Ecole de Nice, we're not tourists,' Klein told an interviewer in 1960. 'That's the essential point. Tourists on vacation come to

65 Martial Raysse, *Tree*, 1959–60
Mixed media, 180 × 80 × 80 cm
Musée d'Art Moderne et d'Art Contemporain, Nice

where we live, we *inhabit* the land of vacation, which gives us this feeling for doing idiotic things. We have a good time, without thinking of religion, or art, or science.'[11] The iconoclasm of the Ecole de Nice was an expression of its members' odd upbringing in Lotus Land, with its special mix of high culture and low, of celebrity artists and ordinary tourists. Indeed, if high culture meant the serious pursuit of artistic accomplishment, then these youngsters would insist that they were doing something else altogether: 'It's important to keep in mind that we are not artists,' Raysse said. 'We're on vacation, we've never worked in our lives.' 'Being perpetually on vacation,' Arman added, 'we have time to eat, destroy and regurgitate anything we feel like.'[12] For one of his first neo-Dada acts, Klein 'signed' the brilliant blue sky of the Riviera, calling it his 'first and biggest monochrome'. He then chose an ultramarine blue as his personal chromatic attribute, renaming it IKB, International Klein Blue. Raysse gathered plastic refuse on the beach or bought objects at cheap shops in Nice, out of which he made sculpture (fig. 65). Arman, whose father owned a furniture store in the city, burned, mutilated and otherwise subjected faux-Louis *meubles* to whatever indignities he could contrive when he wasn't collecting used objects such as cameras or hairbrushes to encase in Plexiglass boxes.

If, by the 1950s, modern art had become a realm of sacred cows and sacred spaces on the Côte d'Azur, then the young artists of the Ecole de Nice would relocate aesthetic experience – even mystical transport – in the realm of the mundane. Klein even envisioned an entirely new geographic configuration for the art world, in which the Riviera would no longer play the role of country cousin to Paris's big-time sophisticate, but would be part of a revamped global system. 'I think the Ecole de Nice is at the origin of everything that's happened in Europe for the last ten years: that seems hard to believe but [after all] we've seen the worldwide spread of the so-called School of Paris, with a group of artists who I swear I respect and that I like very much but which is no longer [representative of] today…we've had enough of it, we Ecole de Nice [artists], for ten years we've nourished Paris and even New York [but] there's a limit to family obligations. Let them do what they like… we look to the west, where we see Los Angeles rather than New York…I therefore envision a new axis for art, Nice–Los Angeles–Tokyo, linking us up to China.'[13] If, for a century, the Côte d'Azur had been the great escape at the end of the railway line from Paris, it would now be, at least in 1960 in Yves Klein's imagination, the *point de départ* for somewhere entirely new.

Translations from the French are my own unless otherwise indicated.

1 Blume 1992 is the best and most recent general history of the Riviera. Three recent exhibition catalogues have taken up the topic of modern art on the Côte d'Azur: Antibes 1997, Portland 1998 and Paris 2000B. See also Silver 2001. Richard Thomson's Edinburgh 1994 is a superb synthetic work. Important specialised studies include: London 1990, Los Angeles 1990, Herbert 1992 and Joachim Pissarro's Fort Worth 1997.
2 Cited in Palm Beach 1999, p. 10.
3 Cited in Penrose 1962, p. 144.
4 For a discussion of this painting in the context of the post-First World War *retour à l'ordre*, see Silver 1989, pp. 273–80.
5 See Eitner 1955, pp. 281–90.
6 Matisse apparently said this to Francis Carco; it is cited in English in Jack Cowart and Dominique Fourcade's contribution to Washington 1986, p. 24.
7 Cocteau 1935.
8 Henri Matisse, interviewed for a radio broadcast in 1942, transcribed in Flam 1973, p. 93.
9 I am grateful to Guitte Masson for guiding me through André Masson's complicated itinerary on the Côte d'Azur.
10 For the Villefranche chapel see Cocteau 1957 and Weisweiller 1998.
11 'Klein, Raysse, Arman: Des Nouveaux Réalistes', interview with Sacha Sosnowsky, 1960, repr. in Paris 1983B, p. 264; emphasis mine.
12 Paris 1983B, p. 264.
13 Paris 1983B, p. 263.

Figure 65

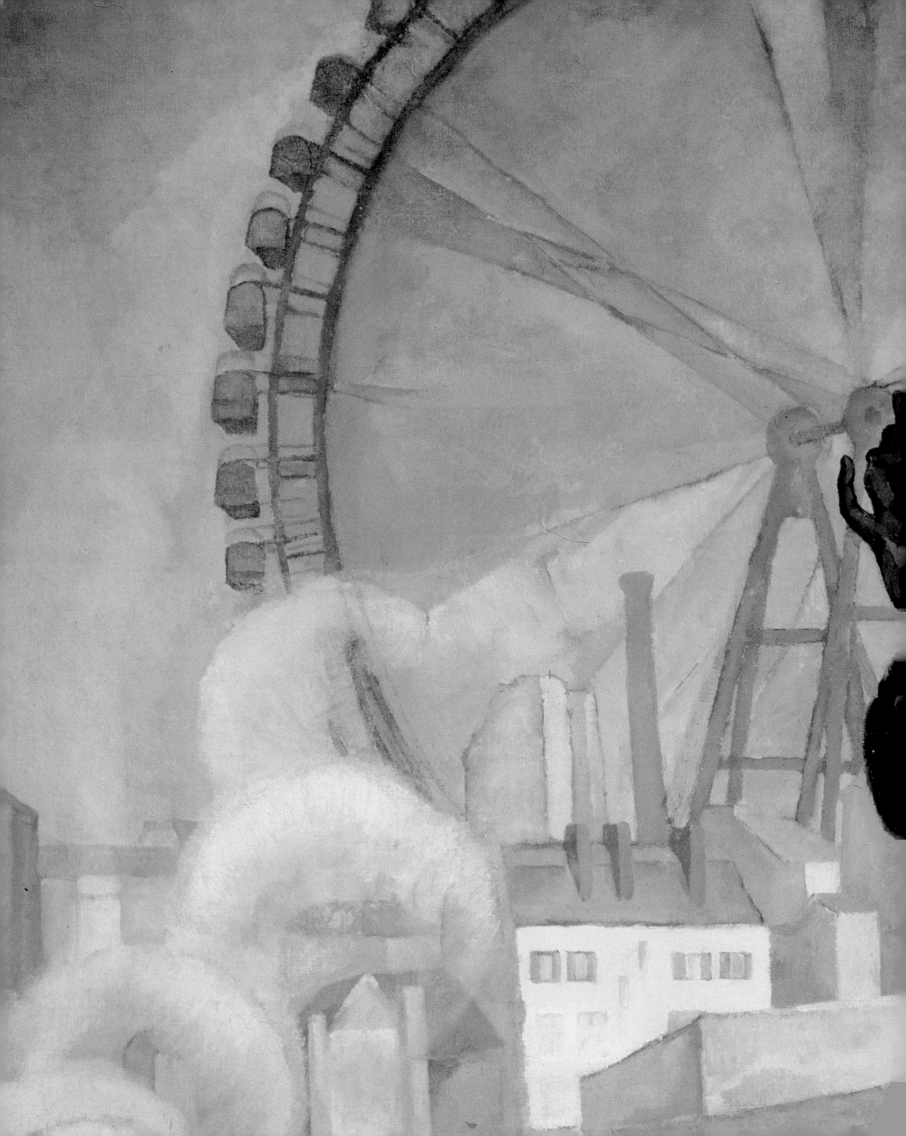

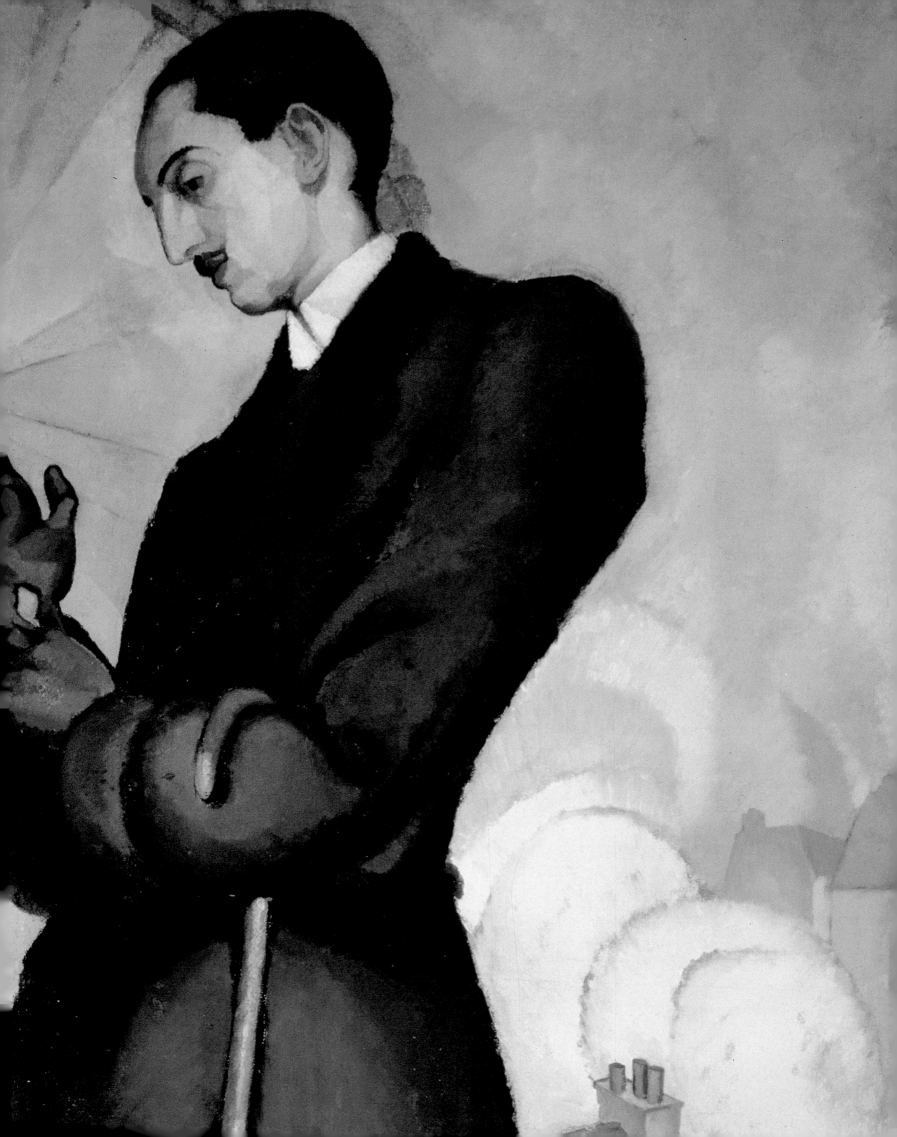

Marcel Duchamp
Air de Paris (50 cc of Paris Air), 1919
Readymade: glass ampoule,
13.5 × 20.5 (diameter) cm
Moderna Museet, Stockholm

Marcel Duchamp
La Gioconde (L.H.O.O.Q.), 1919–30
Pencil on reproduction, 48.3 × 33.3 cm
Lent by the French Communist Party.
Gift of Aragon

50

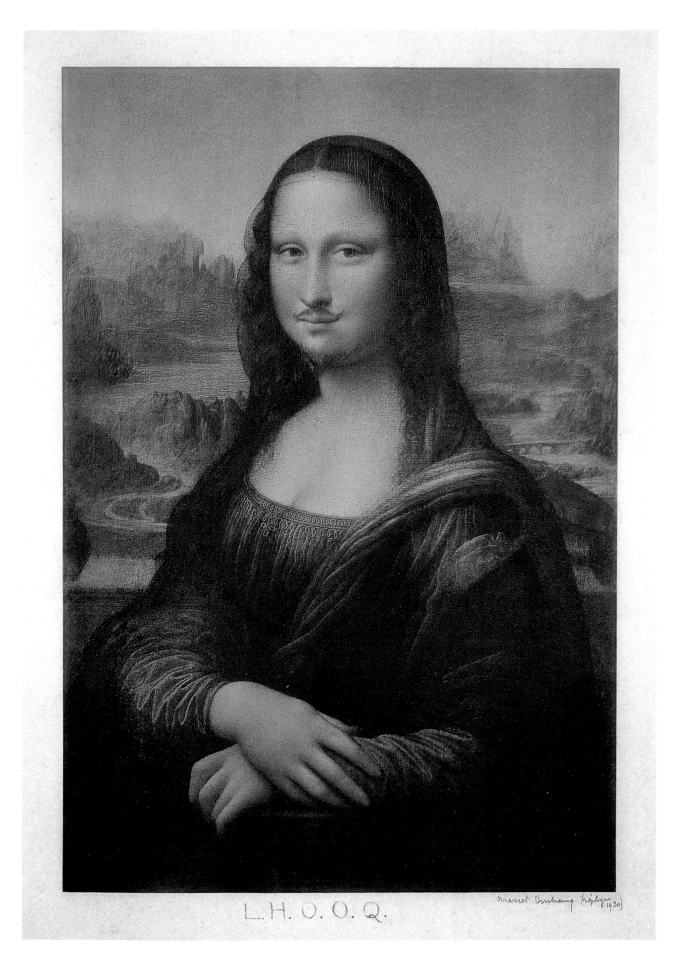

L.H.O.O.Q.

Jean Crotti
O = T + T = O, 1918
Oil on cardboard, 24 × 18 cm
Musée d'Art Moderne de la Ville de Paris

Filippo Tommaso Marinetti
Tactile Board: Paris – Sudan
Assemblage on cardboard panel, 46 × 22.5 cm
Private collection

51

52

Pierre-Antoine Gallien

Self-portrait, 1921
Plaster, glass and oil, 39 × 34.5 cm
Pierre Gallien

Georges Ribemont-Dessaignes

Le Grand Musicien, c. 1920
Oil on masonite, 75 × 56.5 cm
Private collection, Paris.
Courtesy Galerie 1900–2000

53

54

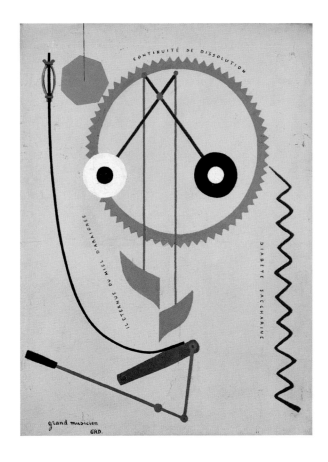

Francis Picabia
Le Lierre unique eunuque, 1920
Ripolin on cardboard, 75 × 105 cm
Kunsthaus Zurich

55

Francis Picabia
L'Oeil, caméra, c. 1919
Oil and mixed media on cardboard panel,
68 × 50.5 cm
Private collection

56

Francis Picabia
La Feuille de vigne (The Fig Leaf), 1922
Ripolin on canvas, 200 × 160 cm
Tate. Purchased 1984

57

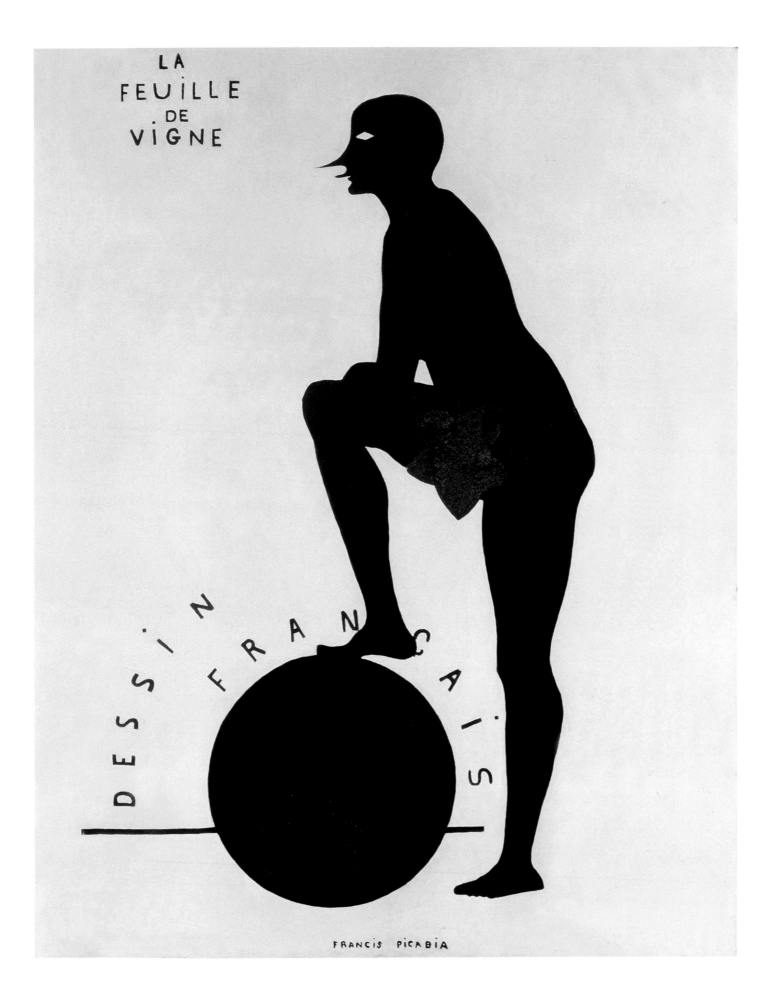

Fernand Léger
Hommage à la Danse, 1925
Oil on canvas, 159 × 121 cm
Paule and Adrien Maeght Collection, Paris

Fernand Léger
Charlot cubiste, 1924
Painted wood nailed to plywood,
73.6 × 33.4 × 6 cm
Musée National d'Art Moderne, Centre
Georges Pompidou, Paris

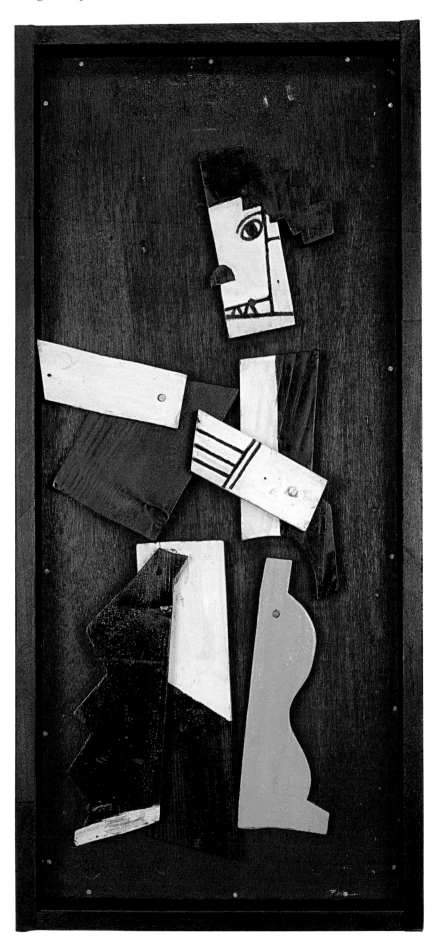

Man Ray
Cadeau, 1921–70
Iron with nails, 16.5 × 10 × 8 cm
Galerie Marion Meyer, Paris

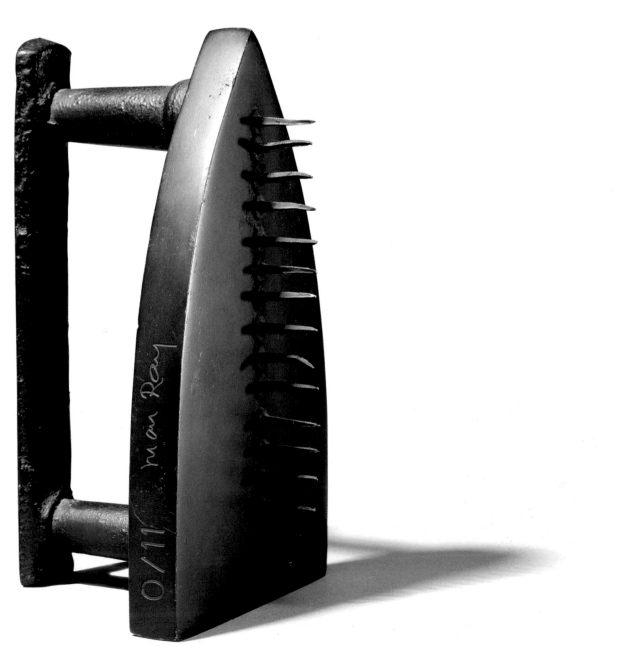

Man Ray
The Enigma of Isidore Ducasse, 1923
Wrapped sewing machine, 45 × 58 × 23 cm
Galerie Marion Meyer, Paris

Romaine Brooks
Jean Cocteau in the Era of the Big Wheel, 1912
Oil on canvas, 250 × 133 cm
Musée National d'Art Moderne – CCI, Centre Georges
Pompidou, Paris. On deposit at the Musée National
de la Coopération Franco-Américaine, Blérancourt

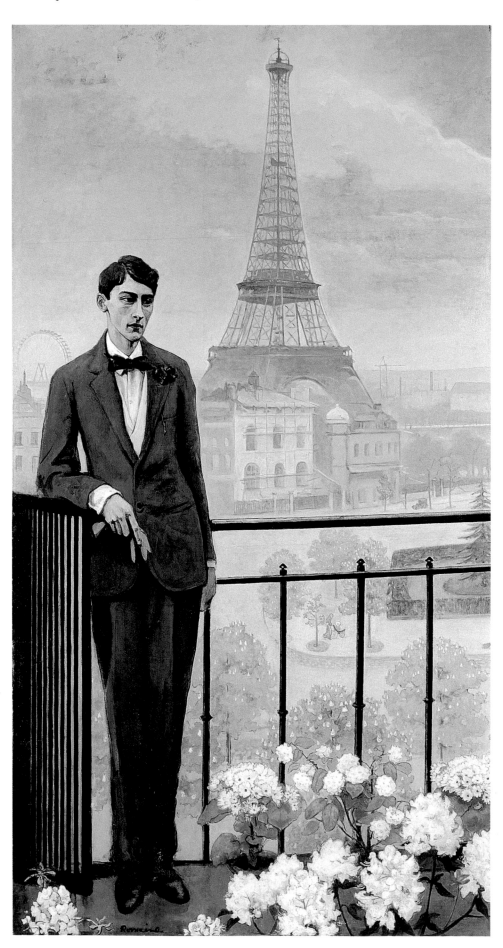

Diego Rivera
Portrait of Adolfo Best Maugard, 1913
Oil on canvas, 227.5 × 161.5 cm
Museo Nacional de Arte, CNCA, INBA,
Mexico City

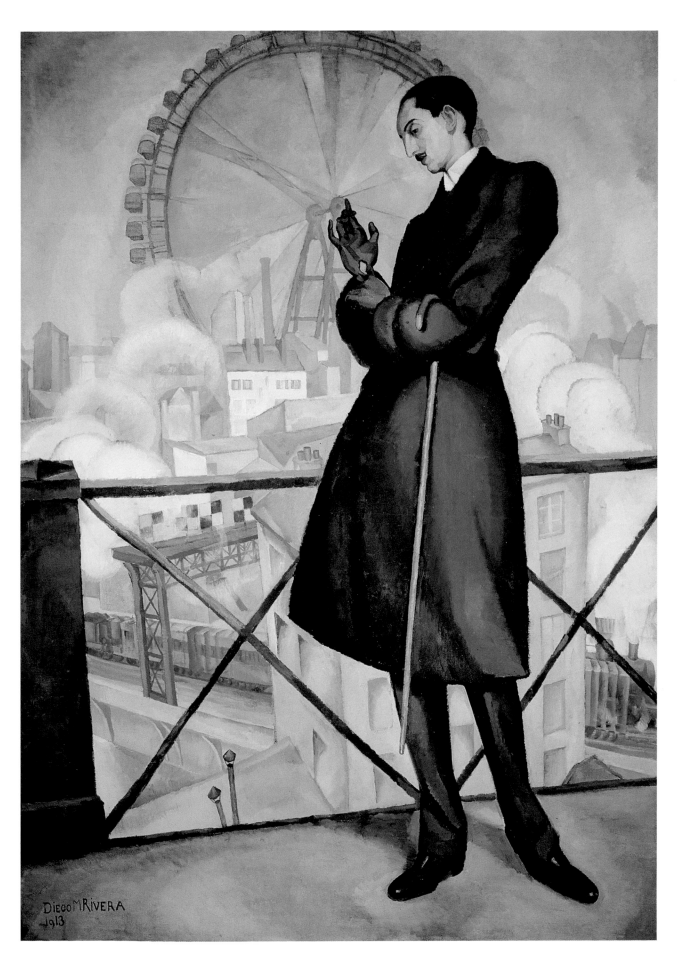

64

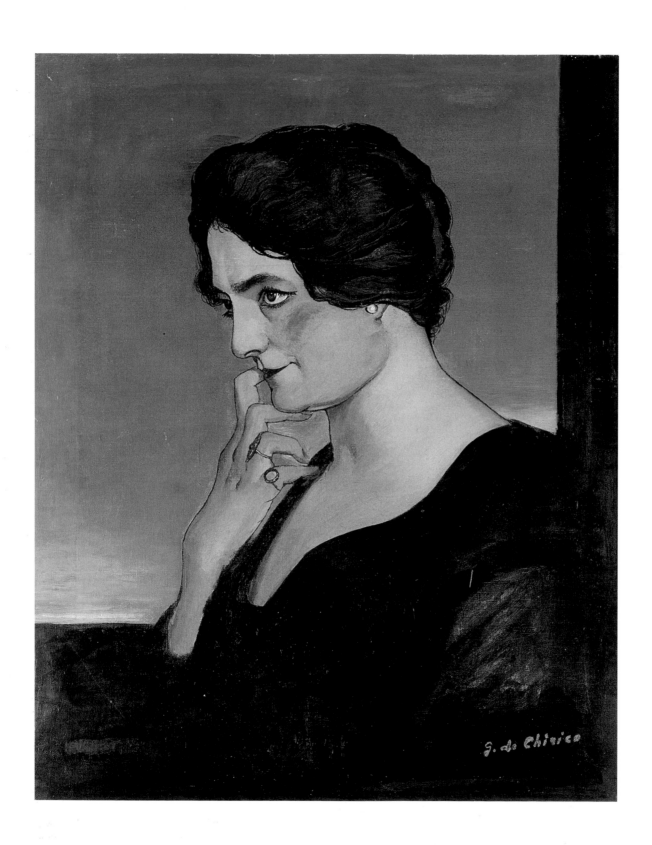

Amedeo Modigliani
*Woman Seated in Front of a Fireplace
(Beatrice Hastings)*, 1915
Oil on canvas, 81 × 65 cm
Courtesy Helly Nahmad Gallery, London

65

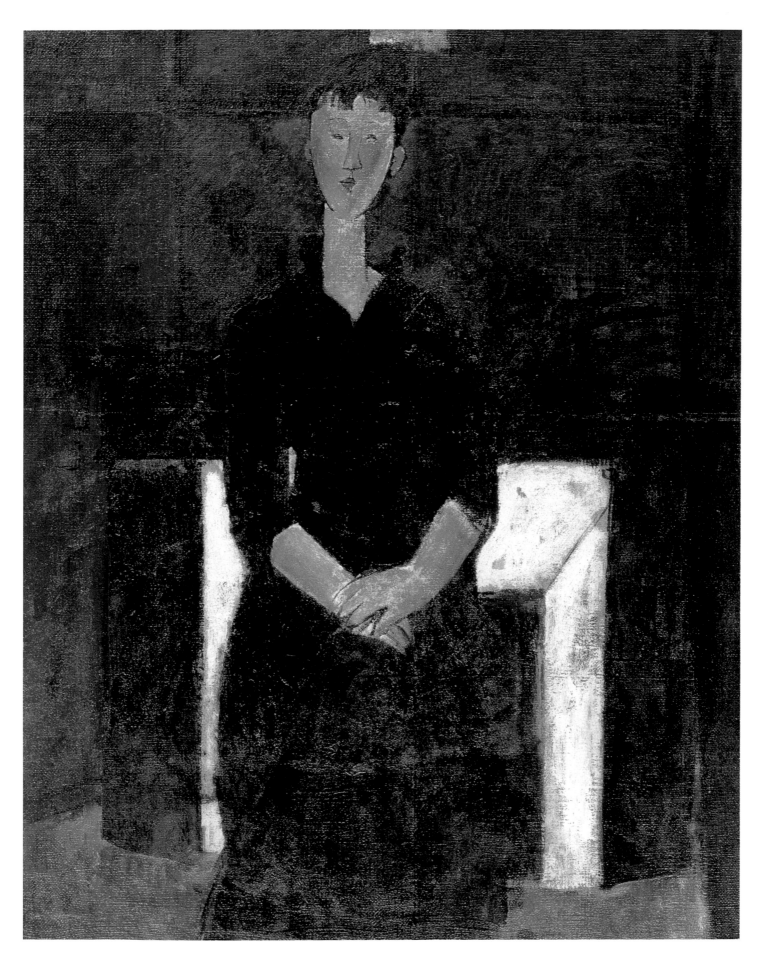

Tamara de Lempicka
Portrait of 'La Duchesse de la Salle', 1925
Oil on canvas, 161.3 × 95.9 cm
Collection Wolfgang Joop

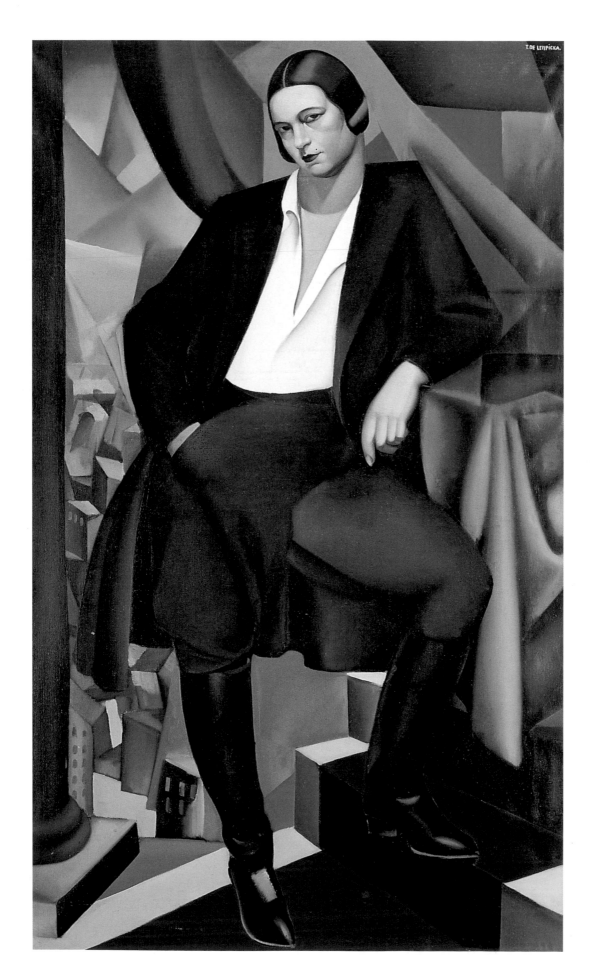

Pablo Picasso
Portrait of Olga, 1923
Oil on canvas, 130 × 97 cm
Private collection

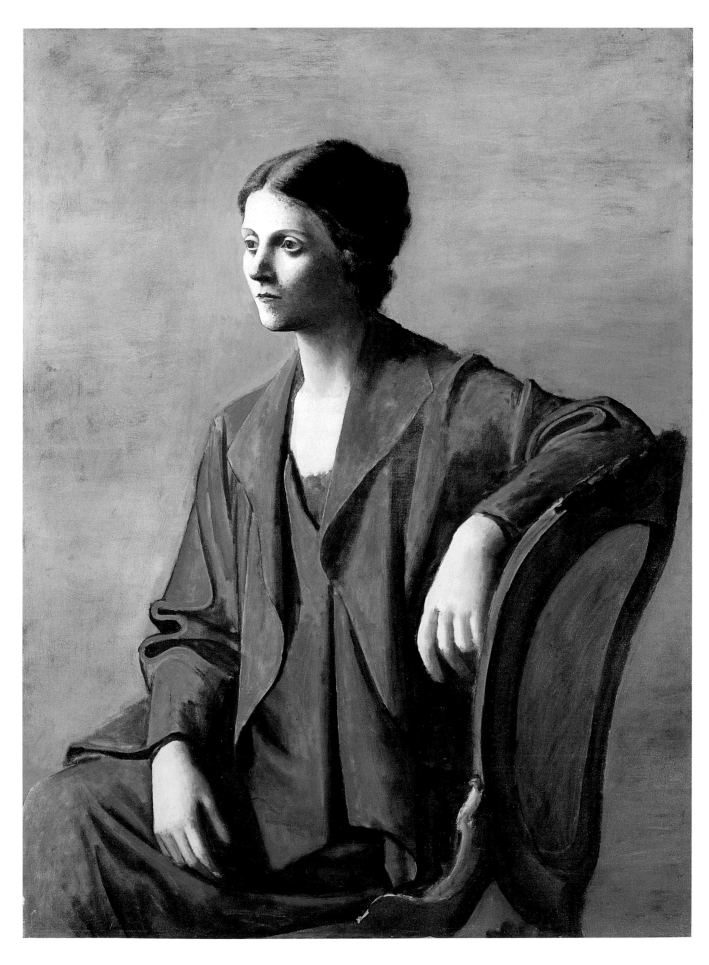

Balthus
Portrait of Pierre Matisse, 1938
Oil on canvas, 128.8 × 86.7 cm
Private collection

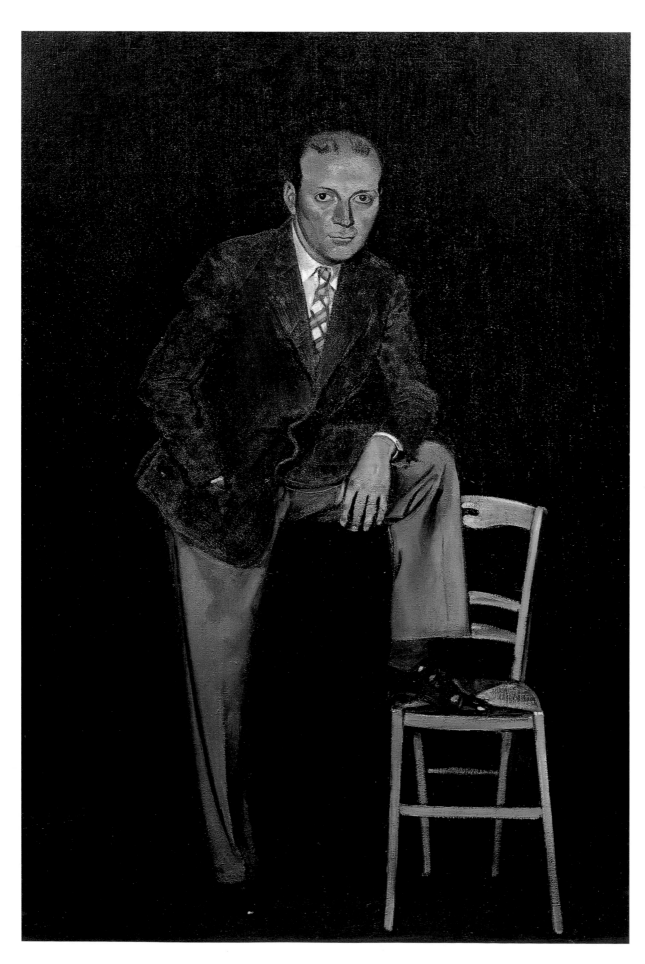

Kees van Dongen
Anna de Noailles, 1931
Oil on canvas, 196 × 131 cm
Stedelijk Museum, Amsterdam

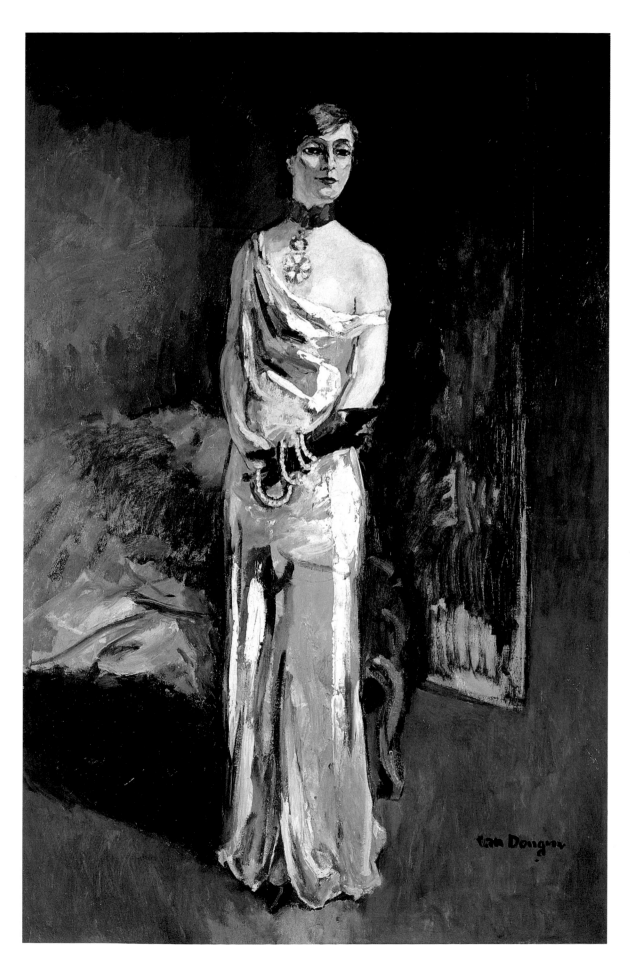

Max Beckmann
Woman with Snake (or *Snake Charmer*), 1940
Oil on canvas, 145.5 × 91 cm
Private collection, Switzerland

70

Nadia Khodossievitch-Léger
Self-portrait, 1936
Oil on canvas, 73 × 92 cm
Private collection

71

Jacques Lipchitz
Gertrude Stein, 1920
Bronze, 33 × 20 × 19 cm
Musée National d'Art Moderne,
Centre Georges Pompidou, Paris

72

Julio González
Head in Depth, 1930
Iron, 26 × 20.1 × 16.1 cm
Fondation Hans Hartung and Anna-Eva
Bergman

Pablo Gargallo
Kiki de Montparnasse, 1928
Polished bronze, 27.5 × 16.5 × 17 cm
Musée d'Art Moderne de la Ville de Paris

73

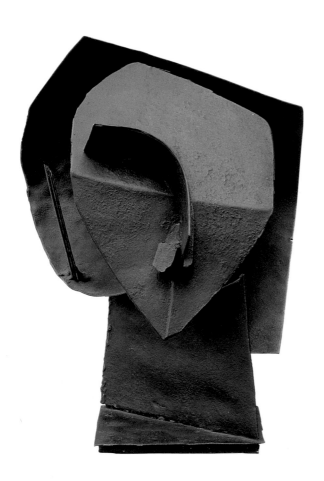

74

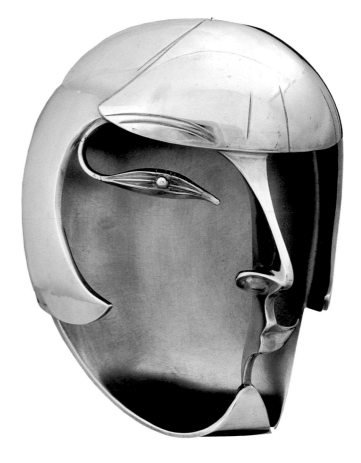

Constantin Brancusi
Nancy Cunard, 1932
Polished bronze, 79.1 × 20.3 × 26.7 cm
(including marble base)
Anonymous loan

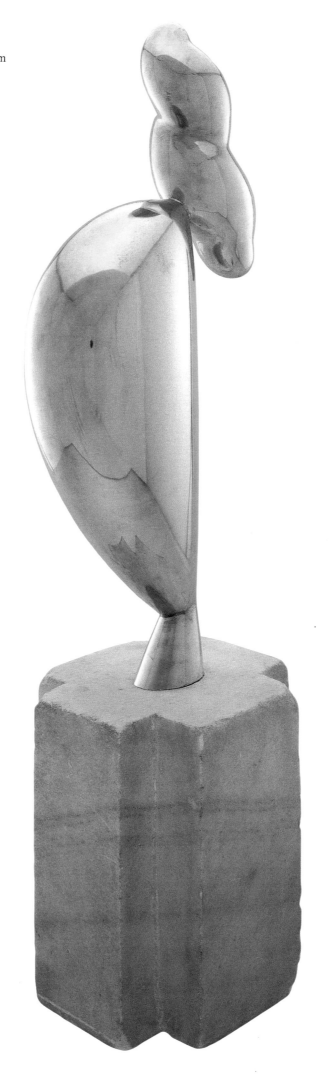

Constantin Brancusi
Bird in Space, 1927
(posthumous cast 4/5, 2000,
after original plaster)
Polished bronze, 185 × 45 cm (diameter)
(including base)
Private collection

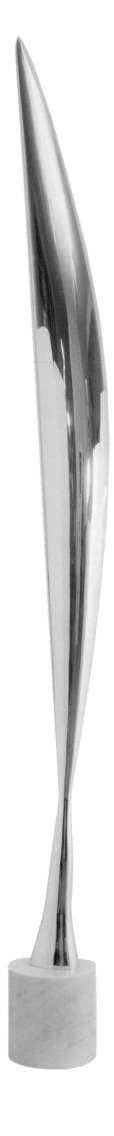

Constantin Brancusi

Prometheus, 1911
Polished bronze, 13.5 × 17.2 × 13.7 cm
Hirshhorn Museum and Sculpture Garden,
Smithsonian Institution, Washington DC.
Gift of Joseph H. Hirshhorn, 1966

77

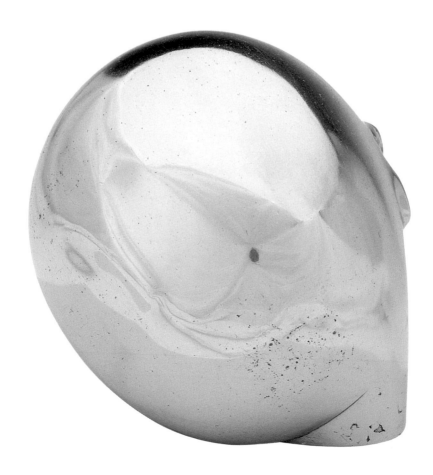

Amédée Ozenfant
Guitar and Bottles, 1920
Oil on canvas, 80.5 × 99.8 cm
Peggy Guggenheim Collection, Venice
(Solomon R. Guggenheim Foundation,
New York)

Le Corbusier
Vertical Guitar (first version), 1920
Oil on canvas, 100 × 81 cm
Fondation Le Corbusier, Paris

79

Le Corbusier
Vertical Guitar (first version), 1920
Oil on canvas, 100 × 81 cm
Fondation Le Corbusier, Paris

Fernand Léger
Mural Painting, 1924
Oil on canvas, 180 × 80 cm
Museo Nacional Centro de Arte Reina Sofía,
Madrid

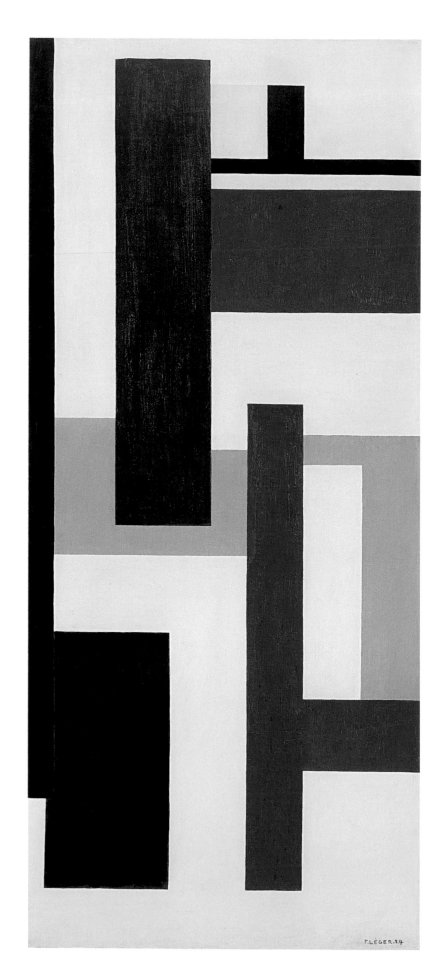

Fernand Léger
Mural Painting, 1924
Oil on canvas, 180 × 80 cm
Museo Nacional Centro de Arte Reina Sofía,
Madrid

Fernand Léger
Composition with Hand and Hats, 1927
Oil on canvas, 248 × 185.5 cm
Musée National d'Art Moderne,
Centre Georges Pompidou, Paris

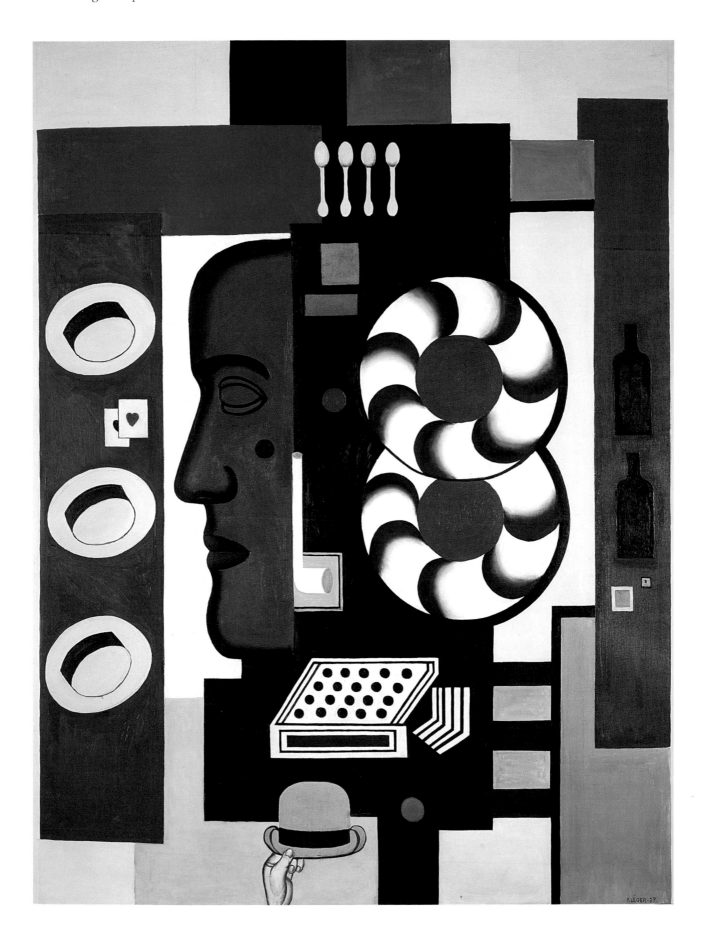

Le Corbusier
Composition with a Pear, 1929
Oil on canvas, 146 × 89 cm
Fondation Le Corbusier, Paris

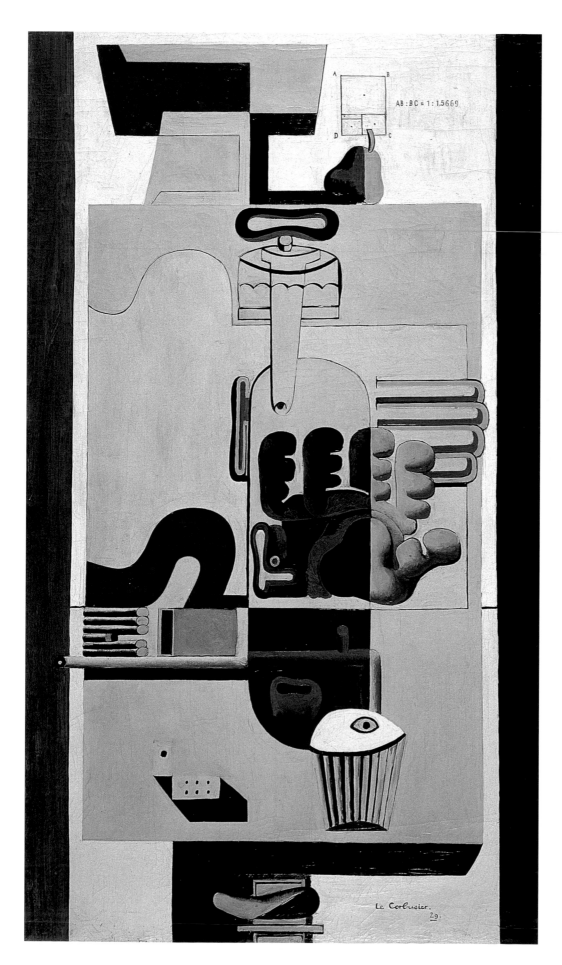

Pablo Picasso
Painter and Model, Paris, 1928
Oil on canvas, 129.8 × 163 cm
The Museum of Modern Art, New York.
The Sidney and Harriet Janis Collection, 1967

83

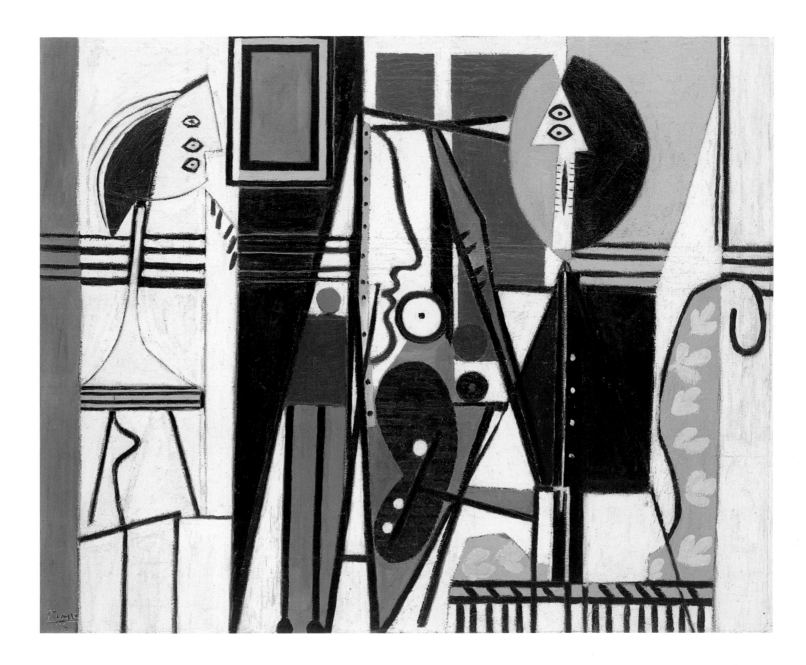

Joaquín Torres-García
Cosmic Composition with Abstract Figure, 1933
Tempera on cardboard, 75 × 53 cm
Alejandro, Aurelio and Claudio Torres
Collection. Courtesy Galerie Jan Krugier,
Ditesheim & Cie, Geneva

Joaquín Torres-García
Construction in White and Black, 1930
Mixed media, 48.9 × 35.6 cm
Carmen Thyssen-Bornemisza Collection

Joaquín Torres-García
Construction in White and Black, 1930

Jean (Hans) Arp
Un Grand et deux petits, 1931
Wood, 66 × 46 × 46 cm
Fondation Arp, Clamart

Jean (Hans) Arp
Configuration with Two Dangerous Points, 1930
Painted wood, 70.2 × 84.8 cm
Philadelphia Museum of Art: The A. E. Gallatin
Collection, 1947

87

Joan Miró
Painting, 1927
Oil on wood, 19 × 24 cm
Private collection

Joan Miró
Painting (Portrait and Shadow), 1926
Oil on canvas, 81 × 100
Courtesy Helly Nahmad Gallery, London

89

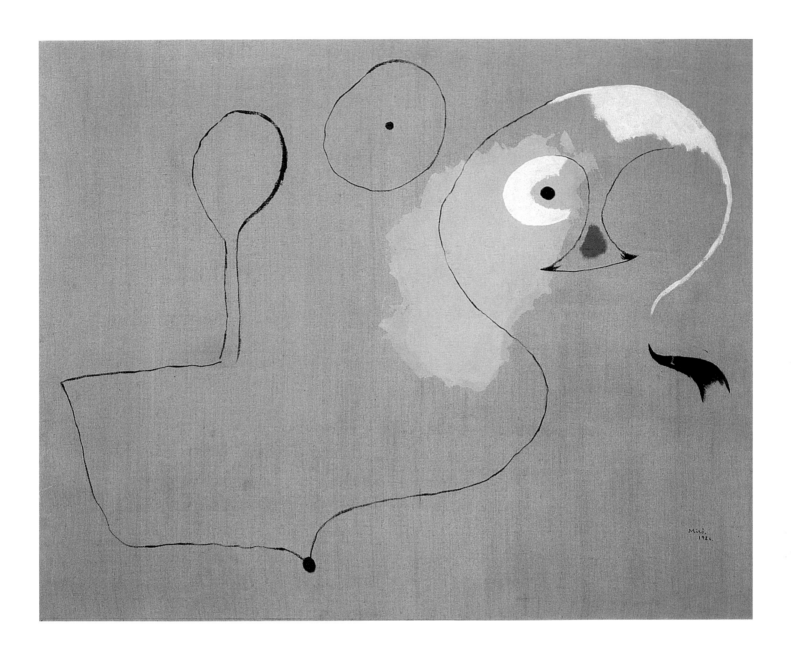

Alexander Calder
Spider, 1938
Painted metal, 104 × 89 × 0.7 cm
Scottish National Gallery of Modern Art,
Edinburgh. Purchased 1976

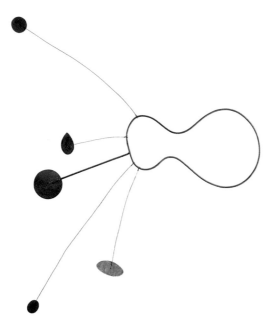

Alexander Calder
Untitled, 1933
Wood, wire, aluminium sheet, iron, cords
and tempera, 120 × 74 × 30 cm
Collecció MACBA, Fundació Museu d'Art
Contemporani de Barcelona

91

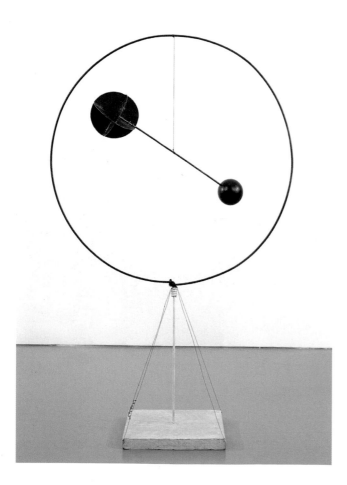

Joan Miró
Painting (Head) or *The White Cat*, 1927
Oil on canvas, 147.3 × 114.6 cm
Courtesy Helly Nahmad Gallery, London

Piet Mondrian
Composition with Large Red Plane, Yellow,
Black, Grey and Blue, 1921
Oil on canvas, 59.5 × 59.5 cm
Gemeente Museum, The Hague

93

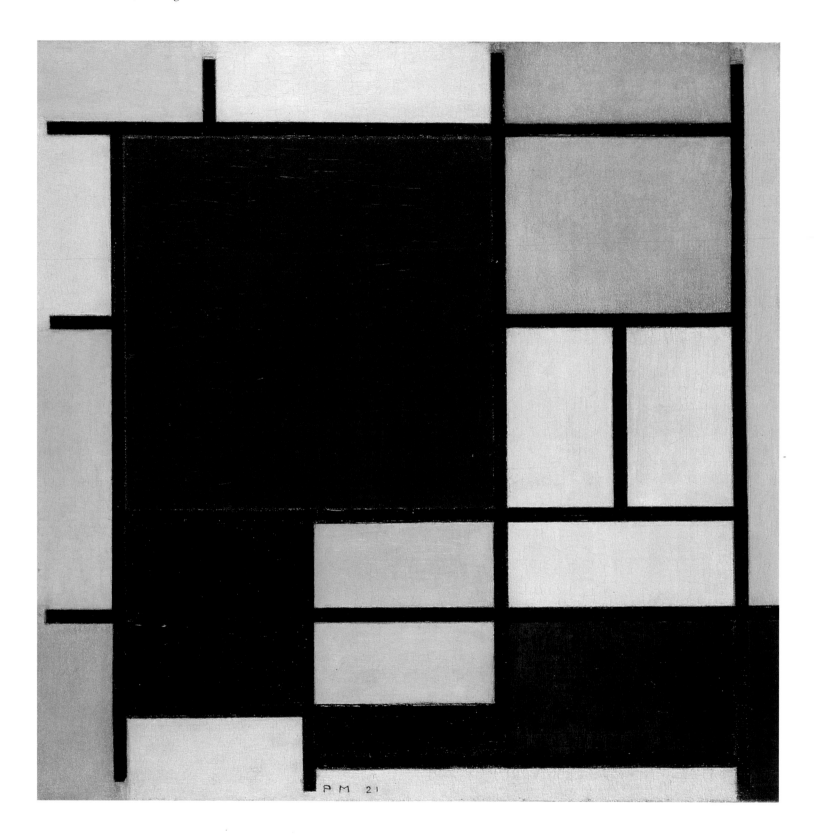

Piet Mondrian
Composition with Double Line and Blue, 1935
Oil on canvas, 72.5 × 70 cm
Private collection. Courtesy Galerie Beyeler

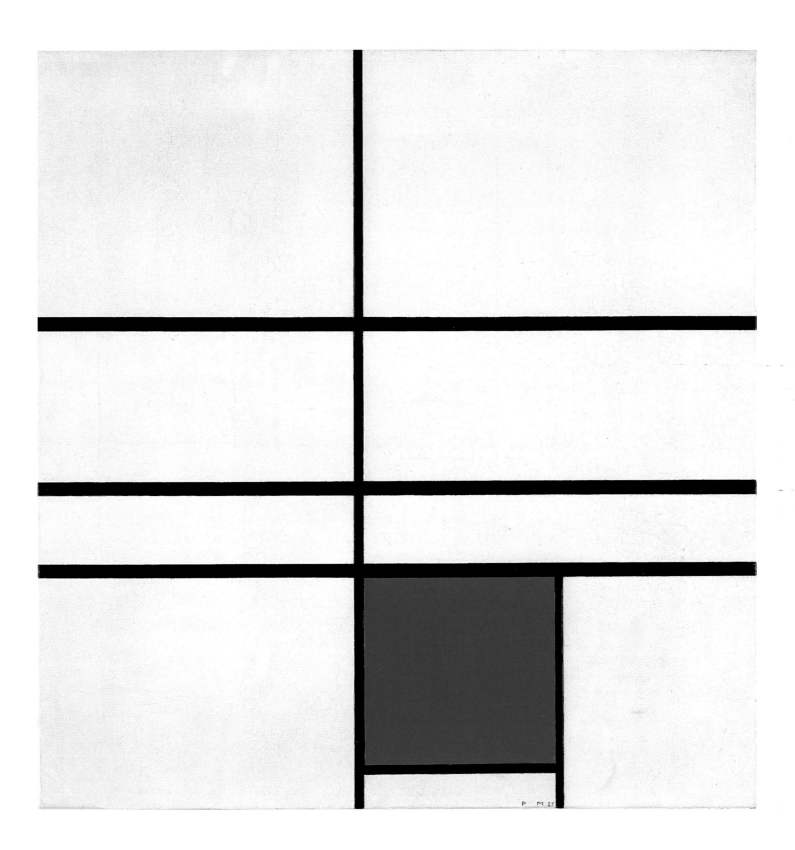

Theo van Doesburg
Counter-Composition V, 1924
Oil on canvas, 100 × 100 cm
Stedelijk Museum, Amsterdam

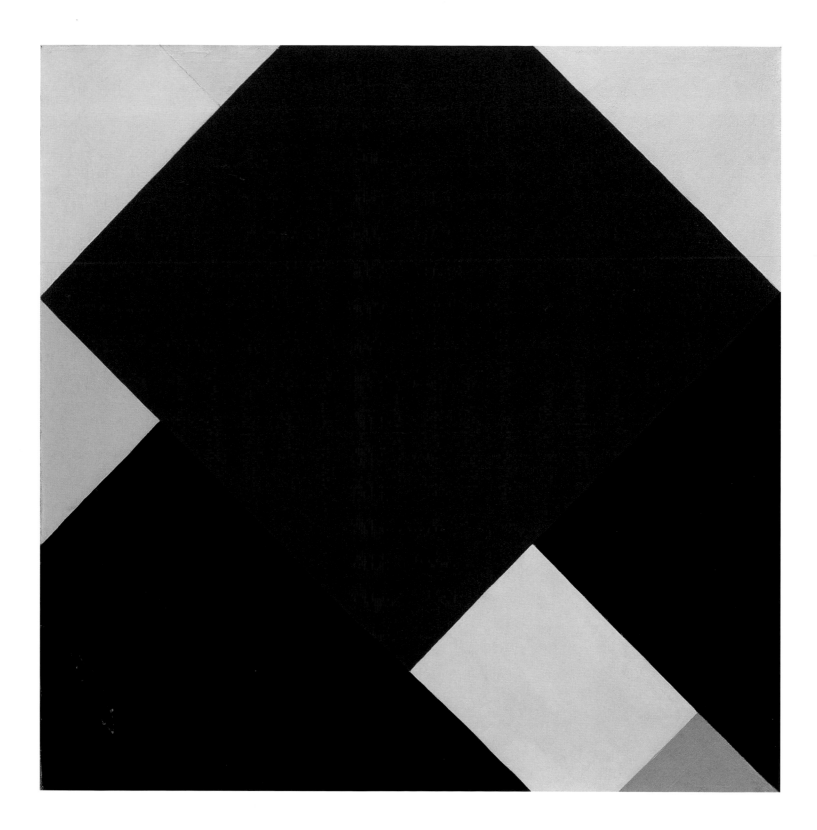

Sophie Täuber-Arp
Composition Vertical-Horizontal, 1927
Oil on canvas, 100 × 65 cm
City of Locarno Collection. Jean and Marguerite
Arp donation

96

Joseph Mellor Hanson
Static Composition, 1927
Oil on canvas, 120 × 57 cm
Private collection, Paris

Joseph Mellor Hanson
Static Composition, 1927
Oil on canvas, 120 × 57 cm
Private collection, Paris

Marlow Moss
Untitled, 1932
Oil on canvas, 45 × 36 cm
Fondazione Marguerite Arp, Locarno

Georges Vantongerloo
Groupe y, 1931
Oil on canvas, 114 × 129 cm
Collection Jakob Bill

Jean Gorin
Composition no. 36, 1937
Oil on wood, 92 × 92 × 5.5 cm
Musée de Grenoble

Jean Hélion
Equilibrium, 1933–34
Oil on canvas, 97.4 × 131.2 cm
Peggy Guggenheim Collection, Venice
(Solomon R. Guggenheim Foundation,
New York)

Leon Tutundjián
Untitled, 1929
Metal and wood, 60 cm (diameter)
Courtesy Galerie Alain Le Gaillard

102

Anton Prinner
Construction in Brass, 1935
Brass and copper, 50 × 50 × 135 cm
Musée de Grenoble

103

179

Jacques Villon
L'Espace, 1932
Oil on canvas, 116 × 89 cm
Galerie Louis Carré & Cie, Paris

Auguste Herbin
Spiral, 1933
Oil on canvas, 95 × 72 cm
Private collection, Paris

105

Naum Gabo
Construction sur un plan, 1937
Metacrylate and celluloid, 48 × 48 × 19.6 cm
Collection Anne and Jean-Claude Lahumière

Antoine Pevsner
Construction, 1935
Metal, 60 × 40 × 17 cm
IVAM, Instituto Valenciano de Arte Moderno,
Generalitat Valenciana

César Domela
Relief no. 12A, 1936
Wood, metal and Plexiglass, 75 × 62.5 × 6 cm
Musée de Grenoble

Otto Freundlich
Composition, 1930
Oil on canvas, 116 × 89 cm
Musée d'Art Moderne, Saint-Etienne

Jean Peyrissac
Cone, 1930–32
Wood, bone, string, lead and iron,
110 × 11 × 21.5 cm
Musée de Grenoble

110

Paule Vézelay
Five Forms, 1935
Plaster, 28 × 38 × 25 cm
Tate. Presented by the Patrons of British Art
through the Tate Gallery Foundation, 2000

111

Vasily Kandinsky

Violet Orange, 1935
Oil on canvas, 88.9 × 116.2 cm
Solomon R. Guggenheim Museum, New York.
Gift of Solomon R. Guggenheim, 1937

112

Amedeo Modigliani
Reclining Nude (Le Grand Nu), c. 1919
Oil on canvas, 72.4 × 116.5 cm
The Museum of Modern Art, New York.
Mrs Simon Guggenheim Fund, 1950

113

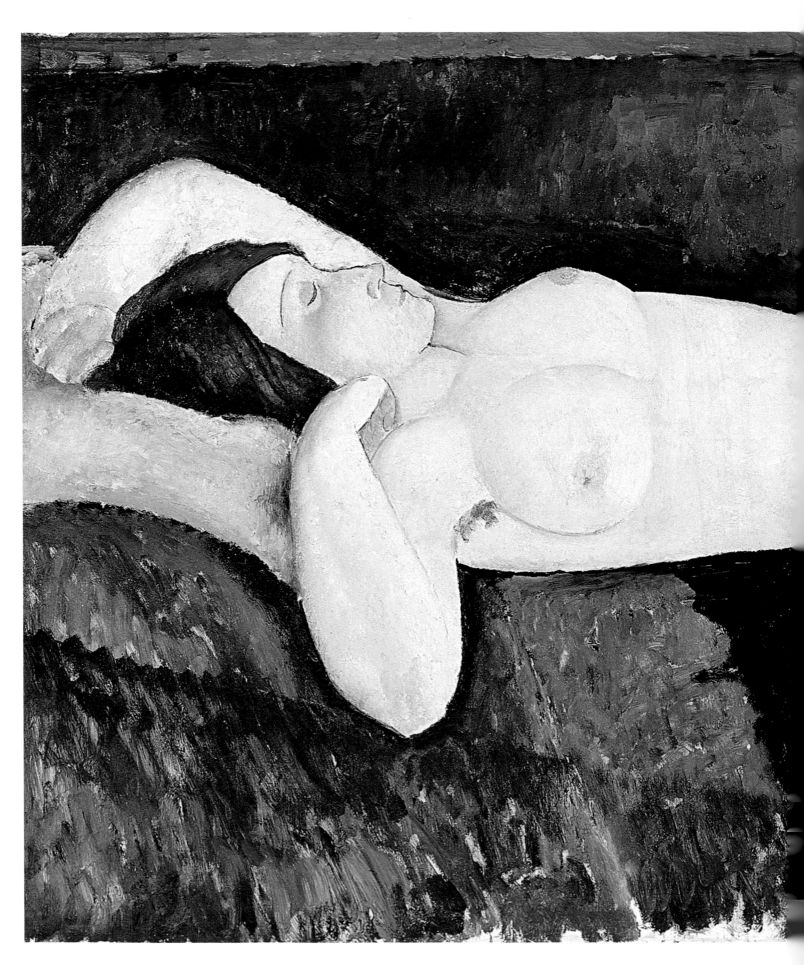

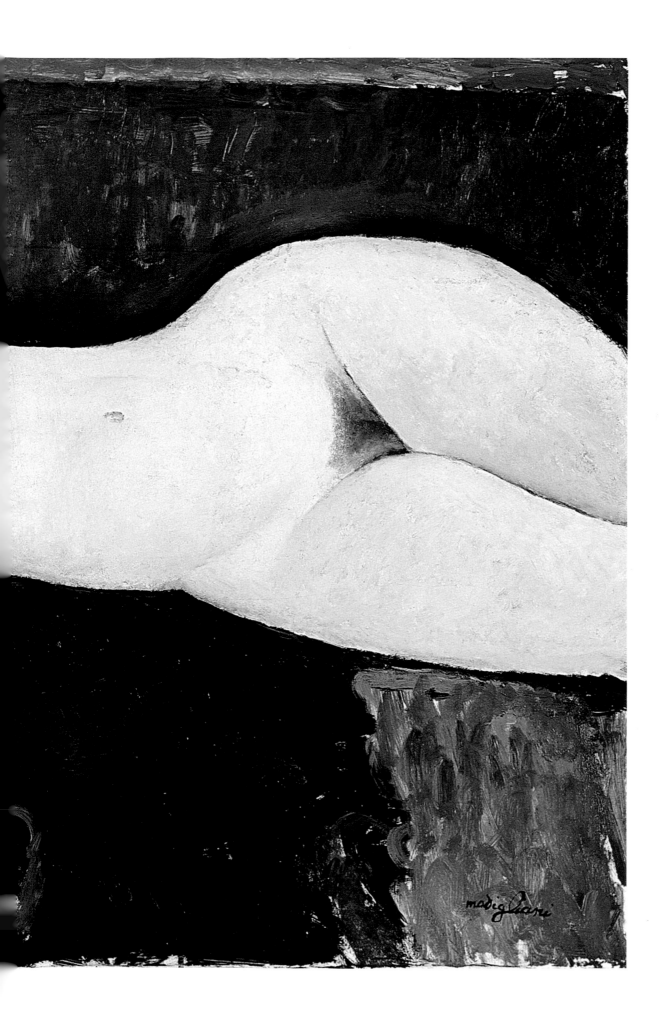

Tsuguharu Foujita

The Two Friends, 1926
Oil on canvas, 92 × 73 cm
Petit Palais, Musée d'Art Moderne, Geneva

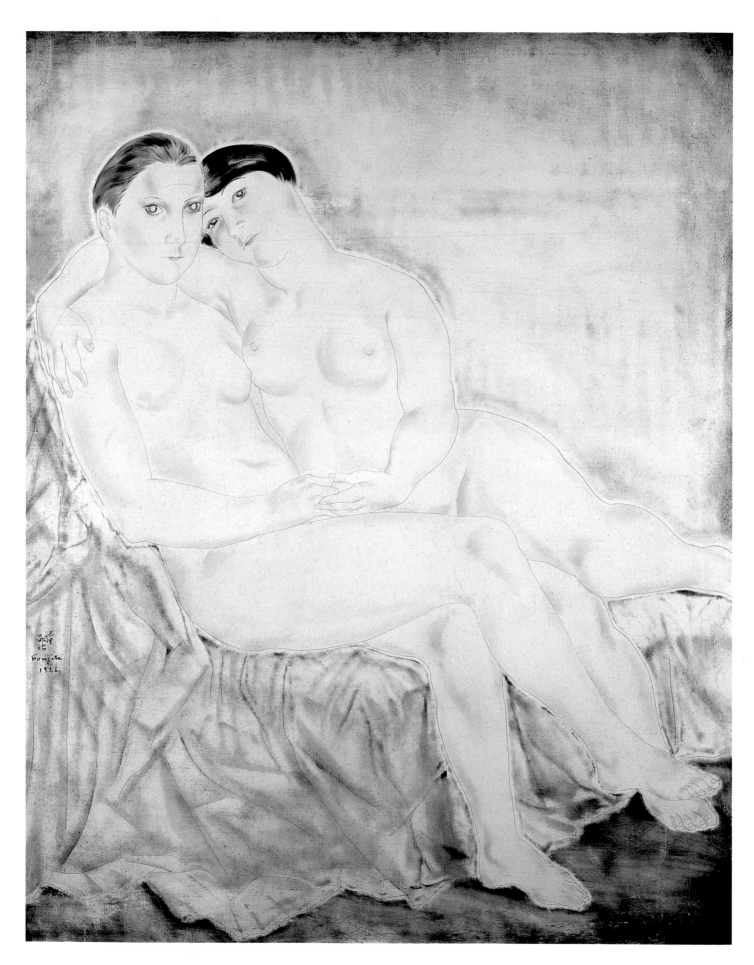

Tsuguharu Foujita
Youki, Snow Goddess, 1924
Oil on canvas, 126 × 173 cm
Petit Palais, Musée d'Art Moderne, Geneva

115

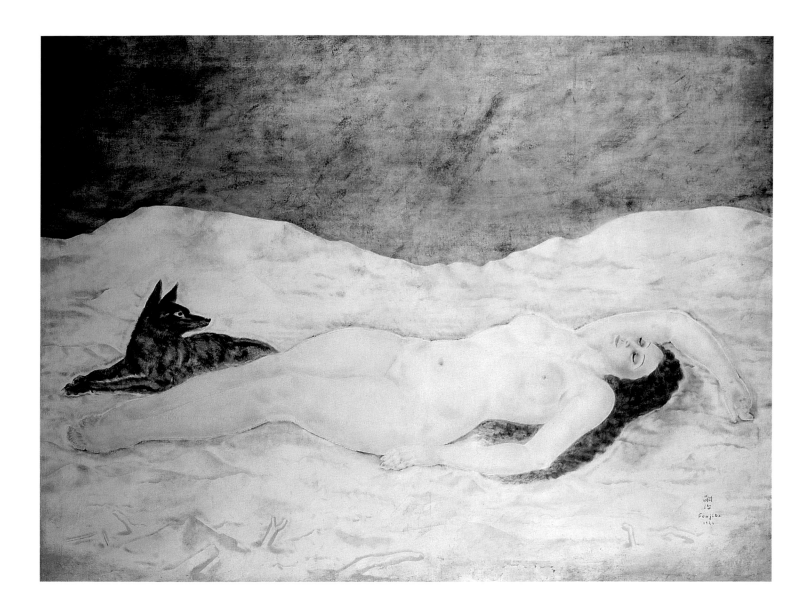

Moïse Kisling
Nude on a Red Sofa, 1918
Oil on canvas, 60 × 73 cm
Petit Palais, Musée d'Art Moderne, Geneva

116

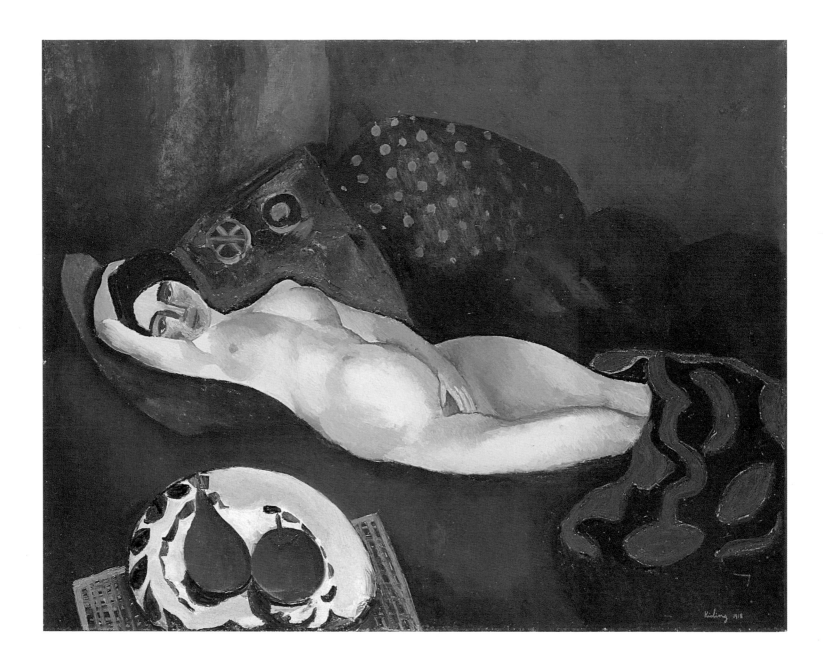

Raoul Dufy
The Model, or *Nude in the Studio at L'Impasse*
Guelma, 1933
Oil on canvas, 65 × 54 cm
Musée d'Art Moderne de la Ville de Paris

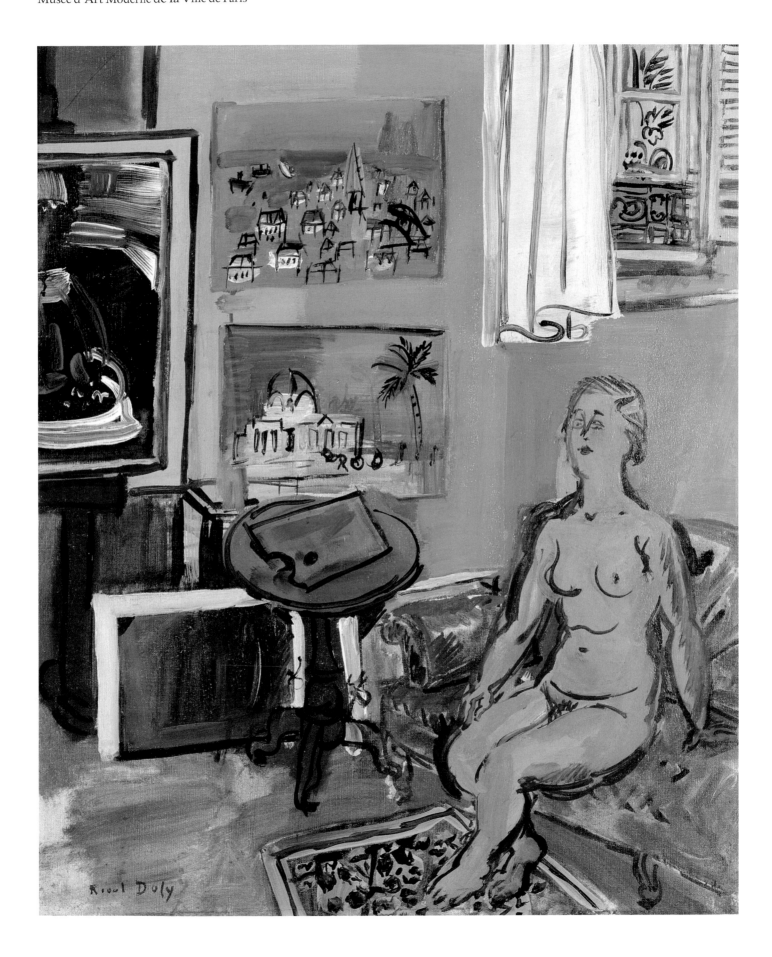

Jules Pascin
Nude at Rest, c. 1926
Oil on canvas, 86.4 × 72.4 cm
Fridart Foundation, Amsterdam

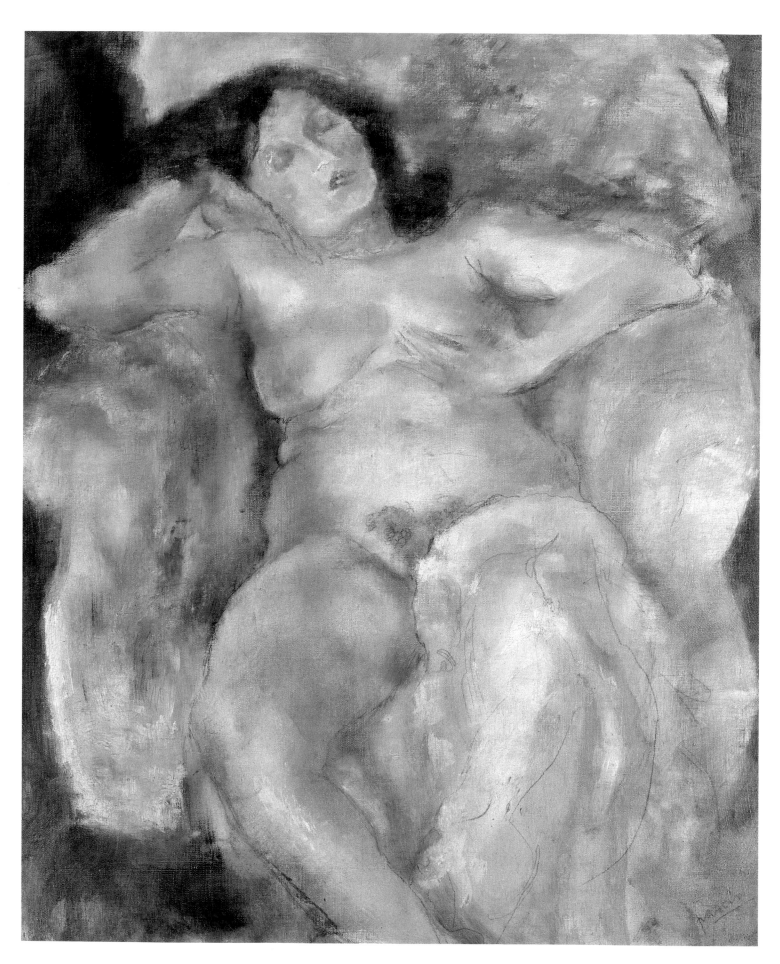

Francis Picabia
Tahiti, 1930
Oil on canvas, 194.3 × 129.5 cm
Barry Flanagan

119

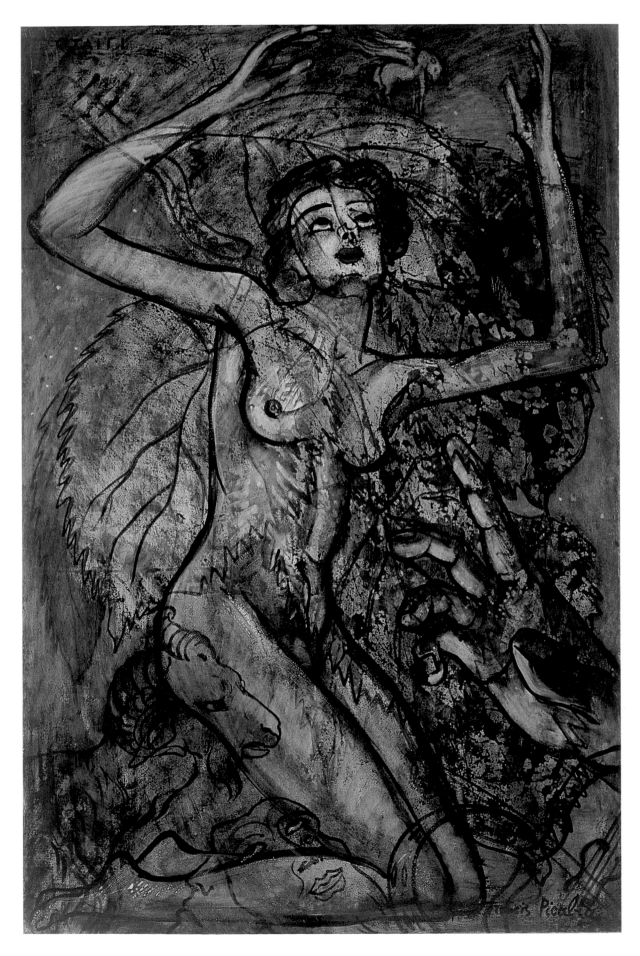

C. R. W. Nevinson
A Studio in Montparnasse, 1926
Oil on canvas, 127 × 76.2 cm
Tate. Presented by H. G. Wells, 1927

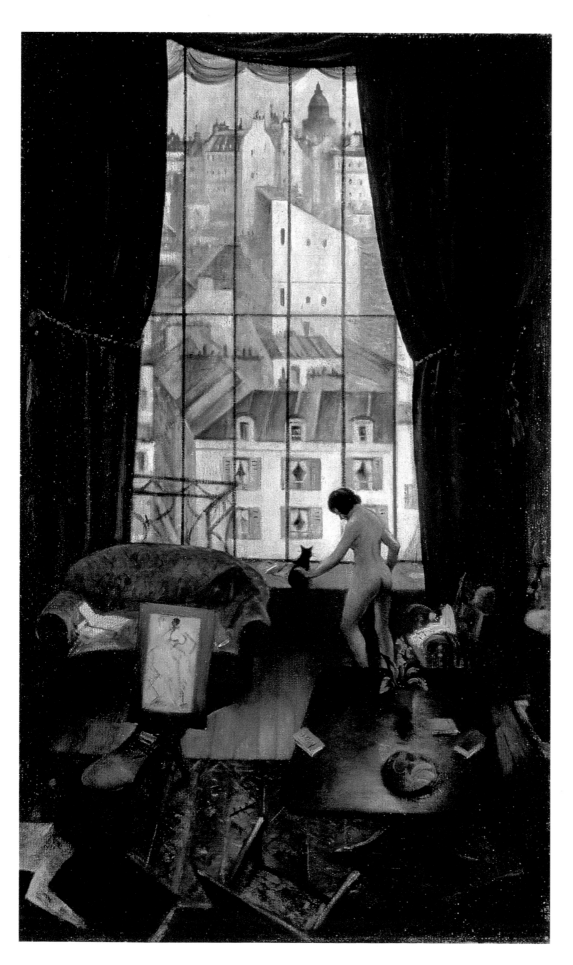

Aristide Maillol
Torso of Venus, 1920
Bronze, 114 × 47 × 30 cm
Collection Musée Maillol, Paris

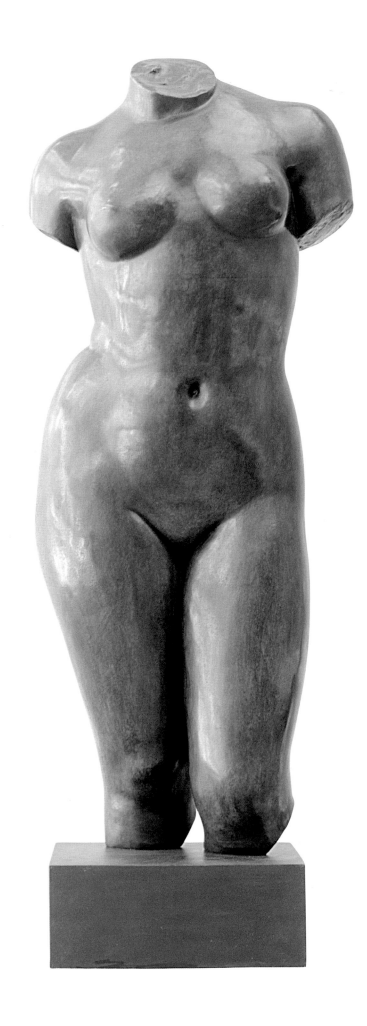

Ossip Zadkine
Female Torso, c. 1925
Wood, 61.6 × 16.4 × 16 cm
Hirshhorn Museum and Sculpture Garden,
Smithsonian Institution, Washington DC.
Gift of Joseph H. Hirshhorn, 1966

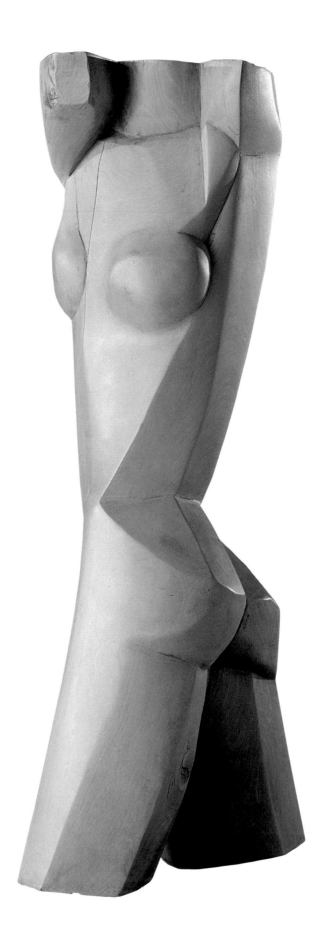

Ossip Zadkine
Female Torso, 1935
Ebony, 138 × 34 × 29 cm
Fonds National d'Art Contemporain –
Ministère de la Culture, Paris.
On deposit at the Musée Réattu, Arles

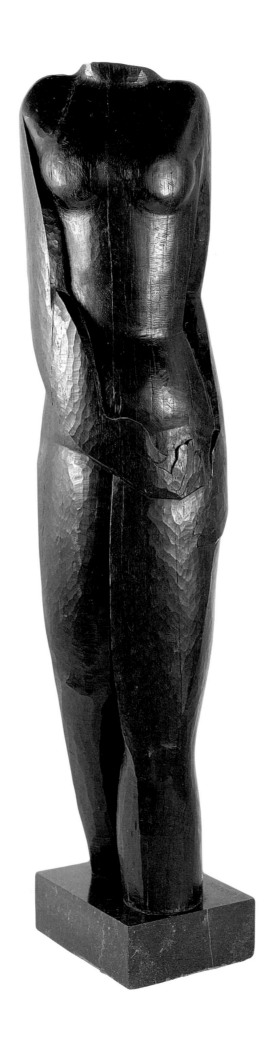

Pierre Bonnard
Nude with Red Slippers, c. 1932
Oil on canvas, 110.2 × 49 cm
Private collection. Courtesy Galerie Odermatt-
Vedovi, Paris

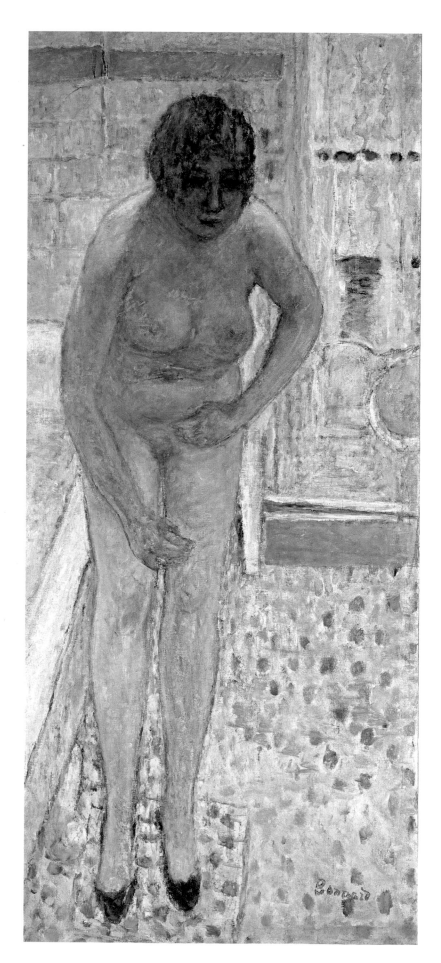

Marcel Gromaire
Seated Nude, 1929
Oil on canvas, 81 × 65 cm
Musée d'Art Moderne de la Ville de Paris

125

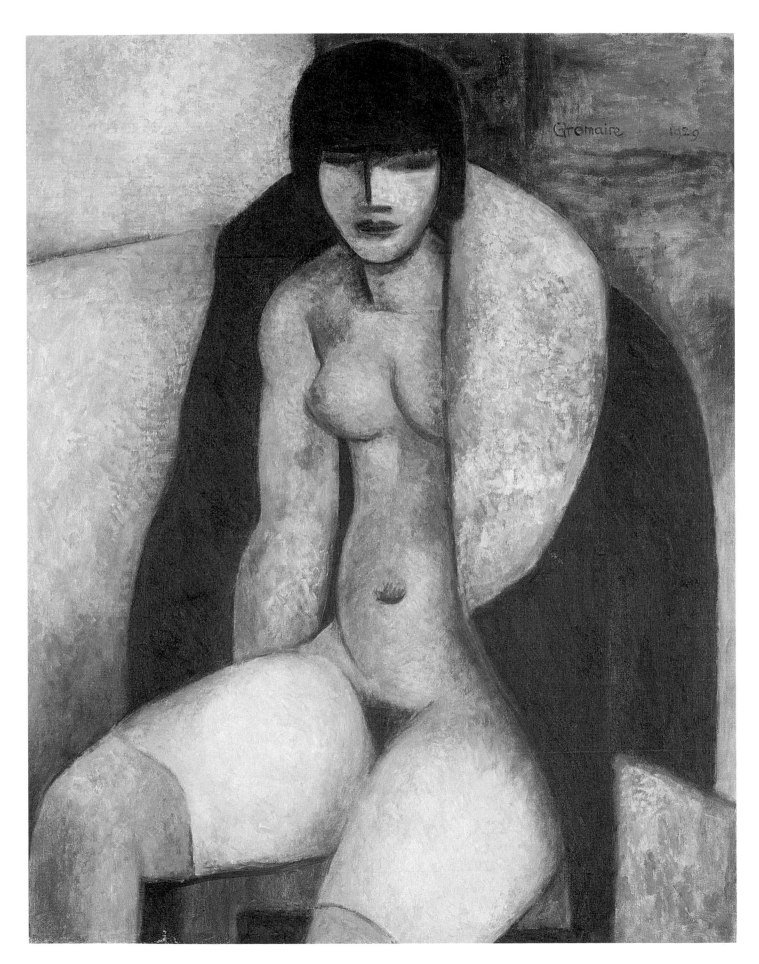

Marcel Gromaire
Seated Nude, 1929
Oil on canvas, 81 × 65 cm
Musée d'Art Moderne de la Ville de Paris

Georges Braque
Seated Woman, c. 1924
Oil and sand on canvas, 99.7 × 81 cm
Courtesy Helly Nahmad Gallery, London

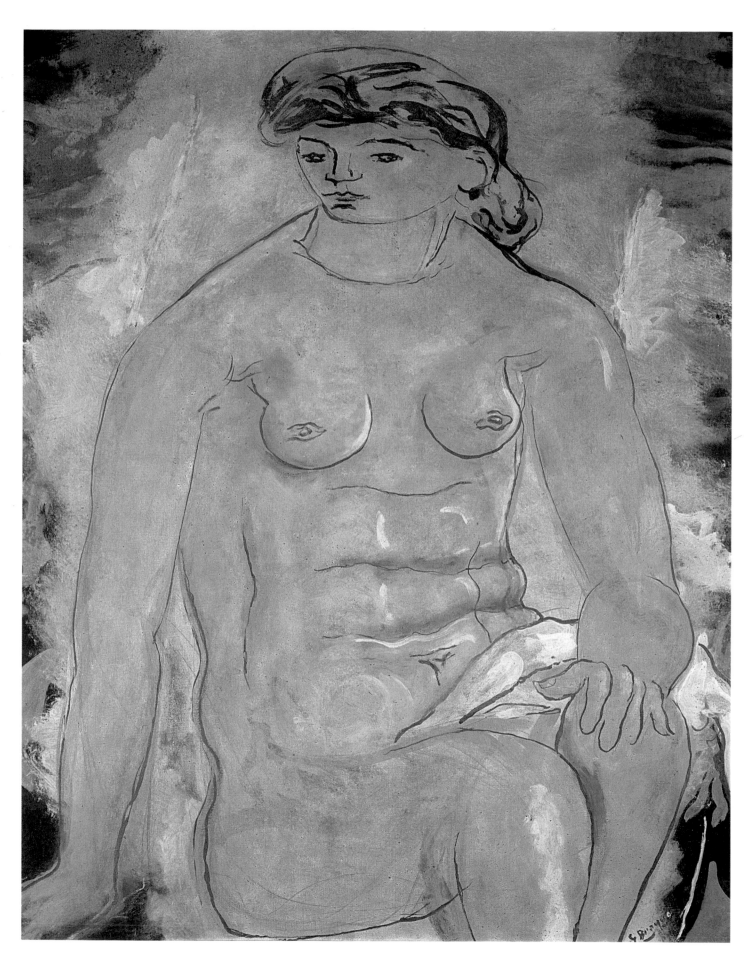

André Derain
Two Nudes with Fruit, c. 1935
Oil on canvas, 112 × 104 cm
Musée d'Art Moderne de Troyes. Pierre and
Denise Lévy donation

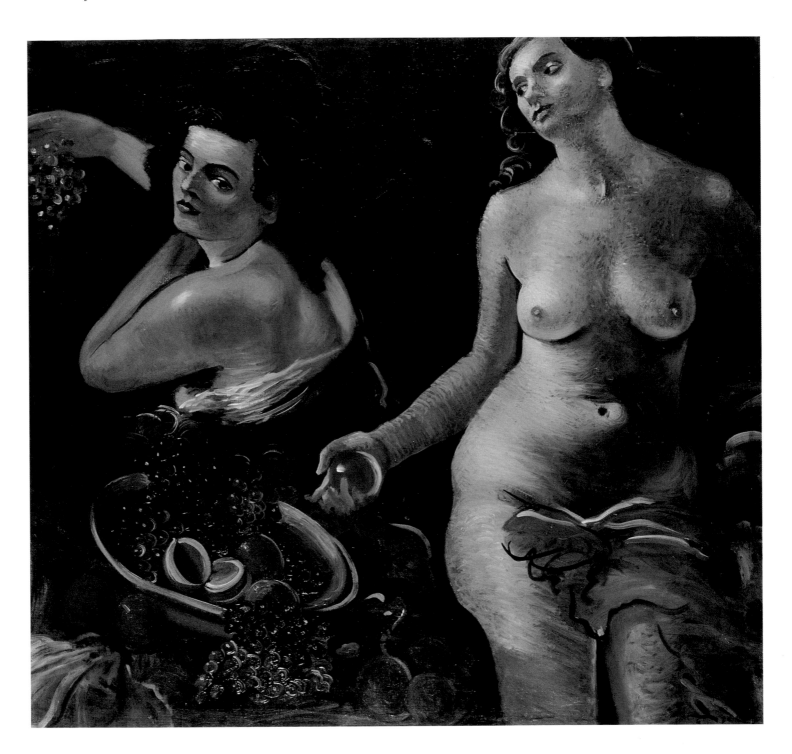

Jules Pascin
Temple of Beauty, 1923
Oil on paper, 124 × 150 cm
Musée d'Art Moderne de la Ville de Paris

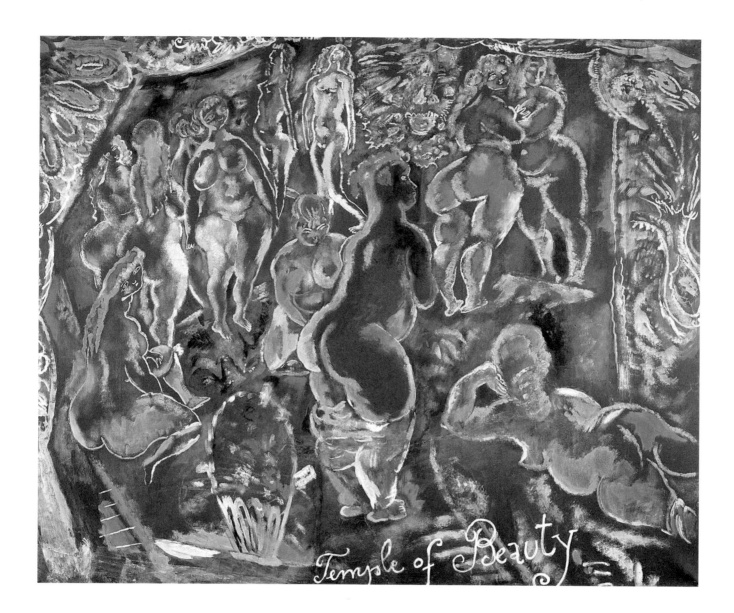

129

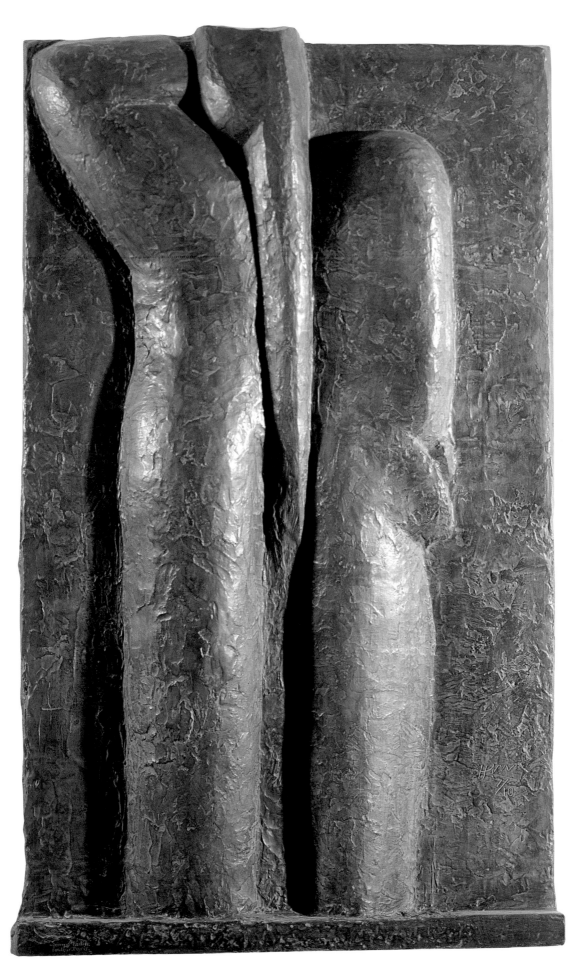

Chaïm Soutine
Carcass of Beef, c. 1925
Oil on canvas, 140.3 × 107.6 cm
Collection Albright-Knox Art
Gallery, Buffalo, New York. Room
of Contemporary Art Fund, 1939

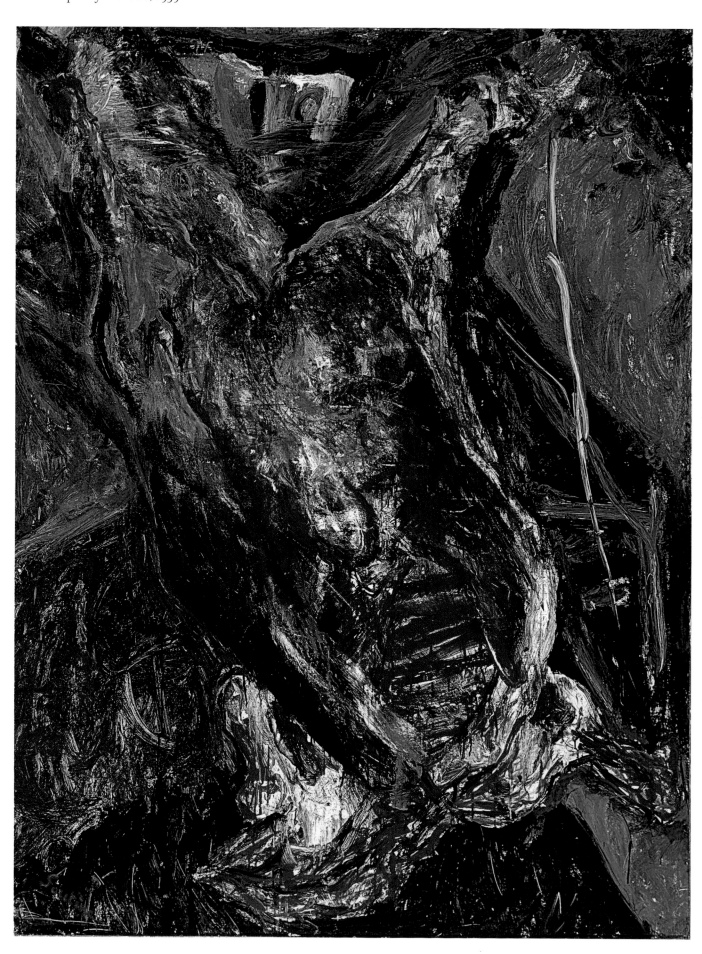

131

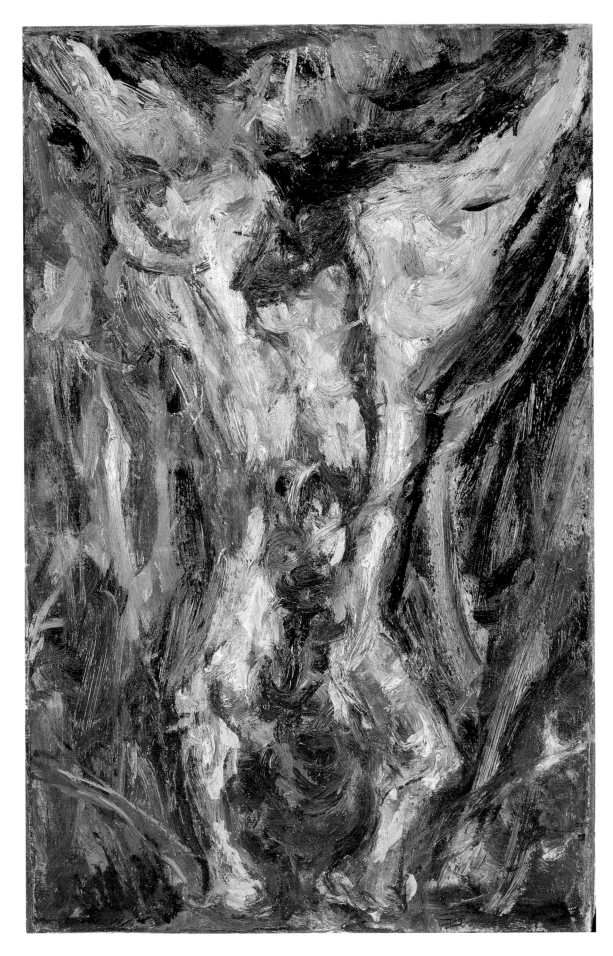

132

Jean Fautrier
Rabbit Pelts, 1927
Oil on canvas, 100 × 81 cm
Marie-José Lefort Collection

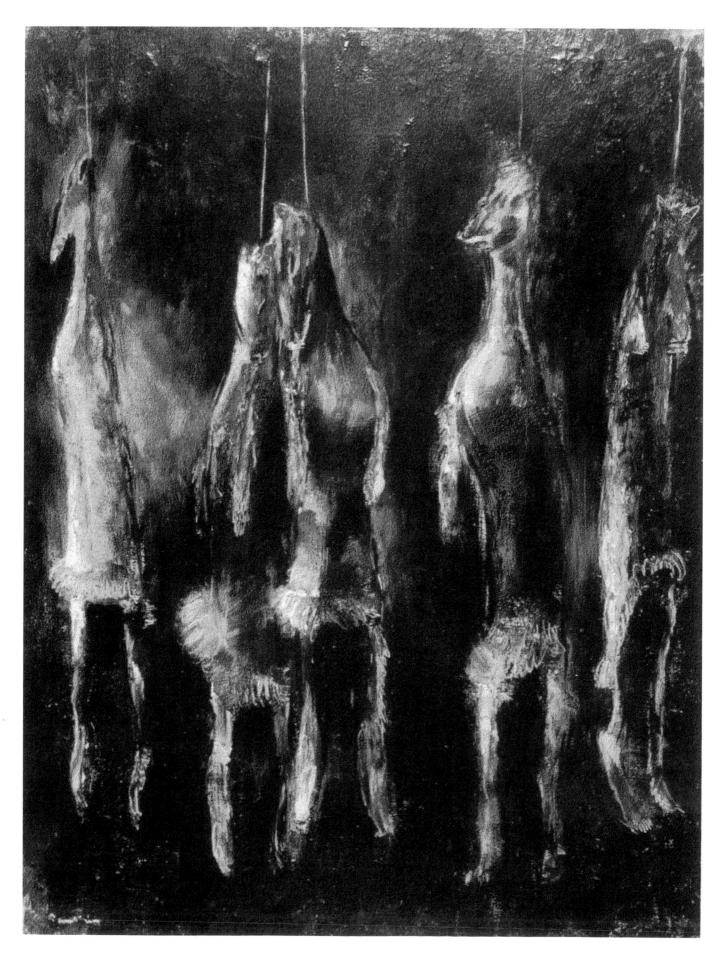

Jean Fautrier
Rabbit Pelts, 1927
Oil on canvas, 100 × 81 cm
Marie-José Lefort Collection

Jean Fautrier
Black Nude, 1926
Oil on canvas, 116.4 × 89 cm
Musée National d'Art Moderne, Centre Georges
Pompidou, Paris

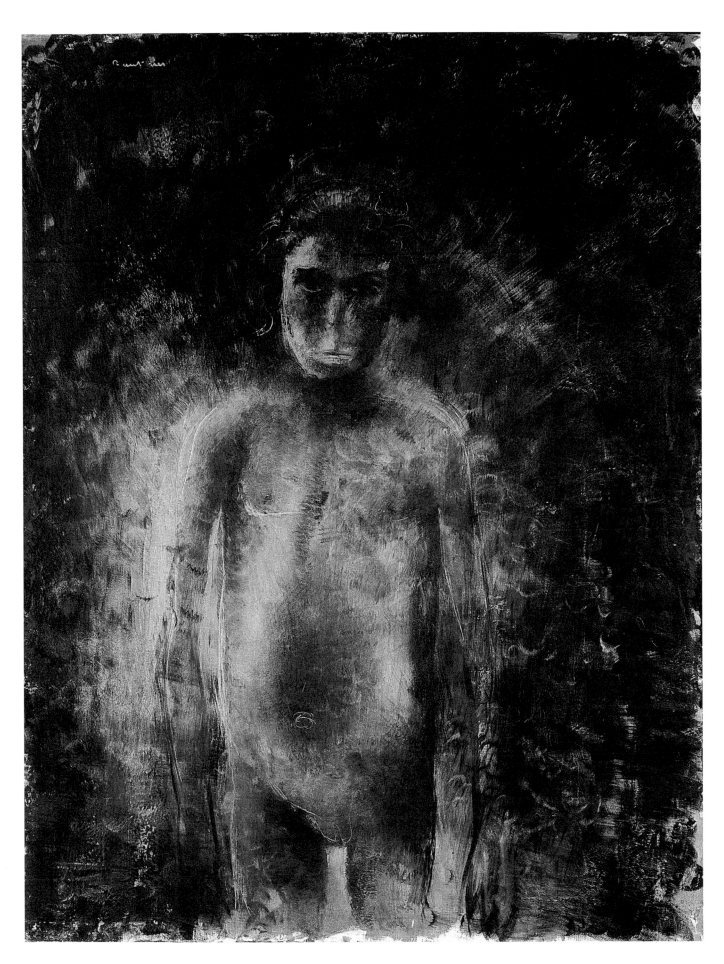

Jean Fautrier
Glaciers, 1926
Oil on canvas, 46 × 56 cm
The Menil Collection, Houston.
Gift of Alexander Iolas

Jean Fautrier
Les Demoiselles, 1929
Oil on canvas, 97 × 112 cm
Marie-José Lefort Collection

135

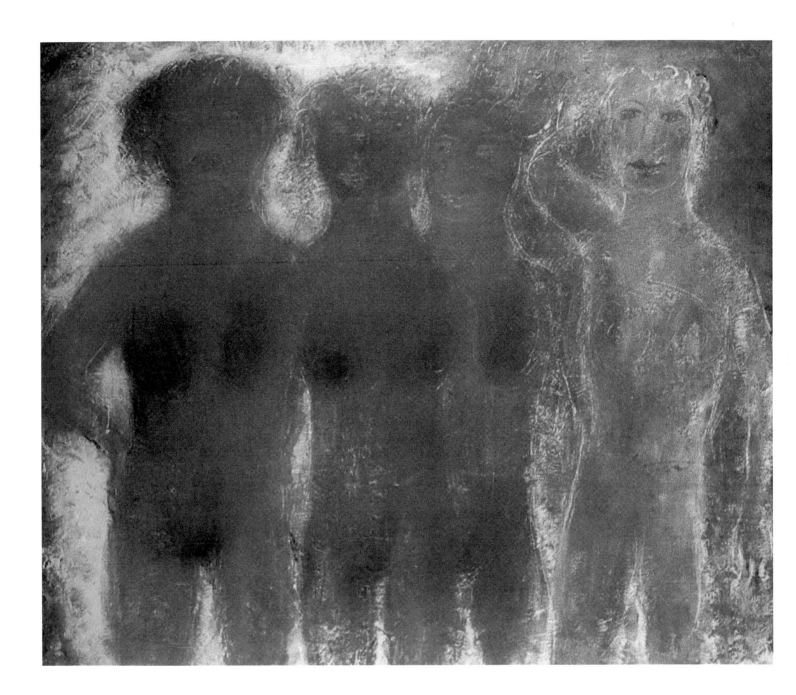

Jean Fautrier
Large Torso, 1928
Bronze, 69 × 24 × 28 cm
Private collection. Germany

Jean Fautrier
Standing Woman, 1935
Bronze, 130 × 40 × 40 cm
Galerie Michael Werner, Cologne
and New York

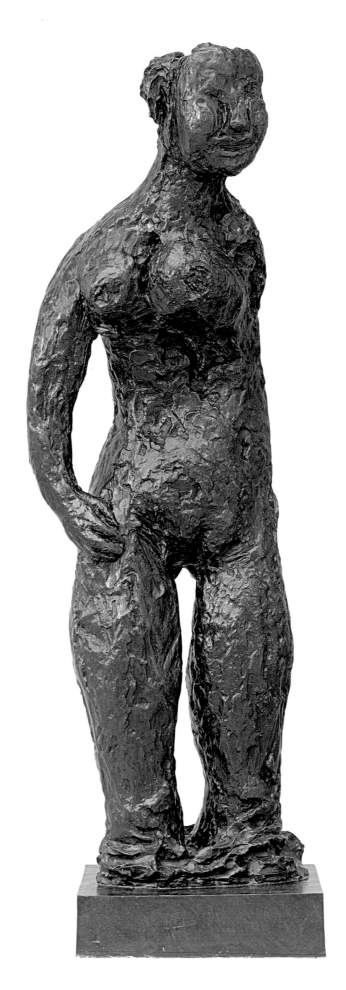

Max Ernst
Laocoön and Sons, 1927
Oil on canvas, 65.4 × 81.3 cm
The Menil Collection, Houston

Max Ernst

Max Ernst Showing a Young Girl the Head of His Father, 1926–27
Oil on canvas, 114.3 × 146.8 cm

Accepted by Her Majesty's government in lieu of inheritance tax on the estate of Gabrielle Keiller (1908–1995) and allocated to the Scottish National Gallery of Modern Art in 1998

139

René Magritte
The Finery of the Storm, 1927
Oil on canvas, 81 × 116 cm
Courtesy of Christie's, London

René Magritte
The End of Contemplation, 1927
Oil on canvas with metal snap fasteners,
72.8 × 99.8 cm
The Menil Collection, Houston

141

Yves Tanguy
Tomorrow, 1938
Oil on canvas, 54.5 × 46 cm
Kunsthaus, Zurich

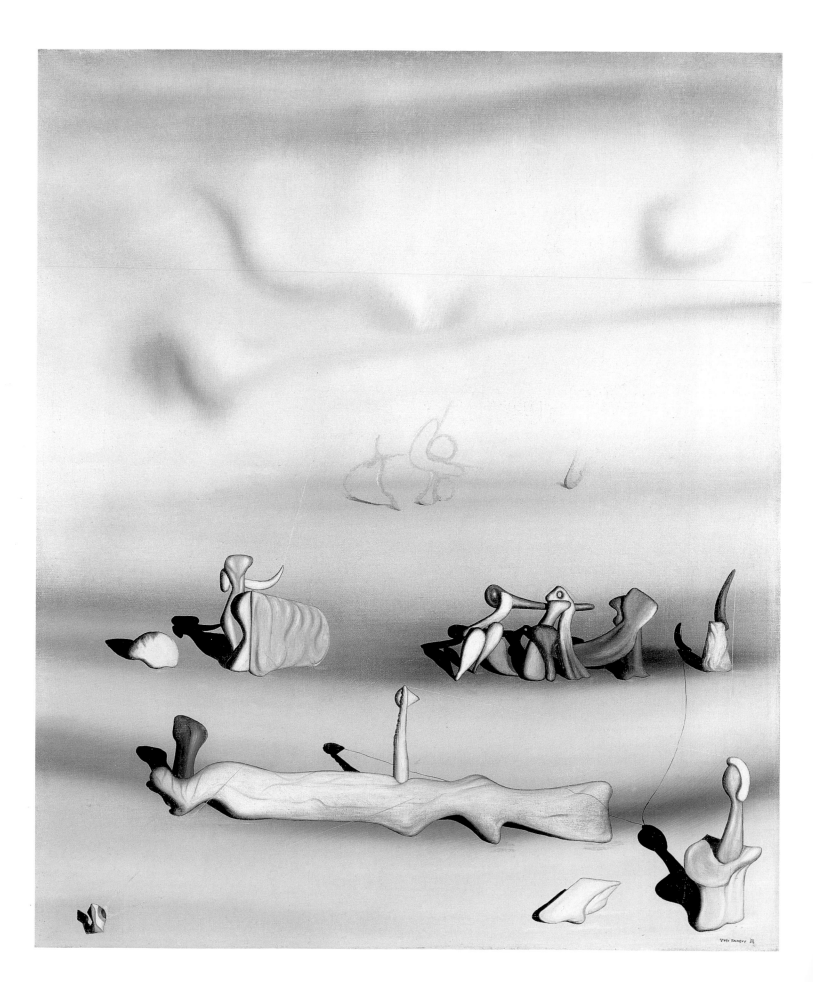

Yves Tanguy
Blue Bed, 1929
Oil on canvas, 60 × 49 cm
Private collection

143

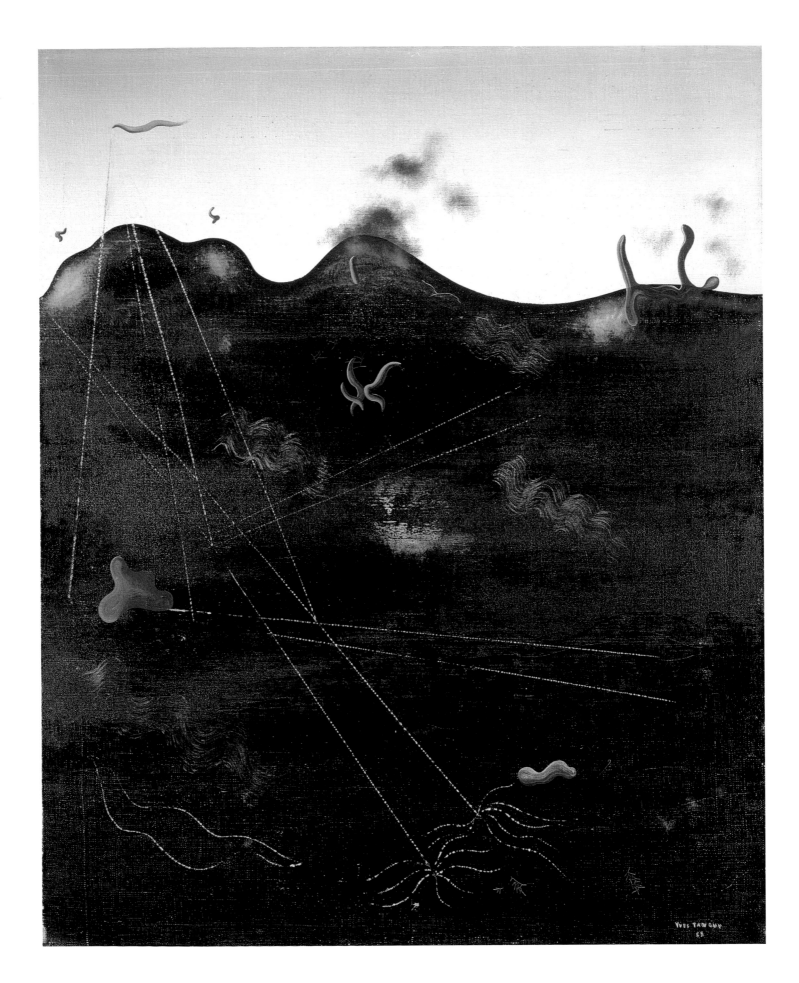

Salvador Dalí
Sleep, 1937
Oil on canvas, 51 × 78 cm
Private collection

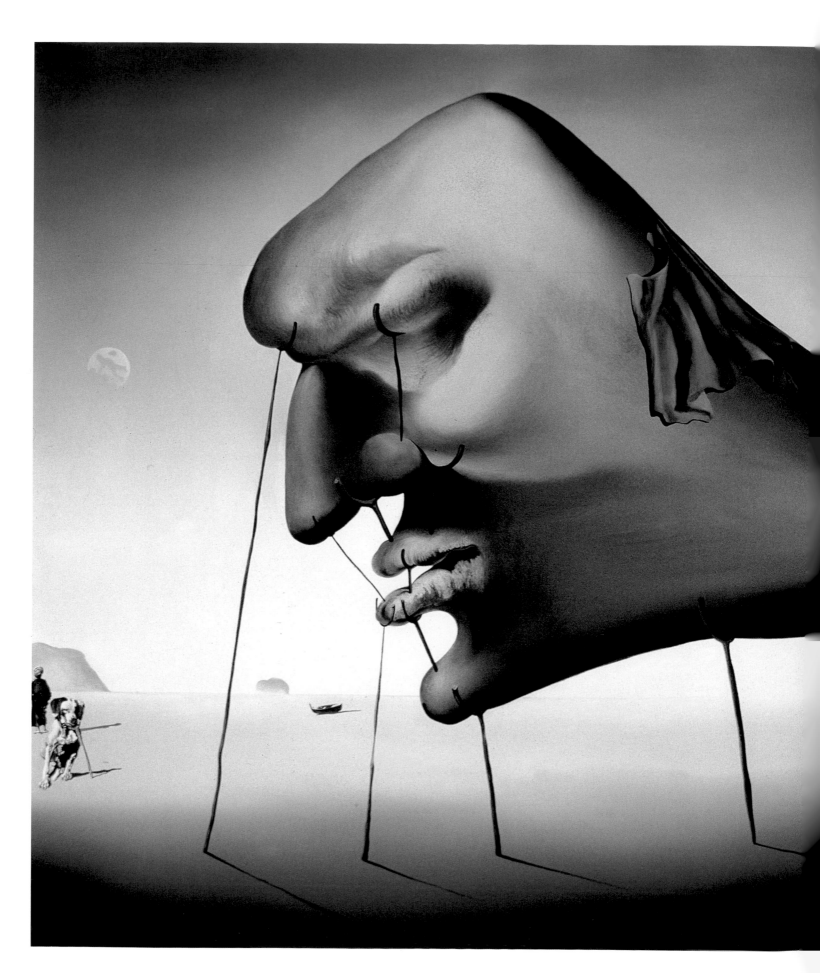

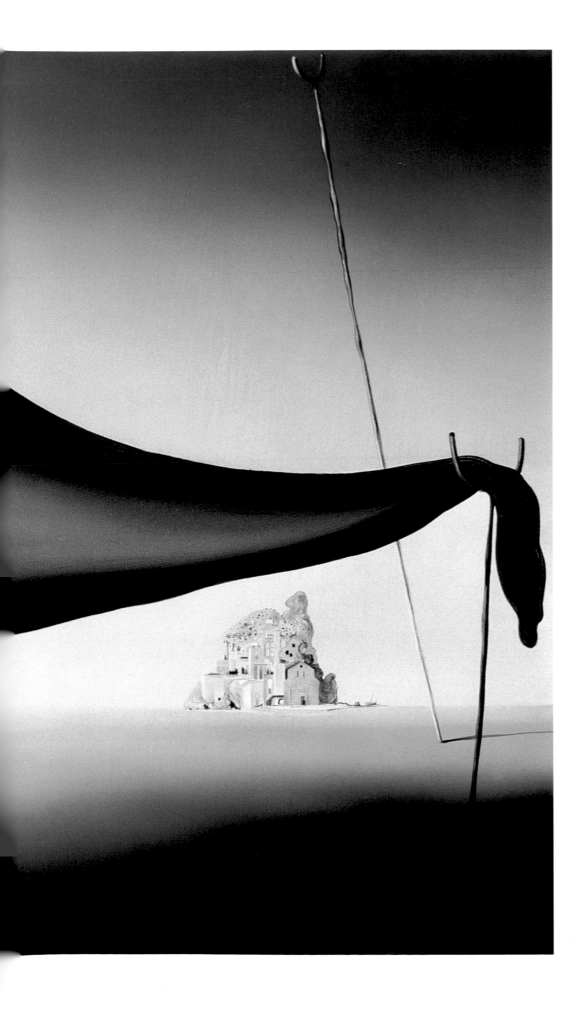

Salvador Dalí
Paranonia, 1935–36
Oil on canvas, 38 × 46 cm
Salvador Dalí Museum, Inc.,
St Petersburg, Florida

145

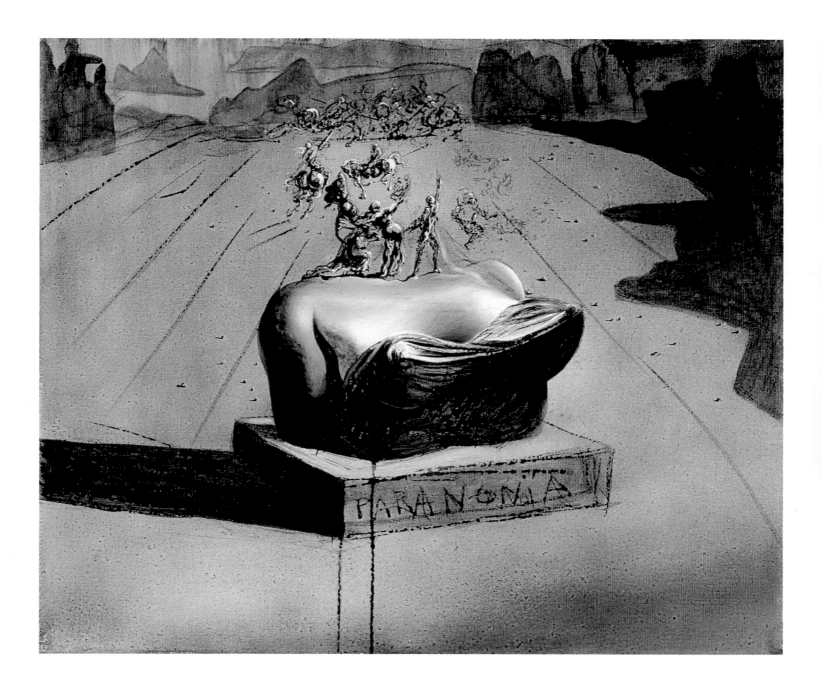

Salvador Dalí
Landscape with Telephone in a Dish, 1939
Oil on canvas, 22 × 30 cm
Courtesy Helly Nahmad Gallery, London

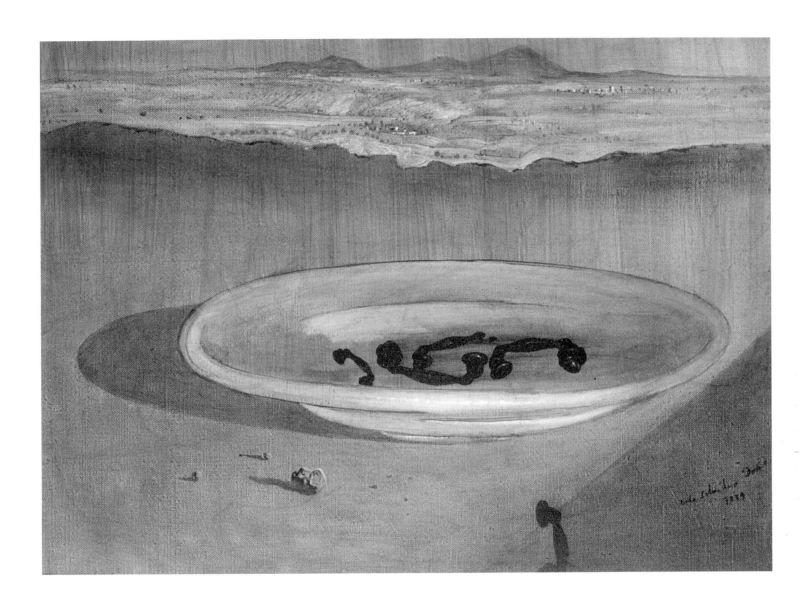

Salvador Dalí
Venus de Milo with Drawers, 1934/64
Painted bronze and fur, 98 × 35.5 × 34 cm
Collection Museum Boijmans
Van Beuningen, Rotterdam

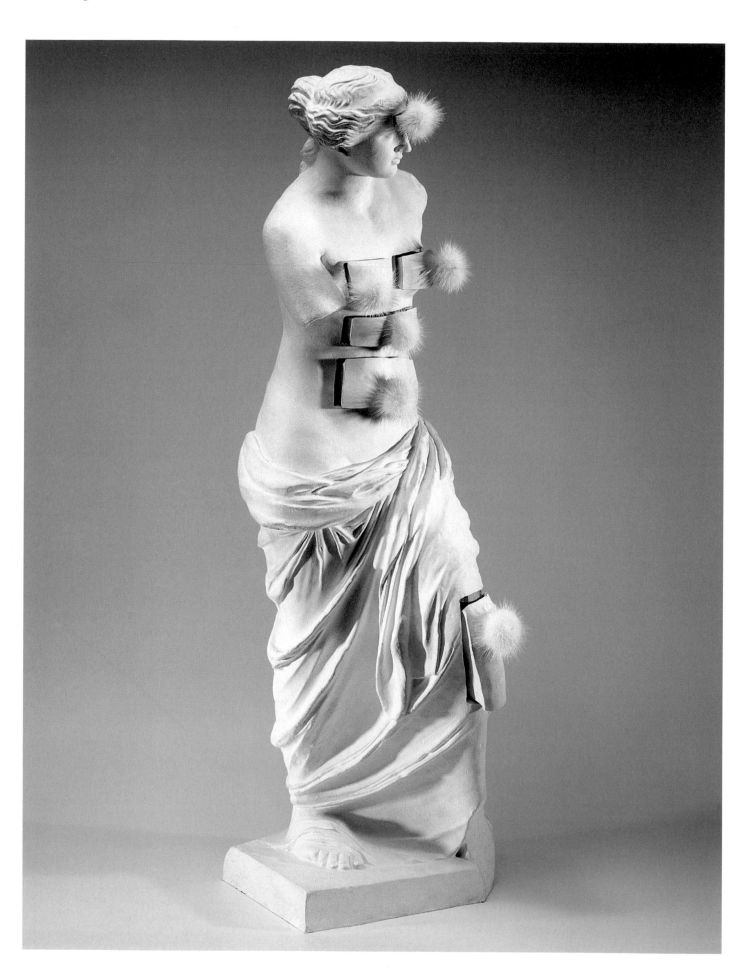

Hans Bellmer
The Top, 1938/68
Painted bronze on a marble socle,
54 × 32 × 32 cm
Madame Bénédicte Petit

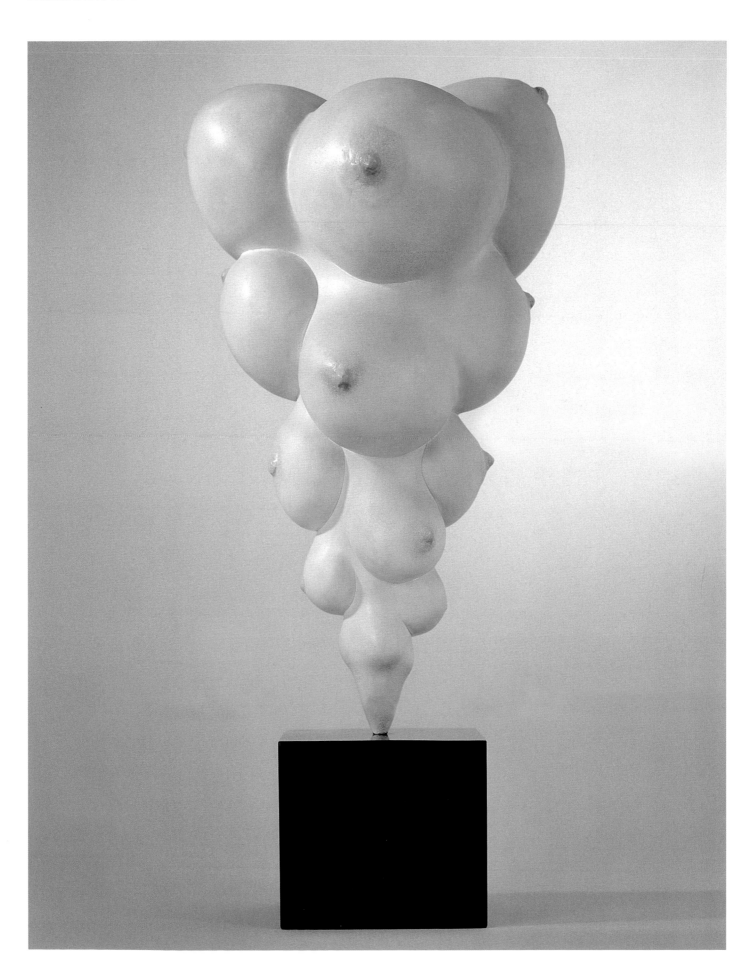

Man Ray
Imaginary Portrait of the Marquis de Sade, 1938
Oil on canvas with painted wood panel,
61.7 × 46.6 cm
The Menil Collection, Houston

Marcel Jean
Spectre du Gardenia, 1936
Plaster, velvet powder, celluloid, leather
and metal, 35 × 18 × 23 cm
Skulpturenmuseum Glaskasten Marl

Alberto Giacometti
Woman with Her Throat Cut, 1932
Bronze, 22 × 87.5 × 53.5 cm
Scottish National Gallery of Modern Art,
Edinburgh. Puchased 1970

151

Julio González
Gothic Man, 1937
Iron, 50 × 13 × 26.5 cm
Fondation Hans Hartung
and Anna-Eva Bergman

Robert Humblot
The Horrors of War, 1937
Oil on canvas, 130 × 96.5 cm
Collection Musée des Années 30,
Boulogne-Billancourt

153

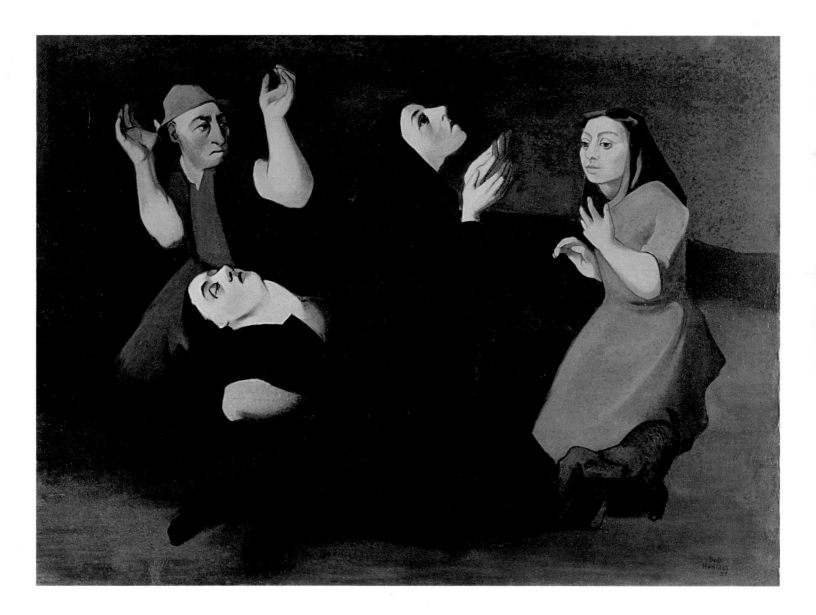

154

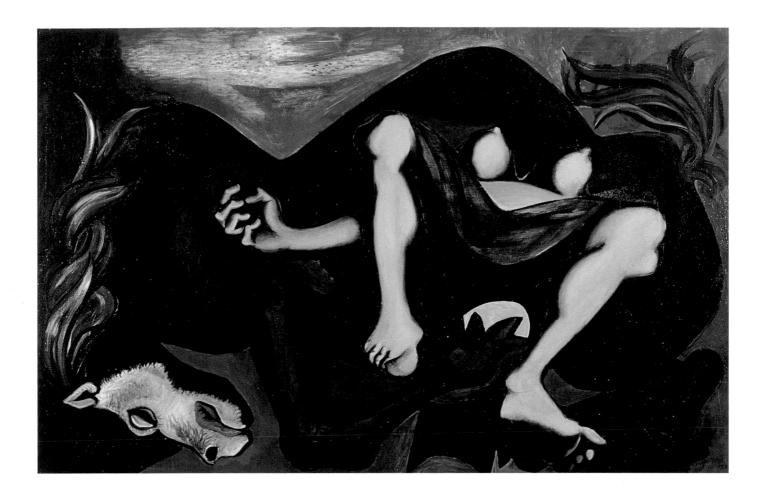

Pablo Picasso
Figure de femme inspirée par la guerre
d'Espagne, 1937
Oil on canvas, 38 × 46 cm
Private collection. Courtesy Jan Krugier,
Ditesheim & Cie, Geneva

155

André Masson

Pygmalion, 1939
Oil on canvas, 130 × 162 cm
Private collection, Paris

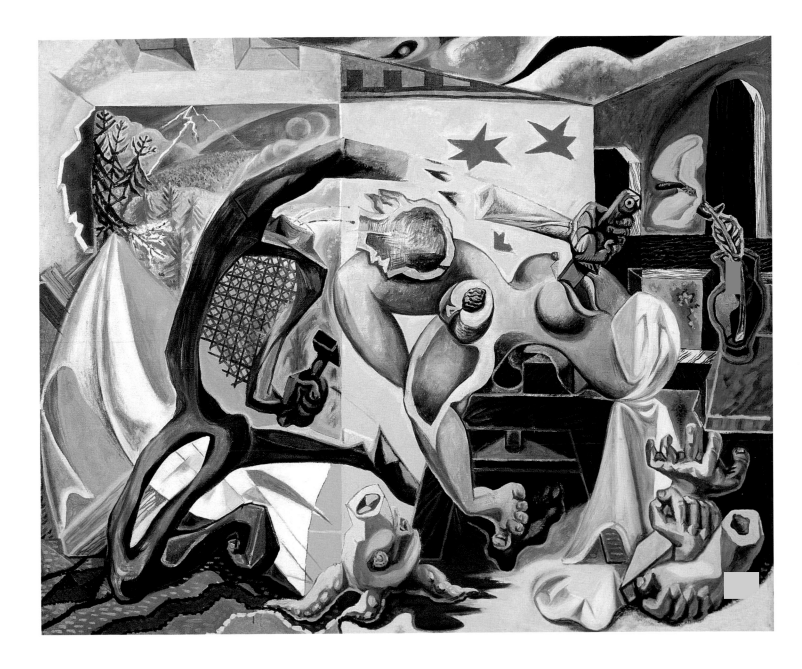

3

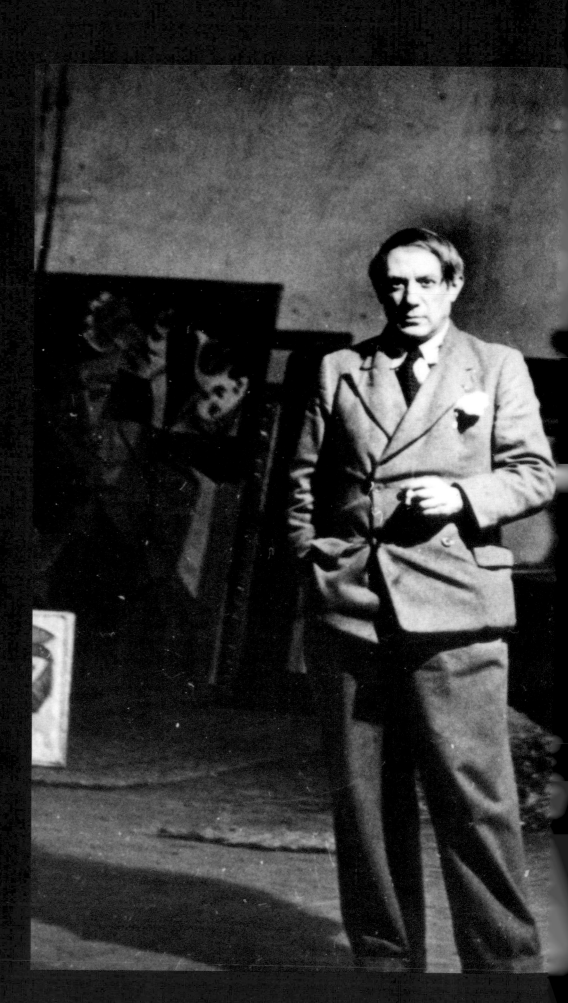

Sarah Wilson

Saint-Germain-des-Prés: Antifascism, Occupation and Postwar Paris

Surrealism, realism and antifascism

The zenith of Parisian creativity represented by the 1937 Exposition Internationale des Arts et des Techniques dans la Vie Moderne was never to be repeated. The achievement had been undercut by anxieties relating to the Nazi–Soviet confrontation, and immense anguish on the left at the plight of Spain, which was symbolised by Picasso's *Guernica* (1937; fig. 56), created in his Rue des Grands-Augustins studio in Saint-Germain-des-Prés. Throughout 1938 and 1939 these anxieties intensified: museums closed down and Paris prepared for war.[1] Neither the humiliation of the Occupation nor the duration of hostilities and the inconceivable atrocities of mass destruction could have been anticipated. The Second World War would fundamentally change the physical fabric of Europe's cities and their intellectual life; the Holocaust and the atomic bomb would sever the two halves of the twentieth century. With the collapse of any ideology of progress, the project of

Figure 66

Figure 67

'modernity' called for redefinition; and artists in Paris would define themselves by their strategies of response.

Although the war marked an abrupt caesura, life had to continue. The dynamics of continuity in conjunction with the terrible problems of memory and of mourning uncompleted – *le deuil inachevé* – define what is now called 'reconstruction culture'.[2] The fierce antagonisms between Surrealist and realist artists and intellectuals, played out on the territory of antifascism in debates of the late 1930s, re-emerged after the war. While the prestige of communist intellectuals such as Louis Aragon intensified the push for a committed realism, new Surrealist exhibitions and abstract Salons, international in scale and aspiration, replicated 1930s stylistic confrontations, thanks to the influx of new artists to Paris.

The late 1930s are the essential backdrop, then, not only for an understanding of 1940s debates, but for the manner in which the major figures of the postwar period, responding to neo-Dada as well as existential currents of thought, were able to break certain moulds. Throughout the 1930s, with their journal *Le Surréalisme au service de la Révolution* and with tracts, debates, international congresses, the Surrealists' political concerns had centred on antifascist politics, yet their 'revolutionary' sympathies were pilloried with Dalí's taunting depictions of Lenin in *Partial Hallucination: Six Apparitions of Lenin on a Grand Piano* (1931; fig. 68) – an extraordinarily daring purchase for the French state under its new Popular Front remit. They were even more horrified by Dalí's eroticised paintings containing references to Hitler, which acknowledged the libidinal energies harnessed by national socialism.[3]

In 1938, the Exposition Internationale du Surréalisme was considered offensive: 'a provocation against Paris, France, French taste, French art, art *tout court*'.[4] The female body, focus of desire for the Surrealists in the 1920s, was now paraded as a series of mannequins, arranged like prostitutes lining the streets of Paris (*Les Plus Belles Rues de Paris*; fig. 66). Various artists indulged their sadomasochistic fantasies: caged by André Masson, sexually travestied by Marcel Duchamp, the mannequins became prescient signifiers of future victimhood, rape and torture. At the late-night *vernissage* of the Surrealist exhibition on 17 January, the public

66 The 1938 installation *Les Plus Belles Rues de Paris*, with mannequins, at the Exposition Internationale du Surréalisme, Galerie des Beaux-Arts, Paris

67 Hélène Vanel performing *The Unconsummated Act* in 1938, at the Exposition Internationale du Surréalisme, Galerie des Beaux-Arts, Paris

68 Salvador Dalí, *Partial Hallucination: Six Apparitions of Lenin on a Grand Piano*, 1931 Oil on canvas, 114 × 146 cm Musée National d'Art Moderne, Centre Georges Pompidou, Paris

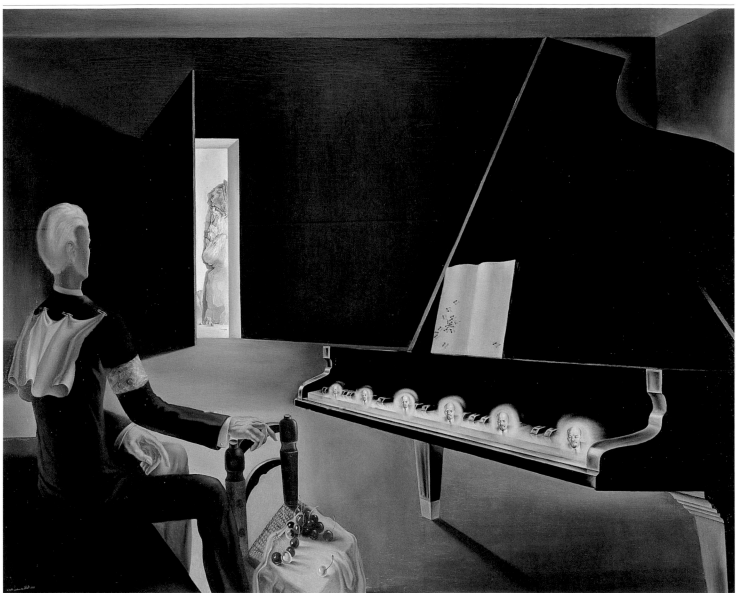

Figure 68

watched Hélène Vanel's *Unconsummated Act* performed on the art world's first 'hysterical bed' to the accompaniment of lunatic laughter (fig. 67). Spectators experienced a veritable *catabasis* – a descent into hell – searching through the darkened spaces by torchlight as coal-sacks, hanging like stalactites from the ceiling, powdered their extravagant outfits with black dust in a prophetic foretaste of the mourning dress to come.[5]

The 1938 Surrealist exhibition was criticised by a generation of younger artists. Francis Gruber attacked this 'funfair for the impotent...pornography of the Quat'z'Arts ball'. He was nonetheless attuned to the 'culture of atrocity' demonstrated by Max Ernst and by Dalí in his *Rainy Taxi* full of live Burgundy snails.[6] Gruber's review appeared

in *Peintres et Sculpteurs de la Maison de la Culture*, the journal of the artists' wing of an organisation originally called the Association des Ecrivains et Artistes Révolutionnaires (AEAR). Founded in Paris in 1932, the organisation's brief was in part to respond to Soviet directives in arts policy emanating directly from Komintern, and in particular the move towards socialist realism.[7] However improbable a Soviet influence might have seemed in the still-effervescent 1930s, the results of the Wall Street crash and disastrous unemployment (only momentarily disguised by the Exposition Internationale's construction programme) had created a climate of immense disaffection. Tastes were changing. Throughout 1935, the former Surrealist poet Louis Aragon gave a series

of lectures published as *Pour un réalisme socialiste*. One talk honoured the militant German photomontage artist John Heartfield.[8] By now German refugee artists and intellectuals were passionately involved in art debates. Max Raphael's *Proudhon, Marx, Picasso* (1933) updated crude Marxist 'reflection theory', attempting to explain the coexistence of realism, Surrealism and the flourishing geometric abstraction of the Abstraction-Création movement.[9] Walter Benjamin's brilliant analyses, together with those of his Frankfurt School colleagues in exile, were published by Editions Alcan.[10] As Marxists they reinforced French calls for a committed realism.

In painting, members of the so-called Forces Nouvelles group such as Robert

69 Boris Taslitzky, *Demonstration at the Père Lachaise Cemetery 1935*, 1936
Oil on canvas, 197 × 130 cm
Collection of the artist

70 Jean Fouquet, *The Virgin and Child Surrounded by Angels*, the right wing of *The Melun Diptych*, c.1450
Oil on panel, 93 × 85 cm
Koninklijk Museum voor Schone Kunsten, Antwerp

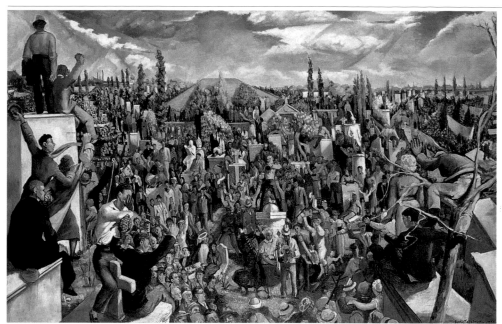

Figure 69

Humblot retained a link with magic realism and metaphysical painting while Edouard Pignon, or indeed Francis Gruber and other young, working-class artists, became passionate promoters of a realism based in the streets.[11] By the time of the election of the left-wing Popular Front government in June 1936, Paris had been reconceived within a topography of left-wing revolution – quite a change from the pomp and circumstance of the 1937 Exposition. Painters and photographers now chose to honour the symbolic sites of the Revolution or the Commune, such as the Place de la Bastille or the Federates Wall in the Père Lachaise Cemetery, site of Popular Front processions depicted by Boris Taslitzky (fig. 69).[12] The 'Querelle du réalisme', a series of debates in 1936, publicised this militant realism, which looked both to the proletarian themes of Léger and to figures from the past such as Daumier, Courbet or indeed Georges de La Tour.[13] La Tour's figure arrangements are vividly recalled in Robert Humblot's *Horrors of War* (1937; cat. 153), a work in which France – Popular Front aspirations crushed by a non-intervention treaty – apprehends her destiny in the tragic fate of Spain.[14]

The show of 'French Masterpieces' at the 1937 Exposition had deliberately constructed a visible 'tradition' of French painting (formerly presented in the Louvre as a provincial response to Italy).[15] In March 1938, Louis Aragon's stirring speech 'Réalisme socialiste et réalisme français' attempted to elide this newly constructed 'tradition'

with the Soviet model, corresponding to a Communist Party policy designed to play on French nationalist feeling.[16] In a period of political instability and increasing xenophobia this emphasis on a 'French tradition' was paramount. Two works from the 'Masterpieces' exhibition, Jean Fouquet's *Melun Diptych* (from Antwerp; fig. 70) and Jacques-Louis David's *Death of Marat* (from Brussels), help us to understand the competing stylistic claims to 'tradition' which would dominate the scene in the 1940s.

The fifteenth-century Fouquet, a harmony of flat reds and blues, shows the sharp shapes of angels' wings around the exposed breast of the Madonna: these are the colours of the Catholic, royal tradition of old France. Alternatively, David's *Death of Marat* dramatises a page from the history of the French Revolution – the moment after Marat's assassination – commemorated as a symbol for future generations; sober colours and careful chiaroscuro emphasise the realism of this scene. During the 1940s, the generally Catholic 'Young Painters of the French Tradition', such as Alfred Manessier and Jean Bazaine, would pursue abstract painting with links to the medieval French tradition of Fouquet: what Bazaine, during the Occupation, would call 'la peinture bleu-blanc-rouge' (the colours of the tricolour flag). This would be developed with a more complex palette in Maurice Estève's densely textured *Homage to Jean Fouquet* (1952; cat. 200).[17] In 1947, with renewed edicts on socialist realism

Figure 70

71 Jacques Lipchitz working on his
Prometheus and the Vulture, 1937
Plaster, dimensions unknown
Destroyed

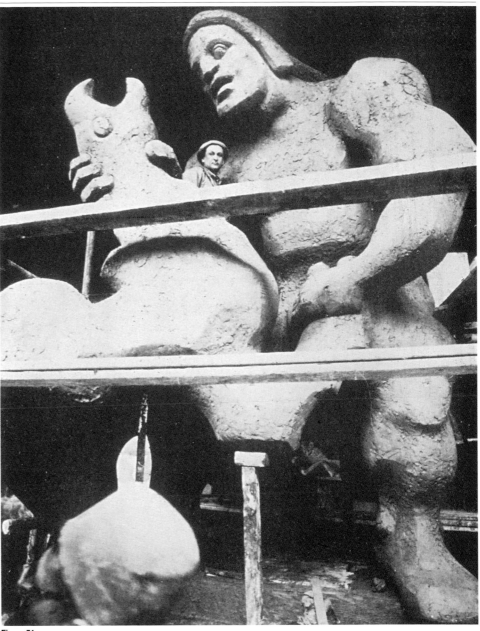

Figure 71

emanating from Moscow after the descent
of the Iron Curtain, the 'revolutionary
tradition' promoted by the French Communist
Party would take its cue from David. Close to
the Surrealists with his *Martyred Spain* (1937;
cat. 154), André Fougeron subsequently
became a Young Painter of the French
Tradition, adopting Matisse's bright, flat
colour and sinuous contours until 1947.
After the call for socialist realism from
Moscow, he would adopt both the academic
realism and the more sober palette of David for
The Judges (1950; cat. 182).[18] These opposing
claims to 'Frenchness' after the war strongly
contested the internationalism which had
been Paris's glory before 1939. In each case

the art of the past would function as an
ideological palimpsest.

This issue of palimpsest was most
forcefully exemplified when the French
authorities, encouraged by the right-wing
Académie des Beaux-Arts, destroyed Jacques
Lipchitz's *Prometheus and the Vulture* (a 1937
Exposition commission for the Palais de la
Découverte; fig. 71) as the work of a 'Jew'
and 'Bolshevik'. Overtly antifascist – the
vulture a substitute for the Nazi eagle, and
Prometheus sporting an improbable Phrygian
bonnet – it embarrassed many art-world
figures embroiled in Franco-German
rapprochement.[19] But full reports on the fate
of both 'degenerate art' and persecuted artists

were published in Paris,[20] and the impressive exhibition 'Free German Art', organised at the Maison de la Culture in November 1938 as an act of protest, included Max Ernst (go-between for 'Twentieth-Century German Art' in London the previous July), Klee, Grosz, Beckmann and Barlach, and a special homage to Kirchner, who had just committed suicide.[21] Critical responses were eclipsed by reports of the Kristallnacht persecutions in Germany.

The non-aggression pact signed between Nazi Germany and the Soviet Union on 23 August 1939 devastated Marxist revolutionaries: the French Communist Party was later forced underground. The German members of the Surrealist group in France, Max Ernst and Hans Bellmer, were interned in the Camp des Milles. With great risk Ernst was able to join fellow members of the group – Breton, Masson, Lam and others – who were waiting in Marseilles to flee, in the wake of Dalí and Tanguy, to the safety of America. As an exile there, he joined figures such as Fernand Léger and Piet Mondrian.

Lipchitz, a victim of overt anti-Semitism, also left for America. (He would return to make a monument of ecumenical reconciliation for the French church of Assy [Haute-Savoie] in 1950.[22]) By 1941, 'Le Juif et la France' (fig. 72), explicitly modelled on the 'Eternal Jew' exhibitions touring Germany from the late 1930s, attracted large crowds. Depicted as a prostitute in many guises by the Surrealists in 1938, Paris during the Occupation would become a hideous parody of her former self.

Saint-Germain-des-Prés: the Occupation and its aftermath

The prolonged continuum of Occupation was nightmarish. In 1944, Henri Michaux wrote 'from the City of Interrupted Time…from the land of atrocity…from the Capital of the sleeping crowd', concluding, 'We live with indifference within the horror.'[23]

With Paris invaded, the Nazi occupiers had set about transforming the appearance of the city: signposts appeared in German and an enormous swastika hung from the Eiffel Tower. These superficial changes concealed far more sinister large-scale operations which involved the art world from the start. Rafts of legislation were introduced to authorise the confiscation of Jewish property and the stockpiling of works of art to be sent to Germany. During the Occupation, Paris was the co-ordinating centre of nationwide pillage;

anti-modernism and anti-Semitism were promoted by the official magazine *Beaux-Arts* which published the art-related edicts of Marshal Pétain's Vichy government. The Direction des Musées Nationaux was generally acquiescent, although the Musée de l'Homme harboured resistance activity. Yet, for many, life, painting, exhibitions and the Salons continued, conforming to the deliberate policy of 'normalisation', Aryanisation by another name: commercial galleries flourished, albeit subject to the censorship of the Nazi Referat. It is chilling, then, to reflect on the cascade of exhibitions and *vernissages* taking place at the same time as the secret roundups or *rafles*, the deportation of convoys in cattle-cars from Drancy to the death camps bound for extermination: 75,000 captives in regular, documented batches of 1,000.[24] Sixty-four named Jewish artists of the Ecole de Paris were gassed in Poland.[25]

These banished citizens were victims of Nazi 'eugenic' ideology – the same ideology which found artistic expression in the works of a former artist of Montparnasse, Arno Breker, now Hitler's chosen sculptor (fig. 73). The exaggerated virility and homoerotic aesthetic of many allegorical works in the major Breker exhibition at the Orangerie des Tuileries reinforced comparisons between Breker and Michelangelo, and the analogy of captive Greece (France) offering her cultural wealth to victorious Rome (Germany).[26] A tour of Germany made by academic sculptors and ex-Fauve painters in November 1941 generated favourable publicity, and Breker's work, on display from May to August 1942, was but one in a succession of propaganda exhibitions, based on successful German models, which disfigured the palaces of Parisian culture: the 'Exposition anti-maçonnique' at the Petit Palais in 1940; the 'Exposition de la France Européenne' at the Grand Palais in 1941; 'Le Juif et la France' at the Palais Berlitz in 1941; and the 'Exposition internationale: le Bolchévisme contre l'Europe' at the Salle Wagram in 1942.[27]

On 27 May 1943, in the gardens of the Musée du Jeu de Paume, canvases by Masson, Miró, Picabia, Klee, Ernst, Léger, Picasso and others deemed 'degenerate' were slashed and burned; yet almost twenty-two thousand works of art, particularly Impressionist and Ecole de Paris works mostly from Jewish collections, were systematically dispatched as war booty to Germany.[28] In contrast, Pétain co-opted the Académie des Beaux-Arts for his

Figure 72

73 Arno Breker, *The Comrades*, c. 1940
Exhibited at the Orangerie, May 1942

74 Pablo Picasso, *Le Charnier*, 1944–45
Oil and charcoal on canvas, 199.8 × 250.1 cm
The Museum of Modern Art, New York:
Mrs Sam A. Lewisohn Bequest (by exchange)
and Mrs Marya Bernard Fund in memory of her
husband Dr Bernard Bernard and anonymous funds

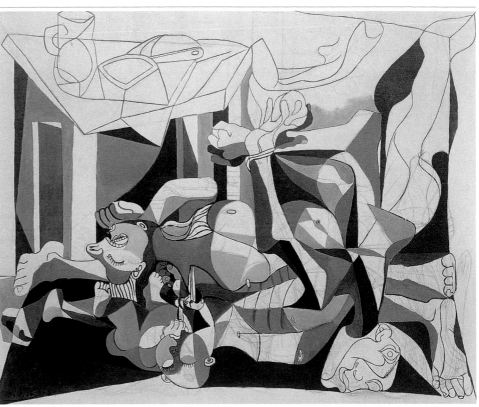

Figure 74

Figure 73

'National Revolution', orchestrated a paternalistic 'cult of personality', and advocated regionalism, peasant and craft culture, disguising the reality of a crippling war debt: millions of francs were sent to Germany, along with raw materials and a sizeable contingent of the French labour force.[29] This nationalist, nostalgic and backward-looking promotion of the 'artisan' and the medieval aesthetic was shared by the Young Painters of the French Tradition. Initially organised under the aegis of the Vichy-based 'Jeune France', the Catholic and personalist tendencies of the group as a whole were at odds with the politics and opinions of the young communist painters in their midst, such as André Fougeron and Edouard Pignon, key figures during the Occupation in the resistant Front National des Arts.[30]

Despite the danger and difficulties of resistance, art-world strategies ranged from the exhibition of works by 'degenerate' artists and the clandestine publication of Surrealist brochures, to overtly political works such as the *Vaincre* lithograph album (1944) depicting Nazi atrocities.[31] Once again, however, the drama of the body politic may be read most vividly in terms of the depiction of the body by Paris's artists in the immediate aftermath of the Liberation, through 1945 and 1946.

The transformations of Dora Maar's face in Picasso's *Weeping Woman* series into the immobilised and finally hideous, skull-headed figures of the Occupation dominate a series of artistic responses to France's symbolic death, based on the theme of the *vanitas*. Picasso's brutal bronze skull, placed Golgotha-like on the ground, stood for the fate of the first man – any man. He contributed *Le Charnier* (fig. 74), literally the charnel house or house of death, with its piles of bodies beneath a bare table, to the major exhibition 'Art et résistance' in 1946. The theme was above all metonymic: a part representing an unrepresentable whole. Just as *Guernica* had responded with metaphor to contemporary black-and-white newsreels of the Spanish Civil War, so *Le Charnier* recalled the *grisaille* of the cinema screen, which, from the spring of 1945 onwards, was showing unrecognisable remnants of humanity being moved by bulldozers into mass graves.[32]

In addition to the *vanitas*, and Bernard Buffet's dramatic self-portrait with a skull (cat. 158), the figure of Melancholy herself was allegorised by Francis Gruber, who placed uncanny, emblematic objects – a plaster arm, a crow – within realist depictions of models in his Montparnasse studio (his wife's red waistcoat pays homage to Cézanne). Gruber

75 Boris Taslitzky, *The Small Camp at Buchenwald*, 1945
Oil on canvas, 300 × 500 cm
Musée National d'Art Moderne, Centre Georges
Pompidou, Paris

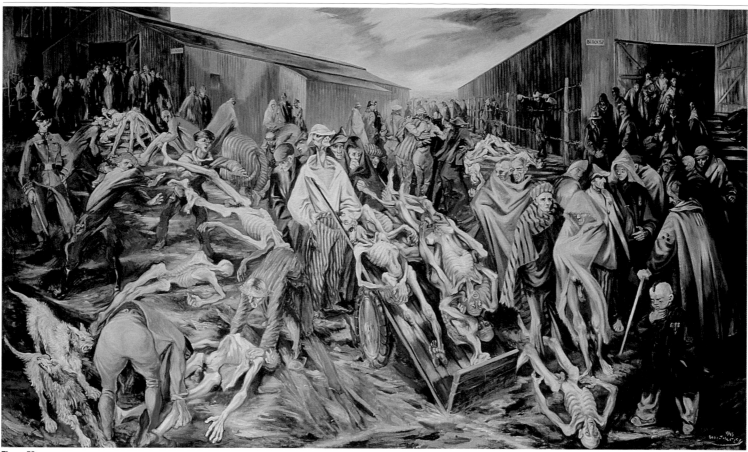

Figure 75

himself would die tragically young in 1948.[33] His close friend Boris Taslitzky, born in France to Jewish emigré parents from Russia, had been a militant young realist of the 1930s; he now became a *déporté*, a survivor of the camps. His *Small Camp at Buchenwald* (1945; fig. 75) was conceived in the tradition of French history painting – the stacked, emaciated, rotting bodies recall Géricault's *Raft of the Medusa* – but without beauty or heroism. As he said: 'I spat out the deportation in my canvases.' His work provokes revulsion: catharsis would be obscene in this context.[34] Jean-Paul Sartre's 'reflections' on the Jewish question, which appeared in *Les Temps modernes* in November 1945 concurrent with, but unaffected by, the first eyewitness accounts of concentration camps, were later published and republished unmodified in book form, despite the overwhelming number of first-hand *reportages* that had subsequently emerged, including David Rousset's influential *L'Univers concentrationnaire* (1946).[35]

The French Communist Party would become the repository of memory and commemorative practices relating to

deportation and the Holocaust. Expelled from coalition government in May 1947, its Moscow-driven policies hardened. In the arts, socialist realism with a nationalist and popular emphasis was now favoured, often appropriating a familiar Catholic iconography of martyrdom in contemporary guise, premised upon depictions of death and the promise of a better future. André Fougeron's *The Judges* (1950; cat. 182), a denunciation of exploitation and underinvestment in the mines, insists upon the body broken, diseased, bereaved.[36] Yet his traditional academicism was counteracted by the deliberate promotion of modernist Party 'stars', such as Léger, Picasso and even Matisse, at the prestigious Maison de la Pensée Française.[37] Picasso's *Massacre in Korea* (1951), arguably his least successful painting, again provoked violent debates about style and content in the context of the Korean War.[38] The overwhelming presence of French Stalinism, and of powerful figures such as Louis Aragon with his art newspaper *Les Lettres françaises*, cannot be underestimated as a force in the 1950s – or, indeed, as a matrix of French cultural life throughout the 1960s and beyond.[39]

Jean Fautrier's *Hostages* series (cats 163, 164), similarly, participate in a discourse of the punished, mutilated, scarred body. Remote from party-political concerns, Fautrier was passionately involved with the Bataillean dialectic of the relationship between victim and executioner. These works incorporate a disturbing sexuality and pleasure; they evoke the pinks and greens of Watteau's *fêtes galantes*, with rape and murder their leitmotif rather than seduction. Fautrier's sculpture was the basis for his high-relief impasto scored with what the writer André Malraux called 'a hieroglyph of pain'. The dissolution of the body and of the symbolic bodies of French art – Watteau, Monet, Rodin, Degas – as remarked upon by Paul Valéry, by Malraux, by Jean Paulhan, in conjunction with Fautrier's collaborations with Georges Bataille in the 1940s, explains the terrible eroticism of his Informel. The imbrication in his art of past with intolerable present, of desire with repulsion, foreshadowed major future developments.[40]

De Gaulle's 'Rassemblement du Peuple Français' (RPF), set up in 1947, challenged the communists at a time when these two violently

76 Iliazd (Ilia Zdanevich), *Poésie des mots inconnus*, Paris, 1949. A page with poems by Antonin Artaud and illustrations by Georges Braque

antagonistic groups were reshaping their histories of a heroic Resistance. Others, including former collaborationists, attacked what they claimed to be the statistically inflated narratives of both communist and Gaullist memory.[41] Jean Paulhan, Fautrier's advocate and once again literary editor of the *Nouvelle Revue Française*, published his indictment of reprisal killings and purge policies in his 'Letter to the Directors of the Resistance'. The riposte came from none other than the director of the Musée National d'Art Moderne, Jean Cassou, in *La Mémoire courte*: 'forgetting' the past was not a solution.[42] Cassou's job was to organise major retrospectives of, among others, Chagall, the Jewish artist symbolically welcomed back to the fold in 1947; and of Léger, also back from America and, following Picasso in 1944, a newly converted communist. Paulhan, in contrast, was promoting his Editions Gallimard artist-writers – Dubuffet, Fautrier, Michaux, even Dubuffet's 'rustic' protégé Gaston Chaissac – at the Galerie René Drouin on the right bank, in the elegant Place Vendôme.[43] For a certain literary élite this was a generation of 'different' artists: 'un art autre' as the critic Michel Tapié would call it. They rejected the tradition of *belle peinture*, preferring ferocious scratchings and blood-like tricklings (Wols), hallucinatory 'exorcisms' (Michaux) or the abject and excremental (Dubuffet). A critic greeted Dubuffet's graffiti-based 'Mirobolus' series by welcoming this post-Dada 'shit-painting': 'Après le dadaisme, voici donc le cacaisme.'[44] This neo-Dada dimension, with Dubuffet's anarchist positioning, Nietzschean overtones and philosophy of *dérision*, essentially distinguishes his impasted works from those of Fautrier which preceded them.

'I feel and declare myself *chaleureusement existentialiste*,' said Dubuffet, without being able to define precisely what this might mean.[45] The links between existentialist philosophy and the new art of the 1940s are manifold: existence reduced to its essence in the spindly figures of Alberto Giacometti – 'martyrs of Buchenwald', said Sartre – and indeed in Giacometti's absurd, for example *The Nose* (1947). They may be examined, via Sartre's extensive art criticism, in the work of Wols, of André Masson and even of the visiting Americans Alexander Calder and David Hare. Samuel Beckett epitomised the current predicament of the 'painter of failure' in his writing on Bram van Velde for the

Galerie Maeght's superb series, with its celebrated painter/writer collaborations, 'Derrière le Miroir'.[46] Maurice Merleau-Ponty, Sartre's co-editor on *Les Temps modernes*, would enrich Sartre's formulations of the gaze via a 'phenomenology of perception' which involved embodiment, offering a key to an empathically *matiériste*, non-visual reading of Dubuffet's fleshy surfaces. Moreover, Merleau-Ponty's essay 'Cézanne's Doubt' explored the persistence of a phenomenological view of the relationship between paint and canvas as adumbrated by Cézanne – so evident in Giacometti's paintings, or in the works of Raymond Mason, from the earliest terracotta reliefs to his great bronze *Crowd* (1967).[47] Nicolas de Staël, mythologised after his quasi-epiphanic return to figuration (see the great 1952 *Parc des Princes*, cat. 203) and his later, unexpected suicide, was to the public at large perhaps *the* existential painter.[48] (Retrospectively, Merleau-Ponty's last work, 'L'Oeil et l'esprit', composed in the light and landscapes of the south, as were de Staël's last paintings, offers most in terms of the reading of the *tache* of paint which *is* roof, rock, hill, sea, and yet contains always the trace of the artist's body as gesture.[49]) De Staël's energetic night-time footballers and his Saint-Germain jazz musicians of 1953 – a blaze of oranges, yellows and purples – create a vibrant and sonorous world of paint. Notwithstanding his tragic death, his work counters dominant readings of postwar Paris whose 'miserablist' vision of Saint-Germain-des-Prés is far from the truth.[50]

Yet the 'existential' emphasis on free will and free love, the possibility of starting anew without encumbrances of the past, was exhilarating. A neo-Dada spirit prevailed, with extraordinary generational clashes. Isidore Isou, the young founder of Lettrism which promoted the 'poetry of the letter', persecuted his fellow Romanian and the founder of Parisian Dada, Tristan Tzara, now alas a grey-haired communist.[51] Isou also exasperated the pioneer Russian *zaoum* poet Iliazd (Ilia Zdanevich) who, in riposte, attempted to set the record straight. His parchment-bound book of folded papers *Poésie des mots inconnus* (1949; fig. 76) re-presented, with great typographic inventiveness, the linguistic experiments of modernism from the Russian Futurists to the recently deceased Kurt Schwitters and Artaud, including the poems of the neo-Dada/Informel painter Camille Bryen whose

Figure 76

77 Cover of Gabriel Pomerand's *Saint Ghetto des Prêts*, 1950

78 Nicolas Vergencèdre (pseud. Alain Vian), Cover of *Tabou*, Paris, 1950, with a preface by Boris Vian

Figure 77

peinture-cri extended the act of painting to the inchoate scream.[52] A co-production between poets and artists, *Poésie des mots inconnus* is the monumental achievement of the *beau livre* in the postwar period, together with Matisse's calligraphed and cut-out book *Jazz* (1947).

Isou's Saint-Germain is immortalised in Gabriel Pomerand's *Saint-Ghetto-des-Prêts* (*The Holy Ghetto of Credit*; fig. 77)[53] and in Boris Vian's equally tongue-in-cheek *Manuel de Saint-Germain-des-Prés*, a complementary guide to the quartier's 'autochtones', 'assimilés', 'envahisseurs permanents', 'incursionistes' and 'troglodytes' – the cave-dwellers who never emerged from the cellars, where drink, jazz and dancing the boogie-woogie were the order of night and day. 'Too much love is made in Saint-Germain-des-Prés,' sniffed a Joseph Leroy. 'Vulgar sexuality' was ubiquitous.[54] At the Tabou club (fig. 78), beauty contests (the election of Miss Tabou and the Tabou Apollo) were an amusing throwback at a time when the irreligious, non-married couple Jean-Paul Sartre and Simone de Beauvoir were redefining free love. After the humiliation of shaven-headed female 'collaborators' during the *épuration* purges, women in France, their war-time roles recognised, had at last been given the vote. 22,000 copies of de Beauvoir's *Le Deuxième Sexe* (1949) were sold in the first week of publication. Young French girls now imbibed her analyses of a still overbearing patriarchy, while Juliette Gréco's songs echoed their desires for new freedoms.[55]

Francis Picabia, back at last from the Riviera, was a habitué of the cafés and a veteran Dada presence. A Picabia retrospective in October 1946, followed by the comprehensive 'Cinquante ans de plaisir' at the Galerie René Drouin in 1949, revealed the Dada spirit *in toto* to a new generation, while 'Picabia Point' at the Galerie des Deux-Iles the same year showed his provocative, overpainted spot canvases on monochrome grounds.[56] However, 'HWPSMTB' (Hartung, Wols, Picabia, Stahly, Mathieu, Tapié, Bryen), the show organised by Georges Mathieu at the Galerie Colette Allendy in 1948, is more revelatory, inasmuch as the initials – a homage to *fmsbwtözäu*, Raoul Hausmann's Dada poster poem of 1918 – spell out the links between the Dada generation, the Dada revivalist (Tapié) and the artists of Georges Mathieu's stable.[57] Mathieu, an Informel original, subsequently overwhelmed by Wols's paintings of 1947, would oppose not only geometric abstraction but Tapié's 'art autre' in favour of a painting of speed – his rapid gesture moving from calligraphy to swashbuckling bravura as he painted his larger battle pieces, often performing in costume (fig. 14).[58] (Alain Resnais's little-known films of painters such as Hartung in action emphasise the performative side of lyrical abstraction at the time.[59]) Mathieu's *japonisme*, a feature also of the work of Hartung, Alechinsky and others, and the important links that existed with Japan as well as New York in the 1950s contrast with the titling of his battle paintings, inscribed with the heroes and sites of French history; his royalism and the adoption of a *grand-seigneur* persona rapidly distanced him from his neo-Dada/Informel beginnings.[60]

The neo-Dada spirit was also specifically distanced from Surrealism of the Bretonian variety, which celebrated its return to Paris in 1947 with another grand international exhibition (featuring 87 artists from 24 countries) at the Galerie Maeght, with a magic theme. Works included black-magic altarpieces, a staircase of Surrealist literary heroes and Frederick Kiesler's 'Room of Superstitions'. Duchamp's invention for the *de luxe* catalogue covers, *Please Touch* (a rubber breast on black velvet made with Enrico Donati in New York; cat. 189), was used as a *cache-sexe*, an improvised bikini for the nude, who posed in front of Miró's snaking strip painting (fig. 79). Roberto Matta, key go-between during the war for the Surrealists in exile and New York painters,

Figure 78

Figure 79

carried out Kiesler's plan with Duchamp. The monstrous and pessimistic cybernetics of his large-scale paintings shown subsequently at the Galerie René Drouin demonstrated Surrealism's new occultism and 'crystalline' dimensions. Breton saw works such as *The Pilgrim of Doubt* and *The Eclectrician* as 'incarnating' the artist.[61] Surrealism extended in two opposing directions at this time: via automatism it grew closer to lyrical abstraction; more importantly, it investigated the Marquis de Sade (cat. 149), a powerful, legally contested arena for literature, art and performance in which a whole 'politics of Eros' was at stake.[62] In a climate, however, in which Roger Vailland, doyen of Saint-Germain-des-Prés, could write 'the revolution has no need of Surrealism. The revolution needs coal, steel, and atomic energy', and in which Sartre's famous 'What is literature?' derided the Surrealists' art of 'booby-traps', calling for an art of true engagement, the Surrealists were perceived to be at an impasse: communism or existentialism had conquered the imaginative high ground.[63] The artists who met at the Café de Notre Dame in Saint-Michel to found the anti-Parisian Cobra (COpenhagen, BRussels, Amsterdam) group in December 1948 around the charismatic Danish figure Asger Jorn, took over an intermediary, pro-communist 'Revolutionary Surrealist' movement. Cobra's art was inspired by children and by folk art, such as the carnival masks of the Belgian Mardi Gras or primitive Viking runes and *geldgubbers*, and looked to precursors such as Van Gogh, Munch and Ensor for its expressionist handling.[64] Stephen Gilbert and William Gear from Britain became members of the group.[65]

At the same period, Jean Dubuffet was promoting what he called Art Brut. This was art made by schizophrenics, mediums and 'outsiders', celebrated by a permanent installation in the basement of the Galerie René Drouin. Schizophrenic art was seen in public in major institutionally organised exhibitions in 1946, 1950 and 1956 (prior to an extensive show of Dubuffet's collection at the Musée des Arts Décoratifs in 1967). It had a profound impact on contemporary artists, such as Karel Appel of the Cobra group.[66] In the 1940s, however, the idea of escape from the 'cultural' constraints of art through madness was explored in Paris by exhibitions of works by William Blake and Van Gogh.[67]

It was in Saint-Germain, at the Vieux-Colombier theatre on 13 January 1947, that Antonin Artaud gave his legendary on-stage lecture 'Histoire vécue d'Artaud-Mômo', which ended with hoarse screams. The following November, after his extraordinary exhibition of crayon *Portraits* shown at the Galerie Pierre Loeb and his outraged response to the Orangerie show, 'Van Gogh, Suicided by Society', he recorded a broadcast entitled 'To Have Done with the Judgement of God'. Its cataclysmic violence precipitated an immediate ban, but two private broadcasts and the publication of the text in April 1948, just after his death, ensured its fame.[68] By 1952, Guy Debord's *Howlings in Favour of Sade* – alternating blank, black-and-white screens duping a bored and then furious audience – posited the decomposition of cinema: the transition from man 'suicided by society' to a society 'suicided' by the spectacle that Debord would theorise in the 1960s.[69]

The horror and rage of Artaud's writing and Debord's violent, post-Lettrist nihilism balance the image of Saint-Germain-des-Prés in which Swing, the Tabou Club, the Crazy Horse, and the cult of Sartre and de Beauvoir ruled. Vercors, author, Resistance hero and founder of the Editions de Minuit, recalled both the literary Saint-Germain before the war, and the change of atmosphere in the postwar period, a corrective to the conceits of Boris Vian. His Saint-Germain was 'less joyous and more chaotic' with a 'pessimism caused by too many horrors against which one sought support not via ardent discussions, as previously, but in the dark, hot and enveloping bosom of the cellars, and the sound of jazz'.[70]

Modernism through the fifties

To the rest of the world, France was still the country of Matisse, Léger, Chagall, Rouault, the internationally renowned artist and tapestry maker Jean Lurçat, and their younger epigones. Indeed, modernism was reborn as early as June 1945, with 'Art concret' in the Galerie René Drouin, and in the relaunched Salon des Réalités Nouvelles in July 1946, baptising a whole new era. Homage was rendered to the deceased pioneers of modern art, including Robert Delaunay, Piet Mondrian and the tragic deportee Otto Freundlich.[71] For the communists, abstract art epitomised the lack of commitment of the bourgeois artist as art became, finally, one of the most public domestic forums of the Cold War itself, involving huge propaganda and counter-propaganda budgets such as the

American-financed 'Paix et Liberté' poster campaign.[72] Ironically, a painter such as Jean Hélion, who had lived the abstract adventure to the full in the 1930s Paris of 'Abstraction-Création' and in America, reverted at this time to a realist painting which, like that of Balthus, was remote from the more violent ideological confrontations. Important publications gave a historical dimension to enterprises such as Jean Dewasne's Atelier d'Art Abstrait with its lecture programme, which were set up in 1950.[73] Despite the inevitable internal factions and the enmities between critics such as Léon Degand and Charles Estienne as well as between rival artists, the dynamism of geometric art thrived upon its generational and stylistic conflicts – excitements which managed to eclipse awareness of developments in America almost completely.[74]

The gallerist Denise René, however, promoted – and continues to promote – an uncompromised and internationalist history of modernism as a living and inspiring example to younger artists. She opened her gallery with a Victor Vasarely show in 1944; a Max Ernst retrospective – his first – followed in 1945; and she turned definitively to abstraction in 1946, with one-man shows of Atlan, Picabia, Vasarely and Herbin. 'Tendances de l'art abstrait' in 1948 announced her future direction, mixing the pioneer generation with newcomers to geometric abstraction such as Dewasne, Berto Lardera and Richard Mortensen. René's exhibition 'Le Mouvement' in April 1955, however, reintroduced the kinetic into abstract art and was immortalised thanks to the film made of the show by Pontus Hulten and Roger Bordier.[75] In 'Le Mouvement' (fig. 80), Calder's mobiles and Duchamp's *Rotary Demisphere* (1925) – the first reappraisal of Duchamp as an *optical* artist – were juxtaposed with works by Agam, Pol Bury, Jacobsen, Soto, Vasarely and Jean Tinguely. Calder influenced Tinguely's first, spindlier, motorised machines; Tinguely subsequently responded to Malevich in the humorous, motorised 'Meta-Malevich' series, first exhibited with Denise René in 1955. The watershed year of 1957 opened with Mortensen and Vasarely's new 'Op art'. This was followed by Mondrian (a show coming from the Venice Biennale); the first exhibition in France devoted to Joseph Albers, the Bauhaus emigré; and Malevich within his alternative context of the monochrome pioneers of Polish Unism.

Yves Klein surely visited this last show. The breakthrough beyond geometric abstraction and Op art was heralded by his pure-colour, monochrome paintings; his first International Klein Blue (IKB) works, shown in Milan as L'Epoca Blu in January, were exhibited at Iris Clert's gallery in May 1957, launched by hundreds of blue balloons released in the square of Saint-Germain-des-Prés.[76]

Towards a new spirituality

The inheritors of protestant neo-plasticism (Mondrian), the judaic mysticism of Agam, even the resolute communism of the renegade abstract painter Auguste Herbin, as demonstrated in his *Lénine-Staline* (1948),[77] all confronted the Catholic aspirations of many artists in postwar Paris. Germaine Richier, trained by the great Emile-Antoine Bourdelle and conscious of the mantle of Rodin through his model Nardone, looked also to the emaciated and death-haunted skeletons of her homonym, the sixteenth-century sculptor Ligier Richier. Her crucifix for the church of Assy in Haute-Savoie – an extraordinary ecumenical experiment – movingly fused body with bark, and Catholicism with an existential anxiety. It provoked crushing disapproval and censorship from the patriarchal ecclesiastical establishment.[78] Catholic intellectuals such as Jacques Maritain or Emmanuel Mounier, editor of the influential review *Esprit*, had challenged the communists from the 1930s onwards, and yet the 1950s were the period of great religious commissions which brought together ideological antagonists. The Assy church project involved the Catholic artists Rouault and Bazaine, the once-persecuted Jewish artists Chagall and Lipchitz and the communist atheists Jean Lurçat and Fernand Léger. The agnostic Matisse's Chapel of the Rosary at Vence (1947–51; fig. 64) and Le Corbusier's Ronchamp (1950–55) are indubitably France's greatest monuments of the era.[79] The Young Painters of the French Tradition were predominantly Catholic: Maurice Estève, Charles Lapicque, whose *Christ with Thorns* (1939) heralded the group's characteristic red-blue armature of the 1940s,[80] or Alfred Manessier, whose works, for example *Salve Regina* (1945; cat. 195) or *The St Matthew Passion* (1948), adopted religious themes which suggest musical as well as liturgical dimensions. But beyond the parameters of an art linked to the church itself, an artist such as the Hungarian Simon Hantaï,

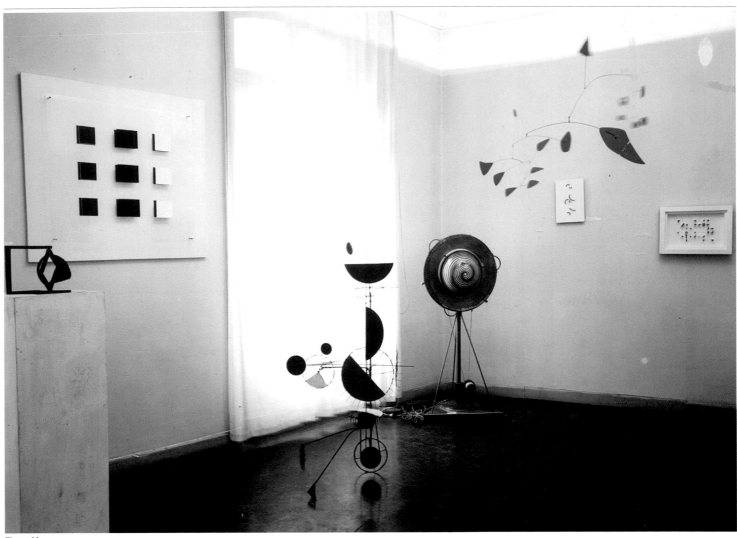

Figure 80

renouncing first Surrealism and then gestural abstraction, could find himself by the early 1960s making works such as the 'Virgin's Mantle' series (cat. 222), where both the theme of maternity – a key to his *pliages* (folded and unfolded canvases) – and the blue of the Madonna's veil infuse an abstract work with spiritual dimensions.[81] Likewise, beyond the formal and historical considerations of the monochrome and the myriad readings of his work through Malevich, Matisse, Duchamp, Max Heindel, Bachelard, *japonisme*, the Zero Group and the spirituality of zen, Yves Klein's work, with its avowed angelism, its flying, leaping bodies, is profoundly Catholic. His art contains the blue and gold of Giotto and Duccio; he made a reliquary of pure pigment, blue, gold and rose, for the shrine of St Rita of Cascia, his patron saint.[82]

In conclusion, both the *tabula rasa* of a rediscovered Malevich or the elemental chaos of Informel painting were posited on an idea

of 'nothingness'.[83] Yet on the monochrome ground, the impasted surface or the blank canvas preceding the perspectival schemes of a Gruber or a Hélion, lines, forms or images persisted in coming into being. Sartre's dialectic between 'l'être et le néant', being and nothingness, is played out in the artistic development of the immediate postwar period.

Problems of mourning, memory and continuity, then, haunted postwar France, whose imperatives were those of reconstruction, change and modernisation. Despite austerity there was hope: Paris rejoiced in her New Look, and with the expanding international art Salons, new galleries and publishing houses, with philosophers, novelists and *cinéastes* of the stature of Merleau-Ponty, Albert Camus and Alain Resnais, and with her glittering Left-Bank life, she regained her supremacy as intellectual capital of Europe: still a beacon for artists from all over the world.

1 Plans for the evacuation of the Louvre commenced in 1936. Thousands of cases were made, numbered and coded in 1938, amidst debates on the pillaging of the Spanish heritage during that country's Civil War (Wilson 1992, pp. 149–51). By August 1939 the museums were closed, and the Louvre was co-ordinating operations for the removal of works to the Château de Chambord. See Hulftegger 1957.

2 Henry Rousso first used Freudian symptomatology to analyse France's body politic, calling the years 1944 to 1954 the *phase de deuil*, 'the mourning phase'. See Rousso 1987, p. 18.

3 Jean Zay was appointed Ministre de l'Education Nationale et des Beaux-Arts in 1936; he was assassinated by Vichy *miliciens* in June 1944. For Popular Front policy in the arts, see Ory 1994, pp. 233–90; Orléans 1995, especially pp. 30–32; and Amsterdam 1996. Jean Cassou, a writer and art critic of Spanish origin, was appointed as Zay's advisor for the visual arts. As a pro-communist, his purchase of the irreverent Dalí is remarkable. For Breton's response to Dalí's Hitler-inspired works, see Maur 1991, pp. 196–202.

4 Nadeau 1945; quoted from 1964 edition, p. 171.

5 See Abadie 1981, pp. 72–74, based on accounts by the Surrealists André Breton, Georges Hugnet and Man Ray. Man Ray photographed the mannequins.

6 See Gruber 1938.

7 For the origins of the AEAR, see Morel 1985; for visual arts involvement see Wilson 1992, chapter 1, especially pp. 36–43, and pp. 409 and 410. Koch 1995 demonstrates Willi Munzenberg's role as a Komintern *éminence grise* in co-ordinating a worldwide mobilisation of intellectuals; the review *Commune*, directed by Stéphane Courtois, continues to study the question with new Soviet archive material.

8 See Aragon 1935; and Wilson 1992, pp. 58–61. Heartfield's exhibition '150 Photomontages d'actualité' at the Maison de la Culture, with its German Dada heritage and propaganda aesthetic, confused the rhetoric in favour of a 'socialist realism' for painters.

9 Raphael 1933. Raphael was involved with the exemplary project of the Ecole Karl Marx built in the communist suburb of Villejuif, in which many painters and sculptors participated.

10 Benjamin's response to Paris *generated* texts such as 'L'Œuvre d'art à l'époque de sa reproduction mécanisée' (Benjamin 1936), translated from the German by the writer Pierre Klossowski), a fundamental text for André Malraux's *musée imaginaire*. See Benjamin 1991, which includes contemporary appreciations by the photographer Gisèle Freund and the bookseller Adrienne Monnier.

11 See Paris 1980. The Forces Nouvelles group create a bridge between the 1920s 'call to order' painters (often on the political right) and the left-wing realists at the Maison de la Culture; their work and the response to it of critics such as Waldemar George reflect these ambiguities. For Edouard Pignon in the 1930s, see Wilson 1997, pp. 17–20.

12 Bonnet and Rogers 1988 trace the 'revolutionary Paris' of theatre and cinema in the 1930s. Jean Renoir's *Marseillaise* (1938), which used hundreds of citizen-actors, was particularly important. For the artists' response, see Taslitzky 1955; and Wilson 1987, particularly pp. 60 and 74.

13 See Aragon 1936 (and Fauchereau's 1987 re-edition); and Wilson 1992, pp. 64–67 (a discussion of the debate of younger artists such as Taslitzky and Gruber omitted by the latter). The international links of the movement were demonstrated at a London show in 1935 (Wilson 1992, pp. 52 and 89–90) and in a protest exhibition against the official artists of the Berlin Olympics; see Amsterdam 1996.

14 Moulignat 1977, which treats the wide-ranging artistic response to the Spanish Civil War, was used for my unfootnoted texts in Paris 1981, pp. 42–46. His pioneering synthesis deserves wider acknowledgement.

15 'Chefs-d'œuvre de l'art français' was held at the Palais de Tokyo (see Paris 1937).

16 See Aragon 1938. The Stalin–Laval pact of May 1935, and approval of the French policy of 'national defence' at the eighth Communist Party Congress of October 1936, elucidates the complex tactics involved (Wilson 1992, pp. 308–09).

17 Souriau 1962, cited in Roque 1986, pp. 158–62, is an essential background to subsequent politicised discussions about the patriotic meanings of red and blue in the Occupation period (see note 30 below).

18 David retrospectives were held in Paris in 1939 and in 1948 at the Orangerie, with ideological repercussions not only for Fougeron's socialist realism, but also for Léger's modernist *Homage to Louis David, Leisure* (1948–49), for example. See Wilson 1987, pp. 64–65.

19 See *Peintres et Sculpteurs de la Maison de la Culture*, 1938, special number, 'La Liberté et l'art'; Wilson 1992, pp. 131–34, and Ory 1996.

20 See Zervos 1937 for a full account of Nazi arts structures and ideology; and Grohmann 1938 for the contemporary German scene, in the luxury review *Cahiers d'art*.

21 Roussel 1984, p. 287. The London exhibition, first named 'Banned Art' in protest, was renamed 'Exhibition of Twentieth-Century German Art', at the New Burlington Galleries, London, July 1938.

22 For Lipchitz's sculpted bronze font, *Notre-Dame de Liesse*, see Rubin 1961, pp. 58–64 and 126–33.

23 '[Je vous écris] de la Cité du Temps interrompu…des pays de l'atroce…de la Capitale à la foule endormie. On vit en indifférence dans l'horreur.' See 'La Lettre dit encore', in Michaux 1945, pp. 59–60; and, for Michaux, London 1982, pp. 139–43; London 1993, pp. 143–53; and London 1999.

24 Compare the 1940–44 chronology and specimen 'Calendrier des Galeries' for May–June 1942 in Bertrand-Dorléac 1986, pp. 235–63 and 265–71, with the dates of the *rafles*, revealed and discussed in Klarsfeld 1978; Klarsfeld 1983; and Klarsfeld 1985 (Bensimmon 1987 provides a resumé). Klarsfeld and Wellers 1987 trace the expanding French historiography of the genocide chronologically, via eighty articles (1946–86) from *Le Monde juif*, the review of the Centre de Documentation Juive Contemporaine (created in 1943 in Grenoble), anticipating contemporary debates (for example, Bouretz, Chaumont, Manevistas and Wieviorska 1998).

25 See Fenster 1951 for the first memorial, in Yiddish, to 'our artist-martyrs', prefaced by Chagall. Nieszawer 2000, based primarily on Fenster, details the lives and often tragic deaths of 151 Jewish artists of the pre-war Ecole de Paris.

26 See Marmin and Infiesta n.d., cited by Bertrand-Dorléac 1986, p. 431. For the Greece/Rome analogy, see Grappe 1943, p. 15. Georges Grappe's 'Groupe Collaboration' met at the Musée Rodin, which he directed, the nerve-centre of art-world collaboration.

27 See Wilson 1992, pp. 225–27 and 271 (with statistics); Paris 1940; Paris 1941; and Paris 1942B. The interrelationships and vast spectacle of these shows (which toured the French provinces with great success) deserve an attention lacking in Bertrand-Dorléac 1986 and Bertrand-Dorléac 1993.

28 The Einsatzstab Reichsleiters Rosenberg report on 14 July 1944 listed 21,903 works inventoried since the beginning of operations, including 10,890 paintings, watercolours and drawings, and 583 sculptures and medallions etc. See Paris 1946; Valland 1961; Nicholas 1994; Paris 1997B; and the official report, Schulmann 2000 and Schulmann 2000B (synopsis). The 'Aryanisation' of the French market and postwar difficulties in legal reclamation of commercial property contributed to a significant and irrecoverable shift of the market to New York (Schulmann 2000, p. 28).

29 See Paris 1990B, especially the inventory of the Fonds Pétain on pp. 272–79, which lists items ranging from Pétain's official bust (1941) by François Cogne to paste jewels or cardboard *francisques*.

30 Wilson 1981; Bertrand-Dorléac 1986, pp. 166–205; Bertrand-Dorléac 1987; Cone 1992; and Bertrand-Dorléac 1993, pp. 244–60. The bitter polemic around initial links between these painters, the ultimately collaborationist Jeune France group and the harsher reading of '"Abstract" Art as a Veil' (Cone 1992) illuminates the nuances of this troubled period and the privileges of hindsight. Compare with a key critic and witness of the time, Diehl 1999.

31 For Surrealist and 'Main à Plume' group activities and publications see Fauré 1982. The Resistance Front National des Arts, with Picasso as nominal director, was run by its secretary André Fougeron who was also an editor of its clandestine periodical *L'Art français*. He masterminded the lithograph album *Vaincre* in 1944. See Wilson 1992, pp. 258–68.

32 See Paris 1946. 'Art et résistance' comprised 455 works. Picasso also exhibited *Hommage aux espagnols morts pour la France*. This show sparked the debate 'Picasso or Taslitzky' (modernism vs. *témoignage*: Taslitzky's realist 'witnessing') which would structure future debates on art within the French Communist Party (PCF), though the socialist-realist edict from Moscow impacted only after the Party left the government in May 1947. See Wilson 1991B; and Wilson 1992, chapter 5, especially pp. 284–90. For Picasso, see also San Francisco 1998.

33 See Bernard-Gruber and Vanazzi 1989. Dead prior to the socialist-realist discourses of 1948–53, Gruber was heroised by the Salon de la Jeune Peinture in the mid-1950s; see Wilson 1993, pp. 29–30 and 48–49.

34 See Taslitzky 1946. Taslitzky's *Death of Danielle Casanova* (1950), a vision of Auschwitz (where Taslitzky's mother perished), served Communist Party arguments against

a Common European Defence policy and German rearmament (Wilson 1992, pp. 352–54). The co-option of historical memory in various commemorative practices, including history painting, by the PCF (Wieviorska 1992) provides the essential and missing backdrop to the discussion of modernist 'dynamics of disavowal' in Buchloh 1998, pp. 88–89.

35 See Rousset 1946; and Wieviorska 1992, pp. 446–76, for the spate of concentration-camp literature and memoirs; and Sartre 1945.

36 Stil n.d.; Fréville 1951; and Wilson 1992, pp. 309–22. Fougeron's *Pays des mines* series was exhibited to bussed-in workers at Paris's bourgeois Galerie Bernheim-Jeune, toured France's mining areas and reached a public of 50,000 prior to a tour of Eastern Europe and sales to the Museum of Fine Arts in Bucharest and the Ministry of Foreign Affairs in Prague.

37 See Paris 1962. Matisse, cultivated by the Party's cultural spokesman Louis Aragon, at one stage had a Communist Party card, and exhibited his Vence chapel designs in the Maison de la Pensée Française in 1950. Provocatively near the presidential palace off the Champs-Elysées in 1950, the Maison de la Pensée Française was crucial for the PCF's strategy of 'champagne communism'.

38 For the problematic reception of *Massacre in Korea*, see Utley 2000, pp. 147–52.

39 The bibliography is vast; one might mention French debates around *Le Livre noir du communisme* (Courtois 1997) and Derrida's *Spectres de Marx* (1997) as recent culminating points. For the visual arts see Berthet 1990 (with caution); Wilson 1992; Wilson 1996B; Wilson 1997; and Wilson 1999B.

40 See Malraux 1945 (Fautrier); Ponge 1946 (Fautrier); Tapié 1952; Vicens 1960; Paulhan 1962 (Informel); Crispolti 1971 (L'Informale); Damisch 1977; Wilson 1995 (Bataille and Fautrier); Bois and Krauss 1997; and Groom 1998, especially pp. 23–30, challenging Bois and Krauss 1997. Let us at last credit Damisch for re-evaluating the Informel, resurrecting the Bataille citation of 1929 and suggesting the *historical* lineage of the Informel stemming from Degas.

41 See Rousso 1987 for the pertinent distinction between 'résistencialisme' and 'résistantialisme'. Louis-Dominique Girard's *La Guerre franco-française* (1950) analysed these divisions (the phrase was resurrected in a discussion of collaboration by Stanley Hoffman, 1968). They are at the heart of Henry Rousso's powerful analysis of 'the Vichy syndrome', and the clashes between lingering Pétainism, Gaullist 'résistancialisme' and the Resistance credentials of Communist memory. Rousso dates to 1971–74 the 'return of the repressed', notably Jewish memory. See Rousso 1987, especially pp. 18–19; and Rioux 1991.

42 Paulhan 1951 quoted a contemporary estimate which stated that 60,000 Frenchmen were killed at the Liberation; distinctions between reprisal killings and state executions as part of the *épuration* purge were invidious. Cassou's Spanish, pro-Republican, Resistance and post-communist past distinguished him in every way from Paulhan. This charismatic battle eclipsed the impact of the posthumous publication of Halbwachs (Halbwachs 1950 and Halbwachs 1992). Sketched by Taslitzky in Buchenwald, Halbwachs is now the acknowledged father of memory studies.

43 See Sables-d'Olonne 2001.

44 See Henri Jeanson, in *Le Canard enchaîné*, 15 May 1946, quoted in Dubuffet 1966, p. 124. For the relationship between Dubuffet's 'Portrait' series, Paulhan and *épuration* politics, see Wilson 1993, pp. 28–29. For the Nietzschean revival of the 1940s, see Wilson 1988B, p. 39. For Dubuffet's anarchist heritage and political ambiguities, see Ragon 1992.

45 See Dubuffet 1946.

46 The collaborations between painters and writers for *Derrière le Miroir* produced by the Galerie Maeght continued until 1982 (Tours 1986B). See also Wilson 1993, pp. 30–31.

47 See Merleau-Ponty 1945; and Wilson 1993, pp. 30–31.

48 See, for example, Brulé 1957, where de Staël joins figures such as Colin Wilson as typical *angoissés*. See also Lledo 1995. Sally Shafto demonstrates the surprising influence of de Staël on Jean-Luc Godard in Shafto 1999.

49 Merleau-Ponty 1961.

50 Following the comprehensive coverage of 'Paris–Paris' (Paris 1981), 'Aftermath' (London 1982) deliberately omitted geometric abstraction. 'Paris, Kunst der 50 Jahre' (Saarbrücken 1989), organised from Paris, showed only seven mostly Informel artists. 'Paris Post War. Art and Existentialism, 1945–1955' (London 1993), admirably selective with 11 artists, suggested coverage in its main title – a highly misleading impression. Bernard Ceysson's 'L'Ecriture griffée' (Saint-

Etienne 1993) showed a similar range of artists, as did Stephen
Barber's book *Weapons of Liberation* (1996).

51 Isou (Jean-Isidore Goldstein) arrived from Romania in 1944. For
Lettrism, see Isou 1947; Isou 1974; contextually Giroud 1981; Paris
1988B; Sabatier 1989; Devaux 1992; and Isou, Satié and Bermond
2000. For relations with Guy Debord, see Hussey 2001, pp. 36–45,
which is particularly important as regards Isou's and Tzara's (Samy
Rosenstock's) Jewish ancestry.

52 See Iliazd 1949; New York 1987; and Schlatter 1993, pp. 259–62.
For Bryen, see Nantes 1997, especially Giroud (pp. 57–67).

53 See Pomerand 1950; and Isou, Satié and Bermond 2000, p. 101.
Gabriel Pomerand exemplified Isou's 'metagraphic' theories in his
paintings (mostly of 1951–52); their swastikas and Hebraic signs
are particularly eloquent. Pomerand was the first to promote
homosexual liberation in Saint-Germain.

54 See Vian 1974, p. 34: '1. Les autochtones, qu'on reconnait
à ce qu'ils restent presque toujours à la surface du sol. 2. Les
assimilés, qui ne sont pas nés à Saint-Germain mais ont fini par
se persuader le contraire. 3. Les envahisseurs permanents, tribus
diverses comportant une proportion considérable d'Américains
et de Suédois, de rares Anglais et quelques Slaves. 4. Les
incursionnistes, bof [beurre, oeufs, fromages = nouveaux
riches] de race pure et citoyens des diverses régions de Paris,
qui font à Saint-Germain de brefs séjours, presque toujours
limités au sous-sol. 5. Les troglodytes ou habitants permanents
du sous-sol.' For Leroy's article (in *Flash*, 1, 1950), see Vian 1974,
p. 72.

55 De Beauvoir 1949; Webster and Powell 1984, pp. 153–59; and
Winock 1999, particularly pp. 548–57. For dance in Saint-
Germain, see Gumplowicz and Klein 1995, pp. 167–82; for song,
see Poulanges 1995.

56 See Wilson 1988B.

57 Mathieu organised 'L'Imaginaire' (a Sartrean title) with the
painter-poet Camille Bryen at the Galerie du Luxembourg in 1947
(artists featured included Arp, Atlan, Brauner, Hartung, Leduc,
Picasso, Riopelle, Solier, Ubac, Verroust, Vuillamy, Wols). See
Mathieu 1963B, pp. 47–51; and Lecombre 1981 (with chronology).
'Véhémences confrontées' at the Galerie Nina Dausset and
'Signifiants de l'Informel I' at the Studio Fachetti in March and
November 1951 preceded Tapié's 'Un Art autre' at the Studio
Fachetti in December 1952.

58 Excluded from Beaubourg's 'Hors-limites', Mathieu has
nonetheless been 'rediscovered' – to his chagrin – as an action
artist. See Los Angeles 1998, p. 31. Grainville and Xuriguera 1993
give a far more extensive idea of his performances, which ranged
from the Zen works of 1952 (p. 33), 'Capetian' history painting of
1954–55 (pp. 38–40), the thirty-minute theatre performance of
1956 (pp. 42–43) and the performance on live television (p. 64),
to drum accompaniment in 1959.

59 See Fleischer 1998, pp. 54–58. Resnais's films (1946–48, now in the
Centre Pompidou collection) on 'painters in action', such as Henri
Goetz, Lucien Coutaud, Hans Hartung, Christine Boumeester,
Félix Labisse and Oscar Dominguez, Charles Malfray and César
Domela, should be compared with the better-known films of Hans
Namuth on Pollock in 1950 and Henri-George Clouzot's *Le Mystère
Picasso* in 1955.

60 See Roberts 1986; and the extensive analysis of the Franco-
Japanese connection in Groom 1998, pp. 80–152. For Mathieu's
action paintings in Japan, see Grainville and Xuriguera 1993,
pp. 49–53. Pierre Alechinsky's film *Calligraphie japonaise*
(1955–57, with a script by Cobra artist Christian Dotrement) was
shown at the Librairie Galerie La Hune in Paris in October 1957
with an exhibition of works by Toko Shinoda. Hartung
participated in the International Symposium of the Fine Arts
in the East and West organised by Unesco in Japan in 1967.

61 See Paris 1947; Pierre 1986; Mitchell 1994, pp. 337–51; and Mahon
1999, pp. 111–81. For Matta see Breton 1947, Golan 1985 and Paris
1985, pp. 279–80.

62 José Pierre discusses the relationship between Breton and Charles
Estienne, promoter of *tachisme*, in Pierre 1986, pp. 340–41. Pierre
Klossowski's *Sade, mon prochain* (1947) and Jean Benoît's *Execution
du Testament du Marquis de Sade* (1949–50; performed 1959) were
crucial. See Mahon 1999, pp. 51–109.

63 See Sartre 1947, quoted from 1993 edition, p. 184; and Vailland
1948, quoted from Vailland 1967, p. 269: 'La révolution n'a pas
besoin de surréalisme, elle a besoin de charbon, de l'energie
atomique…'

64 See Cobra 1980; Lambert 1983; and Miller 1994.

65 Gilbert's 'Cobra'-like paintings, begun in wartime Dublin,
were noticed by Jorn at the Salon des Indépendants of 1948.
See London 1982, pp. 103–04; and Paris 1987D.

66 See Wilson 1992, pp. 122–49, especially pp. 134–36; and
Kuspit, Fuchs and Gachnang 1997, including facsimile pages
of the 1950 catalogue *Psychopathological Art*, drawn over by
Appel.

67 See Paris 1947D; and Paris 1947E. *Cahiers d'art* of 1947 carries
extensive articles on Blake, Van Gogh, and the International
Surrealist exhibition.

68 See Artaud 1974, pp. 130–32, and Dachy 1995, n.p. Pirate
copies of 'Pour en finir…' and a recording were soon in
clandestine circulation. On Artaud's last Paris period, see Brau
1971; Barber 1991, pp. 125–63; and Barber 1996, pp. 41–85.

69 For Debord's *Howlings in Favour of Sade*, shown in 1952, see
Devaux 1992, pp. 119–21; and Hussey 2001, pp. 45 and 62–65.

70 Vercors 1989, p. 11.

71 The Kandinsky retrospective at the Galerie René Drouin in
1946 and the related prize and translations of his writings
were also crucial. See Viéville 1981 and, also in Paris 1981, the
chronology, pp. 286–87. By 1947, 147 artists from various
countries were exhibiting 387 works at the Salon des Réalités
Nouvelles. Freundlich, deported via Gurs and Drancy to
Lublin-Majdanek, died on arrival there in March 1943. See
Münster 2001.

72 For the 'Paix et Liberté' campaign, see Régnier 1986; and
crucially, Grémion 1995, with its exhaustive analysis of 'anti
communist intelligence' which fuelled the 'Congrès de la
Liberté de la Culture' in the 1950s.

73 See Herbin 1949; Seuphor 1949; and, for Dewasne's Atelier
d'Art Abstrait and chronology of lectures from 1950 to 1952
(frequented by Ellsworth Kelly), Paris 1981, pp. 276–77.

74 Furores were caused, for example, by Estienne's pamphlet
of 1950 *L'Art abstrait est-il un académicisme?* or Victor
Vasarely's refusal of the Kandinsky Prize in 1952. See
contemporary synopses: Brion 1956; Courthion 1958;
Ragon 1959; and Paris 1984B, pp. 84–85.

75 For 'Le Mouvement', see Paris 1975; and Paris 2001B,
especially pp. 31–35.

76 See London 1995, pp. 81–99. Innovations 'beyond the
monochrome' in Klein's show included the Japanese-inspired
Large Blue Folding Screen, the *Blue Obelisk* and Klein's
Monochrome Symphony, recorded by the composer Pierre
Henry.

77 In December 1949, at the height of socialist-realism debates,
Herbin, a Party member, issued a manifesto protesting at the
Communists' hostility towards abstract art; Jean Dewasne
was concurrently writing a lecture on abstraction as the
culmination of dialectical materialism applied to the arts –
which remained unpublished by the Party until 1968. See
Wilson in Paris 1981, p. 208.

78 See Rubin 1961, pp. 160–64; Saint-Paul 1996, pp. 112–14;
and Wilson 1998.

79 For *Esprit* and Emmanuel Mounier's Catholic personalism, see
Winock 1975. For 'Art sacré' see Rubin 1961; Couturier 1984;
de Lavergne 1992; and for the continuing story, Linder 2000.

80 '…the blue armature stands out imperiously, the red marks,
on the contrary dissolve, appearing only as a flaming and
insubstantial mass'; see Lapicque 1958, pp. 287–88, quoted
in Perregaux 1983, p. 39, where Lapicque's colour principles
are sourced in both the study of optics and French medieval
art: enamel and the Cluny tapestries.

81 For Hantaï's 'Virgin's Mantle' series (1962–63), see Münster
1999, pp. 27–35.

82 See Restany 1982, p. 255.

83 Counter to the assertion that Klein emphatically 'denied'
Malevich (Buchloh 1998, p. 89), Malevich was specifically
invoked, together with the Informel link at Klein's first
exhibition: 'The old habitués of the informel will agree
about the definition of a 'nothing', a mad attempt to raise
to the power of +• the dramatic (and henceforward classic)
adventure of Malevich's square.' Pierre Restany, preface to
Yves Klein's first exhibition of variegated monochromes,
Galerie Colette Allendy, 1956, in Périer 1998, p. 51.

Katarzyna Murawska-Muthesius

Paris from Behind the Iron Curtain

'...Eastern Europe functions for the West as its Ego-Ideal: the point from which the West sees itself in a likeable, idealised form, as worthy of Love. The real object of fascination for the West is thus the gaze, namely the supposedly naive *gaze* by which Eastern Europe stares back at the West...'[1]
Slavoj Žižek, 1992

The post-1945 split between Western and Eastern Europe, symbolised by the Iron Curtain, reproduced a much older division of the continent, one which had been constructed by Paris during the *siècle des lumières*. The polarity of the enlightened West versus the backward East had displaced the earlier, classical juxtaposition of cultured South against barbarian North. And symmetrically, the creation of *l'orient de l'Europe* – the 'East' of Europe – had been inseparably bound up with the construction of Western Europe, with Paris as its capital.[2] In the aftermath of the Second World War, 'Eastern Europe', hitherto spatially and linguistically underdetermined, was framed and defined by a newly acquired boundary: the Iron Curtain. This compelling metaphor of postwar division entered everyday discourse through Churchill's aggressive Fulton speech of March 1946.[3] The joint project of American and Soviet expansionism went far beyond the old prejudices of the Enlightenment, investing the idea of East/West with a new political significance and spreading it over the whole globe.[4] Crucially, the 'West' was extended much further westwards, and, as a corollary, the contest for the West's new capital was widened.

Crudely, the story might be read as follows: when the Anglo-American spectre of the Soviet Iron Curtain was conjured up, Paris, manoeuvring too closely to its shadow and associating too overtly with communism and discredited socialist realism, lost to New York the battle for cultural hegemony in the reordered world. According to the sweeping account proposed by Serge Guilbaut, it was precisely at the moment when Abstract Expressionism dressed up as the Cold Warrior that a suspiciously red Paris misread the script of the 'postwar painting games' and 'could no longer be trusted in this crucial battle for the soul of the Western world'.[5]

The purpose of this essay is to take another look at the arena of 'postwar painting games', moving beyond the well-trodden Paris–New York axis which decentred and diminished the Parisian image. Extending eastwards, it looks at the 'other' Paris, at the Paris refocused and magnified through the Iron Curtain lens, investigating the changeable reflection of the Parisian myth on the imaginary screen of the Iron Curtain, and looking at the ways in which Paris presented itself, as well as the ways in which it was viewed from behind this new East–West boundary.

Despite the supposed impenetrability of the Iron Curtain, a steady exchange between Paris and Eastern Europe took place from 1946 onwards. A plethora of exhibitions travelled in both directions; periodicals and catalogues were privately circulated; artists and critics, sponsored by cultural and political bodies, travelled both West and East. Relations were never broken off completely, even during the 'darkest nights of Stalinism', although they were closely monitored by the authorities. The Iron Curtain might be compared to a two-way mirror, able to hide and reveal several Parises: the dreamt-of 'fount of modernity'; the 'communist' Paris of Daumier and socialist realism; and finally the 'forbidden' Paris of existentialist anxiety and of the liberating gestures of Tachism. These diverse ways of looking at Paris from the position of an Eastern European observer might be aligned chronologically to form a tentative sequence which would unfold from the brief episode of the return to modern Paris in the period directly after the war (1945–48), through the rise of the 'Iron Curtain Paris' constructed by Stalinism (1949/50–55), to the Paris 'regained' with the post-Stalinist 'Thaw' (from 1956).

Two main problems should be emphasised, however, when attempting to map out a shared topography of those mutable dreams of Paris coming from behind the Curtain. The first is an astonishing lack of investigation of both the decline and the endurance of French artistic hegemony during the period of postwar reconstruction and the redefinition of modernism. Although in the 'other Europe' – Eastern Europe – the authority of French modernity was still taken for granted well into the 1960s, the socio-political conditions of that paradigm remain to be examined. Research is needed, too, on the formative role of institutions, such as the Association Française d'Action Artistique and the Instituts Français, as well as on the activities of the Musée National d'Art Moderne under the leadership of Jean Cassou.[6] Patterns of official promotion and

81 Jadwiga Maziarska, *Collage*, 1948
Mixed media, dimensions unknown
Private collection, Paris
Exhibited in the 'First Exhibition of Modern Art'
in Kraków in 1948

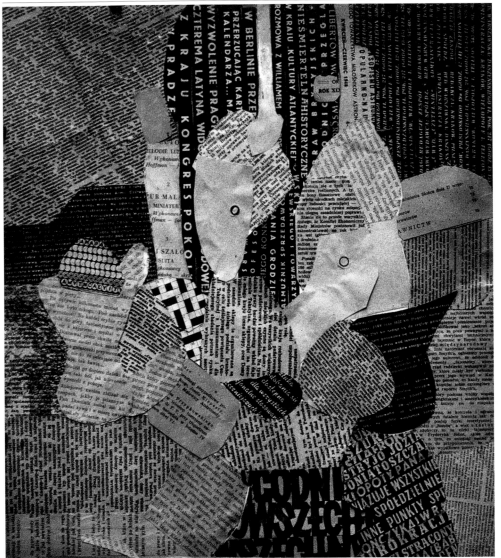

Figure 81

cultural integration differed from the agendas of private bodies, for instance of the Galerie Denise René, as well as from individual contacts developed by critics, such as Michel Seuphor and Pierre Restany. Closer attention, too, needs to be given to the strategies adopted by the numerous French-oriented curators and critics operating within the ideological state apparatuses of Eastern Europe (ministry departments, museums and editorial offices), such as Jindřich Chalupecký in postwar Prague, or the late Ryszard Stanisławski in Łódź.[7] Finally, the complexity of the Parisian dream might be studied in relation to reputations (albeit shifting ones) conferred in their home countries upon those artists who settled successfully in Paris after 1945, such as the Czech Surrealists Toyen (Maria Čermínová) and Jiři Kolař; the Bulgarian-born Christo (who lived in Paris from 1958 to 1964); the Hungarian-born Simon Hantaï; the Polish sculptress Alina Szapocznikow; and later the Polish artist Roman Opałka, whose career breakthrough coincided with his move to France in 1977.

The second major problem is the danger of subscribing to the Orientalist view of Western modernity, which extols the binary relation between centre and periphery, and juxtaposes the Parisian canon with its belated and inferior reproduction in the totalitarian East.[8] A corollary is the perceived dreary homogenisation of the Iron Curtain countries, often represented in Western historiography either as components of a monolithic communist bloc, or as passive satellites of the Soviet Union.[9] Even though the Iron Curtain has been torn down, art history still groups together the visual arts of 'Eastern Europe' as a tangible whole, a unified organism, approachable in its entirety. And yet the postwar transitional period, the Stalinist takeover, and most of all the process of Destalinisation known as the Thaw were experienced at quite different stages and in quite different ways throughout the whole bloc. Any attempt to superimpose onto the entire area an overarching master-script of the Parisian dream, built on the fairy-tale of frost and thaw, might result in hopeless confusion. This essay focuses mainly on Poland, where trust in Paris as a signifier of both artistic and political freedom was greatest, where the pattern of 'having' through 'losing' to 'regaining' Paris was strongest, and where this pattern, furthermore, was turned into the master narrative of Polish art history.

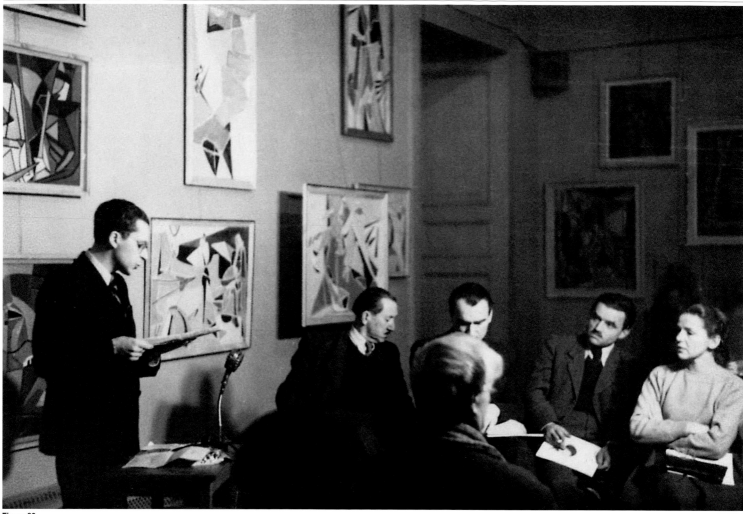

Figure 82

The fount of modernity

What are artists doing in Paris? This was the most burning aesthetic question of the immediate postwar period in Europe, virtually the same question, in fact, that had been asked before the war.[10] Such curiosity was amply satisfied by French-government travel bursaries distributed by the network of Instituts Français and ministerial departments in Central Europe.[11] Tadeusz Kantor, later one of the most internationally visible personalities of the Polish avant-garde, was the first to win a scholarship to Paris in 1947. Kantor's visit is still viewed as a ritual voyage which not only transformed his art by exposing him to the work of Matta and Artaud but even supposedly changed the course of Polish postwar culture. The 'First Exhibition of Modern Art', organised in Kraków in 1948, was a spirited attempt to redefine modernity; contextualised as one of the immediate effects of Kantor's visit, it was heroised as the last cry of the Polish avant-garde before the advent of

Stalinism (figs 81 and 82).[12] In 1998 the fiftieth anniversary of the exhibition was celebrated with a reconstruction in the Galeria Starmach in Kraków; memoirs and photographs assembled in the impressive catalogue testify to the belief in Paris's transformative power held by both the epigones of post-Impressionism and by the avant-garde.[13]

Directly after the Second World War and up until the Stalinist coup of February 1948, however, the Eastern European city most strongly connected to Paris was Prague. Home of significant strands of Art Nouveau, Cubism, Artificialism, Poetism and Surrealism, it had remained in continuous touch with Parisian art movements since 1900. The postwar exhibition of Surrealism at the Galerie Maeght in Paris in 1947 was shown also in Prague, and its Czech catalogue contained texts by André Breton and Karel Teige.[14] Toyen, who helped to organise the show in Paris, moved to the French capital in 1947. Her arrival was marked by an individual show of her paintings and

drawings at the Galerie Denise René, presented by André Breton.[15] Jindřich Chalupecký's socialist periodical *Listy* (*Letters*), published in Prague in 1947–48, was a forum for the discussion of the social responsibilities of Surrealism and existentialism, while Jean Cassou's texts popularising modern art were published in the pro-Communist *Tvorba* (*Creativity*).[16]

Despite its historically strong ties with Vienna and Munich, Budapest leaned heavily towards France as well. The group named the European School (1945–48) promoted Fauvism, Cubism, Expressionism and Surrealism in Hungary and maintained close contact with André Breton. Its more radical offshoot, the Hungarian Society of Abstract Artists, established in 1946, took part in the exhibition of the Parisian Salon des Réalités Nouvelles in 1948.[17] Jean Cassou lectured at the Institut Français in Budapest in 1948, and staged an exhibition of modern Hungarian art in his own Musée National d'Art Moderne in

Paris, in March 1949.[18] Stalin's vilification of Tito, a hero of anti-Nazi resistance, and Yugoslavia's expulsion from the Cominform in 1948 prompted Cassou's departure from the hard-line Stalinist course promoted at the time by the French Communist Party.[19] The art of Yugoslavia, isolated, as it now was, from both East and West, is an intriguing case of political unbelonging.[20] And significantly, Paris, which was relatively accessible to Yugoslavians, lost its magic sooner for them than for those still living behind the Curtain.

While the ideal of Paris as a centre of modernity was maintained in the majority of European countries during the immediate postwar years, Stalinist Russia stood apart. Vivid Parisian memories of the interwar period[21] and the personal links or marital connections of prominent figures there could not prevent Moscow – increasingly entrenched within anti-bourgeois discourse and the obsessive anti-Impressionist campaign of 1948–49 – from restricting the image of Parisian culture to that of *réalisme socialiste*.[22] It was only in 1949, however, that the extraordinary collection of French modernist works in the Pushkin Museum was removed from the public gaze to make room for a display of Stalin's seventieth-birthday gifts which were flooding in from all over the world, one of them being, significantly, André Fougeron's socialist-realist masterwork *Homage to André Houllier*.[23]

In Poland, the appetite for Frenchness, upheld by a lobby of 'colourists' who monopolised art journals, and by former members of Abstraction-Création, was encouraged by the activity of Pierre Francastel, an eminent French art historian who served as the director of the Institut Français in Warsaw both before and after the war.[24] His return to Poland in 1946, now also to the position of a cultural adviser to the French embassy,[25] was marked by two exhibitions of contemporary French drawings and paintings.[26] Both opened in Warsaw in the year in which the Muzeum Narodowe, the only exhibition space in that devastated capital, became a battleground between the hegemonic aspirations of France, Italy, England and the USSR, which were all striving to project their cultures onto the ruined landscape of Central and Eastern Europe. The excitement provoked by the French stood in stark contrast to the lukewarm reception accorded to the other three countries' shows. And yet, responses to

Francastel's display of the art of the 'Young Painters of the French Tradition', including nineteen works by Gischia, Fougeron, Pignon and Tal-Coat, were deeply divided. For many the exhibition served as a 'compass',[27] but others saw in it a regression to figurative painting. Kantor, at the time briefly fascinated with Fougeron,[28] assessed the exhibition as a 'first contact with Europe' and admitted its 'powerful impact'. However, Maria Jarema, a militant communist before the war and a close colleague of Kantor – she would later collaborate with him on the avant-garde theatre Cricot 2 – was alarmingly negative about the exhibition, despite her strong leftist leanings, recording in her diaries in 1946: '…Who do the French think we are, Asia or what, to throw dust in people's eyes by showing this trash? Perhaps our official critics…will understand that the rain they try so hard to squeeze out of socialist realism to water the barren soil of Polish art is very far from any relevant problems of current or future art…'[29]

Maria Jarema's puzzlingly 'prophetic' insight appears, indeed, difficult to comprehend. In the hybrid identity of the Young Painters of the French Tradition which embraced both abstraction and figurative work, looking back, as it did, to both Romanesque murals and French social radicalism, Jarema recognised the portentous signs of the advent of socialist realism. Her own bursary to Paris in 1947, at the time of the

Figure 83

84 Pablo Picasso, *Warsaw Mermaid with Hammer*, 1948
Charcoal on plaster, *c.* 180 × 170 cm
Council housing apartment, Koło, Warsaw
(now destroyed)

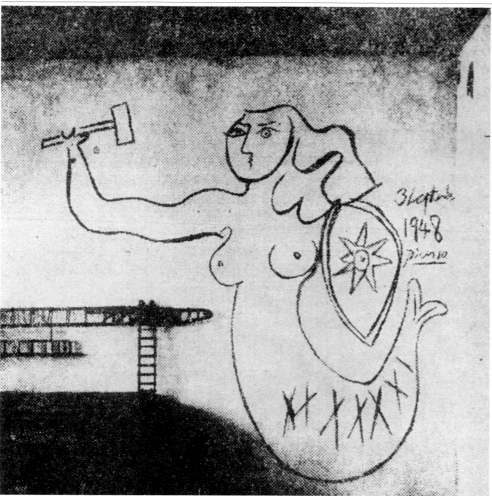

Figure 84

exhibition of Surrealism at the Galerie Maeght and the 'Tendances de l'art abstrait' at the Galerie Denise René, reaffirmed her belief in metaphorical abstraction, in which she worked until her early death in 1958 (fig. 83).

The 'recommended' Paris

Jarema's diary entry articulated the fear that Stalinism might be grafted onto the emaciated body of Polish postwar art through the authority of Paris. Indeed, a peculiar if hardly ever admitted fact about Polish socialist realism was that it came from Moscow via Paris. Many of those who accepted socialist realism did so largely because of its French credentials. In other words, the advent of Stalinism in Poland was justified by its endorsement within the field of the Stalinist development of an erstwhile Surrealist gaze, exemplified by Louis Aragon and Picasso, which, itself, was so adoringly turned towards Moscow. Mieczysław Porębski, one of Poland's most eminent art critics and one of the last stipendiaries of the French

Government before the Stalinist clamp-down, confessed that Surrealism led him to socialist realism, as it had Eluard and Aragon before him.[30] Ryszard Stanisławski, a student of Jean Cassou in Paris in 1948, voiced the belief that the authority of Paris's Left Bank had lent attraction to a socialist utopia; after his return to Poland he curated an exhibition of works by French Communist artists in Warsaw (1952).[31] He later became the director of the museum in Łódź, where he turned his back on socialist realism and devoted himself to the task of reinstating Polish and Eastern European abstract avant-gardes into limited Western accounts of modernity, curating, at the latter end of his career, the exhibitions 'Présences polonaises' in Paris in 1983 and 'Europa–Europa' in Bonn in 1994.[32]

The turning point, when the trope of modernist Paris was displaced by that of the 'recommended' communist Paris, came in the last days of August 1948, during the World Congress of Intellectuals for Peace. The Congress took place in Wrocław, the capital

85 Pablo Picasso, *Polish Woman*, 1948
Ink on paper, 25 × 17.5 cm
Muzeum Narodowe, Warsaw

86 Tadeusz Ćwik, a member of the Polish delegation for
the first Peace Congress in Paris in 1949, helps Picasso to
try on Polish folk dress from the Łowicz region in 1949

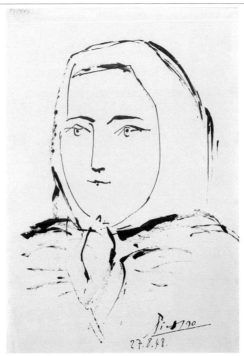

Figure 85

Figure 86

city of the ex-German territories newly joined
to Poland, and, ironically, was endorsed by
Picasso, who was to become an untiring
supporter of the Soviet-sponsored World
Peace Movement and the designer of its most
famous symbol, the Dove of Peace.[33]
Organised by Poland and France, yet believed
to have been steered from Moscow, the
Wrocław Congress initiated a movement
which united the 'partisans of peace' around
the globe in their struggle against the
'imperialist warmongers'. Paradoxically, while
attempting to prevent the division of the
world into East and West, the Congress
petrified the schism between the two sides,
which were mapped out by the rhetoric of the
'containment' and the 'two camps' policies
launched by Truman and Zhdanov.[34]

The French delegation included
luminaries of the intellectual and scientific
left, such as the physicist Irène Joliot-Curie,
the poet Paul Eluard, the writer and publisher
Vercors and the sculptor Emanuel Auricoste,
but its most prominent members were Picasso
and Léger. Léger left the Congress early,
disheartened by the limelight focused on
Picasso, but the latter's presence in Wrocław
and his subsequent two-week-long
triumphal tour through war-struck Poland
were invested with quasi-ritualistic meaning.
He was shown the ruined cities and the sites
of Nazi atrocities, including Auschwitz and
the Warsaw Ghetto, as well as the housing

settlements being constructed by the new
Poland. His gift of his own ceramics to the
Muzeum Narodowe in Warsaw and his
performance of painting emblems of peace
and communism onto the freshly plastered
walls of communal apartments (fig. 84),
were readily presented as a blessing on the
country's cultural politics conferred by the
world's highest artistic authority.[35] A pivotal
significance was attached to Picasso's interest
in Polish folk art and folk dress, prompting the
authorities to present him with a sheepskin
coat made by Tatra mountaineers and other
items of Polish peasant dress.[36] His voluntary
'entering of the Polish skin' provided a
splendid photo opportunity, serving to
legitimise the hardening course of cultural
policy which juxtaposed the sanity of folk
culture with the decadence of bourgeois art
(fig. 86). Picasso's 'sketch of a new Poland' as
communist, anti-American and folklorised
(fig. 85) won him one of the highest honours
of the Polish State, which he received from
the President, Bolesław Bierut.[37]

Picasso's vision of the new Poland ran in
parallel with the image of the enforced 'Iron
Curtain Paris'. The exhibition of seventeen
'Contemporary French Painters' shown in
Wrocław during the Congress and later at
the Muzeum Narodowe in Warsaw was
a complex manifestation of these changes
(fig. 87). Visually 'modernist', although not
provocatively so, it included Picasso's *Seated*

87 The exhibition of 'Contemporary French Painters' at the Muzeum Narodowe, Warsaw, in November 1948, with Taslitzky's *The Delegates* (see cat. 181) on the far right

88 Wojciech Fangor, Film poster for René Clement's *The Walls of Malapaga* (1950), 1952
Muzeum Plakatu, Wilanów, Warsaw

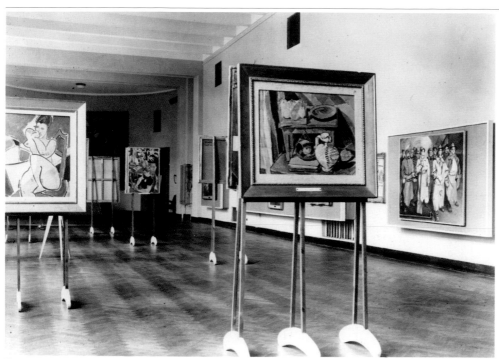

Figure 87

Woman in a Hat (1939),[38] a couple of Picasso drawings, and the set of his ceramic plates. The upholders of post-Impressionism, such as Bonnard and the later Ecole de Paris with Gromaire, were featured, while the socialist-realist tendency in Paris was re-emphasised by a vast canvas, *Delegation*, by Boris Taslitzky. However, it was Jean Marcenac's original introduction to the catalogue, reprinted in the literary magazine *Odrodzenie* (*Rebirth*), which, more forcefully than the display itself, established Paris as a multinational capital of social radicalism. It ended with a hot declaration of the political function of art: 'The era in which painting was a test of skill is over. Today, it is the test of conscience. Painting is not satisfied by illusory truths, but wants to trespass and go beyond them, to reach reality; aiming towards artificial beauty is no longer considered art...Picasso's woman and Boris Taslitzky's workers speak the same language, and express what they essentially are. The woman is what she has been made by the world; the workers are the ones who want to [re]build this world.'[39]

A simulacrum of communist and anti-American Paris – the Paris of the unemployed and the *clochards* – dominated the Polish media of the time. Cinema magnified the heroism of the Front National de Résistance (fig. 88) and the press dwelt upon the miseries of life in 'Marshallised' France. Cultural magazines were keen to report the

'martyrdom' of French realism, focusing on events such as the scandal of the Salon d'Automne of 1951 from which seven paintings by communist artists were removed by police as 'unpatriotic'. Aragon's riposte, his manifesto 'Peindre a cessé d'être un jeu', was reprinted in the widely read Christmas issue of *Nowa Kultura* where it was accompanied by reproductions of the expelled works and a Polish poem commemorating the 'Seven Dangerous Compositions'.[40] Four of them were subsequently shown in Warsaw, at the 1952 exhibition of French art.[41]

And yet, if Paris supported socialist realism in Poland, it also helped to dismantle it. Fangor's *The Figures* (fig. 89) is comparable to the works of André Fougeron. Although flagrantly propagandistic, it lacks academic finish, and through its flatness and the use of primary colours reveals a modernist awareness of the medium.[42] The 1952 Warsaw exhibition, prefaced in a truly inspired manner by Paul Eluard, was intended as evidence of the victory of progressive realism over the self-annihilating abstraction of French postwar art. However, some blatantly 'formalist' paintings, such as Bernard Lorjou's *Conference*,[43] were included as were Léger's *Constructors* and Picasso's notoriously anti-American *Massacre in Korea*. The presence of these works corroborated the use of interventionist art in the service of the Party, but at the same time

Figure 88

89 Wojciech Fangor, *The Figures*, 1950
Oil on canvas, 100×124 cm
Muzeum Sztuki, Łódź

90 Reproduction of Picasso's *Massacre in Korea*
on the streets of Warsaw, October 1956

Figure 90

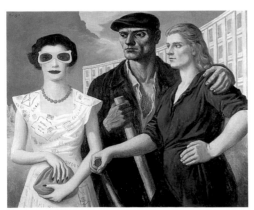

Figure 89

undermined the very essence of socialist realism: the transparency of the medium. The mainstream of Polish critical discourse would soon assert the need for a 'new realism' in Polish art which would derive its strength not from 'dispirited repetitions' but from 'creative experiments', pointing to the 'lessons' of Courbet, Cézanne and Picasso, and would thereby stretch the definition of realism to such lengths that it could incorporate even what was termed 'engaged' abstraction.[44] The latent image of the 'forbidden' Paris was beginning to emerge through that of the 'recommended' Paris, giving Poland a much earlier foretaste of the aesthetic Thaw than other countries of the bloc.

The political Thaw, triggered by Stalin's death in 1953 and named after Ilya Ehrenburg's novel of 1954,[45] only really came about with the denunciation of Stalinist 'errors and distortions' at the Twentieth Soviet Party Congress in Moscow in 1956. Ironically, at precisely the same time, Picasso's *Massacre in Korea* was displayed again to significant effect in Poland. In October, with Picasso's 75th-birthday exhibition opening in Moscow while Soviet tanks were invading Hungary, a large reproduction of the work was displayed in a busy Warsaw street (fig. 90).[46] In the act of redeeming the interventionist potential of Picasso's art, the partisan Polish viewer denounced the artist's political stance, pointing to the proximity between subversion and submission in all politically involved art.

Paris regained

That same Warsaw viewer had already witnessed the sudden consignment of socialist realism to the 'dustbin of history'. According to the narrative of the Thaw, the 'awakening from the nightmare of socialist realism' brought an 'explosion of modernism', the 'restitution of art to the artists' and the revindication of art's holy autonomy, which itself, as argued by Piotr Piotrowski, turned into a dogma.[47]

An essential factor of the Thaw in Poland was that it reopened the road to the 'forbidden' Paris. In other words, the revindication of the 'artness' of art meant a return to the 'real' Paris, a regaining of 'paradise lost'. On the one hand, it opened

91 Andrzej Wróblewski, *Woman in Chair I*, 1956
Oil on canvas, 155 × 125 cm
Muzeum Narodowe, Kraków

92 Tadeusz Kantor, *Amarapura*, 1957
Oil on canvas, 100 × 120 cm
Muzeum Narodowe, Poznań

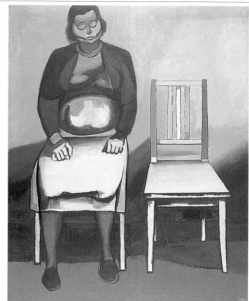

the floodgates of existentialist despair, an act which was eagerly awaited after years of compulsory socialist optimism, even if the existentialism was still framed by figurative idioms (fig. 91).[48] On the other hand, it loosed a euphoric delight in non-representational painting, in Tachism and the Informel, as exemplified by a series of abstract compositions by Kantor, which, made after his second visit to Paris in 1955, share closely the effervescence of the painterly gesture with the euphonic quality of their otherworldly titles, structured as neologisms (fig. 92). Not only was Kantor practising Tachism himself at that time, but he also embarked on a tour around Poland giving slide lectures on the French Informel and arguing that this new strand of abstraction – emphasising gesture and 'matter' as well as the process of creation – was the only adequate expression of contemporary art.[49] In the early 1960s he merged the experience of Surrealism and *peinture de matière* with his intensely theatrical vocabulary of degraded bodies and the degraded reality of *objets trouvés* and *emballages*. This fusion was to become the basis of both his art and his avant-garde theatre, Cricot 2. From the late 1950s he would return to France regularly, exhibiting his work and staging theatrical performances (fig. 93).[50]

The degraded matter of *objets trouvés*, as well as the experiences of Surrealism and Nouveau Réalisme, formed also the boldly experimental art of Władysław Hasior (fig. 94), who, after his visit to France in 1959, cast his sculptures in earth moulds and produced his first assemblages, becoming a member of the late Surrealist Phases Group in 1961.[51]

Although by the late 1950s the ideas of French Tachism and the Informel had been absorbed by Hungarian and Czechoslovakian artists, it was only in Poland that modernism was given a *porte-parole* by the party and 'became an element of official cultural strategy'.[52] Some would argue that it served as a token of an illusory political freedom.[53] The most spectacular demonstration of this new policy came during the gigantic exhibition 'The Art of Socialist Countries', which opened at the end of 1958 in Moscow. The inclusion of abstraction in the Polish section set it apart from all other national representations and caused a scandal which resulted in the placing of protective ropes around the abstract paintings of Adam Marczyński. While Soviet viewers' responses were a mixture of enthusiasm and hostility, the authorities condemned the Polish display unequivocally as a 'treacherous denial of socialist ideology and aesthetics'. Defending

Figure 91

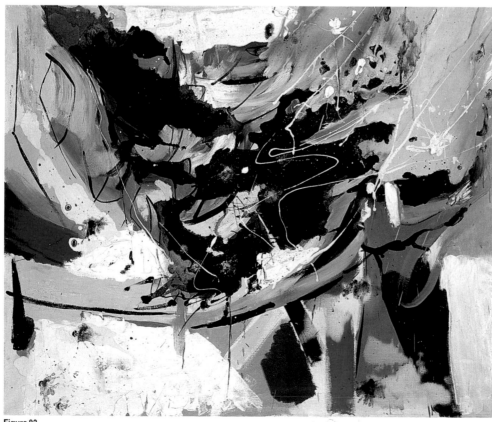

Figure 92

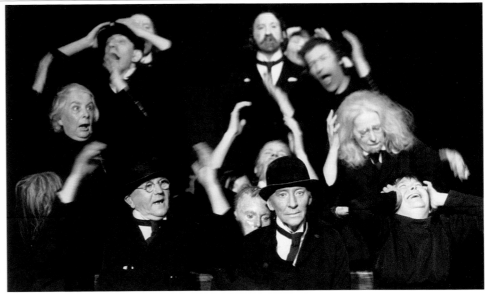

Figure 93

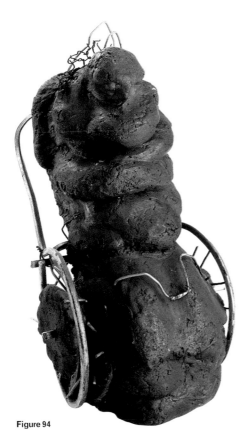

Figure 94

his decision, the curator of the Polish delegation, Juliusz Starzyński, pleaded against the uniformity of socialist art and for the right to pursue national traditions, as well as for the wider understanding of 'realism'; he also admitted, 'unapologetically', the influence of French art.[54] While the 1952 exhibition of French Communist art in Warsaw might have supported the redefinition of socialist art in Poland, the Polish display in Moscow, as argued by Susan Reid, helped in turn to 'admit a range of modern styles as legitimate forms of socialist artistic expression' to the Soviet Union.[55]

During the 1960s, however, the absolute hegemony of the Parisian dream was beginning to turn into a nostalgic memory, even in Poland.[56] The freedom to look at Parisian art mattered increasingly, but so did the chance to be seen there.[57] Throughout the 1950s and the 1960s, Paris was undeniably the city in which artists from Eastern Europe were exhibited by both state museums and private galleries. At the helm was Denise René, with her successive displays of the pioneering Polish Unism (1928) and geometrical abstraction in 1957, of abstract Yugoslavian art in 1959, and of work by the Hungarian Constructivist Lázló Kassak in 1960 and 1967.[58] A young Polish artist, Jan Lebenstein, received the Grand Prix at the Première Biennale de Paris in 1959.[59] And yet, although not losing its supremacy as the most prestigious stage for artists, Paris was being outflanked, quantitatively, by the sheer number of other cities, mainly

in Germany, but also in the Netherlands, Scandinavia, Italy, Switzerland and America, which were now eager to 'discover' art from behind the Iron Curtain. At the time of the balanced show of 'Douze peintres polonaises modernes', organised under the auspices of the Polish Ministry of Art and Culture in the Musée National d'Art Moderne in Paris in 1961,[60] another exhibition of Polish contemporary painting emphasising its more fashionable non-figurative directions opened at MOMA in New York as a private initiative of the American critic Peter Selz.[61] In 1974, Eva Cockroft, a revisionist Cold War historian, read the exhibition through a simplified narrative of postwar Polish modernism, reducing Paris to the site where Kantor encountered Pollock: 'Especially important was the attempt to influence intellectuals and artists behind the "iron curtain". During the post-Stalin era in 1956, when the Polish government under Gomułka became more liberal, Tadeusz Kantor, an artist from Kraków, impressed by the work of Pollock and other abstractionists which he had seen during an earlier trip to Paris, began to lead the movement away from socialist realism in Poland…This kind of development was seen as a triumph for "our side". In 1961, Kantor and 14 other non-objective Polish painters were given an exhibition at MOMA. Examples like this reflect the success of the political aims of the international programs of MOMA.'[62]

This passage, illustrating a larger narrative of the decline of Paris and the ascendancy of New York, might serve as evidence that the

95 Alina Szapocznikow, *Headless Torso*, 1968
Polyester and polyurethane, 46 × 64 × 73 cm
Galeria Sztuki Współczesnej Zacheta, Warsaw

96 Alina Szapocznikow in her Malakoff studio,
near Paris, 1967, with her sculpture *It's Running Red*

constitutive Eastern European gaze was now in much greater demand by the decentred Western self.

Belief in the transformative Parisian dream, in the 'internationale de l'esprit', might have been declining behind the Iron Curtain, but it would not be discarded. While an increasing number of artists, especially the practitioners of the fabulously successful Soviet Sots art, would be heading towards New York from the late 1970s, Poles were more likely to remain loyal to Paris. Alina Szapocznikow, who studied at the Ecole des Beaux-Arts during 1948 (meeting her first husband, Ryszard Stanisławski) and returned to Paris permanently in 1963 (with the graphic designer Roman Cieślewicz), was a success both in Poland and in Paris. Outgoing and well-assimilated in 'le monde Parisien', she befriended César, Annette Messager, Jean Cassou, Pierre Restany and many others. She was also noticed by Marcel Duchamp, who awarded her the Copley Foundation prize at the XXI Salon de Mai of 1965 for her gilded readymade, *Goldfinger*. However, the body-

focused art of her Parisian period, before her early death from cancer in 1973, transcended the boundaries of the 'French influence'. Her casts of her own body narrate a poignant 'herstory' (figs 95 and 96): the spectacle of an untamed sensuality, of voyeurism, tempting with the glamour of her physical beauty; a sensuality which turns later into an introspective consideration of her cancerous tumours, exploring the gap between the polished exteriority and the monstrous otherness of the body, long before Cindy Sherman's late photographs.[63] At the other end of the spectrum lies Roman Opałka's monochrome art, which records the passage of time both in numbers and in sound. Initiated in 1965 in Warsaw and continued since 1977 in France, it combines the rigid intellectualism of 'Eastern' Constructivism with the transnational and hybrid landscape of contemporary art media.[64]

It appears then, that long before the fall of the Berlin Wall, Paris lost its geographical specificity, spreading the paradise of Parisian-ness both East and West.

Figure 96

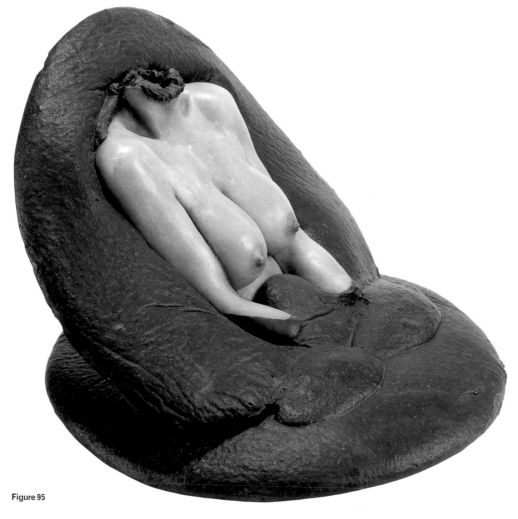

Figure 95

I would like to thank Sarah Wilson, Peter Sawbridge and Maryvonne Gilles for their assistance with my text.

1 Žižek 1992, p. 193.
2 See Wolff 1994; the invention of Eastern Europe forms part of the larger orientalist discourse. See also Todorova 1997.
3 On the Iron Curtain metaphor, see Hinds and Otto-Windt Jr 1991, pp. 89–127; and Murawska-Muthesius 2000B.
4 While American rhetoric had the world divided between 'freedom' and 'totalitarianism', Soviet terminology saw the struggle as between the 'imperialistic and anti-democratic' and the 'democratic and anti-imperialistic' camps; for crucial speeches by Truman and Zhdanov, see Stokes 1996, pp. 33–42.
5 Guilbaut 1990, pp. 33 and 74.
6 Guénard 1994; for a study of the activity of the Institut Français in postwar Vienna, a city which remained in a somewhat ambiguous East/West position until 1955, see Dankl 1996.
7 An exhibition devoted to the activity of the Galerie Denise René was recently staged in Łódź; see Łódź 1997. A posthumous celebration of the lifelong activity of Ryszard Stanisławski is being prepared by the Gallery of Contemporary Art Zachęta in Warsaw. For Jean Cassou's links with Eastern Europe, see his memoirs: Cassou 1981, pp. 245–74.
8 On the problematisation of East–West relationships in studies of Eastern Central European art, see Piotrowski 1999 and Piotrowski 2000, as well as Piotrowski's forthcoming book on the art of Eastern Central Europe; see also Elkins 2000, a review of Mansbach 1999.
9 Among authors who have addressed this problem, see Stanisławski 1988, p. 204; Cârneci 1993; Hegyi 1999; Piotrowski 1999; Piotrowski 2000; and Piotrowski 2000B. Among exhibitions examining the identity and difference of Eastern European art, see Berlin 1994; Chicago 1995; Schwerin 1996; Ljubljana 1998; Stockholm 1999; and Vienna 1999. Eastern Europe is a flourishing topic in the field of politics, human geography and international relations; see Žižek 1992; Simmons 1993; and Hupchick and Cox 1996.
10 See Teresa Tyszkiewicz's diary of 1945–49, written largely in French, and reprinted in Kraków 1998, pp. 58–74: 'Today, we teach students the rules of Impressionism, that is, the perception of colours. Sensitivity to colour shapes form and the image… I very much wonder how the Academy in Paris teaches its students today. No doubt, they also copy nature there, but through another truth. Which?…How impossible is this distance.' See also Folga-Januszewska 1995; and Piotrowski 1999.
11 See Kraków 1998, pp. 15–53, 144 and *passim*; Pejić 1999, p. 118; and Świca 1999.
12 Markowska 1996; Nowaczyk 1996, p. 261; and Kraków 1998, pp. 144–45 and *passim*. Interestingly, this same artist who readily absorbed Parisian novelties was the one who attempted to decentre the Parisian hegemony during the crucial discussion between artists preceding the imposition of socialist realism, trying to convince his audience that 'we cannot constantly depend on France'. See Kraków 2000, vol. 2, p. 33.
13 A snapshot of a Parisian street or café becomes a fetish which certifies passage to the other side, an anointment by immersion in the purity of art, like the Parisian Métro ticket clutched by Yves Montand in the closing scene of *The Wages of Fear* (1953). See Kraków 1998, pp. 15–39, 144 and *passim*.
14 Prague 1947.
15 Toyen remained an active participant in postwar Surrealism, and had numerous individual exhibitions in Paris until her death in 1980. On Toyen, see Paris 1982C; and Prague 2000. On Czech Surrealism, see Prague 1996; and London 2001, pp. 238–39. On Czech art after 1945, see Prague 1994.
16 Cassou 1947B. For Chalupecký's writing, see his complete works: Chalupecký 1999.
17 For the European School and Franco-Hungarian links to 1968, see Láncz 1975; György and Pataki 1990; Budapest 1993; Pataki 1999; and Pataki 2000.
18 Cassou 1981, p. 264.
19 Cassou 1981, pp. 245–59. See also 'M. Jean Cassou prend parti pour le régime de Tito', interview in *Le Monde*, no. 1417, 16 August 1949; Cassou 1949; and Judt 1992, chapter 5, 'Show Trials. Political Terror in the Eastern European Mirror, 1947–1953' and chapter 6, 'The Blind Force of History'.
20 On Yugoslavian art, see Blažević 1999.
21 See Gladys Fabre's essay in this catalogue, pp. 40–53.
22 The novelist Ilya Ehrenburg was a close friend of Louis Aragon and Picasso. Elsa Triolet was married to Aragon, and Nadia Khodossievitch-Léger to Léger. On Moscow's view of Parisian art, see Baudin 1997, pp. 227–32, who stresses the rigorous visual censorship of 'negative' images.
23 Cf. Wilson 1981, and Sarah Wilson's essay in this catalogue, pp. 236–49.

24 Before the war Francastel organised a blockbuster exhibition 'French Painting from Manet Until the Present', which was staged in the newly built Muzeum Narodowe in Warsaw in 1937. See Warsaw 1937; and Jarocki 1981, pp. 162–63. See also Francastel 1996.
25 It is worth mentioning that the same function was given to Michel Foucault in 1958. Although his name is listed among the organisers of the 1959 exhibition of French painting in Warsaw (catalogue: Warsaw 1959), Foucault, according to an oral communication from co-curator Janina Michałkowa, was not actively involved in this event; he stayed in Poland from October 1958 to the summer of 1959. See Macey 1993, pp. 85–87.
26 Warsaw 1946 and Warsaw 1946B. Francastel also brought the exhibition of French cinema to Poland; Warsaw 1947.
27 See the memoirs and interviews with Bogusław Szwacz, Janina Kraupe and Teresa Tyszkiewicz in Kraków 1998, and p. 142.
28 See Kantor 1947; and Markowska 1996.
29 Maria Jarema's controversial assessment of the French 1946 exhibition which, after Warsaw, was shown in Kraków, in the Pałac Sztuki (Palace of Art), comes from her unpublished diary which is kept by her family. I quote here from the catalogue of a large retrospective exhibition of her work, curated recently by Barbara Ilkosz (Wrocław 1998, p. 67).
30 Czerni 1992, pp. 58–59. The French leanings of Polish socialist realism have not been admitted in the major discussions of this movement in Poland, such as Włodarczyk's *Socrealizm*, which was published in 1986 under the aegis of the Institut Littéraire in Paris, culturally the most important centre for Polish emigrés. It is significant that at the time when the anti-modernist/anti-formalist dogma of Soviet socialist realism was being seriously questioned by the strong lobby of Polish post-Impressionists, Aragon's praise of the movement in a series of articles in *Les Lettres françaises*, published throughout 1952, was printed in its defence, abbreviated as a single text, by a popular literary magazine: see Aragon 1952. On Polish socialist realism, see Warsaw 1987; Ilkosz 1988; Murawska-Muthesius 1999; and Kraków 2000.
31 Stanisławski 1988.
32 The popularity of Stanisławski's 'Présences polonaises', shown when Poland was in the grip of martial law, and the dazzling Warsaw success of its 1986 sequel '4 × Paris' have not so far been eclipsed. Both exhibitions were invested with the persevering belief in the redemptory force of the Polish-French alliance, empowered to preserve and to 're-present' Polishness.
33 For more information on Picasso's role as the 'Party artist', see Utley 2000, particularly pp. 101–33.
34 See 'The Truman Doctrine and the Two-Camp Policy', in Stokes 1996, pp. 33–42. I am grateful to Stanley Mitchell for sending me his unpublished paper 'The Wrocław Congress', given at the conference 'Cold War Culture' at University College, London, 1994; see also Taylor 1948; Congrès Mondial 1949; and Topolski 1988.
35 On Picasso in Poland, see Bibrowski 1979; Wilson 1992; Wilson 1996B, pp. 246–47; Bernatowicz 2000; and Utley 2000, pp. 106–08.
36 A particularly splendid sheepskin coat was presented to Picasso by Caziel (Kazimierz Zielenkiewicz), a Polish painter active before and after the Second World War in Paris and later in England (Pery 1997, p. 37). On his visit to Picasso's studio, in a letter to Bibrowski, Caziel reported on Picasso's 'Polish period', a term which was to be adopted by Picasso himself: 'Picasso was then – as he used to say – in the "Polish period"; there were lots of toys, paper cut-outs, saints, textiles, earthenware pots, which he brought from Poland…He liked our folk art very much. While looking at a figure of a saint [carved by a] mountaineer, in *Sztuka Ludowa* (*Folk Art*), he remarked: "You should cast it in gold."' Bibrowski 1979, p. 48.
37 The same order was given to Paul Eluard; two years later Picasso won the Warsaw Peace Prize for the design of the Dove of Peace at the Second World Congress for Peace in Warsaw in November 1950. See Bibrowski 1979, p. 21 and *passim*; and Utley 2000, pp. 113–15.
38 Zervos 1959, no. 158.
39 Marcenac 1948. The Wrocław exhibition was later shown in Warsaw. Augmented there, it included paintings and watercolours by Chagall, Desnoyer, Dufy, Gromaire, Léger, Lhote, Lorjou, Matisse, Picasso, Pignon, Planson, Rouault, Singer, Taslitzky, de Waroquier and others. See Warsaw 1948.
40 Aragon 1951.
41 Among the works displayed were: *1 May Parade* by Anne Marie Lansiaux; Gérard Singer's *10 February at Nice*; *Les Dockers* by Georges Bauquier; and Jean Milhau's *Maurice Thorez Is Getting Better*. See Warsaw 1952, nos 3, 20, 26 and 40.

For a comparison of the visibility of French Nouveau Réalisme in the Soviet Union and Poland, see Baudin 1997. Progressive art from capitalist countries was also presented, usually in fixed sets of approved images, in other Eastern European countries; see Kára 1950. 'Algeria 1952', a travelling exhibition of works by Taslitzky and Mireille Miailhe, went to Bucharest and Prague in 1954. See Wilson 1996B, p. 248.
42 Often misidentified as an emblem of Polish socialist realism, the painting was first exhibited in public only after its acquisition by the Muzeum Sztuki, Łódź, in 1975.
43 The work was subsequently acquired from the exhibition, with the paintings by Fougeron and Taslitzky, by the Muzeum Narodowe in Warsaw.
44 Starzyński 1954.
45 Ilya Ehrenburg, *Ottepel': povest'*, Moscow, 1954. The English translation by Manya Harari appeared as *The Thaw*, London, 1955.
46 See Desanti 1975, p. 341; the photograph, first shown by Penrose 1980 (ills 313 and 314), has recently been reproduced in Utley 2000, p. 152.
47 Piotrowski 1996; Piotrowski 1999B, pp. 40–90; and Piotrowski 2000B, pp. 143–45.
48 On existentialism in Polish art, see Kasprzak 1996.
49 Piotrowski 2000B, p. 144.
50 Bablet 1990; Miklaszewski 1992, pp. 54–59; and Kraków 2000B.
51 Stockholm 1968; Göteborg 1976; and Micińska 1993.
52 See Ševčík and Ševčíková 1999; Pataki 1999; and Piotrowski 2000C.
53 Piotrowski 1996, p. 255; and Piotrowski 2000B, p. 144.
54 Reid 2000, p. 116.
55 Reid 2000. See also Piotrowski 2000B, pp. 134–37.
56 Henry Moore's exhibition, organised by the British Council and touring Poland between 1959–60, unbalanced the hitherto steady equation of Paris with modernity. See Murawska-Muthesius forthcoming.
57 See Hughes 1999.
58 Paris 1957B; Paris 1959; Paris 1960; and Paris 1967D. See also Łódź 1997. Among other major exhibitions of Polish art in France, see Paris 1961; Paris 1969; and Lyons 1992B. Exhibitions of French art in Poland include Warsaw 1956; Warsaw 1959 (organised by Jean Cassou); Warsaw 1986; and recently Warsaw 2001.
59 Paris 1959C.
60 Paris 1961.
61 New York 1961.
62 Cockroft 1985, p. 131–32.
63 On Szapocznikow, see Paris 1967C; Paris 1973; and Warsaw 1998, particularly the essays by Urszula Czartoryska and Anna Król and the texts by French authors: Annette Messager, Olivier O. Olivier and Pierre Restany.
64 On Opałka, see Tours 1986; Opałka 1992; Savinel, Roubaud and Noël 1996; Balon 1998; Desprats-Péquignot 1998; and Sosnowski and Piasecki 1998.

157

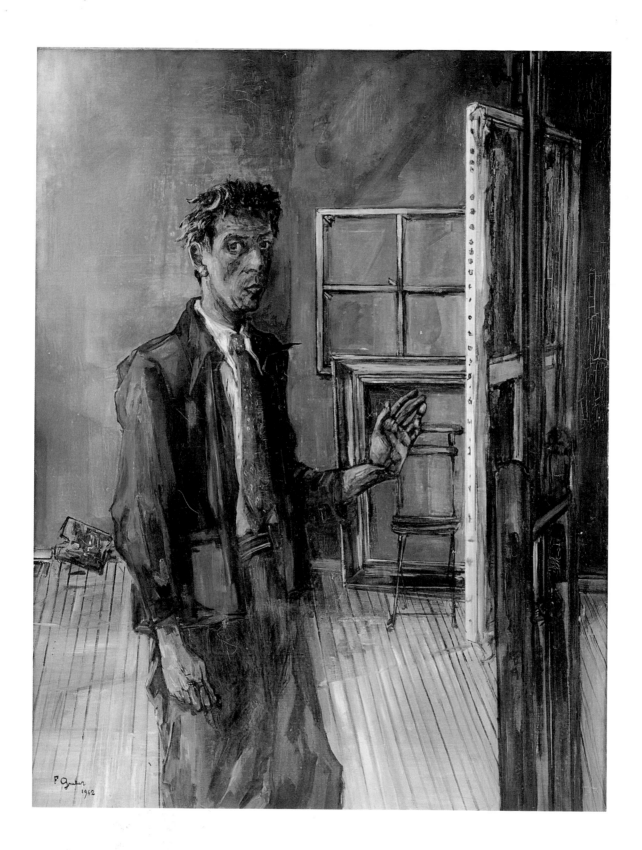

Bernard Buffet
Man with Skull, 1947
Oil on canvas, 177 × 119 cm
Ida and Maurice Garnier

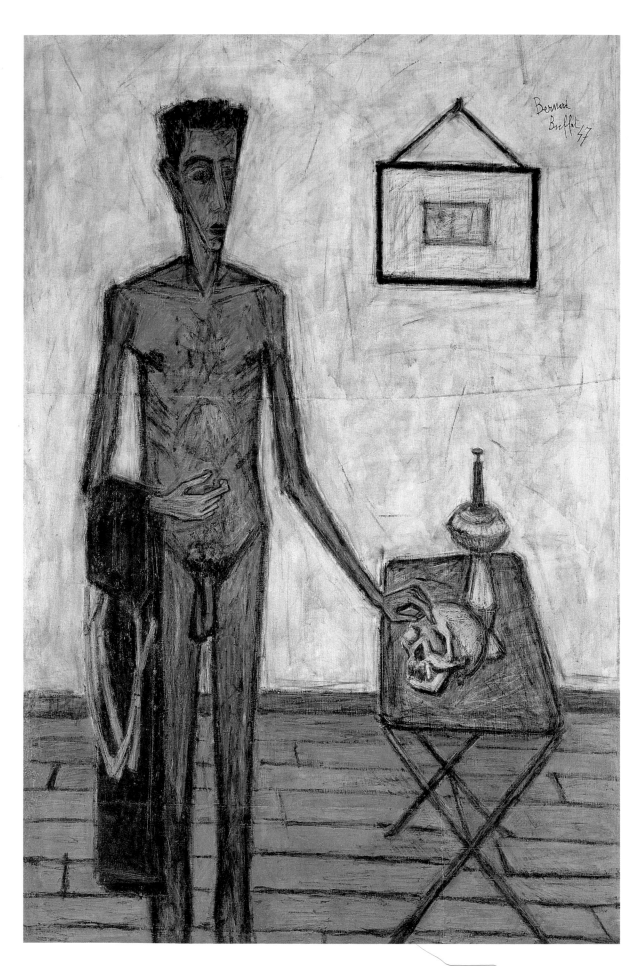

Georges Braque
Vanitas, 1939
Oil on canvas, 38 × 55 cm
Musée National d'Art Moderne, Centre Georges
Pompidou, Paris. Gift of Madame Georges
Braque, 1965

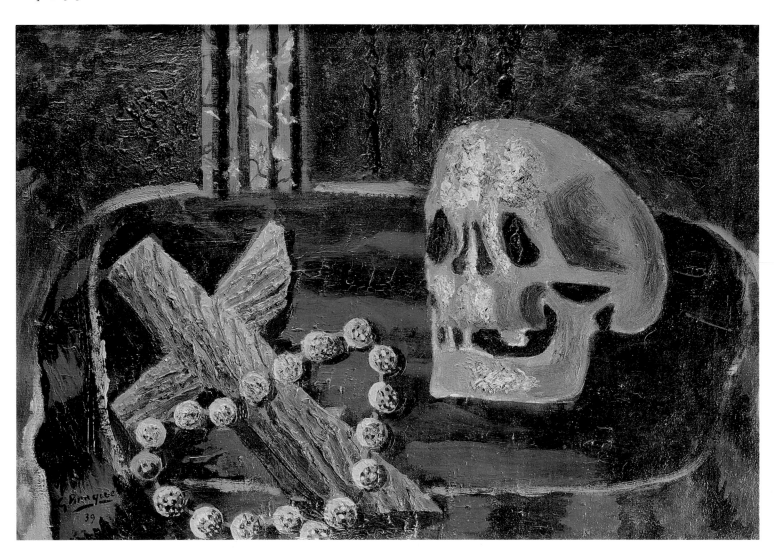

Pablo Picasso
Still-life with Skull and Pitcher, 1943
Oil on canvas, 45.9 × 55 cm
Collection Musée d'Art Moderne de Céret

160

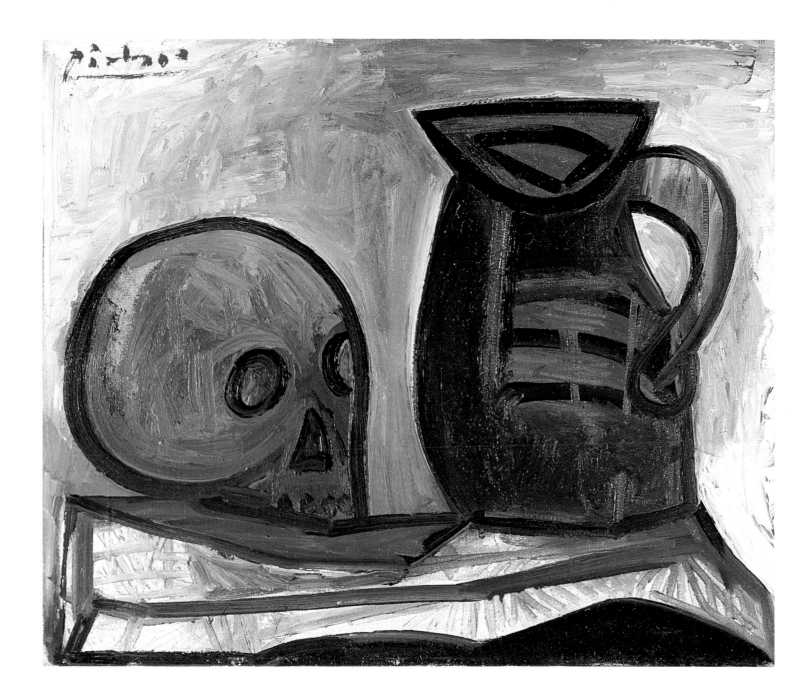

Pablo Picasso
*Death's Head, Leeks and Pitcher Before
a Window*, 1945
Oil on canvas, 73 × 116 cm
Private collection

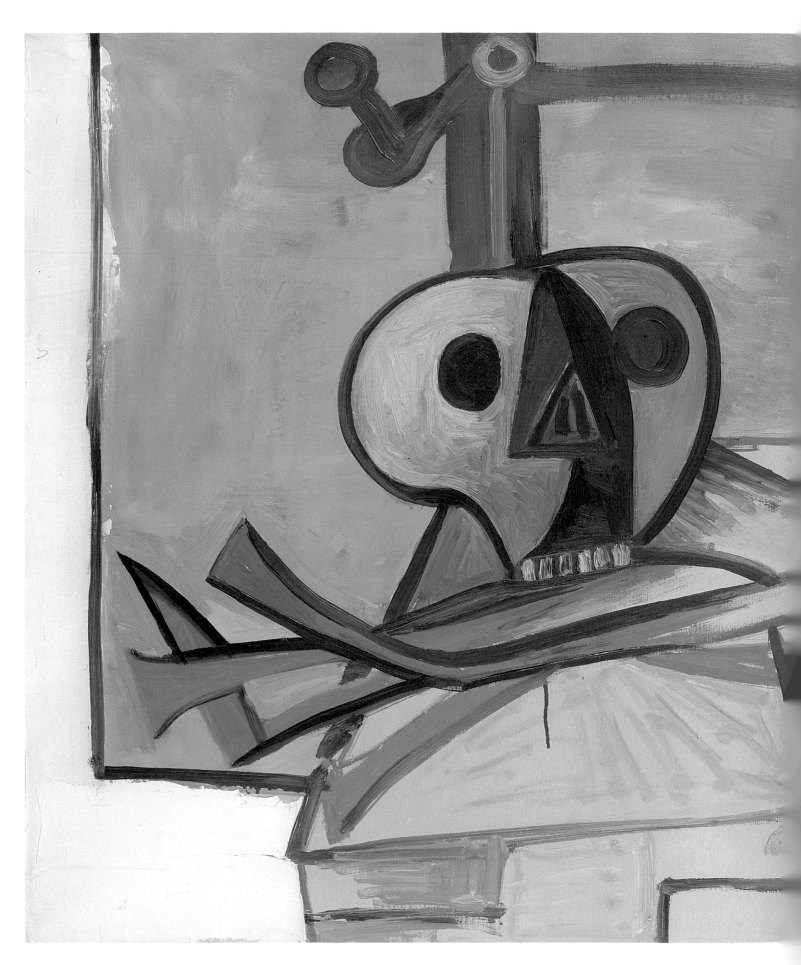

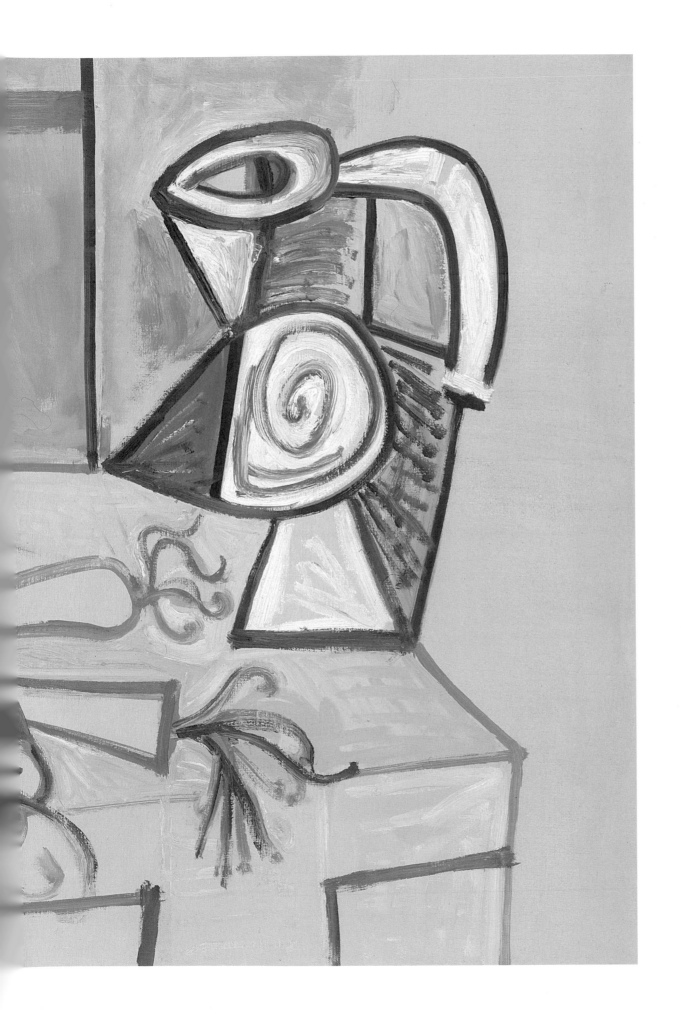

Francis Picabia
Adoration of the Calf, 1941–42
Oil on board, 106.5 × 76.2 cm
Private collection, New York

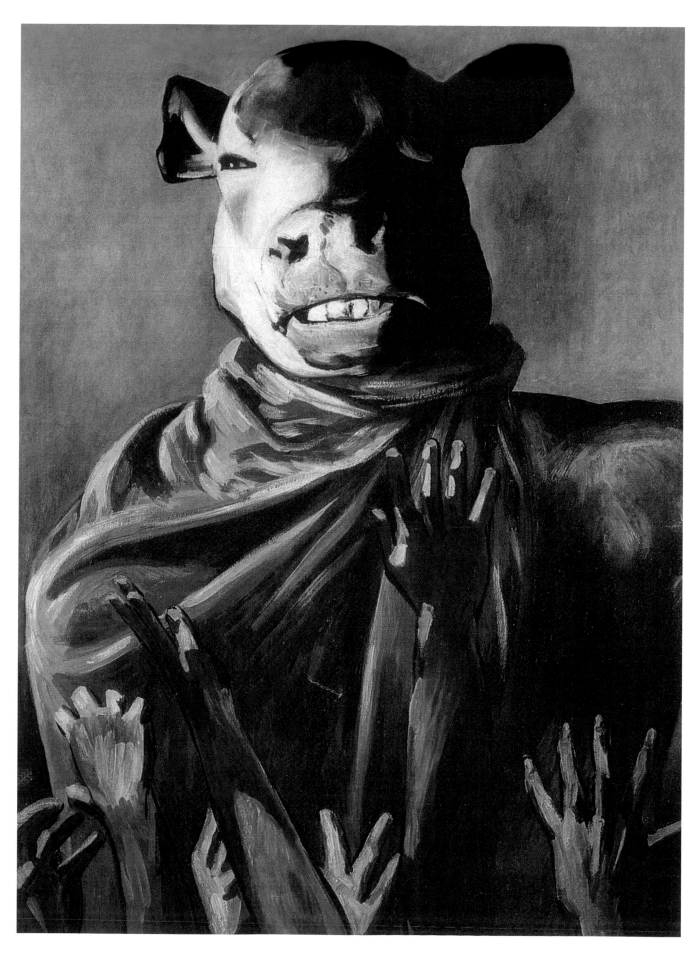

Jean Fautrier
Hostage, 1943
Bronze, 48.5 × 28 × 30 cm
Private collection, Germany

Jean Fautrier

Hostage no. 22, 1944
Oil on paper, pasted on canvas, 27 × 22 cm
Collection Marin Karmitz

164

Jean Fautrier

The Pretty Girl, 1944
Oil on paper, pasted on canvas, 60 × 50 cm
Private collection

165

166

Jean Fautrier
Large Tragic Head, 1942
Bronze, H. 33.5 cm
Collection Welle

Wols
(The Last) Composition, 1951
Oil on canvas, 73 × 60 cm
Collection Welle

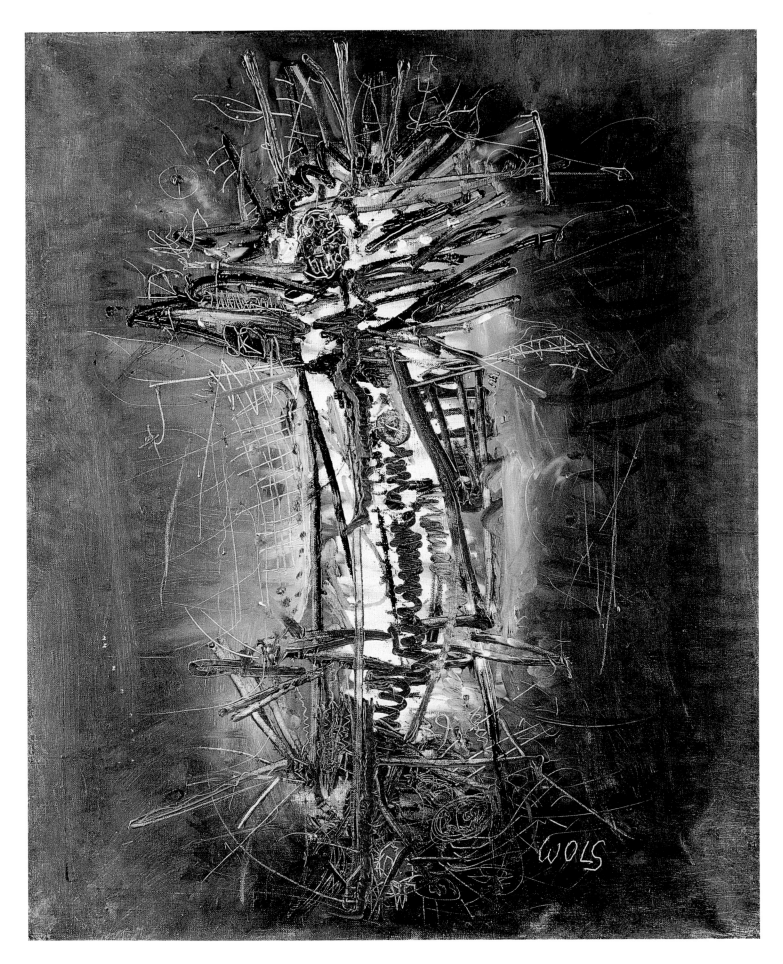

Wols
Composition, 1946–47
Oil on canvas, 41 × 37 cm
Private collection

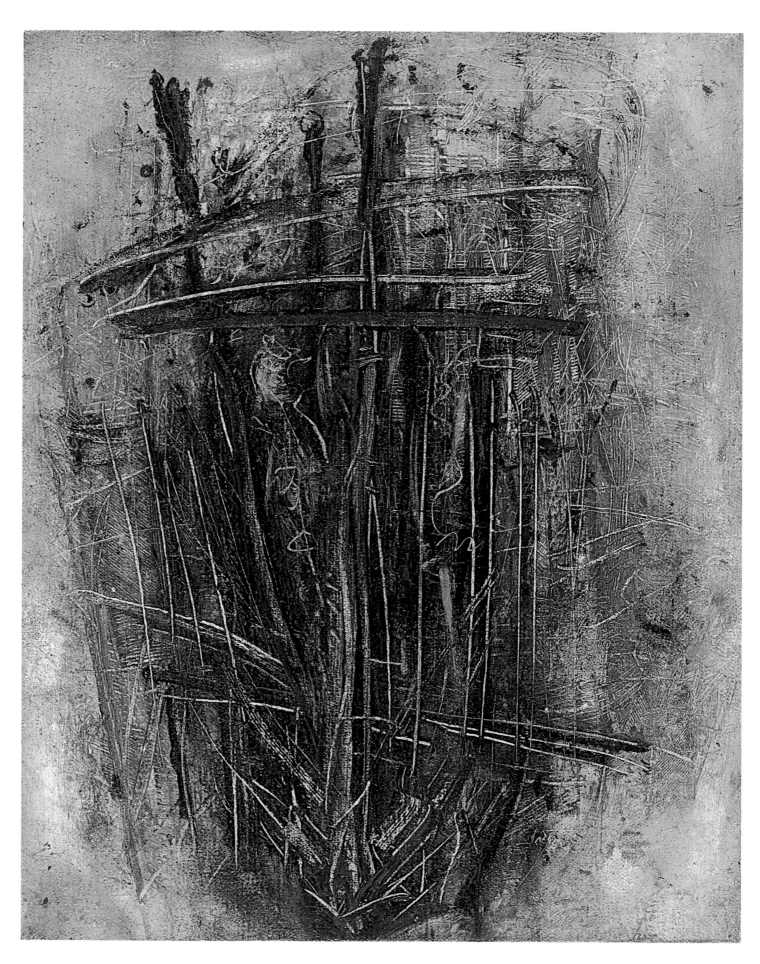

Wols
Champigny Composition, 1951
Oil on canvas, 68 × 57 cm
Collection Welle

170

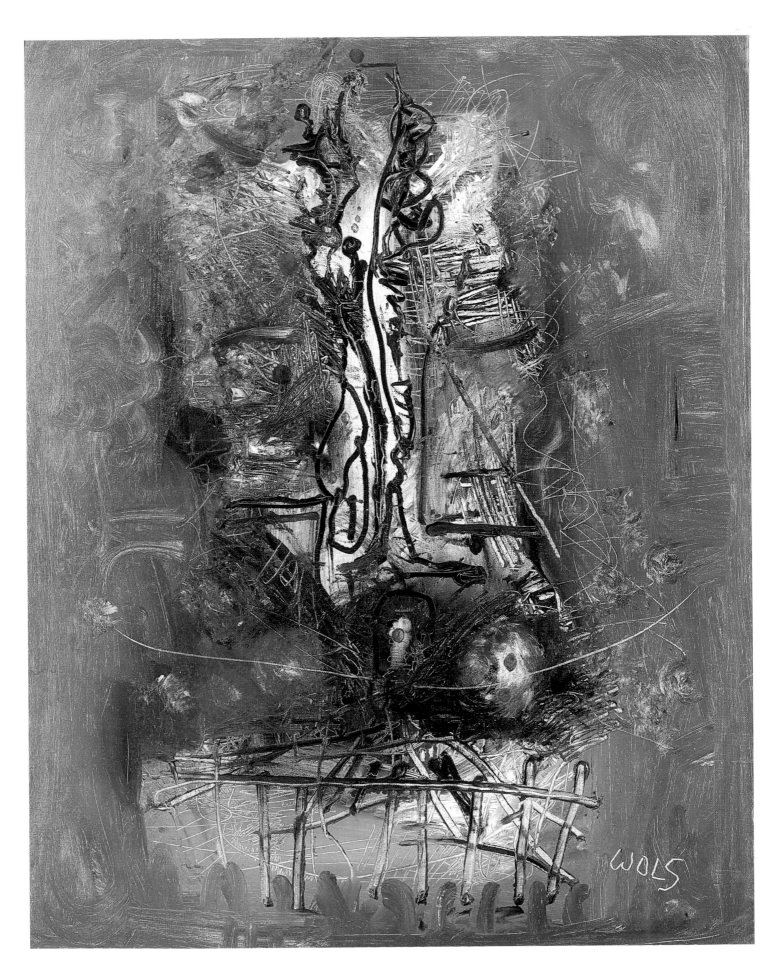

Jean Dubuffet
Building Façades from the 'Mirobolus,
Macadam et Cie' series, 1946
Oil on canvas, 130.5 × 162.3 cm
The Museum of Modern Art, New York.
Nina and Gordon Bunshaft Bequest, 1994

171

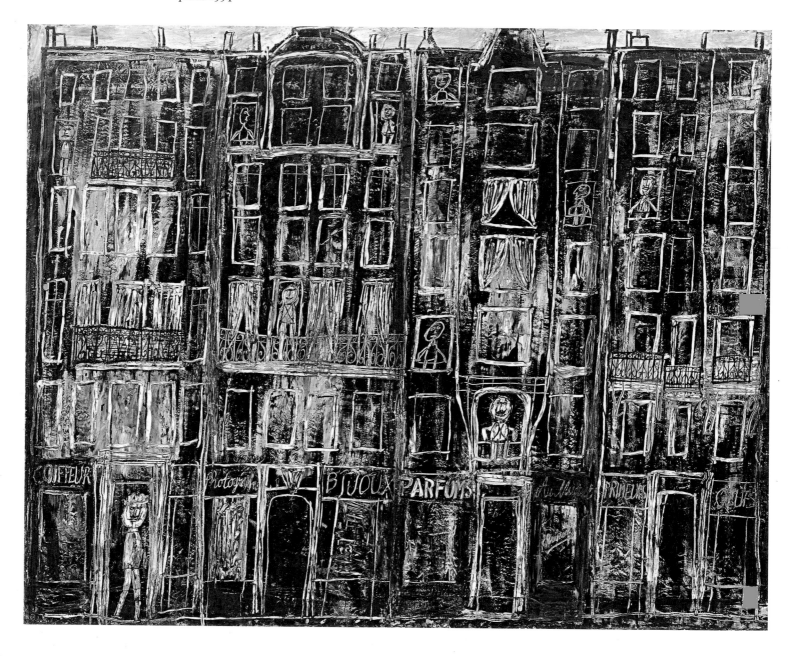

Jean Dubuffet
Berthollet, with a Crayfish Up His Nose, 1947
Oil on canvas, 90 × 73 cm
Kunsthaus, Zurich

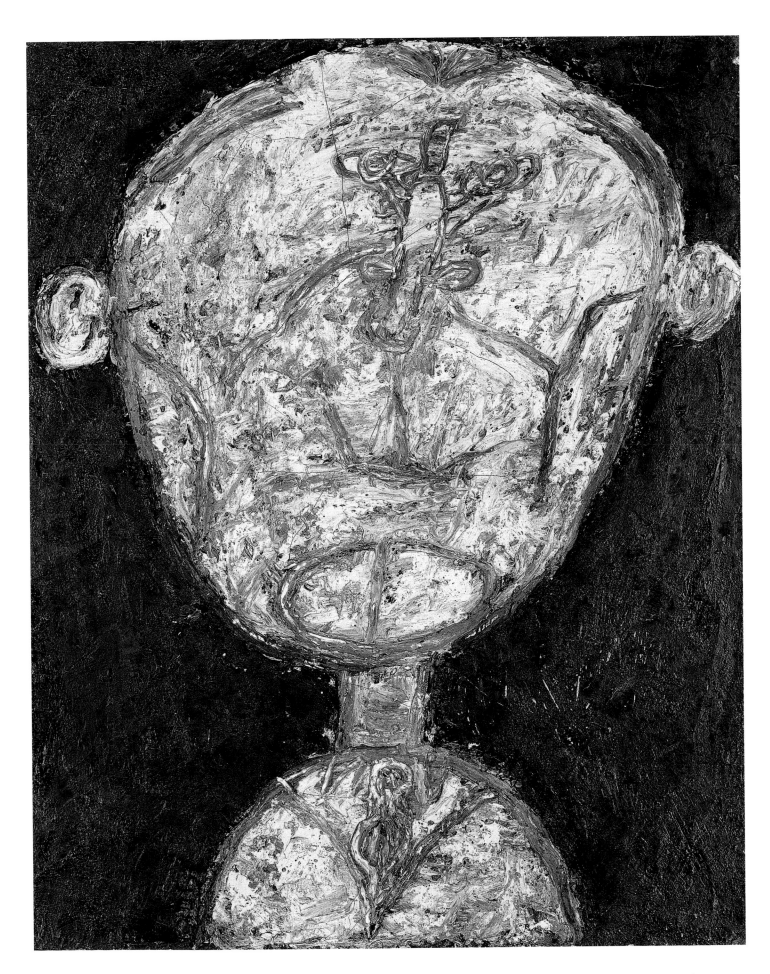

Jean Dubuffet
The Villager with Close-cropped Hair, 1947
Oil on canvas, 130 × 97 cm
Purchased with funds from the Coffin Fine Arts
Trust; Nathan Emory Coffin Collection of the
Des Moines Art Center

173

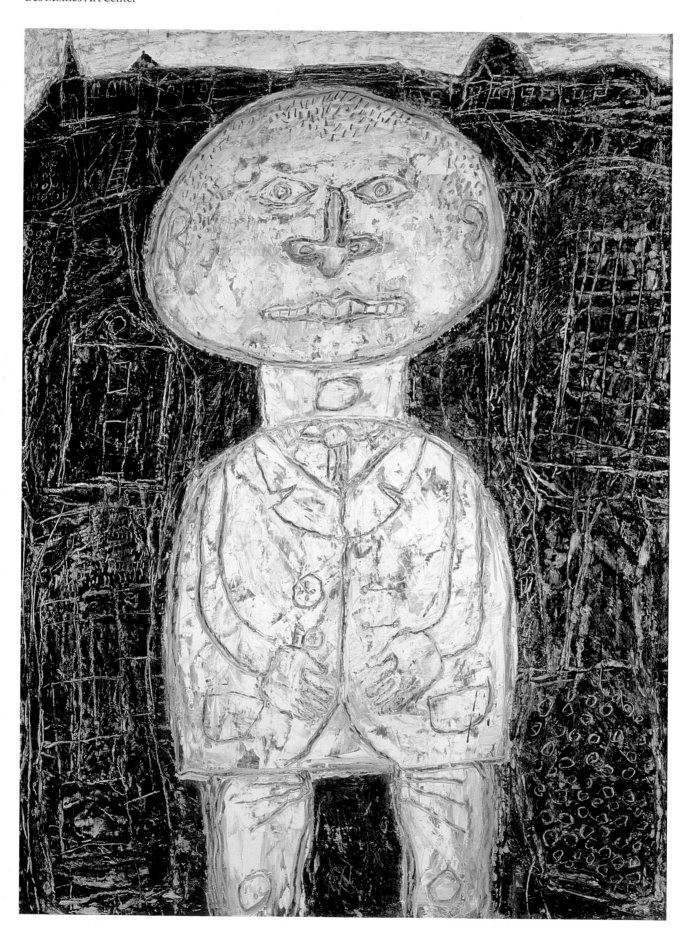

Jean Dubuffet
Miss Cholera, 1946
Oil, sand, pebbles and straw on canvas,
54.6 × 45.7 cm
Solomon R. Guggenheim Museum, New York.
Gift of Katharine Kuh, 1972

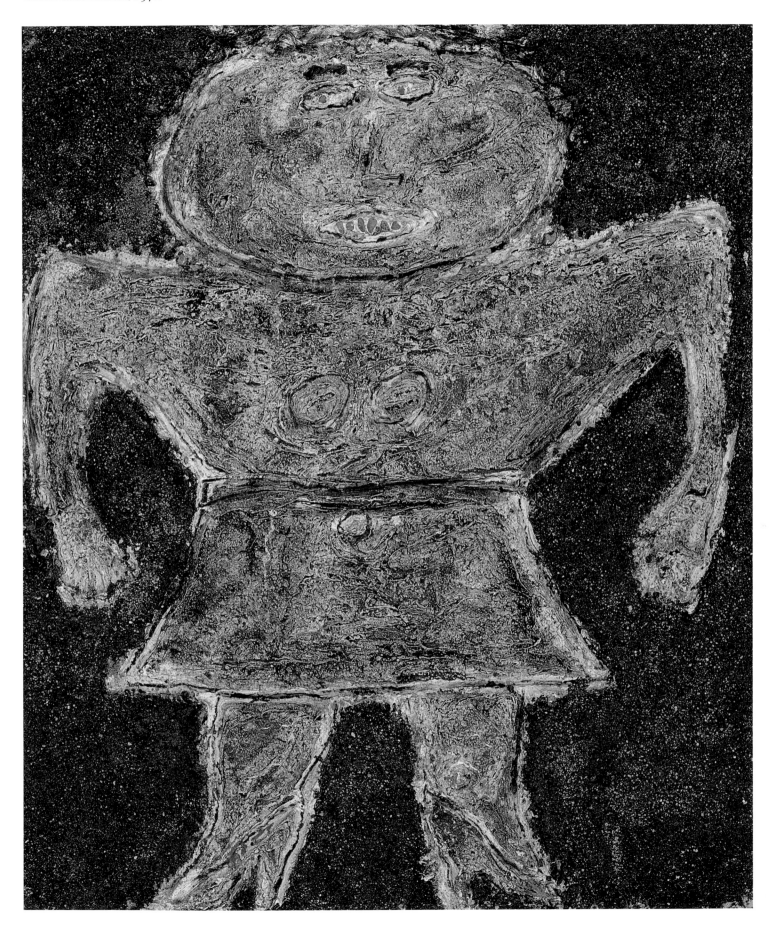

Alberto Giacometti
Tall Figure, 1947
Bronze, 201.2 × 21.1 × 42.2 cm
Hirshhorn Museum and Sculpture Garden,
Smithsonian Institution, Washington DC.
Gift of Joseph H. Hirshhorn, 1966

175

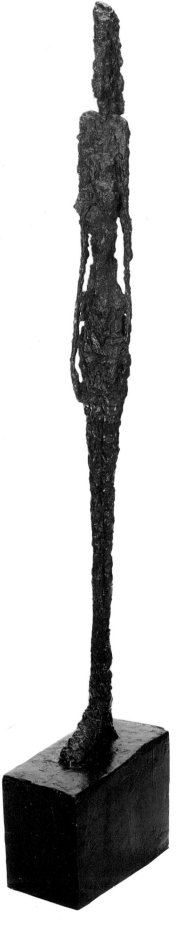

Antonin Artaud
Portrait of Roger Blin, 1946
Pencil on paper, 69.5 × 53 cm
Musée National d'Art Moderne, Centre Georges
Pompidou, Paris. Bequest of Paule Thévenin
(Paris), 1994

176

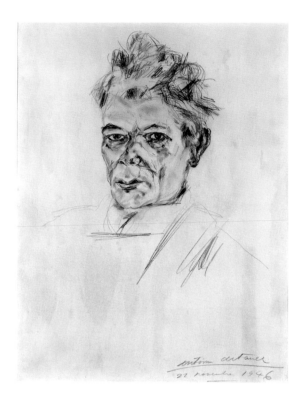

Antonin Artaud
Portrait of Colette Allendy, 1947
Pencil and pink chalk on paper, 64 × 49 cm
Musée National d'Art Moderne, Centre Georges
Pompidou, Paris. Bequest of Paule Thévenin
(Paris), 1994

177

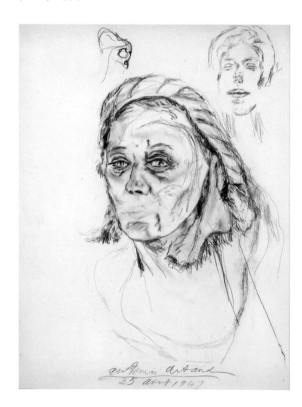

Antonin Artaud
Self-portrait, 1947
Pencil and coloured chalk on paper, 55 × 45 cm
Private collection

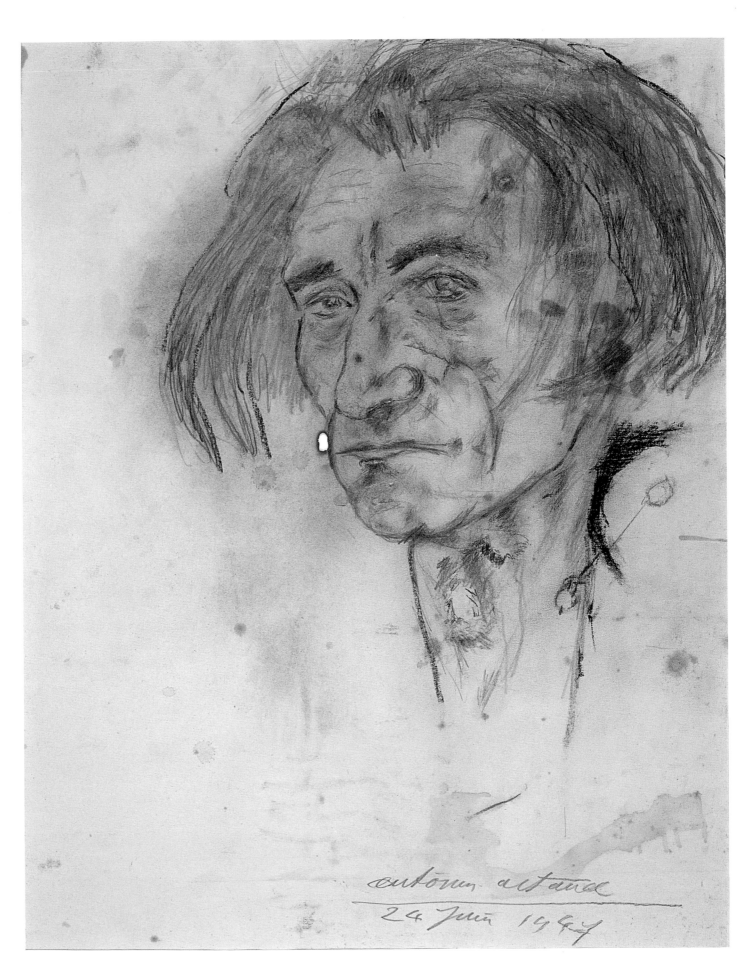

Balthus
Sleeping Nude, 1945
Oil on board, 44.5 × 59.7 cm
Private collection

179

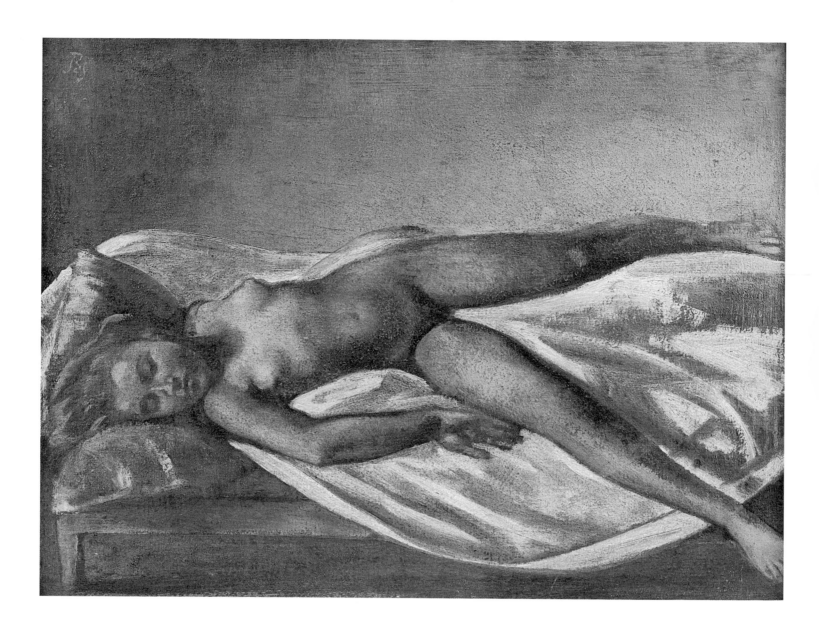

Francis Gruber
Nude with a Red Waistcoat, 1948
Oil on canvas, 66 × 55 cm
Collection Madame Francis Gruber

180

Boris Taslitzky
The Delegate, 1947
Oil on canvas, 195 × 114 cm
Collection B. Taslitzky

181

André Fougeron
The Judges, 1950
Oil on canvas, 195 × 130 cm
Musée National d'Art Moderne,
Centre Georges Pompidou, Paris

Henri Michaux
Mescalin Picture, 1957
Oil on canvas, 41 × 27 cm
Private collection

Henri Michaux
Mescalin Picture, 1957
Oil on canvas, 41 × 22 cm
Galerie Limmer, Cologne

183

184

Georges Mathieu
Inception, 1944
Oil on canvas, 70 × 55 cm
Collection of the artist

185

Wifredo Lam
Rumblings of the Earth, 1950
Oil on canvas, 151.1 × 284.5 cm
Solomon R. Guggenheim Museum, New York.
Gift of Mr and Mrs Joseph Cantor, 1958

Matta
Accidentalité, 1947
Oil on canvas, 192 × 248.5 cm; archive no. 47/3
Private collection, Geneva

Jacques Hérold
Le Grand Transparent, 1947
Bronze, 188 × 44.5 × 39 cm
Galerie Patrice Trigano, Paris

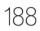
188

Marcel Duchamp
Please Touch, 1947
Exhibition catalogue, velvet and foam rubber,
25 × 21.5 × 5 cm
Paule and Adrien Maeght Collection, Paris

189

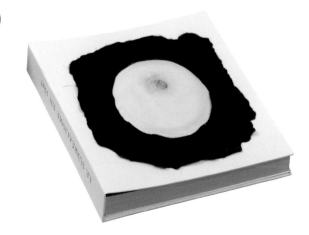

Victor Brauner
Ceremony, 1947
Oil on cotton sheet, laid down on canvas,
187.5 × 236.5 cm
Private collection

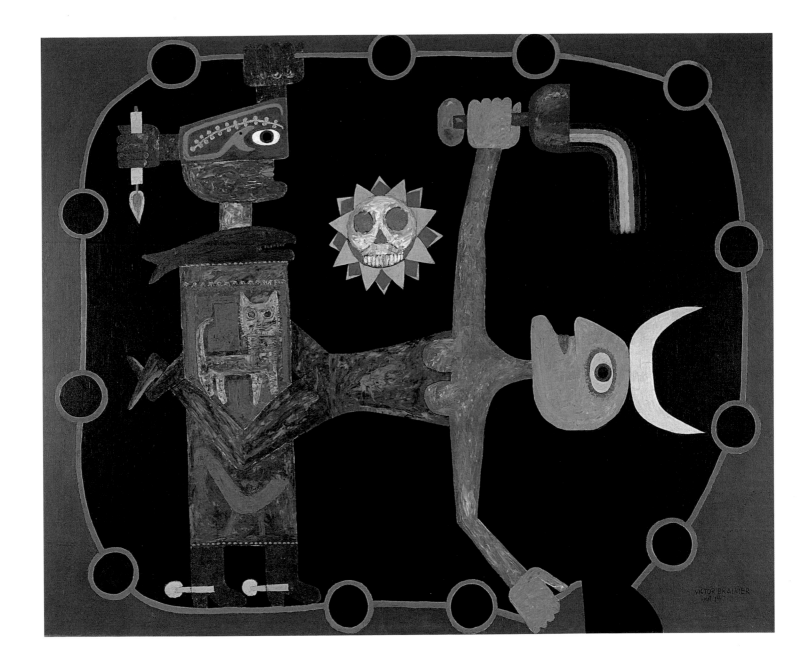

Antoine Pevsner
Extendable Column of Victory, 1946
Bronze, 104 × 79 cm
Kunsthaus, Zurich

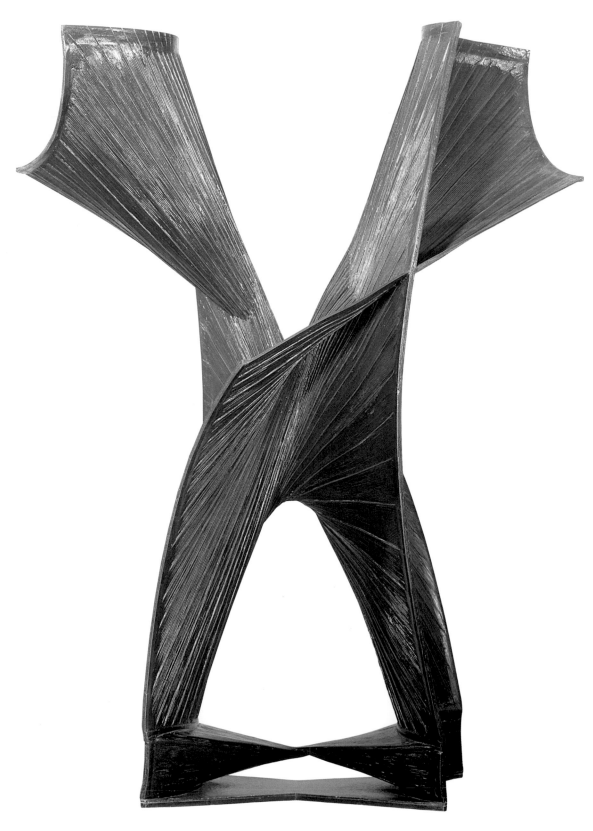

Germaine Richier
The Bat, 1946
Bronze, 91 × 91 × 52 cm
Tate. Lent from a private collection, 2000

192

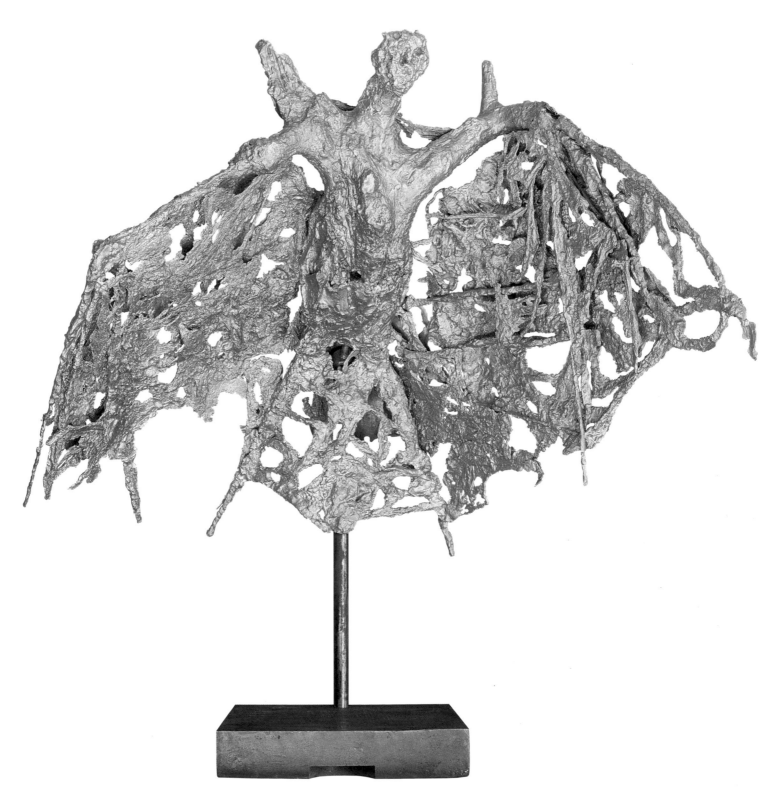

Jean Bazaine
La Messe de l'Homme Armé, 1944
Oil on canvas, 116 × 73 cm
Paule and Adrien Maeght Collection, Paris

193

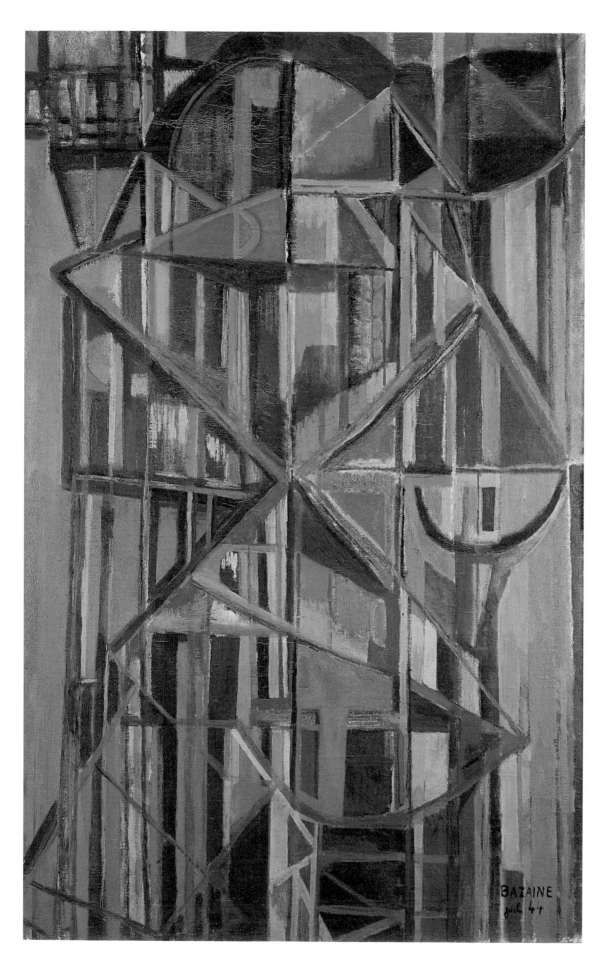

Charles Lapicque
Joan of Arc Crossing the Loire, 1940
Oil on canvas, 100 × 73 cm
Dr Peter Nathan Collection, Zurich

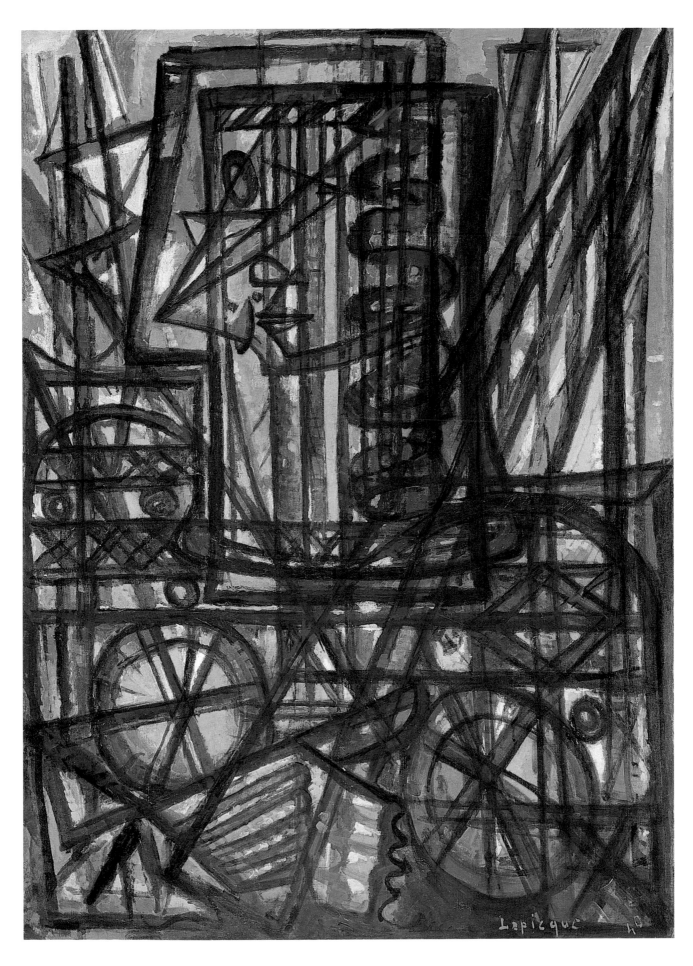

Alfred Manessier
Salve Regina, 1945
Oil on canvas, 195 × 115 cm
Musée des Beaux-Arts, Nantes

Jean Bazaine
Earth and Sky, 1950
Oil on canvas, 195 × 130 cm
Fondation Marguerite and Aimé Maeght,
Saint-Paul

196

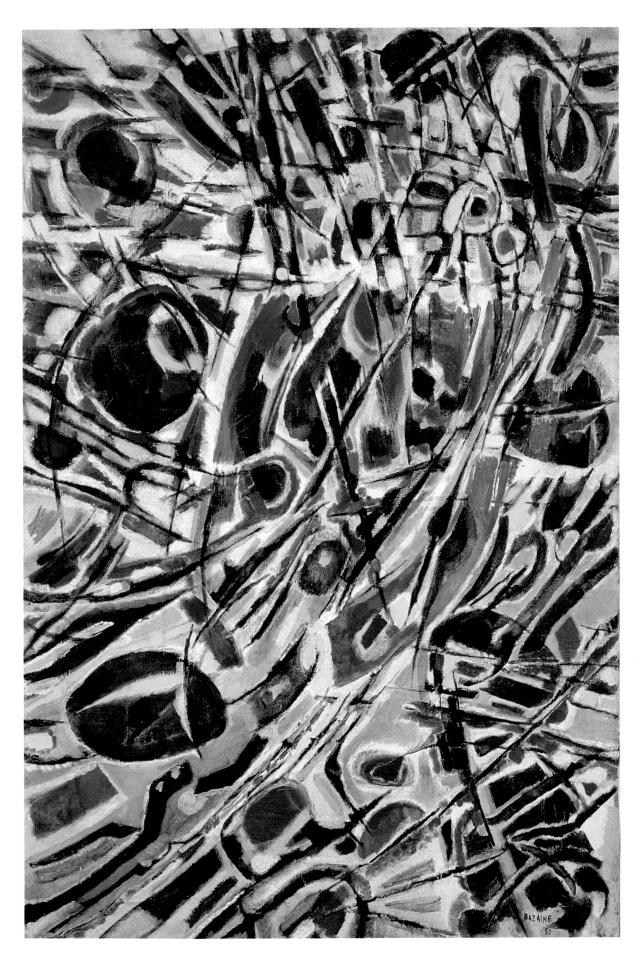

Maria Elena Vieira da Silva
Le Souterrain, 1948
Oil on canvas, 81 × 100 cm
Private collection. Courtesy Jeanne-Bucher,
Paris

Jean-Paul Riopelle
Composition, 1951
Oil on canvas, 97 × 131 cm
Private collection. Courtesy Galerie Daniel
Malingue

198

Gaston Chaissac
Composition, 1951
Oil on plywood, 65 × 50 cm
Musée des Beaux-Arts, Nantes

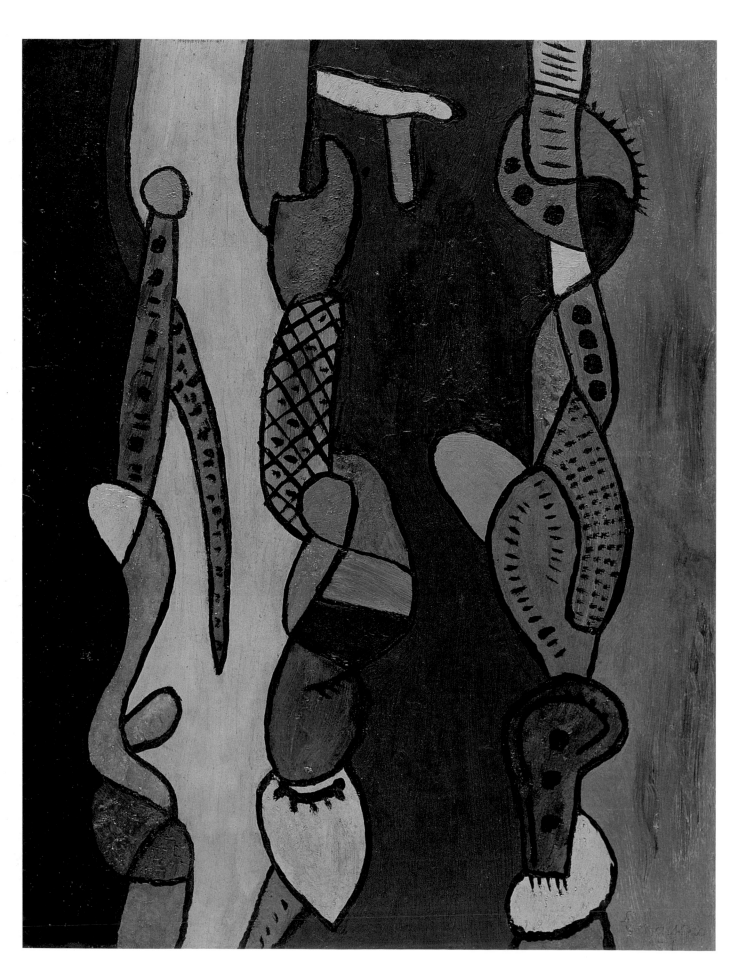

Maurice Estève
Homage to Jean Fouquet, 1952
Oil on canvas, 80.5 × 65 cm
Musée Rolin, Autun

200

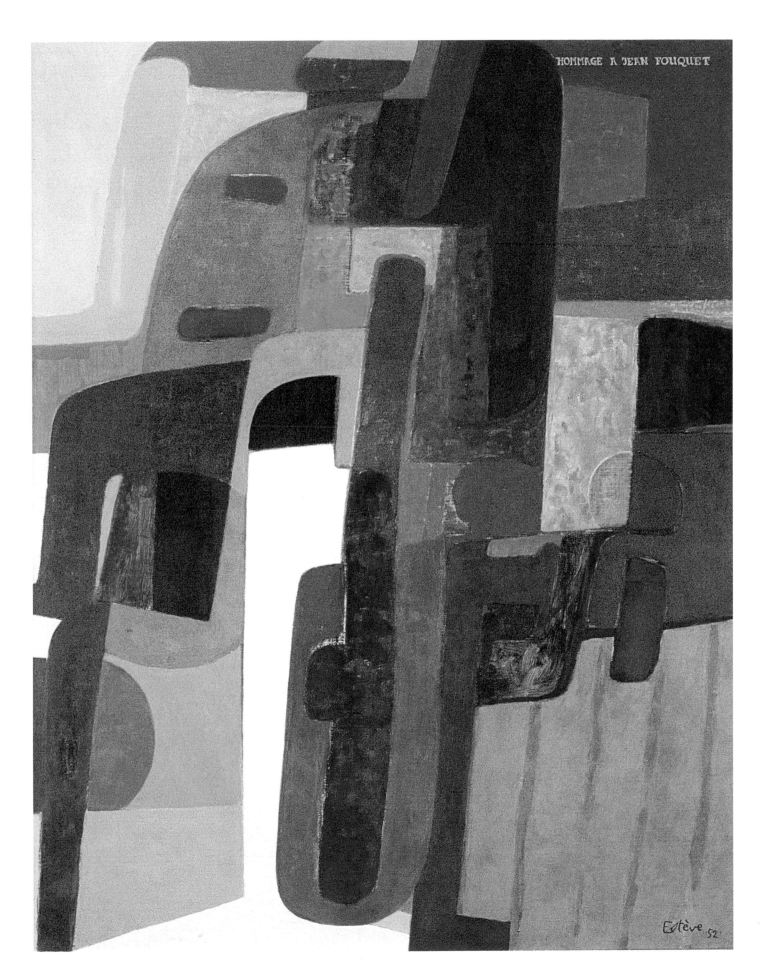

Robert Jacobsen
Invisible Victory, 1957
Iron, 62.1 × 46 × 22.1 cm
Fonds National d'Art Contemporain – Ministère
de la Culture, Paris. On deposit at the Musée
d'Art Moderne, Saint-Etienne

201

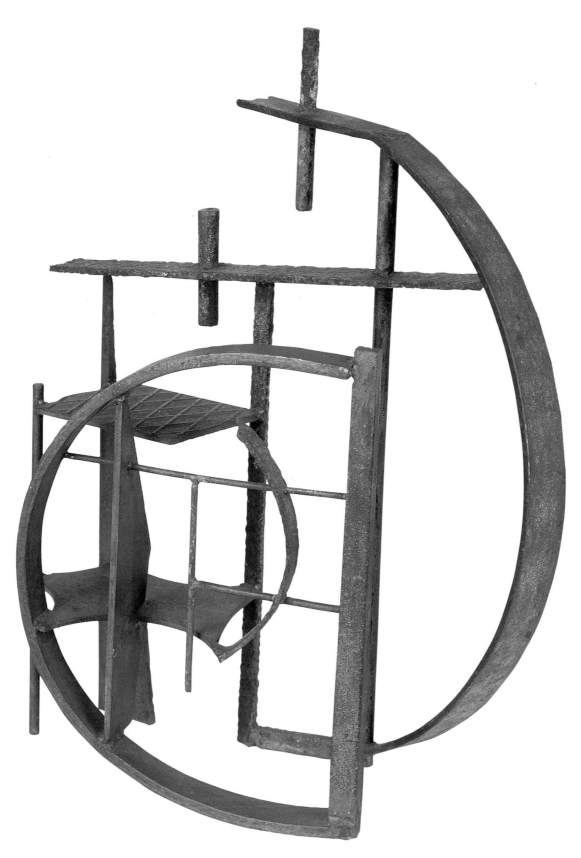

Hans Hartung
T1951–2, 1951
Oil on canvas, 97 × 146 cm
Fondation Hans Hartung and Anna-Eva
Bergman

202

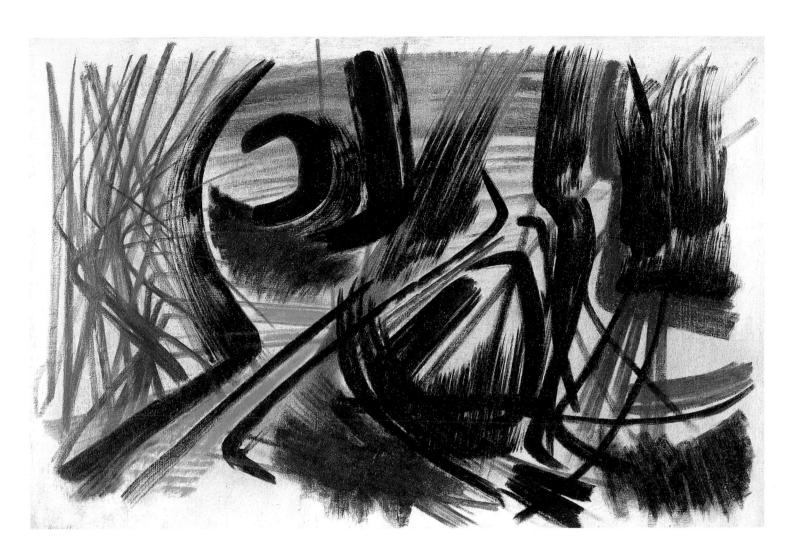

Nicolas de Staël
Parc des Princes (Les Grands Footballers), 1952
Oil on canvas, 200 × 350 cm
Private collection

203

Georges Braque
Bird, 1955
Oil and sand on canvas, 106.7 × 129.6 cm
Courtesy Helly Nahmad Gallery, London

Serge Poliakoff
Abstract Composition, 1959
Oil on canvas, 130 × 162 cm
Alexis Poliakoff Collection

205

Zao Wou-Ki
Homage to Chu-Yun, 1955
Oil on canvas, 195 × 130 cm
Françoise Marquet Collection

Zao Wou-Ki
Homage to Chu-Yun, 1955
Oil on canvas, 195 × 130 cm
Françoise Marquet Collection

Germaine Richier
La Tauromachie, 1953
Gilded bronze, 116 × 54 × 101 cm
Suzanne and Fred Mella Collection

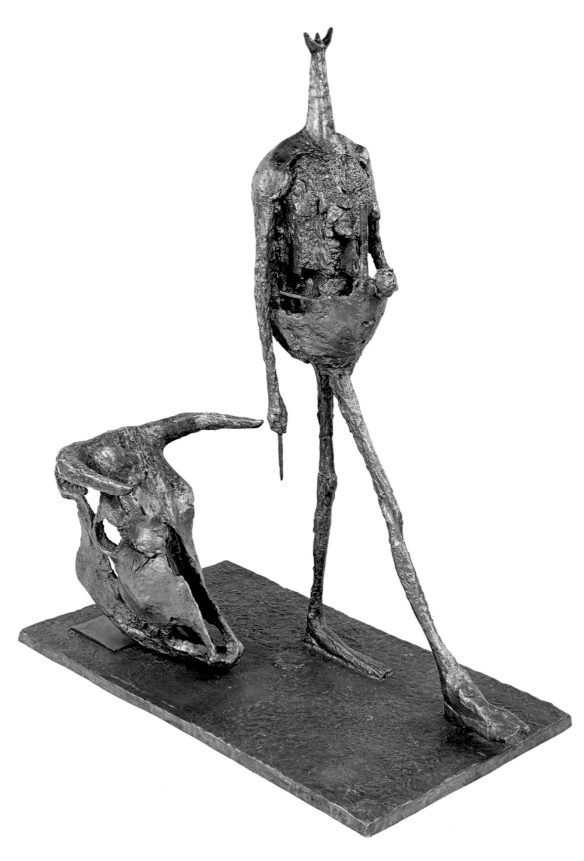

Raymond Mason
Le Boulevard Saint-Germain, Paris, 1958
Bronze relief, 105 × 53 × 7 cm
Collection of the artist

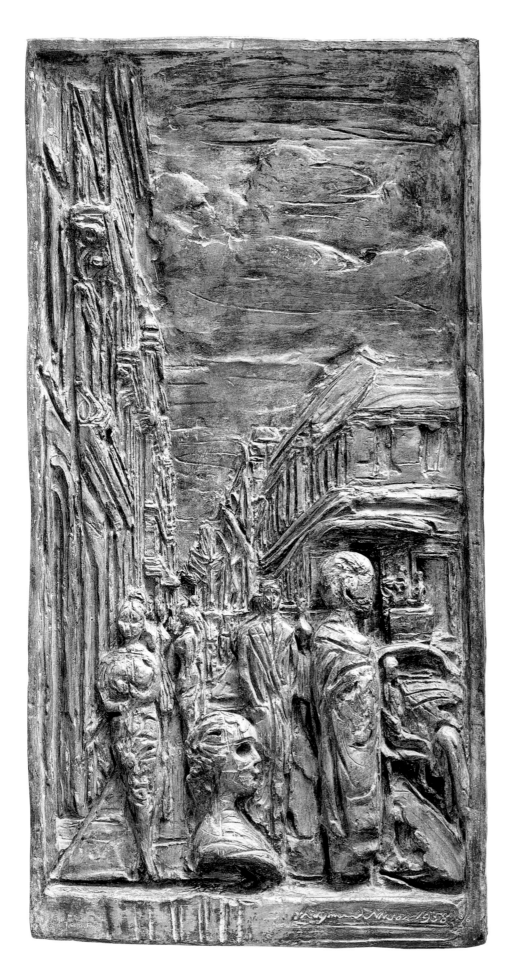

Alberto Giacometti
Standing Woman I, 1960
Painted bronze, 270 × 54 × 36.3 cm
Fondation Marguerite and Aimé
Maeght, Saint-Paul

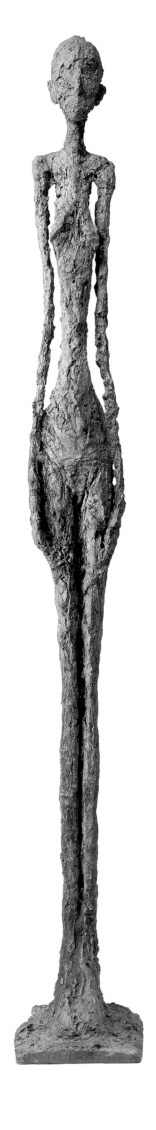

César
The Grand Duchess, 1955
Welded iron, 175 × 73 × 30 cm
Private collection. Courtesy Jean Albou Conseil,
Paris

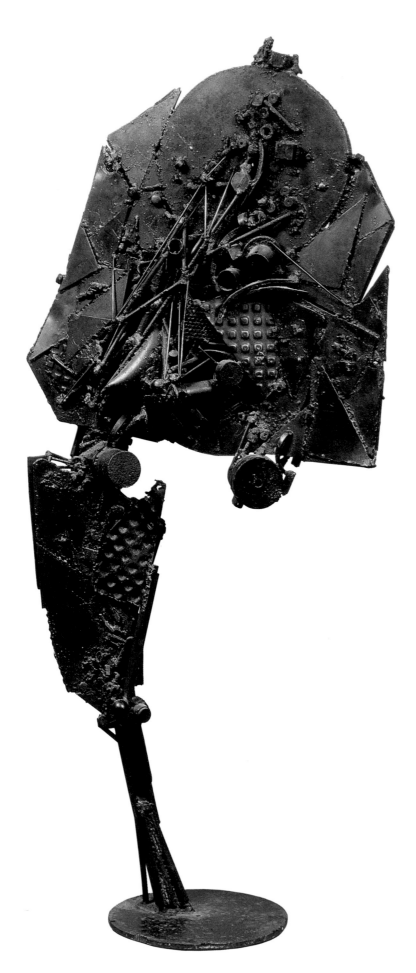

César
Plaque, 1959
Metal, 113 × 71 × 15 cm
Collection du MAC, Galeries Contemporaines
des Musées de Marseille

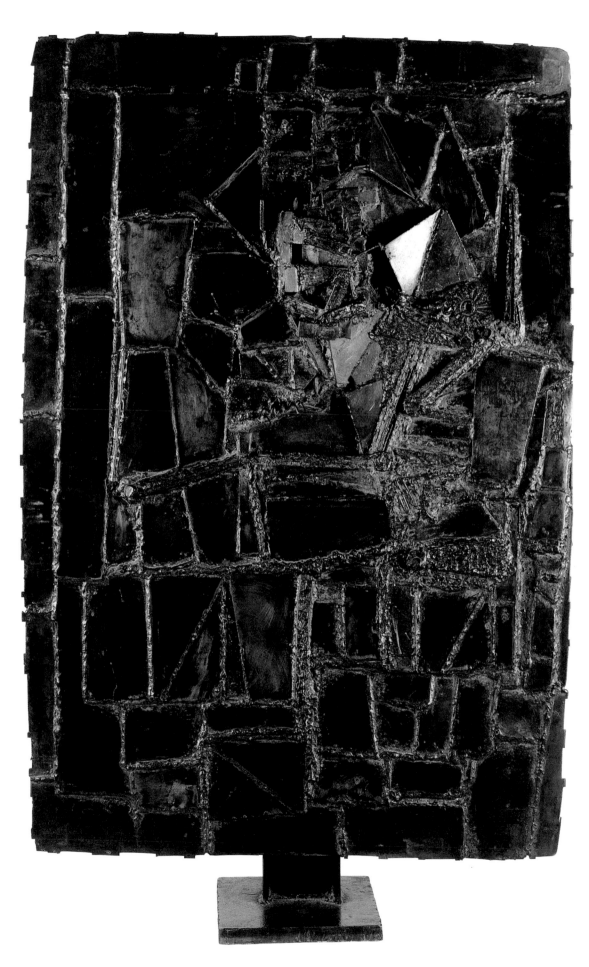

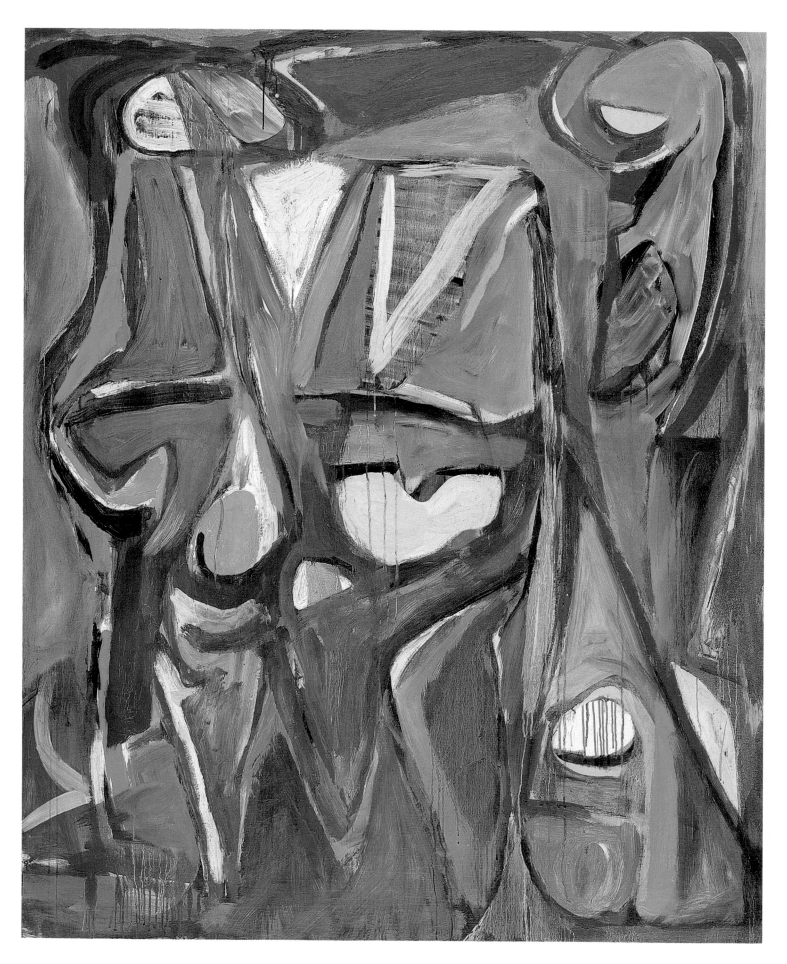

Bram van Velde
Boulevard de la Gare, 1958
Oil on canvas, 162.3 × 130.3 cm
Musée d'Art et d'Histoire, Geneva

212

Asger Jorn
The Rite of Spring II, 1952
Oil on wood, 161 × 183.5 cm
The Berardo Collection, Sintra Museum of
Modern Art

213

Karel Appel
Stéphane Lupasco and Michel Tapié, 1956
Oil on canvas, 130 × 195 cm
Stedelijk Museum, Amsterdam

214

Christian Dotremont and Asger Jorn
Je lève, tu lèves, nous rêvons, 1948
Oil on canvas, 38 × 33 cm
Pierre and Micky Alechinsky Collection,
Bougival

215

Pierre Alechinsky
Les Grands Transparents, 1958
Oil on canvas, 200 × 300 cm
Larock-Granoff Collection, Paris

Ellsworth Kelly
Black Square, 1953
Oil on wood, 109.9 × 109.9 cm
Private collection

217

Sam Francis
Blue Composition on White Ground, 1960
Oil on canvas, 130 × 97 cm
Fonds National d'Art Contemporain – Ministère
de la Culture, Paris. On deposit at the Musée des
Beaux-Arts et d'Archéologie, Rennes

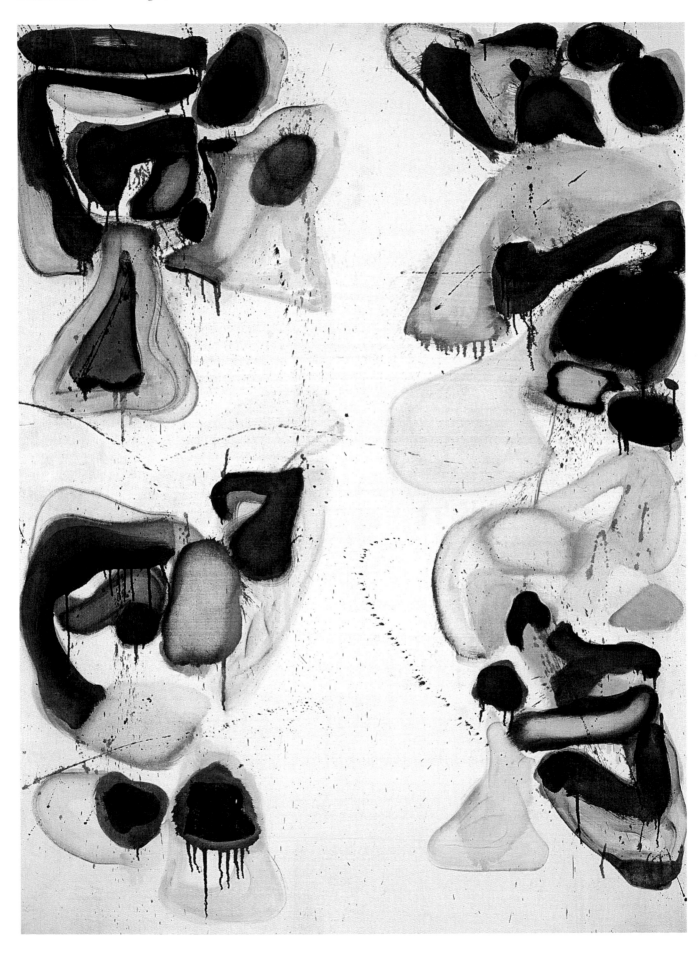

Yves Klein

Untitled Anthropometry (ANT 101), 1960
Pigment, synthetic resin and gold leaf
on marouflé paper, laid down on canvas,
420 × 200 cm

Private collection. On deposit at the Musée
d'Art Moderne et d'Art Contemporain, Nice

219

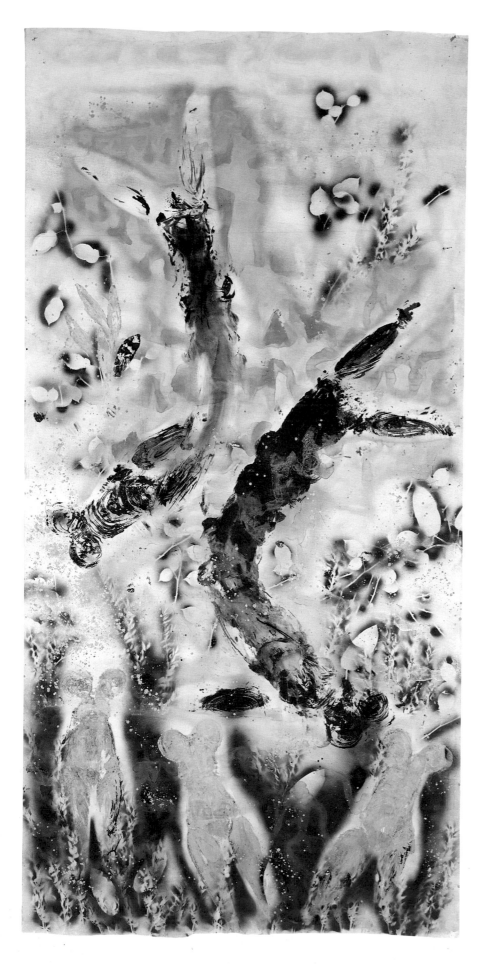

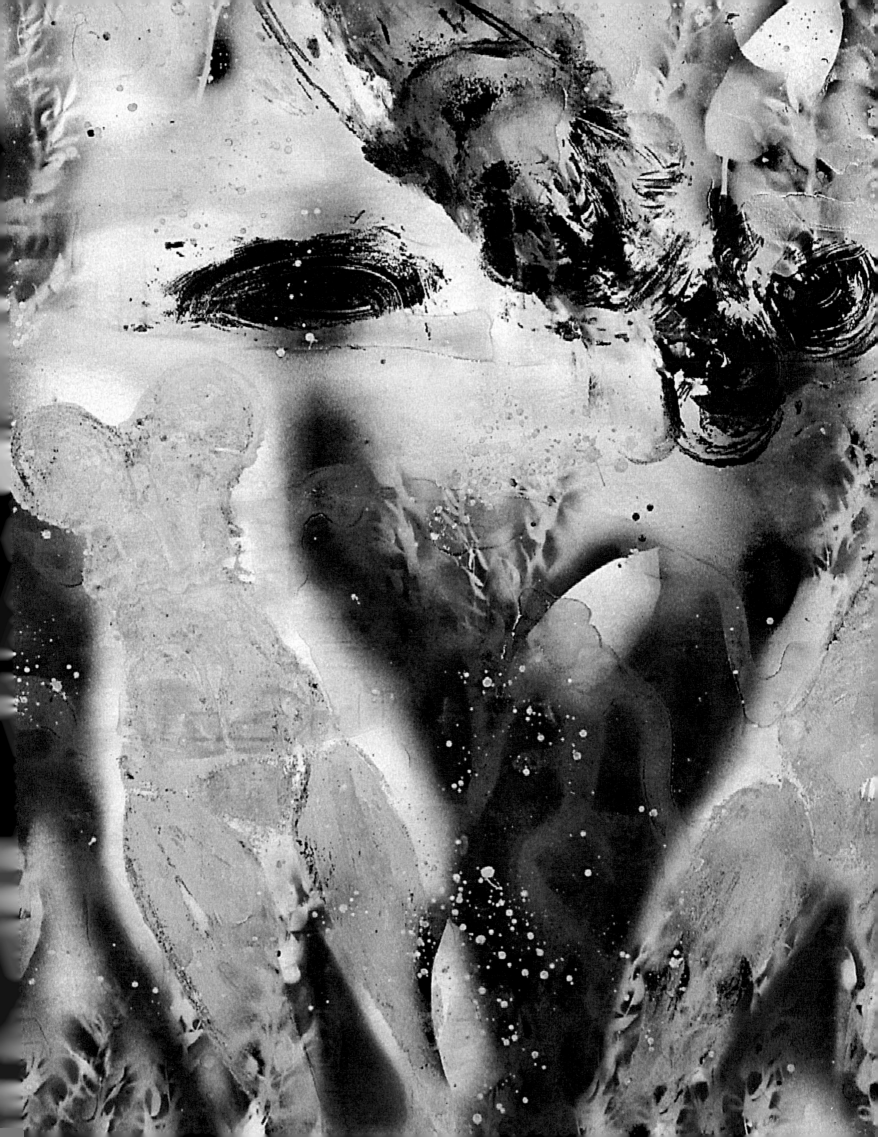

Yves Klein
Untitled Anthropometry (IKB 223), 1961
Pigment and synthetic resin on gauze,
mounted on panel, 195 × 140 cm
Private collection

220

Yves Klein
Silence Is Golden (MG 10), 1960
Gold leaf on wood, 148 × 114 cm
Private collection

Simon Hantaï
Virgin's Mantle, no. 3, 1962
Oil on canvas, 223 × 213 cm
Private collection

Pierre Soulages
Painting, 9 May, 1968
Oil on canvas, 202 × 336 cm
Collection of the artist

4

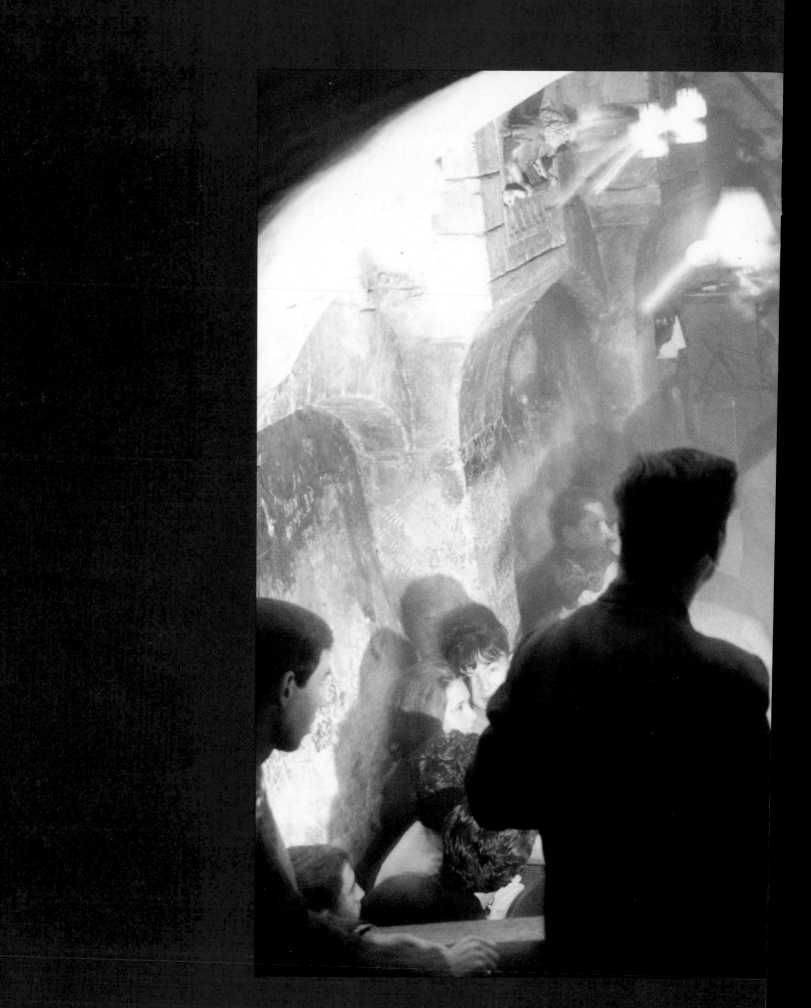

The Latin Quarter:
Towards the Revolution

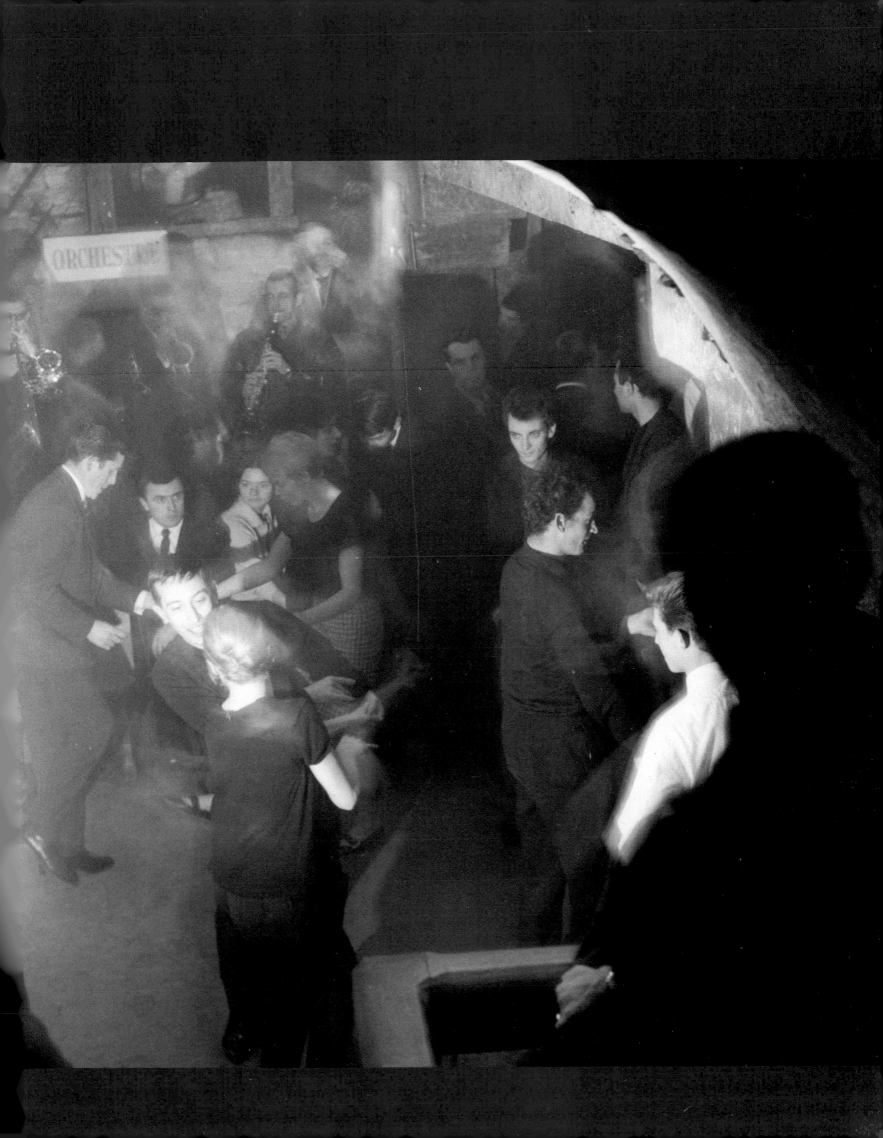

Sarah Wilson

Paris in the 1960s: Towards the Barricades of the Latin Quarter

Metamorphoses: old gods and new

'Art today is a rocket in space. "Prisunics" are the museums of modern art,' claimed the artist Martial Raysse, referring to televised astronauts and Paris's cheap supermarket chain whose tinned peas and washing powders he commemorated in his shelf arrangement *Vision hygiène no. 1* (1961; fig. 98).[1] 'Beauty is bad taste; artificiality must be pushed to the limit. Bad taste is the dream of beauty desired too much – *une beauté trop voulue.*'[2]

As France entered the era of the Fifth Republic under de Gaulle in 1958, her art was transformed by new pressures. André Malraux's magisterial publication *La Métamorphose des dieux* (1957), which continued the vast photographic project of his *musée imaginaire*, a 'museum without walls' of human civilisation,[3] battled for imaginative space with the contemporary *Mythologies* proposed by Roland Barthes and published in the same year. Barthes analysed a world in which new consumer products were marketed with sophisticated psychological strategies that reflected the premises of an increasingly globalised capitalist superstructure. France's economic miracle had been financed by America, with the Marshall Plan, a system of funding set up to assist in the reconstruction of the Western European economies after the war. America as reality (not fantasy or film) was growing ever closer, as those involved in international

diplomacy, business and the art world began to travel by air. A new breed of white-collar worker evolved as the postwar generation grew to adulthood, their desires and expectations challenging those of the generation which had lived through the war and the Occupation.

In art, the earlier twentieth-century gods were dying: Picabia and Dufy in 1953, Matisse and Henri Laurens in 1954, Léger in 1955 and Rouault in 1958. Malraux, writer, Resistance fighter and now de Gaulle's State Minister of Cultural Affairs (a new post), would give grandiloquent obituary speeches for Braque in 1963 and Le Corbusier in 1965.[4] The postwar period had used only traditional materials for its art: paint, clay, bronze, the written word or the spoken voice; man was the measure of the universe, ruined then reborn. But that measure was changing. The structuralist Roland Barthes analysed the new 'mythologies' of contemporary life already present in children's toys which replicated '…all the things the adult does not find unusual: war, bureaucracy, ugliness, Martians, etc…';[5] he immediately perceived the profound impact that television would have in France from the late 1950s: an impact whose cultural potential Malraux would ignore. The avant-garde response to this brave new world would be haunted by its resurrected past. Malraux would welcome the gods of India, Iran, Africa and Egypt to Paris.[6] At the same time he transformed France's cultural heritage and arranged for it to be mapped and inventoried.[7] Restoration programmes were drawn up for Versailles, Reims Cathedral and Le Corbusier's Villa Savoie,[8] and commissions were given to contemporary artists for Sèvres porcelain and Beauvais tapestries.[9] A dry moat was restored around the Louvre and Paris was given a facelift.

But France had no rockets in space. Perceiving both the United States and the USSR as producers of essentially materialist cultures – capitalist or communist – Malraux now saw de Gaulle's new France as the focus of a 'third way', the bearer of intellectual and spiritual values and their embodiment. Paris was to become the political and cultural focus and the organisational model of a new Europe under construction. Two quinquennial plans, 1959–63 and 1964–68, promoted France's art, music, theatre and dance abroad, with ever-expanding budgets.[10]

Modernism and late modernism were still powerful, indeed institutionalised, forces –

Figure 97

97 Marc Chagall, Ceiling of the Paris Opéra, 1964

98 Martial Raysse, *Vision hygiène no. I*, 1961
Shelf of kitchen products, 21.5 × 30.5 cm
Collection Bob Calle, Paris

Figure 98

although they were lamentably represented in the national art collections.[11] The new Unesco buildings opened in Paris in November 1958, with commissions by artists who would range from Picasso and Miró to Matta and Isamu Noguchi.[12] Jean Cassou's exhibition 'Les Sources du vingtième siècle', a mighty Council of Europe exhibition, whose content culminated in the works of the pioneer Cubists and Orphists, was held at the Palais de Tokyo in 1961.[13] The Fondation Maeght commissioned architecture by José Luís Sert, ceramics by Miró, stained glass by Braque and furniture by Diego Giacometti for its private museum in St-Paul-de-Vence – a Mecca for Parisian summer emigrés – which was inaugurated by Malraux in July 1964.[14] Malraux commissioned Chagall to paint a new ceiling for Garnier's Opéra (fig. 97: a ravishing skirt design, according to Marie-Laure de Noailles); asked André Masson to replace the ceiling of the National Theatre at the Odéon ;

arranged Maillol's sculptures in the Tuileries Gardens; and asked Alberto Giacometti to erect a monument to commemorate the Deportation, a project cut short by the artist's death.[15] These were men of the past, however. Ministerial initiatives and popular energies abounded, but retrospectively the 1960s witnessed the slow death of humanism. Barthes and then Michel Foucault soon announced the 'death of the author'; in art, the explosion of the object, concurrently, began to displace mythologies of individual genius, the artist's touch and his – always *his* – signature.[16]

Forty degrees above Dada

1957 had seen the first major Dada retrospective in Paris, and Marcel Duchamp, back from America, soon became a charismatic and supportive presence in the 'anti-art' world.[17] A gleeful embrace of Duchamp's 'readymade' principles now extended to the

rusty, jerrycan world of Jean Tinguely's bohemia as much as to the hygienic universe of Raysse's multicoloured plastics. The shift from the flea markets of the Surrealists to the new supermarkets is exemplified in the works of Daniel Spoerri, whose broken dolls and violins stuck perpendicularly to the surface of *Fleamarket: Homage to Giacometti* (1961) are displaced by his 'readymade' spice rack of the same year (like Raysse's supermarket shelf, an anticipation by over thirty years of Damien Hirst's *Pharmacies*).

This shift to the continuum of the present in the visual arts took place at a time of an intellectual fascination with 'everyday life' which would be reflected in both 'nouveau roman' novels by Alain Robbe-Grillet or those by Georges Perec, and the 'nouvelle vague' cinema of François Truffaut and Jean-Luc Godard.[18] While Jules Monnerot had attempted sociological analyses of both Surrealism and communism in the 1940s,

the Marxist philosopher Henri Lefebvre's continuing analyses of the everyday, from 1947 to the 1960s, were now most influential.[19] Daniel Spoerri also recalls a sense of parallelism with popular publications based on 'everyday life' in the Middle Ages or under Louis XIV, increasing the attraction of an ironic take on the contemporary situation.[20] 'Nouveau Réalisme', the name of the group whose manifesto was drafted by the critic Pierre Restany on 27 October 1960, was a term with a surprisingly fraught critical past, but its agenda was clear: Restany called it the 'sociological grasp of the real' from a point of view 'forty degrees above Dada'.[21] Arman's 1960 exhibition 'Le Plein', Iris Clert's gallery filled with noxious trash, was the riposte to Yves Klein's 1958 show 'Le Vide', a room of empty, 'sensitised' space. Arman's 'Identikit' glass-box portraits of the discarded rubbish of everyday life belonging to Klein, Restany or Iris Clert personalised themes of consumerism and waste as fetished reliquaries; during 1961–62 while Paris was following the events of the trial in Jerusalem of the Nazi criminal Adolf Eichmann, Arman's accumulations of teeth or spectacles had darker overtones.[22] César's smashed, crushed cars of the same period (cat. 251) – outrageous readymades, archaic steles of the contemporary – were also reliquary-like: compressed narratives of death, distortion and rust that contrasted with Klein's gold and blue, light and fire, and imprints of bodies in flight (cat. 219).

The Surrealist movement still saw itself as a vibrant and critically active presence: the 1959 'Exposition inteRnatiOnale du Surréalisme', devoted to Eros with its pulsating, inner-body environments, was another triumph; although more complex polymorphous perversions would be suggested when Pierre Molinier, rejecting Surrealist painting as a mode of expression, turned to self-photography in the 1960s and was embraced by the worlds of contemporary performance and pornography.[23] Yet while orthodox Surrealism continued, with publications such as *Phases*, *Le Surréalisme même*, *La Brèche* and *Archibras*,[24] it was effectively under attack, and bleeding out into other movements: the automatist *rapprochement* with Tachism in the 1950s was followed by its input of surprise, juxtaposition and the fetish into Nouveau Réalisme.[25] Like a phantom repressed, Surrealism returned at the very beginning of Pop, in shows such as Jean Larcade's curious

'Pop Por, Pop Corn, Corny' (1965), which included Dalí's *Venus de Milo with Drawers*, a 1964 remake (cat. 147). Similarly René Magritte, as much as the Americans Hopper or Rosenquist, was important for the dramatic paintings of Jacques Monory in the early 1960s: *film-noir* episodes frozen in blue, which became part of the movement known as 'Figuration Narrative'.[26] From 1960 onwards, Jean–Jacques Lebel (who had imbibed Surrealism in 1940s New York as a child) introduced 'happenings' to Europe. Celebrated by the Surrealist Victor Brauner for his 'liberty, violence, disorder, dialectical movement',[27] Lebel, too, mastered Surrealist tactics, producing a 'blizzard of manifestos' in French, or 'perfectly hipster American' when necessary.[28]

Although attacked by Guy Debord as 'perfectly boring and reactionary', Surrealism offered both a *modus vivendi* and a political blueprint for the Internationale Situationniste founded in 1957.[29] Breaking away from Isidore Isou's Lettrist movement in Saint-Germain, Guy Debord's Internationale Lettriste and Asger Jorn's Mouvement Internationale pour un Bauhaus Imaginiste fused: the competition and issues of self-definition among these artistic groups were deliberately analogous to political parties. The Situationists functioned on orthodox lines, with their charismatic leader, Guy Debord, manifestos, café meetings, rifts and excommunications, and the publication of a periodical, the foil-covered *Internationale Situationniste*, from 1958 to 1969.[30] Highly political, with illustrations kept to a minimum, this was closer to the 1930s journal *Le Surréalisme au service de la révolution* than the earlier *La Révolution surréaliste*. In conjunction with the new discourse on everyday life, the Situationists' key concepts of the deliberately 'constructed situation', of 'psycho-geography' – a study of the relationship between the mapping of urban space and human behaviour, and especially of *détournement* and the *dérive* – would be of capital importance for the insurrectionary Paris of 1968 (fig. 99). *Détournement* involved the perversion of accepted practices and their interpretations via some form of critical intervention or interpolation: 'In this sense there cannot be a Situationist painting or music, but a Situationist usage of these media.'[31] The *dérive*, 'a swerving from the path', transported Charles Baudelaire's *flâneur*, the dandified stroller, from nineteenth-century Paris to the

Figure 99

urbanised, late twentieth-century city. In contrast with the Surrealist idea of *le hasard objectif* – the 'marvellous', chanced upon through sheer serendipity in a Paris of monuments and mysteries – here, the *dérive* as 'drifting', through spaces often defined by reconstruction and modernisation, produced patterns of exploration that were more dislocated and bohemian, a 'drifting' in protest against the alienation of life and forced labour under modern capitalism.

The prioritisation of political activism in 1960 meant, logically, dispensing with traditional art completely, despite such superb collaborations as *Fin de Copenhague* (1957) by Asger Jorn and Guy Debord – an aggressive 'cut-up' book, trickled with paint, like blood, a *détournement* of the idea of the French *beau livre* – and Jorn's own overpainted and 'modified' junk-shop paintings of 1959.[32] The idea of a young, democratic and anonymous art combined with the Situationist revolutionary ethos would be played out on the walls of Paris as art took to the streets.

The intellectual climate was still dominated by debates regarding redefinitions of the left and the constitution of an avant-garde. Despite the denunciation of Stalin's crimes at the Twentieth Soviet Party Congress of the USSR in 1956, the French Communist Party continued to be controlled at a distance

from Moscow. The challenge to the Gaullist state now came not from the communists, who were divided and discredited, but from new configurations further to the left. The imperative for a new post-Stalinist and anti-communist generation of intellectuals was to reread Marx via Louis Althusser's *Pour Marx* (1965) and to reread Freud in the light of the fresh analyses of the psychoanalyst Jacques Lacan.[33] While the Surrealist versus realist debate of the 1930s had been based upon the opposing philosophies of Marx and Freud, in the 1960s the inscription of desire into revolutionary practice would became a possibility. The philosopher Jean-François Lyotard called this the 'désirévolution', a concept born in the new University of Nanterre, where Marshall McLuhan's theories on media and Herbert Marcuse's *Eros and Civilisation* (1955) and *One-dimensional Man* (1964), translated in 1966 and 1968 respectively, were also debated.[34]

Culture was now divided down generational as well as class and political lines. De Gaulle's project for a 'reconquest of Paris' involved not only facelifted monuments but also the banishment of the working classes to faceless skyscraper blocks in zoned areas, such as Sarcelles, train journeys away from the centre. The laudable 'Maisons de la Culture', set up to house exhibitions and performances

100 Jean Tinguely's *Metamatic no. 17*, 1959,
spewing out drawings, on the Trocadéro Esplanade
(Biennale de Paris, 1959)

Figure 100

of high-quality work in the provinces, notably
at Le Havre, Amiens and Grenoble, would
be challenged by local politics, a perceived
cultural dictatorship from Paris, and
a distance from 'youth clubs' that Malraux
was all too anxious to maintain.[35]

Malraux, anticolonialist of the 1930s,
was outspoken in his condemnation of torture
when Unesco was inaugurated in Paris in 1946.
He was one of the signatories of the 17 April
1958 protest, published in *Le Monde*, against
the banning of Henri Alleg's *La Question*, a
graphic personal account of organised torture
in Algeria by the French military authorities.[36]
After the humiliation of her defeat in
Indochina at Dien Bien Phu in 1954, and the
1956 Suez Crisis, France ceded independence

to Morocco and Tunisia in 1956, but was
intransigent about Algeria, one of her
'départements'. Malraux's ambassadorial role
in promoting France's *mission civilisatrice* –
her 'civilising mission' – abroad became
increasingly compromised by international
dismay at the Algerian crisis: a war with no
name, with no 'enemy', but one employing
a conscript army of young French citizens. At
the very moment when France's new affluence
was being expressed by the widespread
availability of televisions, refrigerators,
washing machines and plastics, the Algerian
war was an embarrassment and an
anachronism – a news item, a headline on
a *Paris-Match* cover dominated by Gina
Lollobrigida – until terror itself invaded the

sophisticated metropolis.[37] The police riposte was brutal: dozens of Algerian militants were thrown dead and alive into the Seine on 17 October 1961, an event whose burning repercussions are actively debated today.[38]

In his 1962 'New Realism' catalogue for the New York show which juxtaposed Pierre Restany's Nouveaux Réalistes with American proto-Pop artists, the gallerist Sidney Janis distinguished between the 'angry young men of 1918' and the 'cool young men of today'.[39] This distinction held true, perhaps, for the American neo-Dadaists Johns and Rauschenberg, but it embodied a massive misconception as regards European artists. From Arman's *Colères* – sawed violins, hacked pianos and burnt Louis XV armchairs – to César's crushed cars or the exploding *Tirs* – shooting paintings by Niki de Saint Phalle – and the anti-war 'happenings' of Jean-Jacques Lebel and Erró, art in France in the 1960s expressed immense frustration and rage.

The origins of the 'affiches lacérées', the readymade poster art of a 'France ripped apart', lay in the Occupation, in the scratching and defacement of Nazi edicts and reprisal killing lists, long before Raymond Hains's first work in the genre of 1949.[40] The desperation and clandestine Parisian wanderings of what Jacques de la Villeglé called the 'lacerateur anonyme' – the 'anonymous lacerator' – suggested private narratives in the tradition of the *flâneur*, Louis Aragon's Surrealist 'Paris peasant', or the Situationist drifter.[41] Both authorship and spectatorship were at stake. The advertisements which had turned Parisian streets into a huge capitalist comic strip were slashed through with dislocated, screaming slogans of politics and propaganda: torture over there, the OAS (Organisation Armée Secrète) over here.

In 1959, together with Jean Tinguely's hilarious, petrol-powered *Metamatic no. 17* which spat out metres of 'automatically' produced gestural abstractions (fig. 100), torn posters were *the* scandal and political challenge in the newly founded Biennale de Paris, set up by André Malraux to promote international contemporary art on a massive scale.[42] The very notion of the readymade replacing the work of a painter or sculptor produced apoplectic reactions: Bernard Lorjou was a signatory of the manifesto 'From Protest to Rage'. His 140-metre-long painting *Renart à Sakiet*, which used the medieval epic *Roman de Renart* as an allegory to denounce French bombing of the Algerian town, demonstrated the continued efficacy of large-scale history painting.[43]

'La France déchirée' (France Torn Apart), the torn poster exhibition, was held in June 1961. Jacques Fauvet's analysis, *La France déchirée*, from which the exhibition took its title, had been published in 1954, before the intensification of the crisis. The slogans on the works – 'De Gaulle wants a bloodbath, he'll have it!', 'Algeria lost would become a Sudan!' – shouted urgently, now, at the viewer. As Gaullist versus communist, right versus left, fought a poster war on Paris's walls, Hains and Villeglé's 'authorial' policy of non-intervention reflected the Manichaean structure of French politics at the time. The 'war of signs' may also be interpreted via the Soviet emigré Serge Tchakhotine's analyses of political propaganda as 'mind violation'.[44] Alternatively, a structuralist reading of the works would offer a system of signs and their significations: a reading which would have to embrace the dialectic between political content and the torn posters' implicit parodies of modernist practices, from Cubist collage and Dada to Kurt Schwitters.[45] More immediately, Dubuffet's newspaper *Messages*, or his wall series *Les Murs*, scratched with protest graffiti under the Nazi Occupation, are precursors. Fautrier's creation of a surface which represents an accretion of time layers is also important for the *affichistes*, as is Camille Bryen's 'ultra-letter' experiment, *L'Hypérile éclatée* (1953), a poem without syntax, fractured via photography through fluted glass lenses. Above all, the 'affiches lacérées' – and the opaquely pasted 'dessous d'affiches', the reverse of torn posters, by François Dufrêne (cat. 272) – explode the multicoloured-patchwork, painterly surfaces of the lyrical abstractionists against which this generation rebelled.

Restany's Nouveau Réalisme movement, which 'rescued' Hains and Villeglé from an Informel label, was again an essentially male group following the Bretonian model.[46] Yet in his preface to 'La France déchirée' Restany aligned the miscarriages of justice with miscarriage *tout court*, picking up the issue of France's femininity: the torn posters, bloodied rags, the undergarments of politics, were like those of a 'femme du monde' – an elegant woman, with her airs and graces, her charm and her secret bloody woes.[47] Compare this with 'When you lift the skirts of the city you see its sex', Jean-Luc Godard's epigraph to his film *Two or Three Things I Know About Her*

101 Niki de Saint Phalle, *King Kong*, 1963 (detail)
Mixed media on board, 276 × 611 × 48.2 cm
Moderna Museet, Stockholm

Figure 101

(1967), in which the phenomenon of the young working-class female becomes the bearer of meaning of Paris, and everyday life, as a whole: 'HER, the cruelty of neo-capitalism / HER, prostitution / HER, the Parisian region / HER, the bathroom which 70% of the French lack / HER, the terrible law of the *grands ensembles* / HER, the physique of love / HER, life today / HER, the Vietnam war / HER, the modern call-girl / HER, the death of modern beauty / HER, the circulation of ideas / HER, the gestapo of structures.'[48]

Martial Raysse's women with their sugar-coloured make-up – 'Parisiennes maxfactorisées' – carry the same cluster of meanings as Godard's HER, distinguishing his work from Andy Warhol, whose 'Disasters' and then 'Flower Paintings' were exhibited in Paris but whose 'Marilyns', with their transvestite veneers, Raysse knew from his extensive stay in the United States.[49] Just as Godard chooses Marina Vlady/Juliette Janson to denounce casual prostitution in *Two or Three Things…*, or questions the disturbing potency of Maoist slogans on the lips of Juliette Berto in *La Chinoise* (1967), there is a political dimension accompanying the 1960s *vanitas* in Raysse (his Louvre parodies elide here with contemporary images) which contrasts with Warholian anaesthesia. Bernard Rancillac, problematically close to Warhol, said of American Pop artists at the time: 'We can't reproach them: they just didn't want to be critical, that's all. The French state of mind means that we're critical, in the country of Voltaire, of Zola, of Sartre.'[50]

Yet America also meant exciting travel, new exhibiting possibilities and the exchange of ideas and friendship among artists of a new generation – Erró and Fahlström, Niki de Saint Phalle, her husband the writer Harry Matthews, and Rauschenberg, Larry Rivers and Tinguely – as exemplified in Rivers and Tinguely's joint sculpture *The Turning Friendship of America and France* (1961). The most extraordinary witness to this friendship was surely the performance of John Cage's *Variations II* at the American Embassy in Paris in June 1961 which featured a flowery target by Jasper Johns on stage with the piano, a Rauschenberg combine in the making, and a hired marksman who 'completed' Niki de Saint Phalle's *Shoot-out at the American Embassy* with a bang, under the nose of the diplomats.[51] Niki de Saint Phalle's anger, directed not only at politics but patriarchy

in all its forms – Church, State and family – and on both sides of the Atlantic, is surely the strongest expression of the period. Her *OAS* (cat. 250), a golden altarpiece made for a show of sacred art ('Œuvres d'art sacré'), comments on the death-like impotence and kitschy ineptitude of the church in France in the context of terrorism by the OAS (Organisation Armée Secrète) and police repression.[52] Her Los Angeles *King Kong* altarpiece (1963; fig. 101) captures the monstrosity of American skyscrapers targeted by nuclear warheads at the height of the transatlantic Polaris missile debate.[53] Her shooting paintings, *Tirs*, while delighting the 'have-a-go' males at her openings (among them Jean Fautrier), were deadly serious in their mimicry, above all in the identity of bleeding body and 'picture' – the nude running with paint or splattered with the ejaculatory tricklings of an emasculated abstraction, French or American. *Kennedy-Khrushchev* (1963; cat. 248) is a work remarkable for its hideousness and its prescience – Siamese twins with lifelike rubber masks, completed with a shoot-out at the tense moment of the opening of the New York–Moscow telephone hotline in June 1963. It anticipated Kennedy's November assassination, a 'télétragédie planétaire', by months: the body politic as effigy signifying Cold War apocalypse.

From happenings to the spectacle

Extraordinary prescience was evident again, when the Bulgarian Christo and Parisian Jeanne-Claude blocked the Rue Visconti with a barricade of oil barrels for eight hours in June 1962 (fig. 102): a symbolic representation of an Iron Curtain, a Berlin wall – or the Algerian impasse?[54] Algerian independence would finally be achieved in July. Jean-Jacques Lebel's politicised happening 'To exorcise the spirit of catastrophe' took place in November 1962 (in the wake of his first 'Anti-trial' in May 1960 and *The Great Antifascist Collective Painting* [fig. 103], which incorporated the celebrated *Manifeste des 121*, shown in Milan in 1961).[55] For it, the Icelandic artist Ferro (later Erró) paraded fabulous masks, half-military, half-tribal and decorated with myriad *objets trouvés*, while Lebel, as de Gaulle in a rubber mask, pushed a pram. The spectre of America and the Cold War returned: two naked women in Khruschev and Kennedy masks, their bare flesh plastered with slogans and newsprint, 'strangled' each other in a bloodbath of red liquid. Here catastrophe

Figure 103

Figure 102

was re-enacted as catharsis; Tetsumi Kudo's installation *Philosophy of Impotence* (1962) was part of the set. Happenings could effect protest but not change.[56]

In New York, Erró was the privileged photographer of Carolee Schneeman's private performance *Eye Body* in February 1964. Schneeman brought *Meat Joy* – a piece entirely inspired by French culture, by Proust, de Beauvoir and Artaud – to Jean-Jacques Lebel's Festival de la Libre Expression in May.[57] This was held at the American Center in the Boulevard Raspail, a crucible of permissive counter culture, Fluxus events, music, dance and political discussion, under a regime of intellectual censorship which became increasingly oppressive throughout the 1960s.[58] The constellation of painters around Lebel exemplified another Parisian 'melting-pot' in which the inheritors of Surrealism (Erró and Lebel, Eduardo Arroyo) and of the monstrosities of Dubuffet, Picabia and the Cobra Movement, with Enrico Baj from Italy, encountered the political realism of the Italian communist Antonio Recalcati – whose response to the Algerian atrocities of 1962 involved both acid-coloured Seine landscapes and dark, male-body imprints.[59] The years 1962–65 mark the passage between Surrealist political painting based on

expressionist monstrosity and disfigurement, and the communist/neo-Marxist realism known as 'Figuration Narrative'.

In a riposte to Rauschenberg's success at the Venice Biennale, the exhibition 'Mythologies quotidiennes', held in Paris in July 1964, showed this new narrative painting alert to the 'games of the city...the shock of signals...which traumatise modern man every day'.[60] In 1965, 'La Salle verte', an all-green room of figurative painting, was created at the Salon de la Jeune Peinture – an insult to both socialist realism, abstractions and monochromes.[61] British Pop artists, introduced at the same 1965 Salon de la Jeune Peinture, reinforced French interests in figuration, quotation and the banal, complementing more brazen works from America.[62] The 1965 show 'La Figuration narrative dans l'art contemporain' was dominated by *To Live or Let Die or The Tragic End of Marcel Duchamp* (1965; cat. 280) by Arroyo, Recalcati and Gilles Aillaud. In a narrative sequence of eight paintings, Duchamp is arrested, beaten, interrogated, and knocked nude down a staircase. Assassinated, his coffin is borne beneath the Stars and Stripes like that of a Vietnam War victim, flanked by the 'artist-generals' Warhol, Oldenburg, Raysse, Arman and

Figure 104

Restany. Duchamp's readymade urinal *Fountain* (exhibited as an art object and signed 'R. Mutt' in 1917) is parodied here by a hand-painted appropriation of its image, together with one of *The Large Glass* (1915–23). The Figuration Narrative group's slogan was eloquent: 'Better to paint and not to sign than to sign and not to paint.'[63] Duchamp's flagrant and lifelong apoliticism is countered in *To Live or Let Die* by the message of political realism, a realism of the group overriding the cult of the artist-genius. Duchamp's dictatorship of the arts is aligned with the new American art dictators, as is, above all, his abdication of French nationality. The Figuration Narrative artists were convinced – within this Parisian scene, its critical support structure and French spheres of influence – that art had a viable political role and artists a genuine responsibility. 'I can't turn my eyes from the battlefield, the killing fields, the besieged towns, the tribunals, the meeting rooms, the operating theatres, the torture chambers – all these places in the world where the world is being made, horrifically fast, without me, without us,' said Bernard Rancillac in the catalogue of 'Le Monde en question', a 1966 show.[64] Images from the press, film and TV were being projected onto canvas with an epidiascope long before American hyperrealism hit Paris.[65] 'Bande dessinée et figuration narrative' in 1967 continued this series of exhibitions; work by Rancillac, the

American Peter Saul and Erró declared a passion for the contemporary comic.[66] Erró's *Background of Jackson Pollock* (1967; cat. 277) conflates a comic-strip image of the beleaguered American artist-hero, his global postcard 'photothèque' of modern masterpieces (Malraux's *musée imaginaire* as kitsch), and brilliantly imitated, scaled-down 'drippings': modernism's end of the road.[67]

1967 was a remarkable year for art from Paris, for its global visibility and its global engagement. This was all the more extraordinary, in that it could not anticipate the revolution that was to come. As well as France's pavilion at the Montreal Expo '67 (and de Gaulle's 'Vive le Quebec libre!') 1967 was the fiftieth anniversary of the Russian Revolution of 1917, celebrated in Paris by communists and neo-Marxists alike, and the year of the Sino-Soviet split, releasing Mao's China as another 'territory for the imagination' for French intellectuals: a brighter palette and a pastoral theatre for French artists who were as yet unaware of Peking's Potemkin strategies.[68] Rancillac's 1967 show 'L'Année 1966' presented eighteen paintings on issues ranging from the Cultural Revolution to hostilities between Israelis and Palestinians, torture in Vietnam, famine in third-world countries, contraception, and the assassination of Che Guevara in Bolivia, which plunged Castro's Cuba into mourning.[69] During America's 1967 'summer of love' the

Figure 105

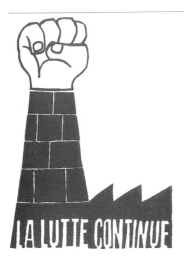

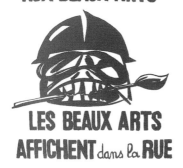

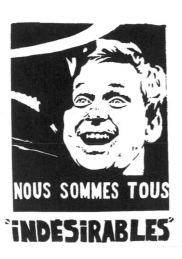

Figure 106

Salon de Mai exhibition was transported *en bloc* from Paris to Cuba. Financed by Castro's government, this was the prelude to the 'anti-imperialist' Cultural Congress of Havana which took place in January 1968. In one night, that of 17 July 1967, in front of the world's TV cameras, a huge, target-like, spiralling pro-revolutionary painting, the *Mural Cuba Colectiva* (fig. 104) – a worthy successor to the *Great Antifascist Collective Painting* – was created by 100 artists from all over the world.[70] Back in Paris in December the dissident, underground currents of both Beat-generation America and the Soviet Union were highlighted in the new art review *Opus International*.[71] This global activity acts as a gloss on the most significant publication of the year, the Situationist Guy Debord's *La Société du spectacle*. Couched in a series of philosophical paragraphs, Debord's text described a nation enslaved by the spectacularised commodity, including global media images, in which it confronted its own image, reflected, diffracted or displaced.[72]

And yet this glut of excess, the counterpart of the flat existence of a France internally bored to death,[73] was also counteracted not just with the *désinvolture* of international Op and Kinetic art – which reached an apogee in 1965 and was translated into contemporary fashion and design[74] – but with a 'degree zero' of painting and sculpture.

Exhibited in Cuba's Salon de Mai, Jean Pierre Raynaud's *Psycho-object, Age 27* (1967; cat. 269), a closed, white structure – a sentry box or a vertical coffin? – witnesses the intersection of repressed autobiography with the then-current 'anti-psychiatric' discourses of Michel Foucault and R. D. Laing.[75] In the same year at the 'headquarters' of Figuration Narrative, the Salon de la Jeune Peinture, Daniel Buren, Olivier Mosset, Michel Parmentier and Niele Toroni, exhibiting as 'BMPT', showed four white canvases marked only with stripes, a circle, bands or rectangular paintbrush 'prints' respectively (fig. 105). They turned their space into a happening with a tape-recorded manifesto, a *décrochage* – or march-out with the paintings – and an anti-Salon tract on the day of the opening. Supremely formalist, yet relating to Bataillean as well as Barthean notions of a 'limit experience', their work still claimed to be political, inasmuch as the blankness, the deliberate 'modernism', symbolised practices of *recouvrement* (covering up): 'Because painting means painting as a function of

aestheticism, flowers, women, eroticism, the everyday environment, art, dada, psychoanalysis, war in Vietnam: WE ARE NOT PAINTERS'.[76] Pierre Buraglio's abstract *Mondrian Camouflaged* (1968; cat. 281) and his spray-painted portrait of Nguyen Huu Tho, for the Salle Rouge de Vietnam (postponed from May 1968 to 1969), set up an exemplary dialectic between modernist *recouvrement* versus political figuration (compare the communist Henri Cueco's Salle Rouge painting recalling Delacroix's 1830 *Liberty Leading the People* [1968; cat. 275]).[77] Superlatively well-informed, BMPT, while acknowledging a paternity (maternity?) in the works of Simon Hantaï, anticipated the flat, painterly dimensions of the Supports-Surfaces movement and the shift from formalism to psychoanalytic art criticism within the literary Tel Quel group of the 1970s.[78] 'L'Art du Réel USA, 1948–1968' held at the Grand Palais in late 1968 would ratify the dialogue, seen through French eyes, between Matisse and Rothko or Newman.[79]

May '68: from jazz to tear gas

'In Saint-Germain des-Prés there's jazz in the streets. Atmosphere 1944–45…But suddenly, a brutal wake-up: Place Saint-André-des-Arts, agitated demonstrators attack. The CRS riot police riposte, hand grenades in action. Suffocation, stinging, tears. Stones are thrown by one group, then by another. The combat's chemical and neolithic…Boulevard Saint-Michel. It's like the apocalypse…Firebursts everywhere. Trees cut down. Up by the Sorbonne, through a grey curtain traced with whitish streaks, you can make out a strange bubbling. Bluish, quivering. A black packet of hate.'[80]

The transition from Saint Germain to the Latin Quarter in this on-the-spot reportage is clear. 'CRS = SS', the students' taunt against the armed riot police (Compagnies Republicains de Sécurité), was adopted as the title of an article by the publisher François Maspero. He reiterated the broad perception on the left that de Gaulle's regime was a 'fascist' Police State: the underside of the French *son et lumière* was silent repression, a constant will to harass and to humiliate 'the slaves of our society' – Algerians and foreign workers in particular.[81] And art? *Combat*, the left-wing newspaper, reported the call for a general strike which would paralyse the economic life of the whole nation from 13 May. Following police repression in the Latin

107 Gérard Fromanger surrounded by *Souffle* sculptures, 1968

108 Jean-Jacques Lebel with Caroline de Bendern on his shoulders, Latin Quarter, 8 May 1968

Figure 108

Quarter, a million demonstrators would turn out in central Paris. *Combat*'s back pages described a definitively tedious Salon de Mai alongside adverts for Rosenquist and Enrico Baj. But 'painting must wait this week'.[82] The Ecole des Beaux-Arts had, in fact, gone on strike on 8 May; student occupation took place on 14 May, and the first poster – *Usines, Universités, Union* – was made in the lithographic workshop. By the next day a platform of resolutions had been adopted and the 'Atelier Populaire' went into poster production, radically speeded-up by silk-screen techniques.[83] The posters (fig. 106) were complemented by a 'wall newspaper' which ran to five issues, each bearing the symbol of a clenched fist combined with a factory.[84] Bernard Rancillac produced *Nous sommes tous des juifs et des allemands* (later modified to *Nous sommes tous 'indésirables'*), arguably the most controversial poster of all, which was based on a press photograph of Daniel Cohn-Bendit, the revolutionary agitator expelled from the University of Nanterre.[85] Rancillac sees the style of the militant posters as 'closer to Daumier than to Warhol', and the Grand Guignol May '68 puppet theatre, with police puppets thwacking students, indeed recalled

Daumier's famous polychrome politicians' heads.[86] Gérard Fromanger mentions the different political groups, the workers, the students, people from Rome, London and the French provinces, all of whom passed through the Atelier, and the particular skills of the group GRAV (Groupe de Recherche d'Art Visuel) with their geometric design flair and experience of street art.[87] Artists such as Asger Jorn, Alechinsky, Matta ('art-guerrilla'), the Yugoslavian painter Vladimir Velikovic and even Vieira da Silva produced posters; dozens, including Jean Hélion and Raymond Mason, went to a spontaneously organised meeting in the Galerie Jeanne Bucher.[88] The absentee Jean Dubuffet – never a man of the left – found his just-published *Asphyxiante culture* completely overtaken by events.[89] Even Salvador Dalí published a revolutionary critique, proposing an 'amethyst' rather than red May '68.[90]

But it was the anonymous creators who triumphed, spreading painted and spray-canned slogans – 'Imagination takes control' (Sciences-Po staircase); 'Be realistic: demand the impossible' (Censier); 'The more I make love, the more I want to make revolution; the more I make revolution, the more I want to make love' (Sorbonne) – over the fabric of the university itself, born from 'ideas which from

Figure 107

Proudhon to Bakounin, from the Surrealists to the Situationists, had stirred France from the time of its oldest barricades'.[91] The Situationist René Vienet 'perverted' André Devambez's venerable 1909 painting in the Sorbonne with the words: 'Humanity will never be happy until the last bureaucrat has been hanged with the guts of the last capitalist.'[92] In addition to the power of slogans, collective 'paintings', generally abstract, were photographed as they erupted in successive waves on the walls of the great amphitheatre of the Nanterre literature faculty: 'This painting exists because it speaks the language of those who are twenty / Its style is the style of revolt / Its matter is violence.'[93]

Jean-Jacques Lebel, inevitably, was at the heart of things: the occupation of the National Theatre at the Odéon. The Comité d'Action Révolutionnaire called for the systematic sabotage of the culture industry. Lebel's May 1968 broadsheet Le Pavé reprinted Antonin Artaud's contemptuous and derogatory letter to the Rectors of European Universities of 1925, together with a passage from Bataille on fear and the limits of being which exist to be transgressed.[94] As soon as the French radio headquarters were occupied, Artaud's 'To Have Done with the Judgement of God' (1947), which had been banned immediately, was illegally broadcast.[95] Lion of the revolt, Lebel bore Caroline de Bendern, the 'Marianne of May '68' waving the Vietnam flag, on his shoulders through the crowds – an image that crossed the world (fig. 108). De Bendern, who appeared in Serge Bard's films Détruisez-vous in April 1968 and Ici et maintenant in May, was the muse of the so-called Zanzibar Group of film-makers – indebted to Godard – which involved the artists Olivier Mosset (of BMPT) and Daniel Pomereulle, and the art critic Alain Jouffroy.[96] Chris Marker's remarkable diptych Le Fond de l'air est rouge, not released until 1977, jump-cut from his film-shorts of May to terrifying scenes of global violence.

After May

Rubber cobblestone pavés with internal whistles were soon, alas, on sale in Paris's 'American' Drugstore.[97] Victory in the legislative elections reinforced de Gaulle's presidential power. With intellectual Paris still in shock, the painter Gérard Fromanger left for London to publish the May '68 posters from the Atelier Populaire with the film-maker Jean-Luc Godard, his collaborator on the film-short Rouge (1968).[98] Paris was still in disarray;

it was time to write and reflect.[99] In October, Fromanger created happenings with his Souffles sculptures in the Boulevard de Clichy in Montmartre and outside the Alésia church south of Montparnasse (cat. 279, fig. 107): Jean-Luc Godard was in the crowd making 'shorts' of the event, together with several policemen. The riot shields of May were parodied by Fromanger's transparent bubble-sculptures. They echoed the inflatable domes of the 'Structures gonflables' exhibition of March 1968, which had been organised by the French architectural group 'Utopie'.[100] But melancholy prevailed after the red-hot experiences of the barricades. With disturbing pragmatism, Daniel Buren wrote that art was a distraction from the real – whether it was exhibited in a factory or not; countering the 'myth' of a revolutionary art, he concluded, 'But art is objectively reactionary.'[101] Cynicism and dandyism would set in – extending to the very definitions of masculinity itself with the 'après-mai des faunes' diagnosed by the homosexual activist Guy Hocquenghem[102] – a complement to the stirrings of a long-overdue Women's Liberation movement that neither the 'Mariannes' of 1968 nor the pneumatic Barbarellas or comic-strip Pravda Girls had been able to catalyse.

The founding of the Centre National d'Art Contemporain (CNAC) in 1967, its exhibitions and projects, and the decision to build a huge library – free for all – in the Beaubourg area in October 1968 set core activities in motion in the French art world over the next decade, which would be marked by the turbulence of painting and sculpture and the uncontested brilliance of Paris's intellectual life.[103]

At its official inauguration in 1977, the Centre Georges Pompidou was still being run by the 1960s CNAC team. Conceived by Renzo Piano and Richard Rogers, it was Paris's greatest monument since the Eiffel Tower. Dedicated to interdisciplinarity, its landmark shows 'Paris–New York', 'Paris–Berlin', 'Paris–Moscou', 'Les Réalismes' and 'Paris–Paris' (1977–81) demonstrated Paris's dialogue with the world. The transparent building invited the street into the museum and extended the museum into the street. As splendid museums came more and more to dominate the heart of the city, the Centre Pompidou became identified with the name of its quartier, Beaubourg, marking a new topographical shift in the Paris art world.

1 'L'art actuel, c'est une fusée dans l'espace. Les Prisunics sont les musées d'art moderne.' Undated, unpublished text cited in the chronology of Paris 1992C, p. 36. Millet 1987, p. 11, describes contemporary art reproductions on sale at Prisunic from 1967.
2 'La beauté c'est le mauvais goût. Il faut pousser la fausseté jusqu'au bout. Le mauvais goût, c'est le rêve d'une beauté trop voulue.' Raysse in conversation with Jean-Jacques Levêque, 'La Beauté c'est le mauvais goût', Arts, 16–22 June 1965, p. 39. Didier Semin emphasises the link between Raysse and Baudelaire's 1863 essay, 'The Painter of Modern Life'. See Semin 1992.
3 See Malraux 1951; Malraux 1957; Sabourin 1972; Saint-Paul 1973; and Paris 2001. For the musée imaginaire, its democratic beginnings, its relationship to cinema, and its ultimate imperialism, see Wilson 1993, pp. 43–44.
4 Late modernist choices prevailed for the 'grands prix nationaux', awarded by Gaëtan Picon to Max Ernst, Giacometti, Bazaine and Beaudin; see Girard and Gentil 1996, p. 40.
5 '…tout ce dont l'adulte ne s'étonne pas: la guerre, la bureaucratie, la laideur, les Martiens, etc.' Barthes 1957, quoted from the 1970 edition, p. 59; English edition, 2000, p. 53.
6 'Les Trésors de l'Inde: 5,000 ans d'art indien à Paris', Petit Palais, April 1960; 'Sept Mille ans d'art en Iran', Petit Palais, October 1961; 'L'Art nègre: sources, évolution, expansion', Musée de l'Homme, June–September 1966; 'Les Trésors de Toutankhamon', Petit Palais, February 1967.
7 Law no 64-203, 4 March 1964 (mooted 1962–63), set up a national commission to prepare an inventory of the monuments and artistic treasures of France; see Balsamo, in Girard and Gentil 1996, pp. 95–105 and 492.
8 Passed on 31 July 1962, law no. 62-880, the 'Law of the Seven Monuments', concerned the restoration programme (1962–66) of the Louvre, the Invalides, the palace of Versailles, the châteaux of Fontainebleau, Vincennes and Chambord, and Reims Cathedral. Law no. 67-1174, passed on 28 December 1967, continued and expanded the programme.
9 Bernard Anthonioz, under Gaëtan Picon, was in charge of the royal- and then state-owned Gobelins, Savonnerie and Beauvais tapestry manufactures and the Sèvres porcelain factory, as well as the 1% for art policy, state purchases and social policy for artists. He would commission works from the manufactures by Arp (1963), Chagall (1964), Calder, Delaunay and Le Corbusier (1965), Miró (1966), and Magnelli and Picasso (1967). See Viatte 1999, pp. 65, 73 and 83–85. For a critical view see Cabanne 1981, pp. 194–202; and Fumaroli 1991, pp. 115–32.
10 For the internal programme see Janine Mossuz-Lavau, in Girard and Gentil 1996, p. 20 and Annexe 10, which illustrates diagrams demonstrating the core structures set in place in 1959 and their expansion by 1989. For the quinquennial plans see Piniau and Tio Bellido 1998, pp. 110–13 and 117–25.
11 See Cabanne 1981, pp. 19–21 and 89–92; and Monnier 1991, pp. 242–49.
12 The three Unesco buildings were planned by Marcel Breuer (USA), Pier Luigi Nervi (Italy) and Bernard Zehrfuss (France). There were paintings by Afro (Italy), Appel (Low Countries), Matta (Chili), Tamayo (Mexico) and Picasso (the controversial Fall of Icarus), and sculpture by Moore and Arp. A mosaic by Bazaine, a Calder mobile, a ceramic wall by Miró and Artigas, and a Japanese garden by Noguchi were financed by an art budget of $191,000 out of a total budget of $9m. See Zehrfuss 1991.
13 See Jean Cassou, Emile Langui and Nikolaus Pevsner in Paris 1961D.
14 See Maeght 1974.
15 For public commissions, and Anthonioz's role in relation to Malraux, see Viatte 1999, pp. 86–97 (including Niki de Saint Phalle's and Jean Tinguely's Paradis fantastique, automated 'Nanas' for the roof of the 1967 Montreal French Pavilion; see fig. 17 in this catalogue). For the Giacometti monument, see Viatte 1999, p. 87.
16 See Barthes 1968; and Foucault 1969.
17 'L'Aventure Dada' at the Galerie de l'Institut, was organised by the Surrealist Georges Hugnet. Robert Lebel's comprehensive monograph on Duchamp was published simultaneously in New York and Paris; see Lebel 1959. Lebel had spent the war in America with his young son Jean-Jacques, and was extremely close to Duchamp and Breton.
18 The extensive parallels cannot be explored here. Georges Perec's Les Choses was published in 1965, Robbe-Grillet's La Jalousie in 1957 and Pour un nouveau roman in 1963. For a preliminary comparative analysis with cinema, see Allen 1995.

19 See Monnerot 1945; Lefebvre 1947; Monnerot 1949; and Lefebvre 1968. The Surrealist Noël Arnaud's review of Lefebvre 1947 in *Le Surréalisme révolutionnaire*, 1, March–April 1948, anticipates such ironical publications within a Surrealist/anthropological tradition as his *La Langue verte et la cuite* (Jorn and Arnaud 1968). Situationists Guy Debord and Raoul Vaneigem attended Lefebvre's sociology lectures at the University of Nanterre from 1957 to 1958.

20 Spoerri referred to the 'Annales' school of history which marked the shift in attention from kings, queens and battles to the everyday in the 1930s, but popularised this material in later works by authors such as Georges Duby and Jacques Soustelle. Tançons 2000, n.p., and Spoerri in conversation with the author, 11 July 2001.

21 '40' au dessus de Dada' was the title of a show held at the Galerie J in May 1961. Lassalle 1993 traces usage of the term 'nouveau réalisme' by Fernand Léger in the 1920s through the 'de-sovietisation' strategies of the socialist realists in 1949 (Taslitzky 1949), through to the Nouveaux Réalistes in the 1960s. See also Restany 1990, p. 88: 'Les Nouveaux Réalistes assumaient à chaud (40° celsius) la même découverte de la nature moderne que Dada-Duchamp avait constaté a froid (37°, la temperature normale du corps humain).' The manifesto was signed by Arman, Dufrêne, Hains, Restany, Tinguely, Klein, Raysse and Spoerri; César and the Italian *affichiste* Mimmo Rotella would join the group, as would Niki de Saint Phalle. See the detailed chronology in Paris 1986, pp. 45–103. See also Francblin 1997. Périer 1998, pp. 38–39, notes Restany's jobs in the Gaullist cabinets of Chaban-Delmas and Corniglion-Moliner, from 1954, writing official speeches – affiliations surely not without importance for the later 'official' success of the movement. Cone's discussion, 'Pierre Restany. Postwar Remnants of Cultural Pétainism Exposed' (*sic*), in Cone 2001, pp. 151–69, is contentious.

22 'Portrait-robot' translates literally as 'Identikit' portrait. For readings of Arman, see Buchloh 1998; but also Amishai-Maizels 1993, pp. 149–50; and Levene 2000, pp. 18–33.

23 See the discussion in Mahon 1998. 'Le Surréalisme, sources, histoire, affinités', was a historical show (Galerie Charpentier, 1964). For Molinier, see Winnipeg 1997.

24 For *Phases*, 1952–, directed by Edouard Jaguer, see Le Havre 1988; Plemet 1994; and Arras 2000. See also *Le Surréalisme, même*, 1956–59; *La Brèche*, 1962–65; and *Archibras*, 1967–69.

25 See for example Tinguely's automated machine *How Green Was My Valley* (1961), which combines the trope of the Dadaist 'celibate machine', a sexual, piston-like movement and metonymic/fetishistic representations of woman, with a feather duster; Paris 1986, p. 204.

26 For Monory's links with Surrealism and the late Surrealist writer Stanislas Rodinski, see Wilson 1998B, pp. 42–44.

27 'Elle [Lebel's ardour] est liberté, elle est violence, elle est désordre, elle est mouvement dialéctique'; Victor Brauner on Lebel (signed Milan, 1961) in Paris 1988, p. 3.

28 Barry Farrell, 'Bacchanal of Nudity, Spaghetti and Poetry', *Life Magazine*, 7 February 1967, in Paris 1988, p. 75.

29 For the Situationist attack on Surrealism see *Internationale Situationniste*, 1, June 1958, pp. 3–4; and Hussey 2001, pp. 141–43.

30 Isou advocated youth revolution in 'Lettrisme et révolution de la jeunesse', a tract of 1946, published in *Hikma* (Tunis), February 1948. See also 'S.O.S. manifeste du soulèvement de la jeunesse', in *Front de la Jeunesse*, 1, Summer 1950. Debord completely expropriated a bewildered Isou with his breakaway 'Internationale Lettriste' and new movement. In London Ralph Rumney's Committee for Psycho-geography also formed part of the Internationale Situationniste. See Woods 2000; and Hussey 2001, pp. 64–73.

31 See 'Définitions', *Internationale Situationniste*, 1, June 1958, pp. 13–14, in London 1991, p. 22, and related documents in translation.

32 For Jorn's 'modified' paintings, see Paris 1959B, with the artist's preface.

33 See Althusser 1965; Althusser 1965B; and Lacan 1966.

34 For Lyotard's 'désirrévolution', see Lyotard 1973, p. 30 (July 1968); and Wilson 1998B (which omitted discussion of Marcuse's influence, pioneered by the 'Arguments' group). For Marcuse, who visited Paris in May '68, see Lefebvre 1968, in the 1969 translation, pp. 24–33; and Lefebvre's subsequent publications.

35 For the Maisons de la Culture, see Girard and Gentil 1996. The brief by the theatre director Pierre Moinot is covered on pp. 381–90; the 'cultural commando operation' and local fears of politico-cultural pollution by Jean-Jack Queyranne on pp. 79–81; and Malraux's grandiose hopes (December 1965), his desire to distinguish the Maisons de la Culture from the Maisons des Jeunes (March 1966), and his admission of crisis (November 1968) on pp. 505–08.

36 Alleg was the communist editor of *Alger Républicain*. See 'Adresse solonnelle à Monsieur le President de la République. A Propos de la saisi de *La Question*, Livre d'Henri Alleg', *L'Express*, 17 April

1958, in Malraux 1996, p. 247. While Gillo Pontecorvo's film *La Bataille d'Algers* (an exposé of the Algerian Front de Libération National and their conflicts from 1954–57) was banned in 1966, Malraux notoriously permitted performances of Jean Genet's critical play on Algeria *Les Paravents* in Paris in the same year.

37 See Gervereau 1992, p. 178; he reproduces *Paris-Match*, 6 November 1954, cover illustration, on p. 179.

38 See Maran 1989; 'La France face à ses crimes en Algérie', *Le Monde*, 3 May 2001, with discussion of the torture and 'counter-terror' operations revealed by General Paul Aussaresses (pp. 1, 6, 14–15 and 18) compared with the crimes of the police chief Maurice Papon, responsible for the 1961 atrocities; and *Le Monde*, 17 October 2001.

39 See New York 1962. Dempsey 1999, pp. 217–25, reproduces Sidney Janis's *New Realism* catalogue, New York, 1962. The preface by the American poet John Ashbery (resident in Paris from 1955–65, who took over Annette Michelson's job reporting for the Paris *Herald Tribune*) is full of references and enthusiasm for European culture, from Juan Gris to Antonioni; see also Ashbery 1989.

40 See Bourguet and Lacretelle 1959; Hains's first work in the 'torn-poster' genre, *Ach Alma Manetro* (1949), in strip format, was conceived in the wake of the exhibition of the Bayeux Tapestry at the Louvre.

41 See Aragon 1926; and Tester 1994, for extensive analyses of the *flâneur*.

42 For the Biennale de Paris, see Paris 1959C; and Monnier 1991, pp. 271–73. The first biennale invited forty-two nations and included over 600 works.

43 Exhibited in part in its own pavilion at the Brussels World Fair, and banned by de Gaulle's brother, Lorjou's *Renart à Sakiet* was subsequently shown at the Grand Palais in the 1958 Salon d'Automne (Gervereau 1992, p. 194). Gervereau's extensive article situates painting within a range of representations including those of popular journalism, photography drawing and cartoons.

44 Bertrand-Dorléac 1992 analyses Fauvet, gives a list of works exhibited in 'La France déchirée' (pp. 202–03), and points out the 1952 re-edition of Serge Tchakhotine's *Le Viol des foules…* (censored in 1939) which influenced Villeglé. See Villeglé 1986, p. 80.

45 Schwitters, who died in England in 1947, was rediscovered in Paris in 1949; his collages were exhibited in 1954 at the Galerie Berggruen. Villeglé 2001 – a meditation on the 'catalogue' – offers a model of potential analyses, influences and subtexts, including Melville, Mallarmé, 'Maldororian comparative syntactic scrambling', Joyce's *epiphanies* and the 'flayed writing of Céline'.

46 Hains, Villeglé and Dufrêne, together with the painters Favory, Miotte, Neiman and Foldes, were exhibited at the 1959 Biennale in the 'Salle des Informels' organised by the painter Georges Noël.

47 'Les dessous de la politique sont ceux d'une femme du monde qui aurait eu des malheurs. Notre histoire est plein de sang, de chichis et de charmes'; Restany, in Paris 1961B.

48 Godard 1984, p. 8: 'Quand on soulève les jupes de la ville, on en voit le sexe'; p. 10: 'ELLE, la cruauté du néo-capitalisme / ELLE, la prostitution / ELLE, la région parisienne / ELLE, les salles de bain que n'ont pas 70% des Français / ELLE, la terrible loi des grands ensembles / ELLE, la physique de l'amour / ELLE, la vie d'aujourd'hui / ELLE, la guerre de Vietnam / ELLE, la call-girl moderne / ELLE, la mort de la beauté moderne / ELLE, la circulation des idées / ELLE, la gestapo des structures.'

49 Warhol exhibited the 'Death in America' series in Paris at the Galerie Ileana Sonnabend in January–February 1964 with texts by Jean-Jacques Lebel, Alain Jouffroy and John Ashbery; and the 'Flower' series in May 1965 at the same venue with text by Otto Hahn. See Lowther 2001 for reproductions of catalogues and the critical reception.

50 'Mais on n'a pas a le leur reprocher, ils ne voulaient pas être critiques c'est tout. L'état d'esprit français fait qu'on est critique, le pays de Voltaire et de Zola et de Sartre'; Bernard Rancillac in conversation with Joanna Boulos, 26 May 2000, in Boulos 2000, n.p.

51 For a comprehensive description and contextualising of *Variations II*, see Dempsey 1999, chapter 5, pp. 131–52 and especially pp. 134–37.

52 *OAS* was made for 'Art moral, art sacré', organised by Restany at the Galerie Rive Droite, June–July 1962 (Paris 1962B). The demonstration against OAS right-wing extremist terrorism by trade unions and those on the left on 8 February 1962 which was intercepted by police at the Métro Charonne resulted in eight deaths and hundreds of injuries. Half a millon attended the funerals.

53 The British prime minister Harold Macmillan was offered American Polaris missiles capable of delivering British nuclear warheads in December 1962 as part of a NATO arsenal and under American control (he accepted the offer in April 1963). France possessed neither the delivery systems nor the nuclear warheads to use them. Malraux's visit to Washington with the *Mona Lisa* in early January preceded de Gaulle's veto of British entry to the Common Market (13 January 1963) and the decision to develop unilateral defence forces. See Lebovics 1999, pp. 9–26, especially 'France's Aesthetic "Force de Frappe"', pp. 22–24.

54 See *Projet du mur provisoire de tonneaux métalliques/Project for a Temporary Wall of Oil Barrels*, a collage, including text, of a project submitted to the Paris Prefecture in October 1961; a translation exists in London 2000, n.p. The erection of the barricade coincided with the opening of the exhibition 'Christo' at the Galerie J, which included drawings for the project and a wall of oil barrels.

55 For the 'Anti-procès 1', an international exhibition and series of events (Galerie des Quatres Saisons, repeated in Venice), and the *Great Antifascist Collective Painting* (1960; fig. 103), a political 'manifesto painting' by Lebel, Crippa, Baj, Dova, Erró and Recalcati which was confiscated by the Italian police, see Baj et al. 2000. The text of the manifesto, which was signed by 121 intellectuals and drafted mainly by the writer Maurice Blanchot, declared the right of young French men to refuse to bear arms against the Algerian people; see Baj et al. 2000, pp. 42–43. See also Addison 1998, p. 35 and interviews with Lebel and Erró.

56 See Mahon 1998.

57 For Carolee Schneeman's *Eye Body*, see Cameron, in New York 1996B, p. 11, and for *Meat Joy*, based on 'my fantasies of French culture' in Paris, see Schleeman in Delanoë 1994, pp. 115 and 122–25. See also 'What's Happening? The Free Expression Workshop', in Paris 1988E, pp. 67 and 90–91.

58 See Delanoë 1994. Delanoë's description of the cultural activities of The American Center, at 261 Boulevard Raspail, since its 1931 foundation, supplements Eric de Chassey's discussions in this catalogue. For an extraordinary list of censored books, films and broadcasts from 1960 to 1963, see pp. 96–97; for the impact of Paris–New York charter flights, see pp. 108–09; for the impact of 'living theatres' on May '68 (Lebel at the Odeon), see pp. 98–99; and for the little-known exhibition 'Artistes en exil, 1936–1946 USA', held during May '68, see p. 138. For the protest groups PARIS (Paris Racial Integration Support) and PACS (Paris American Committee to Stop War), see pp. 126–28.

59 For example, although Arroyo's work is 'realist', his anti-Franco exhibition 'Miró refait' at the Biennale de Paris in 1967 'appropriated' Miró's paintings, hence apparently 'Surrealist' works. Recalcati could be classifed as 'Italian Pop', or with 'neorealismo' and 'nuovo racconto', the Italian movements equivalent to Figuration Narrative in France. The vibrant Paris–Milan axis was crucial here.

60 '…les jeux de la cité…le choc des signaux…qui traumatise journellement l'homme moderne'; Gérald Gassiot-Talabot, in Paris 1964.

61 See '1965, 16ème Salon', in Parent and Perrot 1983, pp. 48–51. The Salon invited British Pop artists, the Equipo Cronica from Valencia, the Munich 'Gruppe Spur' and nine Czech painters.

62 For American Pop in Paris, see Paris 1961C; Paris 1963; Paris 1963B (and also the one-man shows at the Galerie Ileana Sonnabend); and Paris 1965B. The impact of the British presence, particularly that of Patrick Caulfield, is constantly ignored in French accounts: compare his black contours with Adami, and his appropriation of Delacroix's *Greece Expiring on the Ruins of Missolonghi* with Cueco's Delacroix-inspired *La Barricade, Viet Nam 68* (cat. 275).

63 'Mieux vaut travailler sans signer que signer sans travailler'; see Parent and Perrot 1983, p. 46. See Paris 1965; and, for the violent reception of *Live and Let Die…*, see Gassiot-Talabot 1974; and Debray 2001. For shifts in terminology, see Pierre Gaudibert in Lyons 1992, pp. 7–9, and Gassiot-Talabot 1996.

64 'Je ne peux détourner les yeux des champs de bataille, des charniers, des villes assiégées, des tribunaux, des salles de réunion, des salles d'opération ou de torture, tous lieux en ce monde ou le monde se fait, effroyablement vite, sans moi, sans nous'; Rancillac, in Paris 1966.

65 Rancillac used an epidiascope from 1965 onwards, capturing the Vietnam War in press and television images. Conversation with Joanna Boulos, 26 May 2000, in Boulos 2000, n.p. *Hyperréalistes américains* were not shown until 1972, at the Galerie Arditti, Paris; the movement was consecrated in Europe at the Kassel Documenta of 1972.

66 'Bande dessinée et figuration narrative' was held at the Musée des Arts Décoratifs, Paris, 1967; for contemporary comics see also Groensteen and Mercier 1996, and for Saul, Sables-d'Olonne 1999.

67 For Erró's delirious take on modernism from the 1950s to the 1990s, see Wilson 1999B.

68 See Dorroh 1998, in conjunction with Bourseiller 1996, pp. 33–149; and Hourmont 2000 for the French intellectual context.

69 See Fauchereau 1991, pp. 83–96. For 'L'Année 1966' see Paris 1967. Rancillac subscribed to illustrated communist journals such as La Chine nouvelle and L'Albanie nouvelle which he used as source material.

70 The Salon de Mai had travelled to various countries, most recently Japan and Yugoslavia. See Havana 1967; Opus International, 3, 1967, special number, Che Si, pp. 14–36; Paris 1968B; and Scoppetone 1998. The exhibition 'Pintores e guerrillas' showed Cuban artists' work together with that of the twenty Paris-based artists made during the stay; the Parisian contribution was donated to the Museo Nacional de Bellas Artes, Havana. After serving its propaganda purpose, the Mural Cuba Colectiva returned from Cuba to Paris for the Salon de Mai of 1968. Grémion 1995, pp. 549–61, on the Congress for the Liberty of Culture's Latin American activities does not mention the counterthrust of the hugely prestigious Havana Congress which united 500 delegates from 80 countries, including a planeful of the most prestigious Paris-based writers, artists and film-makers (they are listed in Scoppetone 1998, p. 34). The Cuban-born Surrrealist Wifredo Lam acted as the go-between.

71 Miroslav Lamac hailed Ilya Kabakov, Eric Boulatov and Mikhail Grobman as young USSR painters while Allen Ginsberg represented the New York underground; see Opus International, 4, 1967, special number, USA–USSR, pp. 12–52. See also Rancillac's Plexiglass sculptures of Malcolm X, Jack Kerouac, Allen Ginsberg and William S. Burroughs exhibited in 'Les Américains', Galerie Mommaton, Paris, October 1968; Fauchereau 1991, pp. 105–09.

72 See Debord 1967; Debord 1973; Debord 1987; and Hussey 2001, pp. 214–20.

73 See Pierre Viansson-Ponté, 'Quand la France s'ennuie', Le Monde, 15 March 1968, pp. 1–9 (an 1839 quotation of Lamartine, picked up by Benjamin [Benjamin 1999, p. 110]).

74 Besson 2000, p. 17, reports that in the wake of 'The Responsive Eye' exhibition opening at MOMA, New York (a show which ran from February to April 1965), the magazine Elle devoted fifteen pages with photographs to 'Op' art. 'The Responsive Eye' including many artists from the Denise René Gallery, among them Agam and the GRAV group (Groupe de Recherche d'Art Visuel), toured America. See Paris 2001B, p. 102.

75 See Paris 1998; and Lindsell 2000 for French translations of Laing and preliminary interpretations of Raynaud's work within current 'antipsychiatric' discourses.

76 'Puisque peindre c'est peindre en fonction de l'esthétisme, des fleurs, des femmes, de l'érotisme, de l'environnement quotidien, de l'art, de dada, de la psychanalyse, de la guerre au Vietnam, NOUS NE SOMMES PAS DES PEINTRES', in Parent and Perrot 1983, p. 62. For a sophisticated discussion of recouvrement and the relationship with Cage's musical silences and American minimalism, see Besson 2000, pp. 20–21.

77 The 'Salle Rouge pour le Vietnam', 1969, ARC, Musée de la Ville de Paris (an exhibition postponed because of May '68) represents a summit of political painting by the Salon de la Jeune Peinture. See Paris 1969C; Parent and Perrot 1983, pp. 70–75 and 92–95; and Gellatly 1994, pp. 23–32.

78 See Besson 2000. Art criticism in the literary periodical Tel Quel was overtly influenced by the American formalist Clement Greenberg (see Marcelin Pleynet on the Musée d'Art Moderne de la Ville de Paris retrospectives of Mark Rothko and Franz Kline, in Tel Quel, 12, 1962, and Tel Quel, 19, 1964, in Pleynet 1986, pp. 93–96 and 97–105). By mid-1970 (responding to the great Matisse retrospectives), Pleynet's 'Matisse's System' quotes Freud, Melanie Klein, and metaphors of castration; see Pleynet 1984, pp. 7–77. Hantaï's foldings are related to memories of his Hungarian peasant mother's folded apron.

79 The minimalist art presented in 'L'Art du Réel USA, 1948–1968', travelling from MOMA New York to Paris, Zurich and London, would be crucial for the Supports-Surfaces movement of the 1970s. Reciprocally, 'Peinture en France, 1960–1967' toured to Washington, New York, Chicago, Montreal and Detroit throughout 1968. See Viatte 1999, pp. 102–05; and, for Supports-Surfaces, Paris 1998.

80 'A Saint-Germain-des-Prés le jazz est dans la rue. Atmosphère des années '44–45…Mais, tout à coup, c'est le réveil brutal: place Saint-André-des-Arts, l'attaque des manifestants enervés. La riposte des CRS, le lance-grenades en action. L'étouffement, le picotement, les pleurs. Les pierres lancées par les uns et les autres. Un combat à la fois chimique et néolithique…Boulevard Saint-Michel. Une ambiance d'apocalypse…Ça éclate de partout. Des arbres ont été abattus. A la hauteur de la Sorbonne, à travers

un rideau gris chargé de traînées blanchâtres, on devine une effervescence étrange. Bleuâtre, frémissante. Un paquet noir de haine.' For Jean-Claude Kerbouch's reportage for Combat, see Kerbouch 1968.

81 See Maspero 1968, a complex and detailed article. See also the meticulous and densely illustrated 'Chronologie des luttes de mai: textes, tracts, articles, déclarations. Réportage photographique Snark International; photos Chatelain, Dars, Demonestrol, Dufresnes, Ethel, Fourmentaux, Chris Marker, Maury, Pottier', pp. 9–195, in the same publication.

82 François Pluchart, 'En mai, fais ce qu'il te plait', Combat, 13 May 1968: 'Mais la peinture doit attendre cette semaine.'

83 See Atelier Populaire 1969 (including 'The Silk-Screen Process for Printing Posters', n.p.); Parent and Perrot 1983, pp. 70–91; and Gervereau 1988.

84 See 'The Wall Newspaper', in Atelier Populaire 1969, n.p. (news was collected from the workers, their strike committees, or militants from the Action Committees). These were modelled on the 'dazibao' instituted by Chairman Mao, written by the reading public.

85 Cohn-Bendit, a French-German binational of Jewish origin, had opted for German citizenship to dissociate himself from the Algerian War.

86 Bernard Rancillac in conversation with Joanna Boulos, in Boulos 2000, n.p. See 'The Atelier Populaire Puppet Theatre', in Atelier Populaire 1969, n.p. Performances were held from the end of May onwards in venues which included a theatre in the Rue Mouffetard, the courtyard of the Ecole des Beaux-Arts, in an Action Committee, in Clichy, and in the Renault factory at Chably.

87 Fromanger, in Gervereau 1988, pp. 184–85. The GRAV group, associated with the Galerie Denise René, had organised a day of happenings in Paris streets on 19 April 1966; see Lago di Como 1975, pp. 46–49.

88 Jean-François Jaeger, organiser of the event and director of the Galerie Jeanne Bucher from 1946, recalls that this was disappointing: artists went straight back to their studios and their normal economic circuits (in conversation with the author, 23 July 2001). (Hélion's great oil triptych of 1968, Choses vues en mai [Centre Pompidou], was one outcome.) Jaeger's May '68 Mark Tobey opening was the most emotional ever – all eyes were filled with tear gas. Matta's comic-strip Pour le guerrilla dans l'art illustrated Alain Jouffroy's L'Abolition de l'art.

89 See Dubuffet 1968; and Dubuffet 1988. Asphyxiante culture was, however, important for Cassou et al. 1968. Dubuffet's anarchist 'anticultural positions' never proposed political or anti-institutional action. The 1967 'Art Brut' retrospective at the Musée des Arts Décoratifs anticipated the permanent installation of his work there. See Viatte 1993.

90 See Dalí 1968.

91 'L'imagination prend le pouvoir' (Escalier Sciences-Po); 'Soyez réalistes, demandez l'impossible (Censier); 'Plus je fais l'amour, plus j'ai envie de faire la révolution. Plus je fais la révolution, plus j'ai envie de faire l'amour' (Sorbonne); '…avec les idées qui de Proudhon à Bakounine, des surréalistes aux situationnistes, agitent la France depuis ses plus anciens barricades…'. See Besançon 1968, pp. 96–97, 88 and 169.

92 René Vienet was the designated author of Enragés et situationnistes dans le mouvement des occupations; see Vienet 1968. The crucial Situationist input for May '68 deserves far lengthier discussion; see especially Mustapha Khayati's De la Misère en milieu étudiant, considérée sous ses aspects économique, politique, psychologique, sexuel et notamment intellectuel et de quelques moyens pour y remédier, 'par des membres de l'Internationale Situationniste et des étudiants de Strasbourg, 1966', which impacted on the University of Strasbourg; and Raoul Vaneigem's Traité de savoir-vivre à l'usage des jeunes generations, 1967, which was as influential as Debord's Société du spectacle. See Dumontier 1995; and Hussey 2001, pp. 202–49, especially on the occupation of the Sorbonne (pp. 234–36).

93 'Cette peinture existe parce qu'elle parle le langage de 20 ans/ son style est celui de la révolte. Sa matière est celle de la violence.' See Dejacques 1968, with photos by Bernard Lagallais.

94 See Le Pavé, tract no. 1, May 1968 (cartoon by Topor), p. 2.

95 Letter to the author, postmarked 21 June 2001: 'I printed Artaud's (AND [Michel] Leiris's) manifesto "Lettre aux recteurs" as a separate tract distributed in the streets AND in my newspaper Le Pavé (50,000 copies) in May '68…Later in May when we occupied the ORTF (Government Radio Headquarters) we seized A. A.'s play ("Pour en finir…") which was banned and censored since 1948 and broadcast it.'

96 See Shafto 2000. Patrick Deval's films Acéphale and Acéphale bis of August and November 1968 pick up on Georges Bataille's

concept of headless ecstasy. Shafto's discussion of May '68 'dandyism' is particularly interesting. For a broader background, see Harvey 1978.

97 See Jean-Jacques Lebel, in Paris 1988E, p. 96.

98 See Atelier Populaire 1969; Fromanger 1970; and, for the Godard collaboration, Zahm 2000.

99 Begun during and after May, publications on the 'events', followed by commemorative reassessments, are numerous. Mavis Gallant's day-by-day accounts published in the New Yorker on 14 and 28 September 1968, 'The Events in May: A Paris Notebook', are particularly vivid on concierges, dirt, slogans and the changing topographies of Paris. See Gallant 1988, pp. 1–90. For the key responses to May '68 of senior curators and art critics, see Cassou et al. 1968.

100 For Fromanger's Souffles, first exhibited at the Salon de Mai, see Alain Jouffroy, Opus International, 9, December 1968, and Jouffroy and Prévert 1971, pp. 12–24. For 'Structures gonflables', see Paris 1968C; and Paris 1999. The review Utopie (1966–71) involved the architects Jean Aubert, Jean-Paul Jungmann, Antoine Stinco, the landscape architect Isabelle Auricoste, and the sociologists René Loreau and Jean Baudrillard, who wrote the French group's manifesto for the International Design Conference in Aspen, Colorado, in 1970.

101 'Mais l'art est objectivement réactionnaire.' Daniel Buren, 'Faut-il enseigner l'art?', Galerie des Arts, no. 57, October 1968, p. 13, in Buren 1991, p. 57.

102 See Hocquenghem 1974. Posters by the Comité d'Action Pédérastique were the only ones to be torn up or taken down in the Sorbonne. In 1971, Hocquenghem launched the Front Homosexuel d'Action Révolutionnaire (FHAR, pronounced 'phare' = beacon).

103 For the origins of the CNAC under the aegis of Bernard Anthonioz, and its first exhibitions in the Hôtel Salomon de Rothschild in the Rue Berryer (seized in the Second World War), see Viatte 1999, pp. 94–109, including Anthonioz's preface (on p. 106) for the first show, 'Trois Sculptures' (April–May 1968) by Etienne-Martin, Jacques Brown and Raymond Mason (who showed his plaster version of La Foule (the bronze is now in the Tuileries Gardens).

Eric de Chassey

Paris – New York: Rivalry and Denial

In 1945, before the war was even over, the French writer Paul Valéry stated his beliefs about the state of Franco-American relationships: 'Whenever my thoughts become too sombre and I despair of Europe, I can only find some hope again by thinking about the New Continent…What has happened is a true process of "natural selection" which has taken from the European mind its products of universal value, and left in the old world its too conventional and historical elements.'[1] This two-sided opinion held true, at least until the mid-1960s, for most French critics and artists observing developments in American art. American art was seen as worthy of consideration as the expression of a new society, as something young and vital, but only insofar as it still showed the strong influence of the fountainhead of all the arts: Paris. This mixture of admiration for the brashness of American life and disdain for what was deemed its vulgarity was made even more complex by the anti-American political opinions held in the French art world as the Cold War began. These opinions persisted, as contempt for McCarthyism and rejection of the Marshall Plan were replaced by support for the Cuban leaders and opposition to the Vietnam war. For French critics and artists, the USA always remained an 'imperialist' country, geopolitically as well as culturally. Hence, for more than twenty years, few in Paris recognised any merit in new American art, and even fewer allowed themselves to be influenced.

With the exception of Duchamp, all the artists who came back from America around 1945 after several years of exile there thought that nothing of importance had happened in that country, except maybe in their own art: they felt nearly no interest in, nor any kinship with, the young artists they had met.

Subsequent trips by artists as revered as Miró, in 1947 and 1952, generated no more interest in the numerous emerging Abstract Expressionists who were claiming his heritage (and that of Masson and Léger [fig. 109], who had spent the war years in New England and New York respectively). For those masters of modern art and for the critics close to them, America was still what it had been for Matisse and Picasso before the war: a market above all, sometimes a reservoir of pupils, a country where the only great indigenous art was the so-called primitivism produced by Native Americans without any European influence. When in 1947 Bernard Dorival organised – on behalf of the new Musée National d'Art Moderne in Paris – an exhibition in New York about the state of modern painting in France during the war ('Painting in France, 1939–1946' at the Whitney Museum of American Art), no one in Paris could understand why it was so badly reviewed by American critics who felt that it marked the end of French domination over the art world.[2] The reason for this was undoubtedly that the French critics had no idea whatsoever of the art made in New York and San Francisco during the same years, works that set up new standards for the American art world. When paintings by a few emerging American artists – Baziotes, Gottlieb and Motherwell, among others – were shown together at the Galerie Maeght in 1947, they were dismissed by the Parisian art world as mere copies of French masters.[3] While young French artists were thriving on the idea that they were synthesising previous inventions – Jean Bazaine claimed to build on a synthesis of Bonnard and Picasso – Americans were chastised for precisely the same reasons.

Almost without exception, French artists rarely even looked at American art, so great was their prejudice. America was looked down upon, either as too young a country to produce great art (from the point of view of the upholders of the Young Painters of the French Tradition led by Bazaine) or as simply an imperialist country whose culture was based on propaganda and exploitation. A case in point is the great painting *Atlantic Civilisation* (fig. 110), created by André Fougeron in 1953, when he was still the official painter of the Communist Party.[4] In this work, as Aragon pointed out before unleashing his vicious attacks on its supposed 'hasty, crude' character and 'anti-realism', Fougeron clearly focused on 'the American occupation of our

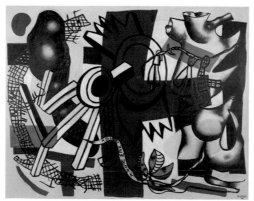

Figure 109

109 Fernand Léger, *Adieu New York*, 1946
Oil on canvas, 130 × 162 cm
Musée National d'Art Moderne, Centre Georges Pompidou, Paris

110 André Fougeron, *Atlantic Civilisation*, 1953
Oil on canvas, 380 × 560 cm
Tate, London

Figure 110

country', symbolised by the GI relaxing on a chair with a porn magazine and by the big blue voracious Buick. He also showed 'the political brutality of the Yankees', embodied by an electric chair on a pedestal, nemesis of the Rosenbergs who had been charged with spying for the USSR.[5]

The fact that the synthesis of examples of the great modernist masters with a new definition of humanism had had very similar results on both sides of the Atlantic – privileging a gestural painting, emphasising the creative and spontaneous act of a subject as well as a new consideration of the material media of paint and canvas – was practically overlooked. Only two French artists showed genuine interest in what was happening in New York. Jean Dubuffet, who spent several months there in 1951–52, was recognised by Pollock as 'exciting' and conversely recognised Pollock as 'one of the few living painters in whom I am interested'.[6] Georges

Mathieu travelled frequently to America and tried to organise a confrontational group exhibition of American and French artists, which would have featured de Kooning, Gorky, Pollock, Reinhardt, Rothko and Tobey, with Camille Bryen, Hans Hartung, Picabia, Wols and Mathieu himself, as early as 1948. Due to some problems between French and American dealers (which Mathieu, significantly, presented as originating from the American side), only a reduced, frenchified version of the exhibition finally took place in Paris.[7] But this interest always remained a kind of condescending gesture: Mathieu refused to recognise what he had borrowed from some of his American counterparts, and then took part in a feud about artistic priority which had its climax in the case of Franz Kline and Pierre Soulages, when their works were shown together in 'Young Painters from the US and France' at the Sidney Janis Gallery in New York in 1950.

The polarisation of the art world at this time – the feeling on the American side that New York was the new artistic capital of the world, and the way that the French despised anything that did not come (at least indirectly) from Paris – brought about disputes over who painted which form first, who used which format first. In fact, any distanced view would have shown that these disputes were mainly caused by instances of pseudomorphisms, of a simultaneous use of similar forms. The big black slabs of paint used by Kline and Soulages on a white ground were the result of dissimilar intentions and produced dissimilar effects: a material occupation of a flat surface in the early Soulages (fig. 111) replaced by elaborate plays of light after 1950; and an architectural, recomposed thrust in Kline after 1949. Even if Kline's abstractions had been stimulated by seeing reproductions of works by Soulages from 1947–48, each was very different in feeling and in execution from the start. As

always when similar issues of artistic priority were raised,[8] the outcome was that each country became incapable of looking at the other's art without feeling it was made of forgeries and thefts. When Nicolas de Staël was given a retrospective at the Solomon R. Guggenheim Museum in 1965, it apparently set a record for low attendance; the Rothko retrospective in 1962 at the Musée d'Art Moderne de la Ville de Paris was equally a critical and popular disaster.

Two French critics should nevertheless be singled out for their early recognition of American art: Michel Tapié and Georges Duthuit. Tapié followed Mathieu's lead by organising the binational exhibition 'Véhémences confrontées' in 1951 at the Galerie Nina Dausset. In his 1952 manifesto *Un Art autre*, he equated New York painters with their Parisian contemporaries, giving much attention to the art of Pollock, whom he considered 'one of the most notable representatives of today's American art adventure, whose paintings I have presented for the first time in Paris this year…For sincere and profound non-figurative art experiences, I think America will have benefited from an especially favourable climate, thanks to its departure from scratch.'[9] Tapié's relationship with the New York dealer Betty Parsons meant that he was fully informed of what was happening in the USA, where he sometimes even acted as a talent scout, as when he discovered the work of Morris Louis.[10] Only when he tried to publicise a so-called 'Ecole du Pacifique', grouping together artists as diverse as Tobey, Graves and Still for the sole reason that they had been working on the West Coast at one time or another, did it become clear that Tapié was also trying to circumvent the rise of New York as the new capital of the arts, and that he was thus playing a very Parisian game.

Duthuit's alliance with American painters was of a different nature. His was more of a solitary game, indifferent to questions of nationality, but very much preoccupied with defending an aesthetic position which followed a trail blazed by Matisse (in this game Duthuit had but one ally, the critic Pierre Schneider, who also worked as his secretary). Duthuit wrote about American artists who had arrived in Paris on the GI Bill,[11] especially Sam Francis, who moved there from San Francisco in 1950, staying until 1961. He praised them, and other Abstract Expressionists from the first generation, for what he felt was a renewal of the *decorative*.

Looking back at the artistic choices he had made in the 1950s, Duthuit nevertheless strongly reproached Abstract Expressionism in general, writing an imaginary dialogue between its upholders and Matisse. Passing over formal aspects, he focused on the way these American artists were trying to establish communion rather than communication, and put in Matisse's mouth a very strong objection to what he previously felt this master had bequeathed overseas: 'You behave as if, starting from the same data as I did, you do not recognise their attendant problems… To prevent this lively reality, so dear to you, from slipping away or withering as a result of stiffening, definition or blockage, you allow it to remain in a state of indecision.'[12]

While some American artists living in Paris became fairly successful there, this success was dependent on their work being analysed in French terms (the very reason that made them seem 'too French' for a New York audience, a situation that lasted until recently). This was especially the case for second-generation Abstract Expressionists who assimilated elements of Impressionist vocabulary, such as Sam Francis (fig. 112) or Joan Mitchell (who came to Paris in 1948–49, settled in France in 1955, and remained there until her death in 1992). The same applied to those artists who could be taken as geometric abstract painters, such as Ellsworth Kelly or Jack Youngerman. Both showed their works in one-man exhibitions at the prestigious Galerie Arnaud in 1951. Kelly showed at the Salon des Réalités Nouvelles in 1950 and 1951, with the likes of Herbin, Vantongerloo or Vasarely; he was then given one-man shows by the Galerie Maeght in 1958 and 1964. Both interacted with a small group of French artists (of whom François Morellet would become the most prominent) who acknowledged their influences. It is even said that the ageing Braque found the solution for a problem he faced in his *Studio* series – a gridded analysis of a bird motif in *Studio IX* (1952–56; fig. 113) – by seeing a painting by Kelly at the Galerie Maeght that had been derived from the cutting up and pasting together of a single pattern along a grid (fig. 114). Only when he came back to New York, in 1954, did Kelly's works stop being talked about in these French terms, coming instead to be considered alongside those of Reinhardt, Newman or Stella. Meanwhile Morellet became well known in Europe but not in America. His work was soon to become the subject of a new

Figure 111

Figure 112

113 Georges Braque, *Studio IX*, 1952–56
Oil on canvas, 146 × 146 cm
Musée National d'Art Moderne, Centre Georges
Pompidou, Paris

114 Ellsworth Kelly, *Meschers*, 1951
Oil on canvas, 149.9 × 149.9 cm
Private collection, New York

Figure 113

feud about artistic priority, which started in the early 1970s when some French curators began comparing some of his works from the 1950s with later ones by Frank Stella or Sol LeWitt in another instance of the rage for pseudomorphisms that has often marred Franco-American art-historical relationships. One has only to look at the different stages of *Sculpture for a Large Wall* (1957) to understand how Kelly abandoned a kind of French constructive art flavour for an American toughness and crispness.[13]

In the early 1960s, the rise of New York as a force in the international art market and the burgeoning influence of American critics, curators and museums made it impossible for the French to ignore what was happening on the American scene. Real working relationships, it seemed, might arise instead of the fierce competition that had prevailed. Some American dealers settled in Paris, convinced that it still counted and that the cultural prestige they would gain from doing so was worth the lack of foreseeable commercial prospects. They reversed the

pattern of French galleries setting up an outlet in New York, sometimes closing their Paris offices after they were convinced that the market was now essentially in the USA, but taking some time before focusing on American artists. This pattern had its origins in Durand-Ruel's exhibition of Impressionist works in New York in 1886. In 1960, Lawrence Rubin left New York and opened the Galerie Neufville, later known as the Galerie Lawrence, in Paris. In 1962, he was followed by the Galerie Anderson-Meyer and by the Galerie Sonnabend. Remaining in Paris until 1980, the Galerie Sonnabend maintained its close ties with Leo Castelli Gallery in New York, to whose owner Ileana Sonnabend had previously been married. The Galerie Sonnabend's real independence, however, lay in the fact that it was the French public's principal source of the latest artistic news from the USA, from Pop to Minimal and Conceptual art.[14]

The critic most closely associated with the Nouveaux Réalistes, Pierre Restany, tried to generalise the principles of these moves by

Figure 114

115 The hanging of the Niki de Saint Phalle exhibition at Galerie J in Paris in 1961, showing (from left to right, in conversation) Robert Rauschenberg, Niki de Saint Phalle and Jasper Johns

116 Martial Raysse, *La France américaine*, 1962 Oil and mixed media, 200 × 122 cm Fonds National d'Art Contemporain, Paris

Figure 115

playing on friendships secured by the visits to Paris of Jasper Johns and Robert Rauschenberg. Johns had his first one-man show in Paris in 1959; significantly several versions of his US flag were treated as vile propaganda. Rauschenberg showed at the Galerie Daniel Cordier in 1961. As for Restany, he tried to christen what was happening simultaneously in Paris and in New York as a homogeneous 'New Realism', which he showed in the exhibition 'La Réalité dépasse la fiction: Le Nouveau-Réalisme à Paris et à New York' at the Galerie Rive Droite in 1961. Hence, for a very short time, and in fact for a very small group of avant-gardists on both sides of the Atlantic, Pop Art was truly an international trend, devoid of priority problems and political feuds (both national groups could be considered apolitical in principle, a position that owed much to the establishment of De Gaulle's personal power in France and to the evolution of McCarthyism in the USA). In 1959, Rauschenberg showed three Combine Paintings at the Paris Biennale alongside Raymond Hains's *Palissade des emplacements réservés* and Jean Tinguely's *Metamatic no. 15*. In 1961, both Johns and Rauschenberg took part in notable collaborations with Niki de Saint Phalle (fig. 115), as did Larry Rivers who was then living in the Impasse Ronsin. But when, under the same banner – 'The New Realists' – a similar grouping took place in New York, at the Sidney Janis Gallery in 1962, it indeed signalled that the American version was taking over, as Restany himself noticed.[15] The only solution for young and rising French artists who wanted to maintain their international visibility was to emigrate to the USA. Thus, reversing a long-established pattern (except in times of war), Arman, Christo, Martial Raysse (fig. 116) and Daniel

Spoerri moved to New York (Jean Tinguely had already created a *succès de scandale* there in 1960 with his *Homage to New York* which exploded in the gardens of MOMA, while Yves Klein wrote his *Chelsea Hotel Manifesto* in 1961, at the end of a short and frustrating visit). They were to make major exhibitions in the New World which the Old One only heard or read about.

This situation – the recognition that Paris had been defeated by New York – was only generally acknowledged when Rauschenberg won the Grand Prize at the Venice Biennale of 1964. The outrage that swept through the art columns of the French newspapers indicates the insular nature of the Paris art world of the time. The critic Jean Clair summed it up: 'Meanwhile, reading the art weeklies of the period, it seemed that their editors were no longer concerned to defend the purity of the French tradition against foreign contamination, and particularly against the so-called vulgarity of American art…The fact was that, cut off from reality and isolated in arrogant provincialism, Paris had long since ceased to play a role of the slightest importance on art's international stage.'[16] Some accused American art in general, and Rauschenberg in particular, of coarseness. Gérald Gassiot-Talabot wrote of 'the vulgarity and bumptiousness of the official representatives of the United States'.[17] Others played the old card of the politically assaulted Old World, not only in the Communist Party vein, but also in the plainly nationalist rhetoric of de Gaulle. Pierre Daix declared: 'One must not lose sight of the fact that the battles waged by American organisations at the Venice Biennale or at the cinema festivals are not uniquely commercial and that they are never without an ideology. Pop Art is praised as the artistic expression of the American civilisation; *Le Mépris* [Jean-Luc Godard's film] is vilified because it brings about the buying and selling of intellectual endeavour which is taken for granted there.'[18]

This seemingly possible reconciliation of French and American art after the demise of Abstract Expressionism on the one hand and of the abstract Ecole de Paris on the other was quickly superseded by a renewed rivalry. Even in the domain of Pop Art, in which the importance of American artists was paramount, French artists and critics tended to downplay this in favour of political vindications. Only one American Pop artist was fully recognised as influential: Peter Saul,

Figure 116

Figure 117

who had settled in Paris because of his left-wing leanings in 1958, and went back to San Francisco in 1964. What were considered elsewhere the strengths of American art – its visual efficiency, its economy of means, its ambiguities of content – were despised in France. Even though the critic Gassiot-Talabot had invited several Americans to his seminal exhibition 'Mythologies quotidiennes', which took place in 1964 at the Musée d'Art Moderne de la Ville de Paris (simultaneously with a Kline retrospective), he saw them only as taking part in a parallel process of renewed forms of narrative, a process which, of course, French artists took further.[19] If Bernard Rancillac and Hervé Télémaque made use of comics, they did so more in the vein of Peter Saul than of Andy Warhol or Roy Lichtenstein.

But by now, for the first time in the history of French art, it could be said that French artists were reacting against precedents set up by Americans: the single image of American Pop was being replaced by the multi-layered narrative of French Narrative Figuration.[20] Gassiot-Talabot thought this was a neutral move in 1977: 'The stake was to place a group of young painters of Narrative Figuration in front of the dominant tendencies, and particularly in front of American Pop Art, which was then at its zenith',[21] and the critic Michel Ragon was much more to the point when he remarked: 'After the colonisation of English painting…this exhibition showed that the colonisation of French painting had begun.'[22] Also to the point was a series of eight paintings, *To Live or Let Die, or The Tragic End of Marcel Duchamp* (cat. 280) made collectively in 1965 by three artists living in Paris who were either French by birth or had elected Paris as their capital of the arts: Gilles Aillaud, Eduardo Arroyo and Antonio Recalcati. The last painting of this narrative series polemically showed Duchamp's coffin, covered with the US flag, carried by Oldenburg, Warhol, Raysse, Arman and Restany, as if the three French protagonists were traitors to the French cause. In the essay that accompanied the series – 'Comment s'en débarrasser, ou un an plus tard' (How to Get Rid of Him, or One Year Later) – they showed their hostility to American aesthetics by linking those with political positions: 'Thus Marcel Duchamp can be seen to be a particularly successful defender of bourgeois culture. He endorses all the falsehoods for which culture anaesthetises lively energies

and makes it live in illusion, thus condoning trust in the future.'[23]

The Iceland-born artist Erró was perhaps the only one to treat Paris–New York relationships humorously (fig. 117). In numerous paintings between 1959 and 1967, he showed them as a violent fight which could only find a political outcome in the defeat of both French and American systems by the even greater Pop-ness (or actual popular character) of Russian mujiks or Chinese Red Guards (a Maoist aesthetic that was taken up much less lightly in the 25 paintings by 25 artists assembled for a 'Salle Rouge pour le Vietnam' devised for the 1968 Salon de la Jeune Peinture against 'American imperialism').[24]

At the end of the 1960s, American influence was not only being felt in figurative painting, it was also being acknowledged as the vital force behind the renewal of abstract painting which was set forth by Simon Hantaï and his unlikely heirs: Daniel Buren, Olivier Mosset, Michel Parmentier and Niele Toroni (before and after they performed together as the BMPT group, during 1966), as well as members and associates of the Supports-Surfaces group (between 1966 and 1971). Jean Clair summed up this new situation very clearly in 1972: 'When someone from this new generation finds, or thinks that he has found, instruction from some of the greatest figures of modern European art, particularly Matisse, Léger, Magritte and Duchamp, it is significant to notice that this instruction will be followed not directly, but mediated by a foreign experience: Matisse will become "visible" again through Pollock, Newman, Rothko and American "field painting"…A reading which, setting itself against the rational, humanist tradition – that which makes Matisse the painter of odalisques and *bonheur de vivre*…requires of itself a reading which is both literal and rigorous, above all concerned…to re-establish the specific field of art.'[25]

At a time when France was trying to remain a global power through emphatic gestures enacted by her leaders (de Gaulle's siding with 'Free Quebec' against the 'Anglo-Saxon' world; protests against 'Yankee' intervention in Vietnam), the only way her most courageous artists could give the artistic tradition new momentum was by looking at New York painters with unapologetic eyes, learning everything they could from Pollock and Newman (especially the emphasis on the

Figure 118

experimental possibilities of the medium[26]) while deeply transforming the meaning of their achievements. Harold Rosenberg's spiritual, existentialist interpretations of American 'action painting' were known through the French translation of his *Tradition of the New*, published by the prestigious Editions de Minuit in 1962. Clement Greenberg's formalism was known later, especially in an adapted version popularised by the critic Marcelin Pleynet in an influential series of articles from 1967.[27] For French artists, these American theories of American art were only springboards from which they would evolve new practices and new theories, as epitomised by this early remark about Pollock made by the painter Pierre Buraglio: 'We have no alternative now but to look more closely at the artist's relationship with the canvas as defined by Jackson Pollock. This introduced a new, resolutely distant method of painting involving various requirements from which a "new painting" could develop…It forced us to acknowledge

that "putting the world between parentheses" was different from "putting it under wraps". And also that it is no contradiction in terms to claim, firstly, that to confront one's own painting resources with concrete reality is fruitless while claiming, secondly, that painting has to be subversive to exist. The subversiveness of painting is exercised initially against itself. "Painting" is constructed upon its own ruins.'[28]

As Claude Viallat recently recalled (fig. 118), after 1966 he devised new experimental processes, such as working on immense pieces of unstretched canvas, by gleaning scanty and inaccurate information about Pollock: 'We had often imagined a certain idea of American painting, linked above all to the scale of the American continent, that is to say we envisaged American painting as limitless…When I began to paint on the floor, I walked on my canvases: it was quite normal; Pollock had done it before me. It wasn't until the Pollock exhibition at the Centre Pompidou

[in 1982] that I noticed that in fact he only painted from the edges.'[29] *Vis-à-vis* American abstract painting, French abstract painters finally found themselves in a common 'misreading', to use Harold Bloom's expression.[30]

The situation was thus totally reversed from 1945. New York was now recognised by Paris as a fountainhead of the arts, an example from which it was possible to start anew. Political animosity against the USA insisted upon this new start, and, although it was rendered problematic as a result, ultimately it could not be ruled out. Conversely New York had no desire to acknowledge that new starts were possible and completely overlooked what was happening in Paris, simply as if the city did not exist. While exhibitions of American artists in Paris multiplied, French artists had great trouble showing their works in the USA. They were deemed provincial from the beginning: too French. A prejudice which has still to be overcome.

1 Valéry 1945.
2 Clement Greenberg wrote: 'The show itself is shocking. Its general level is, if anything, below that of the past four of five Whitney annual exhibitions of American painting – about the lowness of which I have expressed myself rather strongly in the past…' From 'Review of the Exhibition "Painting in France, 1939–1946"', in *The Nation*, 22 February 1947, reprinted in Greenberg 1986, pp. 128–29.
3 On this exhibition, see Paul 1986.
4 Notwithstanding the fact that this work was precisely the excuse for Aragon's change of artistic model, the loosening up of a Zhdanovian socialist-realist aesthetic in favour of a more open position, which could encompass the likes of Picasso, Léger and Edouard Pignon.
5 Aragon 1953.
6 See Pacquement 1977.
7 Mathieu 1963, pp. 59 ff.
8 Kirchner, for example, felt obliged to predate his paintings so that they would not appear to have been influenced by Matisse.
9 'L'un des plus prestigieux représentants de l'aventure américaine de maintenant, dont j'ai présenté un ensemble d'œuvres cette année pour la première fois à Paris…Je pense que, pour des expériences sincères et profondes de la non-figuration, l'Amérique aura bénéficié d'un climat spécialement propice, dû à un départ à zéro réel.' Tapié 1952.
10 Tapié wrote an introductory essay for Louis's first New York solo show in 1957; see Grenoble 1996, p. 102.
11 American war veterans were given a $75 monthly stipend to study in Paris. Many artists arrived on this programme in the late 1940s for one or two years. Most of them enrolled in Léger's and Zadkine's studios (as did Al Held, Kenneth Noland, Jules Olitski, Richard Stankiewicz and George Sugarman). Robert Rauschenberg spent 1948 in the Académie Julian. See Château de Jau 1988.
12 'Vous agissez comme si, ayant en main les mêmes données que moi, vous ne reconnaissiez pas leur nature problématique… Pour empêcher que cette réalité vive qui vous est chère se dérobe ou s'étiole par durcissement, définition et bloquage, vous la maintenez dans un état d'indécision.' Duthuit 1961, pp. 63–64.
13 On this particular work by Kelly, see New York 1998C. Changing its meaning, Bernard Ceysson included a small early model for this work in his 1999 Luxembourg exhibition 'L'Ecole de Paris? 1945–1964'.
14 See Phélip 2000.
15 See Restany 1977.
16 'Cependant, à lire les hebdomadaires d'art de l'époque, il semblait que leurs éditorialistes ne fussent occupés qu'à défendre la pureté de l'art de tradition française contre les contaminations étrangères et en particulier contre la soi-disant vulgarité de l'art américain… Le fait était que, coupé de toute réalité, isolé dans un provincialisme arrogant, Paris avait depuis longtemps cessé de jouer le moindre rôle sur le plan artistique international.' Clair 1972, p. 11.
17 '…la vulgarité et l'outrecuidance des représentants officiels des Etats-Unis.' Gassiot-Talabot 1964.
18 'Il ne faut pas perdre de vue que les batailles livrées par les organismes américains à la Biennale de Venise ou dans les festivals de cinéma ne sont pas uniquement d'ordre commercial et que l'idéologie n'en est jamais absente. Le pop-art est exalté comme expression artistique de la civilisation américaine, *Le Mépris* est vilipendé parce qu'il met en cause l'achat et la vente du travail intellectuel qui y sont la règle.' Daix 1965, cited in Parent and Perrot 1983, p. 27.
19 Narrative was not a problem as such for American artists. They did not react against modernism by using narrative strategies, but rather used modernist qualities in a new, unorthodox way.
20 In the words of Gérald Gassiot-Talabot: 'A la dérision statique du pop américain, ils opposent la précieuse mouvance de la vie'; in Gassiot-Talabot 1964.
21 'L'enjeu était de situer un groupe de jeunes peintres, nouveaux figuratifs, en face des tendances dominantes, et particulièrement du Pop'Art américain alors à son zénith.' Foreword to Gassiot-Talabot 1977, n.p.
22 'Après la colonisation de la peinture anglaise…cette exposition démontrait que la colonisation de la peinture française était commencée.' Ragon 1969, cited in Parent and Perrot 1983, p. 39.
23 'C'est en ce sens que Marcel Duchamp est un défenseur particulièrement efficace de la culture bourgeoise. Il avalise toutes les falsifications pour lesquelles la culture anesthésie les énergies vitales et fait vivre dans l'illusion, autorisant ainsi la confiance dans l'avenir.' Aillaud, Arroyo and Recalcati in 1966, cited in Parent and Perrot 1983, p. 46.
24 On the Salle Rouge, see Parent and Perrot 1983, pp. 70–75.
25 'Quand tel ou tel de cette nouvelle génération trouvera ou pensera trouver un enseignement chez certains des plus grands représentants de l'art moderne européen, en particulier chez Matisse, Léger, Magritte et Duchamp, il est significatif de voir que cet enseignement sera suivi non pas de façon directe, mais médiatisé par une expérience étrangère: Matisse redeviendra ainsi "visible" à travers Pollock, Newman, Rothko et la "field painting" américaine…Lecture qui, s'élevant contre la tradition rationaliste et humaniste – celle qui fait de Matisse le peintre des Odalisques et du bonheur de vivre…se voudra une lecture littérale et rigoureuse, soucieuse surtout…de rétablir le champ spécifique de l'art.' Clair 1972, pp. 17–18.
26 See Tramoni 2000.
27 See Pleynet 1967, reprinted in Pleynet 1986, pp. 217 ff.
28 'Force nous est d'inviter à mieux considérer la relation à la toile définie par J. Pollock, déterminante d'une nouvelle pratique de peindre résolument distanciée. Impliquant certaines exigences à partir desquelles peut se développer une "nouvelle peinture"…Il faudrait admettre que la "mise entre parenthèses du monde" n'est pas sa mise à l'abri. Et qu'il n'est pas contradictoire d'affirmer en même temps, d'une part que l'affrontement des moyens propres à la peinture avec la réalité concrète est vain, et d'autre part que la peinture doit être subversive pour être. Sa subversion s'exerçant d'abord à l'égard d'elle-même. La peinture s'édifie sur ses ruines.' Pierre Buraglio, in the catalogue of the 17th Salon de la Jeune Peinture, 1967, reprinted in Buraglio 1991, p. 26.
29 'Nous avons beaucoup fantasmé sur une certaine idée de la peinture américaine, liée avant tout à la dimension du continent américain, c'est-à-dire que nous envisagions la peinture américaine comme une démesure…Quand j'ai commencé à peindre au sol, j'ai marché directement sur les toiles: c'était une chose normale, Pollock l'avait fait avant moi. Ce n'est qu'à l'exposition Pollock du Centre Pompidou que je me suis aperçu qu'en fait il ne peignait que du bord.' Claude Viallat, in Chassey 2000, pp. 98–99.
30 Bloom 1973.

Auguste Herbin
Morning II, 1952
Oil on canvas, 146 × 97 cm
Musée Matisse, Musée Départemental,
Le Cateau-Cambrésis

Jean Dewasne
The Tomb of Anton Webern (Anti-sculpture),
1951
Enamel on aluminium, 151 × 123 × 92 cm
Musée National d'Art Moderne, Centre
Georges Pompidou, Paris

225

Nicolas Schöffer
Spatiodynamic 13, 1952
Aluminium with polychrome moving
circular elements, 223 × 56 × 57 cm
E. de L. Schöffer

Yaacov Agam
Three Movements, 1953 (three views of the same work)
Oil on wood, 73.7 × 84.4 cm
Y. Agam. Courtesy of Artlife Gallery, New York

Jean Tinguely
Meta-Malevich, 1954
Black wooden box, metal elements, wheels,
rubber belt and electric motor, 61 × 50 × 20 cm
Museum Jean Tinguely, Basle

Jean Tinguely

Blue, White, Black, 1955
Black wooden base with eleven differently
shaped, blue-and-white, painted metal
elements. In the back of the base,
wooden pulley wheels, rubber belts,
metal fixings and an electric
motor, 105 × 59 × 20 cm
Private collection

Takis
Signal, 1954–55
Bronze, 238 × 90 × 33 cm
Simon Spierer Collection, Geneva

Takis
Signal, 1959
Iron, 254 × 216 × 32 cm
Musée National d'Art Moderne, Centre Georges
Pompidou, Paris. Gift of Daniel Cordier
(Juan-les-Pins), 1982

230

231

Francisco Sobrino
Permutational Structure HG, no. 1/3, 1966/70
Stainless steel, 187 × 56 × 56 cm
Galerie Denise René

232

Julio Le Parc
Twisting Form, 1966
Wood, metal and motors, 260 × 53 × 20 cm
Collection of the artist

233

Equipo 57
Untitled, 1961
Oil on wood, 75 × 75 cm
Galerie Denise René

234

Equipo 57
PA9, 1957
Oil on canvas, 95 × 68 cm
Galerie Denise René

235

Pol Bury
Mobile Relief 5, 1954
Painted metal, 54 × 44 × 6 cm
Fonds National d'Art Contemporain – Ministère
de la Culture, Paris. On deposit at the Musée
d'Art Moderne, Saint-Etienne

236

Geneviève Claisse
Jazz, 1966
Oil on canvas, 100 × 100 cm
Collection of the artist

Richard Mortensen
Homage to Auguste Herbin, 1960
Oil on canvas, 130 × 195 cm
Galerie Denise René

Victor Vasarely
Bora II, 1964
Acrylic on canvas, 186 × 160 cm
Galerie Denise René

Victor Vasarely
Tlinko C, 1955–64
Two engraved glass plaques on metal,
74 × 62 cm
Galerie Denise René

François Morellet
Sphère-Trames, 1962
Stainless steel, 130 cm (diameter)
Collection of the artist

Jesús Rafaël Soto
Penetrable Curtain, 1967/2002
Wood and plastic, 123 × 70 × 48 cm
Museo Municipal de Arte Contemporáneo,
Madrid

Georges Mathieu
The Last Feast of Attila, 1961
Oil on canvas, 300 × 200 cm
Collection of the artist

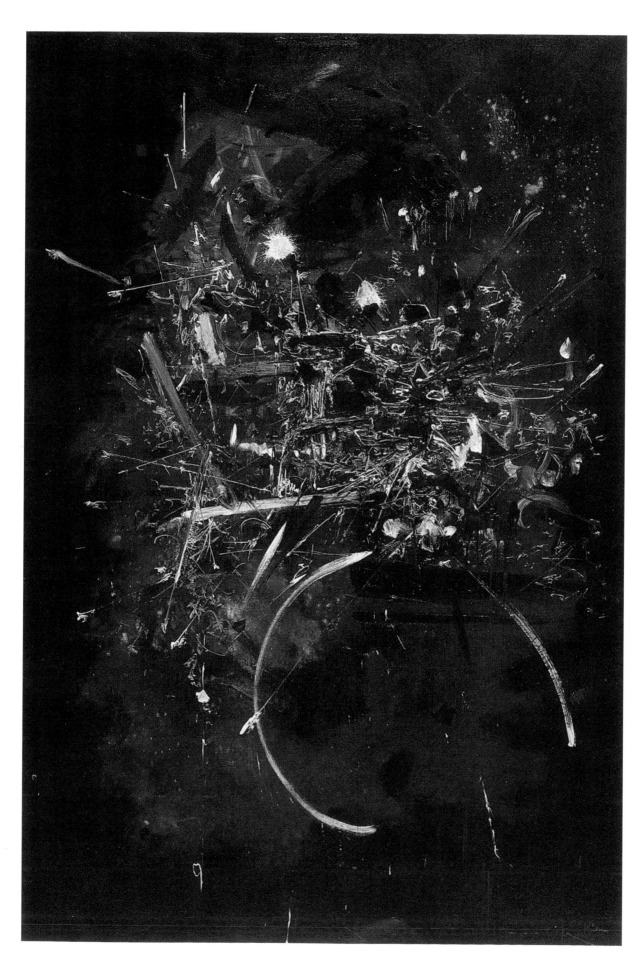

Matta

Temps-space du pissenlit, 1967–69
Oil on canvas, 305 × 405 cm; archive no. 159
Private collection, Paris

244

Gérard Deschamps
Bâche de signalisation, 1961
Oil on metal, 79 × 168 cm
Museum of Modern Art Ludwig Foundation,
Vienna. Formerly Hahn Collection, Cologne

245

Jean Tinguely
Ballet of the Poor, 1961
Metal, different materials, electric motor and
eight suspension points, 380 × 350 × 220 cm
Museum Jean Tinguely, Basle

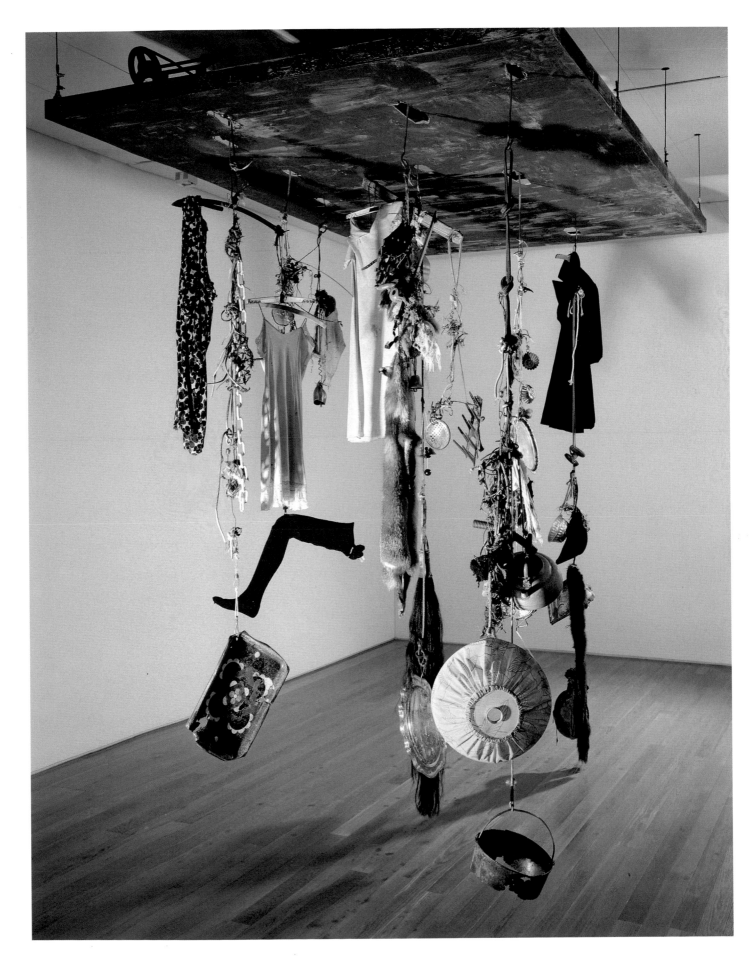

247

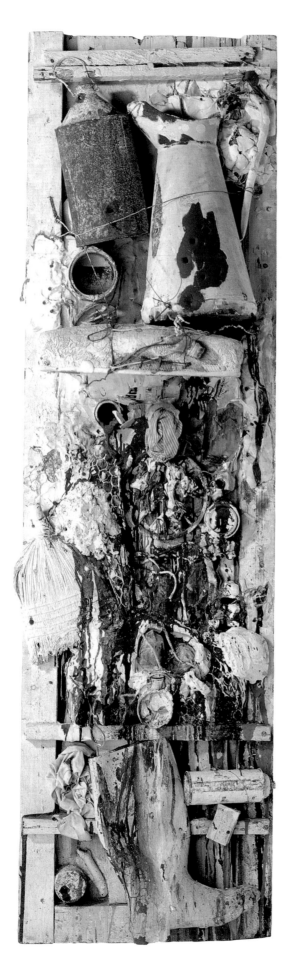

Niki de Saint Phalle
Kennedy-Khrushchev, 1963
Mixed media, 202 × 122.5 × 40 cm
Sprengel Museum, Hanover

248

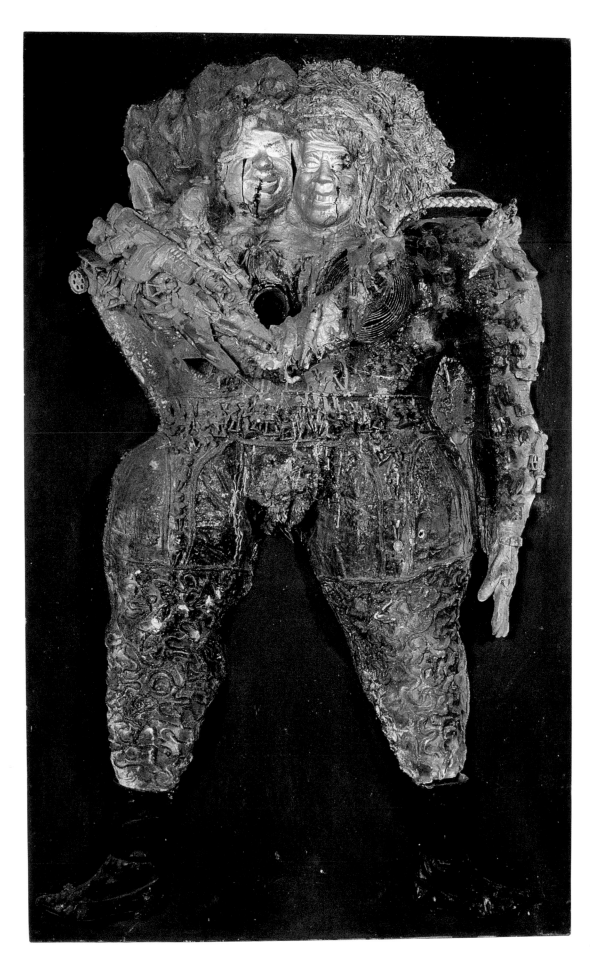

Niki de Saint Phalle
Kennedy-Khrushchev, 1963
Mixed media, 202 × 122.5 × 40 cm
Sprengel Museum, Hanover

Niki de Saint Phalle
Exploded Woman (The Birth of the Bull), 1963
Mixed media, 190 × 131 × 32 cm
Sprengel Museum, Hanover

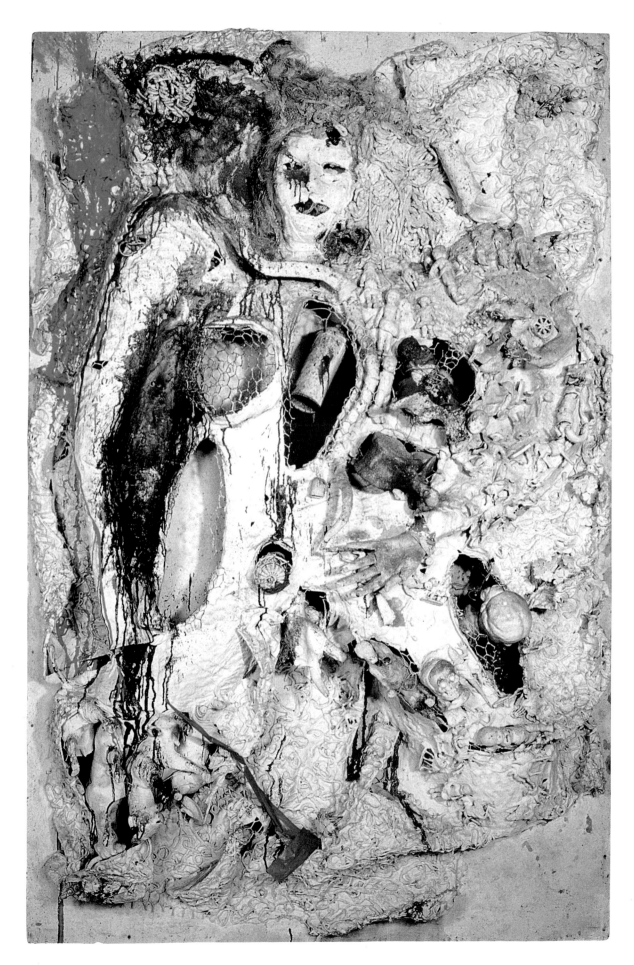

Niki de Saint Phalle
OAS, 1962
Bronze, 252 × 241 × 41 cm
Galerie de France, Paris

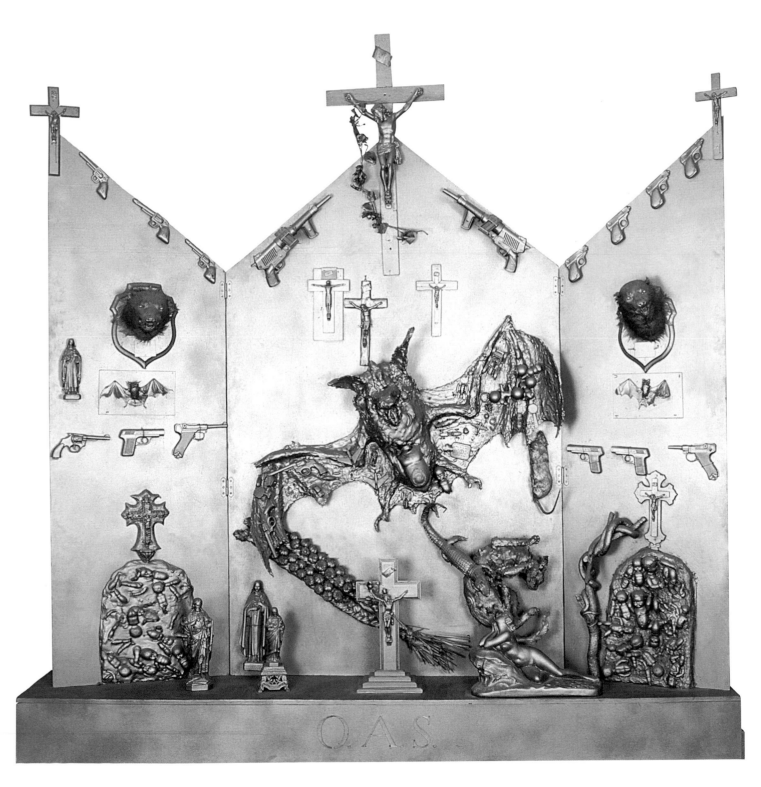

César
Sunbeam, 1961
Compressed car, 156 × 75 × 62 cm
Private collection. Courtesy Jean Albou Conseil,
Paris

251

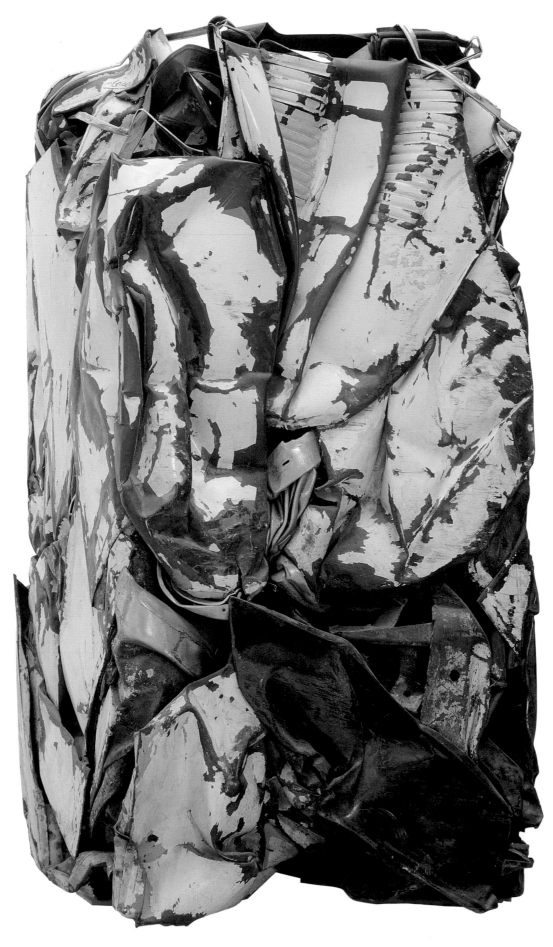

Arman
Accumulation Renault no. 106, 1967
Compressed car panels, 110 × 120 × 225 cm
Courtesy Galerie Georges-Philippe and Nathalie
Vallois

252

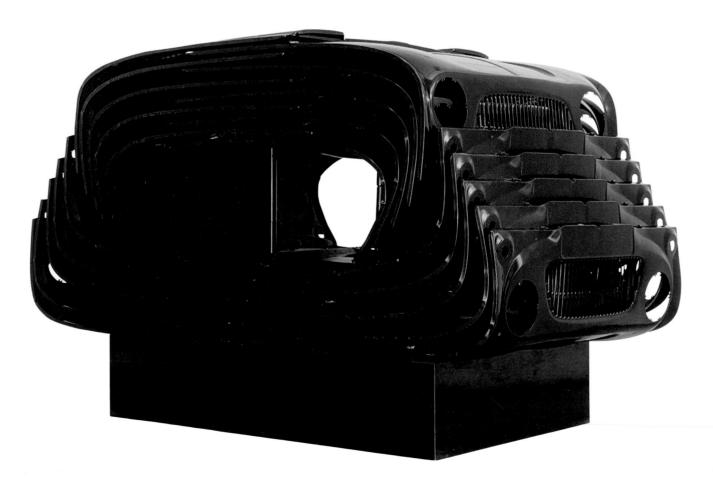

Arman
Ulysses' Armchair, 1965
Burnt armchair, polyester residue and wood,
107 × 81 × 81 cm
Private collection, France

253

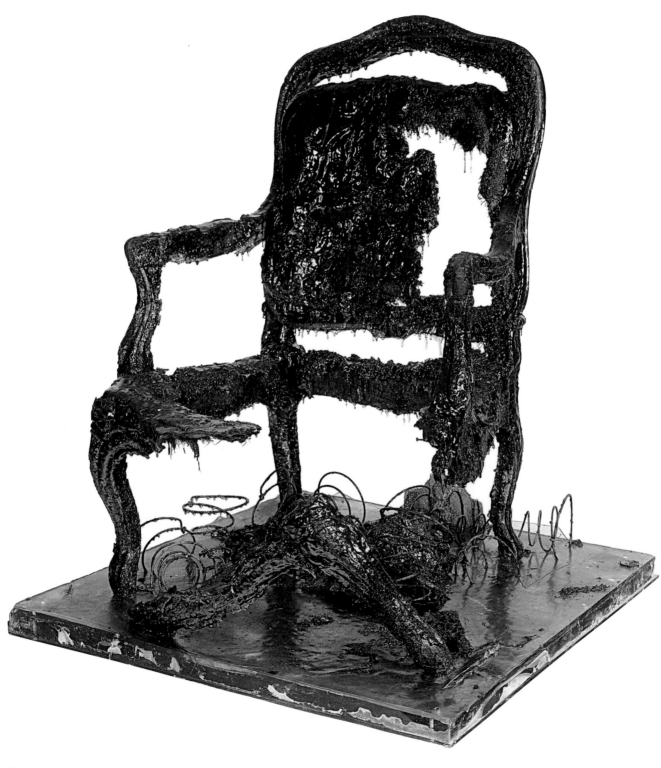

Christo
Package on Luggage Rack, 1962
Polyethene, rope, rubberised cord,
mattress, baby carriage and steel luggage rack,
63.5 × 136 × 95.2 cm
Lilja Art Fund Foundation

254

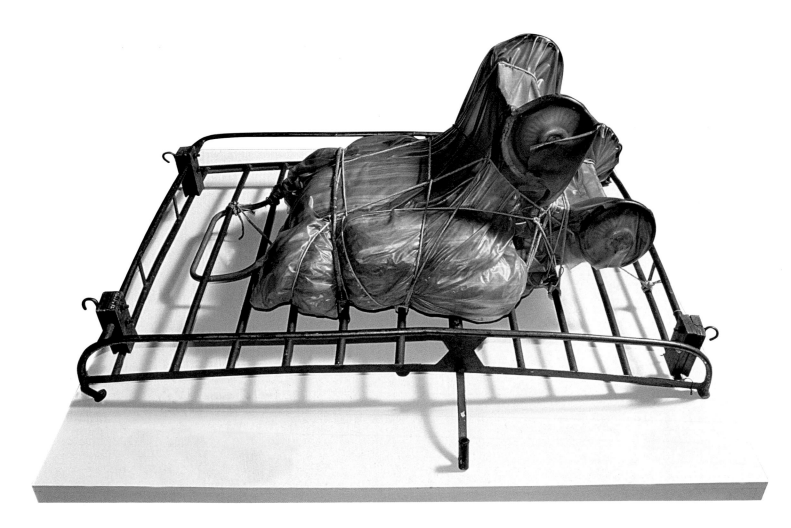

Christo
Wrapped Vespa Motorcycle, 1963
Polyethylene, Vespa and rope,
110 × 160 × 60 cm
Lent by Christo and Jeanne-Claude

255

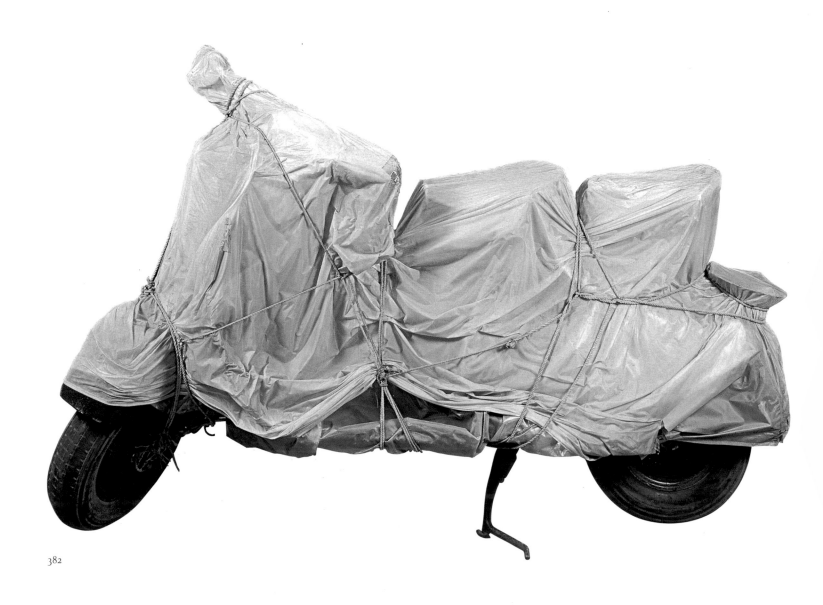

Christo

Wrapped Portrait of Jeanne-Claude, 1963
Oil on canvas painted by Christo Javacheff,
wrapped in polyethylene, fabric and rope by
Christo, mounted on a black wooden board,

78.5 × 51.2 cm
Lent by Christo and Jeanne-Claude

256

Wrapped Portrait of Jeanne-Claude, 1963
Oil on canvas painted by Christo Javacheff,
wrapped in polyethylene, fabric and rope by
Christo, mounted on a black wooden board,

78.5 × 51.2 cm
Lent by Christo and Jeanne-Claude

Martial Raysse
Suzanna, Suzanna, 1964
Oil on canvas, collage with wood paint and film
projection of 'Arman dans le rôle de Vieillard',
192 × 141 × 10 cm
Courtesy Galerie Natalie Seroussi

Martial Raysse
La France orange, 1963
Photograph and acrylic on canvas and wood,
83 × 55 cm
Madame Georges Pompidou Collection

Daniel Spoerri
Old Kitchen Utensils from the Galerie J, 1962
Mixed media, 109 × 135 × 33 cm
Private collection, Milan

Robert Filliou
La Joconde est dans les escaliers, 1968
Cardboard, long-handled scrubbing brush,
bucket and floor cloth, life size
Musée d'Art Moderne, Saint-Etienne. Vicky
Remy donation

Jean-Jacques Lebel
Parfum Grêve Générale, bonne odeur, 1960
Paint and collage on cardboard, 112 × 85 cm
Private collection

Jean-Jacques Lebel
Monument to Antonin Artaud, 1959
Mixed media, wood, metal, human hair,
human skull, electric light bulb, 200 × 170 cm
Private collection

261

262

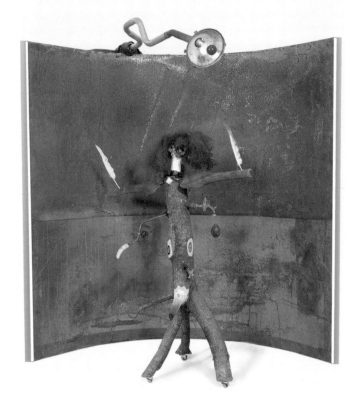

Roland Sabatier
Peinture déambulatoire, 1966
Ink and collage on a plan of Paris, 56.2 × 75.7 cm
Private collection, Venice

263

Roland Sabatier
Hyperthéâtrie (de Zola à Mao), 1967
Oil and collage on canvas, 80.7 × 65 cm
Collection of the artist

Isidore Isou
Talking Plastic, 1960–87
Mixed media, 15 × 40 × 30 cm
Private collection, Brussels

264

265

Alina Szapocznikow

Self-portrait 1, 1966
Marble, polyester and resin, 41 × 30 × 20 cm
Collection of the artist's family, Paris

266

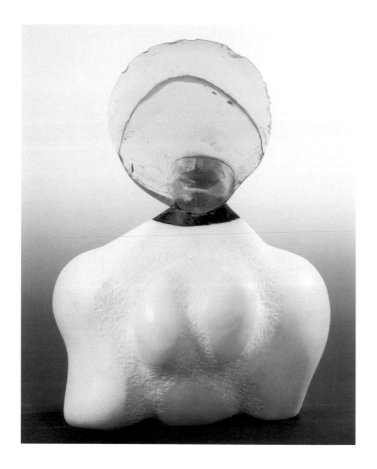

Ruth Francken

Telephone 5, 1967
Mixed media, 30 × 30 × 30 cm
Fondation Marguerite and Aimé Maeght,
Saint-Paul

267

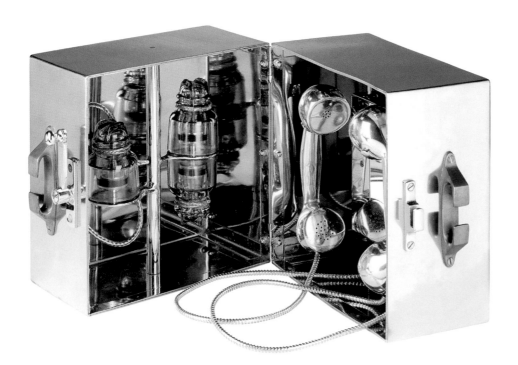

Jean Pierre Raynaud
*Psycho-object with Blind Man's Stick
(Portrait of the Art Critic Alain Jouffroy),* 1964
Mixed media, 150 × 50 cm
Courtesy Galerie Natalie Seroussi

268

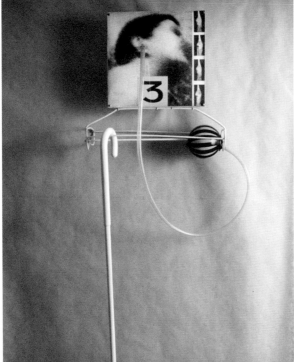

Jean Pierre Raynaud
Psycho-object, Age 27, 1967
Metal and plastic, 253 × 76 × 84 cm
Collection of the artist

269

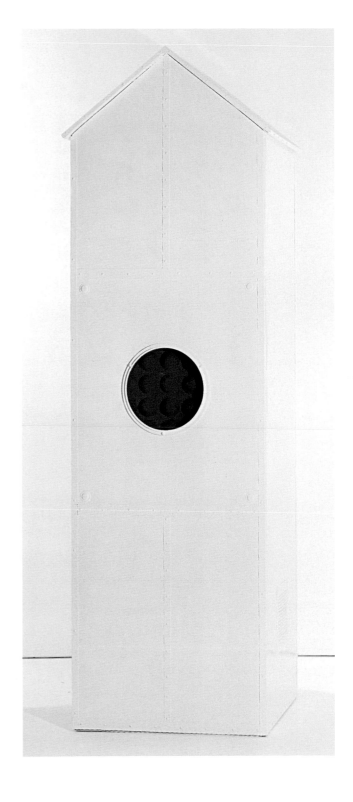

Raymond Hains
Cet homme est dangereux, 1957
Torn poster on canvas, 95 × 61 cm
Collection Ginette Dufrêne

Raymond Hains
OAS Fusillez les plastiqueurs, 1961
Torn poster on canvas, 50 × 73 cm
Private collection

François Dufrêne
Mai-juin 1968, 1968
Torn posters on canvas, 61 × 50 cm
Collection Ginette Dufrêne

272

Jacques de la Villeglé

Gare Montparnasse, Rue de Départ,
12 Juillet, 1968
Torn posters on canvas, 109 × 158 cm
Courtesy Galerie Georges-Philippe and Nathalie
Vallois

273

Jacques de la Villeglé

Boulevard de la Bastille, 1969
Torn posters on canvas, 84 × 145 cm
Galerie Patrice Trigano, Paris

274

Henri Cueco
La Barricade, Viet Nam 68, 1968
Oil and glycerophtalic paint on canvas,
200 × 200 cm
Collection of the artist

275

Bernard Rancillac
Mai 68, 1968
Paint on wood, Altuglas,
45 × 40 × 2.4 cm
Private collection

276

Erró

The Background of Jackson Pollock, 1967
Oil on canvas, 250 × 200 cm
Musée National d'Art Moderne, Centre Georges
Pompidou, Paris

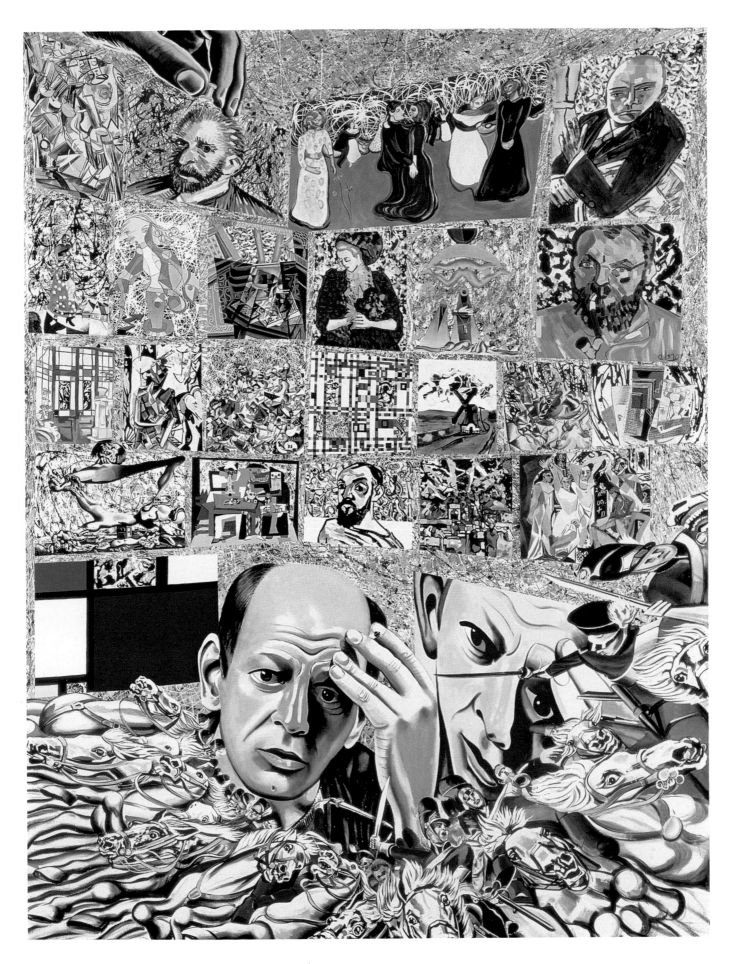

Jacques Monory
Murder no. 10/2, 1968
Acrylic on canvas and mirror, 160 × 400 cm
Musée National d'Art Moderne, Centre Georges
Pompidou, Paris. Gift of the artist, 1975

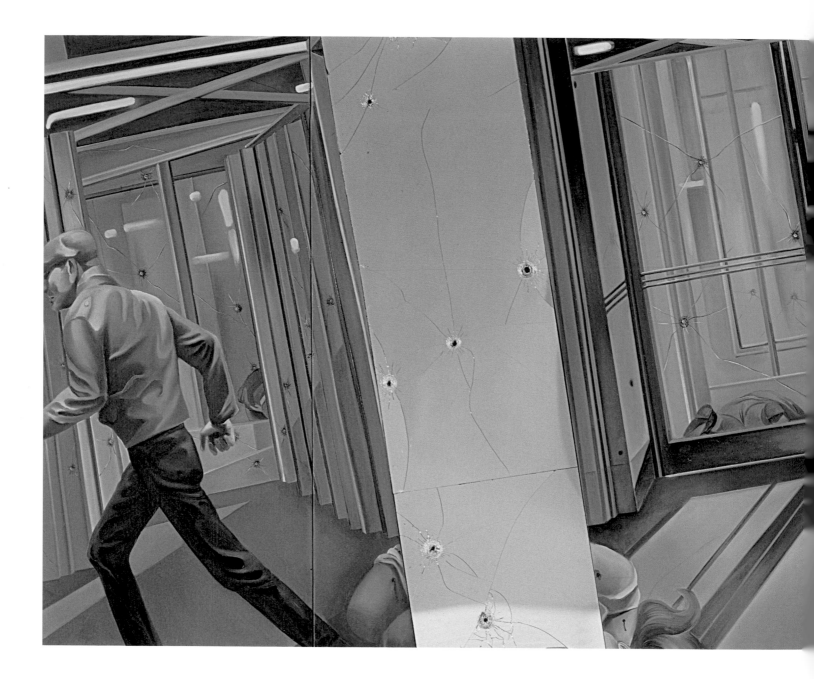

Gérard Fromanger
Souffle de mai '68, 1968
Transparent Altuglas, stainless steel
and ridged iron base, 240 × 150 × 150 cm
Collection of the artist

Gilles Aillaud, Eduardo Arroyo and Antonio Recalcati
To Live or Let Die, or The Tragic End of Marcel Duchamp, 1965
Oil on canvas (1–3, 5, 7–8) 162 × 130 cm;
(4, 6) 162 × 114 cm
Museo Nacional Centro de Arte Reina Sofía, Madrid

1

2

3

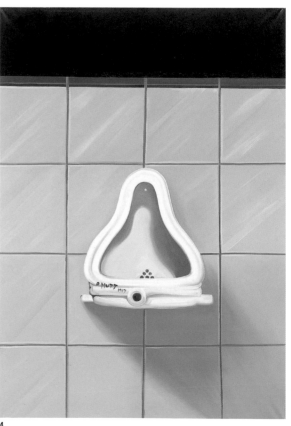

4

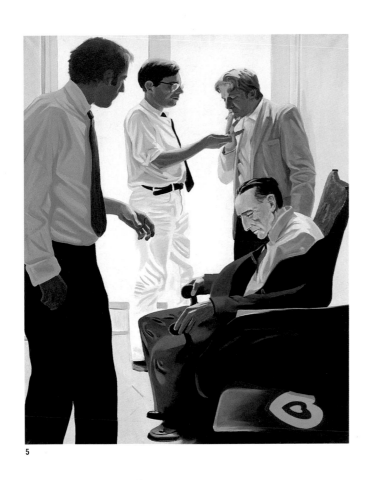

5

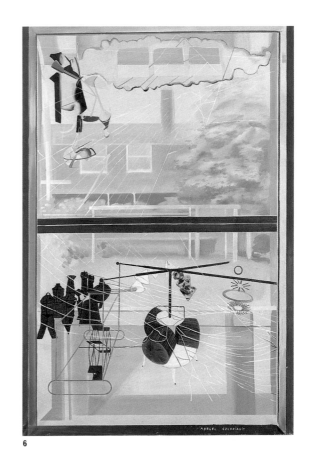

6

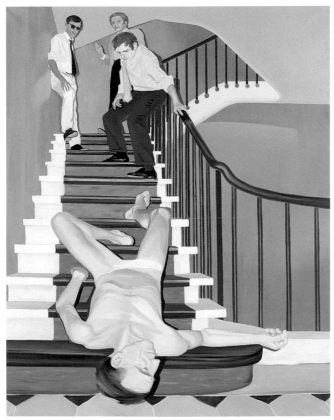

7

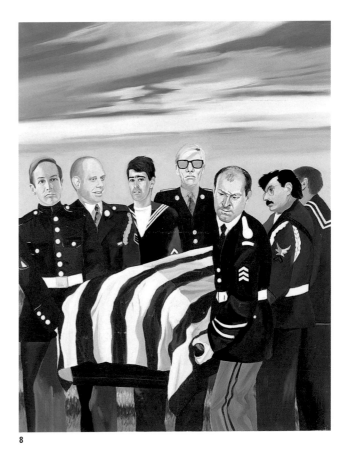

8

Pierre Buraglio
Mondrian Camouflaged, 1968
Stretcher and canvas and assembled
camouflage elements, 200 × 180 cm
Gilles and Nadege Blanckaert Collection

281

Daniel Buren
Painting with Variable Forms, 1966
Oil on canvas, 223.6 × 190.6 cm
Collection of the artist

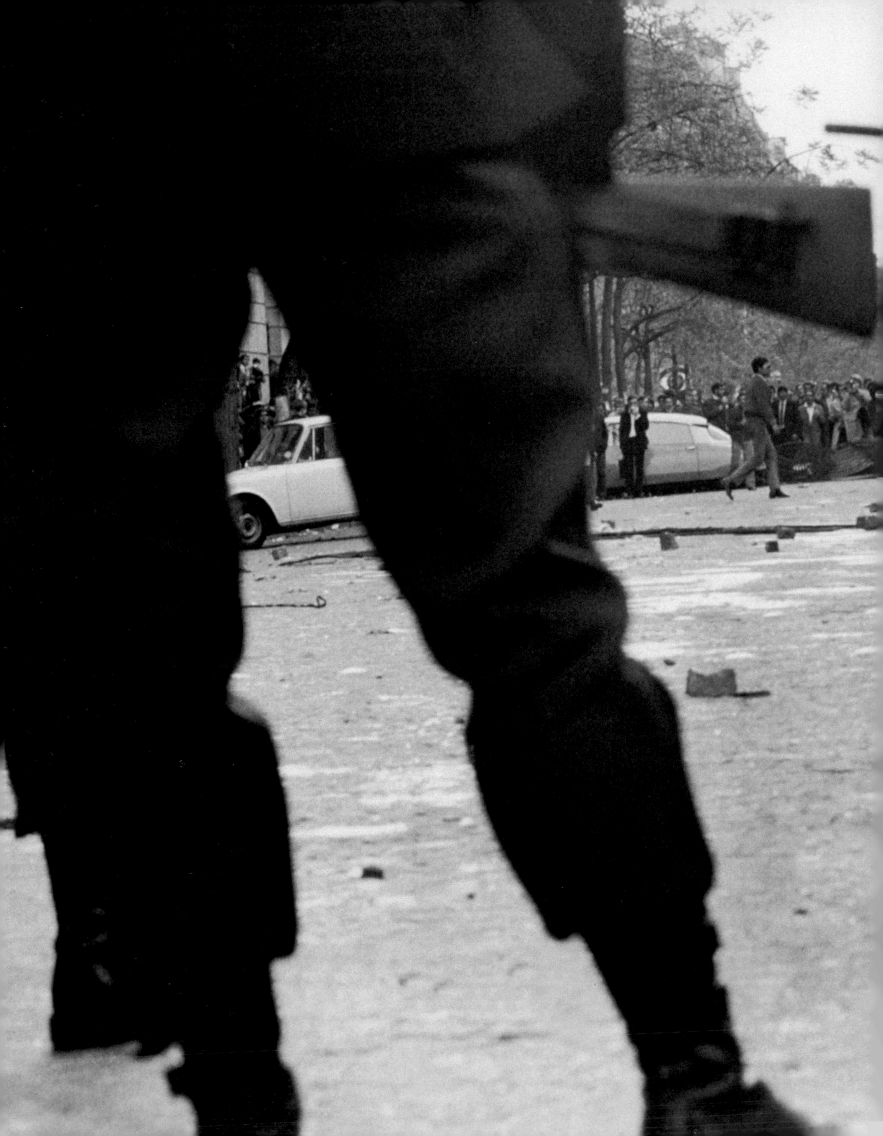

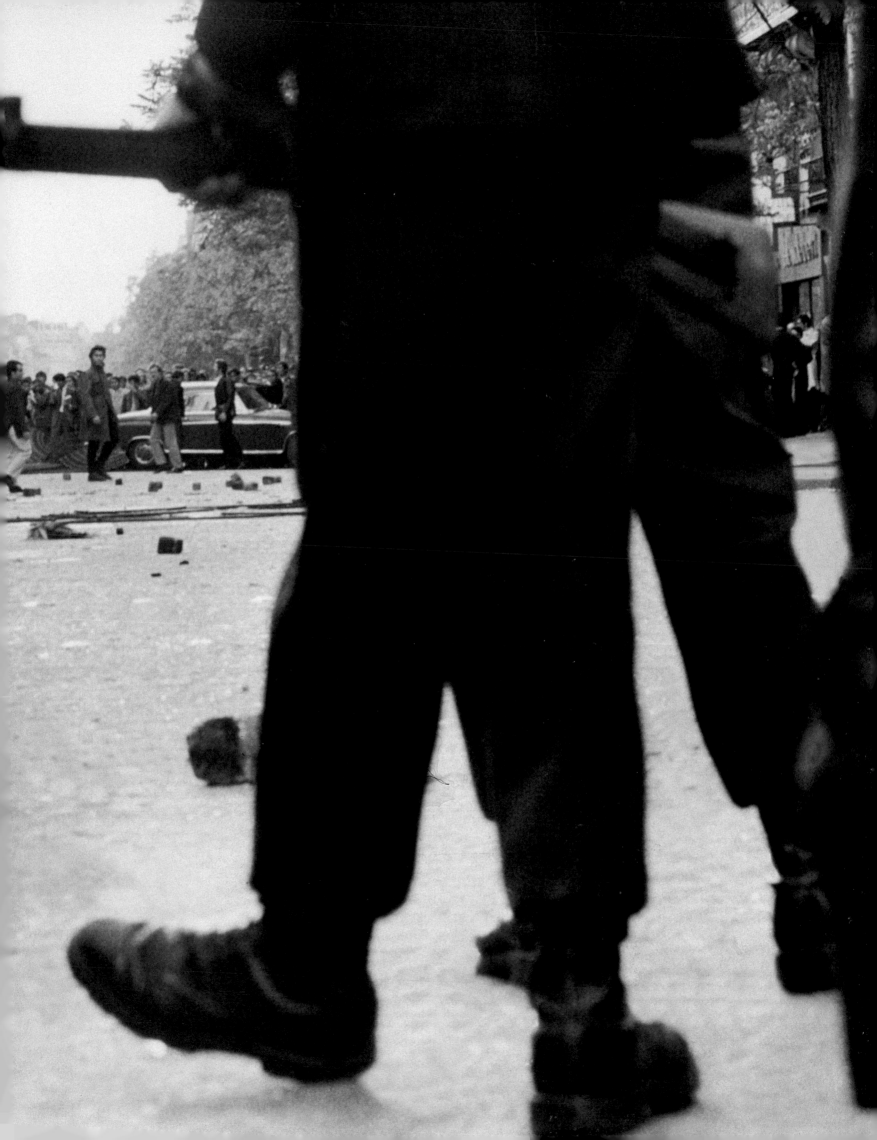

The entrance to the Métro station at the Porte Dauphine, designed by Hector Guimard, c. 1900

The first motion-picture camera and projector combined, designed by Louis Lumière and patented in 1895

A scene from **Georges Méliès**'s *Une Voyage à la lune*, 1902

Claude Debussy taking photographs in Eastbourne, 1904

Gertrude Stein

1900

● The Exposition Universelle brings a record 51 million visitors to Paris. The new Beaux Arts-style Grand Palais and Petit Palais house great retrospectives of French art, while the Pont Alexandre III, a reinforced concrete structure, symbolises the modernity of the Republic.
● The Orléans Railway Company builds the Gare d'Orsay, designed by Victor Laloux.
● The Paris Métro, the first on the Continent, opens its No. 1 line (Vincennes–Neuilly). Hector Guimard designs the station entrances, which are made of glass and cast iron in the form of naturalistic, Art Nouveau-style elements (1900–04; commissioned 1899).
● The Lumière brothers, pioneers of French cinema, promote their Cinématographe, a camera designed to show moving pictures, throughout Europe and the United States.

1901

● Formal constitution of the Republican Radical Party, which will dominate France's political scene until 1936.
● Ambroise Vollard, dealer of Renoir, Cézanne and Gauguin, exhibits Picasso's work for the first time in Paris. The very successful show includes at least 64 works, such as *Le Divan japonais* (cat. 2), *Les Blondes chevelures* and *L'Absinthe*. Picasso's art displays a dazzling variety and versatility and recalls many of the modern art styles of the time, while looking towards his Blue Period.

1902

● Elections result in a famous victory for the left, with a large Republican presence. The moderate Republican premier, René Waldeck-Rousseau, resigns in favour of the anti-clerical Emile Combes.
● Art-Nouveau architect Auguste Perret adopts a trabeated (beamed) concrete structure for his eight-storey block of flats in the Rue Franklin, in a return to the classical tradition.
● In André Gide's *L'Immoraliste*, a novel about the author's journey to North Africa and sexual desires, homosexuality becomes an acceptable literary subject.
● Claude Debussy's *Pelléas et Mélisande* (1893–1902), an anti-realist opera based on a play by the Belgian Symbolist Maurice Maeterlinck (1892), is premièred at the Opéra Comique, rather than the Opéra.
● Georges Méliès, the world's leading film producer during the early years of cinema, makes *Une Voyage à la lune*, the first multi-shot fiction film in French.

1903

● Pierre and Marie Curie are jointly awarded the Nobel Prize for physics.
● Inauguration of the breakaway Salon d'Automne, held at the Grand Palais, as a showcase for new art. The Salon's retrospectives of Manet, Seurat and Ingres (1905), Gauguin (1906), Cézanne (1906, 1907) and Corot (1909) have an important influence on young painters.
● The American dealer Leo Stein and his sister, the writer and collector Gertrude Stein, establish themselves in Paris and become an important force in the world of avant-garde art.

1904

● Franco-British Entente Cordiale.
● Claude Debussy composes *La Mer*, symphonic sketches considered to be his masterpiece, in Eastbourne, Sussex.
● Matisse's *Luxe, calme et volupté* (fig. 58) painted in Neo-Impressionist style reflects time spent with Paul Signac in St Tropez.
● Romain Rolland publishes the first volume of his novel *Jean-Christophe*.

● As Germany begins to assert military power, the Reichstag ratifies the Second Navy Law which orders a fleet of 38 battleships to be built in 20 years.
● Boxer Rebellion in China: the 'Boxers' demonstrate their hatred of foreigners by besieging the compound of the diplomatic community in Peking.
● Freud publishes *The Interpretation of Dreams*.
● Death of Nietzsche, whose legacy of pessimism and a zest for life unfettered by Christian morality greatly influences artists at the turn of the century.
● Max Planck introduces quantum theory.
● Catalan architect Antoni Gaudí works on Parque Güell in Barcelona (completed 1914).
● In Brussels, Victor Horta completes the Maison du Peuple for the Belgian Socialist Workers' Party in a Neo-Gothic-style.

● Queen Victoria dies after 63 years on the British throne.
● US President McKinley is assassinated by an anarchist. Vice-President Theodore Roosevelt becomes President.
● Collapse of negotiations for an Anglo-German alliance.
● Viennese Secession architect Joseph Maria Olbrich opens the progressive Ernst Ludwig House, the first structure to be built in the Darmstadt artists' colony (founded 1899), exhibiting the artists' lifestyle and living space as a total work of art.
● Edmund Husserl, the principal founder of phenomenology, publishes the first volume of *Logical Investigations*.
● Guglielmo Marconi transmits wireless signals across the Atlantic.

● Anglo-Japanese Alliance forged.
● Renewal of the Triple Alliance of Germany, Austria-Hungary and Italy.
● Boer War ends.
● Italian philosopher Benedetto Croce writes *Estetica*, his influential philosophy of art based on 'intuition'.
● Posthumous publication of Nietzsche's *The Will to Power*, a collection of aphorisms and fragments arranged and edited by the philosopher's sister that convey the notorious concepts of the 'Übermensch' and the 'will to power' as the basis of human nature, adopted by Mussolini and the German National Socialists.
● First trans-Pacific communications cable laid.

● A Serb nationalist regime, in confrontation with Austria-Hungary over Bosnia-Herzegovina, brutally replaces King Alexander of Serbia, whose dynasty is subservient to the monarchy in Vienna.
● Wright brothers fly first aeroplane at Kitty Hawk, North Carolina.
● Lenin's faction, 'Bolsheviki' (members of the majority), wins control of the Russian Social Democratic Labour Party at the Second Party Congress in Brussels.
● Viennese Secession architect Josef Hoffmann and artist Koloman Moser form the Wiener Werkstätte, to produce high-quality decorative objects.

● Japan humiliates the great Russian Empire in the Russo-Japanese War (1904–05), as the balance of world power shifts.
● Entente Cordiale settles Anglo-French differences in Morocco and Egypt. Britain recognises the Suez Canal Convention and surrenders her claim to Madagascar.
● Work on Panama Canal begins.

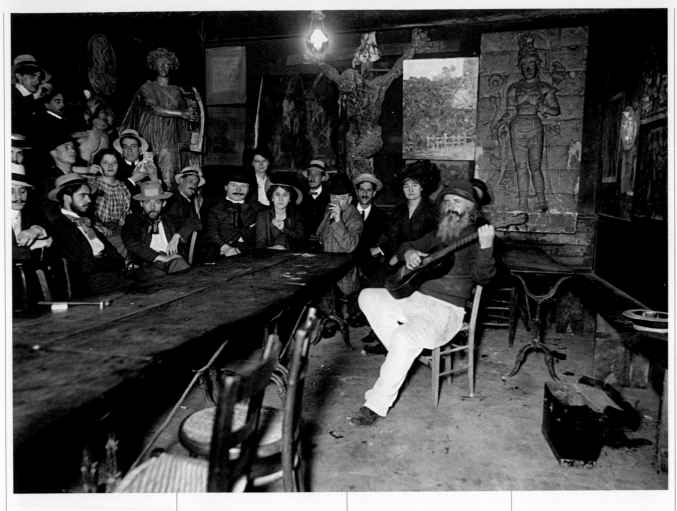

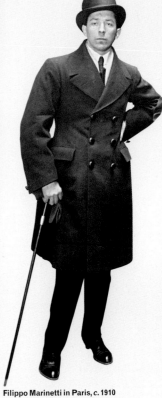

Filippo Marinetti in Paris, c. 1910

1905

● France, fearing the growth of German power, pursues a policy of entente with Russia and Italy. Kaiser visits Tangier to test the strength of the alliance: First Moroccan Crisis.
● Formation of a French section of the Workers' International, the SFIO (Section Française de l'Internationale Ouvrière).
● Separation of Church and State in France decreed, giving rise to a secular system of State education.
● Matisse, Vlaminck, Derain and their friends at the Salon d'Automne provoke controversy in the Paris art world with their contrasting and boldly applied colours, and are baptised 'fauves' (wild animals) by the critic Louis Vauxcelles.
● Paul Cézanne's Les Grandes Baigneuses and Henri Rousseau's The Hungry Lion are shown at the Salon d'Automne.

● Revolution breaks out in Russia, leading to the Tsar's concession of constitutional government in the 'October Manifesto'.
● The Expressionist painters Kirchner, Heckel, Schmidt-Rottluff and Bleyl revolt against the naturalism of German art and found Die Brücke in Dresden.
● Einstein publishes his Special Theory of Relativity.
● Freud's ground-breaking Three Essays on the Theory of Sexuality traces the development of the human sexual instinct from infancy to adulthood.
● Josef Hoffmann designs the Palais Stoclet in Brussels (completed 1911), a linear, Secessionist-style building with murals by Klimt and interior design by Moser that remains the highest achievement of their association as the Wiener Werkstätte and of the Gesamtkunstwerk (total work of art) aesthetic.

1906

● Georges Clémenceau becomes Président du Conseil at the head of a radical-dominated cabinet. His three-year term, beset by strikes, sees repression of the labour unions.
● Algeciras Conference: France is given control of Morocco.
● The Dreyfus Affair is reopened and Dreyfus formally cleared, marking the victory of Republicans over the French right and traditionalists.
● Matisse exhibits Le Bonheur de vivre (fig. 5) at the Salon des Indépendants, emphasising his position as chef d'école of the Fauve painters.
● Sergei Diaghilev, the great Russian impresario, begins his career in Paris with a large exhibition of Russian art from the seventeenth century to the modern period at the Salon d'Automne. Twelve rooms of the Salon, decorated by Léon Bakst, house 750 works by 53 artists, including Kandinsky and Jawlensky.
● Foundation of a community of artists and writers, including the painter Gleizes, at the Abbaye de Créteil outside Paris.

● Election of the first Duma (parliament) in Russia.
● Trans-Siberian Railway completed.
● Britain's Liberal government, committed to a programme of radical domestic reform, is forced to build up the British navy under pressure from rising German dominance and to forge alliances with Britain's old imperial rivals France and Russia. Britain's Labour Party formed.

1907

● Matisse's Nu bleu, souvenir de Biskra and Derain's Baigneuses are the sensation of the Salon des Indépendants. Picasso takes up the challenge with the radical Demoiselles d'Avignon (June–December 1907; fig. 1) but does not exhibit the work publicly until 1916. In retrospect, the Demoiselles is perhaps the most important painting of the twentieth century.
● At the age of barely twenty, Daniel-Henry Kahnweiler, dealer of Picasso, Braque, Léger, Juan Gris and André Derain, opens his first art gallery at 28 Rue Vignon.
● Philosopher Henri Bergson's L'Evolution créatrice embraces an evolution driven not by a deterministic natural selection but by a creative force (élan vital).
● A. Lumière improves technique of colour reproduction.

● Anglo-Russian Entente puts an end to colonial rivalries in Persia, Afghanistan and Tibet.
● French fleet bombs Casablanca in response to nationalist uprisings.

1908

● Charles Maurras, founder of the radical rightist party Action Française (1898), establishes an influential daily newspaper bearing the party's name to promote his violent anti-Semitic and anti-Republican views.
● The Salon d'Automne rejects six landscapes by Braque painted at L'Estaque the previous summer. Braque exhibits 27 paintings, including the rejected works, at Kahnweiler's gallery in November. The celebrated critic Louis Vauxcelles sees these works as no more than compositions of 'little cubes'.
● Matisse opens the Académie Matisse which attracts many foreign students, such as the Steins, Margaret and Oscar Moll and Max Weber. Matisse publishes 'Notes of a Painter', an important statement on 'expression' and 'artistic intuition'.
● Montparnasse begins to assert itself as a new centre of modern art in Paris.
● Publication of Georges Sorel's Reflections on Violence, important for Futurism.

● Austria-Hungary annexes the former Turkish provinces of Bosnia and Herzegovina with German support, initiating a series of crises that leads to the Balkan Wars (1912–13).
● Frank Lloyd Wright builds the Robie House, Chicago (completed 1909), one of his famous 'prairie houses', characterised by a broad, overhanging roof of thin slabs.
● Wilhelm Worringer's Abstraction and Empathy makes an important contribution to the psychology of style.

1909

● Aristide Briand, an independent socialist, succeeds Clémenceau as prime minister, as the left starts to disintegrate.
● Franco-German Agreement over Morocco.
● Louis Blériot makes the first flight across the English Channel.
● Italian poet and propagandist Filippo Marinetti publishes the Futurist manifesto for the modernisation of Italian culture on the front page of the relatively conservative newspaper Le Figaro ('Le Futurisme', 20 February 1909).
● André Gide and his circle found La Nouvelle Revue Française, a literary and arts review representing the young generation. Backed by the publishers Gallimard, it remains an important arbiter of literary taste until the Second World War.
● Diaghilev inaugurates his twenty years as impresario of the Ballets Russes on 19 May at the Théâtre du Châtelet. The performance features a suite of ballets that includes Prince Igor, conceived as a total work of art, with music by Borodin, choreography by Fokine and set and costumes by Roerich. The principal dancers are Nijinsky, Fokine and Coralli. Legendary performances of Le Spectre de la Rose, L'Après-midi d'un faune, Schéhérazade and Le Dieu bleu follow.

● Henry Ford's Model T car heralds streamlined industrial mass-production.
● Charles Rennie Mackintosh completes the Glasgow School of Art (1896–1909), a Gothic Revival structure of granite, glass and iron, incorporating the most up-to-date systems of environmental control.
● Peter Behrens uses glass and steel to construct his AEG Turbine Hall for the production of electricity in Berlin.
● Schoenberg writes his Three Pieces for piano, Op. 11, the first wholly atonal piece of music.

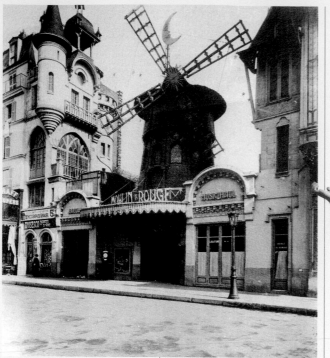

The Moulin-Rouge, photographed by Eugène Atget. This famous dance-hall was opened in 1889, and by the early twentieth century had become the meeting place for Paris society, artists and the demi-monde

The completed Théâtre des Champs-Elysées, 1913

Nijinsky dances in *Le Dieu bleu*, 1912

Dancers from the Ballets Russes perform Stravinsky's *Rite of Spring* in 1913

Mikhail Larionov's portrait of Guillaume Apollinaire, c. 1913

Paris

1910

- Marie Curie's *Treatise on Radiography* published.
- At the Salon d'Automne Matisse exhibits the large decorative panels *Dance* and *Music* which are striking in their size, simplicity and clashing, non-naturalistic colour.
- Charles Péguy publishes *Le Mystère de la Charité de Jeanne d'Arc*. Painters such as André Derain and Max Jacob respond to the contemporary Catholic revival.

1911

- France occupies Fez, provoking the Second Moroccan Crisis. Caillaux's secret negotiations with the Germans outrage nationalists, who force his resignation.
- First group showing of 'Cubist' artists, including Albert Gleizes, Jean Metzinger and Robert Delaunay, at the April Salon des Indépendants. Picasso and his collaborator Georges Braque show privately at Kahnweiler's gallery and in prestigious exhibitions abroad.
- Guillaume Apollinaire implicated in the theft of Leonardo da Vinci's *Mona Lisa* from the Louvre.
- Jacob Epstein's provocative *Tomb of Oscar Wilde* erected in the Père Lachaise Cemetery.

1912

- Raymond Poincaré takes over as prime minister.
- First Futurist exhibition, organised by Félix Fénéon at the Galerie Bernheim-Jeune, opens with works by Gino Severini, Giacomo Balla, Umberto Boccioni, Carlo Carrà and Luigi Russolo.
- The Salon des Indépendants features Robert Delaunay's large painting-manifesto, the 'cubified' *City of Paris*, Wassily Kandinsky's abstract *Improvisations* and Juan Gris's *Homage to Picasso*.
- At the Salon de la Section d'Or, Duchamp exhibits the Futurist-inspired *Nude Descending a Staircase* (fig. 7), along with work by his brothers Jacques Villon and Raymond Duchamp-Villon. Léger lectures on Cubism at the Salon de la Section d'Or, and later at the Collège de France.
- Picasso and Braque work in tandem to develop the new media of collage, *papier collé* and assemblage.
- Gleizes and Metzinger publish *Du 'Cubisme'*.
- Robert Delaunay theorises his approach to abstraction in the *Simultaneous Windows*, published in *Der Sturm* the following year.

1913

- Raymond Poincaré becomes president of France.
- Apollinaire's *Alcools*, and Blaise Cendrars' *Prose du Transsibérien* (fig. 31), impressions of a railway journey across Russia, apply Cubist techniques to literary language. Apollinaire produces his first calligrams, poems arranged on the page according to the formal devices of Cubism (published in *Calligrammes: Poèmes de la paix et de la guerre*, 1918).
- Apollinaire publishes *Les Peintres cubistes: méditations esthétiques*, a compilation of his writings which includes articles from his newspaper *Les Soirées de Paris*.
- Auguste Perret, in collaboration with the Belgian architect Henry van de Velde, the painter Maurice Denis and the sculptor Antoine Bourdelle, completes the Théâtre des Champs-Elysées (begun 1911), a Symbolist-inspired, classical building.
- Stravinsky's score for the Diaghilev ballet *The Rite of Spring* establishes the composer as a leader of the avant-garde.
- Marcel Proust publishes *Du Côté de chez Swann*.

1914

- Jean Jaurès, the Socialist leader and pacifist, is assassinated in Paris by a deranged Action Française supporter.
- President Poincaré remains in charge of French policy. As war is declared, the government is ruled by the 'Union Sacré', an alliance of ministers representing socialists, Marxists and the moderate right, but excluding the clerical right.
- At the Salon des Indépendants a large exhibition of Russian art in the neo-Primitivist and Cubo-Futurist vein is the culmination of a period of artistic exchange between Russia and France.
- Non-French artists remain in Paris as their French counterparts await call-up to the Front.

World

- Herwarth Walden, the Berlin promoter of the avant-garde, publishes the first issue of his anarchistic, counter-cultural journal *Der Sturm* (1910–32).
- Frank Lloyd Wright's unique fusion of the classical and exotic influences European architecture, following an exhibition of his work in Berlin and the publication of his Wasmuth portfolios there.
- Publication of the first volume of Bertrand Russell and A. N. Whitehead's *Principia Mathematica*.
- Roger Fry's first Post-Impressionist exhibition in London introduces modernism to the British public.

- Chinese Republic proclaimed.
- Franz Marc, Wassily Kandinsky, Alexander Jawlensky, August Macke and Paul Klee form Der Blaue Reiter (The Blue Rider) group in Munich. French artists, such as Robert Delaunay, collaborate with them in their journal of the same name. The artists share similar aims: artistic freedom, synthaesthesia and the integration of the arts, and mysticism.
- Kandinsky publishes *Concerning the Spiritual in Art*, his theory of art, as he works towards abstraction.

- First Balkan War (October 1912–May 1913): Balkan League (Serbia, Montenegro, Bulgaria and Greece), supported by Russia, attacks Ottoman Empire to gain territory in Macedonia.
- Herwarth Walden opens his influential gallery Der Sturm.
- Freud's *Totem and Taboo* applies psychoanalysis to the discipline of anthropology.

- Second Balkan War (June–August): Bulgaria attacks Serbia and Greece for refusing to hand over territory in Macedonia and is defeated. A strengthened Serbia poses a threat to Austria-Hungary.
- Mikhail Larionov, leader of Russia's avant-garde painters, issues the manifesto of 'Rayism', his linear style of non-objective painting derived indirectly from Italian Futurism and Cubism.
- The New York Armory Show displays works by modern French, especially Cubist, artists: Picasso, Braque, Léger, Delaunay, Gleizes, La Fresnaye, Duchamp, Villon, Duchamp-Villon, Matisse, Picabia, Kandinsky and Kirchner.
- Publication of Edmund Husserl's *Phenomenology*.

- Assassination of Archduke Franz Ferdinand by Bosnian Serb nationalist in Sarajevo (28 June). Austria-Hungary declares war on Serbia (28 July). Russia defends the Serbs. Germany declares war on France, and Great Britain mobilises (August).
- In England a group of artists and writers issue the journal *Blast*, announcing the Vorticist movement (1914–15): Wyndham Lewis, Ezra Pound, Edward Wadsworth, C. R. W. Nevinson, William Roberts, Frederick Etchells, Henri Gaudier-Brzeska and Jacob Epstein. Like the Futurists, they favour machine forms, dynamic movement and the energy of the mind.

The horrors of war: dead soldiers at the Battle of Verdun, 1916

Signatures and seals of the parties to the Treaty of Versailles, 28 June 1919

The French composers known as Les Six: (from left) Germaine Tailleferre, Francis Poulenc, Arthur Honegger, Darius Milhaud, Louis Durey and Georges Auric

Signatories of the Treaty of Versailles: (from left) Georges Clémenceau, Woodrow Wilson and David Lloyd George

1915

● Poincaré accepts General Joffre as France's military Commander-in-Chief.
● Foundation of the satirical journal *Le Canard enchaîné*.
● Sale of absinthe prohibited in France.

● Italy enters the war on the Allied side (May).
● Armenian massacres (November).
● Kasimir Malevich launches the Suprematist movement with the pamphlet 'From Cubism and Futurism to Suprematism' and with the exhibition '0.10' ('Zero-Ten') in St Petersburg. On show are his *Black Square* and other abstract compositions.
● Wegener proposes his theory of continental drift which will influence anthropological and linguistic theory.

1916

● Battle of Verdun: a pyrrhic victory for France as 300,000 French troops die.
● Battle of the Somme: 200,000 French casualties. French military strategy fails to overcome superior German artillery. Joffre resigns. Opposition to the war grows.
● Henri Barbusse's First World War novel *Le feu* wins the Prix Goncourt. The author describes life in the trenches from personal combat experience, countering the heroic and propagandistic view of the war.
● Eugène Freyssinet designs airship hangars at Orly, the first use of reinforced concrete on a giant scale.

● Albert Einstein's *General Theory of Relativity* overturns classical Newtonian theory.
● The Dada group of pacifist artists and writers, including Tristan Tzara, Richard Huelsenbeck, Jean Arp, Marcel Janco and the actor and playwright Hugo Ball, meets in Ball's Cabaret Voltaire, a Zurich music hall, to dance, sing, debate, compose and read nonsense poetry, and hold avant-garde art exhibitions. Characterised by an attitude of nihilism and anarchy, the Dada movement has no leader and no programme. The reviews *Cabaret Voltaire* and *Dada* disseminate Dada ideas.
● Jazz sweeps America.
● Publication of James Joyce's *Portrait of the Artist as a Young Man*.

1917

● Due to incompetent leadership, mutiny is rife in the French army. General Pétain represses the mutinies, changes tactics and reinvigorates the troops.
● Clémenceau becomes prime minister and shows no tolerance for pacifism.
● The poet Pierre Reverdy brings out the first issue of *Nord-Sud* (1917–18), a review of Cubist art and poetry which propounds a theoretical position for Cubism, distinguishing it from the decorative painting of the Salon Cubists of 1911–12.
● Première of Diaghilev's one-act ballet *Parade* (scenario by Jean Cocteau, music by Erik Satie, choreography by Léonide Massine, and sets and costumes by Picasso) on 18 May at the Théâtre du Châtelet. Based on a circus theme and staged in both a realist and a Cubist mode, the performance, taking place only 150 miles from the Front, provokes the usual outcries of 'Boches!', referring to the supposed German origin of modernist art.
● Performance of Apollinaire's *Les Mamelles de Tirésias* on the theme of wartime population decline. In the play Thérèse pops her balloon-breasts and becomes the Greek seer Tiresias. In the prologue Apollinaire refers to the play as 'surréaliste', coining the term.

● United States Congress declares war on Germany (April 5).
● The Russian Revolution co-opts the artists Tatlin, Rodchenko, El Lissitzky and Malevich within an avant-garde programme. Pevsner, Gabo and Chagall return home.
● In Amsterdam the painters Mondrian and van Doesburg and the architect Oud launch De Stijl, an abstract movement emphasising the social and spiritual value of art. Mondrian baptises his art Neo-Plasticism.
● In Ferrara de Chirico, his brother Savinio and Carrà formulate the principles of Metaphysical Painting (1917–19).
● The French painter Francis Picabia publishes *391* (1917–24), a periodical central to the development of Dada.
● German art historian Heinrich Wölfflin originates the notion of art history as a system, a history 'without proper names', in *Principles of Art History*.

1918

● A major German offensive from the Marne to the Somme poses a threat to Paris (March–May). French General Foch launches a successful counter-offensive (8 August). On 3 October Germany accepts Woodrow Wilson's 'Fourteen Points' and asks for an armistice (11 November 1918).
● French artist Amédée Ozenfant and Swiss architect Charles-Edouard Jeanneret (Le Corbusier) publish the manifesto of Purism, *Après le Cubisme*. Their first exhibition of Purist art at Galerie Thomas shows works whose clear, simple forms are based on the precepts of mathematics and industrially produced forms.
● The avant-garde musicians known as 'Les Six' – Georges Auric, Francis Poulenc, Darius Milhaud, Arthur Honegger, Louis Durey, Germaine Tailleferre – are brought together by Jean Cocteau and Erik Satie for *soirées* of poetry readings, musical recitals and art exhibitions at the Association Lyre et Palette.

● US President Woodrow Wilson sets out his 'Fourteen Points' for peace and postwar reconstruction.
● Austria-Hungary breaks up; Czechs and Slovaks form an independent Czechoslovakia (October).
● First World War ends with Armistice between Germany and the Allied Powers (11 November): Poland, Hungary and Yugoslavia become independent states; Austria and Germany are declared republics.
● German essayist Oswald Spengler, in *The Decline of the West*, denounces technology and science with intimations of racism.
● Tzara writes the Dada manifesto, published in *Dada*, no. 3 (18 December 1918).

1919

● November parliamentary elections result in triumph for the Bloc National, a coalition of nationalists, centre parties and some radicals. Conservative government dominates the postwar years, halting the momentum of women's suffrage and the rise of Bolshevism.
● Cubists are absent from the first big non-academic Salon d'Automne after the Armistice, but Francis Picabia contributes *Child Carburettor*, his mechanomorphic painting with words, as the Dada movement comes to Paris.
● Léonce Rosenberg's Galerie de l'Effort Moderne becomes the major champion of postwar Cubism.
● A young generation of Dada French writers, André Breton, Louis Aragon, Philippe Soupault, Paul Eluard and Robert Desnos, run *Littérature* (1919–24), the radical avant-garde journal, noted, ironically, for its 'anti-literary' stance.
● Marcel Proust wins the Prix Goncourt for *À l'Ombre des jeunes filles en fleurs* (1918), the second book of his *roman fleuve*, *À la Recherche du temps perdu* (1913–27). Proust identifies with the writer-hero of the novels as he bares his thoughts on the self, time, art, sex and death.

● Social Democrats put down armed 'Sparticist' Revolt in Berlin, led by Rosa Luxemburg and Karl Liebknecht, who are assassinated.
● German national assembly at Weimar authorises signature of Treaty of Versailles. Alsace-Lorraine is returned to France.
● Benito Mussolini, former editor of the socialist newspaper *Avanti*, establishes Italian Fascist party.
● Lenin establishes Third International or Comintern to foment revolution in Europe.
● Max Ernst, with Jean Arp and Johannes Baargeld, founds a Dada group in Cologne.
● Walter Gropius founds the Bauhaus in Weimar.
● Russian Constructivist Vladimir Tatlin designs 1,130-foot (400-metre) monument to the Third International, a metaphor for the harmony of the new social order.

Shakespeare and Company, the Paris bookshop owned by Sylvia Beach, photographed by Gisèle Freund, showing (from left) James Joyce, Sylvia Beach and Adrienne Monnier, 1922

Rolf de Maré, the Swedish art collector and founder of the Ballet Suédois

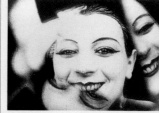

A still from Fernand Léger's film *Le Ballet mécanique*, 1924

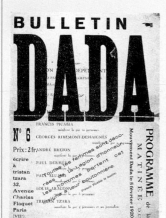

The sixth number of the *Bulletin Dada*, 5 February 1920, designed by Duchamp

Le Corbusier's 1922 vision of *Paris in the Year 2000*

Paris

1920

● French Communist Party (PCF) is formed at the Socialists' Congress of Tours (December).
● Tristan Tzara opens the era of Dada protest in Paris (1920–23) at the soirées of André Breton's group around the journal *Littérature*.
● André Breton and Philippe Soupault publish their collaborative *Les Champs magnétiques*, an experiment in 'automatic' writing designed to explore psychic states, and thus the archetypal Surrealist work.
● Le Corbusier and Amédée Ozenfant bring out the first number of *L'Esprit nouveau* (1920–25), their platform for Purism and an international review of contemporary culture.
● Daniel-Henry Kahnweiler re-establishes himself in Paris at the Galerie Simon, representing Braque, Gris, Laurens, Manolo, Klee and Masson. He publishes *Der Weg zum Kubismus* (*The Rise of Cubism*). Picasso exhibits at Paul Rosenberg's rival gallery.
● Constantin Brancusi's *Princess X* (fig. 10) causes a scandal at the newly reopened Salon des Indépendants.
● *Pulcinella*, Stravinsky's ballet suite for Diaghilev's Ballets Russes, is premièred at the Opéra, with sets and costumes by Picasso.

1921

● René Maran's *Batouala, véritable roman nègre* (*Batouala: A Real Black Novel*) wins the Prix Goncourt, heralding a period of negrophilia.

1922

● The conciliatory Aristide Briand government falls (January). Poincaré becomes prime minister and takes a hard line on German reparations.
● Formal publication by Shakespeare & Company, Sylvia Beach's Paris bookshop, of James Joyce's *Ulysses* (February), after its serialisation brings obscenity charges on the American avant-garde magazine *The Little Review*, and the London review *The Egoist*.
● Kandinsky decides to return to Paris after the exhibition of Soviet artists in Berlin.

1923

● France occupies the Ruhr on the pretext of a German default on reparation payments, alienating former allies and causing hyperinflation in Germany.
● The new Salon des Tuileries brings together the official and the independent art worlds. It is presided over by two juries, one 'academic', one 'modern', and marks the changing status of 'l'art vivant', or 'independent art', encompassing the 'école de Paris', the ambiguous term for artists, especially foreigners, working in Paris in a range of modern styles.
● Léonce Rosenberg's Galerie de l'Effort Moderne, the main showcase for postwar Cubist art, mounts a De Stijl exhibition that proves instrumental for the acceptance of non-objective art in France.
● Breton and his *Littérature* group stage a riot at a performance of Tzara's play *Le Coeur à gaz* at the Théâtre Michel, provoking a final break with Dada.
● Swedish art collector Rolf de Maré's Ballet Suédois performs *La Création du monde*, a 'Negro' ballet with scenario by Blaise Cendrars, based on West African Baoulé myths; Darius Milhaud's music incorporates New York jazz and Brazilian rhythms. Léger's sets include authentic African masks.

1924

● The Poincaré coalition is defeated by the 'Cartel des gauches', an alliance of socialists and radicals. Edouard Herriot becomes prime minister and effects a policy of conciliation with Germany.
● André Breton publishes the *Manifeste du Surréalisme* and launches, with Louis Aragon, Philippe Soupault, Paul Eluard and Robert Desnos, the review *La Révolution surréaliste* (12 numbers, 1924–29). The movement's exponents dedicate themselves to the exploration of the unconscious by means of 'pure psychic automatism'.
● Léger develops his 'machine aesthetic' (*Bulletin de l'Effort Moderne*, I, January–February 1924), a synthesis of modern-life Cubism with De Stijl and Constructivist notions of the geometric, seen in his flat, stylised paintings with machine-like forms. His film *Le Ballet mécanique* shows everyday objects in rhythmic motion.
● Première of Léonide Massine's controversial ballet *Mercure*, with music by Erik Satie, and Surrealist-inspired, curvilinear Cubist sets and curtain by Picasso.
● Louis de Broglie publishes his Wave/Particle Theory.

World

● League of Nations and Permanent Court of International Justice are established.
● United States Senate refuses to ratify Treaty (March).
● German reparations are determined at Brussels Conference (15–22 December).
● Anton Drexler, a Munich locksmith, founds German Workers' Party, renamed Nazi Party the following year.
● Poles gain territory from Russia and Germany, to the Germans' consternation.
● Freud's *Beyond the Pleasure Principle* introduces the concept of the 'compulsion to repeat' and the theory of the 'death instinct'.

● Red Army crushes the Kronstadt Rebellion. Lenin ends War Communism and adopts New Economic Policy (NEP), allowing limited private enterprise.
● Chinese Communist Party founded in secret in Shanghai with help from Lenin's Comintern agents.
● Washington Naval Conference results in a new regional order in China and Japan, and inaugurates American cultural and economic dominance.
● Anglo-Irish treaty creates the Irish Free State, dividing Ireland into Protestant north and mainly Catholic south and sparking civil war among Irish nationalists.
● Austrian philosopher Ludwig Wittgenstein publishes *Tractatus Logico-Philosophicus*, his major work on the nature of language and how it represents the world, with important implications for logic and mathematics.

● Lenin suffers a stroke; Stalin becomes General Secretary of the Communist Party in Russia; the Soviet Union is established.
● Rapallo Treaty (April): secret German and Soviet *rapprochement*, with agreement to renounce reparations.
● Benito Mussolini establishes his regime in Italy (October).
● Hans Prinzhorn brings out his influential study of the art of the mentally ill, *Bildnerei der Geisteskranken* (*Artistry of the Mentally Ill*), in Berlin.
● Lord Carnavon and Howard Carter discover the Tomb of Tutankhamun at Luxor in Egypt.
● Publication of T. S. Eliot's *The Wasteland*.

● Hitler is imprisoned after the beer-hall putsch in Munich (8–9 November); he writes *Mein Kampf* (first volume published 1925).
● German Dada artist Kurt Schwitters brings out the first issue of his Hanover art journal *Merz* (1923–32). 'Merz', from 'Commerz', also describes his refuse assemblages dating from 1918 and his one-man movement and philosophy of art.
● Mussolini launches the first showing of Italian Novecento artists, including Mario Sironi and Carlo Carrà, favoured for their revitalisation of the classical tradition in a modern mode, at the Pesaro Gallery in Milan.
● In New York, Marcel Duchamp leaves 'definitively unfinished' his large painting on glass, *The Bride Stripped Bare by Her Bachelors, Even* (begun 1915), also known as *The Large Glass*, an enigmatic work at the origin of twentieth-century conceptual art. He devotes himself to playing chess.

● Lenin's death provokes a power struggle within the Soviet leadership (21 January).
● Greece becomes a republic (24 March).
● US Dawes Plan (July): America proposes a settlement of European debt crisis, thus accepting some economic, if not political, responsibility for European security.
● German author Thomas Mann publishes *The Magic Mountain*, a novel of ideas set in an Alpine sanatorium which serves as a metaphor for the decline of European society on the eve of the First World War.

412

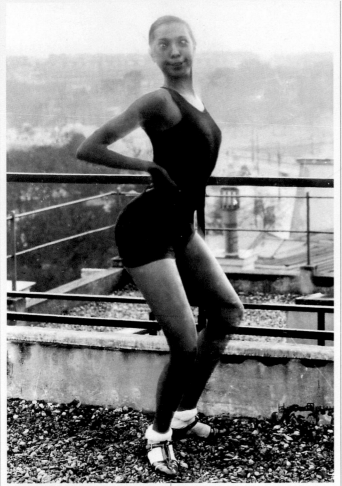

Josephine Baker on the roof of the Théâtre des Champs-Elysées, 1925

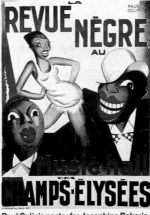

Paul Colin's poster for Josephine Baker's 'Revue Nègre', 1925

Antonin Artaud as Marat in Abel Gance's epic film *Napoléon*, 1927

One of the images from the notorious opening sequence of *Un Chien andalou* by Salvador Dalí and Luís Buñuel, first shown in Paris in 1928

Detail of Man Ray's photograph of André Breton, 1930

1925

- Herriot resigns over manipulation of illegal government bonds.
- The Exposition Internationale des Arts Décoratifs et Industriels Modernes (April–October) marks the high point of France's creativity in the decorative arts. Germany and the Bauhaus do not take part. Notable among the modern-style pavilions is the Pavillon de l'Esprit Nouveau by Le Corbusier. The department-store pavilions Au Bon Marché and Au Printemps promote mass production.
- 'Peintures Surréalistes' at the Galerie Pierre marks the first encounter between Surrealism and painting, with works by Picasso, de Chirico and lesser-known artists.
- Victor Poznanski, with Léger's backing, organises 'L'Art aujourd'hui, Exposition Internationale', highlighting the growing trend towards abstract or non-objective art.
- Léger's Académie de l'Art Moderne, founded with Amédée Ozenfant, becomes a centre for the 'machine aesthetic'.
- Le Corbusier's unrealised Plan Voisin sets out a visionary scheme of 18 identical tower blocks in the new International Style.
- La Revue Nègre performs the new jazz dances and rhythms at the Théâtre des Champs-Elysées.

- Stalin becomes ruler of the Soviet Union and declares his policy of 'socialism in one country', abandoning Trotsky's aim of worldwide revolution.
- Locarno Conference and treaties establish a mutual guarantee of Franco-Belgian-German borders (1 December).
- First exhibition of the Neue Sachlichkeit (New Objectivity, or Sobriety) group of realist painters, many of them former Expressionists, including Otto Dix, George Grosz, Christian Schad and Rudolf Schlichter, takes place in Mannheim, Germany.
- Heisenberg applies Planck's theory of quantum mechanics to atoms.
- Publication of Franz Kafka's *The Trial*.
- First screening of Sergei Eisenstein's *The Battleship Potemkin*.

1926

- The authoritarian Poincaré becomes prime minister and takes control of finance.
- The Musée de Luxembourg reopens under the directorship of Charles Masson, who focuses on modern art: he rehangs the Caillebotte bequest along with artists of the Ecole de Paris (Luce, Vlaminck, Friesz, Waroquier, Marchand, Utrillo and many more), and academic painters.
- Christian Zervos brings out the first number of *Cahiers d'art* (1926–60), the prestigious modern art review.
- Marcel Duchamp's 'anti-retinal' film, ironically titled *Anémic cinéma* (Anemic Cinema), juxtaposes slowly rotating spirals implying sexual images with salacious and near-incomprehensible puns that undermine the normal experience of viewing.

- Germany is admitted to the League of Nations.
- The Bauhaus moves to Dessau and becomes closely aligned with Neue Sachlichkeit.
- General Strike in Britain.
- Chiang Kai-shek reorganises Kuomintang (the National People's Party) and leads the Northern Expedition to unify China.

1927

- Eugène Jolas publishes the first number of the English-language review *Transition* (1927–38), promoting avant-garde artists and writers, and including regular instalments of James Joyce's 'Work in Progress', which would be published twelve years later under the title *Finnegans Wake*.
- Philosopher Henri Bergson wins the Nobel Prize for Literature.
- Première of Abel Gance's *Napoléon*, the first film to be shown at the Paris Opéra: Gance introduces revolutionary projection techniques such as triple screens and mobile cameras, and accompanies the screening with music played by a complete orchestra.

- Trotsky is expelled from the Communist Party.
- Chiang Kai-shek attempts to destroy the Chinese Communist Party, as nationalists and communists split into factions.
- German philosopher Martin Heidegger publishes *Being and Time*, an analysis of being which reorientates philosophy from metaphysical concerns to an emphasis on 'existence'. Heidegger's ideas penetrate the Parisian avant-garde in the 1930s and are important for the development of 'existentialism'.

1928

- Poincaré triumphs with the support of the centre and right parties, beginning a period of apparent economic buoyancy.
- The Kellogg–Briand Pact, a general treaty for the renunciation of war as an instrument of national policy, is signed in Paris.
- Breton's *Le Surréalisme et la peinture* sets out his theory of Surrealist painting, emphasising the primacy of vision in the Surrealist project and citing the Cubist Picasso as its most important precursor.
- Première of Antonin Artaud's *The Seashell and the Clergyman*, a film which uses displacement techniques and hallucinatory imagery to depict a priest's sexual obsessions.
- Salvador Dalí and Luís Buñuel stir up the Parisian avant-garde with *Un Chien andalou*. The film begins with the image of a razor slicing an eye and continues to assault vision and good taste in quick montage fashion to the accompaniment of phonograph recordings of Wagner's *Tristan and Isolde* and tango music.
- Publication of André Malraux's *Les Conquérants*, a critique of French colonial rule in Indochina.

- Stalin announces the first Five Year Plan to transform Soviet agriculture and industry, as the planned economy is introduced and civil society obliterated.
- Chiang Kai-shek is elected president of China; the communists are driven underground or retreat to isolated areas of the country to regroup.
- Première in Berlin of Bertolt Brecht, Kurt Weill and Elisabeth Hauptmann's hugely successful *Threepenny Opera*, a 'play with music' derived from John Gay's *The Beggar's Opera* (1728).
- Walt Disney releases *Mickey Mouse*.

1929

- French writer Georges Bataille, in collaboration with the rebel Surrealists Michel Leiris, Robert Desnos and Georges Limbour, initiates the luxury art review *Documents* (1929–30), which includes commentary on primitive and modern works of art, as well as photography and images of popular culture. Bataille's articles draw on the disciplines of philosophy, aesthetics, anthropology, psychoanalysis and politics, denoting the review's ultra-avant-garde orientation.
- Publication of *Bifur* (1929–30), edited by Georges Ribemont-Dessaignes, which aims to break down intellectual barriers and in so doing to present a new view of man. Contributors include Jean-Paul Sartre, Ilya Ehrenburg, Henri Michaux, Giorgio de Chirico, Tristan Tzara, James Joyce, Tina Modotti and Martin Heidegger. An avant-garde rival to the *Nouvelle Revue française*, *Bifur* was too far ahead of its time to endure.
- Dziga Vertov makes *I Am a Camera*.

- Wall Street crash and beginning of Great Depression undermines economic and political stability in Europe.
- Stalin becomes dictator of the Soviet Union.
- New York's Museum of Modern Art is founded to house important works of late nineteenth-century and contemporary art; Alfred H. Barr is appointed director.
- Bauhaus architect Ludwig Mies van der Rohe designs the modernist glass German Pavilion at the Barcelona World's Fair.

A scene from René Clair's film *A nous la Liberté*, 1931

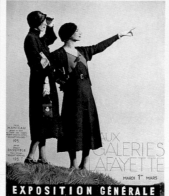

An advertising poster for the department store Galeries Lafayette, 1932

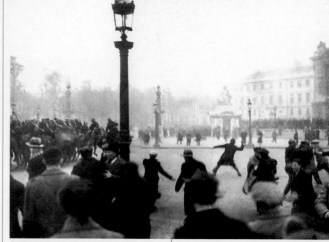

Anti-government fascist riots in the Place de la Concorde, 1934

Kiki de Montparnasse, model and muse, the figure who epitomised the bohemian lifestyle of the age

André Malraux, photographed by Gisèle Freund, 1935

1930

● Demonstration against unemployment is organised by the Confédération du Travail.
● André Breton publishes the *Second Surrealist Manifesto*, promoting communist politics and purging the movement in the final number of *La Révolution Surréaliste*.
● 'Cercle et Carré' and 'Art Concret' groups exhibit works by Jean Hélion and Theo van Doesburg.
● Salon des Surindépendants exhibits works by non-figurative artists from the 1920s.
● Luis Buñuel and Salvador Dalí's film *L'Age d'or*, a mixture of Surrealism and Spanish anti-clericalism, provokes riots by ultra-rightist hooligans in Montmartre's Studio 28 theatre.

1931

● The effects of the Wall Street Crash are felt.
● The Exposition Coloniale de Paris in the Vincennes Forest, south-east of Paris, celebrates the role of the French empire in Africa and Asia.
● The Belgian Michel Seuphor forms the Abstraction-Création group of post-Cubist artists, including Jean Hélion, Auguste Herbin, Georges Vantongerloo and Etienne Béothy.
● René Clair directs *A nous la liberté*, a cinematic satire of modern, industrialised life, considered to be the model for Chaplin's *Modern Times*.
● Première of Jean Cocteau's Surrealist-inspired film about the life of a poet, *Le Sang d'un poète*, with music by Georges Auric.
● Matisse designs murals for Albert Barnes's private museum in Merion, Pennsylvania.
● Publication of the aviator and writer Antoine de Saint-Exupéry's *Vol de nuit*.

1932

● The Radical Party holds the balance of power between left and right in the National Assembly.
● Unemployment in France reaches 250,000.
● France signs Non-Aggression Pact with Russia.
● Picasso's first retrospective at the Galerie Georges Petit travels to the Zurich Kunsthalle. The Swiss psychoanalyst Carl Jung criticises the show and refers to Picasso as a 'schizophrenic' in one of the first attacks on 'degenerate' art (*Neue Zürcher Zeitung*, 13 November 1932).
● Calder exhibits his first mobiles at Marie Cuttoli's gallery.
● The newly autonomous Musée du Jeu de Paume begins to exhibit works by the Ecole de Paris, provoking controversy about what constitutes the national school.
● Louis-Ferdinand Céline wins the Prix Renaudot, for his first novel, *Voyage au bout de la nuit*. The book, set during the First World War, explores unprecedented levels of violence and obscenity.
● Jacques Lacan's doctoral thesis *De la Psychose paranoïaque dans ses rapports avec la personnalité* draws on Surrealism, the discourse on paranoia and the work of Freud and the celebrated psychiatrist Clérambault.

1933

● Stavisky Affair highlights corruption in French government. Alexandre Stavisky, a financier involved with politicians from the Radical Party, is found guilty of fraud involving false municipal bonds and dies in suspicious circumstances (January 1934).
● Albert Skira and Tériade bring out the first issue of *Minotaure*, a luxury Surrealist review (1933–39).
● Russian emigré philosopher Alexandre Kojève gives seminars on Hegel's *Phenomenology of Mind* (1933–39), based on a radical re-reading of Hegel through Marx and Heidegger. These are attended by intellectuals such as Jean-Paul Sartre, Jacques Lacan, André Breton and Georges Bataille.
● André Malraux wins the Prix Goncourt for his anti-colonial novel *La Condition humaine*, set during the failed Shanghai rebellion of 1927. The narrative focuses on the heroic Chinese leaders of the rebellion and their terrorist campaign. Comparisons of the story with the unravelling of French society are made.
● Raymond Queneau, a former Surrealist, writes his first novel *Le Chiendent*, in which a Parisian concierge philosophises about the meaninglessness of life.

1934

● Radical Party premier Edouard Daladier takes power after the Stavisky Affair. He dismisses the Paris Prefect of Police Jean Chiappe, who is known to have extreme right-wing sympathies. Radical Party actions provoke anti-government fascist riots in the Place de la Concorde (6 February). Fifteen people die and hundreds are injured. The left retaliates with a one-day general strike and claims victory over fascism (12 February). Daladier resigns (7 February).
● Gaston Doumergue's coalition government of radicals, centrists and conservatives takes power (9 February). Marshal Pétain, 'the hero of Verdun', becomes Minister of War. Deflationary policies impede economic recovery and lead to Doumergue's downfall.
● Michel Leiris publishes *L'Afrique fantôme*, a philosophical diary written during the Dakar-Djibouti Mission of 1931–32, a trip organised by the Musée de l'Homme to gather artefacts for the new museum.

● Allied occupation of the Rhineland ends.
● Hitler rises to power in the aftermath of the Wall Street Crash. His National Socialist Party wins 107 seats in the Reichstag elections and emerges as a decisive force in German politics (September).
● Freud's *Civilisation and Its Discontents* attempts to apply the techniques of psychoanalysis to society.
● Austrian novelist Robert Musil's *The Man Without Qualities* examines the cultural void and disarray left by the collapse of the Austro-Hungarian Empire.
● Discovery of Pluto.
● Shreve, Lamb & Harmon erect the Empire State Building, New York.
● Invention of acrylic plastics.

● Spanish Republic, dedicated to liberalisation and reform, is established.
● Japan occupies Manchuria.
● Construction of Rockefeller Center, New York, underway.
● Boris Karloff stars in James Whale's *Frankenstein*.

● Economic conditions deteriorate in Germany, with 30% unemployed. In the summer elections Nazis become the dominant political party in the Reichstag.
● James Chadwick's discovery of neutrons.

● Hitler becomes chancellor (30 January) and goes on to assume dictatorial powers.
● First 'black list' for the fine arts is published (March). Goering closes the Bauhaus for its purported Bolshevik leanings (11 April). Nazis attack 'degenerate' modern art.
● José Antonio Primo de Rivera founds the nationalist Falange movement in Spain.
● Stalin announces the Second Five-Year Plan.
● Roosevelt inaugurates the 'New Deal' programme of economic reforms.
● The Warburg Institute, with its archives of Renaissance culture, moves from Hamburg to London.

● Hitler begins a cultural offensive to inculcate his Aryan doctrine through art, music, drama, architecture and the media. Hundreds of thousands take part in the nationalist-inspired Nuremberg rally, one of many such events.
● Gorky presides over the First Congress of the Union of Soviet Writers in Moscow. Socialist Realism is promoted and hotly debated among international delegates.
● China's communists undertake the Long March (1934–35).

Popular Front leaders meet at the Mur des Fédérés in the Père Lachaise Cemetery to commemorate the anniversary of the 1871 Commune, 19 May 1935: Léon Blum wears a striped tie; Maurice Thorez leans forward

Joan Miró's 1935 cover of the Surrealist review *Minotaure*

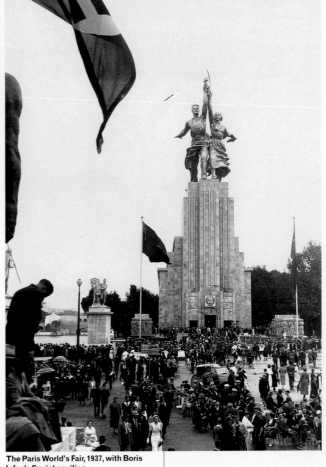

The Paris World's Fair, 1937, with Boris Iofan's Soviet pavilion

Refugees from the Spanish Civil War cross into France

1935

- Soviet Union and France sign Mutual Assistance Treaty. Laval visits Stalin in Moscow.
- Successive conservative governments under Pierre-Etienne Flandin (November 1934–May 1935) and Pierre Laval (June 1935–January 1936) fail to bring about recovery, and social unrest ensues. The communist Maurice Thorez, the socialist Léon Blum and the radical Edouard Daladier form the 'Popular Front against Fascism', a broadly-based left-wing coalition. They lead a mass popular demonstration on Bastille Day.
- Breton and Bataille join forces to form Contre-Attaque, a group of revolutionary intellectuals against fascism.
- *Les Cenci*, a play inspired by the English romantic poet Shelley with sets and costumes by Balthus, is produced at the Théâtre des Folies-Wagram by Antonin Artaud. Attempting to embody his concept of a Theatre of Cruelty, it is greeted with derision by the critics and soon closes.
- Louis Aragon lectures at the Maison de la Pensée Française on Soviet art and literature.

- Germany repudiates the disarmament clauses of the Treaty of Versailles.
- Nuremberg Laws strip Jews of citizenship and forbid intermarriage.
- Mussolini invades Abyssinia (now Ethiopia).

1936

- Large workers' protest in the lead-up to the spring elections. Léon Blum, leader of the majority Socialist Party, forms the first Popular Front government (June). A number of communist deputies are elected. Workers strike in May and June. Government reforms working conditions by instituting paid holidays, the 40-hour week and wage rises (September).
- Devaluation of the franc. Economic conditions worsen, the pace of social reform slows and disillusionment sets in.
- Debates on realism in painting take place at the Maison de la Culture on 16 and 29 May. The proceedings are published in July as *La Querelle du réalisme*.
- Walter Benjamin's essay 'The Work of Art in the Age of Mechanical Reproduction' analyses the impact of photography on the authenticity or 'aura' of the work of art.
- 'The Surrealist Exhibition of Objects' at the Charles Ratton gallery features Man Ray's objects, Picasso's Cubist constructions, Dalí's aphrodisiac jacket and Meret Oppenheim's fur cup and saucer.
- Bataille brings out the first issue of *Acéphale* (1936–39), a review dedicated to Nietzschean philosophy and social subversion.

- Hitler enters the Rhineland, breaking the terms of the Treaty of Versailles.
- Berlin hosts the Olympic Games.
- Spanish Civil War begins (July). Arrest and murder of the poet Federico García Lorca cause outrage within the international artistic community (August).
- Stalin's purges begin.
- New York's Museum of Modern Art mounts 'Cubism and Abstract Art', followed by 'Fantastic Art, Dada, Surrealism'.
- 'International Surrealist Exhibition' held at the New Burlington Galleries, London.
- Abdication of Edward VIII.
- Sixteen of Stalin's opponents, including two of his former associates, Grigori Zinoviev and Leon Kamenev, are executed by firing squad after a five-day show trial in Moscow.
- The black American athlete Jesse Owens wins four gold medals at the Berlin Olympics and is snubbed by Hitler.

1937

- Resignation of Léon Blum's Popular Front government. The Radical Party leader Camille Chautemps assumes power.
- The Paris World's Fair (Exposition Internationale des Arts et des Techniques dans la Vie Moderne) celebrates technical achievement, architecture and the arts (May–November). The centrepiece of the exhibition is the Palais de Chaillot, an imposing neoclassical building designed by Carlu, Boileau and Azéma, on the site of the old Trocadéro. Albert Speer's German pavilion and Boris Iofan's Soviet pavilion stand opposite each other, embodying the ideological conflict of fascism and communism. José Luis Sert's International Style Spanish pavilion devoted to the Civil War displays Picasso's *Guernica* (fig. 56), Miró's *Catalan Peasant in Revolt* and Calder's *Mercury Fountain*.
- Georges Bataille, Michel Leiris and Roger Caillois found Le Collège de Sociologie, which focuses on anthropology and the sacred.
- Publication of Céline's anti-Semitic polemical pamphlet *Bagatelles pour un massacre*.
- Jean-Louis Barrault produces Cervantes' *Numances*, designed by André Masson.

- Hitler attends 'Entartete Kunst' (Degenerate Art), an exhibition of works by banned modern artists such as Beckmann, Nolde, Kirchner, Schwitters and Kandinsky.
- Málaga falls to the Nationalists (February).
- Battle of Madrid (March).
- Mussolini and Hitler support Franco's Nationalists, while the Soviet Union gives limited support to the Republicans. 'International Brigades' fight on the Republican side. France and Great Britain call for non-intervention. The ancient Basque capital of Guernica, an open city, is bombed by the German Condor Legion (26 April).
- Japanese invasion of China leads to war in Asia.

1938

- Léon Blum tries to form a coalition government with communist and independent leaders, without success. The conservative Daladier takes over. His policies include higher taxation, reduced expenditure and a 48-hour working week.
- The Musée de l'Homme within the new Palais de Chaillot proposes an enlightened definition of man and culture.
- The fourth 'Exposition Internationale du Surréalisme' at the Galerie des Beaux-Arts features Duchamp's 1,200 coal sacks suspended from the ceiling and mannequins by Arp, Dalí, Dominguez, Duchamp, Ernst, and others (January–February).
- From Mexico, André Breton and Diego Rivera, and clandestinely Leon Trotsky, draw up the manifesto 'Pour un art révolutionnaire indépendant' (25 July 1938) and found FIARI (Fédération Internationale de l'Art Révolutionnaire Indépendant).
- Jean-Paul Sartre completes his existential novel *La Nausée*, begun in 1931.
- Antonin Artaud publishes his manifestos and essays on the theatre, *Le Théâtre et son double*.

- Anschluss, the German annexation of Austria (March).
- Daladier, Chamberlain and Hitler sign the Munich Agreement (September).
- Hitler occupies the Sudetenland.
- Kristallnacht, destruction of synagogues and Jewish businesses in Germany (9–10 November).
- The Italian Chamber of Deputies, long dominated by Fascists, becomes the Chamber of Fasces and Corporations, a fulfilment of Mussolini's authoritarian 'corporate state'.

1939

- France recognises Spain's fascist government, while 450,000 refugees cross into France (February).
- After Czechoslovakia falls, the Daladier government seeks and wins power to rule by decree.
- Russia proposes a military alliance with France (April). The French and British delegations, slow to act, go to Moscow, but Stalin, feeling betrayed by France, signs a pact with Germany (August).
- Beginning of the 'Drôle de guerre' ('phoney war') as Germany invades France. Prime Minister Daladier's defensive military strategy fails and he resigns. Paul Reynaud forms a new government.
- The first Salon des Réalités Nouvelles at the Galerie Charpentier shows abstract work in the spirit of Abstraction-Création.
- German artists, including Max Ernst, Hans Bellmer and Wols, leave Paris and are interned in camps in the South.

- Germany invades Czechoslovakia (15 March). Great Britain and France follow a policy of appeasement.
- Franco declares the end of the Spanish Civil War (1 April).
- The Nazi-Soviet Non-Aggression Pact signed in Moscow (23 August) by Ribbentrop and Molotov devastates left-wing intellectuals around the world.
- Germany invades Poland (1 September).
- Great Britain and France declare war on Germany (3 September).
- New York hosts the 1939 World's Fair.
- James Joyce publishes his multi-level, multi-lingual *Finnegans Wake* simultaneously in London (Faber & Faber) and New York (Viking Press).

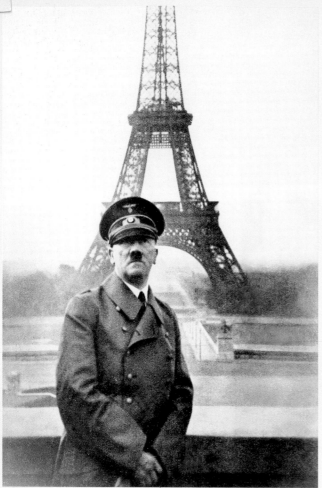

Adolf Hitler in Paris, 1940

Jewish mothers and babies awaiting deportation, 1943

Parisian artists, including Vlaminck, van Dongen and Derain, at the Gare de l'Est in 1941, before boarding a train to Germany to view art at the invitation of the Reich

Marshal Pétain at his trial after the fall of the Vichy régime

Paris

1940

● Germans invade France after sweeping through Belgium and Luxembourg, causing an exodus of the population. Wehrmacht occupies Paris. General Charles de Gaulle proclaims 'Free French' movement in London. Marshal Pétain's Vichy government accepts occupation of the North and the West coast of France and signs armistice with Germany. Vichy National Assembly draws up a new Constitution of the French State, ending the Third Republic. Pétain's ultra-rightist regime, based on 'Work, Family, Fatherland', begins. Pétain arrests Reynaud, Daladier, Blum and others identified with the Popular Front. Pétain proclaims 'collaboration' with Hitler. Rafts of legislation introduced to appropriate Jewish property and works of art.
● Varian Fry's American Committee for the Aid of Intellectuals shelters members of the Paris avant-garde, including Breton and other Surrealists, at the Villa Air-Bel in Marseilles, awaiting departure for America.
● Lascaux caves discovered in southern France.
● Publication of Gertrude Stein's *Paris, France*.

1941

● 'Young Painters of the French Tradition' show semi-abstract, 'resistance' art at the Galerie Braun.
● 'Exposition de la France Européenne' and 'Le Juif et la France' attract huge crowds.
● Parisian artists, including van Dongen, Derain, Dunoyer de Segonzac and Vlaminck, travel to Germany to view art at the invitation of the Reich.
● Editions de Minuit publishing house is founded.
● Olivier Messiaen, held in a German prison camp, composes his *Quartet for the End of Time*, based on the Book of Revelation.

1942

● Show trials of arrested Popular Front ministers (February–April). Deportation of Jews from Drancy to Auschwitz begins (March).
● Allied recognition of Free French Forces (June).
● Germany occupies Vichy zone (11 November).
● Exhibition at the Orangerie of works by Arno Breker, Hitler's official sculptor, symbolises the Occupation of the Paris art world.
● Albert Camus publishes his nihilistic, existential novel *L'Étranger* and his philosophical essay *Le Mythe de Sisyphe*.
● Jacques Decour and Jean Paulhan found *Les Lettres françaises*.
● Publication of Vercors' (Jean Bruller's) *Le Silence de la mer*.

1943

● Resistance leader Jean Moulin forms 'Mouvements unis de la Résistance' and 'Conseil national de la Résistance'.
● The exhibition 'Douze Peintres d'Aujourd'hui' by the Young Painters of the French Tradition is pilloried in the right-wing collaborationist press.
● German authorities pillage 'degenerate art' and burn works by Masson, Picabia, Miró, Klee, Ernst, Léger and Picasso stored in the Musée du Jeu de Paume .
● Emergence of Jean-Paul Sartre's existentialist treatise *L'Etre et le néant* (1943) and his hit play *Les Mouches* (1943), a parable of the Occupation with sets by André Masson. These two works establish him as a major avant-garde thinker.
● Gestapo in Lyons under Klaus Barbie rounds up Resistance leaders. Jean Moulin tortured and murdered.

1944

● D-Day landings in Normandy (June).
● The CFLN proclaims itself the provisional government of the French (Fourth) Republic.
● Last deportations to Buchenwald and Ravensbrück (August).
● Vichy regime ends. Free French and Allied armies liberate Paris (25 August). Allies recognise de Gaulle's goverment (23 October).
● Liberation followed by *épuration* (purge) of French military, government, business and intellectual collaborators.
● Première of Picasso's Dada play *Le Désir attrapé par la queue* (14–17 January 1941) at the apartment of Michel Leiris (Quai des Grands-Augustins): Camus, Sartre, de Beauvoir, Queneau, Leiris and Dora Maar read the various parts (19 March).
● The Salon d'Automne, the 'Salon de la Libération', opens, showing a large retrospective of Picasso's wartime work.
● First non-clandestine publication of Albert Camus's review *Combat*.

World

● German *blitzkrieg* targets Denmark, Norway, Holland, Belgium and France (April–May); Winston Churchill becomes British prime minister (May); Italy declares war on Britain. Battle of Britain as Luftwaffe tries to bomb Britain into submission (August–September). German air raids on British cities (7 September 1940, continuing until April 1941). Mussolini attacks Greece (28 October). Successful British campaigns in North Africa drive Italians out of East Africa.
● Assassination of Trotsky in Mexico (21 August).
● Walt Disney's *Fantasia* released.
● Charlie Chaplin's *The Great Dictator* released.
● Publication of Ernest Hemingway's *For Whom the Bell Tolls*.
● Michael Tippett's oratorio *A Child of Our Time*.

● US Lend-Lease provides arms and material assistance to Allies.
● Germany overruns Yugoslavia and Greece and drives out British forces. Germans counterattack in the Western Desert. Germany dominates Western Europe.
● Germany invades USSR and mounts the Siege of Leningrad (ends January 1944).
● The course of the war shifts as the USSR counterattacks north of Moscow (6 December) and the Japanese bomb the US fleet at Pearl Harbor (7 December). America and Britain declare war on Japan (8 December); Germany and Italy declare war on America (11 December).
● Publication of Ilya Ehrenburg's *Fall of Paris*.
● Henry Moore's air-raid shelter drawings.
● Bertolt Brecht's play *Mother Courage and Her Children*.

● Senior Nazis plan the 'Final Solution', or extermination of Jews, at the Wannsee Conference (20 January).
● Japanese take over Malay peninsula and Dutch East Indies (January–February).
● Gandhi launches the 'Quit India' movement (August) and is jailed (October).
● British defeat Germans at El Alamein (23 October).
● Peggy Guggenheim opens 'Art of This Century' in New York (1942–47), where New York School artists, including Pollock, Motherwell, Hofmann, Still, Rothko and Gottlieb, meet their European avant-garde counterparts.
● Breton and Duchamp's exhibition 'First Papers of Surrealism' in New York reunites European Surrealists in exile.
● Le Corbusier establishes an architectural masterplan for Algiers.

● Germans surrender at Stalingrad (31 January) and are defeated at the Battle of Kursk, a turning point on the Eastern Front.
● Allied air attack on Hamburg begins Combined Allied Air Offensive against Germany (24–28 June).
● Anglo-American invasion of Italy leads to overthrow of Mussolini and Italy's surrender; new Italian government declares war on Germany.
● Renato Guttuso's album *Gott mit Uns* expresses the anguish of Italy under occupation.
● Cairo Conference: Roosevelt, Churchill and Chiang Kai-shek discuss surrender of Japan and postwar settlement of East Asia.
● Tehran Conference: Roosevelt, Churchill and Stalin discuss postwar settlement of Europe.
● De Gaulle forms the CFLN (Comité Français de Libération Nationale) in Algiers.

● Allies liberate Rome (4 June); D-Day, Allied cross-Channel invasion of Europe (6 June).
● 2,300 tons of bombs dropped by the British on Berlin.
● Allies drop 81,400 tons of bombs on Germany and occupied Europe.
● German officers fail in their plot to kill Hitler (20 July).
● Bretton Woods Agreement on postwar world economy includes establishment of World Bank and International Monetary Fund (22 July).
● Red Army allows Germans to crush Warsaw Uprising.
● Publication of T. S. Eliot's *Four Quartets*.
● Laurence Olivier stars in the film of Shakespeare's *Henry V*.

A poster by P. Baudouin celebrates victory over the Nazis

Le Corbusier examines a model of his Unité d'Habitation for Marseilles, 1947

Simone de Beauvoir, photographed by Gisèle Freund, (detail)

André Fougeron's *Parisian Women at the Market*, shown at the Salon d'Automne, 1948

1945

● The first Constituent Assembly elected; representatives include Communists (PCF), Socialists (SFIO) and the Christian Democrats (MRP) (21 October).
● French women vote for the first time.
● Fautrier shows his *Hostages* series (cats 163, 164), inspired by Nazi massacres in Paris, at the Galerie René Drouin. The thickly painted images, suggesting a death-like human head, are a precursor of Informel art.
● Collaborationist intellectual Robert Brasillach, prolific writer and editor of the fascist weekly *Je suis partout*, is executed by firing squad.
● Maurice Merleau-Ponty publishes *The Phenomenology of Perception*, an analysis of perception as mediated through the body rather than individual consciousness.
● Marcel Carné's *Les Enfants du paradis* released.

● First Nazi death camps liberated.
● Yalta Conference: Churchill, Roosevelt and Stalin discuss war strategy and postwar outcome for Germany.
● Roosevelt dies and Harry Truman becomes US president.
● Mussolini killed by Italian partisans.
● Hitler and Eva Braun commit suicide as Russians enter Berlin.
● Germany surrenders (7 May); VE Day, war in Europe ends (8 May); Allies divide Germany into British, American, French and Russian occupation zones.
● United Nations Charter signed in San Francisco (26 June).
● Potsdam Conference debates questions of postwar Germany, Eastern Europe and Japan (17 July–2 August).
● US drops atomic bombs on Hiroshima and Nagasaki; Japanese surrender ends Second World War (2 September).

1946

● De Gaulle resigns over disagreements among the members of his coalition government.
● First Unesco Conference, at the Sorbonne.
● Introduction of Jean Monnet's plan for the modernisation of French industry and agriculture.
● Léon Blum becomes president of a provisional government (December).
● War breaks out in French Indo-China between Ho Chi Minh's nationalists and French occupying forces (ends 1954).
● 'Art et résistance' at the Musée National d'Art Moderne features Picasso's *Le Charnier* (1944–45; fig. 74) and work by realist artists such as Fougeron, Taslitzsky and Gruber.
● Dubuffet's *hautes pâtes*, on view in the 'Mirobolus, Macadam et Cie' exhibition at the Galerie René Drouin, establish his reputation.
● Isidore Isou founds Lettrisme (1946–57), a movement that seeks to expand creativity beyond the conventional categories of art.
● Sartre founds his journal *Les Temps modernes*, encompassing philosophy, literature and politics. He opens the debate on humanism with his lecture 'Existentialism Is a Humanism'.

● Britain, America and France appeal to the Spanish to depose Franco.
● Winston Churchill denounces Soviet regime in his Fulton 'Iron Curtain' speech.
● Italy becomes a Republic.
● New York becomes permanent home of the UN.
● Nuremberg trial verdicts pronounced on leading Nazi officials, including Ribbentrop, Goering and Hess.
● A. A. Zhdanov condemns the 'decadent' West and persecutes Soviet writers, including Anna Akhmatova.
● Publication of Bertrand Russell's *History of Western Philosophy*.
● Salzburg Festival resumes.

1947

● Blum resigns and the socialist Ramadier becomes prime minister. De Gaulle founds the Rassemblement du Peuple Français (RPF). Communist ministers refuse to give the government their vote of confidence and are dismissed. The PCF orchestrates a series of strikes that continue until 1948.
● Official opening of the Musée National d'Art Moderne at the Palais de Tokyo.
● Exhibition of Artaud's crayon 'Portraits et dessins' at the Galerie Pierre Loeb.
● Breton and Duchamp organise the 'Exposition Internationale du Surréalisme' at the Galerie Maeght.
● Le Corbusier builds the first Unité d'Habitation (1947–52), an eighteen-storey, 'brutalist'-style apartment block outside Marseilles.
● André Gide is awarded the Nobel Prize for Literature.
● Albert Camus's novel *La Peste* likens the German Occupation to a plague whose cause is unknown, a nihilistic and amoral view of events that draws sharp criticism from Sartre.
● André Malraux's *Le Musée imaginaire* proposes a 'museum without walls'.
● Christian Dior's 'New Look' promotes waisted silhouettes and long skirts.

● Truman Doctrine proposes 'containment' of communism. US Secretary of State Marshall formulates the 'Marshall Plan' to aid European recovery.
● Warsaw Conference: Cominform (Communist Information Bureau) established by Soviets to co-ordinate activities of European communist parties.
● Greek Civil War begins (ends 1949).
● Independence of India. Partition of India and Pakistan results in violence in the Punjab.
● First supersonic flight.
● Discovery of Dead Sea Scrolls.
● Léopold Senghor, Aimé Césaire and Léon Damas found the journal *Présence africaine*, which promotes the concept of 'négritude'.

1948

● Marshall Plan provides France with $2.8 billion in aid.
● Works of Informel artists on show in 'H.W.P.S.M.T.B.' (Hartung, Wols, Picabia, Stahly, Mathieu, Tapié, Bryen) at the Galerie Colette Allendy.
● First exhibition at the Galerie du Bac of L'Homme Témoin, a group of realist artists including Lorjou, Yvonne Mottet and Rebeyrolle.
● André Fougeron exhibits the realist *Parisian Women at the Market* at the Salon d'Automne in 1948.
● A group of Expressionist painters from Copenhagen, Brussels and Amsterdam, led by the Dane Asger Jorn and the Belgian poet Christian Dotremont, found Cobra in Paris.
● 'Picasso Ceramics' shown at the Maison de la Pensée Française.
● Messiaen's *Turangalîla-Symphonie*, conceived on a visit to America, employs an instrument known as the ondes Martenot.

● Tito's regime in Yugoslavia condemned by USSR. Soviet coup instates hardline communist government.
● Year-long Soviet blockade of Berlin leads to massive airlift by the West, heightening Cold War tensions.
● State of Israel created; first Arab-Israeli war.
● Gandhi assassinated.
● Afrikaner regime in South Africa institutes apartheid laws.
● UN adopts Universal Declaration of Human Rights.
● Picasso addresses the first Conference of Intellectuals for Peace in Wrocław, Poland.
● Alberto Giacometti's spindly figures are shown at Pierre Matisse's gallery in New York, with catalogue essay by Sartre.
● Jackson Pollock shows his drip paintings at Betty Parsons's gallery in New York.
● A. C. Kinsey's *Sexual Behavior in the Human Male* published.

1949

● France is a founding member of NATO.
● Dubuffet's Compagnie de l'Art Brut (1948–51) displays 'outsider' art in 'L'Art Brut préféré aux arts culturels' at the Galerie René Drouin.
● Fougeron's Socialist-Realist protest canvas *Homage to André Houllier* is sent as part of Stalin's seventieth-birthday tribute from France to the Pushkin Museum, Moscow.
● Auguste Herbin publishes *L'Art non-figuratif, non-objéctif*.
● Michel Seuphor organises 'L'Art abstrait, ses origines, ses premiers maîtres' at the Galerie Maeght.
● Simone de Beauvoir's *Le Deuxième Sexe* published, the first influential feminist work.
● Claude Lévi-Strauss publishes *Les Structures élémentaires de la parenté*, applying structural linguistics to the field of anthropology.
● The Unesco symposium on human rights is published, edited by Jacques Maritain.
● Jean Genet publishes his confessional *Journal d'un voleur*.

● Soviets detonate their first atomic bomb.
● Konrad Adenauer becomes Chancellor of the new Federal Republic of Germany; German Democratic Republic established in East Germany.
● Communists gain power in Hungary.
● North Atlantic Treaty establishing NATO alliance signed in Washington DC.
● Chinese Communists drive out Nationalists, who set up government in Taiwan; Mao proclaims the People's Republic of China (1 October).
● Ireland leaves British Commonwealth; Republic of Eire proclaimed in Dublin.
● Picasso's drawing of a dove of peace, *La Colombe*, is chosen for the poster announcing the World Peace Conference in Warsaw.
● George Orwell publishes *1984*, a parable of life under totalitarianism.
● Formation of the Berliner Ensemble.

Poster advertising transatlantic flights, 1951

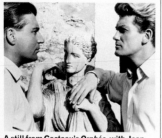

A still from Cocteau's *Orphée*, with Jean Marais (right) in the title role

A scene from the production of Samuel Beckett's *Waiting for Godot* at the Théâtre de Babylone, 1953

1950

● Picasso is awarded the Lenin Peace Prize at the Second World Congress for Peace in Warsaw.

● At Ronchamp, Le Corbusier builds Notre-Dame-du-Haut, a sculptural, Mediterranean-inspired pilgrimage chapel (1950–55).

● Consecration of Notre-Dame-de-Toute-Grâce on the Plateau d'Assy in the Haute Savoie marks the renewal of sacred art spearheaded by Père Couturier. The church is designed by the architect Maurice Novarina and decorated ecumenically with works by Matisse, the Jews Chagall and Lipchitz, and the communists Léger and Lurçat; Richier's existentialist crucifix creates a scandal.

● Jean Dewasne and Edgard Pillet create the Atelier d'Art Abstrait as a centre for the teaching, practice and dissemination of information about abstract art.

● Charles Estienne publishes *L'Art abstrait est-il un académicisme?*

● Eugène Ionesco's grotesque and dehumanised drama *La Cantatrice chauve* first performed.

● Jean Cocteau's *Orphée* released.

1951

● Election of an uneasy coalition of Socialists (SFIO), Christian Democrats (MRP) and those on the Republican left (RGR). A new system of proportional representation creates political instability.

● 'Le Pays des mines', Fougeron's exhibition at the Galerie Bernheim-Jeune, presents the artist as the official communist painter.

● Picasso's *Massacre in Korea* is rejected by the PCF for its lack of a clear message.

● 'Véhémences confrontées' at the Galerie Nina Dausset juxtaposes American and French lyrical abstractionists: Pollock, de Kooning, Capogrossi, Wols, Mathieu, Bryen, Riopelle, Hartung.

● First Cobra exhibition in Paris showing Appel, Corneille, Jacobsen and Jorn is organised by Michel Ragon.

● Giacometti exhibits in Paris for the first time in 19 years at the Galerie Maeght.

● Creation of the Groupe Espace, devoted to art, architecture and urbanism, by André Bloc.

● French critic Michel Tapié organises 'Signifiants de l'Informel I' at the Studio Facchetti.

● Camus publishes *L'Homme révolté*, advocating personal rebellion and rejecting dictatorship from the right as well as the left.

1952

● Jackson Pollock has his first European one-man show at the Studio Facchetti.

● Michel Tapié organises the exhibition 'Un Art autre' (also the title of a book), his term for 'abstraction lyrique', 'art Informel' and 'Tachisme', showing works by Fautrier, Mathieu, Soulages, Hartung and Wols, at the Studio Facchetti.

● Charles Estienne's 'Peintres de la nouvelle Ecole de Paris' at the Galerie de Babylone presents a very diverse group, encompassing Estève, Hartung, Lapicque, Pignon, Soulages, de Staël, Tal-Coat, Ubac, Vasarely and Vieira da Silva.

● Picasso conceives a 'Temple of Peace', with the panels *War* and *Peace*, for a deconsecrated fifteenth-century chapel in Vallauris.

● Guy Debord and Gil Wolman found the Internationale Lettriste, a group detached from the Lettrist movement, which seeks to integrate art and life.

● Matisse creates his paper cut-out 'Blue Nude' series.

● The anti-Semitic writer Céline, back from exile in Denmark, publishes *Féerie pour une autre fois*.

1953

● De Gaulle withdraws from politics. Anti-French riots break out in Morocco (ending in 1955). Modernisation and the postwar economic boom take off, but the perceived Americanisation of French culture is fiercely debated. The execution in America of Julius and Ethel Rosenberg as Soviet spies galvanises French intellectuals on the left.

● 'Twelve American Painters and Sculptors' and 'Mexican Art from Pre-Columbian Times to Today' at the Musée National d'Art Moderne provide a transatlantic focus for artists in France. André Fougeron's *Atlantic Civilisation* (fig. 110), dominated by an empty electric chair and symbols of American culture in Paris, is condemned.

● Samuel Beckett's play *Waiting for Godot* (1952) presents the theatre of the 'absurd': two tramps who wait in vain for Godot. This new theatrical language is popularised in plays by Ionesco, Beckett and Genet.

● Alain Robbe-Grillet's *Les Gommes* launches the 'Nouveau Roman'.

● Jacques Lacan begins his influential weekly seminars at the Hôpital Sainte-Anne where, for the next ten years, he develops a system of thought based on a reinterpretation of Freud in the light of structural linguistics.

1954

● The French surrender to communist forces at Dien Bien Phu, resulting in the division of Vietnam into South and communist North Vietnam. French government falls due to the Dien Bien Phu fiasco. Pierre Mendès France becomes prime minister and takes decisive action in foreign policy. The Geneva Conference on Indochina and Korea involves France, Great Britain, Russia, China and America.

● France sends 20,000 troops to Algeria (December).

● François Truffaut publishes his vitriolic manifesto, 'Une Certaine Tendance du cinéma français' (*Cahiers du cinéma*, January 1954), in which he promotes the 'auteur' theory of cinema. Five years later, with Truffaut's Cannes prize-winning *Les Quatre Cents Coups* (1959), the 'nouvelle vague' (Jean-Luc Godard, Alain Resnais and Louis Malle) takes off.

● Françoise Sagan's *Bonjour Tristesse* published.

● President Truman orders development of hydrogen bomb.

● Korean War breaks out as North Korea invades South Korea (to 1953).

● Britain recognises Israel.

● The Abstract Expressionist movement becomes increasingly prominent in New York. This stylistically divergent group of artists includes Jackson Pollock, Willem de Kooning, Clyfford Still, Franz Kline, Adolph Gottlieb, Robert Motherwell, Barnett Newman and Mark Rothko.

● Robert Schuman proposes co-ordination of European coal and steel production.

● Pope Pius XII pronounces dogma on the bodily assumption of the Virgin Mary.

● UN Building completed in New York.

● Arthur Koestler publishes *The God that Failed*.

● Huge Communist Youth rally takes place in Berlin.

● North Korean forces launch offensive. Americans cross 38th parallel. Subsequent armistice negotiations fail.

● Winston Churchill becomes prime minister of Great Britain.

● Robert Rauschenberg's series of monochrome black or white paintings at Black Mountain College inspire John Cage to compose *4'33"*, a silent work in three movements.

● Le Corbusier designs the buildings of Chandigarh, administrative capital of the Punjab and symbol of the new India.

● São Paulo Biennale founded.

● Festival of Britain takes place in London.

● Karlheinz Stockhausen and Pierre Boulez study with Messiaen at the summer school in Darmstadt, a centre for research into serial music (Schoenberg and Webern).

● Dwight D. Eisenhower elected president of the US.

● US tests hydrogen-fuelled thermonuclear weapons in the Pacific.

● Chinese communists accuse America of germ warfare in Korea.

● Elizabeth II accedes to the throne of Great Britain.

● Anti-French riots take place in Casablanca and later in French Morocco.

● Andy Warhol has first solo exhibition in New York.

● Lever House in New York, by Gordon Bunshaft of Skidmore, Owings & Merrill.

● Stalin's death leaves a power vacuum in the USSR which Nikita Khrushchev gradually begins to fill.

● Soviet Union tests hydrogen bomb.

● German Bundestag approves Bonn agreement to establish a European defence community.

● Queen Elizabeth II's coronation watched on television by a global audience.

● Edmund Hillary and Sherpa Tenzing conquer Mount Everest.

● James D. Watson and Francis Crick publish their discovery of the double-helix structure of DNA.

● The 'Unknown Political Prisoner' competition, held at the Institute of Contemporary Arts, London, marks the apotheosis of Cold War imagery in sculpture.

● Ossip Zadkine's *Monument to a Destroyed City* is erected in the port of Rotterdam.

● Experimental colour television in America.

● US Senator Joseph McCarthy conducts his 'witch hunts', investigations to expose alleged communist infiltrators in the US Government.

● Seven-power agreement on Western European union signed.

● Algerian uprising led by Mohammed Ben Bella and the FLN (Front de Libération Nationale).

● All-China People's Congress in Peking.

● Ilya Ehrenburg publishes *The Thaw*.

● Richard Wright publishes *Black Force*.

● Alfred Hitchcock's *Rear Window* released.

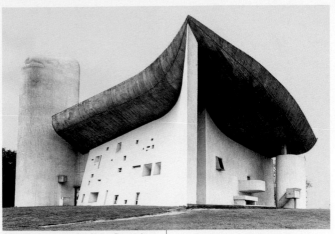
Le Corbusier completes Notre-Dame-du-Haut, Ronchamp, 1955

Yves Klein

Anthony Caprio and Brigitte Bardot in Roger Vadim's *Et Dieu créa la femme*, 1956

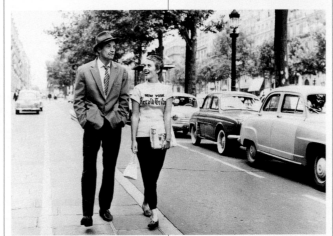
Jean Paul Belmondo and Jean Seberg in Jean-Luc Godard's *A bout de souffle*, 1960

General de Gaulle

1955

● The government of Mendès France falls due to domestic issues and his North African policy. Another Radical Party member, Edgar Faure, replaces him.
● 'Fifty Years of Art from the United States', organised by New York's MOMA at the Musée National d'Art Moderne, shows American painting, sculpture, decorative arts and advertising.
● 'Le Mouvement', the first exhibition of Kinetic art, takes place at the Galerie Denise René.
● Claude Lévi-Strauss publishes *Tristes tropiques*, an anthropological travelogue recounting his expedition to Brazil in the 1930s.
● The serial composer Pierre Boulez completes *Le Marteau sans maître*, a work for voice, flute, viola, guitar, vibraphone, xylorimba and unpitched percussion, inspired by the Surrealist poetry of René Char.
● Henri Clouzot's *Le Mystère Picasso* released.
● Le Corbusier builds the convent of Notre-Dame-de-la-Tourette near Lyons.

● Formation of the Warsaw Pact, the collective security system of the Soviet Union and its satellites in Eastern Europe.
● Communist Youth Congress in Warsaw.
● West Germany joins NATO.
● Jonas E. Salk licenses his polio vaccine.
● Pop Art, featuring the satirical use of popular images from the media, practised by Richard Hamilton and Eduardo Paolozzi, takes off in London.
● The first Documenta exhibition in Kassel marks the return of the avant-garde in Germany.
● *The Diary of Anne Frank* published.
● Edward Steichen curates 'The Family of Man', a photography exhibition at the Museum of Modern Art, New York.
● Disneyland opens in Anaheim, California.

1956

● Early elections bring the leftist SFIO leader Guy Mollet to power. Morocco and Tunisia become independent as French protectorate ends. Intellectuals against the war in North Africa publish a declaration demanding a ceasefire. The Suez Crisis weakens French international standing. Algerian War escalates.
● Soviet intervention in the Hungarian uprising provokes violent demonstrations against the Communist Party and anti-Soviet appeals from intellectuals such as Sartre, de Beauvoir, Leiris, Breton, Picasso and Pignon.
● Nicolas Schöffer creates his first 'cybernetic' sculpture, *CYSP 1*, a robot that responds to colours and sounds, with the aid of Philips technicians.
● The geometrically biased Salon des Réalités Nouvelles becomes 'Réalités Nouvelles, Nouvelles Réalités' and opens up to lyrical abstraction.
● Roger Vadim's *Et Dieu créa la femme* stars Brigitte Bardot.
● Alain Resnais's film *Nuit et brouillard* dramatically reveals the structure of the Nazi concentration-camp system.

● At the Twentieth Soviet Party Congress Nikita Khrushchev denounces Stalin's crimes, leading to a period of de-Stalinisation.
● Hungarian Revolution brutally suppressed by Soviet forces.
● Works by Picasso belonging to the USSR are exhibited in Moscow.
● Eisenhower wins a second term as president of the US.
● After aggressive Anglo-French attacks on Egypt, US intervention forces a humiliating withdrawal.
● Karlheinz Stockhausen composes his first mature electronic piece, *Gesang der Jünglinge*, a Mass which interweaves synthesised sounds and a boy's voice, half-singing, half-reciting syllables and words from the third Book of Daniel.
● Pollock exhibits at New York's MOMA and the Venice Biennale in the year of his death.

1957

● Battle of Algiers won by the French general Massu, who suppresses the FLN's reign of terror through torture. In France, his methods attract criticism. Fall of the Mollet government, which is seen as economically and morally bankrupt. Félix Gaillard comes to power (November) after Bourgès-Manoury's interim administration.
● Raymond Hains and Jacques de la Villeglé show works consisting mainly of torn political posters in the exhibition 'Loi du 29 juillet 1881' (law concerning the display of posters) at the Galerie Colette Allendy.
● Roland Barthes establishes the field of semiology with *Mythologies*, a collection of subversive essays on French mass culture. The themes range from cuisine, films, fashion, washing powder and plastics.
● Georges Bataille's *L'Erotisme* published.
● Samuel Beckett publishes *Fin de Partie* and *Tous ceux qui tombent*.

● Treaty of Rome establishes European Economic Community (EEC).
● Sputnik satellite launched in the USSR.
● Influential New York dealer Leo Castelli's exhibition 'New Work', featuring Robert Rauschenberg and Jasper Johns, announces the new trend of Pop Art.
● At a conference in Cosio d'Arroscia, Guy Debord establishes the Internationale Situationniste (1957–72), a group amalgamating the Mouvement International pour un Bauhaus Imaginiste (descended from Cobra), the Internationale Lettriste, and the Committee for Psycho-geography (London). The group promotes artistic, social and sexual revolution.
● In Japan the neo-Dada Gutai group come together with French Informel artists.
● Jack Kerouac publishes *On the Road*.
● First performance of Leonard Bernstein's *West Side Story*.

1958

● French bombers destroy a suspected FLN base in Tunisia, resulting in many civilian deaths. Gaillard's resignation heralds the demise of the Fourth Republic. After riots in Algiers (13 May), de Gaulle announces that 'he is ready to assume the powers of the Republic' (15 May). De Gaulle is invested with special powers for six months by the National Assembly (1 June). Proclamation of the Fifth Republic (28 September). De Gaulle elected president with a new autocratic constitution (21 December).
● FLN leaders set up the provisional government of the Algerian Republic.
● Inauguration of the Unesco Building, featuring Miró's ceramic murals and Picasso's *The Fall of Icarus* panels.
● The journal *Internationale Situationniste* is launched (12 issues, 1958–69).
● Claude Lévi-Strauss brings out his anthology *Anthropologie structurale*, which applies structural methods to various aspects of anthropological study, such as language, kinship, social organisation, magic, religion and art.
● Francis Poulenc's *La Voix humaine*, with texts and sets by Jean Cocteau.

● Mao presides over the 'Great Leap Forward' to encourage industrialisation in China.
● Election of Pope John XXIII.
● Mies van der Rohe and Philip Johnson design the Seagram Building, a monumental, slab-shaped office tower of bronze and brown glass in New York.
● Le Corbusier designs the Philips pavilion for the Brussels World Fair.
● Edgar Varèse composes *Poème électronique*.
● André Wajda's film *Ashes and Diamonds* released.
● Ludwig Wittgenstein's *The Blue Book* and *The Brown Book* published posthumously.

1959

● On 8 January de Gaulle is formally installed as President of the Fifth Republic. Michel Debré becomes prime minister. André Malraux is named minister of culture, with a brief to expand French high culture through the creation of a dozen Maisons de la Culture in the regions and to oversee the systematic cleaning of major national monuments.
● The New York Museum of Modern Art's celebrated exhibition 'The New American Painting', on tour in Europe, reaches the Musée National d'Art Moderne in Paris.
● The first Paris Biennale at the Musée d'Art Moderne de la Ville de Paris includes works by Hains, Tinguely and Rauschenberg.
● The 'Exposition Internationale du Surréalisme' at the Galerie Daniel Cordier is dedicated to the theme of Eros.
● Jean Genet's *Les Nègres* at the Théâtre de Lutèce shocks Paris.
● Alain Resnais's *Hiroshima mon amour*, with a script by Marguerite Duras, conflates layers of traumatic wartime and postwar history in France and Japan.

● After several years of guerrilla war, Fidel Castro takes power in Cuba.
● The failure of China's 'Great Leap Forward' leads to food shortages and millions of deaths from starvation.
● President Eisenhower tours European capitals.
● Knud W. Jensen founds the Louisiana Museum, Humlebaek.
● The Solomon R. Guggenheim Museum designed by Frank Lloyd Wright, opens in New York.
● Allan Kaprow's first 'Happening' incorporates elements of theatre and the visual arts at the Reuben Gallery in New York.
● William Burroughs's *The Naked Lunch* published.
● Peter Selz organises 'New Images of Man' at the Museum of Modern Art, New York, a humanist confrontation between American and European art.

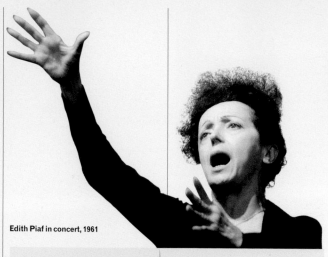

Edith Piaf in concert, 1961

Marcel Marceau's 'Cirque d'hiver', 1962

Carolee Schneeman's *Meat Joy*, at the Festival de la Libre Expression, 1964

Tanks guard the Assemblée Nationale during the Algerian crisis, April 1961

Harold Nicholas, Eddie Barclay and Johnny Halliday at the Club St-Hilaire, 1963

1960

- France grants independence to the Central African Republic, Chad, Dahomey, Gabon, Ivory Coast, Mali, Niger and Upper Volta.
- The Algerian issue causes deep division in French society. 121 intellectuals and artists sign an anti-war manifesto. De Gaulle visits Algeria, provoking FLN demonstrations which are brutally repressed.
- First French atomic bomb test in the Sahara.
- César shows his first 'compressions', crushed car sculptures, at the Salon de Mai.
- Yves Klein directs the first performance of *Les Anthropométries de l'époque bleue*.
- Arman presents his first 'accumulations' of rubbish at the exhibition 'Le Plein' at the Galerie Iris Clert.
- Manifesto of the Nouveaux Réalistes.
- The Groupe de Recherche d'Art Visuel (GRAV, 1960–68) takes a scientific approach to art using modern industrial materials.
- Rauschenberg, Stella, Stankiewicz and Chamberlain exhibit in 'Younger American Painters' at the Galerie Lawrence.
- Publication of the first number of *Tel quel* (1960–82), which goes on to publish Sollers, Kristeva, Derrida and Pleynet.
- Jean-Luc Godard's *A bout de souffle* introduces a new realism to French cinema.

- John F. Kennedy becomes American president.
- The shooting down of an American U-2 spy plane over Russia exacerbates Cold War tension.
- First contraceptive pill introduced in America.
- Jean Tinguely explodes his monumental self-destructing sculpture *Homage to New York* in the sculpture garden of the Museum of Modern Art in New York.
- French critic Pierre Restany brings together the 'Nouveaux Réalistes', including Arman, Hains, Dufrêne, Klein, Tinguely and Villeglé, at the Galleria Apollinaire in Milan.
- Oscar Niemeyer's Congress Building in Brasilia.
- A. J. Ayer's *Logical Positivism* influences British and American thinkers.
- Federico Fellini's *La Dolce Vita* released.

1961

- In a referendum 75% of French voters approve Algerian independence, while settlers vote against it. The negotiations de Gaulle begins at Evian on independence break down. A failed French Algerian officers' revolt leads to the formation of the extremist OAS (Organisation Armée Secrète). The OAS and the FLN wage a terror campaign in Algeria and France. Assassination attempts on de Gaulle fail.
- The exhibition 'La France déchirée', featuring torn posters by Hains and Villeglé, responds to the Algerian crisis.
- Pierre Restany's '40° au dessus de Dada' serves as the second manifesto of Nouveau Réalisme. 'La Réalité dépasse la fiction: le Nouveau-Réalisme à Paris et à New York' at the Galerie Rive Droite includes John Chamberlain and Jasper Johns.
- Michel Foucault publishes *Folie et déraison: histoire de la folie à l'âge classique*, a study of social attitudes to madness from 1500 to 1800.
- Christo conceives *Project for a Wrapped Public Building*, comprising collaged photographs and typed text.
- Franz Fanon's *Les Damnés de la terre* champions the cause of colonised peoples.
- Goscinny and Uderzo create *Astérix*.

- Soviet cosmonaut Yuri Gagarin becomes the first man in space. American astronaut Alan Shepard orbits the earth.
- The East German Government builds the Berlin Wall to prevent free transit to the West.
- The Sino-Soviet split isolates China.
- US severs relationship with Cuba; Bay of Pigs invasion.
- Adolf Eichmann convicted as a Nazi criminal in Israel.
- US Pop Art takes off as Andy Warhol, Roy Lichtenstein, Tom Wesselmann, Jim Dine and Claes Oldenburg gain recognition in a series of exhibitions from New York to California (1961–64).
- 'The Art of Assemblage' at New York's MOMA features Pop Art and the Fluxus movement.
- The Dwan Gallery brings the Nouveaux Réalistes to Los Angeles in a series of individual shows, beginning with Yves Klein.

1962

- Evian agreements recognise Algeria's independence. OAS and FLN violence continues. Georges Pompidou is named prime minister.
- Anglo-French agreement to develop the supersonic passenger airliner Concorde.
- Ileana Sonnabend opens a Paris gallery to show American Pop Art.
- Christo erects his *Wall of Oil Barrels – Iron Curtain*, a four-metre-high wall of 240 stacked oil drums, for eight hours on the night of 27 June in the Rue Visconti in protest against the construction of the Berlin Wall the previous year. A small-scale version of the project with architectural drawings on show at the nearby Galerie J sets out the concept of environmental art.
- Gilles Deleuze's counter-rationalist *Nietzsche et la philosophie* contributes to the increasing presence of Nietzsche as a model for thinking in French philosophy and literary studies, marking an important stage in the passage to post-structuralism.
- Pierre Boulez completes his monumental *Pli selon pli*, a setting of sonnets by Mallarmé for soprano and nine-piece percussion ensemble.
- Manessier and Giacometti win prizes at the Venice Biennale.

- Cuban Missile Crisis.
- Second Vatican Council.
- 'The New Realists' takes place at the Sidney Janis Gallery in New York. The Nouveaux Réalistes and fellow European artists show alongside the American Pop artists Lichtenstein, Oldenburg and Warhol.
- George Maciunas, Nam June Paik and Wolf Vostell co-ordinate one of the first Fluxus festivals at the Städtisches Museum in Wiesbaden. A loose international coalition of artists, poets and musician/composers, philosophically identified with the work of John Cage and Marcel Duchamp, Fluxus organises concerts, happenings, street art and similar events in New York, Amsterdam, Copenhagen, Düsseldorf, London and Paris.
- Consecration of Basil Spence's Coventry Cathedral.
- Khrushchev closes a modernist exhibition in Moscow; a new era of repression begins.

1963

- De Gaulle vetoes Britain's entry to the EEC.
- Inauguration of the Centre d'Etudes Nucléaires at Cadarache.
- André Malraux takes the *Mona Lisa* to Washington and New York.
- '31 American Painters', an exhibition organised by the Art Institute of Chicago, at the American Center.
- Fluxus Festival in Nice.
- Foundation of Musée Matisse at Cimiez.
- Chagall commissioned to paint a new ceiling for the Paris Opéra.
- British Pop artists, including Blake, Boshier, Hockney, Jones and King, exhibit at the third Biennale des Jeunes.

- Martin Luther King leads a civil rights march on Washington.
- Establishment of the US–USSR 'hotline' between the White House and the Kremlin.
- President Kennedy assassinated. Lyndon Johnson becomes US president.
- Malcolm X founds the Organisation of Afro-American Unity.
- Gordon Bunshaft's transparent alabaster Beinecke Library opens at Yale University.
- First Duchamp retrospective at the Pasadena Art Museum.
- The Beatles epitomise the new youth culture of the 1960s.
- Opening of Picasso Museum in Barcelona.

1964

- France establishes diplomatic relations with communist China.
- Anglo-French agreement on rail Channel Tunnel.
- 'Lettrisme et hypergraphie' at the Galerie Stadler takes Lettrism into the 1960s.
- The artist Jean-Jacques Lebel organises the first Festival de la Libre Expression, including happenings, films and Fluxus activities for 300 guests at the American Center in Paris.
- Warhol shows his *Blue Electric Chair* and related works at the Galerie Sonnabend.
- Art dealers Aimé and Marguerite Maeght open the Fondation Maeght in Saint-Paul-de-Vence, designed by the Catalan architect José Luis Sert in collaboration with Miró and Braque.

- Opening of Aswan High Dam by Krushchev.
- Krushchev is deposed and Leonid Brezhnev succeeds him.
- Civil Rights Act is passed by US Congress.
- US establishes a link between smoking and lung cancer.
- PLO (Palestine Liberation Organisation) is founded.
- Independence of Zambia (formerly Northern Rhodesia).
- 'Post-Painterly Abstraction' organised by Clement Greenberg in Los Angeles.
- Documenta III in Kassel has a strong representation of artists from Paris.
- Venice Biennale Grand Prize is won for the first time by an American, Robert Rauschenberg.
- Marshall McLuhan declares 'the medium is the message' in *Understanding Media: The Extensions of Man*.

Martin Luther King in Paris, 1966

Models wearing transparent dresses by Yves Saint-Laurent, 1966

Riot police on the Boulevard Saint-Michel in the Latin Quarter, May 1968

1965

● De Gaulle is re-elected President of France. François Mitterrand becomes leader of the left.
● First French satellite launched.
● Cueco, Arroyo and Michèle Troche transform the Salon de la Jeune Peinture (founded 1949) at the Musée d'Art Moderne de la Ville de Paris into a forum for activist art, which will include that of Chinese, Cuban, Algerian and Soviet artists.
● 'La Figuration narrative dans l'art contemporain' at the Galerie Creuze organised by Gérald Gassiot-Talabot.
● Louis Althusser publishes *Pour Marx* and *Lire le Capital*, theoretical re-readings of Marx through a structuralist filter.
● André Masson working on new ceiling for Théâtre de l'Odéon.
● Creation of modernist Maison de la Culture, Grenoble.
● Georges Perec publishes *Les Choses*, in which Structuralism embraces consumer objects.

● US troops deployed in South Vietnam; regular bombing of North Vietnam begins.
● Assassination of Malcolm X in Manhattan.
● Watts race riots in Los Angeles.
● State funeral of Sir Winston Churchill.
● American art critic Barbara Rose applies the term Minimalism to 'empty, repetitious, uninflected art'. British philosopher Richard Wollheim first analyses Minimalism as an aesthetic problem.
● 'The Responsive Eye' exhibition tours four American venues after New York, showing many Op artists from Denise René's gallery in Paris.
● James Rosenquist exhibits *F-111* at Leo Castelli Gallery, New York.
● Joseph Beuys performs *How to Explain Pictures to a Dead Hare* at the Schmela Gallery in Düsseldorf.
● Victor Vasarely and Jean Tinguely win prizes at the eighth São Paulo Biennale.

1966

● De Gaulle withdraws France from NATO's operational structures, while maintaining membership in the alliance.
● Indira Gandhi visits Paris as new Indian prime minister.
● André Malraux refuses to intervene over Jean Genet's play *Les Paravents*, a violent and sexual parable of the Algerian War.
● Michel Foucault brings out *Les Mots et les choses: une archéologie des sciences humaines*, a study of the foundations of the human sciences from the Renaissance to the twentieth century, which includes an analysis of contemporary modes of thinking. Foucault introduces the concept of 'archaeology', which he uses to uncover the substrata of thinking he terms 'epistemes'.
● Jacques Lacan publishes *Ecrits*, a collection of his psychoanalytical lectures (1936–66) which establishes Lacanianism and the structuralist Lacan as a master thinker.
● Ileana Sonnabend presents a documentary exhibition on the 'happening'.
● The Japanese Gutai group show takes place at the Galerie Stadler.
● 403,000 visitors attend the Picasso retrospective at the Grand Palais; modern art achieves an unprecedented popularity.

● The *Quotations of Chairman Mao* (the 'little red book') is published. Mao's repressive Cultural Revolution is at its height (1966–70).
● USSR signs agreement with Fiat and Renault to improve its car-manufacturing standards.
● England wins the World Cup.
● National Organisation of Women (NOW) founded; Betty Friedan is its first president.
● Black Panther movement founded in Oakland, California.
● Robert Rauschenberg, with the engineer and laser specialist Billy Klüver, creates EAT (Experiments in Art and Technology).
● Lucy Lippard's 'Eccentric Abstraction' exhibition of 'soft' sculptures includes work by Eva Hesse and Bruce Nauman.
● Robert Venturi's *Complexity and Contradiction in Architecture* published.
● Michelangelo Antonioni's *Blow-Up* released.

1967

● De Gaulle's nuclear policy comes into effect: France operates 62 Mirage IV planes with atomic capability and launches its first nuclear submarine.
● Pierre Gaudibert creates the 'ARC' (Animation, Recherches, Confrontation) space devoted to experimental art at the Musée d'Art Moderne de la Ville de Paris.
● BMPT (Buren, Mosset, Parmentier and Toroni) demonstrate at the Salon de la Jeune Peinture.
● Situationist leader Guy Debord's *La Société du spectacle* describes a consumer society in which 'spectacle' (appearance) replaces 'reality'.
● Gérald Gassiot-Talabot and Alain Jouffroy launch the review *Opus International*.
● Jacques Derrida's theory of writing, *De la Grammatologie*, presents a critique of 'logocentrism' (an excessive faith in reason and its truth claims) and introduces his strategy of deconstruction (the dismantling of the underlying structure of a text to expose its grounding in logocentrism).
● The French publication of Mao Zedong's *Le Petit Livre rouge* sets off a Maoist trend among French intellectuals.
● Jean-Luc Godard's film *Weekend* portrays the violent débâcle of consumer culture.

● Six Day War: Israel occupies Sinai, the Old City of Jerusalem, the West Bank and the Golan Heights.
● Che Guevara killed in Bolivia.
● Expo 67 in Montreal is dominated by Buckminster Fuller's geodesic dome.
● American artist Sol LeWitt describes his art as 'conceptual', identifying a trend (Dan Flavin, Donald Judd and Joseph Kosuth) in which 'the idea or concept is the most important aspect of the work'.
● In Genoa Germano Celant organises the first exhibition of Arte Povera, a type of conceptual art made of 'poor' materials. Works by Michelangelo Pistoletto, Mario Merz and Jannis Kounellis provide a critique of contemporary consumerism.
● Harald Szeemann organises 'Science Fiction' at the Kunsthalle, Berne.
● Gabriel García Márquez's *One Hundred Years of Solitude* published.

1968

● France tests its first hydrogen bomb on Muroroa Atoll in the Pacific.
● French universities erupt into mass revolt in May. Police enter the occupied Sorbonne, unleashing riots in the Latin Quarter. Jean-Luc Godard and Chris Marker film on the streets.
● An estimated ten million workers, as well as middle-class professionals, strike all over France.
● June elections return de Gaulle to power.
● The École des Beaux-Arts, renamed the 'Atelier Populaire', is occupied and makes revolutionary posters (fig. 106).
● The *Mural Cuba Colectiva* (fig. 104) moves from Havana to the Salon de Mai.
● A room devoted to Lettrism opens in the Musée National d'Art Moderne.
● 'L'Art du réel. USA 1948–1968' moves from New York to the Grand Palais.
● Reproductions of masterpieces from the Louvre are installed in the Métro station serving the museum.
● Jean Baudrillard's *Le Système des objets* published.
● The intellectual revolution ('post-structuralism') continues in the work of Jacques Derrida, Gilles Deleuze, Félix Guattari, Michel Foucault and Julia Kristeva.

● Czechoslovakia invaded by Warsaw Pact forces, putting an end to Alexander Dubcek's liberal reforms.
● Martin Luther King is assassinated.
● Senator Robert F. Kennedy is shot dead while running for US president.
● Richard Nixon elected president of US.
● Andy Warhol is shot and seriously injured by the actress Valerie Solanis.
● 'Dada, Surrealism and Their Heritage' opens at MOMA, New York.
● Student protests at the 34th Venice Biennale cause many artists to close their shows in sympathy.
● Kassel Documenta IV displays Kinetic and Op art, Nouveau Réalisme and Narrative Figuration, together with Pop Art and American Minimalism.
● Christo wraps the Kunsthalle, Berne.
● Stanley Kubrick's *2001: A Space Odyssey* released.

Bibliography

Abadie 1981 Daniel Abadie, 'L'Exposition Internationale du Surréalisme, Paris, 1938', in Paris 1981, pp. 72–74

Addison 1998 Claire Addison, *Imagining Identity/Mutilating Identity: Representations of the Algerian War, 1954–1962*, MA dissertation, Courtauld Institute of Art, University of London, 1998

Adler 1990 Laure Adler, *La Vie quotidienne dans les maisons closes, 1830–1930*, Paris, 1990

Affron and Antliff 1997 Matthew Affron and Mark Antliff, *Fascist Visions: Art and Ideology in France and Italy*, Princeton, 1997

Afoumado 1990 Diane Afoumado, *La Propagande anti-sémite en France sous l'occupation par l'affiche et l'exposition*, MA dissertation, Université de Paris-Nanterre, 1990

Agulhon 1998 Maurice Agulhon, 'Paris: A Transversal from East to West', in *Realms of Memory, The Construction of the French Past*, Pierre Nora (ed.), III, *Symbols*, New York, 1998, pp. 523–54

Allan 1977 Tony Allan, *The Glamour Years: Paris 1919–1940*, Chicago, 1977

Allen 1995 Victoria Allen, *Nouveau Réalisme, Nouvelle Vague. Documents from the New World. (French Cinema, 1955–1968)*, MA dissertation, Courtauld Institute of Art, University of London, 1995

Alper and Bloch-Morhange 1980 *Artiste et méteque à Paris*, David Alper and Lise Bloch-Morhange (eds), Paris, 1980

Althusser 1965 Louis Althusser, *Lire le 'Capital'*, Paris, 1965

Althusser 1965B Louis Althusser, *Pour Marx*, Paris, 1965

Amishai-Maizels 1993 Ziva Amishai-Maizels, *Depiction and Interpretation: The Influence of the Holocaust on the Visual Arts*, Oxford, New York, Seoul and Tokyo, 1993

Amsterdam 1996 *Een Kunstolympiade in Amsterdam. Reconstructie van de tentoonstelling D.O.O.D., 1936*, exh. cat., Gemeentearchief, Amsterdam, 1996; *Die Olympiade unter der Diktatur*, exh. cat., Stadtmuseum, Berlin, 1996

André 1993 Paul André, *L'Art sacré du XXième siècle en France*, Paris, 1993

Antibes 1996 *1946: L'Année de la reconstruction*, exh. cat., Musée Picasso, Antibes, 1996

Antibes 1997 *La Côte d'Azur et la modernité, 1918–1958*, exh. cat., Musée Picasso, Antibes, and various other Côte d'Azur venues, 1997

Apollinaire 1909 Guillaume Apollinaire (pseud.), *L'Enchanteur pourrissant*, with woodcuts by André Derain, Paris, 1909; facsimile edition, Paris, 1971

Apollinaire 1911 Guillaume Apollinaire (pseud.), *Le Bestiaire ou Cortège d'Orphée*, with woodcuts by Raoul Dufy, Paris, 1911; facsimile edition with translations by Laureen Shakely, New York, 1977

Apollinaire 1913 Guillaume Apollinaire (pseud.), 'L'Antitradition futuriste', *Lacerba*, 15 September 1913

Apollinaire 1913B Guillaume Apollinaire (pseud.), *Les Peintres cubistes: méditations esthétiques*, Paris, 1913

Apollinaire 1914 Guillaume Apollinaire (pseud.), 'Le Douanier', *Les Soirées de Paris*, 15 January 1914; reprinted in Apollinaire 1991, pp. 627–41

Apollinaire 1966 Guillaume Apollinaire (pseud.), *Alcools*, Paris, 1966

Apollinaire 1991 Guillaume Apollinaire (pseud.), *Œuvres complètes en prose*, Pierre Caizergues and Michel Décaudin (eds), Paris, 1991

Aragon 1926 Louis Aragon, *Le Paysan de Paris*, Paris, 1926; *Paris Peasant*, Simon Watson Taylor (trans.), London, 1971

Aragon 1935 Louis Aragon, *Pour un réalisme socialiste*, Paris, 1935

Aragon 1936 *La Querelle du réalisme*, Louis Aragon (ed.), Paris, 1936; republished with a preface by Serge Fauchereau, Paris, 1987

Aragon 1938 Louis Aragon, 'Réalisme socialiste et réalisme français', *Europe*, 183, 1938, pp. 289–303

Aragon 1951 Louis Aragon, 'Peindre a cessé d'être un jeu', in *L'Art et le sentiment national*, Paris, 1951; 'Malowanie przestało być zabawą', Julia Hartwig (trans.), *Nowa Kultura*, 51–52, 1951

Aragon 1952 Louis Aragon, 'Réflexions sur l'art soviétique', *Les Lettres françaises*, 1952; 'O sztuce radzieckiej' ('On Soviet Art'), Julia Hartwig (trans. and ed.), *Przegląd Kulturalny*, 12, 1952, p. 7

Aragon 1953 Louis Aragon, 'Toutes les couleurs d'automne', *Les Lettres françaises*, 12 November 1953

Archer-Straw 2000 Petrine Archer-Straw, *Negrophilia: Avant-Garde Paris and Black Culture in the 1920s*, London and New York, 2000

Armogathe 1993 Jean-Roberte Armogathe, Pierre Buraglio, *Chapelle Saint-Symphorien, Eglise Saint-Germain-des-Prés*, Paris, 1993

Arp and El Lissitzky 1925 Hans Arp and El Lissitzky, *Der Kunstismen, Les Ismes de l'art, The Isms of Art*, Munich and Zurich, 1925; facsimile edition, New York, 1968

Arras 2000 *Exposition Phases*, exh. cat., Centre Culturel Noroit, Arras, 2000

Artaud 1974 Antonin Artaud, *Œuvres complètes*, Paule Thévenin (ed.), vol. XIII, Paris, 1974

Ashbery 1989 John Ashbery, *Reported Sightings: Art Chronicles, 1957–1987*, David Bergman (ed.), New York, 1989

Aspley, Cowling and Sharratt 2000 *From Rodin to Giacometti: Sculpture and Literature in France 1880–1950*, Keith Aspley, Elizabeth Cowling and Peter Sharratt (eds), Amsterdam, 2000

Astruc 1929 Gabriel Astruc, *Le Pavillon des fantômes, souvenirs*, Paris, 1929

Atelier Populaire 1969 Atelier Populaire, *Mai '68, début d'une lutte prolongée*, London, 1969

Bablet 1990 T. Kantor. *Le Théâtre Cricot 2. La Classe Morte. Wielopole-Wielopole*, Denis Bablet (ed.), *Les Voies de la création théâtrale*, vol. XI, 1990

Baj et al. 2000 Enrico Baj, Laurence Bertrand-Dorléac, Julien Blaine, Robert Fleck, Annie Gouëdard and Jean-Jacques Lebel, *Grand Tableau antifasciste collectif*, Laurent Chollet (ed.), Paris, 2000

Balon 1998 Kasia Balon, *Roman Opałka: The Art of Life for a Life of Art*, MA dissertation, Courtauld Institute of Art, University of London, 1998

Balsamo 1996 Isabelle Balsamo, 'André Chastel et "l'aventure" de l'inventaire', in Girard and Gentil 1996, pp. 95–105

Barber 1991 Stephen Barber, *Artaud: Blows and Bombs*, London, 1991

Barber 1996 Stephen Barber, *Weapons of Liberation*, London, 1996

Barcelona 2001 *Albert Gleizes: le cubisme en majesté*, exh. cat., Museu Picasso, Barcelona, and Musée des Beaux-Arts, Lyons, 2001

Barker 1993 Oliver Barker, *Art from France in Britain: Influence and Reception*, MA dissertation, Courtauld Institute of Art, University of London, 1993

Barreyre 1959 Jean Barreyre, 'Les Nuits de Montmartre', *Le Crapouillot*, 45, 1959, pp. 63–71

Barthes 1957 Roland Barthes, *Mythologies*, Paris, 1957; Annette Lavers (trans.), London, 2000

Barthes 1968 Roland Barthes, 'La Mort de l'auteur', *Mantéia*, V, 1968; 'The Death of the Author', in *Image, Music, Text*, Stephen Heath (trans. and ed.), London, 1977, pp. 142–48

Basler 1929 Adolphe Basler, *Le Cafard après la fête*, Paris, 1929

Baudin 1997 Antoine Baudin, '"Why Is Soviet Painting Hidden from Us?" Zhdanov Art and Its International Fallout, 1947–1953', in *Socialist Realism Without Shores*, Thomas Lahusen and Evgeny Dobrenko (eds), Durham and London, 1997, pp. 227–56

Baudson 1999 *Le Nouveau Réalisme*, Michel Baudson (ed.), papers of a conference held at the Galerie du Jeu de Paume, Paris, 1999

Bazaine 1943 Jean Bazaine, 'La Peinture bleu-blanc-rouge', *Comoedia*, 30 January 1943

Beach 1956 Sylvia Beach, *Shakespeare and Company*, New York, 1956

Belgrade 1989 *Socijalistčki realizam u Srbiji 1945–1950 (Socialist Realism in Serbia 1945–1950)*, exh. cat., Umetnički Paviljon Cvijeta Zuzorić, Belgrade, 1989

Benjamin 1936 Walter Benjamin, 'L'Œuvre d'art à l'époque de sa reproduction mécanisée', *Zeitschrift für Sozialforschung*, Pierre Klossowski (trans.), vol. V, Paris, 1936, pp. 40–66

Benjamin 1968 Walter Benjamin, *Illuminations*, Harry Zohn (trans.), Hannah Arendt (ed. and preface), New York, 1968; London, 1973

Benjamin 1991 Walter Benjamin, *Ecrits français*, J.-M. Monnoyer (ed. and preface), Paris, 1991

Benjamin 1999 Walter Benjamin, *The Arcades Project*, Howard Eiland and Kevin McLaughlin (trans. and eds), Cambridge, Mass., and London, 1999

Benjamin 1999B Walter Benjamin, *Selected Writings, Volume 2: 1927–1934*, Cambridge, Mass., and London, 1999

Bensimmon 1987 Doris Bensimmon, *Les Grands Rafles: les juifs en France, 1940–1944*, Paris, 1987

Berk Jimenez 2001 *Dictionary of Artists' Models*, Jill Berk Jimenez (ed.), London, 2001

Berkeley 1990 *Anxious Visions: Surrealist Art*, exh. cat., University Art Museum, University of California at Berkeley, 1990

Berlin 1994 *Der Riss im Raum: Positionen der Kunst seit 1945 in Deutschland, Polen, der Slowakei und Tschechien*, Matthias Flügge and Jiří Svestka (eds), exh. cat., Martin-Gropius-Bau, Berlin, 1994; Galerie Zachęta, Warsaw, 1995; Gallery of the City of Prague, 1996

Bernard-Gruber and Vanazzi 1989 Catherine Bernard-Gruber and Armelle Vanazzi, *Francis Gruber*, Neuchâtel, 1989

Bernatowicz 2000 Piotr Bernatowicz, 'Picasso w Polsce zaraz po wojnie' ('Picasso in Poland Immediately after the Second World War'), *Artium Quaestiones*, 11, 2000, pp. 155–220

Berthet 1990 Dominique Berthet, *Le PCF, la culture et l'art*, Paris, 1990

Bertrand-Dorléac 1986 Laurence Bertrand-Dorléac, *Histoire de l'art, Paris, 1940–1944*, Paris, 1986

Bertrand-Dorléac 1987 Laurence Bertrand-Dorléac, 'Jean Bazaine 1940–1944. Imaginaire politique et modernité picturale. Remarques sur le rouge et le bleu', *Image et histoire*, Paris, 1987, pp. 219–35

Bertrand-Dorléac 1990 Laurence Bertrand-Dorléac, 'Les Arts plastiques', in Paris 1990B, pp. 212–23

Bertrand-Dorléac 1992 Laurence Bertrand-Dorléac, 'La France déchirée. Hains et Villeglé', in Paris 1992B, pp. 202–09

Bertrand-Dorléac 1993 Laurence Bertrand-Dorléac, *L'Art de la défaite, 1940–1944*, Paris, 1993

Bertrand-Dorléac 1994 Laurence Bertrand-Dorléac, 'De la France aux magiciens de la terre. Les artistes étrangers à Paris depuis 1945', in Marès and Milza 1994, pp. 403–28

Besançon 1968 Julien Besançon, 'Les Murs ont la parole', *Journal mural, mai '68, Sorbonne, Odéon, Nanterre etc.*, Paris, 1968

Besson 2000 Christian Besson, 'Naissance de Daniel Buren', in Buren 2000, pp. 6–22

Béthencourt-Devaux 1972 Robert Béthencourt-Devaux, *Montmartre, Auvers-sur-Oise et Van Gogh*, Paris, 1972

Bibrowski 1979 *Picasso w Polsce (Picasso in Poland)*, Mieczysław Bibrowski (ed.), Kraków, 1979

Biélinky 1929 Jacques Biélinky, 'L'Art juif à Zurich', *L'Univers israélite*, 30 August 1929

Biély 2000 Andreï Biély, *Le Collecteur d'espaces, notes, mémoires, correspondance*, Claude Frioux (introduction and trans.), Paris, 2000

Blake 1999 Jodie Blake, *Le Tumulte noir: Modernist Art and Popular Entertainment in Jazz-Age Paris, 1900–1930*, Pennsylvania, 1999

Blažević 1999 Dunja Blažević, 'Who's That Singing Over There? Art in Yugoslavia and After…1949–1989…', in Vienna 1999, pp. 85–99

Bloom 1973 Harold Bloom, *The Anxiety of Influence*, London and New York, 1973

Blume 1992 Mary Blume, *Côte d'Azur: Inventing the French Riviera*, London and New York, 1992

Bois 1996 Yve-Alain Bois, 'Sophie Täuber Arp, Against Greatness', in Boston 1996, pp. 413–17

Bois and Krauss 1997 Yve-Alain Bois and Rosalind Krauss, *Formless: A User's Guide*, New York, 1997 (republication of Paris 1996B)

Bonn 1994 *Europa–Europa. Das Jahrhundert der Avantgarde in Mittel- und Osteuropa*, Ryszard Stanisławski and Christoph Brockhaus (eds), exh. cat., 4 vols, Kunst- und Ausstellungshalle der Bundesrepublik Deutschland, Bonn, 1994

Bonn 1996 Lutz Jahre, *Das Gedrückte Museum von Pontus Hulten*, exh. cat., Kunst- und Ausstellungshalle der Bundesrepublik Deutschland, Bonn, 1996

Bonnet and Rogers 1988 Jean-Claude Bonnet and Philippe Rogers, *La Légende de la Révolution au XXème siècle, de Gance à Renoir, de Romain Rolland à Claude Simon*, Paris, 1988

Bony 1982 *Les Années '50*, Anne Bony (ed.), Paris, 1982

Bony 1983 *Les Années '60*, Anne Bony (ed.), Paris, 1983

Bony 1985 *Les Années '40*, Anne Bony (ed.), Paris, 1985

Bony 1987 *Les Années '30*, 2 vols, Anne Bony (ed.), Paris, 1987 (1994)

Bony 1989 *Les Années '20*, Anne Bony (ed.), Paris, 1989

Bony 1991 *Les Années '10*, 2 vols, Anne Bony (ed.), Paris, 1991

Boston 1996 *Inside the Visible: An Elliptical Traverse of Twentieth-Century Art, in and from the Feminine*, Catherine de Zegher (ed.), exh. cat., Institute of Contemporary Arts, Boston, 1996

Bougault 1997 Valerie Bougault, *Paris Montparnasse: The Heyday of Modern Art, 1910–1940*, Paris, 1997 (English edition)

Boulos 2000 Joanna Boulos, *Bernard Rancillac: les années politiques*, MA dissertation, Courtauld Institute of Art, University of London, 2000

Bouretz, Chaumont, Manevistas and Wieviorska 1998 Pierre Bouretz, Jean-Michel Chaumont, Richard Manevistas, Michel Wieviorska, 'Unicité de la Shoah', section of *Le Débat*, 98, 1988, pp. 155–86

Bourguet and Lacretelle 1959 Pierre Bourguet and Charles Lacretelle, *Sur les Murs de Paris, 1940–1944*, Paris, 1959

Bourseiller 1996 Christophe Bourseiller, *Les Maoïstes: la folle histoire des Gardes Rouges français*, Paris, 1996

Bracken 1997 Len Bracken, *Guy Debord, Revolutionary*, Venice, California, 1997

Brassaï 1964 Brassaï (Gyula Halasz), *Conversations avec Picasso*, Paris, 1964; *Picasso & Co.*, Francis Price (trans.), New York, 1967

Brassaï 1976 Brassaï (Gyula Halasz), *The Secret Paris of the 1930s*, New York, 1976

Brau 1971 Jean-Louis Brau, *Antonin Artaud*, Paris, 1971

Braudel 1958 Fernand Braudel, 'Histoires et sciences sociales: la longue durée', *Annales ESC*, 4, October–December 1958, pp. 725–53; English translation, 'The *Longue Durée*', in Fernand Braudel, *On History*, Chicago, 1980, pp. 25–54

Breton 1924 André Breton, *Manifeste du surréalisme*, Paris, 1924 (revised editions 1929, 1946, 1962); *Manifestoes of Surrealism*, Ann Arbor, 1969

Breton 1928 André Breton, *Le Surréalisme et la peinture*, Paris, 1928 (revised editions 1946, 1965); *Surrealism and Painting*, Simon Watson Taylor (trans.), New York, 1972

Breton 1929 André Breton, *Nadja*, Paris, 1929; Richard Howard (trans.), New York, 1960

Breton 1935 André Breton, *Position politique du Surréalisme*, Paris, 1935

Breton 1947 André Breton, 'Préliminaires sur Matta', 'La Perle est gâtée à mes yeux', 'Mot à Mante', 'Il y a trois ans', in Paris 1947C

Breton 1953 André Breton, *La Clé des champs*, Paris, 1953

Breton 1969 André Breton, *Manifestoes of Surrealism*, R. Searer and H. R. Lane (trans.), Ann Arbor, 1969

Breton 1978 André Breton, *Selected Writings: What Is Surrealism?*, Franklyn Rosemont (ed.), New York, 1978

Breton 1988 André Breton, *Œuvres complètes*, vol. I, Paris, 1988

Breton 1992 André Breton, *Œuvres complètes*, vol. II, Paris, 1992

Brion 1956 Marcel Brion, *L'Art abstrait*, Paris, 1956

Brulé 1957 Claude Brulé, 'Nicolas de Staël, un artiste hanté par la mort', *Réalités, Femina-Illustration*, 137, 1957, special number, *La Seconde Moitié du XXe siècle*, pp. 54 and 62–63

Brunhammer 1983 Yvonne Brunhammer, *Art Deco Style*, London, 1983 (first published as *Lo Stile 1925*, Milan, 1966)

Brunner 1997 Kathleen Brunner, *Picasso Rewriting Picasso: Poetry and Plays, 1936–1959*, PhD dissertation, University of London, 1997

Brussels 1989 Władysław Hasior, Camiel van Breedam, exh. cat., Atelier 340, Brussels, 1989; Kunsthalle, Darmstadt, 1990; Museum Bochum, Bochum, 1990; Palace of Exhibitions Müscarnok, Budapest, 1991; CBWA Zachęta, Warsaw, 1991; TWPSP, Kraków, 1991 (parallel texts in Dutch, English, French, German and Polish)

Buchloh 1998 Benjamin Buchloh, 'Plenty of Nothing: From Yves Klein's *Le Vide* to Arman's *Le Plein*', in New York 1998, pp. 86–99

Budapest 1993 K. Keserü, *Variations on Pop Art: Chapters in the History of Hungarian Art Between 1950–1990*, exh. cat., Ernst Muzeum, Budapest, 1993

Buisson and Parisot 1996 Sylvie Buisson and Christian Parisot, *Paris-Montmartre: les artistes et les lieux 1860–1920*, Paris, 1996

Buraglio 1991 Pierre Buraglio, *Ecrit entre 1962 et 1990*, Paris, 1991

Buren 1991 Daniel Buren, *Daniel Buren, les écrits (1965–1990)*, J.-M. Poinsot (ed.), vol. I, Paris, 1991

Buren 2000 Daniel Buren, *Catalogue raisonné chronologique*, Annick Boisnard (ed.), vol. II, Le Bourget, 2000

Burgess 1910 Gelett Burgess, 'The Wild Men of Paris', *The Architectural Record*, May 1910, pp. 400–14

Cabanne 1981 Pierre Cabanne, *Le Pouvoir culturel sous la Vème République*, Paris, 1981

Cârneci 1993 Magda Cârneci, 'Another Image of Eastern Europe', *Revue Roumaine d'Histoire de l'Art*, 30, 1993, pp. 41–49

Carrière 1963 *Humour 1900*, Jean-Claude Carrière (ed.), Paris, 1963

Cassou 1947 Jean Cassou, *Le Pillage par les Allemands des œuvres d'art et des bibliothèques appartenant à des juifs en France*, Paris, 1947

Cassou 1947B Jean Cassou, 'Proč je moderní malířstvi "nesrozumitelné" ('Modern Painting Is "Unintelligible", or Is It?'), *Tvorba*, XVI, 29, 1947, pp. 552–53

Cassou 1949 Jean Cassou, 'La Révolution et la vérité', *Esprit*, 12, December 1949

Cassou 1953 Jean Cassou, *La Mémoire courte*, 1953; Marc Olivier Baruch (ed. and epilogue), Paris, 2001

Cassou et al. 1968 Jean Cassou, André Fermigier, Gilbert Lascault, Gérald Gassiot-Talabot, Raymonde Moulin, Pierre Gaudibert, René Micha and Alain Jouffroy, *Art et contestation*, Brussels, 1968; *Art and Confrontation: France and the Arts in an Age of Change*, London, 1970

Cassou 1981 Jean Cassou, *Une Vie pour la liberté*, Paris, 1981

Cate 1991 Phillip Dennis Cate, 'The Cult of the Circus', in *Pleasures of Paris: Daumier to Picasso*, Barbara Stern Shapiro (ed.), exh. cat., Museum of Fine Arts, Boston, 1991, pp. 38–46

Cate 1996 Phillip Dennis Cate, 'The Spirit of Montmartre', in *The Spirit of Montmartre: Cabarets, Humor and the Avant-Garde, 1875–1905*, Phillip Dennis Cate and Mary Shaw (eds), New Brunswick, 1996

Caute 1967 David Caute, *Communism and the French Intellectuals, 1914–60*, London, 1967; *Le Communisme et les intellectuels français, 1914–60*, Paris, 1967

Ceysson 1987 Bernard Ceysson, 'Réalismes et engagement', in Saint-Etienne 1987, pp. 75–85

Ceysson 1990 Bernard Ceysson, 'La Tradition française', in Paris 1990, pp. 7–14

Ceysson 1995 Bernard Ceysson, 'Le Peintre engagé', in Daniel Abadie, Bernard Ceysson and Jean-Luc Daval, *Gérard Singer*, Geneva, 1995, pp. 11–26

Chadwick 1985 Whitney Chadwick, *Women Artists of the Surrealist Movement*, Boston, 1985

Chalupecký 1999 Jindřich Chalupecký, *Cestou necestou*, Jinočany, 1999

Charters 1934 James Charters, *This Must Be the Place: Memoirs of Montparnasse*, London, 1934

Chassey 1998 Eric de Chassey, *La Violence décorative: Matisse et les Etats-Unis*, Nîmes, 1998

Chassey 2000 *Supports/Surfaces, Conférences et colloques*, Eric de Chassey (ed.), papers of a conference held at the Galerie Nationale du Jeu de Paume, Paris, 2000

Château de Jau 1988 *Des Américains à Paris. 1950–1965*, Yves Michaud (ed.), exh. cat., Cases de Pene, Château de Jau, 1988

Chave 1993 Anna Chave, *Constantin Brancusi: Shifting the Bases of Art*, New Haven and London, 1993

Chevalier 1980 Louis Chevalier, *Montmartre du plaisir et du crime*, Paris, 1980

Chicago 1995 *Beyond Belief: Contemporary Art from East Central Europe*, Laura J. Hoptman (ed.), exh. cat., Museum of Contemporary Art, Chicago, 1995

Chisholm 1979 Anne Chisholm, *Nancy Cunard: A Biography*, London, 1979

Chollet 2000 Laurent Chollet, *L'Insurrection situationniste*, Paris, 2001

Clair 1972 Jean Clair (pseud.), *Art en France: une nouvelle génération*, Paris, 1972

Clair 1996 Jean Clair (pseud.), *Malinconia: motifs saturniens dans l'art de l'entre-deux-guerres*, Paris, 1996

Claridge 1999 Laura P. Claridge, *Tamara de Lempicka: A Life of Deco and Decadence*, New York, 1999; London, 2000

Clark 1999 T. J. Clark, *Farewell to an Idea: Episodes from a History of Modernism*, New Haven and London, 1999

Clert 1978 Iris Clert, *Iris-time (l'artventure)*, Paris, 1978

Clifford 1988 James Clifford, *The Predicament of Culture: Twentieth-Century Ethnography, Literature, and Culture*, Cambridge, Mass., 1988

Clifford 1989 James Clifford, 'Negrophilia', in *A New History of French Literature*, Denis Hollier (ed.), Cambridge, Mass., 1989

Cobra 1980 *Cobra*, nos 1–12, and *Petit Cobra* (facsimile), Paris, 1980

Cockroft 1985 Eva Cockroft, 'Abstract Expressionism, Weapon of the Cold War', in *Pollock and After: The Critical Debate*, Francis Frascina (ed.), London, 1985, pp. 125–33

Cocteau 1935 Jean Cocteau, 'Nice', originally published in 1935, in *Souvenir Portraits: Paris in the Belle Epoque*, Jesse Browner (trans.), New York, 1990, pp. 92–93

Cocteau 1957 Jean Cocteau, *La Chapelle Saint-Pierre, Villefranche-sur-Mer*, Beaulieu-sur-Mer, 1957

Cohen 1999 Evelyne Cohen, *Paris dans l'imaginaire national de l'entre-deux-guerres*, Paris, 1999

Cone 1992 Michèle C. Cone, '"Abstract" Art as a Veil. Tricolour Painting in Vichy France', *Art Bulletin*, LIV, 2, June 1992, pp. 191–204; republished in Cone 2001, pp. 81–99

Cone 1992B Michèle C. Cone, *Artists Under Vichy: A Case of Prejudice and Persecution*, Princeton, 1992

Cone 1999 Michèle C. Cone, 'Wartime Gilt', *Art in America*, September 1999, pp. 57–59; republished in Cone 2001, pp. 129–37

Cone 2001 Michèle C. Cone, *French Modernisms: Perspectives on Art Before, During and After Vichy*, Cambridge, Mass., 2001

Congrès Mondial 1949 *Congrès Mondial des Intellectuels pour la Paix, Wrocław, Pologne, 25–28 août: Compte rendu présenté par le Bureau du Secrétariat Général*, Warsaw, 1949

Conil Lacoste 1995 Michel Conil Lacoste, *The Story of a Grand Design: Unesco 1946–1953*, Paris, 1995

Cooper 1970 Douglas Cooper, *The Cubist Epoch*, Oxford and New York, 1970

Courthion 1958 Pierre Courthion, *Art indépendant*, Paris, 1958

Courtois 1997 *Le Livre noir du communisme*, Stéphane Courtois (ed.), Paris, 1997

Couturier 1984 Marie-Alain Couturier, *La Vérité blessée*, Paris, 1984

Crespelle 1976 Jean-Paul Crespelle, *La Vie quotidienne à Montparnasse à la Grande Epoque, 1905–1930*, Paris, 1976

Crespelle 1978 Jean-Paul Crespelle, *La Vie quotidienne à Montmartre au temps de Picasso, 1900–1910*, Paris, 1978

Crispolti 1971 Enrico Crispolti, *L'Informale: storia e poetica*: vol. I, 'In Europa, 1940–1951'; vol. IV, 'Antologia di poetica', Assisi, 1971

Culot and Foucart 1992 *Boulogne-Billancourt, Ville des Temps Modernes*, Maurice Culot and Bruno Foucart (eds), Liège, 1992

Czerni 1992 Krystyna Czerni, *Nie tylko o sztuce: Rozmowy z profesorem Mieczysławem Porębskim (Not Only About Art: Conversations with Professor Mieczysław Porębski)*, Wrocław, 1992

Dachy 1995 Marc Dachy, 'A Devil of a Snag: The Story of a Banned Broadcast', in *Antonin Artaud. Pour en finir avec le jugement de dieu*, compact disc, Brussels, 1995

Daix 1965 Pierre Daix, 'L'Amérique à l'Avant-Garde?', *Les Lettres françaises*, 14 January 1965, pp. 1 and 13

Dalí 1968 Salvador Dalí, 'Ma Révolution culturelle', 13 May 1968 (from *La Vie publique de Salvador Dalí*, Paris, 1979, p. 166), in *The Collected Writings of Salvador Dalí*, Haim Finkelstein (ed.), New York and Cambridge, 1999, pp. 374–76

Damisch 1977 Hubert Damisch, 'Stratégies 1950–1960', in Paris 1977, pp. 130–41

Dankl 1996 Günther Dankl, 'Zur Rezeption der französischen Kunst in Österreich 1945 bis 1960', in *Kunst in Österreich 1945–1995*, Patrik Werkner (ed.), Vienna, 1996

de Beauvoir 1949 Simone de Beauvoir, *Le Deuxième Sexe*, Paris, 1949; *The Second Sex*, H. M. Parshley (ed.), London, 1953

de Bonneville 1983 Françoise-Rose de Bonneville, 'Spectacle', in Bony 1983, pp. 103–45

Debord 1967 Guy Debord, *La Société du spectacle*, Paris, 1967; *The Society of the Spectacle*, Donald Nicholson Smith (trans.), New York, 1994

Debord 1973 Guy Debord, *La Société du spectacle*, film, 1973

Debord 1987 Guy Debord, *Commentaires sur la société du spectacle*, Paris, 1987

Debord and Jorn 1957 Guy Debord and Asger Jorn, *Fin de Copenhague*, Copenhagen, 1957 (Paris, 2001)

Debray 2001 Cécile Debray, 'Donner davantage à penser. *Vivre et laisser mourir ou la fin tragique de Marcel Duchamp*', in Monte Carlo 2001, pp. 19–32

Degand 1988 Léon Degand, *Abstraction/Figuration: langage et signification de la peinture*, Daniel Abadie (ed.), Paris, 1988

Dejacques 1968 Claude Dejacques, *A toi l'angoisse, à moi la rage: Mai '68, les fresques de Nanterre*, Paris, 1968

Delanoë 1994 Nelcya Delanoë, *Le Raspail vert: L'American Center à Paris, 1934–1994. Une histoire des avant-gardes franco-américaines*, Paris, 1994

de Lavergne 1992 Sabine de Lavergne, *Art sacré et modernité: les grandes années de la revue 'Art Sacré'*, Namur, 1992

Deleuze 1973 Gilles Deleuze, 'Le Froid et le chaud', 1973, in Deleuze, Foucault and Rifkin 1999, pp. 63–77

Deleuze, Foucault and Rifkin 1999 Gilles Deleuze, Michel Foucault and Adrian Rifkin, *Photogenic Painting: Gérard Fromanger*, Sarah Wilson (ed.), London, 1999

Dempsey 1999 Amy J. Dempsey, *The Friendship of America and France: A New Internationalism, 1961–1964*, PhD dissertation, University of London, 1999

de Ridder 1928 André de Ridder, 'Paris: centre mondial des arts', *Le Centaure*, 1928

Derrida 1997 Jacques Derrida, *Spectres de Marx*, Paris, 1997

Desanti 1975 Dominique Desanti, *Les Staliniens (1944–1956): une expérience politique*, Paris, 1975

Desprats-Péquignot 1998 Catherine Desprats-Péquignot, *Roman Opałka: une vie en peinture*, Paris, 1998

Devaux 1992 Frédérique Devaux, *Le Cinéma lettriste, 1951–1991*, Paris, 1992

Didi-Huberman 1998 Georges Didi-Huberman, *L'Etoilement: conversations avec Hantaï*, Paris, 1998

Diehl 1999 Gaston Diehl, *La Peinture en France dans les années noires, 1935–1945*, Paris, 1999

Dijon 1997 *Prague 1900–1938, capitale secrète des avant-gardes*, exh. cat., Musée des Beaux-Arts de Dijon, 1997

Dluhosch and Švácha 1999 *Karel Teige (1900–1951): The Enfant Terrible of the Czech Modernist Avant-Garde*, Eric Dluhosch and Retislav Švácha (eds), Cambridge, Mass., 1999

Dorival 1946 Bernard Dorival, *Les Etapes de la peinture française contemporaine, 1911–1944*, Paris, 1946 (sixth edition)

Dorroh 1998 Atissa Dorroh, *A Territory for the Imagination: Mao's China in French Painting, 1966–1976*, MA dissertation, Courtauld Institute of Art, University of London, 1998

Dubuffet 1946 Jean Dubuffet, 'Lettre no. 114', Summer 1946, in Paris 1974, pp. 98–99

Dubuffet 1966 *Mirobolus, Macadam et Cie. Catalogue des travaux de Jean Dubuffet*, Max Loreau (ed.), fascicule II, Paris, 1966

Dubuffet 1968 Jean Dubuffet, *Asphyxiante culture*, Paris, 1968

Dubuffet 1988 Jean Dubuffet, *Asphyxiating Culture and Other Writings*, Carol Volk (trans.), New York, 1988

Dumontier 1995 Pascal Dumontier, *Les Situationnistes et mai '68. Théorie et pratique de la révolution (1966–1972)*, Paris, 1995

Duncan 1988 Alistair Duncan, *Art Deco*, London, 1988 (1991)

Duthuit 1961 Georges Duthuit, *L'Image en souffrance*, vol. I of *Coulures*, Paris, 1961

Edinburgh 1988 *Francis Picabia 1879–1953*, exh. cat., National Gallery of Scotland, Edinburgh, 1988

Edinburgh 1994 Richard Thomson, *Monet to Matisse: Landscape Painting in France, 1874–1914*, exh. cat., National Gallery of Scotland, Edinburgh, 1994

Einstein 1929 Carl Einstein, 'L'Exposition de l'art abstrait à Zurich', in *Documents*, 6, November 1929; facsimile edition, Denise Paulme-Schaeffer, Arlette Albert-Biro and Bernard Noël (eds), Paris, 1987 (1991), p. 342

Eitner 1955 Lorenz Eitner, 'The Open Window and the Storm-Tossed Boat', *The Art Bulletin*, 37, 1955, pp. 281–90

Elkins 2000 James Elkins, review of Mansbach 1999, in *The Art Bulletin*, 122, 2000, pp. 781–85

Estienne 1950 Charles Estienne, *L'Art abstrait est-il un académisme?*, Paris, 1950

Fabre 1981 Gladys Fabre, 'L'Atelier de Fernand Léger', in Paris 1981, pp. 190–95

Fabre 1982 Gladys Fabre, 'L'Esprit moderne dans la peinture figurative', and 'L'Esprit moderne et le problème de l'abstraction chez Léger, ses amis, et ses élèves de l'Academie Moderne', in Paris 1982B, pp. 82–141 and 356–406

Fabre 1987 Gladys Fabre, 'L'Art abstrait-concret: vous avez dit indépendant?', in *…und nicht die Leiseste Spur einer Vorschrift. Positionen unabhängiger Kunst in Europa um 1937*, exh. cat., Kunstsammlung Nordrhein-Westfalen, Düsseldorf, 1987, pp. 35–41

Fabre 1989 Gladys Fabre, 'La Création artistique comme métaphore du vivant: de l'œuvre de Kupka comme organisme au sein du milieu artistique parisien', in *František Kupka*, exh. cat., Musée d'Art Moderne de la Ville de Paris, 1989, pp. 31–39

Fabre 1990 Gladys Fabre, 'Cercle et Carré 1930', 'Art concret 1930' and 'Abstraction-création 1931–1936', in Valencia 1990, pp. 31–34, 63–68 and 91–96

Fabre 1992 Gladys Fabre, 'La Pologne, relations internationales 1920–1939', in Lyons 1992B, pp. 19–21

Fabre 1994 Gladys Fabre, 'Herbin le militant de l'art non objectif', in *Herbin 1882–1960*, exh. cat., Musée d'Art Moderne de Céret; Musée Matisse, Le Cateau-Cambrésis, 1994, pp. 109–18

Fabre 1995 Gladys Fabre, 'Le Cercle de l'Abbaye, l'occultisme et l'avant-garde en France 1906–1915', *Okkultismus und Avantgarde, von Munch bis Mondrian 1900–1915*, exh. cat., Schirn Kunsthalle, Frankfurt, 1995, pp. 350–73

Fabre 1997 Gladys Fabre, 'La Dernière Utopie: le réel', in Paris 1997, pp. 35–41

Fabre 1997B Gladys Fabre, 'Paris/Prague: la querelle des cubistes', in Dijon 1997, pp. 132–37

Fabre 2000 Gladys Fabre, 'Qu'est-ce que l'école de Paris?', in Paris 2000, pp. 25–40

Fabre 2001 Gladys Fabre, 'Gleizes et l'Abbaye de Créteil', in Barcelona 2001, pp. 130–43

Fauchereau 1976 Serge Fauchereau, *Expressionnisme, Dada, Surréalisme et autres 'ismes'*, Paris, 1976 (2001)

Fauchereau 1982 Serge Fauchereau, *La Révolution cubiste*, Paris, 1982

Fauchereau 1991 Serge Fauchereau, *Bernard Rancillac*, Paris, 1991

Fauchereau 2001 Serge Fauchereau, 'Paris 1905–1915', in *Century City: Art and Culture in the Modern Metropolis*, Iwona Blazwick (ed.), exh. cat., Tate Modern, London, 2001, pp. 150–71

Faure 1989 Christian Faure, *Le Projet culturel de Vichy*, Lyons, 1989

Fauré 1982 Michel Fauré, *Histoire du surréalisme sous l'occupation*, Paris, 1982

Feliciano 1995 Hector Feliciano, *Le Musée disparu: enquête sur le pillage des œuvres d'art en France par les Nazis*, Paris, 1995; *The Lost Museum: The Nazi Conspiracy to Steal the World's Greatest Works of Art*, London, 1997

Fenster 1951 Hersch Fenster, *Undzere farpainikte Kinstler (Our Artist-Martyrs)*, Paris, 1951

Fer, Batchelor and Wood 1993 Briony Fer, David Batchelor and Paul Wood, *Realism, Rationalism and Surrealism: Art Between the Wars*, New Haven and London, 1993

Fitch 1983 Noel Riley Fitch, *Sylvia Beach and the Lost Generation: A History of Literary Paris in the Twenties and Thirties*, New York, 1983

Flam 1973 *Matisse on Art*, Jack Flam (ed.), New York, 1973

Flandin 1982 Simone Flandin, *André Fougeron, le parti pris du réalisme, 1948–1953*, MA dissertation, Université de Clermont-Ferrand, 1981–82

Flanner 1973 Janet Flanner, *Paris Was Yesterday 1925–39*, London, 1973

Flanner 1977 Janet Flanner, *Paris Journal 1965–1971*, 2 vols, New York and London, 1977

Fleischer 1998 Alain Fleischer, *L'Art d'Alain Resnais*, Paris, 1998

Folga-Januszewska 1995 Dorota Folga-Januszewska, 'The Waves of Frenchness in Twentieth-Century Polish Art', in *Polish and English Responses to French Art and Architecture: Contrasts and Similarities*, Francis Ames-Lewis (ed.), London, 1995, pp. 123–30

Fontaine 1927 Charles Fontaine, *Un Maître de la caricature: André Gill 1840–1885*, Paris, 1927

Forest 1995 Philippe Forest, *Histoire du Tel Quel 1960–1982*, Paris, 1995

Fort Worth 1997 Joachim Pissarro, *Monet and the Mediterranean*, exh. cat., Kimbell Art Museum, Fort Worth, 1997

Foucault 1969 Michel Foucault, 'Qu'est-ce que c'est qu'un auteur', *Bulletin de la Société Française de Philosophie*, 63, no. 3, 1969, pp. 73–104; 'What Is an Author?', in *Language, Counter-Memory, Practice*, Donald F. Buchard (ed.), Ithaca, 1977, pp. 124–27

Francastel 1946 Pierre Francastel, *Nouveau Dessin, nouvelle peinture*, Paris, 1946

Francastel 1996 Galienne Francastel, 'Francastel, Pierre', in *The Dictionary of Art*, Jane Turner (ed.), vol. XI, London, 1996, p. 502

Francblin 1997 Catherine Francblin, *Les Nouveaux Réalistes*, Paris, 1997

Frank 1992 Robert Frank, 'Les Migrations en Europe, 1919–1939', in Paris 1992, pp. 26–27

Fréville 1936 Jean Fréville (pseud.), *Sur la Littérature et l'art: Karl Marx et Frédéric Engels*, Paris, 1936

Fréville 1938 Jean Fréville (pseud.), *Sur la Littérature et l'art: Lénine, Staline*, Paris, 1938

Fréville 1951 Jean Fréville (pseud.), 'Peintre de la classe ouvrière', in *Le Pays des mines*, Paris, 1951

Frey 1995 Julia Frey, *Toulouse-Lautrec: A Life*, London, 1995

Fromanger 1970 Gérard Fromanger, *Le Rouge, 10 drapeaux, 10 images*, lithograph album, Paris, 1970

Fumaroli 1991 Marc Fumaroli, *L'Etat culturel: essai sur une religion moderne*, Paris, 1991

Gallant 1988 Mavis Gallant, *Paris Notebooks*, London, 1988

Gascoyne 1935 David Gascoyne, *A Short Survey of Surrealism*, London, 1935 (2000)

Gassiot-Talabot 1964 Gérald Gassiot-Talabot, 'La Panoplie de l'Oncle Sam à Venise', *Aujourd'hui: art et architecture*, 47, October 1964, pp. 30–33

Gassiot-Talabot 1974 Gérald Gassiot-Talabot, 'Persistent et signent', *Opus International*, 49, March 1974, pp. 97–101

Gassiot-Talabot 1977 Gérald Gassiot-Talabot, *Mythologies quotidiennes II*, Paris, 1977

Gassiot-Talabot 1996 Gérald Gassiot-Talabot, 'De la Figuration narrative à la figuration critique', in Paris 1996, pp. 358–63

Gaudibert 1981 Pierre Gaudibert, 'La Peinture des années cinquante', *Silex*, 20, 1981, pp. 145–55

Gaze 1997 *Dictionary of Women Artists*, Delia Gaze (ed.), 2 vols, London, 1997

Gaze 2001 *A Concise Dictionary of Women Artists*, Delia Gaze (ed.), London, 2001

Gee 1981 Malcolm Gee, *Dealers, Critics and Collectors of Modern Painting: Aspects of the Parisian Art Market Between 1910 and 1930*, London and New York, 1981

Gee 1993 Malcolm Gee, *Art Criticism Since 1900*, Manchester and New York, 1993

Gee 2000 Malcolm Gee, 'Le Réseau économique', in Paris 2000, pp. 127–37

Gellatly 1994 Andrew Gellatly, *Gauche Assumptions: Art and Politics of the Extreme Left in France, 1965–1968*, MA dissertation, Courtauld Institute of Art, University of London, 1994

George 1925 Waldemar George, 'L'Exposition des arts décoratifs et industriels de 1925: les tendances générales', *L'Art vivant*, 1925, pp. 285–88

George 1931 Waldemar George, 'Ecole française ou école de Paris?' and 'Défense et illustration de l'art français', *Formes*, June and December 1931

George 1936 Waldemar George, *L'Humanisme et l'idée de patrie*, Paris, 1936

Gervereau 1988 Laurent Gervereau, 'L'Art au service du mouvement', 'La Sérigraphie à l'Ecole des Beaux-Arts. Entretien avec Rougemont', 'L'Atelier populaire de l'Ecole des Beaux-Arts. Entretien avec Gérard Fromanger' and 'L'Atelier des Arts décoratifs. Entretien avec François Miehe et Gérard Paris-Chevel', in Paris 1988F, pp. 160–71, 180–83, 184–91 and 192–97

Gervereau 1992 Laurent Gervereau, 'Des Bruits et des silences: cartographie des représentations de la guerre d'Algérie', in Paris 1992B, pp. 178–200

Gervereau 1995 Laurent Gervereau, 'Entretien avec Boris Taslitzky', in Paris 1995B, pp. 262–65

Gheerbrant 1988 Bernard Gheerbrant, *A la Hune: histoire d'une librairie-galerie à Saint-Germain-des-Prés*, Paris, 1988

Gibson 1995 *Chapelle Saint-Symphorien: transcription des interventions de la table ronde*, Michael Gibson (ed.), Paris, 1995

Girard 1950 Louis-Dominique Girard, *La Guerre franco-française*, Paris, 1950

Girard and Gentil 1996 *Les Affaires culturelles au temps d'André Malraux*, Augustin Girard and Geneviève Gentil (eds), Paris, 1996

Giroud 1981 Michel Giroud, 'Le Mouvement des reviews d'avant-garde, 1937–1957', in Paris 1981, pp. 174–79

Giroud 1997 Michel Giroud, '"Mianutes parpillon […] Je suis un décadenassé", Camille Bryen inventeur de la poésie naturelle', in Nantes 1997, pp. 57–67

Gleizes and Metzinger 1912 Albert Gleizes and Jean Metzinger, *Du 'Cubisme'*, Paris, 1912 (1980)

Godard 1984 Jean-Luc Godard, *Deux ou trois choses que je sais d'elle, découpage intégral*, Paris, 1984

Golan 1985 Romy Golan, 'Matta, Duchamp et le mythe: un nouveau paradigme pour la dernière phase du surréalisme', in Paris 1985, pp. 37–51

Golan 1991 Romy Golan, 'The Representation of Paris in the Twenties', in Montreal 1991, pp. 336–75

Golan 1995 Romy Golan, 'From Fin-de-Siècle to Vichy: The Cultural Hygienics of Camille (Faust) Mauclair', in *The Jew in the Text: Modernity and the Construction of Identity*, Tamar Garb and Linda Nochlin (eds), London and New York, 1995, pp. 156–73, 317–20

Golan 1995B Romy Golan, *Modernity and Nostalgia: Art and Politics in France Between the Wars*, New Haven and London, 1995

Golan 1998 Romy Golan, 'Oceanic Sensations: Monet's Grandes Décorations and Mural Painting in France from 1927 to 1952', in *Monet in the Twentieth Century*, exh. cat., Museum of Fine Arts, Boston; Royal Academy of Arts, London, 1998, pp. 86–97

Golding 1968 John Golding, *Cubism: A History and an Analysis 1907–1914*, London, 1968

Göteborg 1976 *Władysław Hasior*, exh. cat., Kunsthallen, Göteborg, 1976

Goytisolo 1997 Juan Goytisolo, 'Paris, Capitale du XXIème siècle?', 1990, in *La Forêt de l'écriture*, Paris, 1997, pp. 133–44

Grainville and Xuriguera 1993 Patrick Grainville and Gérard Xuriguera, *Georges Mathieu*, Paris, 1993

Gran Canaria 2001 Serge Fauchereau, *L'Art abstrait et la Galerie Denise René*, exh. cat., Centro Atlántico de Arte Moderno, Las Palmas de Gran Canaria, 2001

Granoff 1981 Katia Granoff, *Ma Vie et mes rencontres*, Paris, 1981

Grappe 1943 Georges Grappe, 'La Pérennité de la collaboration européenne', *Bulletin Collaboration*, May–June 1943

Green 1987 Christopher Green, *Cubism and Its Enemies: Modern Movements and Reactions in French Art, 1916–1928*, New Haven and London, 1987

Green 2000 Christopher Green, *Art in France, 1900–1940*, New Haven and London, 2000

Green 2001 *Picasso's Les Demoiselles d'Avignon*, Christopher Green (ed.), Cambridge and New York, 2001

Greenberg 1986 Clement Greenberg, *The Collected Essays and Criticism*, John O'Brian (ed.), vol. II, *Arrogant Purpose, 1945–1949*, Chicago and London, 1986

Greff 1990 Jean-Pierre Greff, 'Bazaine, 1941–1947, les années décisives', in Paris 1990, pp. 139–49

Grémion 1995 Pierre Grémion, *Intelligence de l'anticommunisme. Le Congrès de la Liberté de la Culture à Paris, 1950–1975*, Paris, 1995

Grenoble 1996 *Morris Louis*, exh. cat., Musée de Grenoble, 1996

Grenoble 1998 *GRAV: Horatio Garcia Rossi, Julio Le Parc, François Morellet, Francisco Sobrino, Joel Stein, Yvaral, stratégies de participation, Grav-groupe de recherche d'art visuel, 1960–68*, exh. cat., Le Magasin, Centre d'Art Contemporain de Grenoble, 1998

Grenoble 2001 *L'Esprit Nouveau: le Purisme à Paris 1918–1925*, exh. cat., Musée de Grenoble, 2001

Groensteen and Mercier 1996 Thierry Groensteen and Michel Mercier, 'Bande dessinée et dessin de presse, l'aube d'une révolution', in Paris 1996C, pp. 132–61

Grohmann 1938 Will Grohmann, 'L'Art contemporain en Allemagne', *Cahiers d'art*, 1–2, 1938, pp. 5–28

Gronberg 1998 Tag Gronberg, *Designs on Modernity: Exhibiting the City in 1920s Paris*, Manchester and New York, 1998

Groom 1998 Simon Groom, 'Un Art autre': Michel Tapié and the Informel Adventure in France, Japan and Italy', PhD dissertation, University of London, 1998

Gruber 1938 Francis Gruber, 'Le Surréalisme', *Peintres et sculpteurs de la Maison de la Culture*, 4, 1938, p. 39

Guénard 1994 Annie Guénard, 'De la reconstruction à l'éviction: entre 1944 et 1949, une politique culturelle française en Europe centrale et orientale confrontée à l'organisation du Bloc communiste', *Matériaux pour l'histoire de notre temps*, 36, 1994, pp. 21–27

Guide 1900 *Guide de Poche 1900*, Paris, 1900

Guilbaut 1983 Serge Guilbaut, *How New York Stole the Idea of Modern Art*, Arthur Goldhammer (trans.), Chicago, 1983

Guilbaut 1990 *Reconstructing Modernism: Art in New York, Paris and Montreal 1945–1964*, Serge Guibault (ed.), Cambridge, Mass., and London, 1990

Guilbaut 1996 Serge Guilbaut, 'The Taming of the Saccadic Eye: The Work of Vieira da Silva in Paris', in Boston 1996, pp. 319–29

Gumplowicz 1995 Philippe Gumplowicz, 'Au Hot Club de France, on ne fait pas danser les filles', in Gumplowicz and Klein 1995, pp. 167–82

Gumplowicz and Klein 1995 *Paris 1944–1954, Artistes, intellectuels, publics: la culture comme enjeu*, Philippe Gumplowicz and Jean-Claude Klein (eds), Paris, 1995

György and Pataki 1990 Péter György and Gábor Pataki, *Az Európai Iskola és az Elvont művészek csoportja* (*The European School and the Society of Abstract Artists*), Budapest, 1990

Halbwachs 1950 Maurice Halbwachs, *La Mémoire collective*, Paris, 1950; *The Collective Memory*, Mary Douglas (ed. and introduction), New York, 1950

Halbwachs 1992 Maurice Halbwachs, *On Collective Memory*, Lewis A. Coser (ed. and introduction), Chicago, 1992

Harvey 1978 Sylvia Harvey, *May '68 and Film Culture*, London, 1978

Havana 1967 *Mural Cuba Colectiva*, exh. cat., Museo Nacional de Bellas Artes, Havana, 1967

Hegyi 1999 Lóránd Hegyi, 'Central Europe as a Hypothesis and a Way of Life', in Vienna 1999, pp. 9–42

Hélion 1943 Jean Hélion, *They Shall Not Have Me*, New York, 1943

Hemingway 1964 Ernest Hemingway, *A Moveable Feast*, London, 1964

Herbert 1992 James D. Herbert, *Fauve Painting: The Making of Cultural Politics*, New Haven and London, 1992

Herbert 1998 James D. Herbert, *Paris 1937: Worlds on Exhibition*, Ithaca, 1998

Herbin 1949 Auguste Herbin, *L'Art non-figuratif, non-objectif*, Paris, 1949

Hewitt 1993 Nicholas Hewitt, 'Images of Montmartre in French Writing 1920–1960: "La Bohème réactionnaire"', *French Cultural Studies*, IV, 1993, pp. 129–43

Hewitt 1996 Nicholas Hewitt, 'Shifting Cultural Centres in Twentieth-Century Paris', in Sheringham 1996, pp. 30–45

Hewitt 2000 *La France et les pays de l'Est*, Nicholas Hewitt (ed.), special number of *French Studies*, 2, part 3, 33, October 2000

Hewitt 2000B Nicholas Hewitt, 'From "lieu de plaisir" to "lieu de mémoire": Montmartre and Parisian Cultural Topography', *French Studies*, IV, 54, 2000, pp. 453–67

Hillairet 1979 Jacques Hillairet, *Dictionnaire historique des rues de Paris*, Paris, 1979

Hinds and Otto-Windt Jr 1991 Lynn Boyd Hinds and Theodore Otto-Windt Jr, *The Cold War as Rhetoric: The Beginnings*, New York, 1991

Hirschfeld and Marsh 1988 *Collaboration in France, 1940–1944*, Gerhard Hirschfeld and Patrick Marsh (eds), New York, Munich and Oxford, 1988

Hocquenghem 1974 Guy Hocquenghem, *L'Après-mai des faunes. Volutions*, Paris, 1974

Home 1988 Stuart Home, *The Assault on Culture: Utopian Currents from Lettrisme to Class War*, London, 1988

Horová 1995 Anděla Horová, *Nová encyklopedie českého výtvarného umění*, Prague, 1995

Hourmont 2000 François Hourmont, *Au Pays de l'avenir radieux. Voyages des intellectuels français en URSS, à Cuba et en Chine populaire*, Paris, 2000

Houston 1982 *Yves Klein, 1928–1962: A Retrospective*, exh. cat., Institute for the Arts, Rice University, Houston, 1982

Hughes 1999 Henry Meyric Hughes, 'Were We Looking Away? The Reception in the West of Art from Central and East Central Europe at the Time of the Cold War', in Vienna 1999, pp. 47–58

Hulftegger 1957 Adeline Hulftegger, 'Les Musées en guerre', *Le Jardin des Arts*, 32, 1957, pp. 496–503

Hupchick and Cox 1996 Dennis P. Hupchick and Harold E. Cox, *A Concise Historical Atlas of Eastern Europe*, Basingstoke, 1996

Hussey 2001 Andrew Hussey, *The Game of War. The Life and Death of Guy Debord*, London, 2001

Iliazd 1949 Iliazd (Ilia Zdanevich), *Poésie des mots inconnus*, Paris, 1949

Ilkosz 1988 Jerzy Ilkosz, 'La Peinture du réalisme socialiste en Pologne', *Polish Art Studies*, 9, 1988, pp. 195–210

Isle-sur-la-Sorgue 2000 *Galerie Louis Carré: histoire et actualité*, exh. cat., Centre Xavier Battini, Isle-sur-la-Sorgue, 2000

Isou 1947 Isidore Isou, *Introduction à une nouvelle poésie et à une nouvelle musique*, Paris, 1947

Isou 1974 Isidore Isou, *De l'Impressionnisme au lettrisme*, Paris, 1974

Isou, Satié and Bermond 2000 Isidore Isou, Alain Satié and Gérard Bermond, *La Peinture lettriste*, Paris, 2000

Jappe 1995 Anselm Jappe, *Guy Debord*, Marseilles, 1995; English edition, Berkeley, 1999

Jarocki 1981 Robert Jarocki, *Rozmowy z Lorentzem* (*Conversations with Lorentz*), Warsaw, 1981

Jones 1994 Amelia Jones, *Postmodernism and the Engendering of Marcel Duchamp*, New York, 1994

Jorn and Arnaud 1968 Asger Jorn and Noël Arnaud, *La Langue verte et la cuite: étude gastrophonique sur la marmythologie musiculinaire, linguophilée par Asger Jorn, linguophagée et postpharyngée par Noël Arnaud*, Paris, 1968

Jouffroy and Prévert 1971 Alain Jouffroy and Jacques Prévert, *Fromanger, Boulevard des Italiens*, Paris, 1971

Jouffroy 1974 Alain Jouffroy, *Les Pré-voyants*, Brussels, 1974

Judt 1992 Tony Judt, *Past Imperfect: French Intellectuals 1944–1956*, Berkeley, Los Angeles and Oxford, 1992

Kantor 1947 Tadeusz Kantor, 'Rozmowa z Fougeronem' ('A Conversation with Fougeron'), *Przegląd Artystyczny*, 4–5, 1947

Kára 1950 Lubor Kára, 'Cesta pokrokových výtvarných umělců v kapitalistických zemích' ('Progressive Arts in Capitalist Lands'), *Výtvarné Umění*, 1, 1950, pp. 178–88

Kaspi and Marès 1989 *Le Paris des étrangers*, Antoine Kaspi and Antoine Marès (eds), Paris, 1989

Kasprzak 1996 Katarzyna Kasprzak, 'Reconstructing the Portrait of Man After the Catastrophe: Polish Painting and Existentialism', in Poznań 1996, pp. 272–81

Kassel 1955 *Documenta I*, exh. cat., Kassel, 1955; reprint, Munich and New York, 1995

Kassel 1972 *Documenta V*, exh. cat., Kassel, 1972

Kear 1996 Jon Kear, 'Vénus noire: Josephine Baker and the Parisian Music Hall', In Sheringham 1996, pp. 46–70

Kerbouch 1968 Jean-Claude Kerbouch, 'Du Jazz aux lacrymogènes', *Le Crapouillot*, new series, 3, 1968, special number, *Histoires secrètes de la Vème République*, pp. 23–24

Khardjiev 1982 Nicolas Khardjiev, 'La Tournée de Marinetti en Russie en 1914', in *Présence de Marinetti*, Paris, 1982, pp. 198–233

Khayati 1966 Mustapha Khayati, *De la Misère en milieu étudiant, considérée sous ses aspects économique, politique, psychologique, sexuel et notamment intellectuel et de quelques moyens pour y remédier*, pamphlet, Paris, 1966; republished Paris, 1996

Kiki 1930 Kiki (Alice Prin), *Kiki's Memoirs*, Paris, 1930 (English edition)

Klarsfeld 1978 Beate and Serge Klarsfeld, *La Mémoriale de la déportation des juifs de France*, Paris, 1978; *Memorial to the Jews Deported from France, 1942–1944*, New York, 1983

Klarsfeld 1983 Serge Klarsfeld, *Vichy-Auschwitz, Le rôle de Vichy dans la solution finale de la question juive en France, 1942*, Paris, 1983

Klarsfeld 1985 Serge Klarsfeld, *Vichy-Auschwitz, Le rôle de Vichy dans la solution finale de la question juive en France, 1943–44*, Paris, 1985

Klarsfeld and Wellers 1987 *Mémoire du Génocide, un recueil de 80 articles du 'Monde juif'*, Serge Klarsfeld and Georges Wellers (eds), Paris, 1987

Klein 1961 Yves Klein, 'Prayer to St Rita of Cascia', in Houston 1982, p. 257

Klossowski 1947 Pierre Klossowski, *Sade, mon prochain*, Paris, 1947

Klüver and Martin 1989 Billy Klüver and Julie Martin, *Kiki's Paris: Artists and Lovers 1900–1930*, New York, 1989

Koch 1995 Stephen Koch, *Double Lives. Stalin, Willi Munzenberg and the Seduction of the Intellectuals*, London, 1995; published in France as *La Fin de l'innocence, les intellectuels d'Occident et la tentation stalinienne: trente ans de guerre secrète*, Paris, 1995

Kraków 1998 *I Wystawa Sztuki Nowoczesnej: pięćdziesiąt lat później* (*First Exhibition of Modern Art: Fifty Years Later*), Józef Chrobak and Marek Świca (eds), exh. cat., Galeria Starmach, Kraków, 1998

Kraków 2000 *Nowocześni a socrealizm* (*Modern Painters versus Socialist Realism*), Józef Chrobak and Marek Świca (eds), exh. cat., 2 vols, Galeria Starmach, Kraków, 2000

Kraków 2000B *Tadeusz Kantor: Niemożliwe* (*Tadeusz Kantor: Unbelievable*), exh. cat., Bunkier Sztuki, Kraków, 2000

Krauss 1998 Rosalind E. Krauss, *The Picasso Papers*, London and New York, 1998

Kuhmer, Niedermaier and Strey 1994 Franz Kuhmer, Irene Niedermaier and Karin Strey, *Zeichen des Aufbruchs, Spuren des Abschieds: deutsche Künstler aus Ostmittel- und Südosteuropa*, Munich, 1994

Kuspit, Fuchs and Gachnang 1997 Donald Kuspit, with Rudi Fuchs and Johannes Gachnang, *Karel Appel. Art psychopathologique, Carnet 1948–1950, dessins et gouaches*, Neuchâtel, 1997

Lacan 1966 Jacques Lacan, *Ecrits*, Paris, 1966

Lago di Como 1975 *GRAV. Groupe de recherche d'art visuel, 1960–1968*, exh. cat., various venues, Lago di Como, 1975

La Jolla 1984 *Lettrisme: Into the Present*, exh. cat., Art Gallery, University of San Diego, La Jolla, 1984

Lambert 1983 Jean-Clarence Lambert, *Cobra*, Paris and London, 1983

Láncz 1975 S. Láncz, 'L'Ecole européenne', *Acta historiae artium Academiae scientiarum Hungaricae*, 21, 1975, pp. 167–94

Lapicque 1958 Charles Lapicque, *Essais sur l'espace, l'art et la destinée*, Paris, 1958

Lassalle 1993 Hélène Lassalle, 'Art Criticism as Strategy: The Idiom of "New Realism" from Fernand Léger to the Pierre Restany Group', in *Art Criticism Since 1900*, Malcolm Gee (ed.), Manchester and New York, 1993, pp. 199–218

Laurent 1982 Jeanne Laurent, *Arts et pouvoirs en France de 1793 à 1981. Histoires d'une démission artistique*, Saint-Etienne, 1982

Lazarsfeld 1995 *Kulturelle Interaktionen: Ost–West 1985–1995: Wirtschaft, Individualisierung, Kunst, Massenmedien, bildende Kunst, Theater, Literatur, Musik, Film*, Paul Lazarsfeld (ed.), Vienna, 1995

Lebel 1959 Robert Lebel, *Marcel Duchamp/Sur Marcel Duchamp*, London, New York and Paris, 1959

Lebel 1968 Jean-Jacques Lebel, *Le Pavé*, 1, May 1968

Lebel 1988 Jean-Jacques Lebel, 'Rendons la parole aux murs', in Paris 1988, p. 96

Lebel and Labelle-Rojoux 1994 Jean-Jacques Lebel and Arnaud Labelle-Rojoux, *Poésie directe*, Paris, 1994

Lebovics 1999 Herman Lebovics, *Mona Lisa's Escort. André Malraux and the Reinvention of French Culture*, Ithaca and London, 1999

Lecombre 1981 Sylvain Lecombre, 'Vivre une peinture sans tradition', in Paris 1981, pp. 216–31

Le Corbusier 1925 Le Corbusier, *L'Art décoratif d'aujourd'hui*, Paris, 1925; *Decorative Art of Today*, J. Dunnett (trans.), London, 1987

Lefebvre 1947 Henri Lefebvre, *Critique de la vie quotidienne*, Paris, 1947

Lefebvre 1968 Henri Lefebvre, *L'Irruption de Nanterre au sommet*, Paris, 1968; *The Explosion. Marxism and the French Revolution*, New York, 1969

Lefebvre 1968B Henri Lefebvre, *La Vie quotidienne dans le monde moderne*, Paris, 1968

Le Havre 1988 *Phases: l'expérience continue, 1952–1988*, exh. cat., Musée des Beaux-Arts André Malraux, Le Havre, 1988

Le Magnen and Valabrègue 1998 Catherine Le Magnen and Catherine Valabrègue, *Guide des artistes et d'ateliers à Paris*, with photographs by Catherine Lambert, Paris, 1998

Lemestre 1974 Marthe Lemestre (Martoune), *Madame Sphinx vous parle*, Paris, 1974

Levene 2000 Ariane Levene, *Le Deuil inachevé: Art, Memory and the Holocaust in France, 1945–1990*, MA dissertation, Courtauld Institute of Art, University of London, 2000

Lille 1997 *Edouard Pignon*, exh. cat., Palais des Beaux-Arts, Lille, 1997

Linder 2000 Inge Linder, *Pilgrimage to the Millennium: Sacred Art in France, 1962–1995*, PhD dissertation, University of London, 2000

Lindsell 2000 Katharine Lindsell, *Jean Pierre Raynaud, Psycho-Objects and the Institution*, MA dissertation, Courtauld Institute of Art, University of London, 2000

Ljubljana 1998 *Body and the East: From the 1960s to the Present*, Zdenka Badovinac (ed.), exh. cat., Moderna Galerija, Ljubljana, 1998

Lledo 1995 Elena Lledo, *Postwar Abstractions: The Paradox of Nicolas de Staël*, PhD dissertation, University of London, 1995

Łódź 1971 *Grupa a.r*, exh. cat., Muzeum Sztuki, Łódź, 1971

Łódź 1997 *Galeria Denise René: Sztuka konkretna/Galerie Denise René: Art concret*, Urszula Czartoryska (ed.), exh. cat., Muzeum Sztuki, Łódź, 1997 (parallel Polish and French texts)

London 1938 *Exhibition of Twentieth-Century German Art*, exh. cat., New Burlington Galleries, London, 1938

London 1970 *Léger and Purist Paris*, exh. cat., Tate Gallery, London, 1970

London 1978 *Dada and Surrealism Reviewed*, Dawn Ades (ed.), exh. cat., Hayward Gallery, London, 1978

London 1982 *Aftermath, France 1945–1954. New Images of Man*, exh. cat., Barbican Art Gallery, London, 1982

London 1987 *Fernand Léger: The Later Years*, exh. cat., Whitechapel Art Gallery, London, 1987

London 1990 Elizabeth Cowling and Jennifer Mundy, *On Classic Ground: Picasso, Léger, De Chirico and the New Classicism 1910–1930*, exh. cat., Tate Gallery, London, 1990

London 1991 *An Endless Adventure…an Endless Passion…an Endless Banquet. A Situationist Scrapbook. The Situationist International. Selected Documents from 1957–1962. Documents Relating to the Impact on British Culture of the 1960s to the 1980s*, exh. publication, Institute of Contemporary Arts, London, 1991

425

London 1993 *Paris Post War. Art and Existentialism, 1945–1955*, exh. cat., Tate Gallery, London, 1993

London 1995 *Art and Power: Europe Under the Dictators 1930–45*, exh. cat., Hayward Gallery, London, 1995

London 1999 *Henri Michaux (1899–1984)*, exh. cat., Whitechapel Art Gallery, London, 1999

London 2000 *Christo and Jeanne-Claude: Black and White*, exh. cat., Annely Juda Fine Art, London, 2000

London 2001 *Jacques Villeglé*, exh. cat., Mayor Gallery, London, 2001

London 2001B *Surrealism: Desire Unbound*, Jennifer Mundy (ed.), exh. cat., Tate Modern, London, 2001

Los Angeles 1990 *The Fauve Landscape*, Judi Freeman (ed.), exh. cat., Los Angeles County Museum of Art, 1990

Los Angeles 1992 *Parallel Visions: Modern Artists and Outsider Art*, exh. cat., Los Angeles County Museum of Art, 1992

Los Angeles 1998 *Out of Actions: Between Performance and the Object*, exh. cat., Museum of Contemporary Art, Los Angeles, 1998

Lowther 2001 Joan Lowther, *The Warhol Effect in France, 1963–1971*, MA dissertation, Courtauld Institute of Art, University of London, 2001

Lucie-Smith 1990 Edward Lucie-Smith, *Art Deco Painting*, Oxford, 1990

Luxembourg 1999 *L'Ecole de Paris? 1945–1964*, Bernard Ceysson (ed.), exh. cat., Musée National d'Histoire et de l'Art, Luxembourg, 1999

Lyons 1992 *Figurations critiques, 1965–1975*, exh. cat., Espace Lyonnais d'Art Contemporain (ELAC), Lyons, 1992

Lyons 1992B *Muzeum Sztuki w Łodzi 1931–1992: la collection du musée de Łodz*, Ryszard Stanisławski (ed.), exh. cat., Musée d'Art Contemporain, Lyons, 1992

Lyotard 1973 Jean-François Lyotard, *Dérive à partir de Marx et Freud*, Paris, 1973

Lyotard 1998 Jean-François Lyotard, *The Assassination of Experience by Painting: Monory*, Sarah Wilson (ed.), London, 1998

Macey 1993 David Macey, *The Lives of Michel Foucault*, London, 1993

Maeght 1974 *La Fondation Marguerite et Aimé Maeght*, Aimé Maeght (ed.), Paris, 1974

Mahon 1998 Alyce Mahon, 'Outrage aux bonnes moeurs: Jean-Jacques Lebel and the Marquis de Sade', in Vienna 1998, pp. 93–112

Mahon 1999 Alyce Mahon, *Surrealism and the Politics of Eros in France After 1945*, PhD dissertation, University of London, 1999

Mainardi 1993 Patricia Mainardi, *The End of the Salon: Art and the State in the Early Third Republic*, Cambridge, Mass., 1993

Malraux 1945 André Malraux, Preface, in *Fautrier*, exh. cat., Galerie René Drouin, Paris, 1945

Malraux 1951 André Malraux, *Les Voix du silence*, Paris, 1951 (a republication of *Psychologie de l'Art: Le Musée Imaginaire*, Geneva, 1947; *La Création artistique*, Geneva, 1948; *La Monnaie de l'absolu*, Paris, 1950); see also *The Voices of Silence*, Stuart Gilbert (trans.), New York, 1953

Malraux 1957 André Malraux, *La Métamorphose des dieux*, Paris, 1957

Malraux 1996 *André Malraux. La Politique, la culture. Discours, articles, entretiens (1925–1975)*, Janine Mossuz-Lavau (ed.), Paris, 1996

Mann 1996 Carol Mann, *Paris: Artistic Life in the Twenties and Thirties*, London, 1996

Mansbach 1999 S. A. Mansbach, *Modern Art in Eastern Europe: From the Baltic to the Balkans, c. 1890–1939*, Cambridge, 1999

Maran 1989 Rita Maran, *Torture: The Role of Ideology in the French-Algerian War*, New York, 1989

Marcenac 1948 Jean Marcenac, 'Malarstwo francuskie na kongresie wrocławskim' ('French Painting at the Wrocław Congress'), *Odrodzenie*, 3, 1948, p. 4

Marcus 1989 Greil Marcus, *Lipstick Traces: A Secret History of the Twentieth Century*, New York and Los Angeles, 1989

Marelli 2000 Gianfranco Marelli, *La Dernière Internationale. Les Situationnistes au-delà de l'art et de la politique*, Arles, 2000

Marès 1994 Antoine Marès, 'Exilés d'Europe centrale de 1945 à 1967', in Marès and Milza 1994, pp. 129–58

Marès and Milza 1994 *Le Paris des étrangers depuis 1945*, Antoine Marès and Pierre Milza (eds), Paris, 1994

Markowska 1996 Anna Markowska, 'The Great *Now*, or on Art', in Poznań 1996, pp. 282–90

Marmin and Infiesta n.d. M. Marmin and J. Infiesta, *Arno Breker, Le Michel-Ange du XXème siècle*, Barcelona, n.d.

Marseilles 1986 *La Planète affolée: surréalisme, dispersion et influences, 1938–1947*, exh. cat., Centre de la Vieille Charité, Marseilles, 1986

Marseilles 1989 *Peinture-Cinéma-Peinture*, exh. cat., Centre de la Vieille Charité, Marseilles, 1989

Marseilles 1993 *Poésure et peintrie, 'd'un art, l'autre'*, exh. cat., Centre de la Vieille Charité, Marseilles, 1993

Mathieu 1963 Georges Mathieu, *Au-delà du tachisme*, Paris, 1963

Mathieu 1963B Georges Mathieu, *De la Révolte à la Renaissance*, Paris, 1963 (1972)

Mathieu 1975 Georges Mathieu, *L'Abstraction prophétique*, Paris, 1975 (1984)

Mauclair 1942 Camille Mauclair, *La Crise de l'art moderne*, Paris, 1942

Maur 1991 Karin von Maur, 'Breton et Dalí, à la lumière d'une correspondance inédite', in Paris 1991, pp. 196–202

McEveilly 1982 Thomas McEveilly, 'Conquistador of the Void', in Houston 1982, pp. 19–87

Merleau-Ponty 1945 Maurice Merleau-Ponty, 'La Doute de Cézanne', *Fontaine*, 47, 1945, pp. 80–100; 'Cézanne's Doubt', in *Sense and Non-sense*, Evanston, Illinois, 1964, pp. 9–25

Merleau-Ponty 1945B Maurice Merleau-Ponty, *La Phénoménologie de la perception*, Paris, 1945; *The Phenomenology of Perception*, London, 1962 (1981)

Merleau-Ponty 1961 Maurice Merleau-Ponty, 'L'Oeil et l'esprit', *Arts de France*, 1, 1961, pp. 187–208; published in book form, Paris, 1964

Metzinger 1972 Jean Metzinger, *Le Cubisme était né*, Paris, 1972

Michaux 1945 Henri Michaux, *Epreuves, exorcismes, 1940–1944*, Paris, 1945

Micińska 1993 Anna Micińska, *Władysław Hasior*, Warsaw, 1993

Miklaszewski 1992 Krzysztof Miklaszewski, *Spotkania z Tadeuszem Kantorem (Meeting Tadeusz Kantor)*, Kraków, 1992

Miller 1994 Richard Miller, *Cobra*, Paris, 1994

Millet 1987 Catherine Millet, *L'Art contemporain en France*, Paris, 1987

Millet 1991 Catherine Millet, *L'Aventure de Denise René*, Paris, 1991

Milner 1988 John Milner, *The Studios of Paris: The Capital of Art in the Late Nineteenth Century*, New Haven and London, 1988

Minière 1994 Claude Minière, *L'Art en France 1960–1995*, Paris, 1994

Mitchell 1994 Clio Mitchell, 'Secrets de l'art magique surréaliste': Magic and the Myth of the Artist-Magician in Surrealist Aesthetic Theory and Practice, PhD dissertation, University of London, 1994

Monnerot 1945 Jules Monnerot, *La Poésie moderne et le sacré*, Paris, 1945

Monnerot 1949 Jules Monnerot, *Sociologie du communisme*, Paris, 1949

Monnier 1976 Adrienne Monnier, *The Very Rich Hours of Adrienne Monnier*, Richard McDougall (trans.), London, 1976

Monnier 1991 Gérard Monnier, *Des Beaux-Arts aux arts plastiques*, Besançon, 1991

Monnier 1995 Gérard Monnier, *L'Art et ses institutions en France de la Révolution à nos jours*, Paris, 1995

Mont-de-Marsan 1993 *Assia, sublime modèle*, exh. cat., Musée Despiau-Wlerick, Mont-de-Marsan, 1993

Monte Carlo 2001 *Gilles Aillaud: la jungle des villes*, exh. cat., Salle de Quai Antoine-Ier, Monte Carlo, 2001

Montefiore 1907 Dora B. Montefiore, in *Social Democrat*, 15 October 1907

Montier 1995 Pascal du Montier, *Les Situationnistes et Mai '68. Théorie et pratique de la révolution (1966–1972)*, Paris, 1995

Montreal 1991 *The 1920s: Age of Metropolis*, exh. cat., Montreal Museum of Fine Arts, 1991

Morel 1985 Jean-Pierre Morel, *Le Roman insupportable. L'Internationale littéraire en France (1920–1932)*, Paris, 1985

Morton 2000 Patricia A. Morton, *Hybrid Modernities: Architecture and Representation at the 1931 Colonial Exposition, Paris*, Cambridge, Mass., 2000

Mossuz-Lavau 1996 Janine Mossuz-Lavau, 'André Malraux ministre: une nouvelle vision de la France, une idée certaine de la culture', in Girard and Gentil 1996, pp. 19–33

Moulignat 1977 François Moulignat, *Les Artistes face à la crise et la montée du fascisme, 1936–1939*, 3ème cycle dissertation, Université de Paris-Sorbonne, 1977

Moulin 1967 Raymonde Moulin, *Le Marché de la peinture en France*, Paris, 1967

Munich 1979 *Ungarische konstruktivische Kunst 1920–1977*, exh. cat., Kunstverein, Munich, 1979

Münster 1978 Gladys Fabre, *Abstraction-Création 1931–1936*, exh. cat., Westfälisches Landesmuseum für Kunst und Kulturgeschichte, Münster; Musée d'Art Moderne de la Ville de Paris, 1978

Münster 1999 *Simon Hantaï, Werke von 1960 bis 1995*, exh. cat., Westfälisches Landesmuseum für Kunst und Kulturgeschichte, Münster, 1999

Münster 2001 *Otto Freundlich, Kräfte der Farbe*, exh. cat., Westfälisches Landesmuseum für Kunst und Kulturgeschichte, Münster, 2001

Murawska-Muthesius 1999 Katarzyna Murawska-Muthesius, 'Curator's Memory: The Case of the Missing "Man of Marble", or the Rise and Fall of Socialist Realism in Poland', in *Memory and Oblivion* (Proceedings of the XXIXth International Congress of the History of Art, Amsterdam, 1–7 September 1996), W. Reinink and J. Stumpel (eds), Rotterdam, 1999, pp. 905–12

Murawska-Muthesius 2000 *Borders in Art: Revisiting 'Kunstgeographie'*, Katarzyna Murawska-Muthesius (ed.), Warsaw, 2000

Murawska-Muthesius 2000B Katarzyna Murawska-Muthesius, 'Who Drew the Iron Curtain? Images East and West', in Murawska-Muthesius 2000, pp. 241–48

Murawska-Muthesius forthcoming Katarzyna Murawska-Muthesius, 'Dreams of Sleeping Beauty: Henry Moore in Polish Art Criticism and Media', in *Henry Moore*, Jane Beckett and Fiona Russell (eds)

Nadeau 1945 Maurice Nadeau, *Histoire du surréalisme*, Paris, 1945; republished 1964

Nantes 1984 *Autour de Michel Ragon*, exh. cat., Musée des Beaux-Arts, Nantes, 1984

Nantes 1997 *Camille Bryen*, exh. cat., Musée des Beaux-Arts, Nantes, 1997

New York 1961 *Fifteen Polish Painters*, with an introduction by Peter Selz, exh. cat., Museum of Modern Art, New York, 1961

New York 1962 *The New Realists*, exh. cat., Sidney Janis Gallery, New York, 1962

New York 1976 John Elderfield, *The 'Wild Beasts': Fauvism and Its Affinities*, exh. cat., Museum of Modern Art, New York, 1976

New York 1985 Romy Golan and Kenneth E. Silver, *The Circle of Montparnasse: Jewish Artists in Paris 1905–1945*, exh. cat., Jewish Museum, New York, 1985

New York 1987 *Iliazd and the Illustrated Book*, exh. cat., Museum of Modern Art, New York, 1987

New York 1991 *High and Low: Modern Art and Popular Culture*, Kirk Varnedoe and Adam Gopnik (eds), exh. cat., Museum of Modern Art, New York, 1991

New York 1996 *Antonin Artaud*, Margit Rowell (ed.), exh. cat., Museum of Modern Art, New York, 1996

New York 1996B *Carolee Schneemann. Up to and Including Her Limits*, exh. cat., New Museum of Contemporary Art, New York, 1996

New York 1997 *Gender Performance and Photography*, exh. cat., Solomon R. Guggenheim Museum, New York, 1997

New York 1998 *Premises: Invested Spaces in Visual Arts, Architecture and Design from France, 1958–1998*, exh. cat., Solomon R. Guggenheim Museum, New York, 1998

New York 1998B *Rendezvous*, exh. cat., Solomon R. Guggenheim Museum, New York, 1998

New York 1998C *Sculpture for a Large Wall, 1957*, James Meyer (ed.), exh. cat., Matthew Marks Gallery, New York, 1998

Nice 1993 *Chroniques niçoises: genèse d'un musée 1945–72*, exh. cat., Musée d'Art Moderne et d'Art Contemporain, Nice, 1993

Nice 1993B *Marie Raymond Rétrospective, 1937–1907*, exh. cat., Musée d'Art Moderne et d'Art Contemporain, Nice, 1993

Nice 2000 *Yves Klein, la vie, la vie elle-même qui est l'absolu/Yves Klein, Long Live the Immaterial*, exh. cat., Musée d'Art Moderne et d'Art Contemporain, Nice, 2000 (French and English editions)

Nicholas 1994 Lynn H. Nicholas, *The Rape of Europa. The Fate of Europe's Treasures in the Third Reich and the Second World War*, New York, 1994

Nieszawer 2000 Nadine Nieszawer, with Marie Boyé and Paul Fogel, *Peintres juifs de Paris, 1905–1939, Ecole de Paris*, Paris, 2000

Nora 1984 *Les Lieux de Mémoire*, Pierre Nora (ed.), vol. I, *La République*, Paris, 1984

Nora 1986 *Les Lieux de Mémoire*, Pierre Nora (ed.), vol. II, *La Nation*, Paris, 1986

Nora 1992 *Les Lieux de Mémoire*, Pierre Nora (ed.), vol. III, *Les Frances*, Paris, 1992

Nowaczyk 1996 Włodzimierz Nowaczyk, 'The Tropes of Modernity', in Poznań 1996, pp. 260–71

Oberthür 1994 Mariel Oberthür, *Montmartre en liesse, 1880–1900*, Paris, 1994

Opałka 1992 Roman Opałka, *Opałka: 1965/1–∞*, Christian Schlatter (ed.), Paris, 1992

Orléans 1995 *Le Front Populaire et l'art moderne. Hommage à Jean Zay, 1936–1939*, exh. cat., Musée des Beaux-Arts, Orléans, 1995

Ory 1976 Pascal Ory, *Les Collaborateurs*, Paris, 1976

Ory 1994 Pascal Ory, *La Belle Illusion: culture et politique sous le signe du Front Populaire, 1935–1938*, Paris, 1994

Ory 1994B Pascal Ory, 'Paris, lieu de création et de légitimation internationales', in Marès and Milza 1994, pp. 359–72

Ory 1996 Pascal Ory, 'L'Affaire Lipchitz, ou Prométhée fracassé', in Paris 1996, pp. 152–53

Pacquement 1977 Alfred Pacquement, 'Jean Dubuffet à New York: Américains à Paris dans les années 50', in Paris 1977, pp. 679 ff

426

Palm Beach 1999 David Setford, *Raoul Dufy: Last of the Fauves*, exh. cat., Norton Museum of Art, West Palm Beach, 1999

Parent and Perrot 1983 François Parent and Raymond Perrot, *Le Salon de la Jeune Peinture: une histoire 1950–1983*, Montreuil, 1983

Paris 1937 *Chefs-d'œuvre de l'art français*, exh. cat., Palais de Tokyo, Paris, 1937

Paris 1939 *Exposition David*, exh. cat., Orangerie des Tuileries, Paris, 1939

Paris 1940 'Exposition antimaçonnique', unpublished photographic dossier of exhibition, Petit Palais, Paris, 1940

Paris 1941 'Exposition de la France Européenne', unpublished photographic dossier of exhibition, Grand Palais, Paris, 1941

Paris 1941B *Le Juif et la France*, exh. cat., Palais Berlitz, Paris, 1941

Paris 1942 *Exposition Arno Breker*, exh. cat., Orangerie des Tuileries, Paris, 1942

Paris 1942B 'Exposition internationale: le Bolchévisme contre l'Europe', unpublished photographic dossier of exhibition, Salle Wagram, Paris, 1942

Paris 1946 *Art et résistance*, exh. cat., Musée des Arts Modernes [sic], Paris, 1946

Paris 1946B *Les Chefs-d'œuvre des collections privées françaises retrouvées en Allemagne par la Commission de Récupération Artistique et les Services Alliés*, exh. cat., Orangerie de Tuileries, Paris, 1946

Paris 1946C *Mirobolus, Macadam et Cie*, exh. cat., Galerie René Drouin, Paris, 1946

Paris 1946D *La Tapisserie française du moyen âge à nos jours*, exh. cat., Musée d'Art Moderne, Paris, 1946

Paris 1946E *UNESCO: Exposition internationale d'art moderne*, exh. cat., Musée d'Art Moderne, Paris, 1946

Paris 1947 *Exposition internationale du Surréalisme*, André Breton (ed.), exh. cat., Galerie Maeght, Paris, 1947

Paris 1947B André Breton, *Exposition Toyen*, exh. cat., Galerie Denise René, Paris, 1947

Paris 1947C *Matta*, exh. cat., Galerie René Drouin, Paris, 1947

Paris 1947D *Vincent van Gogh*, exh. cat., Orangerie des Tuileries, Paris, 1947

Paris 1947E *William Blake*, exh. cat., Galerie René Drouin, Paris, 1947

Paris 1948 *David, exposition en honneur du 2ème centenaire de sa naissance*, exh. cat., Orangerie des Tuileries, Paris, 1948

Paris 1949 *Matisse, œuvres récentes, 1947–1948*, exh. cat., Musée National d'Art Moderne, Paris, 1949

Paris 1957 *L'Aventure dada, 1916–1922*, exh. cat., Galerie de l'Institut, Paris, 1957

Paris 1957B *Précurseurs de l'art abstrait en Pologne: Kazimierz Malewicz, Katarzyna Kobro, Władysław Strzemiński, Henryk Berlewi, Henryk Stażewski*, Henryk Berlewi, Jean Cassou and Julian Przyboś (eds), exh. cat., Paris, 1957

Paris 1959 *L'Art abstrait et l'avant-garde en Yougoslavie*, exh. cat., Galerie Denise René, Paris, 1959

Paris 1959B *Modifications. Vingt peintures modifiées par Asger Jorn*, exh. cat., Galerie Rive Gauche, Paris, 1959

Paris 1959C *Première Biennale de Paris*, exh. cat., Musée d'Art Moderne de la Ville de Paris, 1959

Paris 1960 *Lajos Kassak*, exh. cat., Galerie Denise René, Paris, 1960

Paris 1961 *Douze peintres polonaises modernes*, Stanisław Lorentz and Jerzy Zanoziński (eds), exh. cat., Musée National d'Art Moderne, Paris, 1961

Paris 1961B *La France déchirée*, exh. cat., Galerie J, Paris, 1961

Paris 1961C *Le Nouveau Réalisme à Paris et à New York*, exh. cat., Galerie Rive Droite, Paris, 1961

Paris 1961D *Les Sources du vingtième siècle: les arts en Europe de 1884 à 1914*, exh. cat., Palais du Tokyo, Paris, 1961

Paris 1962 *15 Ans d'activités artistiques à la Maison de la Pensée Française*, exh. cat., Maison de la Pensée Française, Paris, 1962

Paris 1962B *Art moral, art sacré*, exh. cat., Galerie Rive Droite, Paris, 1962

Paris 1963 *31 Peintres américains*, exh. cat., American Center, Paris, 1963

Paris 1963B *Pop art américain*, exh. cat., Galerie Ileana Sonnabend, Paris, 1963

Paris 1964 Gérald Gassiot-Talabot, *Mythologies quotidiennes*, exh. cat., Musée d'Art Moderne de la Ville de Paris, 1964

Paris 1965 *La Figuration narrative dans l'art contemporain*, exh. cat., Galerie Creuze, Paris, 1965

Paris 1965B *Pop Por, Pop Corn, Corny*, exh. cat., Galerie Jean Larcade, Paris, 1965

Paris 1966 *Le Monde en question*, exh. cat., Musée d'Art Moderne de la Ville de Paris, 1966

Paris 1967 *L'Année 1966*, exh. cat., Galerie Mommaton, Paris, 1967

Paris 1967B *Bande dessinée et figuration narrative*, Musée des Arts Décoratifs, Paris, 1967

Paris 1967C *Exposition Szapocznikow*, exh. cat., Galerie Florence Houston-Brown, Paris, 1967

Paris 1967D *Hommage à Kassak*, exh. cat., Galerie Denise René, Paris, 1967

Paris 1968 *Les Américains*, exh. cat., Galerie Mommaton, Paris, 1968

Paris 1968B *Salon de Mai*, exh. cat., Musée d'Art Moderne de la Ville de Paris, 1968

Paris 1968C *Structures gonflables*, exh. cat., Musée d'Art Moderne de la Ville de Paris, 1968

Paris 1969 *Peinture moderne polonaise: sources et recherches*, Mieczysław Porębski (ed.), exh. cat., Musée Galliéra, Paris, 1969

Paris 1969B *Au Pied du mur. Asger Jorn, collages*, exh. cat., Galerie Jeanne Bucher, Paris, 1969

Paris 1969C *La Salle rouge du Vietnam*, exh. cat., ARC, Musée d'Art Moderne de la Ville de Paris, 1969

Paris 1972 *Douze Ans d'art contemporain*, exh. cat., Grand Palais, Paris, 1972

Paris 1973 *Alina Szapocznikow*, exh. cat., Musée d'Art Moderne de la Ville de Paris, 1973

Paris 1974 *Jean Paulhan et ses amis peintres*, exh. cat., Grand Palais, Paris, 1974

Paris 1975 *Le Mouvement/The Movement, Paris 1955*, exh. cat., Galerie Denise René, Paris, 1975

Paris 1976 *Francis Picabia*, exh. cat., Grand Palais, Paris, 1976

Paris 1977 *Paris–New York, 1905–1965*, exh. cat., Musée National d'Art Moderne, Centre Georges Pompidou, Paris, 1977; reissued 1991

Paris 1978 *Paris–Berlin, 1900–1933*, exh. cat., Musée National d'Art Moderne, Centre Georges Pompidou, Paris, 1978

Paris 1979 *Paris–Moscou, 1900–1933*, exh. cat., Musée National d'Art Moderne, Centre Georges Pompidou, Paris, 1979

Paris 1980 *Forces Nouvelles, 1935–1939*, exh. cat., Musée de la Ville de Paris, 1980

Paris 1980B *Les Réalismes entre révolution et réaction 1919–1939*, exh. cat., Musée National d'Art Moderne, Centre Georges Pompidou, Paris, 1980

Paris 1981 *Paris–Paris, Créations en France, 1937–1957*, exh. cat., Musée National d'Art Moderne, Centre Georges Pompidou, Paris, 1981; reissued 1992

Paris 1982 *Les Affiches de mai '68, ou l'imagination graphique*, exh. cat., Bibliothèque Nationale, Paris, 1982

Paris 1982B Gladys Fabre, *Léger and the Modern Spirit*, exh. cat., Musée d'Art Moderne de la Ville de Paris; Museum of Fine Arts, Houston, 1982

Paris 1982C *Štyrský, Toyen, Heisler*, J. Claverie (ed.), exh. cat., Musée National d'Art Moderne, Centre Georges Pompidou, Paris, 1982

Paris 1983 *Présences polonaises: l'art vivant autour du Musée de Łódź*, Dominique Bozo, Urszula Czartoryska, Nicole Ouvrard and Ryszard Stanisławski (eds), exh. cat., Musée National d'Art Moderne, Centre Georges Pompidou, Paris, 1983

Paris 1983B *Yves Klein*, exh. cat., Musée National d'Art Moderne, Centre Georges Pompidou, Paris, 1983

Paris 1984 *Un Art autre/Un Autre Art*, exh. cat., Artcurial, Paris, 1984

Paris 1984B *Charles Estienne et l'art à Paris, 1945–1966*, exh. cat., Centre National des Arts Plastiques, Paris, 1984

Paris 1985 *Matta*, exh. cat., Musée National d'Art Moderne, Centre Georges Pompidou, Paris, 1985

Paris 1986 *1960: Les Nouveaux Réalistes*, exh. cat., Musée d'Art Moderne de la Ville de Paris, 1986

Paris 1986B *Roland Barthes: le texte et l'image*, exh. cat., Pavillon des Arts, Paris, 1986

Paris 1987 *André Fougeron, pièces détachées, 1937–1987*, exh. cat., Galerie Jean-Jacques Dutko, Paris, 1987

Paris 1987B *Cinquantenaire de l'Exposition Internationale des arts et des techniques dans la vie moderne*, exh. cat., Musée d'Art Moderne de la Ville de Paris, 1987

Paris 1987C *Paris 1937. L'art indépendant*, exh. cat., Musée d'Art Moderne de la Ville de Paris, 1987

Paris 1987D Stephen Gilbert, *Peintures de l'époque Cobra et structures en métal, 1958–1984*, exh. cat., Galerie 1900–2000, Paris, 1987

Paris 1988 *Les Années cinquante*, exh. cat., Musée National d'Art Moderne, Centre Georges Pompidou, Paris, 1988

Paris 1988B *Le Demi-siècle lettriste*, exh. cat., Galerie 1900–2000, Paris, 1988

Paris 1988C *Les Demoiselles d'Avignon*, Hélène Seckel (ed.), exh. cat., Musée Picasso, Paris; Museu Picasso, Barcelona, 1988

Paris 1988D *Denise René présente… Mes années 50*, exh. cat., Galerie Denise René, Paris, 1988

Paris 1988E *Jean-Jacques Lebel, Retour d'exil, peintures, dessins, collages, 1954–1988*, exh. cat., Galerie 1900–2000, Paris, 1988

Paris 1988F *Mai '68. Les mouvements étudiants en France et dans le monde*, exh. cat., Musée d'Histoire Contemporaine (BDIC), Paris, 1988

Paris 1989 *Le Couteau entre les dents*, Philippe Buton and Laurent Gervereau (eds), exh. cat., Musée d'Histoire Contemporaine (BDIC), Paris, 1989

Paris 1989B *Happenings and Fluxus*, exh. cat., Galerie 1900–2000, Paris, 1989

Paris 1989C *Saint-Germain-des-Prés, 1945–1950*, exh. cat., Pavillon des Arts, Paris, 1989

Paris 1990 *Jean Bazaine*, exh. cat., Grand Palais, Paris, 1990

Paris 1990B *La Propagande sous Vichy, 1940–1944*, exh. cat., Musée d'Histoire Contemporaine (BDIC), Paris, 1990

Paris 1991 *André Breton. La beauté convulsive*, exh. cat., Musée National d'Art Moderne, Centre Georges Pompidou, Paris, 1991

Paris 1991B *Guillaume Apollinaire 1880–1918*, exh. cat., Bibliothèque Historique de la Ville de Paris, 1991

Paris 1992 *La Course au moderne: France et Allemagne dans l'Europe des années vingt, 1919–33*, exh. cat., Musée d'Histoire Contemporaine (BDIC), Paris, 1992

Paris 1992B *La France en guerre d'Algérie*, exh. cat., Musée d'Histoire Contemporaine (BDIC), Paris, 1992

Paris 1992C *Martial Raysse*, exh. cat., Galerie Nationale du Jeu de Paume, Paris, 1992

Paris 1993 *Apollinaire, critique d'art*, exh. cat., Pavillon des Arts, Paris, 1993

Paris 1993B *Manifeste. Une histoire parallèle, 1960–1990*, exh. cat., Musée National d'Art Moderne, Centre Georges Pompidou, Paris, 1993

Paris 1994 *Hors Limites. L'Art et la vie 1952–1994*, exh. cat., Musée National d'Art Moderne, Centre Georges Pompidou, Paris, 1994

Paris 1994B *Quelque Chose de très mystérieux: intuitions esthétiques de Michel Tapié*, exh. cat., Artcurial, Paris, 1994

Paris 1995 *Brancusi*, exh. cat., Musée National d'Art Moderne, Centre Georges Pompidou, Paris; Philadelphia Museum of Art, 1995

Paris 1995B *La Déportation, le système concentrationnaire nazi*, exh. cat., Musée d'Histoire Contemporaine (BDIC), Paris, 1995

Paris 1995C *Jean Cassou, un musée imaginé*, exh. cat., Bibliothèque Nationale de France, Paris, 1995

Paris 1995D *Maurice Lemaître*, exh. cat., Musée National d'Art Moderne, Centre Georges Pompidou, Paris, 1995

Paris 1995E *Passions privées. Collections particulières d'art moderne et contemporain en France*, exh. cat., Musée d'Art Moderne de la Ville de Paris, 1995

Paris 1996 *Face à l'histoire. L'artiste moderne devant l'événement historique, 1933–1996*, exh. cat., Musée National d'Art Moderne, Centre Georges Pompidou, Paris, 1996

Paris 1996B Yve-Alain Bois and Rosalind Krauss, *L'Informe, mode d'emploi*, exh. cat., Musée National d'Art Moderne, Centre Georges Pompidou, Paris, 1996

Paris 1996C *Les Sixties, années utopies*, David Alan Mellor and Laurent Gervereau (eds), exh. cat., Musée d'Histoire Contemporaine (BDIC), Paris, 1996; republished in English as *Les Sixties: Britain and France 1962–73. The Utopian Years*, London, 1997

Paris 1997 *Les Années trente en Europe: le temps menaçant 1929–1939*, exh. cat., Musée d'Art Moderne de la Ville de Paris, 1997

Paris 1997B *Présentation des œuvres récupérées après la Seconde Guerre mondiale/A Presentation of Artworks Recovered After the Second World War in the Care of the Musée National d'Art Moderne*, exh. cat., Musée National d'Art Moderne, Centre Georges Pompidou, Paris, 1997

Paris 1998 *Les Années Supports-Surfaces dans les collections du Centre Georges Pompidou*, exh. cat., Galerie Nationale du Jeu de Paume, Paris, 1998

Paris 1998B *Jean Pierre Raynaud*, exh. cat., Galerie Nationale du Jeu de Paume, Paris, 1998

Paris 1999 *Bernard Anthonioz ou la liberté d'art*, exh. cat., Couvent des Cordeliers, Paris, 1999

Paris 1999B *Erró, images du siècle*, exh. cat., Galerie Nationale du Jeu de Paume, Paris, 1999

Paris 1999C *Gutai*, exh. cat., Galerie Nationale du Jeu de Paume, Paris, 1999

Paris 2000 *L'Ecole de Paris, 1904–1929, la part de l'autre*, exh. cat., Musée d'Art Moderne de la Ville de Paris, 2000

Paris 2000B *La Méditerranée de Courbet à Matisse*, Françoise Cachin (ed.), exh. cat., Grand Palais, Paris, 2000

Paris 2001 *André Malraux, le dernier des romantiques, et la modernité*, exh. cat., Musée de la Vie Romantique, Paris, 2001

Paris 2001B *Denise René, une galerie dans l'aventure de l'art abstrait, 1944–1978*, exh. cat., Musée National d'Art Moderne, Centre Georges Pompidou, Paris, 2001

Pataki 1999 Gábor Pataki, 'The History of Hungarian Art', in Vienna 1999, pp. 251–60

Pataki 2000 Gábor Pataki, 'Two Chapters of Franco-Hungarian Art Connections: The European School (1945–1948) and the Zugló Circle (1958–1968)', in Hewitt 2000, pp. 397–408

Paul 1986 April Paul, 'Introduction à la peinture moderne américaine. Six Young American Painters of the Samuel Kootz Gallery: An Inferiority Complex in Paris', *Arts Magazine*, 60, 6, February 1986, pp. 65–71

Paulhan 1946 Jean Paulhan, *Braque le patron*, Geneva and Paris, 1946

Paulhan 1951 Jean Paulhan, *Lettres aux directeurs de la Résistance*, Paris, 1951; republished in an expanded edition, Paris, 1968

Paulhan 1962 Jean Paulhan, *L'Art informel. Eloge*, Paris, 1962

Pejić 1999 Bojana Pejić, 'Serbia: Socialist Modernism and the Aftermath', in Vienna 1999, pp. 115–23

Penrose 1962 Roland Penrose, *Picasso: His Life and Work*, New York, 1962

Penrose 1980 Roland Penrose, *Portrait of Picasso*, New York, 1980 (third edition)

Périer 1998 Henry Périer, *Pierre Restany, l'alchimiste de l'art*, Paris, 1998

Perregaux 1983 Aloys Perregaux, *Charles Lapicque*, Paris, 1983

Perruchot 1959 Henri Perruchot, 'Les Peintres de Montmartre', *Le Crapouillot*, 45, 1959, pp. 19–27

Perry 1995 Gill Perry, *Women Artists and the Parisian Avant-Garde: Modernism and 'Feminine' Art, 1900 to the Late 1920s*, Manchester, 1995

Perry and Wilson 1997 Gill Perry and Sarah Wilson, 'Training and Professionalism. France. Twentieth Century', in Gaze 1997, pp. 92–98

Pery 1997 Jenny Pery, *The Grand Play of Light: The Art and Life of Caziel 1906–1988*, London, 1997

Peyré 2001 Yves Peyré, *Peinture et poésie. Le dialogue par le livre 1874–2000*, Paris, 2001

Phélip 2000 Laure Phélip, *La Réception des artistes américains à Paris, 1958–1968: Néo-Dadaïsme et Pop Art*, MA dissertation, Université Paris I, 2000

Piene and Mach 1973 *Zero*, Otto Piene and Heinz Mach (eds), Howard Bedman (trans.), Cambridge, Mass., 1973

Pierre 1982 *Tractes surréalistes et déclarations collectives*, vol. I: 1922–1939, vol. II: 1940–1969, José Pierre (ed.), Paris, 1982

Pierre 1986 José Pierre, 'Le Surréalisme en 1947', in Marseilles 1986, pp. 283–88

Piniau and Tio Bellido 1998 Bernard Piniau and Ramon Tio Bellido, *L'Action artistique de la France dans le monde*, Paris, 1998

Piotrowski 1996 Piotr Piotrowski, The 'Thaw', in Poznań 1996, pp. 243–59

Piotrowski 1997 Piotr Piotrowski, 'Art versus History; History versus Art', in Rottenberg 1997, pp. 209–57

Piotrowski 1999 Piotr Piotrowski, 'The Grey Zone of Europe', in Stockholm 1999, pp. 35–41

Piotrowski 1999B Piotr Piotrowski, *Znaczenia modernizmu: W stronę historii sztuki polskiej po 1945 roku* (*The Meanings of Modernism: Towards a History of Polish Art After 1945*), Poznań, 1999

Piotrowski 2000 Piotr Piotrowski, 'The Geography of Central/East European Art', in Murawska-Muthesius 2000, pp. 43–50

Piotrowski 2000B Piotr Piotrowski, 'Modernism and Socialist Culture: Polish Art in the Late 1950s', in Reid and Crowley 2000, pp. 133–48

Piotrowski 2000C Piotr Piotrowski, 'Totalitarianism and Modernism: The "Thaw" and Informel Painting in Central Europe, 1955–1965', *Artium Quaestiones*, 10, 2000, pp. 119–74

Piotrowski 2000D Piotr Piotrowski, 'Modernism and Totalitarianism [sic] II. Myths of Geometry: Neo-Constructivism in Central Europe, 1948–1970', *Artium Quaestiones*, 11, 2000, pp. 101–54

Piotrowski forthcoming Piotr Piotrowski, *The Avant-Garde in the Shadow of Yalta: Central European Art 1945–1990*

Plemet 1994 *87 Images, 71 artistes, 23 pays de la planisphère Phases*, exh. cat., Collège Public Louis Guilloux, Plemet, 1994

Pleynet 1967 Marcelin Pleynet, 'De la Peinture aux Etats-Unis', in three parts, *Les Lettres françaises*, 30 March 1967, pp. 27–28; 6 April 1967, pp. 31–32; and 13 April 1967, p. 33

Pleynet 1977 Marcelin Pleynet, 'De la Culture moderne', in Paris 1977, pp. 180–226

Pleynet 1984 Marcelin Pleynet, *Painting and System*, Chicago and London, 1984

Pleynet 1986 Marcelin Pleynet, *Les Etats-Unis de la peinture*, Paris, 1986

Polizzotti 1995 Mark Polizzotti, *Revolution of the Mind: The Life of André Breton*, London, 1995

Pomerand 1950 Gabriel Pomerand, *Saint-Ghetto-des-Prêts*, Paris, 1950

Ponge 1946 Francis Ponge, *Note sur les Otages*, Paris, 1946

Portland 1998 *Impressions of the Riviera: Monet, Renoir, Matisse and Their Contemporaries*, Kenneth Wayne (ed.), exh. cat., Portland Museum of Art, 1998

Poulanges 1995 Alain Poulanges, 'La Chanson à Saint-Germain et alentour', in Gumplowicz and Klein 1995, pp. 183–93

Poznań 1996 *Odwilz: Sztuka ok. 1956 r./ The Thaw: Polish Art c. 1956*, Piotr Piotrowski (ed.), exh. cat., Muzeum Narodowe, Poznań, 1996 (parallel Polish and English texts)

Prague 1947 *Mezinárodní surrealismus* (*International Surrealism*), André Breton and Karel Teige (eds), exh. cat., Topičův Salon, Prague, 1947

Prague 1993 *Jean Dubuffet*, exh. cat., Jízdárna Prazskévo hradu, Národní Galerie, Prague, 1993

Prague 1994 *Ohniska znovuzrozeni/České umění 1956–1963* (*Focal Points of Revival/Czech Art 1956–1963*), exh. cat., Gallery of the City of Prague, 1994

Prague 1996 *Český surrealismus 1929–1953: Skupina surrealistů v ČSR: události, vztahy, inspirace* (*Czech Surrealism 1929–1953. Association of Surrealists in the Czechoslovakian Republic: Events, Relations, Inspirations*), Karel Srp and Lenka Bydžovská (eds), exh. cat., Gallery of the City of Prague, 1996

Prague 2000 *Toyen*, Karel Srp (ed.), exh. cat., City Art Gallery, Prague, 2000

Ragon 1959 Michel Ragon, *La Peinture actuelle*, Paris, 1959

Ragon 1969 Michel Ragon, *25 ans d'art vivant: chronique vécue de l'art contemporain de l'abstraction au pop art, 1944–1969*, Tournai, 1969

Ragon 1992 Michel Ragon, 'Jean Dubuffet, sa relation aux écrivains libertaires', in *Dubuffet*, Hubert Damisch (ed.), papers of a conference held at the Galerie Nationale du Jeu de Paume, Paris, 1992, pp. 36–44

Ragon 2001 Michel Ragon, *Chronique vécue de la peinture et de la sculpture, 1950–2000*, Paris, 2001

Raphael 1933 Max Raphael, *Proudhon, Marx, Picasso. Trois études sur la sociologie de l'art*, Paris, 1933

Régnier 1986 Philippe Régnier, *La Propagande anti-communiste de paix et liberté, France, 1950–1956*, dissertation, Université de Bruxelles, 1986

Reid 1996 Susan E. Reid, *Destalinisation and the Remodernisation of Soviet Art: The Search for a Contemporary Realism, 1953–1963*, PhD dissertation, University of Pennsylvania, 1996

Reid 2000 Susan E. Reid, 'The Exhibition "Art of Socialist Countries", Moscow 1958–59, and the Contemporary Style of Painting', in Reid and Crowley 2000, pp. 101–32

Reid and Crowley 2000 *Style and Socialism: Modernity and Material Culture in Postwar Eastern Europe*, Susan E. Reid and David Crowley (eds), Oxford and New York, 2000

Reims 1995 *Créer pour survivre*, exh. cat., Musée des Beaux-Arts, Reims, 1995

Rennes 1991 *Une Scène parisienne 1968–1972*, exh. cat., Centre d'Histoire de l'Art Contemporain, Rennes, 1991

Rennes 1994 *Murmures des rues. François Dufrêne, Raymond Hains, Mimmo Rotella, Jacques Villeglé, Wolf Vostell*, exh. cat., Centre d'Histoire de l'Art Contemporain, Rennes, 1994

Restany 1958 Pierre Restany, 'Japan Made in Paris', *Cimaise*, 5, 5, May–June 1958

Restany and Taillandier 1963 Pierre Restany and Yvon Taillandier, 'Le Japon a rejoint l'art moderne en prolongeant ses traditions', and 'Les Peintres japonais manquent des murs', *Galerie des Arts*, November 1963, pp. 16–25

Restany 1977 Pierre Restany, 'Chelsea 1960', in Paris 1977, pp. 227 ff

Restany 1982 Pierre Restany, 'The Ex-voto for St Rita of Cascia', in Houston 1982, pp. 255–56

Restany 1990 Pierre Restany, *60/90: trente ans de Nouveau Réalisme*, Paris, 1990

Reut-Arman 2000 Tita Reut-Arman, *Il y a lieux, l'album d'Arman*, Paris, 2000

Reynolds 1999 Michael Reynolds, *Hemingway: The Paris Years*, New York and London, 1999

Richardson 1996 John Richardson, with Marilyn McCully, *A Life of Picasso, Vol. II: 1907–1917: The Painter of Modern Life*, London, 1996

Rifkin 1993 Adrian Rifkin, *Street Noises: Parisian Pleasure 1900–1940*, Manchester, 1993

Rioux 1991 Jean-Pierre Rioux, 'La Guerre franco-française', in Scriven and Wagstaff 1991, pp. 273–91

Roberts 1986 James Roberts, *Japanese Influence on the School of Paris, Masson, Alechinsky, Degottex, 1947–1967*, with chronology, BA dissertation, Courtauld Institute of Art, University of London, 1986

Romains 1908 Jules Romains, *La Vie unanime*, L'Abbaye de Créteil, 1908

Rome 1987 *Sartre e l'arte*, exh. cat., Villa Medici, Rome, 1987

Roque 1986 Georges Roque, 'Colour in French Painting', in *Colour Since Matisse*, New York, 1986, pp. 156–66

Ross 1995 Kristin Ross, *Fast Cars, Clean Bodies. Decolonisation and the Reordering of French Culture*, Cambridge, Mass., and London, 1995

Rottenberg 1997 *Art from Poland: 1945–1996*, Anda Rottenberg (ed.), Warsaw, 1997

Roussel 1984 Hélène Roussel, 'Les Peintres allemands émigrés en France et l'Union des Artistes Libres', in *Les Bannis de Hitler: accueil et lutte des exilés en France 1933–39*, Gilbert Badia (ed.), Paris, 1984, pp. 287 ff

Rousset 1946 David Rousset, *L'Univers concentrationnaire*, Paris, 1946

Rousso 1987 Henry Rousso, *Le Syndrome de Vichy de 1944 à nos jours*, Paris, 1987 (1990); *The Vichy Syndrome*, Arthur Goldhammer (trans.), Cambridge, Mass., and London, 1991

Roux et al. 1978 Louis Roux et al., *Art et idéologies: l'art en Occident 1945–1949*, Saint-Etienne, 1978

Rubin 1961 William Rubin, *Modern Sacred Art and the Church of Assy*, New York, 1961

Saarbrücken 1989 *Paris, Kunst der 50 Jahre. Artaud, Chaissac, Dubuffet, Fautrier, Michaux, Requichot, Wols*, exh. cat., Saarband Museum, Saarbrücken, 1989

Sabatier 1989 Roland Sabatier, *Le Lettrisme: les créations et les créateurs*, Nice, 1988

Sables-d'Olonne 1999 *Peter Saul*, exh. cat., Musée de l'Abbaye Sainte Croix, Les Sables-d'Olonne, 1999

Sables-d'Olonne 2001 *René Drouin, galeriste et éditeur d'art visionnaire*, exh. cat., Musée de l'Abbaye Sainte Croix, Les Sables-d'Olonne, 2001

Sabourin 1972 Pascal Sabourin, *La Réflexion sur l'art d'André Malraux*, Paris, 1972

Sadler 1998 Simon Sadler, *The Situationist City*, Cambridge, Mass., and London, 1998

Saint-Etienne 1987 *L'Art en Europe, les années décisives, 1945–1953*, Bernard Ceysson (ed.), exh. cat., Musée de Saint-Etienne, 1987

Saint-Etienne 1993 Bernard Ceysson, *L'Ecriture griffée*, exh. cat., Musée de Saint-Etienne, 1993

Saint-Paul 1973 *André Malraux*, exh. cat., Fondation Maeght, Saint-Paul, 1973

Saint-Paul 1996 *Germaine Richier, rétrospective*, exh. cat., Fondation Maeght, Saint-Paul, 1996

San Francisco 1998 *Picasso and the War Years 1937–1945*, exh. cat., Palace of the Legion of Honor, San Francisco, 1998

Sartre 1945 Jean-Paul Sartre, 'Réflexions sur la question juive', *Les Temps modernes*, 1945; published in book form, Paris, 1946 (1954)

Sartre 1947 Jean-Paul Sartre, 'Qu'est-ce que la littérature?', *Les Temps modernes*, 1947; published in book form, Paris, 1948 (1993)

Sartre 1948 Jean-Paul Sartre, 'The Search for the Absolute', in *Alberto Giacometti: Exhibition of Sculpture, Painting, Drawing*, exh. cat., Pierre Matisse Gallery, New York, 1948, pp. 2–22; published in French as 'La Recherche de l'absolu', in *Situations III*, Paris, 1949 (1992), pp. 289–305

Savinel, Roubaud and Noël 1996 Christine Savinel, Jacques Roubaud and Bernard Noël, *Roman Opałka*, Paris, 1996

Schiffmann 1983 Winifred Schiffmann, *Americans in Paris, 1945–1965*, MA dissertation, Courtauld Institute of Art, University of London, 1983

Schimmel 1998 Paul Schimmel, 'Leap into the Void: Performance and the Object', in Los Angeles 1998, pp. 17–119

Schlatter 1993 Christian Schlatter, 'La Formation des avant-gardes françaises à partir de 1945', in Marseilles 1993, pp. 259–83

Schulmann 2000 Didier Schulmann, *Le Pillage de l'art en France pendant l'occupation et la situation des 2000 œuvres confies aux musées nationaux*, Paris, 2000

Schulmann 2000B Didier Schulmann, 'Les Spoliations d'œuvres d'art par les nazis: le cas de la France', in *Encyclopédie Universalis*, 2000, pp. 34–91

Schwerin 1996 *Mail Art: Osteuropa im internationalen Netzwerk/Eastern Europe in the International Network*, Katrin Mrotzek and Kornelia Röder (eds), exh. cat., Staatliches Museum, Schwerin, 1996; Kunsthalle, Budapest, 1998

Scoppetone 1998 Dina Scoppetone, *The Salon de Mai in Cuba, 1967*, MA dissertation, Courtauld Institute of Art, University of London, 1998

Scriven and Wagstaff 1991 *War and Society in Twentieth-Century France*, Michael Scriven and Peter Wagstaff (eds), New York, Munich and Oxford, 1991

Seckel 1976 Hélène Seckel, 'Don Juan, unique eunuque', in *Francis Picabia*, exh. cat., Grand Palais, Paris, 1976, pp. 35–39

Segré 1998 Monique Segré, *L'Ecole des Beaux-Arts, XIX–XX siècles*, Paris, 1998

Semin 1992 Didier Semin, 'Martial Raysse, alias Hermès: la voie des images', in Paris 1992C, pp. 13–26

Semin and Ewig 2000 Didier Semin and Isabelle Ewig, 'Comment se fait une exposition? A propos "When Attitudes Become Form"', *Cahiers du Musée National d'Art Moderne*, Autumn 2000, pp. 5–7, 34–35

Seuphor 1949 Michel Seuphor, *L'Art abstrait, ses origines, ses premiers maîtres*, Paris, 1949

Ševčík and Ševčíková 1999 Jiří Ševčík and Jana Ševčíková, 'Thinking About Identity on the Threshold of Europe', in Vienna 1999, pp. 231–41

Seyne-sur-mer 2000 J.-L. Pradel, *La Figuration narrative*, exh. cat., Villa Tamaris, La Seyne-sur-mer, 2000

Shafto 1999 Sally Shafto, 'Saut dans le vide. Godard et le peintre', *Cinémathèque*, Autumn 1999, pp. 92–107

Shafto 2000 Sally Shafto, *The Zanzibar Films and the Dandies of May 1968*, New York, 2000

Sheringham 1996 *Parisian Fields*, Michael Sheringham (ed.), London, 1996

Sherman 1999 Daniel J. Sherman, *The Construction of Memory in Interwar France*, Chicago, 1999

Silver 1977 Kenneth E. Silver, 'Purism: Straightening Up After the Great War', *Artforum*, March 1977, pp. 56–63

Silver 1985 Kenneth E. Silver, 'Jewish Artists in Paris 1905–1945', in New York 1985, pp. 50–57

Silver 1989 Kenneth E. Silver, *Esprit de Corps: The Art of the Parisian Avant-Garde and the First World War, 1914–1925*, London and New York, 1989

Silver 2000 Kenneth E. Silver, 'Made in Paris', in Paris 2000, pp. 41–57

Silver 2001 Kenneth E. Silver, *Making Paradise: Art, Modernity, and the Myth of the French Riviera*, Cambridge, Mass., and London, 2001

Simenon and Bouret 1958 Georges Simenon and Jean Bouret, *Bernard Buffet*, Paris, 1958

Simmons 1993 Thomas W. Simmons Jr, *Eastern Europe in the Postwar World*, New York, 1993

Sintra 1996 *The Berardo Collection*, exh. cat., Sintra Museum of Modern Art, 1996

Soffici 1954 Ardengo Soffici, *Il salto vitale*, Florence, 1954

Sogno 1989 Agnès Sogno, 'La Revue "Atalante" pendant l'occupation', in *Art et fascisme*, Pierre Milza and Fanette Roche-Pézard (eds), Paris, 1989

Sosnowska 1999 Joanna Sosnowska, *Polacy na Biennale Sztuki w Wenecji 1895–1999* (Poles at the Venice Biennale 1895–1999), Warsaw, 1999

Sosnowski and Piasecki 1998 *Roman Opałka: Katalog wczesnych prac* (Roman Opałka. The Early Works. A Catalogue Raisonné), Paweł Sosnowski and Maciej Piasecki (eds), Warsaw, 1998

Souriau 1962 Etienne Souriau, 'Existe-t-il une palette française?', *Arts de France*, 2, 1962, pp. 23–42

Spire 1997 Marie-Brunette Spire, 'André Spire ou la renaissance de l'identité juive', in *L'École de pensée juive de Paris*, special number of *Pardès*, 23, 1997, pp. 45–56

Stanisławski 1988 Ryszard Stanisławski, 'Réalisme socialiste et avant-garde', in Paris 1988, pp. 204–09

Stanisławski 1992 Ryszard Stanisławski, 'Le Musée: un instrument critique', in Lyons 1992, pp. 9–12

Starzyński 1954 Juliusz Starzyński, 'Od Courbeta do Picassa, czyli o perspektywach sztuki nowoczesnej' ('From Courbet to Picasso, i.e. On the Perspectives of Modern Art'), *Materiały do Studiów i Dyskusji z Zakresu Teorii i Historii Sztuki, Krytyki Artystycznej oraz Badań nad Sztuką*, 5, 3–4, 1954, pp. 5–29

Stein 1938 Gertrude Stein, *Picasso*, London and Paris, 1938

Stein 1940 Gertrude Stein, *Paris, France*, London, 1940 (1995)

Sternhell 1983 Zeer Sternhell, *Ni droite, ni gauche. L'idéologie fasciste en France*, Paris, 1983 (1987)

Stil n.d. André Stil, 'Avance Fougeron!' (preface), in *Les Pays des mines d'André Fougeron*, Paris, n.d. [1950]

Stockholm 1968 Władysław Hasior, exh. cat., Moderna Museet, Stockholm, 1968

Stockholm 1999 *After the Wall: Art and Culture in Post-Communist Europe*, David Elliott and Bojana Pejić (eds), exh. cat., Moderna Museet, Stockholm, 1999

Stokes 1996 *From Stalinism to Pluralism: A Documentary History of Eastern Europe Since 1945*, Gale Stokes (ed.), Oxford and New York, 1996

Stonor Saunders 1999 Frances Stonor Saunders, *The Cultural Cold War: The CIA and the World of Arts and Letters*, London, 1999 (New York, 2000)

Strasbourg 1994 *Jeanne Bucher, une galerie d'avant-garde, 1925–1946*, exh. cat., Musée d'Art Moderne et Contemporain, Strasbourg, 1994

Strasbourg 2001 *La Planète Jorn*, Laurent Gervereau and Paul-Hervé Parsy (eds), exh. cat., Musée d'Art Moderne et Contemporain, Strasbourg, 2001

Strauss 1995 Thomas Strauss, *Zwischen Ostkunst und Westkunst: von der Avantgarde zur Postmoderne: Essays (1970–1995)*, Munich, 1995

Świca 1999 'Fifty Years Later' (interview with Mieczysław Porębski conducted by Marek Świca), *Exit: Nowa Sztuka w Polsce/New Art in Poland*, 1, 1999, pp. 1852–61

Szeemann 2000 Harald Szeemann, 'Journal et carnets de voyage touchant aux préparatifs et aux retombées de l'exposition 'When Attitudes Become Form' (Works, Concepts, Processes, Situations, Information) et à rien d'autre', *Cahiers du Musée National d'Art Moderne*, Autumn 2000, pp. 8–35

Tançons 2000 Claire Tançons, *Daniel Spoerri, ethnosyncrétisme*, MA dissertation, Courtauld Institute of Art, University of London, 2000

Tapié 1952 Michel Tapié, *Un Art autre*, Paris, 1952, n.p.; facsimile reprinted in Paris 1994B

Tapié 1956 Michel Tapié, *Observations of Michel Tapié in English*, Paul and Esther Jenkins (eds), New York, 1956

Taslitzky 1946 Boris Taslitzky, *Cent onze dessins faits à Buchenwald*, Paris, 1946 (1989, with preface by Julien Cain)

Taslitzky 1949 Boris Taslitzky, 'De la critique d'art et du nouveau réalisme français', *La Nouvelle Critique*, January 1949, pp. 77–83

Taslitzky 1955 Boris Taslitzky, 'Le Front Populaire et les intellectuels', *La Nouvelle Critique*, December 1955, pp. 11–16

Taylor 1948 A. J. P. Taylor, 'A Strange Congress', *Manchester Guardian*, 2 September 1948

Tchakhotine 1939 Serge Tchakhotine, *Le Viol des foules par la propagande politique*, Paris, 1939 (banned) (1954)

Temkin 1995 Ann Temkin, 'Brancusi and His American Collectors', in Paris 1995, pp. 50–71

Tesdorpf 2001 Catharina Tesdorpf, *Attitudes and Connections: Curating the Sixties, Pontus Hulten and Harald Szeemann in Paris, Stockholm and Bern*, MA dissertation, Courtauld Institute of Art, University of London, 2001

Tester 1994 *The Flâneur*, Keith Tester (ed.), London, 1994

Thorez 1962 Maurice Thorez, *Le PCF, la culture et les intellectuels: textes de Maurice Thorez*, Paris, 1962

Todorova 1997 Maria Todorova, *Imaging the Balkans*, New York and Oxford, 1997

Topolski 1988 Felix Topolski, 'Confessions of a Congress Delegate', in *Fourteen Letters*, London, 1988

Tours 1986 Bernard Lamarche-Vadel, *Opałka: 1965/1–∞*, exh. cat., Centre de Création Contemporaine, Tours, 1986

Tours 1986B *A proximité des poètes et des peintres. Quarante ans d'édition Maeght*, exh. cat., Centre de Création Contemporaine, Tours, 1986

Tramoni 2000 Dorothée Tramoni, *Newman et la France*, MA dissertation, Université de Paris I, 2000

Trotsky 1923 Leon Trotsky, *Littérature et révolution*, Moscow, 1923

Troy 1991 Nancy J. Troy, *Modernism and the Decorative Arts in France: Art Nouveau to Le Corbusier*, New Haven and London, 1991

Turowski 1986 Andrzej Turowski, *Existe-t-il un art de l'Europe de l'Est? Utopie et idéologie*, Paris, 1986

Unesco 1991 *Unesco. Foyer vivant des bonheurs possibles*, Paris, 1991

Utley 2000 Gertje R. Utley, *Picasso: The Communist Years*, New Haven and London, 2000

Vailland 1948 Roger Vailland, *Le Surréalisme contre la Révolution*, Paris, 1948; reprinted in Vailland 1967, pp. 233–81

Vailland 1967 Roger Vailland, *Le Regard froid*, Lausanne, 1967

Valencia 1990 *Paris 1930, Arte Abstracto, Arte Concreto, Cercle et Carré*, Gladys C. Fabre (ed.), exh. cat., IVAM, Valencia, 1990

Valéry 1945 Paul Valéry, 'L'Amérique, projection de l'Europe', C. A. Hackett (trans.), *Variété*, 1, 1945, p. 9

Valland 1961 Rose Valland, *Le Front de l'art, défense des collections françaises*, Paris, 1961 (1997)

Vaneigem 1967 Raoul Vaneigem, *Traité de savoir-vivre à l'usage des jeunes générations*, Paris, 1967

Venice 1987 Pontus Hulten, *Jean Tinguely: A Magic Stronger than Death*, exh. cat., Palazzo Grassi, Venice, 1987

Venice 1990 *La France à Venise*, exh. cat., Peggy Guggenheim Foundation, Venice, 1990

Vercors 1989 Vercors (pseud.), 'Saint-Germain-des-Prés avant Saint-Germain-des-Prés', in Paris 1989C, pp. 6–11

Verdès-Leroux 1983 Janine Verdès-Leroux, *Au Service du Parti: le parti communiste, les intellectuels et la culture, 1944–1956*, Paris, 1983

Verdès-Leroux 1987 Janine Verdès-Leroux, *Le Réveil des somnambules: le parti communiste, les intellectuels et la culture, 1956–1985*, Paris, 1987

Vian 1974 Boris Vian, *Manuel de Saint-Germain-des-Prés*, Noël Arnaud (ed.), Paris, 1974

Viatte 1993 Germain Viatte, 'Dubuffet et les pouvoirs publics français', in Prague 1993, pp. 81–104

Viatte 1999 Germain Viatte, 'Au Service de la création artistique', in Paris 1999, pp. 59–111

Viatte 2001 Germain Viatte, 'André Malraux et les arts sauvages', in Paris 2001, pp. 145–48

Vicens 1960 *Prolégomènes à une esthétique autre de Michel Tapié*, Francesc Vicens (ed.), Barcelona, 1960

Vienet 1968 René Vienet, *Enragés et situationnistes dans le mouvement des occupations*, Paris, 1968

Vienna 1992 *Reduktivismus: Abstraktion in Polen, Tschechoslovakei, Ungarn 1950–1980*, exh. cat., Museum Moderner Kunst, Vienna, 1992

Vienna 1998 *Jean-Jacques Lebel*, exh. cat., Museum Moderner Kunst, Vienna, 1998

Vienna 1999 *Aspects/Positions: Fifty Years of Art in Central Europe 1949–1999*, Lóránd Hegyi (ed.), exh. cat., Museum Moderner Kunst, Vienna, 1999

Viéville 1981 Dominique Viéville, 'Vous avez dit géometrique? Le Salon des Réalités Nouvelles, 1946–1957', in Paris 1981, pp. 270–83

Vignoht 1985 Guy Vignoht, *La Jeune Peinture, 1941–1961*, Paris, 1985

Villeglé 1986 Jacques de la Villeglé, *Urbi et Orbi*, Mâcon, 1986

Villeglé 2001 Jacques Villeglé [sic], 'Catalogue, or Constitutive Ambiguity', in London 2001, n.p.

Warnod 1925 André Warnod, *Les Berceaux de la jeune peinture: l'Ecole de Paris*, Paris, 1925

Warnod 1978 Jeanine Warnod, *La Ruche and Montparnasse*, Paris, 1978

Warnod 1988 Jeanine Warnod, *Les Artistes de Montparnasse: La Ruche*, Paris, 1988

Warsaw 1937 *Od Maneta do dzień dzisiejszy/Exposition de la peinture française de Manet à nos jours*, Pierre Francastel, Claude Roger-Marx and Juliusz Starzyński (eds), exh. cat., Muzeum Narodowe, Warsaw, 1937

Warsaw 1946 Pierre Francastel and Michał Walicki, *Współczesne malarstwo francuskie* (Contemporary French Painting), exh. cat., Muzeum Narodowe, Warsaw, 1946

Warsaw 1946B Pierre Francastel and Michał Walicki, *Współczesne rysunki francuskie* (Contemporary French Drawings), exh. cat., Muzeum Narodowe, Warsaw, 1946

Warsaw 1947 *50 lat filmu francuskiego* (Fifty Years of French Cinema), exh. cat., Muzeum Narodowe, Warsaw, 1947

Warsaw 1948 *Współcześni malarze francuscy oraz ceramika Pabla Picassa ofiarowana przez autora Muzeum Narodowemu w Warszawie* (Contemporary French Painters and Pablo Picasso's Ceramics, Presented by the Artist to the National Museum in Warsaw), Pierre Moissy, Maria Rogoyska and Michał Walicki (eds), exh. cat., Muzeum Narodowe, Warsaw, 1948

Warsaw 1952 *Wystawa współczesnej plastyki francuskiej* (Exhibition of Contemporary French Art), Ryszard Stanisławski (ed.), with a foreword by Paul Eluard, exh. cat., CBWA Zachęta, Warsaw, 1952

Warsaw 1956 *Malarstwo francuskie od Davida do Cézanne'a* (French Painting from David to Cézanne), Germain Bazin and Jan Białostocki (eds), exh. cat., Muzeum Narodowe, Warsaw, 1956

Warsaw 1959 Jean Cassou and Jan Białostocki, *Malarstwo francuskie od Gauguina do naszych dni* (French Painting from Gauguin to the Present), exh. cat., Muzeum Narodowe, Warsaw, 1959

Warsaw 1986 *4 ×Paryż* (4 ×Paris), Urszula Czartoryska and Stanislas Zadora (eds), exh. cat., CBWA Zachęta, Warsaw, 1986

Warsaw 1987 *Oblicza Socrealizmu* (Faces of Socialist Realism), Maryla Sitkowska and Anna Zacharska (eds), exh. cat., Muzeum Narodowe, Warsaw, 1987

Warsaw 1995 *Picasso w zbiorach polskich* (Picasso in Polish Collections), Dorota Folga-Januszewska (ed.), exh. cat., Muzeum Narodowe, Warsaw, 1995

Warsaw 1998 *Alina Szapocznikow: 1926–1973*, Jolanta Chrzanowska-Pieńkos, Zofia Gołubiew and Anda Rottenberg (eds), exh. cat., Galeria Sztuki Współczesnej Zachęta, Warsaw, 1998 (English edition)

Warsaw 2001 *Od Maneta do Gauguina: Impresjoniści i postimpresjoniści ze zbiorów Musée d'Orsay w Paryżu*, Iwona Danielewicz and Caroline Mathieu (eds), exh. cat., Muzeum Narodowe, Warsaw, 2001

Washington 1986 *Henri Matisse: The Early Years in Nice, 1916–1930*, exh. cat., National Gallery of Art, Washington DC, 1986

Weber 1995 Eugen Weber, *The Hollow Years: France in the 1930s*, London, 1995

Webster and Powell 1984 Paul Webster and Nicholas Powell, *Saint-Germain-des-Prés: French Postwar Culture from Sartre to Bardot*, London, 1984

Weiss 1990 Jeffrey S. Weiss, 'Picasso, Collage and the Music Hall', in *Modern Art and Popular Culture: Readings High and Low*, Kirk Varnedoe (ed.), New York, 1990

Weisweiller 1998 *Les Murs de Jean Cocteau*, Carole Weisweiller (ed.), Paris, 1998

Whiting 1999 Steven Moore Whiting, *Satie the Bohemian: From Cabaret to Concert Hall*, Oxford, 1999

Wieviorska 1992 Annette Wieviorska, *Déportation et génocide. Entre la mémoire et l'oubli*, Paris, 1992

Wilson 1981 Sarah Wilson, 'Problèmes de la peinture en marge de l'exposition internationale', 'La Vie artistique à Paris sous l'Occupation', 'Les Jeunes peintres de tradition française' and 'Débats autour du réalisme socialiste' (chronology), in Paris 1981, pp. 42–44, 96–102, 106–12 and 206–12

Wilson 1987 Sarah Wilson, 'Fernand Léger, Art and Politics, 1935–1955', in *Fernand Léger: The Later Years*, exh. cat., Whitechapel Art Gallery, London, 1987, pp. 55–75

Wilson 1988 Sarah Wilson, 'Collaboration in the Fine Arts, 1940–1944', in Hirschfeld and Marsh 1988, pp. 103–25

Wilson 1988B Sarah Wilson, 'The Late Picabia, Iconoclast and Saint', in Edinburgh 1988, pp. 27–43

Wilson 1991 Sarah Wilson, 'Jean Fautrier, ses écrivains et ses poètes', in *Ecrire la peinture*, Philippe Delaveau (ed.), Paris, 1991, pp. 241–49

Wilson 1991B Sarah Wilson, 'Martyrs and Militants', in Scriven and Wagstaff 1991, pp. 219–46

Wilson 1992 Sarah Wilson, *Art and the Politics of the Left in France c. 1935–1955*, PhD dissertation, University of London, 1992

Wilson 1992B Sarah Wilson, 'From the Asylum to the Museum: Marginal Art in Paris and New York, 1938–1968', in Los Angeles 1992, pp. 120–49

Wilson 1993 Sarah Wilson, 'Paris Post War. In Search of the Absolute', in London 1993, pp. 25–52

Wilson 1995 Sarah Wilson, '"Fêting the Wound": Georges Bataille and Jean Fautrier in the 1940s', in *Writing the Sacred: Georges Bataille*, Carolyn Gill (ed.), London, 1995, pp. 172–92

Wilson 1996 Sarah Wilson, 'A Crucible of Change: Paris and Beyond, 1944–1960', in Sintra 1996, pp. 21–34

Wilson 1996B Sarah Wilson, 'Kunst en het Franse Volksfront' ('Art and the French Popular Front'), in Amsterdam 1996, pp. 33–38

Wilson 1996C Sarah Wilson, 'Réalismes sous le signe du drapeau rouge, 1945–1960', in Paris 1996, pp. 243–51

Wilson 1997 Sarah Wilson, 'Edouard Pignon. La peinture au défi', in Lille 1997, pp. 7–29

Wilson 1998 Sarah Wilson, 'Germaine Richier und der eschatologische Raum', in *Raum und Körper in den Künsten der Nachkriegszeit*, Angela Lammert (ed.), Berlin, 1998, pp. 106–20

Wilson 1998B Sarah Wilson, 'Introduction' and 'Postmodern Romantics/Romantiques postmodernes', in Lyotard 1998, pp. 12–17 and 21–81

Wilson 1999 Sarah Wilson, 'Duncan Philips et Robert Sainsbury: L'"Ecole" de Paris en Angleterre et en Amérique'/'Duncan Phillips and Robert Sainsbury: The School of Paris in England and America', in Luxembourg 1999, pp. 39–55 and 323–32

Wilson 1999B Sarah Wilson, 'Erró, l'extase matérielle', in Paris 1999B, pp. 38–56

Wilson 2001 Sarah Wilson, 'Assia Granatouroff' and 'Dina Vierny', in Berk Jimenez 2001, pp. 243–46 and 548–52

Windsor 1990 *Windows Through the Curtain: An Exhibition of Photographs of Communist Europe Prior to the Fall of 1989*, David Hlynsky (ed.), exh. cat., Art Gallery of Windsor, Ontario, 1990

Winnipeg 1997 *Pierre Molinier, 1900–1976*, exh. publication, Plug-In Inc., Winnipeg, 1997

Winock 1975 Michel Winock, *Histoire politique de la revue 'Esprit', 1930–1950*, Paris, 1975

Winock 1999 Michel Winock, *Le Siècle des intellectuels*, Paris, 1999

Wiser 1983 William Wiser, *The Crazy Years*, London, 1983

Wiser 2000 William Wiser, *The Twilight Years: Paris in the 1930s*, New York, 2000

Włodarczyk 1986 Wojciech Włodarczyk, *Socrealizm: Sztuka polska 1950–1954* (*Socialist Realism: Polish Art 1950–1954*), Paris, 1986

Wolff 1886 Albert Wolff, *La Capitale de l'art*, Paris, 1886

Wolff 1994 Larry Wolff, *Inventing Eastern Europe: The Map of Civilisation and the Mind of the Enlightenment,* Stanford, California, 1994

Woods 2000 Alan Woods, *Ralph Rumney: The Map Is Not the Territory*, Manchester, 2000

Wrocław 1998 Barbara Ilkosz, *Maria Jarema*, exh. cat., Muzeum Narodowe, Wrocław, 1998 (parallel Polish and English texts)

Zahm 2000 Olivier Zahm, 'Fromanger/Godard. Le cinéma voit rouge', *Beaux-Arts Magazine*, 198, November 2000, pp. 54–55

Zehrfuss 1991 Bernard Zehrfuss, 'L'Histoire d'un palais', in Unesco 1991, pp. 8–17

Zervos 1937 Christian Zervos, 'Réflexions sur la tentative d'esthétique dirigée du IIIème Reich', *Cahiers d'Art*, 6–7, 1937, pp. 51–61

Zervos 1959 Christian Zervos, *Pablo Picasso, vol. 10: Œuvres de 1939 et 1940*, Paris, 1959

Žižek 1992 Slavoj Žižek, 'Eastern Europe's Republic of Gilead', in *Dimensions of Radical Democracy in Pluralism, Citizenship, Community*, Chantal Mouffe (ed.), London and New York, 1992, pp. 193–207

Zurich 1929 *Jüdische Künstler unserer Zeit*, Waldemar George (ed.), exh. cat., Salon Henri Brendlé, Zurich, 1929

Artists' Bibliography

Yaacov Agam
born Rishon-le-Zion (now Israel), 11 May
1928
in Paris: from 1951
● Yaacov Agam, *Agam: Texts by the Artist*,
Neuchâtel, 1962
● *Homage to Yaacov Agam*, special number
of *XXe Siècle*, New York, 1980
● Sayako Aragaki, *Agam, Beyond the Visible*,
Jerusalem, 1997

Gilles Aillaud
born Paris, 5 June 1928
in Paris: throughout career
● *Gilles Aillaud*, André Dimanche (ed.),
Marseilles, 2001
● *Gilles Aillaud: la jungle des villes*, exh. cat.,
Salle de Quai Antoine, Monte Carlo, 2001

Pierre Alechinsky
born Brussels, 19 October 1927
in Paris: from 1951
● Pierre Alechinsky, *Alechinsky: Paintings
and Writings*, New York, 1977 (including
foreword by Eugène Ionesco)
● *Pierre Alechinsky: Margin and Center*, exh.
cat., Solomon R. Guggenheim Museum,
New York, 1987
● *Pierre Alechinsky*, exh. cat., Galerie
Nationale du Jeu de Paume, Paris, 1998

Hermenegildo Anglada Camarasa
born Barcelona, 11 September 1871
died Port de Pollença, Mallorca, 7 July 1959
in Paris: 1894–1914
● *Anglada-Camarasa*, Francesc Fontbona
and Francesc Miralles (eds), exh. cat., Centro
Cultural Caixa Pensions, Barcelona, 1981
● Francesc Fontbona and Francesc Miralles,
Anglada-Camarasa, Barcelona, 1981
(including catalogue raisonné)
● Jaime Socias Palau, *Cien años de pintura
en España y Portugal*, Madrid, 1988

Karel Appel
born Amsterdam, 25 April 1921
in Paris: from 1950
● Karel Appel, *Karel Appel on Karel Appel*,
Amsterdam, 1971
● Michel Ragon, *Karel Appel. The Early Years,
1937–1957*, Paris, 1988 (English and French
editions)
● Donald Kuspit, with Rudi Fuchs and
Johannes Gachnang, *Karel Appel. Art
psychopathologique. Carnet 1948–1950,
dessins et gouaches*, Neuchâtel, 1997

Arman (Armand Fernandez)
born Nice, 17 November 1928
in Paris: 1949–mid-1963
● Denyse Durand-Ruel, *Arman: catalogue
raisonné*, 3 vols, Paris, c. 1991–94
● *Arman*, exh. cat., Galerie Nationale du Jeu
de Paume, Paris, 1998
● *Arman*, exh. cat., Musée d'Art Moderne et
d'Art Contemporain, Nice, 2001

Jean (Hans) Arp
born Strasbourg, 16 September 1886
died Basle, 7 June 1966
in Paris: 1908, 1912, 1920–40, and from 1946
● Jean Arp, *On My Way: Poetry and Essays,
1912–47*, New York, 1948
● *Jean Arp 1886–1966*, exh. cat., Musée
National d'Art Moderne, Centre Georges
Pompidou, Paris, 1986
● *Arp: Reliefs*, exh. cat., Henry Moore Centre
for the Study of Sculpture, Leeds, 1995

Eduardo Arroyo
born Madrid, 26 February 1937
in Paris: 1958–68, and from 1978
● *Eduardo Arroyo*, exh. cat., Musée National
d'Art Moderne, Centre Georges Pompidou,
Paris, 1982
● *Eduardo Arroyo, obra gráfica*, exh. cat.,
IVAM Centro Julio González, Valencia, 1989
● *Eduardo Arroyo*, exh. cat., Museo Nacional
Centro de Arte Reina Sofía, Madrid, 1998

Antonin Artaud
born Marseilles, 4 September 1896
died Ivry-sur-Seine, 4 March 1948
in Paris: 1920–35, and from 1937
● Jacques Derrida and Paule Thévenin, *The
Secret Art of Antonin Artaud*, Mary Ann Caws
(trans. and preface), Cambridge, Mass., and
London, 1988
● Stephen Barber, *Artaud: Blows and Bombs*,
London, 1991
● *Antonin Artaud: Works on Paper*, exh. cat.,
Museum of Modern Art, New York, 1996

**Balthus (Count Balthazar Klossowski
de Rola)**
born Paris, 19 February 1908
died La Rossinière, Switzerland,
18 February 2001
in Paris: until 1921, 1924–43, 1946–54
● *Balthus*, exh. cat., Musée National d'Art
Moderne, Centre Georges Pompidou, Paris,
1983
● Jean Clair and Virginie Monnier, *Balthus:
Catalogue Raisonné of the Complete Works*,
Paris and New York, 1999
● *Balthus*, exh. cat., Palazzo Grassi, Venice,
2001 (English, French and Italian editions)

Jean Bazaine
born Paris, 21 December 1904
died Clamart, Paris, 4 March 2000
in Paris: throughout career
● Jean Bazaine, *Le Temps de la peinture*,
Paris, 1990
● Jean-Claude Schneider, *Habiter la lumière.
Regards sur la peinture de Jean Bazaine*,
Paris 1994
● *Jean Bazaine et ses amis poètes*, exh. cat.,
Musée Toulouse-Lautrec, Albi, 1996

Max Beckmann
born Leipzig, 12 February 1884
died New York, 27 December 1950
in Paris: 1925–31, 1938–39
● *Max Beckmann Retrospective*, Carla
Schulz-Hoffman and Judith C. Weiss (eds),
exh. cat., St Louis Art Museum, 1984
● Max Beckmann, *Self-portrait in Words:
Collected Writings and Statements,
1903–1950*, Barbara Copeland Buenger (ed.),
Chicago and London, 1997
● *Max Beckmann and Paris*, exh. cat.,
Kunsthaus Zurich, 1998; Saint Louis Art
Museum, 1999

Hans Bellmer
born Kattowitz, Germany (now Katowice,
Poland), 13 March 1902
died Paris, 24 February 1975
in Paris: from 1935
● *Bellmer*, exh. cat., Musée National d'Art
Moderne, Centre Georges Pompidou, Paris,
1983–84
● Peter Webb, with Robert Short, *Hans
Bellmer*, London, 1985
● Sue Taylor, *Hans Bellmer: The Anatomy of
Anxiety*, Cambridge, Mass., 2001

Maria Blanchard
born Santander, 6 March 1881
died Paris, 5 April 1932
in Paris: 1908–13, from 1917
● Isabelle Rivière, *Maria Blanchard*, Paris,
1934
● M. Campoy, *Maria Blanchard*, Madrid, 1981
● Liliane Caffin Madaule, *Catalogue
raisonné des œuvres de Maria Blanchard*, 2
vols, London, 1992–94

Pierre Bonnard
born Fontenay-aux-Roses, near Paris, 3
October 1867
died Le Cannet, 27 January 1947
in Paris: until 1925
● Jean and Henry Dauberville, *Bonnard:
catalogue raisonné de l'œuvre peint*, Paris,
1966–74
● *Pierre Bonnard*, exh. cat., Musée National
d'Art Moderne, Centre Georges Pompidou,
Paris, 1984
● Sarah Whitfield, *Bonnard*, exh. cat., Tate
Gallery, London, 1998; Museum of Modern
Art, New York, 1998

Constantin Brancusi
born Hobitza, Gorj, Romania, 2 March 1876
died Paris, 16 March 1957
in Paris: from 1904
● Marielle Tabart and Isabelle Monod-
Fontaine, *Brancusi photographe*, exh. cat.,
Musée National d'Art Moderne, Centre
Georges Pompidou, Paris, 1979
● Pontus Hulten, Natalia Dumitresco and
Alexandre Istrati, *Brancusi: catalogue
raisonné*, Paris, 1986
● *Brancusi*, exh. cat., Philadelphia Museum
of Art, 1995

Georges Braque
born Argenteuil-sur-Seine, Seine-et-Oise, 13
May 1882
died Paris, 31 August 1963
in Paris: from 1900
● William Rubin, *Picasso and Braque:
Pioneering Cubism*, exh. cat., Museum of
Modern Art, New York, 1989
● *Georges Braque, rétrospective*, Fondation
Maeght, Saint-Paul-de-Vence, 1994
● John Golding, *Braque: The Late Works*, exh.
cat., Royal Academy of Arts, London, 1997

Victor Brauner
born Piatra Neamt, Moldavia, 15 June 1903
died Paris, 12 March 1966
in Paris: 1930–35, 1938–42, 1945–53
● Sarane Alexandrian, *Victor Brauner
l'illuminateur*, Paris, 1954
● Didier Semin, *Victor Brauner*, Paris, 1990
● *Victor Brauner*, exh. cat., Musée d'Art
Moderne, Saint-Etienne; Musée
d'Unterlinden, Colmar, 1992

Romaine Brooks
born Rome, 1 May 1874
died Nice, 7 December 1970
in Paris: 1899, 1904–40
● Meryle Secrest, *Between Me and My Life: A
Biography of Romaine Brooks*, London, 1976
● Françoise Werner, *Romaine Brooks*, Paris,
1990
● Whitney Chadwick, *Amazons in the
Drawing Room: The Art of Romaine Brooks*,
exh. cat., National Museum of Women in the
Arts, Washington DC; Berkeley Art Museum,
Berkeley, 2000–01

Bernard Buffet
born Paris, 10 July 1928
died Var, 4 October 1999
in Paris: throughout career
● Yann le Pichon, *Bernard Buffet 1943–1961,
1962–1981*, 2 vols, Paris, 1986
● *Bonjour, Monsieur Buffet!*, exh. cat., Musée
Gustave Courbet, Ornans, 1993
● Otto Letze and Thomas Buchheister,
Bernard Buffet, exh. cat., Documenta-Halle,
Kassel, 1994

Pierre Buraglio
born Charenton, 4 March 1939
in Paris: from c. 1965
● Alfred Pacquement, *Buraglio*, exh. cat.,
Musée National d'Art Moderne, Centre
Georges Pompidou, Paris, 1982
● *Buraglio*, exh. cat., Sara Hildénin
Taidemuseo, Tampere, Finland, 1990
● Pierre Buraglio, *Ecrit entre 1962 and 1990*,
Paris, 1999

Daniel Buren
born 25 March 1938, Boulogne-sur-Seine
in Paris: from 1956
● Jean-Hubert Martin, Benjamin Buchloh
and Jean-François Lyotard, *Daniel Buren: les
couleurs et les formes*, Musée National d'Art
Moderne, Centre Georges Pompidou, Paris,
1981
● *Daniel Buren: les écrits 1965–1990*, 3 vols,
Jean-Marc Poinsot (ed.), Bordeaux, 1991
● Daniel Buren, *Catalogue raisonné
chronologique*, Annick Boisnard (ed.), vol. II,
Le Bourguet, 2000

Pol Bury
born Haine-Saint-Pierre, near La Louvière,
26 April 1922
in Paris: from 1955
● Pol Bury, *La Boule et le trou*, Brussels, 1961
● Pol Bury, *L'Art à bicyclette et la révolution à
cheval*, Paris, 1972
● Rosemarie E. Pahlke, *Pol Bury,
rétrospective 1939–1994*, exh. cat., Museum
am Ostway, Dortmund; Musée d'Art
Moderne, Ostende, 1994–95

Alexander Calder
born Philadelphia, 22 July 1898
died New York, 11 November 1976
in Paris: from 1926
● Alexander Calder, *Calder: An
Autobiography with Pictures*, New York, 1966
● *Alexander Calder 1898–1976*, exh. cat.,
Musée d'Art Moderne de la Ville de Paris,
1996
● Joan M. Marter, *Alexander Calder*,
Cambridge, 1997

César (César Baldaccini)
born Marseilles, 1 January 1921
died Paris, 6 December 1998
in Paris: from 1943
● *César: œuvres 1947 à 1993*, exh. cat., Centre
de la Vieille Charité, Marseilles, 1993
● Denyse Durand-Ruel, *César: catalogue
raisonné*, Paris, 1994 (including preface by
Pierre Restany)
● *César*, exh. cat., Galerie Nationale du Jeu
de Paume, Paris, 1997

Auguste Chabaud
born Nîmes, 3 October 1882
died Graveson, near Avignon, 23 May 1955
in Paris: 1899–1919
● Auguste Chabaud, *Poésie pure, peinture
pure*, Paris, 1927
● Ray Charmet, *Auguste Chabaud*,
Lausanne, 1973
● *Auguste Chabaud, 1882–1955, Gemalde,
aquarelle, zeichnungen und sculpturen*,
Saarland Museum, Saarbrücken, 1993

Marc Chagall
born Vitebsk, Belarus, 7 July 1887
died Saint-Paul-de-Vence, 28 March 1985
in Paris: 1910–14, 1923–41, 1948–50
● Marc Chagall, *Ma Vie*, Paris, 1931; English
translations: New York, 1960, and London,
1967
● *Chagall*, Susan Compton, exh. cat., Royal
Academy of Arts, London; Philadelphia
Museum of Art, 1985
● *Chagall: A Retrospective*, Jacob Baal-
Teshuva (ed.), New York, 1995

Gaston Chaissac
born Avallon, Yonne, 10 May 1910
died La Roche-sur-Yon, 7 November 1964
in Paris: from 1934, 1937–48
● Gaston Chaissac, *Hippobosque au Bocage*,
Paris, 1951
● *Gaston Chaissac 1910–1964*, exh. cat.,
Musée des Beaux-Arts, Nantes, 1998
● *Chaissac*, exh. cat., Galerie Nationale du
Jeu de Paume, Paris, 2000

Christo
born Gavrovo, Bulgaria, 13 June 1935
in Paris: 1958–64
● Jacob Baal-Teschuva, *Christo and Jeanne-
Claude*, Cologne, 2001
● *Christo and Jeanne-Claude, Early Works
1958–1969*, exh. cat., Martin-Gropius Bau,
Berlin, 2001
● Burt Chernow, *Christo and Jeanne-Claude*,
New York, forthcoming (includes epilogue by
Wolfgang Volz)

Geneviève Claisse
born Quiévy, 17 July 1935
in Paris: from 1958
● *Claisse*, exh. cat., Galerie Denise René,
Paris, 1968
● Dominique Szymusiak and Serge
Fauchereau, *Geneviève Claisse: parcours,
1960–1989*, exh. cat., Musée Matisse, Le
Cateau-Cambrésis, 1989
● *Claisse: du construit au linéaire. Œuvres de
1959 à 1980. Transparence et Plénitude,
œuvres récentes 1980–1985*, exh. cat., Galerie
Denise René, 1995

Jean Crotti
born Bulle, Switzerland, 24 April 1878
died Paris, 30 January 1958
in Paris: 1901–14, and from 1916
● Waldemar George, *Jean Crotti et la
primauté du spirituel*, Geneva, 1959
● *Rétrospective Jean Crotti*, exh. cat., Musée
Galliera, Paris, 1959
● *Tabu Dada, Jean Crotti and Suzanne
Duchamp, 1915–1922*, exh. cat., Kunsthalle,
Bern; Musée Nationale d'Art Moderne,
Centre Georges Pompidou; Houston
Museum of Fine Art, 1983

Henri Cueco
born Uzerche, Corrèze, 19 October 1929
in Paris: from 1968
● Michel Troche and Pierre Gaudibert, *Henri
Cueco, Michel Parré*, exh. cat., Musée d'Art
Moderne de la Ville de Paris, 1970
● Henri Cueco, *Le Chemin de l'atelier*, Paris,
1988
● Henri Cueco, *Cueco*, Paris, 1995 (including
preface by Gérald Gassiot-Talabot)

Salvador Dali
born Figueres, 11 May 1904
died Figueres, 25 January 1989
in Paris: 1928, 1929–40
● Salvador Dali, *The Secret Life of Salvador
Dalí*, New York, 1942
● *Salvador Dali: Rétrospective 1920–80*,
Daniel Abadie (ed.), exh. cat., Musée
National d'Art Moderne, Centre Georges
Pompidou, Paris, 1979
● Robert Descharnes and Gilles Neret, *Dali
1904–1989: The Paintings*, 2 vols, Cologne,
1994

Giorgio de Chirico
born Volos, Greece, 10 July 1888
died Rome, 20 November 1978
in Paris: 1911–15, 1924–31
● *De Chirico*, William Rubin (ed.), exh. cat.,
Museum of Modern Art, New York; Musée
National d'Art Moderne, Centre Georges
Pompidou, Paris, 1982
● Giorgio de Chirico, *Il meccanismo del
pensiero: critica, polemica, autobiografia
1911–1943*, Mario Fagiolo dell'Arco (ed.),
Turin, 1985
● Paolo Baldacci, *Giorgio de Chirico
1888–1919: la métaphysique*, Paris, 1997

Robert Delaunay
born Paris, 12 April 1885
died Montpellier, 25 October 1941
in Paris: until 1914, and from 1920
● Robert Delaunay, *Du Cubisme à l'art
abstrait*, Pierre Francastel (ed.), Paris, 1957
(includes catalogue by Guy Habasque)
● Robert and Sonia Delaunay, *The Writings of
Robert and Sonia Delaunay (The New Art of
Colour)*, A. A. Cohen (ed.), New York, 1978
● *Robert et Sonia Delaunay*, exh. cat., Musée
d'Art Moderne de la Ville de Paris, 1985
● *Robert Delaunay 1906–1914: de
l'impressionisme à l'abstraction*, exh. cat.,
Musée National d'Art Moderne, Centre
Georges Pompidou, Paris, 1999

Sonia Delaunay-Terk
born Gradizhsk, Ukraine, 14 November 1885
died Paris, 5 December 1979
in Paris: 1905–14, and from 1920
● Jacques Damase and Sonia Delaunay, *Sonia Delaunay, rhythmes et couleurs*, Paris, 1971
● Bernard Dorival, *Sonia Delaunay, sa vie, son œuvre, 1885–1979*, Paris, 1980
● Stanley Baron with Jacques Damase, *Sonia Delaunay: The Life of an Artist*, London and New York, 1995

Tamara de Lempicka
born Warsaw, 1898
died Mexico, 18 March 1980
in Paris: 1918–39
● Maurizio Calvesi and Alessandra Borghese, *Tamara de Lempicka: tra eleganza e transgressione*, exh. cat., Centro Culturale Alessandra Borghese, Accademia di Francia, Rome, 1994
● Alain Blondel, *Tamara de Lempicka: catalogue raisonné 1921–1979*, Lausanne, 1999
● Laura P. Claridge, *Tamara de Lempicka: A Life of Deco and Decadence*, New York, 1999

André Derain
born Chatou, near Paris, 17 June 1889
died Garches, 8 September 1954
in Paris: throughout career
● Jane Lee, *Derain*, exh. cat., Museum of Modern Art, Oxford, 1990
● *André Derain, le peintre du 'trouble moderne'*, exh. cat., Musée d'Art Moderne de la Ville de Paris, 1994
● Michel Kellermann, *André Derain: catalogue raisonné de l'œuvre peint*, Paris, 1999

Gérard Deschamps
born Lyons, 1937
in Paris: from 1956
● Pierre Restany, *Les Nouveaux Réalistes*, Paris, 1968
● Jacques Soulillou, 'Gérard Deschamps', *Art Press*, 153, 1990
● Gérard Deschamps, *Homo accessoirus*, exh. cat., Fondation Cartier, Paris, 1998

Jean Dewasne
born Hellemmes-Lille, 21 May 1921
died Paris, 24 July 1999
in Paris: from c. 1940
● *Jean Dewasne*, exh. cat., Quadrat Bottrop, Josef Albers Museum, Bottrop, 1991
● *Jean Dewasne, Tenu de rigueur*, Paris, 1995
● *Dewasne, Arche de la Défense, et ronds bosses*, exh. cat., Centre Noroit, Arras, 1995

Theo van Doesburg
born Utrecht, 30 August 1883
died Davos, Switzerland, 7 March 1931
in Paris: 1923, 1929–31
● Theo van Doesburg, *Principles of Neo-Plastic Art*, London, 1968
● Yve-Alain Bois et al., *De Stijl à Paris et l'architecture en France*, Liège and Paris, 1985
● Marleen Blokhuis et al., *Theo van Doesburg: œuvre catalogue*, exh. cat., Els Hoek (ed.), Centraal Museum, Utrecht; Kröller-Müller Museum, Otterlo, 2000

César Domela
born Amsterdam, 15 January 1900
in Paris: 1923–27, and from 1933
● Alain Clairet, *Catalogue raisonné de l'œuvre de César Domela-Nieuwenhuis (peintures, reliefs, sculptures)*, Paris, 1978
● Hans Ludwig C. Jaffé, *Domela*, Paris, 1980
● Serge Lemoine, *Domela: 65 ans d'abstraction*, Musée Moderne de la Ville de Paris; Musée de Grenoble, 1987

Kees van Dongen
born Delfshaven, near Rotterdam, 26 January 1877
died Monte Carlo, 28 May 1968
in Paris: 1897–1959
● *Kees van Dongen*, exh. cat., Museum Boijmans van Beuningen, Rotterdam, 1989
● *Van Dongen le peintre 1877–1968*, exh. cat., Musée d'Art Moderne de la Ville de Paris, 1990
● Jacques Chalom des Cordes, *Van Dongen catalogue raisonné* (in preparation)

Christian Dotremont
born Tervuren, Belgium, 12 December 1922
died Buizingen, near Halle, 1979
in Paris: 1948–51
● *Christian Dotremont: 'Vois ce que je t'écris'*, exh. cat., Musée d'Art Moderne, Liège; Maison de la Culture, Namur; Centre d'Art Contemporain, Brussels, 1984
● Christian Dotremont, *Isabelle: Texts on Cobra, 1948–1978*, Brussels, 1985
● Christian Dotremont, *Œuvres poétiques complètes*, Michel Sicard (ed.), Paris, 1998

Jean Dubuffet
born Le Havre, 31 July 1901
died Paris, 12 May 1985
in Paris: from 1918
● *Catalogue des travaux de Jean Dubuffet*, 38 vols, Paris, 1964–91
● Jean Dubuffet, *Prospectus et tous écrits suivants*, Hubert Damisch (ed.), vols I–II, Paris, 1967; vols III–IV, Paris, 1995
● *Dubuffet*, exh. cat., Musée National d'Art Moderne, Centre Georges Pompidou, Paris, 2001

Marcel Duchamp
born Blainville, Normandy, 28 July 1887
died Neuilly-sur-Seine, 2 October 1968
in Paris: 1904–15, 1919–20, 1923–42
● Marcel Duchamp, *Marchand du sel*, Paris, 1958–59
● *Marcel Duchamp*, exh. cat., Palazzo Grassi, Venice, 1993 (Italian and English editions)
● *The Complete Works of Marcel Duchamp*, Arturo Schwarz (ed.), 2 vols, London, 1997; vol. I, revised, New York, 2000

Raymond Duchamp-Villon
born Damville, Eure-et-Loire, 5 November 1876
died Cannes, 7 October 1918
in Paris: 1894–1916
● Jean Cassou and Roger van Gindertaël, *Le Cheval majeur*, exh. cat., Galerie Louis Carré & Cie, Paris, 1966
● Pierre Cabanne, *The Brothers Duchamp*, Boston, 1976
● *Duchamp-Villon: collections du Centre Georges Pompidou, Musée National d'Art Moderne et du Musée des Beaux-Arts de Rouen*, Paris, 1998

François Dufrêne
born Paris, 21 September 1930
died Paris, 12 December 1982
in Paris: 1950s–1960s
● Jacques Beauffet and Bernard Ceysson, *Beautés volées*, exh. cat., Musée de l'Art et de l'Industrie, Saint-Etienne, 1976
● *François Dufrêne*, exh. cat., Musée de l'Abbaye Sainte-Croix, Les Sables-d'Olonne, 1988
● *François Dufrêne*, exh. cat., Galerie Mathias Fels, Paris, 1990

Raoul Dufy
born Le Havre, 3 June 1877
died Forcalquier, Basses-Alpes, 23 March 1953
in Paris: 1900–40
● Maurice Laffaille, *Raoul Dufy: catalogue raisonné de l'œuvre peint, vols I–IV*, Geneva, 1972–77 (supplementary volume, Paris, 1985)
● Dora Perez-Tibi, *Raoul Dufy*, London and Paris, 1989
● Fanny Guillon-Laffaille, *Raoul Dufy: catalogue raisonné des aquarelles, gouaches et pastels*, Paris, 1991

Equipo 57
José Cuarte, born Córdoba, 1928
Juan Cuenca, born Puente Genil, Córdoba, 1934
José Duarte, born Aldeanueva del Camino, Cáceres, 1930
Agustín Ibarrola, born Bilbao, 1930
Juan Serrano, born Córdoba, 1929
in Paris: 1957–66
● Frank Popper, *Origins and Development of Kinetic Art*, London, 1968
● *Equipo 57*, Museo Nacional Centro de Arte Reina Sofía, Madrid, 1993
● *Equipo 57, rétrospective*, exh. cat., Galerie Denise René, Paris, 1996

Max Ernst
born Brühl, near Cologne, 2 April 1891
died Paris, 1 April 1976
in Paris: 1922–39, 1953–55
● Max Ernst, *Beyond Painting and Other Writings by the Artist and His Friends*, Robert Motherwell (ed.), New York, 1948
● *Max Ernst: Œuvre-Katalog, vols 1–6*, Werner Spies (ed.), Cologne, 1975–98
● *Max Ernst: A Retrospective*, Werner Spies (ed.), exh. cat., Tate Gallery, London; Staatsgalerie, Stuttgart; Kunst- und Austellungshalle der Nordrhein Westfalen, Düsseldorf; Musée National d'Art Moderne, Centre Georges Pompidou, Paris, 1991–92

Erró (Gudmundr Gudmundsson)
born Olafsvik, Iceland, 19 July 1932
in Paris: from 1958
● *Erró. Catalogues généraux, vols I–III*, Paris, 1976–1998
● Marc Augé, *Erró, peintre mythique*, Paris, 1994
● *Erró*, exh. cat., Galerie Nationale du Jeu de Paume, Paris, 1999–2000

Maurice Estève
born Culan, Cher, 2 May 1904
died Culan, Cher, 27 June 2001
in Paris: from 1924
● *Estève*, exh. cat., Grand Palais, Paris, 1986
● Monique Prudhomme-Estève, *Catalogue du Musée Estève*, Bourges, 1990
● Robert Maillard, *Maurice Estève: catalogue raisonné de l'œuvre peint*, Monique Prudhomme-Estève (ed.), Neuchâtel, c. 1995

Alexandra Exter
born Bielostok, near Kiev, Ukraine, 6 January 1882
died Fontenay-aux-Roses, near Paris, 17 March 1949
in Paris: from 1924
● *Alexandra Exter: Marionettes and Theatrical Designs*, exh. cat., Hirshhorn Museum and Sculpture Garden, Washington DC, 1980
● *Alexandra Exter*, exh. cat., Odessa Art Museum, 1989
● Georgii Kovalenko, 'Alexandra Exter', in *Amazons of the Avant-Garde*, John E. Bowlt and Matthew Drutt (eds), exh. cat., Deutsche Guggenheim Berlin; Royal Academy of Arts, London; Peggy Guggenheim Collection, Venice; Solomon R. Guggenheim Museum, New York, 1999–2000, pp. 131–54

Jean Fautrier
born Paris, 16 May 1898
died Châtenay-Malabry, Seine-et-Oise, 21 July 1964
in Paris: 1922–34, and from 1940
● *Fautrier: 1898–1964*, exh. cat., Musée d'Art Moderne de la Ville de Paris, 1989
● Yves Peyré, *Fautrier ou les outrages de l'impossible*, Paris, 1990
● Pierre Cabanne, *Jean Fautrier*, Paris, 1998

Robert Filliou
born Sauve, Gard, 17 January 1926
died Les Eyzies-de-Tayac, near Périgueux, 2 December 1987
in Paris: until 1948, and from 1951
● Robert Filliou and George Brecht, *Games at the Cedilla, or the Cedilla Takes Off*, New York, 1967
● Robert Filliou, with George Brecht, John Cage, Allan Kaprow et al., *Teaching and Learning as Performance Arts*, Cologne, 1970
● *Das immerwährende Ereignis zeigt: Robert Filliou/The Eternal Network Presents: Robert Filliou/La Fête permanente présente: Robert Filliou*, exh. cat., Sprengel Museum, Hanover; Musée d'Art Moderne de la Ville de Paris; Kunsthalle, Bern, 1984

André Fougeron
born Paris, 1 October 1912
died Paris, 10 Septembre 1998
in Paris: throughout career
● J. Rollin, *André Fougeron*, Berlin, 1972
● *André Fougeron, pièces détachées 1937–1987*, exh. cat., Galerie Jean-Jacques Dutko, Paris, 1987
● *Fougeron: de 1936 à aujourd'hui*, exh. cat., Musée de la Résistance Nationale, Champigny-sur-Marne, 1992 (including preface by Boris Taslitzky)

Tsuguharu Foujita
born Tokyo, 27 November 1886
died Zurich, 29 January 1968
in Paris: 1913–31, 1939–40, and from 1950
● Sylvie Buisson and Dominique Buisson, *La Vie et l'œuvre de Léonard Tsuguharu Foujita*, Paris, 1987
● *Paris in Japan: The Japanese Encounter with European Painting*, exh. cat., Japan Foundation, Tokyo; Washington University, Saint Louis, 1987
● Sylvie Buisson, *Léonard Tsuguharu Foujita*, Paris, 2001

Sam Francis
born San Mateo, California, 25 June 1923
died Santa Monica, California, 4 November 1994
in Paris: 1950–61
● Pontus Hulten, *Sam Francis*, exh. cat., Kunst- und Austellungshalle der Bundesrepublik Deutschland, Bonn; Los Angeles County Museum of Art, 1993
● Sam Francis, *Saturated Blue: Writings from the Notebooks*, Santa Monica, 1995
● *Sam Francis: les années parisiennes, 1950–1961*, exh. cat., Galerie Nationale du Jeu de Paume, Paris, 1995

Ruth Francken
born Prague, 8 August 1924
in Paris: from 1952
● *Ruth Francken: sculptures, objets, tableaux*, exh. cat., ARC, Musée d'Art Moderne de la Ville de Paris, 1971
● Ruth Francken and Jean-François Lyotard, *L'Histoire de Ruth*, Paris, 1983
● *Ruth Francken Werke, 1950–1994*, exh. cat., Magdeburger Museen, Magdeburg, 1994

Otto Freundlich
born Stolp, Pomerania (now Stupsk, Poland), 10 July 1878
died Maidanek concentration camp, near Lublin, Poland, 9 March 1943
in Paris: 1908–14, 1924–39
● Otto Freundlich, *Otto Freundlich: Schriften*, Uli Bohnen (ed.), Cologne, 1982
● *Otto Freundlich: Kräfte der Farbe*, exh. cat., Westfälisches Landesmuseum, Münster; Kunstmuseum, Lichtenstein, 2001
● Edda Maillet, *Freundlich: catalogue raisonné* (in preparation)

Gérard Fromanger
born Pontchartrain, 6 September 1939
in Paris: throughout career
● Jacques Prévert and Alain Jouffroy, *Fromanger, Boulevard des Italiens*, Paris, 1971
● Gilles Deleuze, Michel Foucault and Adrian Rifkin, *Gérard Fromanger: Photogenic Painting/La Peinture photogénique*, Sarah Wilson (ed.), London, 1999
● Serge July, *Gérard Fromanger*, Paris, 2001

Naum Gabo
born Klimovichi, Belarus, 5 August 1890
died Waterbury, Connecticut, 23 August 1977
in Paris: 1913–14, 1932–35
● *Circle: International Survey of Constructive Art*, J. L. Martin and Ben Nicholson (eds), London, 1937 (including two essays by the artist)
● Alexei Pevsner, *A Biographical Sketch of My Brothers: Naum Gabo and Antoine Pevsner*, Amsterdam, 1964
● Martin Hammer and Christina Lodder, *Constructing Modernity: The Art and Career of Naum Gabo*, New Haven and London, 2000

Pierre-Antoine Gallien
born 14 December 1896
died 3 December 1963
in Paris: throughout his career
● *Pierre-Antoine Gallien: peintre à la ligne noire*, exh. cat., ARC, Musée d'Art Moderne de la Ville de Paris, 1979

Pablo Gargallo
born Maella, Saragossa, 5 January 1881
died Reus, Catalonia, 28 December 1934
in Paris: 1903–04, 1907, 1912–14, and from 1924
● *Catálogo del Museo Pablo Gargallo*, Saragossa, 1988
● *Gargallo y los metales*, exh. cat., Museo Pablo Gargallo, Saragossa, 1994
● Pierrette Gargallo-Anguera, *Pablo Gargallo: catalogue raisonné*, Paris, 1998

Alberto Giacometti
born Borgonova, near Stampa, 10 October 1901
died Chur, Switzerland, 11 January 1966
in Paris: 1922–41, and from 1945
● Alberto Giacometti, *Ecrits*, Michel Leiris and Jacques Dupin (eds), Paris, 1990
● Yves Bonnefoy, *Alberto Giacometti: A Biography of His Work*, Paris, 1991
● *Alberto Giacometti 1901–1966*, exh. cat., Kunsthalle, Vienna; Scottish National Gallery of Modern Art, Edinburgh; Royal Academy of Arts, London, 1996–97

Albert Gleizes
born Paris, 8 December 1881
died Avignon, 23 June 1953
in Paris: until 1914, 1919–23
● Pierre Alibert, *Albert Gleizes: naissance et avenir du cubisme*, Saint-Etienne, 1985
● Anne Varichon, *Albert Gleizes: catalogue raisonné*, Paris, 1998
● *Albert Gleizes: le cubisme en majesté*, exh. cat., Museu Picasso, Barcelona; Musée des Beaux-Arts, Lyons, 2001

Natalia Goncharova
born Negayevo, Tula Province, Central Russia, 1881
died Paris, 17 October 1962
in Paris: from 1914
● Marina Tsvetaeva, *Nathalie Gontcharova*, Paris, 1990
● *Nathalie Gontchorova. Michel Larionov*, exh. cat., Musée National d'Art Contemporain, Centre Georges Pompidou, Paris, 1995
● Jane A. Sharp, 'Natalya Goncharova', in *Amazons of the Avant-Garde*, John E. Bowlt and Matthew Drutt (eds), exh. cat., Deutsche Guggenheim Berlin; Royal Academy of Arts, London; Peggy Guggenheim Collection, Venice; Solomon R. Guggenheim Museum, New York, 1999–2000, pp. 155–84

432

Julio González
born Barcelona, 21 September 1876
died Arcueil, 27 March 1942
in Paris: from 1900
● *Julio González*, Margit Rowell (ed.), exh. cat., Solomon R. Guggenheim Museum, New York, 1983
● Jörn Merkert, *Julio González: catalogue raisonné des sculptures*, Milan, 1987
● *González/Picasso, dialogue*, exh. cat., Musée National d'Art Contemporain, Centre Georges Pompidou, Paris, 1999

Jean Gorin
born Saint-Emilion-de-Blain, Loire-Atlantique, 2 December 1899
died Niort, 29 March 1981
in Paris: 1914–16, and from 1923
● Jean Gorin, 'La Fonction plastique dans l'architecture future', *Cercle et Carré*, 3, 30 June 1930
● *Jean Gorin, peintures, reliefs, constructions dans l'espace, 1922–1968*, exh. cat., Centre National d'Art Contemporain, Paris, 1969
● Serge Lémoine and Marianne Le Pommeré, *Reconnaître Jean Gorin*, Grenoble, 1998

Juan Gris
born Madrid, 23 March 1887
died Boulogne-sur-Seine, 11 May 1927
in Paris: from 1906
● Daniel-Henry Kahnweiler, *Juan Gris: His Life and Work*, Douglas Cooper (trans.), London, 1968–69
● Douglas Cooper and Margaret Potter, *Juan Gris: catalogue raisonné de l'œuvre peint*, Paris, 1977
● *Juan Gris: peinture et dessins, 1887–1927*, exh. cat., Musée Cantini, Marseilles, 1998–99

Marcel Gromaire
born Noyelles-sur-Sambre, Nord, 24 July 1892
died Paris, 11 April 1971
in Paris: from 1910
● *Marcel Gromaire, 'Peinture'. Notes de peintre rédigées de 1921 à 1929*, Paris, 1980
● *Marcel Gromaire, 1892–1971*, exh. cat., Musée d'Art Moderne de la Ville de Paris, 1980
● François Gromaire and Françoise Chibret-Plaussu, *Marcel Gromaire: la vie et l'œuvre. Catalogue raisonné des peintures*, Paris, 1993

Francis Gruber
born Nancy, 15 March 1912
died Paris, 1 December 1948
in Paris: from 1916
● *Francis Gruber, 1912–1948*, exh. cat., Kunsthalle, Bern; Musée des Beaux-Arts, Nancy; Musée d'Art Moderne de la Ville de Paris, 1976
● Catherine Bernard-Gruber and Armelle Vanazzi, *Francis Gruber*, Neuchâtel, 1989
● *Paris Post War: Art and Existentialism 1945–55*, exh. cat., Tate Gallery, London, 1993, pp. 128–31

Raymond Hains
born Saint-Brieuc, 9 November 1926
in Paris: 1947–68, and from 1971
● *Raymond Hains: mises en plis* (a catalogue of the Hains collection at the Musée National d'Art Moderne, Centre Georges Pompidou), Paris, 1990
● *Murmures des rues. François Dufrêne, Raymond Hains, Mimmo Rotella, Jacques Villeglé, Wolf Vostell*, exh. cat., Centre d'Histoire de l'Art Contemporain, Rennes, 1994
● *Raymond Hains*, exh. cat., Musée National d'Art Moderne, Centre Georges Pompidou, Paris, 2001

Joseph Mellor Hanson
born Halifax, Nova Scotia, 1900
died 1961?
in Paris: 1925–35
● Paul Ziff, *J. M. Hanson*, Ithaca, 1962
● *Léger et l'esprit moderne: une alternative d'avant-garde à l'art non-objectif (1918–1931)*, exh. cat., Musée d'Art Moderne de la Ville de Paris, 1982; Museum of Fine Arts, Houston, 1982
● *Arte abstracto, arte concreto. Cercle et carré, Paris, 1930*, exh. cat., IVAM Centro Julio González, Valencia, 1990

Simon Hantaï
born Bia, near Budapest, 8 December 1922
in Paris: from 1949
● *Hantaï (rétrospective)*, exh. cat., Musée National d'Art Moderne, Centre Georges Pompidou, Paris, 1976
● Georges Didi-Huberman, *L'Etoilement, conversation avec Simon Hantaï*, Paris, 1998
● *Simon Hantaï, Werke von 1960 bis 1995*, exh. cat., Westfälisches Landesmuseum für Kunst und Kulturgeschichte, Münster, 1999

Hans Hartung
born Leipzig, 21 September 1904
died Antibes, 7 December 1989
in Paris: 1926–32, 1935–39, and from 1945
● Hans Hartung, *Autoportrait*, Paris, 1976
● Pierre Daix, *Hans Hartung*, Paris, 1991
● Jennifer Mundy, *Hans Hartung: Works on Paper 1922–1956*, exh. cat., Tate Gallery, London, 1996

Jean Hélion
born Couterne, Orne, 21 April 1904
died Paris, 27 October 1987
in Paris: 1921–36, and from 1945
● *Jean Hélion*, exh. cat., IVAM Centro Julio González, Valencia; Tate Liverpool, 1990
● Henry-Claude Cousseau, *Hélion*, Paris, 1992
● Jean Hélion, *Journal d'un peintre: carnets I, 1929–1962; carnets II, 1963–1984*, Anne Moeglin-Delcroix (ed.), Paris, 1992

Auguste Herbin
born Quiévy, Nord, 29 April 1882
died Paris, 31 January 1960
in Paris: from 1901
● Auguste Herbin, *L'Art non-figuratif non-objectif*, Paris, 1949
● Geneviève Claisse, *Herbin: catalogue raisonné de l'œuvre peint*, Lausanne and Paris, 1993
● Geneviève Claisse, *Herbin*, Lausanne, 1993

Jacques Hérold
born Piatra Neamtz, Romania, 10 October 1910
died Paris, 11 January 1987
in Paris: 1930–40, and from 1943
● Jacques Hérold, *Maltraité de peinture*, Paris, 1957 (1976)
● *Jacques Hérold*, exh. cat., Galerie Patrice Trigano, Paris, 1990
● Sarane Alexandrian, *Jacques Hérold*, Paris, 1995

Robert Humblot
born Fontenay-sous-Bois, 13 May 1907
died Paris, 14 March 1962
in Paris: 1924–39, and from 1943
● *Bob Humblot*, exh. cat., Galerie Billiet-Worms, Paris, 1937 (including preface by Raymond Cogniat)
● *Robert Humblot: rétrospective*, exh. cat., Musée Galliéra, Paris, 1964
● Pierre Worms et al., *Forces Nouvelles, 1935–1939*, exh. cat., Musée d'Art Moderne de la Ville de Paris, 1980

Isidore Isou
born Botosani, Romania, 25 January 1925
in Paris: from 1944
● Isidore Isou, *Introduction à une nouvelle poésie et une nouvelle musique*, Paris, 1947
● *Isidore Isou. De l'Impressionnisme au lettrisme: l'évolution des moyens de réalisation de la peinture moderne*, Paris, 1974
● Roland Sabatier, *Le Léttrisme, les créations et les créateurs*, Nice, 1989

Robert Jacobsen
born Copenhagen, 4 June 1912
in Paris: 1947–69
● Jean Dewasne, *Le Sculpteur: Robert Jacobsen, sculpteur danois*, Copenhagen, 1951
● *Robert Jacobsen Retrospective*, exh. cat., Ancien Evêché, Musée d'Evreux, 1991
● *Robert Jacobsen et Paris*, exh. cat., Staatens Museum for Kunst, Copenhagen, 2001

Marcel Jean
born La Charité-sur-Loire, 16 December 1900
died Paris, 1994
in Paris: 1919–24, 1930–38, and from 1945
● Marcel Jean and Arpad Mezei, *Histoire de la peinture surréaliste*, Paris, 1959 (1967)
● Marcel Duchamp and Marcel Jean, *Briefe an Marcel Jean; Lettres à Marcel Jean/Marcel Duchamp; Letters to Marcel Jean/Marcel Duchamp*, Munich, 1987
● *Marcel Jean: peintures, dessins: arbre à tiroirs, commode domino, table-piano, médailles*, exh. cat., Galerie 1900–2000, Paris, 1987–88

Asger Jorn
born Vejrum, Jutland, 3 March 1914
died Arhus, 1 May 1973
in Paris: 1936–39, 1947–51, 1955–71
● Guy Atkins, *Catalogue raisonné, vol. I: Jorn in Scandinavia, 1930–1953*, Copenhagen and London, 1968; Troels Andersen, *Catalogue raisonné, vol. II: The Crucial Years, 1954–1964*, Copenhagen and London, 1977; *Catalogue raisonné, vol. III: The Final Years, 1965–1973*, Copenhagen and London, 1980; Guy Atkins and Troels Andersen, *Catalogue raisonné, vol. IV: Paintings, 1930–1973*, London, 1986
● Graham Birtwistle, *Living Art: Asger Jorn's Comprehensive Theory of Art Between Helhesten and Cobra, 1946–49*, Utrecht, 1986
● Laurent Gervereau, *Critique de l'image quotidienne Asger Jorn*, Paris, 2001

Vasily Kandinsky
born Moscow, 4 December 1866
died Neuilly-sur-Seine, 13 December 1944
in Paris: 1906–07, 1934–44
● *Kandinsky: Complete Writings on Art*, Kenneth C. Lindsay and Peter Vergo (trans. and eds), Boston, 1982
● Hans K. Roethel, *Kandinsky. Catalogue Raisonné of the Oil Paintings, vol. I*, New York, 1982; Karl Flinker, *Kandinsky. Catalogue Raisonné of the Oil Paintings, vol. II*, Paris, 1984
● *Kandinsky, rétrospective*, exh. cat., Fondation Maeght, Saint-Paul-de-Vence, 2001

Ellsworth Kelly
born Newburgh, New York, 31 May 1923
in Paris: 1948–54
● E. C. Goossen, *Ellsworth Kelly*, exh. cat., Museum of Modern Art, New York, 1973
● *Ellsworth Kelly: les années françaises, 1948–1954*, exh. cat., Galerie Nationale du Jeu de Paume, Paris; National Gallery of Art, Washington DC, 1992–93
● *Ellsworth Kelly: A Retrospective*, exh. cat., Solomon R. Guggenheim Museum, New York; Museum of Contemporary Art, Los Angeles; Tate Gallery, London; Haus der Kunst, Munich, 1996–98

Nadia Khodossievitch-Léger
born near Vitebsk, 7 November 1904
died Grasse, 7 November 1982
in Paris: from c. 1924
● *Nadia Léger. Evolution Première. 1920–1926*, exh. cat., Galerie 'Centre d'Art Internationale', Paris, 1971
● Christophe Czwiklitzer, *Suprématisme de Nadia Khodossievitch-Léger*, Paris, 1972
● *Hommage à Nadia Léger. Rétrospective 1967–1992*, exh. cat., Musée National Fernand Léger, Biot, 1992

Moïse Kisling
born Kraków, 22 January 1891
died Sanary, France, 29 April 1953
in Paris: 1910–40, 1946–53
● Joseph Kessel, Henri Troyat and Jean Dutourd, *Kisling, 1891–1953*, 3 vols, Jean Kisling (ed.), Turin, 1971 and 1982, and Landshut, 1995
● *Montparnasse, atelier du monde, ces artistes venus d'ailleurs, hommage à Kisling*, exh. cat., Forum des Arts, Palais de la Bourse, Marseilles, 1992
● *Kisling and His Friends: Paintings and Sculptures from the Collection of the Musée du Petit Palais, Geneva*, exh. cat., Muzeum Narodowe, Warsaw; Muzeum Narodowe, Kraków, 1996

Yves Klein
born Nice, 28 April 1928
died Paris, 6 June 1962
in Paris: from 1955
● *Yves Klein, 1928–62: rétrospective*, exh. cat., Rice University Institute of Art, Rice Museum, Houston; Museum of Contemporary Art, Chicago; Musée National d'Art Moderne, Centre Georges Pompidou, Paris, 1983
● Nicolas Charlet, *Yves Klein*, Paris, 2000 (English and French editions)
● *Yves Klein: Long Live the Immaterial*, exh. cat., Musée d'Art Moderne et d'Art Contemporain, Nice, 2000 (English and French editions)

František Kupka
born Opocno, Bohemia, 22 September 1871
died Puteaux, Paris, 21 June 1957
in Paris: from 1895
● Meda Mladek and Margit Rowell, *František Kupka, 1871–1957*, exh. cat., Solomon R. Guggenheim Museum, New York, 1975
● Jaroslav Andeel and Dorothy Kosinski, *Painting the Universe: František Kupka: Pioneer in Abstraction*, Dallas Museum of Art; Kunstmuseum Wolfburg; National Gallery of Prague, 1997–98
● *František Kupka 1871–1957, ou la naissance de l'abstraction*, exh. cat., Musée d'Ixelles, Brussels, 1998

Wifredo Lam
born Sagua la Grande, Cuba, 8 December 1902
died Paris, 11 September 1982
in Paris: 1938–41, and from 1952
● Michel Leiris, *Wifredo Lam*, Milan, 1970
● *Four Crosscurrents of Modernism: Latin American Pioneers. Diego Rivera, Joaquín Torres-Garcia, Wifredo Lam, Matta*, exh. cat., Hirshhorn Museum, Washington DC, 1992
● *Wifredo Lam: Catalogue Raisonné of the Painted Work I: 1923–1960*, Lou Laurin-Lam (ed.), Paris, 1996

Charles Lapicque
born Taizé, Rhône, 6 October 1898
died Orsay, 15 July 1988
in Paris: from 1909
● Charles Lapicque, *Essais sur l'espace, l'art et la destinée*, Paris, 1958
● Bernard Balanci and Elmina Auger, *Charles Lapicque: catalogue raisonné de l'œuvre peint et de la sculpture*, Paris, 1972 (including unpublished texts by the artist)
● Aloys Perregaux, *Charles Lapicque*, Paris, 1983

Marie Laurencin
born Paris, 31 October 1883
died Paris, 8 June 1956
in Paris: until 1914, and from 1922
● Marie Laurencin, *Le Carnet des nuits*, Brussels, 1942
● Daniel Marchesseau, *Catalogue raisonné de l'œuvre peint de Marie Laurencin*, Nagano-Ken, 1986
● Douglas K. S. Hyland and Heather McPherson, *Marie Laurencin: Artist and Muse*, exh. cat., Museum of Art, Birmingham, Alabama, 1989

Jean-Jacques Lebel
born Neuilly-sur-Seine, 30 June 1936
in Paris: throughout career
● Jean-Jacques Lebel, *Le Happening*, Paris, 1966
● Jean-Jacques Lebel, *Poésie directe, happenings et interventions*, Paris, 1994
● *Jean-Jacques Lebel*, exh. cat., Museum Moderner Kunst, Vienna, 1998

Le Corbusier (Charles-Edouard Jeanneret)
born La Chaux-de-Fonds, Switzerland, 6 October 1887
died Cap Martin, 27 August 1965
in Paris: from 1917
● Amédée Ozenfant and Le Corbusier, *Après le Cubisme*, Paris, 1918 (1999, with a preface by Françoise Ducros)
● *Le Corbusier: Architect of the Century*, exh. cat., Hayward Gallery, London, 1987
● *Le Corbusier: œuvres complètes en 8 volumes*, Willi Boesiger, O. Stonorov and Max Bill (eds), Zurich, 1991 (English, French and German editions)

Fernand Léger
born Argentan, Orne, 4 February 1881
died Gif-sur-Yvette, Seine-et-Oise, 17 August 1955
in Paris: 1900–14, 1920–45
● Fernand Léger, *Fonctions de la peinture*, Paris, 1965
● *Fernand Léger, catalogue raisonné: le catalogue raisonné de l'œuvre peint*, 7 vols (1903–1948), Georges Bauquier (ed.), Paris, 1990–
● *Fernand Léger*, exh. cat., Musée National d'Art Moderne, Centre Georges Pompidou, Paris; Museo Nacional Centro de Arte Reina Sofia, Madrid; Museum of Modern Art, New York, 1997–98

Julio Le Parc
born Mendoza, Argentina, 23 September 1928
in Paris: from 1958
● Julio Le Parc and Enzo Mari, *Julio Le Parc*, Milan, 1968
● *Julio Le Parc: experiencias 30 años 1958–1988*, exh. cat., Dirección Nacional de Artes Visuales, Buenos Aires, 1988
● Jean-Louis Pradel, *Julio le Parc*, Milan, 1995

Jacques Lipchitz
born Druskieniki, Lithuania, 22 August 1891
died Capri, 26 May 1973
in Paris: 1909–40, 1946–47
● Jacques Lipchitz with H. H. Arnason, *My Life in Sculpture*, London, 1972
● Deborah A. Stott, *Jacques Lipchitz and Cubism*, New York and London, 1978
● Alan G. Wilkinson, *The Sculpture of Jacques Lipchitz: A Catalogue Raisonné. The Paris Years, 1910–1940*, vol. I, London, 1996; vol. II, London, 2000

René Magritte
born Lessines, Hainaut, 21 November 1898
died Schaerbeek, Brussels, 15 August 1967
in Paris: 1927–30
● René Magritte, *Ecrits complets*, André Blavier (ed.), Paris, 1979
● David Sylvester, *Magritte: The Silence of the World*, New York, 1992
● *René Magritte: Catalogue Raisonné*, 3 vols, David Sylvester (ed.), London, 1992

433

Aristide Maillol
born Banyuls-sur-Mer, 8 October 1861
died Perpignan, 24 September 1944
in Paris: 1881–1939
● Judith Cladel, *Maillol: sa vie, son œuvre, ses idées*, Paris, 1937
● Bertrand Lorquin, *Artistide Maillol*, Geneva 1994; London, 1995
● *Maillol: peintre*: exh. cat., Fondation Dina Vierny-Musée Maillol, Paris, 2001

Alfred Manessier
born Saint-Ouen, near Amiens, 5 December 1911
died Orléans, 1 August 1993
in Paris: from 1929
● Pierre Encrevé, *Manessier, la passion 1948–88*, exh. cat., Grand Palais, Paris, 1992–93
● *Manessier*, exh. cat., Grand Palais, Paris, 1992–93
● *Alfred Manessier 1911–1993, peintures, aquarelles, vitraux, lithographies*, exh. cat., Musée des Beaux-Arts, Angers, 1994

Man Ray
born Philadelphia, 25 August 1890
died Paris, 18 November 1976
in Paris: 1921–40, 1951–76
● Man Ray, *Man Ray: Self-portrait*, Boston, 1963
● *Man Ray*, exh. cat., Musée National d'Art Moderne, Centre Georges Pompidou, Paris, 1981–82
● Janus, *Man Ray, œuvres 1909–1972*, Milan, 1990

Filippo Tommaso Marinetti
born Alexandria, 22 December 1876
died Bellagio di Como, 2 December 1944
in Paris: 1893, 1909
● Filippo Tommaso Marinetti, *Les Mots en liberté futuristes*, Milan, 1919
● Filippo Tommaso Marinetti, *Marinetti: Selected Writings*, R. W. Flint (ed.), New York and London, 1972
● *Pour un temps: F. T. Marinetti*, exh. cat., Musée National d'Art Moderne, Centre Georges Pompidou, Paris, 1982

Raymond Mason
born Birmingham, 2 March 1922
in Paris: from 1946
● *Raymond Mason*, exh. cat., Musée National d'Art Moderne, Centre Georges Pompidou, Paris, 1985
● *Raymond Mason: Sculptures and Drawings*, exh. cat., Birmingham City Museum and Art Gallery, 1989
● Michael Edwards, *Raymond Mason*, Paris and London, 1995

André Masson
born Balagne, 4 January 1896
died Paris, 28 October 1987
in Paris: 1912–14, 1922–30, 1937–41, and from 1955
● André Masson, *Le Rebelle du surréalisme: ecrits*, Françoise Will-Levaillant (ed.), Paris, 1976
● William Rubin and Carol Lanchner, *André Masson*, exh. cat., Museum of Modern Art, New York, 1976
● Dawn Ades, *André Masson*, New York, 1994

Georges Mathieu
born Boulogne-sur-Mer, 27 January 1921
in Paris: from 1947
● Georges Mathieu, *De la Révolte à la Renaissance*, Paris, 1963 (1972)
● Dominique Quignon-Fleuret, *Mathieu*, Naefels, 1977 (French and English editions)
● Grainville and Gérard Xuriguera, *Georges Mathieu*, Paris, 1993

Henri Matisse
born Le Cateau-Cambrésis, near Cambrai, Picardy, 31 December 1869
died Nice, 3 November 1954
in Paris: 1891–1940
● Henri Matisse, *Matisse on Art*, Jack Flam (ed.), Oxford, 1973
● John Elderfield, *Matisse: A Retrospective*, exh. cat., Museum of Modern Art, New York, 1992–93
● Hilary Spurling, *The Unknown Matisse: A Life of Henri Matisse*, London, 1998

Matta (Roberto Matta Echaurren)
born Santiago de Chile, 11 November 1911
in Paris: 1933–34, 1937–39, and from the mid-1950s
● *Matta*, exh. cat., Musée National d'Art Moderne, Centre Georges Pompidou, 1985
● Roberto Matta Echaurren, *Entretiens morphologiques. Notebook no. 1, 1936–44*, G. Ferrari (ed.), London, 1987
● *Four Crosscurrents of Modernism: Latin American Pioneers. Diego Rivera, Joaquín Torres-García, Wifredo Lam, Matta*, exh. cat., Hirshhorn Museum, Washington DC, 1992

Henri Michaux
born Namur, Belgium, 24 May 1899
died Paris, 19 October 1984
in Paris: early 1920s–1927, and from c. 1940
● Alain Jouffroy, *Avec Henri Michaux*, Monaco, 199?
● *Henri Michaux, œuvres choisis, 1927–1984*, exh. cat., Musée Cantini, Marseilles; IVAM Centro Julio González, Valencia, 1993–94
● Jean-Michel Maulpoix and Florence de Lussy, *Henri Michaux: peindre, composer, écrire*, exh. cat., Bibliothèque Nationale de France, Paris, 1999

Joan Miró
born Barcelona, 20 April 1893
died Palma de Mallorca, 25 December 1983
in Paris: 1919–40
● Jacques Dupin, *Joan Miró: Life and Work*, New York, 1962
● *Joan Miró: Selected Writings and Interviews*, Margit Rowell (ed.), Boston, 1986
● Jacques Dupin and Ariane Lelong-Mainaud, *Joan Miró. Catalogue Raisonné: Paintings, vol. I, 1908–30*, *Joan Miró. Catalogue Raisonné: Paintings, vol. II, 1931–41*, Paris, 1999

Amedeo Modigliani
born Livorno, 12 July 1884
died Paris, 24 January 1920
in Paris: 1906–18, 1919–20
● *Amedeo Modigliani*, exh. cat., Musée d'Art Moderne de la Ville de Paris, 1981
● *Modigliani: catalogue raisonné*, 2 vols, Christian Parisot and Giorgio and Guido Guastalla (eds), Livorno, 1990
● *Modigliani: testimonianze, documenti e disegni inediti provenienti dalla collezione del dottor Paul Alexandre*, Noël Alexandre (ed.), Turin and Antwerp, 1993

Piet Mondrian
born Amersfoort, 7 March 1872
died New York, 1 February 1944
in Paris: 1912–14, 1919–38
● *The New Art, The New Life: The Collected Writings of Piet Mondrian*, London, 1987
● *Piet Mondrian: 1872–1944*, Yve-Alain Bois (ed.), exh. cat., Haags Gemeentemuseum, The Hague; National Gallery of Art, Washington; Museum of Modern Art, New York, 1995–96
● J. M. Joosten and R. P. Welsh, *Piet Mondrian: Catalogue Raisonné*, 2 vols, New York, 1997

Jacques Monory
born Paris, 25 June, 1924
in Paris: throughout career
● Jacques Monory, *Eldorado*, Paris, 1991
● Pierre Tilman, *Monory*, Paris, 1992 (French and English editions)
● Jean-François Lyotard, *The Assassination of Experience by Painting/Jacques Monory. L'Assassinat de l'experience par la peinture*, Sarah Wilson (ed.), London, 1999

François Morellet
born Cholet, Maine-et-Loire, 30 April 1926
in Paris: from 1945
● François Morellet, *Je n'ai plus rien à dire*, Paris, 1994
● Serge Lemoine, *François Morellet*, Paris, 1996
● *Morellet*, exh. cat., Musée National du Jeu de Paume, Paris, 2000–01

Richard Mortensen
born Copenhagen, 23 October 1910
died Copenhagen, 12 January 1993
in Paris: 1947–64
● *Mortensen: maleri 1929–1993, Painting, 1929–1933*, exh. cat., Statens Museum for Kunst, Copenhagen, 1993
● *Richard Mortensen: l'œuvre graphique, 1942–1993*, exh. cat., Statens Museum for Kunst, Copenhagen, 1995
● *Mortensen*, exh. cat., Galerie Denise René, Paris, 1998

Marlow Moss
born Richmond, 29 May 1890
died Penzance, 23 August 1958
in Paris: 1927–39
● Antoinette H. Nijhoff, *Marlow Moss*, exh. cat., Stedelijk Museum, Amsterdam, 1962
● *Marlow Moss*, exh. cat., Galerie Gimpel & Hanover, Zurich, 1973–74
● Florette Dijkstra, *Marlow Moss, Constructivist, and the Reconstruction Project*, Penzance, 1995

C. R. W. (Christopher Richard Wynne) Nevinson
born London, 13 August 1889
died London, 7 October 1946
in Paris: 1912–13
● C. R. W. Nevinson, *Paint and Prejudice*, London, 1937
● *C. R. W. Nevinson, Retrospective Exhibition of Paintings, Drawings and Prints*, exh. cat., Kettle's Yard, University of Cambridge, 1988
● *C. R. W. Nevinson: The Twentieth Century*, exh. cat., Imperial War Museum, London, 1999–2000

Amédée Ozenfant
born Saint-Quentin, Aisne, 15 April 1886
died Cannes, 4 May 1966
in Paris: 1905–35
● Amédée Ozenfant, *Art: bilan des arts modernes et structure d'un nouvel esprit*, Paris, 1928; *Foundations of Modern Art*, London, 1931 (revised 1952)
● Amédée Ozenfant, *Mémoires, 1886–1962*, Paris, 1968
● *Amédée Ozenfant*, exh. cat., Musée Lécuyer, Saint-Quentin, 1985

Jules Pascin
born Vidin, Bulgaria, 31 March 1885
died Paris, 2 June 1930
in Paris: 1905–14, and from 1920
● Georges Papazoff, *Pascin…! Pascin…! C'est moi*, Geneva, 1959
● Yves Hémin, *Jules Pascin. Catalogue raisonné, dessins, aquarelles, pastels, peintures, dessins érotiques*, Paris, 1991
● *Pascin*, exh. cat., Musée-Galerie de la Seita, Paris, 1994

Antoine Pevsner
born Oryol, Russia, 18 January 1884
died Paris, 12 April 1962
in Paris: 1911, 1913, 1923–62
● Antoine Pevsner, *Pevsner au Musée National d'Art Moderne: les ecrits de Pevsner*, Paris, 1964 (including catalogue of works in the Musée National d'Art Moderne, Paris)
● Doïna Lemny, *Antoine Pevsner dans les collections du Centre Pompidou, Musée National d'Art Moderne*, Paris, 2001
● Pierre Brullé and Elisabeth Lebon, *Catalogue raisonné de l'œuvre sculpté d'Antoine Pevsner*, Paris, 2001

Jean Peyrissac
born Cahors, Lot, 1895
died Paris, 22 June 1974
in Paris: from 1957
● Jean Peyrissac, 'Construction dans l'espace', *Derrière le miroir*, Paris, June 1948
● *Jean Peyrissac* (retrospective), exh. cat., Galerie Charley Chevalier, Paris, 1974

Francis Picabia
born Paris, 22 January 1879
died Paris, 30 November 1953
in Paris: until 1915, 1919–25, 1945–53
● Francis Picabia, *Ecrits, vol. I: 1913*, *Ecrits, vol. II: 1921–1953*, Paris, 1975–78
● William A. Camfield, *Francis Picabia: His Art, Life and Times*, Princeton, 1979
● *Picabia et la Côte d'Azur*, exh. cat., Musée d'Art Moderne et d'Art Contemporain, Nice, 1991

Pablo Picasso
born Málaga, 25 October 1881
died Mougins, 8 April 1973
in Paris: 1900, 1901, 1902, 1904–48
● Christian Zervos, *Pablo Picasso*, 34 vols, Paris, 1932–78
● *Les Demoiselles d'Avignon*, exh. cat., 2 vols, Musée Picasso, Paris, 1988; Museu Picasso, Barcelona, 1988
● John Richardson, *A Life of Picasso*, vol. I, New York, 1991; vol. II, New York, 1996

Serge Poliakoff
born Moscow, 8 January 1906
died Paris, 12 October 1969
in Paris: 1923–35, and from 1937
● Serge Poliakoff, *Enluminures*, Saint Gallen, 1972
● *Poliakoff*, exh. cat., Musée Maillol, Fondation Dina Vierny, Paris, 1999
● Gérard Durozoi, *Rétrospective Serge Poliakoff*, exh. cat., Centre Xavier Battini, L'Isle-sur-la-Sorgue, 2001

Anton Prinner
born Budapest, 1 December 1902
died Paris, 1983
in Paris: 1927–50, and from 1964
● *Anton Prinner*, exh. cat., Galerie Pierre Loeb, Paris, 1945
● *L'Avant-garde en Hongrie 1910–30*, exh. cat., Galerie Franka Berndt, Paris, 1984
● *Anton Prinner, 1902–1983*, exh. cat., Galerie Meyer-Bugel, Paris, 1985

Bernard Rancillac
born Paris, 29 August 1931
in Paris: throughout career
● Serge Fauchereau, *Bernard Rancillac*, Paris, 1991
● Bernard Rancillac, *Voir et comprendre la peinture*, Paris, 1991
● Bernard Rancillac, *Le Regard idéologique*, Paris, 2000

Jean Pierre Raynaud
born Courbevoie, Hauts-de-Seine, 23 April 1939
in Paris: from 1957
● Gladys Fabre, *Jean Pierre Raynaud*, Paris, 1986
● Denyse Durand-Ruel, *Jean Pierre Raynaud: catalogue raisonné*, Paris, 1998–
● *Jean Pierre Raynaud*, exh. cat., Galerie Nationale du Jeu de Paume, Paris, 1998–99

Martial Raysse
born Golfe-Juan, near Cannes, 12 February 1936
active in Paris: 1960–73
● *Martial Raysse, maître et esclave de l'imagination*, exh. cat., Stedelijk Museum, Amsterdam, 1965
● Pierre Restany, *Martial Raysse*, exh. cat., Palais des Beaux-Arts, Brussels, 1967
● *Martial Raysse*, exh. cat., Galerie National du Jeu de Paume, Paris; Museum Moderner Kunst Stiftung Ludwig Wien, Vienna; IVAM Centro Julio González, Valencia, 1992–93

Antonio Recalcati
born Bresso, Italy, 1938
in Paris: frequently, from the mid-1960s
● Alain Jouffroy, *Les Empreintes de Recalcati, 1960–1962*, Paris, 1975
● *Recalcati, Dall'impronta all'immagine*, exh. cat., Palazzo Braschi, Rome, 1988
● *Mano a mano, Antonio Recalcati*, exh. cat., Villa Tamaris, La-Seyne-sur-mer, 1999

Georges Ribemont-Dessaignes
born Montpellier, 19 June 1884
died Saint-Jeannet, Haute Provence, 9 July 1974
in Paris: 1904
● Noël Arnaud, *Georges Ribemont-Dessaignes: déjà jadis, ou du mouvement Dada à l'espace abstrait*, Paris, 1958
● Philippe Soupault and Robert Butheau, *Déjà jadis, G. Ribemont-Dessaignes 1884–1974, un écrivain et ses amis*, exh. cat., Centre National des Arts Plastiques, Villa Arson, Nice, 1984
● Georges Ribemont-Dessaignes, *Dada: manifestes, poèmes, nouvelles, articles, projets, théâtre, cinéma, chroniques (1915–1929)*, Jean-Pierre Begot (ed.), Paris, 1994

Germaine Richier
born Grans, near Arles, 16 September 1904
died Montpellier, 31 July 1959
in Paris: 1925–39, and from 1946
● *Germaine Richier*, exh. cat., Musée National d'Art Moderne, Paris, 1955
● *Germaine Richier*, exh. cat., Galerie Creuzevault, Paris, 1966 (including letters from the artist)
● Jean-Louis Prat, *Germaine Richier: rétrospective*, exh. cat., Fondation Maeght, Saint-Paul-de-Vence, 1996

Jean-Paul Riopelle
born Montreal, baptised 7 October 1923
in Paris: from 1947
● Pierre Schneider, *Riopelle: signes mêlés*, Paris, 1972
● Pierre Schneider, *Jean-Paul Riopelle: peinture 1946–1977*, exh. cat., Musée National d'Art Moderne, Centre Georges Pompidou, Paris; Musée du Québec; Musée d'Art Contemporain, Montreal, 1981
● Yseult Riopelle, *Jean-Paul Riopelle: catalogue raisonné*, Michel Waldberg and Monique Brunet-Weinmann (eds), Montreal, 1999

Diego Rivera
born Guanajuato, 13 December 1886
died Mexico City, 24 November 1957
in Paris: 1911–20
● G. March, *Diego Rivera: My Art, My Life*, New York, 1960
● *Diego Rivera: The Cubist Years*, exh. cat., Art Museum, Phoenix, 1984
● *Diego Rivera: Art and Revolution*, exh. cat., Cleveland Museum of Art; Museo de Arte Moderno, Mexico City, 1999

Georges Rouault
born Paris, 27 May 1871
died Paris, 13 February 1958
in Paris: throughout career
● Georges Rouault, *Souvenirs intimes*, Paris, 1926
● Bernard Dorival and Isabelle Rouault, *Georges Rouault: l'œuvre peint*, 2 vols, Monte Carlo, 1988
● *Georges Rouault: The Early Years 1903–1920*, exh. cat., Royal Academy of Arts, London, 1993

Morgan Russell
born New York, 1886
died 1953
in Paris: 1908–46
● *Synchromism and American Color Abstraction 1910–1925*, G. Levin (ed.), exh. cat., Whitney Museum of American Art, New York, 1978
● M. S. Kushner, *Morgan Russell*, New York, 1990
● *Morgan Russell: The Origins of a Modern Masterpiece*, exh. cat., Pennsylvania Academy of the Fine Arts, Philadelphia, 1998

Roland Sabatier
born Toulouse, 23 July 1942
in Paris: from 1960
● Roland Sabatier, *Manipulitude*, Paris, 1963
● Roland Sabatier, *Œuvres de cinéma, 1963–1983*, Paris 1983
● Roland Sabatier, *Le Léttrisme, les créations et les créateurs*, Nice, 1989

Niki de Saint Phalle
born Neuilly-sur-Seine, 29 October 1930
in Paris: from 1951
● *Niki de Saint Phalle*, exh. cat., Kunst- und Austellungshalle der Bundesrepublik Deutschland, Bonn; Musée de la Ville de Paris; McLellan Galleries, Glasgow, 1992–93
● Janice Parente, *Niki de Saint Phalle: catalogue raisonné*, Lausanne, 2000
● *Niki de Saint Phalle*, exh. cat., Musée d'Art Moderne et Art Contemporain, Nice, 2001

Nicolas Schöffer
born Kalocsa, Hungary, 6 September 1912
died 8 January 1992
in Paris: from 1936
● Guy Habasque, *Nicolas Schöffer*, Neuchâtel, 1963
● Nicolas Schöffer, *La Ville cybernétique*, Paris, 1970
● Philippe Sers, *Entretiens avec Nicolas Schöffer*, Paris, 1971

Gino Severini
born Cortona, 7 April 1883
died Paris, 26 February 1966
in Paris: 1906–28, 1929–35, and from 1946
● Gino Severini, *Tutta la vita di un pittore*, Milan, 1921; *The Life of a Painter: The Autobiography of Gino Severini*, Princeton, 1995
● Simonetta Fraquelli and Christopher Green, *Gino Severini, From Futurism to Classicism*, exh. cat., Estorick Collection, London, 1999
● *Gino Severini: The Dance, 1909–1916*, exh. cat., Peggy Guggenheim Collection, Venice, 2001

Walter Sickert
born Munich, 31 May 1860
died Bathampton, Somerset, 22 January 1942
in Paris: 1883–1905
● *Sickert: Paintings*, exh. cat., Royal Academy of Arts, London, 1992
● David Peters Corbett, *Walter Sickert Drawings*, London, 1996
● *Walter Sickert: Complete Writings on Art*, Anna Greutzner-Robins (ed.), Oxford, 2000

Francisco Sobrino
born Guadalajara, Spain, 1932
in Paris: from 1959
● Frank Popper, *Origins and Development of Kinetic Art*, London, 1968
● *GRAV – Groupe de recherche d'art visuel, 1960–1968*, exh. cat., Le Magasin, Centre d'Art Contemporain de Grenoble, 1998
● *Sobrino. Rétrospectiva 1958–1998*, exh. cat., Museo Guadalajara, Palacio del Infantado, 1998–99

Jesús Rafaël Soto
born Ciudad Bolívar, 5 July 1923
in Paris: from 1950
● Marcel Joray, *Jesús Rafaël Soto*, Neuchâtel, 1984
● Gérard-Georges Lemaire, *Soto*, Paris, 1997
● *Soto: œuvres actuelles*, exh. cat., Galerie Nationale du Jeu de Paume, Paris, 1997

Pierre Soulages
born Rodez, Aveyron, 24 December 1919
in Paris: from 1946
● Pierre Encrevé, *Soulages: l'œuvre complet, peintures*, 3 vols, Paris, 1994–98
● *Soulages: noir lumière*, exh. cat., Musée d'Art Moderne de la Ville de Paris, 1996
● Jean-Michel le Lannou, *Pierre Soulages. La Plénitude du visible*, Paris, 2001

Chaïm Soutine
born Smilovitchi, near Minsk, 1893
died Paris, 9 August 1943
in Paris: 1913–41
● *Chaïm Soutine, 1893–1943*, exh. cat., Tate Gallery, London, 1963 (including introduction by David Sylvester)
● Maurice Tuchman, *Chaïm Soutine: Catalogue Raisonné*, 2 vols, Cologne, 1993
● Kenneth E. Silver et al., *An Expressionist in Paris. The Paintings of Chaïm Soutine*, exh. cat., Jewish Museum, New York, 1998

Daniel Spoerri
born Galati, Romania, 27 March 1930
in Paris: from 1959
● Daniel Spoerri, *Topographie anecdotée du hasard*, Paris, 1962 (English translation, London, 1995)
● *Daniel Spoerri: From A to Z*, exh. cat., Fondazione Mudima, Milan, 1991 (Italian and English editions)
● *Daniel Spoerri*, exh. cat., Museum Jean Tinguely, Basle, 2001

Nicolas de Staël
born St Petersburg, 5 January 1914
died Antibes, 16 March 1955
in Paris: 1938–39, 1943–54
● *Nicolas de Staël*, exh. cat., Fondation Maeght, Saint-Paul-de-Vence, 1991
● Germain Viatte, André Chastel and Anne de Staël, *Catalogue raisonné de l'œuvre peint de Nicolas de Staël*, Françoise de Staël (ed.), Neuchâtel, 1996 (including letters from the artist)
● Anne de Staël, *Staël: du trait à la couleur*, Paris, 2001

Alina Szapocznikow
born Kalisz, Poland, 16 May 1926
died Praz-Coutant, Haute-Savoie, 2 March 1973
in Paris: 1948–51, 1963–73
● Pierre Restany, *Alina Szapocznikow*, exh. cat., Galerie Florence Houston-Brown, Paris; Galerie Zachęta, Warsaw; Latina Gallery, Stockholm; Marya Gallery, Copenhagen, 1967
● *Alina Szapocznikow*, exh. cat., ARC, Musée d'Art Moderne de la Ville de Paris, 1973
● *Alina Szapocznikow 1926–1973*, exh. cat., Galerie Zachęta, Warsaw, 1998 (Polish and English editions)

Takis (Panayotis Vassilakis)
born Athens, 29 October 1925
in Paris: 1955–68
● *Takis, Estafilades*, Paris, 1961 (autobiography)
● *Takis: Monographie*, Helena Calas and Nicolas Calas (eds), Paris, 1984
● *Takis*, exh. cat., Galerie National du Jeu de Paume, Paris; Fundación 'La Caixa', Madrid, 1993

Yves Tanguy
born Paris, 5 January 1900
died Woodbury, Connecticut, 15 January 1955
in Paris: until 1942
● André Breton, *Yves Tanguy*, New York, 1946 (book design by Marcel Duchamp)
● Patrick Waldberg, *Yves Tanguy*, Brussels, 1977
● Roland Penrose, Robert Lebel and José Pierre, *Yves Tanguy: rétrospective, 1925 1955*, exh. cat., Musée National d'Art Moderne, Centre Georges Pompidou, Paris; Staatliche Kunsthalle Baden-Baden, 1982

Boris Taslitzky
born Paris, 30 September 1911
in Paris: throughout career
● Boris Taslitzky, *Tu parles*, Paris, 1959
● *Boris Taslitzky*, exh. cat., Musée de la Résistance Nationale, Champigny-sur-Marne, 1989
● *Boris Taslitzky*, exh. cat., Siège Nationale du Parti Communiste Français, Paris, 2001

Sophie Täuber-Arp
born Davos, 19 January 1889
died Zurich, 13 January 1943
in Paris: 1928–40
● *Sophie Täuber-Arp*, Georg Schmidt (ed.), Basle, 1948 (including catalogue raisonné by Hugo Weber)
● Michel Seuphor, *Mission spirituelle de l'art à propos de l'œuvre de Sophie Täuber-Arp et de Jean Arp*, Paris, 1953
● *Sophie Täuber*, exh. cat., Musée d'Art Moderne de la Ville de Paris, 1989–90

Jean Tinguely
born Fribourg, 22 May 1925
died Bern, 30 August 1991
in Paris: from 1953
● Christina and Bruno Bischofberger, *Jean Tinguely: Catalogue Raisonné. Sculpture and Reliefs, 1954–68*, 2 vols, Zurich, 1982–90
● Pontus Hulten, *Jean Tinguely: A Magic Stronger than Death*, exh. cat., Palazzo Grassi, Venice, 1987
● *Museum Jean Tinguely, Basle, The Collection*, Bern, 1996

Joaquín Torres-García
born Montevideo, 25 July 1874
died Montevideo, 8 August 1949
in Paris: 1924–32
● Joaquín Torres-García, *Historia de mi vida*, Montevideo, 1934
● Joaquín Torres-García, *Universalismo constructivo*, Madrid, 1984
● Margit Rowell, Theo van Doesburg and Joaquín Torres-García, *Torres-García: Grid-Pattern-Sign, Paris-Montevideo, 1924–1944*, exh. cat., Hayward Gallery, London, 1985–86

Leon Tutundjián
born Amassia, Turkey (Armenia), November 1905
died Paris, 1 December 1968
in Paris: from 1923
● Robert Claude, *Leon Tutundjián 1905–1968, aquarelles, dessins, peintures*, Paris, 1970
● Robert Claude, *Leon Tutundjián: œuvres géometriques et constructivistes*, Paris, 1977
● Gladys Fabre, *Tutundjián*, Paris, 1994

Maurice Utrillo
born Paris, 26 December 1883
died Dax, 5 November 1955
in Paris: throughout career
● *Maurice Utrillo*, exh. cat., Galerie Bernheim-Jeune, Paris, 1927
● Paul Pétridès, *L'Œuvre complet de Maurice Utrillo*, 5 vols, Paris, 1959–74
● *Centenaire d'Utrillo*, Jeanine Warnod (ed.), exh. cat., Mitsukoshi, Tokyo, 1985

Suzanne Valadon
born Bessines-sur-Gartempe, near Limoges, 23 September 1865
died Paris, 7 April 1938
in Paris: from 1870
● Robert Rey, *Suzanne Valadon*, Paris, 1922
● Paul Pétridès, *Catalogue raisonné de l'œuvre de Suzanne Valadon*, Paris, 1971
● *Suzanne Valadon*, exh. cat., Fondation Pierre Gianadda, Martigny, 1996

Georges Vantongerloo
born Antwerp, 24 November 1886
died Paris, 5 October 1965
in Paris: from 1928
● Georges Vantongerloo, *L'Art et son avenir*, Antwerp, 1924
● *Georges Vantongerloo: A Travelling Retrospective Exhibition*, exh. cat., Corcoran Art Gallery, Washington DC; Dallas Museum of Fine Arts; Los Angeles County Museum of Art; Musées Royaux des Beaux-Arts, Brussels, 1980–81 (including catalogue raisonné and text by the artist)
● Max Bill, *Georges Vantongerloo: A Working Friendship. Fifty Years of Sculpture, Painting and Drawing*, exh. cat., Annely Juda Fine Art, London, 1996

Victor Vasarely
born Pécs, Hungary, 9 April 1908
died Paris, 15 March 1997
in Paris: from 1930
● Victor Vasarely, *Vasarely: la grande monographie*, 4 vols, Neuchâtel, 1965–78
● Jean-Louis Ferrier, *Entretiens avec Victor Vasarely*, Paris, 1970
● *Victor Vasarely*, exh. cat., Fundación Juan March, Madrid, 2000

Bram van Velde
born Zoeterwoude, near Leiden, 19 October 1895
died Grimaud, 28 December 1981
in Paris: 1924–30, 1931, 1936–58, 1959, 1977–80
● Samuel Beckett, Georges Duthuit and Jacques Putman, *Bram van Velde*, Paris, 1958
● *Bram van Velde*, exh. cat., Musée National d'Art Moderne, Centre Georges Pompidou, Paris; IVAM Centro Julio González, Valencia, 1989–90
● *Bram van Velde 1895–1981. Rétrospective du centenaire*, exh. cat., Musée Rath, Geneva, 1996

Paule Vézelay
born Clifton (Bristol), 14 May 1893
died London, 20 March 1984
in Paris: 1923–39
● Ronald Alley, *Paule Vézelay*, exh. cat., Tate Gallery, London, 1983
● Sarah Wilson, *Paule Vézelay – Hans Arp: The Enchantments of Purity*, exh. cat., Henry Moore Centre for the Study of Sculpture, Leeds, 1995
● Jane England, *Paule Vézelay: Retrospective*, exh. cat., England & Co., London, 2000

Maria Elena Vieira da Silva
born Lisbon, 13 June 1908
died Paris, 6 March 1992
in Paris: 1928–40, and from 1947
● *Vieira da Silva*, exh. cat., Fundação Calouste Gulbenkian, Lisbon; Grand Palais, Paris, 1988
● *Vieira da Silva: catalogue raisonné*, Geneva, 1994
● *Vieira da Silva*, exh. cat., Musée Maillol, Fondation Dina Vierny, Paris, 1999

Jacques de la Villeglé
born Quimper, 27 March 1926
in Paris: from 1949
● *Jacques Mahé de la Villeglé: lacéré anonyme*, Musée National d'Art Moderne, Centre Georges Pompidou, 1977
● Jacques de la Villeglé, *Urbi et Orbi*, Mâcon, 1986
● Jacques de la Villeglé, *Jacques de la Villeglé: catalogue thématique des affiches lacérées*, 14 vols, Paris, 1989

Jacques Villon
born Damville, 31 July 1875
died Puteaux, 9 June 1963
in Paris: 1894–1914, 1919–40, and from 1944
● Pierre Cabanne, *Les Trois Duchamp: Jacques Villon, Raymond Duchamp-Villon, Marcel Duchamp*, Neuchâtel, 1975
● *Jacques Villon*, exh. cat., Fogg Art Museum, Harvard, 1976
● Innis Howe Shoemaker, *Jacques Villon and His Cubist Prints*, Philadelphia, 2001

Maurice de Vlaminck
born Paris, 5 April 1876
died Rueil-la-Gadelière, Eure-et-Loire, 7 October 1958
in Paris: until 1925
● Marcel Sauvage, *Vlaminck: sa vie et son message*, Geneva, 1956 (including selections of the artist's writings)
● *Maurice de Vlaminck 1876–1958: peintures, estampes, céramiques, mobiliers, broderies. Collection du Musée des Beaux-Arts, Chartres*, Chartres, 2000
● Maïthé Vallès-Vled and Godelièvre de Vlaminck, *Vlaminck catalogue raisonné* (in preparation)

Edouard Vuillard
born Cuiseaux, Saône-et-Loire, 11 November 1868
died La Baule, 21 June 1940
in Paris: from 1878
● Edouard Vuillard, unpublished 'Journal', 48 vols, Institut de France, Paris
● Claude Roger-Marx, *Vuillard: His Life and Work*, London, 1946
● *Vuillard: catalogue des œuvres*, Paris, 1990
● Claire Freches-Thory, *The Nabis: Bonnard, Vuillard and Their Circle*, New York, 1991

Wols (Alfred Otto Wolfgang Schulze)
born Berlin, 27 March 1913
died Champigny-sur-Marne, near Paris, 1 September 1951
in Paris: 1932, 1933, 1935–39, and from 1946
● Laszlo Glozer, *Wols photographe*, Musée National d'Art Moderne, Centre Georges Pompidou, Paris, 1980
● *Wols*, exh. cat., Kunsthaus, Zurich, 1988–89
● *Wols, Aphorismes*, Amiens, 1989

Ossip Zadkine
born Vitebsk, 14 July 1890
died Paris, 25 November 1967
in Paris: 1909, and from 1910
● Ossip Zadkine, *Le Maillet et le ciseau. Souvenirs de ma vie*, Paris, 1968
● Sylvain Lecombre, *Musée Zadkine: sculptures*, Paris, 1989
● Sylvain Lecombre, *Ossip Zadkine, l'œuvre sculpté*, Paris, 1994

Zao Wou-Ki
born Peking, 13 February 1921
in Paris: from 1948
● Jean Leymarie, *Zao Wou-Ki*, Barcelona, 1979
● Pierre Daix, *Zao Wou-Ki: l'œuvre peint 1935–1993*, Neuchâtel, 1994
● Bernard Noël, *Zao Wou-Ki: au bord du visible*, Paris, 2000

435

List of Works

Yaacov Agam
● *Three Movements* (three views of the same work), 1953. Oil on wood, 73.7 × 84.4 cm. Y. Agam. Courtesy of Artlife Gallery, New York: cat. 227

Gilles Aillaud, Eduardo Arroyo and Antonio Recalcati
● *To Live or Let Die, or The Tragic End of Marcel Duchamp*, 1965. Oil on canvas (1–3, 5, 7–8) 162 × 130 cm; (4, 6) 162 × 114 cm. Museo Nacional Centro de Arte Reina Sofía, Madrid: cat. 280

Pierre Alechinsky
● *Les Grands Transparents*, 1958. Oil on canvas, 200 × 300 cm. Larock-Granoff Collection, Paris: cat. 216

Hermenegildo Anglada Camarasa
● *The White Peacock*, 1904. Oil on board, 78.5 × 99.5 cm. Carmen Thyssen-Bornemisza Collection. Bilbao only: cat. 1

Karel Appel
● *Stéphane Lupasco and Michel Tapié*, 1956. Oil on canvas, 130 × 195 cm. Stedelijk Museum, Amsterdam: cat. 214

Arman
● *Accumulation Renault no. 106*, 1967. Compressed car panels, 110 × 120 × 225 cm. Courtesy Galerie Georges-Philippe and Nathalie Vallois: cat. 252
● *Ulysses' Armchair*, 1965. Burnt armchair, polyester residue and wood, 107 × 81 × 81 cm. Private collection, France: cat. 253

Jean (Hans) Arp
● *Configuration with Two Dangerous Points*, 1930. Painted wood, 70.2 × 84.8 cm. Philadelphia Museum of Art: The A. E. Gallatin Collection, 1947: cat. 87
● *Un Grand et deux petits*, 1931. Wood, 66 × 46 × 46 cm. Fondation Arp, Clamart: cat. 86

Antonin Artaud
● *Portrait of Colette Allendy*, 1947. Pencil and pink chalk on paper, 64 × 49 cm. Musée National d'Art Moderne, Centre Georges Pompidou, Paris. Bequest of Paule Thévenin (Paris), 1994. RA only: cat. 177
● *Portrait of Roger Blin*, 1946. Pencil on paper, 69.5 × 53 cm. Musée National d'Art Moderne, Centre Georges Pompidou, Paris. Bequest of Paule Thévenin (Paris), 1994. RA only: cat. 176
● *Self-portrait*, 1947. Pencil and coloured chalk on paper, 55 × 45 cm. Private collection: cat. 178

Balthus
● *Portrait of Pierre Matisse*, 1938. Oil on canvas, 128.8 × 86.7 cm. Private collection: cat. 68
● *Sleeping Nude*, 1945. Oil on board, 44.5 × 59.7 cm. Private collection: cat. 179

Jean Bazaine
● *Earth and Sky*, 1950. Oil on canvas, 195 × 130 cm. Fondation Marguerite and Aimé Maeght, Saint-Paul: cat. 196
● *La Messe de l'Homme Armé*, 1944. Oil on canvas, 116 × 73 cm. Paule and Adrien Maeght Collection, Paris: cat. 193

Max Beckmann
● *Woman with Snake* (or *Snake Charmer*), 1940. Oil on canvas, 145.5 × 91 cm. Private collection, Switzerland. RA only: cat. 70

Hans Bellmer
● *The Top*, 1938/68. Painted bronze on a marble socle, 54 × 32 × 32 cm. Madame Bénédicte Petit: cat. 148

Maria Blanchard
● *Cubist Composition*, c. 1917. Oil on canvas, 57 × 54 cm. Zorrilla de Lequerica Collection, Bilbao. Bilbao only: cat. 46

Pierre Bonnard
● *Nude with Red Slippers*, c. 1932. Oil on canvas, 110.2 × 49 cm. Private collection. Courtesy Galerie Odermatt-Vedovi, Paris: cat. 124

Constantin Brancusi
● *Bird in Space*, 1927 (posthumous cast 4/5, 2000, after original plaster). Polished bronze, 185 × 45 cm (diameter) (including base). Private collection: cat. 76
● *Nancy Cunard*, 1932. Polished bronze, 79.1 × 20.3 × 26.7 cm (including marble base). Anonymous loan. RA only: cat. 75
● *Prometheus*, 1911. Polished bronze, 13.5 × 17.2 × 13.7 cm. Hirshhorn Museum and Sculpture Garden, Smithsonian Institution, Washington DC. Gift of Joseph H. Hirshhorn, 1966: cat. 77

Georges Braque
● *Bird*, 1955. Oil and sand on canvas, 106.7 × 129.6 cm. Courtesy Helly Nahmad Gallery, London: cat. 204
● *Cards and Dice*, 1914. Oil on canvas, 35.5 × 44 cm (oval). Courtesy Helly Nahmad Gallery, London. RA only: cat. 24
● *Seated Woman*, c. 1924. Oil and sand on canvas, 99.7 × 81 cm. Courtesy Helly Nahmad Gallery, London. RA only: cat. 126
● *Still-life with Violin*, 1913. Oil and charcoal on canvas, 65.4 × 92.1 cm. Mugrabi Collection. RA only: cat. 23
● *Vanitas*, 1939. Oil on canvas, 38 × 55 cm. Musée National d'Art Moderne, Centre Georges Pompidou, Paris. Gift of Madame Georges Braque, 1965: cat. 159

Victor Brauner
● *Ceremony*, 1947. Oil on cotton sheet, laid down on canvas, 187.5 × 236.5 cm. Private collection: cat. 190

Romaine Brooks
● *Jean Cocteau in the Era of the Big Wheel*, 1912. Oil on canvas, 250 × 133 cm. Musée National d'Art Moderne, CCI, Centre Georges Pompidou, Paris. On deposit at the Musée National de la Coopération Franco-Américaine, Blérancourt, 1949. RA only: cat. 62

Bernard Buffet
● *Man with Skull*, 1947. Oil on canvas, 177 × 119 cm. Ida and Maurice Garnier: cat. 158

Pierre Buraglio
● *Mondrian Camouflaged*, 1968. Stretcher and canvas and assembled camouflage elements, 200 × 180 cm. Gilles and Nadège Blanckaert Collection: cat. 281

Daniel Buren
● *Painting with Variable Forms*, 1966. Oil on canvas, 223.6 × 190.6 cm. Collection of the artist: cat. 282

Pol Bury
● *Mobile Relief 5*, 1954. Painted metal, 54 × 44 × 6 cm. Fonds National d'Art Contemporain – Ministère de la Culture, Paris. On deposit at the Musée d'Art Moderne, Saint-Etienne: cat. 236

Alexander Calder
● *Spider*, 1938. Painted metal, 104 × 89 × 0.7 cm. Scottish National Gallery of Modern Art, Edinburgh. Purchased 1976. Illustrated but not exhibited: cat. 90
● *Untitled*, 1933. Wood, wire, aluminium sheet, iron, cords and tempera, 120 × 74 × 30 cm. Col·lecció MACBA, Fundació Museu d'Art Contemporani de Barcelona. RA only: cat. 91

César
● *The Grand Duchess*, 1955. Welded iron, 175 × 73 × 30 cm. Private collection. Courtesy Jean Albou Conseil, Paris: cat. 210
● *Plaque*, 1959. Metal, 113 × 71 × 15 cm. Collection du MAC, Galeries Contemporaines des Musées de Marseille: cat. 211
● *Sunbeam*, 1961. Compressed car, 156 × 75 × 62 cm. Private collection. Courtesy Jean Albou Conseil, Paris: cat. 251

Auguste Chabaud
● *Au Salon*, 1907. Oil on hardboard, 108 × 76 cm. Petit Palais, Musée d'Art Moderne, Geneva. Bilbao only: cat. 8
● *Hotel Corridor*, 1907–08. Oil on cardboard, 105 × 76 cm. Städelsches Kunstinstitut und Städtische Galerie, Frankfurt am Main. RA only: cat. 7

Marc Chagall
● *Paris Through the Window*, 1913. Oil on canvas, 135.8 × 141.4 cm. Solomon R. Guggenheim Museum, New York. Gift of Solomon R. Guggenheim, 1937: cat. 34

Gaston Chaissac
● *Composition*, 1951. Oil on plywood, 65 × 50 cm. Musée des Beaux-Arts, Nantes: cat. 199

Christo
● *Package on Luggage Rack*, 1962. Polyethene, rope, rubberised cord, mattress, baby carriage and steel luggage rack, 63.5 × 136 × 95.2 cm. Lilja Art Fund Foundation. Bilbao only: cat. 254
● *Wrapped Portrait of Jeanne-Claude*, 1963. Oil on canvas painted by Christo Javacheff, wrapped in polyethylene, fabric and rope by Christo, mounted on a black wooden board, 78.5 × 51.2 cm. Lent by Christo and Jeanne-Claude: cat. 256
● *Wrapped Vespa Motorcycle*, 1963. Polyethylene, Vespa and rope, 110 × 160 × 60 cm. Lent by Christo and Jeanne-Claude. RA only: cat. 255

Geneviève Claisse
● *Jazz*, 1966. Oil on canvas, 100 × 100 cm. Collection of the artist: cat. 237

Jean Crotti
● *O = T + T = O*, 1918. Oil on cardboard, 24 × 18 cm. Musée d'Art Moderne de la Ville de Paris: cat. 51

Henri Cueco
● *La Barricade, Viet Nam 68*, 1968. Oil and glycerophtalic paint on canvas, 200 × 200 cm. Collection of the artist: cat. 275

Salvador Dalí
● *Landscape with Telephone in a Dish*, 1939. Oil on canvas, 22 × 30 cm. Courtesy Helly Nahmad Gallery, London. RA only: cat. 146
● *Paranoia*, 1935–36. Oil on canvas, 38 × 46 cm. Salvador Dalí Museum, Inc., St Petersburg, Florida: cat. 145
● *Sleep*, 1937. Oil on canvas, 51 × 78 cm. Private collection: cat. 144
● *Venus de Milo with Drawers*, 1934/64. Painted bronze and fur, 98 × 35.5 × 34 cm. Collection Museum Boijmans Van Beuningen, Rotterdam: cat. 147

Giorgio de Chirico
● *Madame Gartzen*, 1913. Oil on canvas, 73 × 60 cm. Stanley J. Allen, New York: cat. 64

Robert Delaunay
● *La Fenêtre sur la ville no. 3*, 1911–12. Oil on canvas, 113.5 × 130.7 cm. Solomon R. Guggenheim Museum, New York. RA only: cat. 28
● *Tour Eiffel*, 1911. Oil on canvas, 202 × 138.4 cm. Solomon R. Guggenheim Museum, New York. Gift of Solomon R. Guggenheim, 1937. RA only: cat. 30
● *Tour Eiffel aux arbres*, 1910. Oil on canvas, 126.4 × 92.8 cm. Solomon R. Guggenheim Museum, New York. Gift of Solomon R. Guggenheim, 1937. Bilbao only: cat. 27
● *La Ville*, 1911. Oil on canvas, 145 × 111.9 cm. Solomon R. Guggenheim Museum, New York. Gift of Solomon R. Guggenheim, 1938. Bilbao only: cat. 25

Sonia Delaunay-Terk
● *Le Bal Bullier*, 1913. Oil on canvas, 97 × 132 cm. Kunsthalle Bielefeld: cat. 40
● *Dubonnet*, 1914. Watercolour on canvas, 61 × 76 cm. Museo Nacional Centro de Arte Reina Sofía, Madrid. Bilbao only: cat. 37

Tamara de Lempicka
● *Portrait of 'La Duchesse de la Salle'*, 1925. Oil on canvas, 161.3 × 95.9 cm. Collection Wolfgang Joop: cat. 66

André Derain
● *Henri Matisse*, 1905. Oil on canvas, 46 × 34.9 cm. Tate. Purchased 1958: cat. 12
● *Two Nudes with Fruit*, c. 1935. Oil on canvas, 112 × 104 cm. Musée d'Art Moderne de Troyes. Pierre and Denise Lévy donation: cat. 127
● *Woman in a Chemise*, 1906. Oil on canvas, 100 × 81 cm. Statens Museum for Kunst, Copenhagen: cat. 3

Gérard Deschamps
● *Bâche de signalisation*, 1961. Oil on metal, 79 × 168 cm. Museum of Modern Art Ludwig Foundation, Vienna. Formerly Hahn Collection, Cologne: cat. 245

Jean Dewasne
● *The Tomb of Anton Webern (Anti-sculpture)*, 1951. Enamel on aluminium, 151 × 123 × 92 cm. Musée National d'Art Moderne, Centre Georges Pompidou, Paris: cat. 225

Theo van Doesburg
● *Counter-Composition V*, 1924. Oil on canvas, 100 × 100 cm. Stedelijk Museum, Amsterdam: cat. 95

César Domela
● *Relief no. 12A*, 1936. Wood, metal and Plexiglass, 75 × 62.5 × 6 cm. Musée de Grenoble. RA only: cat. 108

Kees van Dongen
● *Anna de Noailles*, 1931. Oil on canvas, 196 × 131 cm. Stedelijk Museum, Amsterdam. RA only: cat. 69
● *Daniel-Henry Kahnweiler*, 1907. Oil on canvas, 65 × 54 cm. Petit Palais, Musée d'Art Moderne, Geneva: cat. 11
● *Portrait of Fernande*, 1905. Oil on canvas, 100 × 81 cm. Private collection: cat. 5

Christian Dotremont and Asger Jorn
● *Je lève, tu lèves, nous rêvons*, 1948. Oil on canvas, 38 × 33 cm. Pierre and Micky Alechinsky Collection, Bougival: cat. 215

Jean Dubuffet
● *Berthollet, with a Crayfish Up His Nose*, 1947. Oil on canvas, 90 × 73 cm. Kunsthaus, Zurich: cat. 172
● *Building Façades* from the 'Mirobolus, Macadam et Cie' series, 1946. Oil on canvas, 130.5 × 162.3 cm. The Museum of Modern Art, New York. Nina and Gordon Bunshaft Bequest, 1994. RA only: cat. 171
● *Miss Cholera*, 1946. Oil, sand, pebbles and straw on canvas, 54.6 × 45.7 cm. Solomon R. Guggenheim Museum, New York. Gift of Katharine Kuh, 1972: cat. 174
● *The Villager with Close-cropped Hair*, 1947. Oil on canvas, 130 × 97 cm. Purchased with funds from the Coffin Fine Arts Trust; Nathan Emory Coffin Collection of the Des Moines Art Center: cat. 173

Marcel Duchamp
● *Air de Paris (50cc of Paris Air)*, 1919. Readymade: glass ampoule, 13.5 × 20.5 cm (diameter). Moderna Museet, Stockholm: cat. 49
● *Bicycle Wheel*, 1913. Readymade, 126.7 × 64.1 × 32 cm. Hessisches Landesmuseum, Darmstadt: cat. 44
● *La Gioconde (L.H.O.O.Q.)*, 1919–30. Pencil on reproduction, 48.3 × 33.3 cm. Lent by the French Communist Party. Gift of Aragon: cat. 50
● *Please Touch*, 1947. Exhibition catalogue, velvet and foam rubber, 25 × 21.5 × 5 cm. Paule and Adrien Maeght Collection, Paris: cat. 189

Raymond Duchamp-Villon
● *Large Horse*, 1914 (cast 1961). Bronze, 100 × 98.7 × 66 cm. Tate. Purchased 1978: cat. 47

François Dufrêne
● *Mai-juin 1968*, 1968. Torn posters on canvas, 61 × 50 cm. Collection Ginette Dufrêne: cat. 272

Raoul Dufy
● *The Model*, or *Nude in the Studio at L'Impasse Guelma*, 1933. Oil on canvas, 65 × 54 cm. Musée d'Art Moderne de la Ville de Paris: cat. 117

Equipo 57
● *PA9*, 1957. Oil on canvas, 95 × 68 cm. Galerie Denise René: cat. 235
● *Untitled*, 1961. Oil on wood, 75 × 75 cm. Galerie Denise René: cat. 234

Max Ernst
● *Laocoön and Sons*, 1927. Oil on canvas, 65.4 × 81.3 cm. The Menil Collection, Houston: cat. 138
● *Max Ernst Showing a Young Girl the Head of His Father*, 1926–27. Oil on canvas, 114.3 × 146.8 cm. Accepted by Her Majesty's government in lieu of inheritance tax on the estate of Gabrielle Keiller (1908–1995) and allocated to the Scottish National Gallery of Modern Art in 1998. RA only: cat. 139

Erró
● *The Background of Jackson Pollock*, 1967. Oil on canvas, 250 × 200 cm. Musée National d'Art Moderne, Centre Georges Pompidou, Paris: cat. 277

Maurice Estève
● *Homage to Jean Fouquet*, 1952. Oil on canvas, 80.5 × 65 cm. Musée Rolin, Autun: cat. 200

Alexandra Exter
● *Still-life*, 1913. Oil, tempera and printed matter on paper on canvas, 68 × 53 cm. Museo Thyssen-Bornemisza, Madrid: cat. 35

Jean Fautrier
● *Black Nude*, 1926. Oil on canvas, 116.4 × 89 cm. Musée National d'Art Moderne, Centre Georges Pompidou, Paris. RA only: cat. 133
● *Les Demoiselles*, 1929. Oil on canvas, 97 × 112 cm. Marie-José Lefort Collection: cat. 135
● *Glaciers*, 1926. Oil on canvas, 46 × 56 cm. The Menil Collection, Houston. Gift of Alexander Iolas: cat. 134
● *L'Homme qui est malheureux*, 1947. Oil on marouflé paper, pasted on canvas, 44 × 59 cm. Gunter Sachs Collection. RA only: cat. 166
● *Hostage*, 1943. Bronze, 48.5 × 28 × 30 cm. Private collection, Germany: cat. 163
● *Hostage no. 22*, 1944. Oil on paper, pasted on canvas, 27 × 22 cm. Collection Marin Karmitz: cat. 164
● *Large Torso*, 1928. Bronze, 69 × 24 × 28 cm. Private collection, Germany: cat. 136
● *Large Tragic Head*, 1942. Bronze, H. 33.5 cm. Collection Welle: cat. 167
● *The Pretty Girl*, 1944. Oil on paper, pasted on canvas, 60 × 50 cm. Private collection: cat. 165
● *Rabbit Pelts*, 1927. Oil on canvas, 100 × 81 cm. Marie-José Lefort Collection: cat. 132
● *Standing Woman*, 1935. Bronze, 130 × 40 × 40 cm. Galerie Michael Werner, Cologne and New York: cat. 137

Robert Filliou
● *La Joconde est dans les escaliers*, 1968. Cardboard, long-handled scrubbing brush, bucket and floor cloth, life size. Musée d'Art Moderne, Saint-Etienne. Vicky Remy donation: cat. 260

436

André Fougeron
● *The Judges*, 1950. Oil on canvas, 195 × 130 cm. Musée National d'Art Moderne, Centre Georges Pompidou, Paris: cat. 182

Tsuguharu Foujita
● *The Two Friends*, 1926. Oil on canvas, 92 × 73 cm. Petit Palais, Musée d'Art Moderne, Geneva: cat. 114
● *Youki, Snow Goddess*, 1924. Oil on canvas, 126 × 173 cm. Petit Palais, Musée d'Art Moderne, Geneva: cat. 115

Sam Francis
● *Blue Composition on White Ground*, 1960. Oil on canvas, 130 × 97 cm. Fonds National d'Art Contemporain – Ministère de la Culture, Paris. On deposit at the Musée des Beaux-Arts et d'Archéologie, Rennes: cat. 218

Ruth Francken
● *Telephone 5*, 1967. Mixed media, 30 × 30 × 30 cm. Fondation Marguerite and Aimé Maeght, Saint-Paul: cat. 267

Otto Freundlich
● *Composition*, 1930. Oil on canvas, 116 × 89 cm. Musée d'Art Moderne, Saint-Etienne: cat. 109

André Fougeron
● *Martyred Spain*, 1937. Oil on canvas, 98 × 154 cm. Tate. Purchased 2001: cat. 154

Gérard Fromanger
● *Souffle de mai '68*, 1968. Transparent Altuglas, stainless steel and ridged iron base, 240 × 150 × 150 cm. Collection of the artist: cat. 279

Naum Gabo
● *Construction sur un plan*, 1937. Metacrylate and celluloid, 48 × 48 × 19.6 cm. Collection Anne and Jean-Claude Lahumière: cat. 106

Pierre-Antoine Gallien
● *Self-portrait*, 1921. Plaster, glass and oil, 39 × 34.5 cm. Pierre Gallien: cat. 53

Pablo Gargallo
● *Kiki de Montparnasse*, 1928. Polished bronze, 27.5 × 16.5 × 17 cm. Musée d'Art Moderne de la Ville de Paris: cat. 74

Alberto Giacometti
● *Standing Woman I*, 1960. Painted bronze, 270 × 54 × 36.3 cm. Fondation Marguerite and Aimé Maeght, Saint-Paul. RA only: cat. 209
● *Tall Figure*, 1947. Bronze, 201.2 × 21.1 × 42.2 cm. Hirshhorn Museum and Sculpture Garden, Smithsonian Institution, Washington DC. Gift of Joseph H. Hirshhorn, 1966: cat. 175
● *Woman with Her Throat Cut*, 1932. Bronze, 22 × 87.5 × 53.5 cm. Scottish National Gallery of Modern Art, Edinburgh. Puchased 1970. RA only: cat. 151

Albert Gleizes
● *Portrait of the Editor Figuière*, 1913. Oil on canvas, 143 × 102 cm. Musée des Beaux-Arts, Lyons. RA only: cat. 32

Natalia Goncharova
● *Electric Lamp*, 1913. Oil on canvas, 105 × 81.5 cm. Musée National d'Art Moderne, Centre Georges Pompidou, Paris. Gift of the Société des Amis du Musée National d'Art Moderne, Paris, 1966: cat. 43

Julio González
● *Gothic Man*, 1937. Iron, 50 × 13 × 26.5 cm. Fondation Hans Hartung and Anna-Eva Bergman: cat. 152
● *Head in Depth*, 1930. Iron, 26 × 20.1 × 16.1 cm. Fondation Hans Hartung and Anna-Eva Bergman: cat. 73

Jean Gorin
● *Composition no. 36*, 1937. Oil on wood, 92 × 92 × 5.5 cm. Musée de Grenoble. RA only: cat. 100

Juan Gris
● *Man in a Café*, 1912. Oil on canvas, 128.2 × 88 cm. Philadelphia Museum of Art: The Louise and Walter Arensberg Collection, 1950: cat. 31
● *The Smoker*, 1913. Oil on canvas, 73 × 54 cm. Museo Thyssen-Bornemisza, Madrid. Bilbao only: cat. 36

Marcel Gromaire
● *Seated Nude*, 1929. Oil on canvas, 81 × 65 cm. Musée d'Art Moderne de la Ville de Paris: cat. 125

Francis Gruber
● *Nude with a Red Waistcoat*, 1948. Oil on canvas, 66 × 55 cm. Collection Madame Francis Gruber: cat. 180
● *Self-portrait*, 1942. Oil on canvas, 116 × 89 cm. Private collection: cat. 157

Raymond Hains
● *Cet homme est dangereux*, 1957. Torn poster on canvas, 95 × 61 cm. Collection Ginette Dufrêne: cat. 270
● *OAS Fusillez les plastiqueurs*, 1961. Torn poster on canvas, 50 × 73 cm. Private collection: cat. 271

Joseph Mellor Hanson
● *Static Composition*, 1927. Oil on canvas, 120 × 57 cm. Private collection, Paris: cat. 97

Simon Hantaï
● *Virgin's Mantle, no. 3*, 1962. Oil on canvas, 223 × 213 cm. Private collection: cat. 222

Hans Hartung
● *T1951–2*, 1951. Oil on canvas, 97 × 146 cm. Fondation Hans Hartung and Anna-Eva Bergman: cat. 202

Jean Hélion
● *Equilibrium*, 1933–34. Oil on canvas, 97.4 × 131.2 cm. Peggy Guggenheim Collection, Venice (Solomon R. Guggenheim Foundation, New York): cat. 101

Auguste Herbin
● *Morning II*, 1952. Oil on canvas, 146 × 97 cm. Musée Matisse, Musée départemental, Le Cateau-Cambrésis: cat. 224
● *Spiral*, 1933. Oil on canvas, 95 × 72 cm. Private collection, Paris: cat. 105

Jacques Hérold
● *Le Grand Transparent*, 1947. Bronze, 188 × 44.5 × 39 cm. Galerie Patrice Trigano, Paris: cat. 188

Robert Humblot
● *The Horrors of War*, 1937. Oil on canvas, 130 × 96.5 cm. Collection Musée des Années 30, Boulogne-Billancourt: cat. 153

Isidore Isou
● *Talking Plastic*, 1960–87. Mixed media, 15 × 40 × 30 cm. Private collection, Brussels: cat. 265

Robert Jacobsen
● *Invisible Victory*, 1957. Iron, 62.1 × 46 × 22.1 cm. Fonds National d'Art Contemporain – Ministère de la Culture, Paris. On deposit at the Musée d'Art Moderne, Saint-Etienne: cat. 201

Marcel Jean
● *Spectre du Gardenia*, 1936. Plaster, velvet powder, celluloid, leather and metal, 35 × 23 cm. Skulpturenmuseum Glaskasten Marl: cat. 150

Asger Jorn
● *The Rite of Spring II*, 1952. Oil on wood, 161 × 183.5 cm. The Berardo Collection, Sintra Museum of Modern Art: cat. 213

Vasily Kandinsky
● *Violet Orange*, 1935. Oil on canvas, 88.9 × 116.2 cm. Solomon R. Guggenheim Museum, New York. Gift of Solomon R. Guggenheim, 1937: cat. 112

Ellsworth Kelly
● *Black Square*, 1953. Oil on wood, 109.9 × 109.9 cm. Private collection: cat. 217

Nadia Khodossievitch-Léger
● *Self-portrait*, 1936. Oil on canvas, 73 × 92 cm. Private collection: cat. 71

Moïse Kisling
● *Nude on a Red Sofa*, 1918. Oil on canvas, 60 × 73 cm. Petit Palais, Musée d'Art Moderne, Geneva: cat. 116

Yves Klein
● *Silence Is Golden (MG 10)*, 1960. Gold leaf on wood, 148 × 114 cm. Private collection: cat. 221
● *Untitled Anthropometry (ANT 101)*, 1960. Pigment, synthetic resin and gold leaf on marouflé paper, laid down on canvas, 420 × 200 cm. Private collection. On deposit at the Musée d'Art Moderne et d'Art Contemporain, Nice: cat. 219
● *Untitled Anthropometry (IKB 223)*, 1961. Pigment and synthetic resin on gauze, mounted on panel, 195 × 140 cm. Private collection: cat. 220

František Kupka
● *The First Step*, 1909. Oil on canvas, 83.2 × 129.6 cm. The Museum of Modern Art, New York, Hillman Periodicals Fund, 1956: cat. 41

Wifredo Lam
● *Rumblings of the Earth*, 1950. Oil on canvas, 151.1 × 284.5 cm. Solomon R. Guggenheim Museum, New York. Gift of Mr and Mrs Joseph Cantor, 1958: cat. 186

Charles Lapicque
● *Joan of Arc Crossing the Loire*, 1940. Oil on canvas, 100 × 73 cm. Dr Peter Nathan Collection, Zurich: cat. 194

Marie Laurencin
● *Apollinaire and His Friends*, 1909. Oil on canvas, 130 × 194 cm. Musée National d'Art Moderne, Centre Georges Pompidou, Paris: cat. 21

Jean-Jacques Lebel
● *Monument to Antonin Artaud*, 1959. Mixed media, wood, metal, human hair, human skull, electric light bulb, 200 × 170 cm. Private collection: cat. 262
● *Parfum Grève Générale, bonne odeur*, 1960. Paint and collage on cardboard, 112 × 85 cm. Private collection: cat. 261

Le Corbusier
● *Composition with a Pear*, 1929. Oil on canvas, 146 × 89 cm. Fondation Le Corbusier, Paris: cat. 82
● *Vertical Guitar* (first version), 1920. Oil on canvas, 100 × 81 cm. Fondation Le Corbusier, Paris: cat. 79

Fernand Léger
● *Charlot cubiste*, 1924. Painted wood nailed to plywood, 73.6 × 33.4 × 6 cm. Musée National d'Art Moderne, Centre Georges Pompidou, Paris: cat. 59
● *Composition with Hand and Hats*, 1927. Oil on canvas, 248 × 185.5 cm. Musée National d'Art Moderne, Centre Georges Pompidou, Paris: cat. 81
● *Hommage à la Danse*, 1925. Oil on canvas, 159 × 121 cm. Paule and Adrien Maeght Collection, Paris: cat. 58
● *Mural Painting*, 1924. Oil on canvas, 180 × 80 cm. Museo Nacional Centro de Arte Reina Sofía, Madrid: cat. 80
● *Nude Model in Studio*, 1912–13. Oil on burlap, 127.8 × 95.7 cm. Solomon R. Guggenheim Museum, New York: cat. 33

Julio Le Parc
● *Twisting Form*, 1966. Wood, metal and motors, 260 × 53 × 20 cm. Collection of the artist: cat. 233

Jacques Lipchitz
● *Gertrude Stein*, 1920. Bronze, 33 × 20 × 19 cm. Musée National d'Art Moderne, Centre Georges Pompidou, Paris: cat. 72
● *Pierrot with a Clarinet*, 1919. Bronze, 75.5 × 25 × 26 cm. Private collection, Switzerland. RA only: cat. 45

René Magritte
● *The End of Contemplation*, 1927. Oil on canvas with metal snap fasteners, 72.8 × 99.8 cm. The Menil Collection, Houston: cat. 141
● *The Finery of the Storm*, 1927. Oil on canvas, 81 × 116 cm. Courtesy of Christie's, London: cat. 140

Aristide Maillol
● *Torso of Venus*, 1920. Bronze, 114 × 47 × 30 cm. Collection Musée Maillol, Paris: cat. 121

Alfred Manessier
● *Salve Regina*, 1945. Oil on canvas, 195 × 115 cm. Musée des Beaux-Arts, Nantes: cat. 195

Man Ray
● *Cadeau*, 1921–70. Iron with nails, 16.5 × 10 × 8 cm. Galerie Marion Meyer, Paris: cat. 60
● *The Enigma of Isidore Ducasse*, 1923. Wrapped sewing machine, 45 × 58 × 23 cm. Galerie Marion Meyer, Paris: cat. 61
● *Imaginary Portrait of the Marquis de Sade*, 1938. Oil on canvas with painted wood panel, 61.7 × 46.6 cm. The Menil Collection, Houston: cat. 149

Filippo Tommaso Marinetti
● *Tactile Board: Paris – Sudan*. Assemblage on cardboard panel, 46 × 22.5 cm. Private collection: cat. 52

Raymond Mason
● *Le Boulevard Saint-Germain, Paris*, 1958. Bronze relief, 105 × 53 × 7 cm. Collection of the artist: cat. 208

André Masson
● *Pygmalion*, 1939. Oil on canvas, 130 × 162 cm. Private collection, Paris: cat. 156

Georges Mathieu
● *Inception*, 1944. Oil on canvas, 70 × 55 cm. Collection of the artist: cat. 185
● *The Last Feast of Attila*, 1961. Oil on canvas, 300 × 200 cm. Collection of the artist: cat. 243

Henri Matisse
● *The Back IV*, 1929. Bronze, 189 × 114 × 16 cm. Städtische Kunsthalle, Mannheim: cat. 129
● *Carmelina*, 1903–04. Oil on canvas 81.3 × 59 cm. Museum of Fine Arts, Boston, Tomkins Collection: cat. 6
● *Two Women*, 1907–08. Bronze, 46.6 × 25.6 × 19.9 cm. Hirshhorn Museum and Sculpture Garden, Smithsonian Institution, Washington DC. Gift of Joseph H. Hirshhorn, 1966: cat. 15

Matta
● *Accidentalité*, 1947. Oil on canvas, 192 × 248.5 cm; archive no. 47/3. Private collection, Geneva: cat. 187
● *Temps-space du pissenlit*, 1967–69. Oil on canvas, 305 × 405 cm, archive no. 159. Private collection, Paris: cat. 244

Henri Michaux
● *Mescalin Picture*, 1957. Oil on canvas, 41 × 27 cm. Private collection: cat. 183
● *Mescalin Picture*, 1957. Oil on canvas, 41 × 22 cm. Galerie Limmer, Cologne: cat. 184

Joan Miró
● *Painting*, 1927. Oil on wood, 19 × 24 cm. Private collection: cat. 88
● *Painting (Head)* or *The White Cat*, 1927. Oil on canvas, 147.3 × 114.6 cm. Courtesy Helly Nahmad Gallery, London. RA only: cat. 92
● *Painting (Portrait and Shadow)*, 1926. Oil on canvas, 81 × 100. Courtesy Helly Nahmad Gallery, London. RA only: cat. 89

Amedeo Modigliani
● *Reclining Nude (Le Grand Nu)*, c. 1919. Oil on canvas, 72.4 × 116.5 cm. The Museum of Modern Art, New York. Mrs Simon Guggenheim Fund, 1950: cat. 113
● *Woman Seated in Front of a Fireplace (Beatrice Hastings)*, 1915. Oil on canvas, 81 × 65 cm. Courtesy Helly Nahmad Gallery, London. RA only: cat. 65

Piet Mondrian
● *Composition with Double Line and Blue*, 1935. Oil on canvas, 72.5 × 70 cm. Private collection. Courtesy Galeric Boyeler: cat. 94
● *Composition with Large Red Plane, Yellow, Black, Grey and Blue*, 1921. Oil on canvas, 59.5 × 59.5 cm. Gemeente Museum, The Hague: cat. 93

Jacques Monory
● *Murder no. 10/2*, 1968. Acrylic on canvas and mirror, 160 × 400 cm. Musée National d'Art Moderne, Centre Georges Pompidou, Paris. Gift of the artist, 1975: cat. 278

François Morellet
● *Sphère-Trames*, 1962. Stainless steel, 130 cm (diameter). Collection of the artist: cat. 241

Richard Mortensen
● *Homage to Auguste Herbin*, 1960. Oil on canvas, 130 × 195 cm. Galerie Denise René: cat. 238

Marlow Moss
● *Untitled*, 1932. Oil on canvas, 45 × 36 cm. Fondazione Marguerite Arp, Locarno: cat. 98

C. R. W. Nevinson
● *A Studio in Montparnasse*, 1926. Oil on canvas, 127 × 76.2 cm. Tate. Presented by H. G. Wells, 1927: cat. 120

Amédée Ozenfant
● *Guitar and Bottles*, 1920. Oil on canvas, 80.5 × 99.8 cm. Peggy Guggenheim Collection, Venice (Solomon R. Guggenheim Foundation, New York): cat. 78

Jules Pascin
● *Nude at Rest*, c. 1926. Oil on canvas, 86.4 × 72.4 cm. Fridart Foundation, Amsterdam. Bilbao only: cat. 118
● *Temple of Beauty*, 1923. Oil on paper, 124 × 150 cm. Musée d'Art Moderne de la Ville de Paris. Bilbao only: cat. 128

Antoine Pevsner
● *Construction*, 1935. Metal, 60 × 40 × 17 cm. IVAM, Instituto Valenciano de Arte Moderno, Generalitat Valenciana: cat. 107
● *Extendable Column of Victory*, 1946. Bronze, 104 × 79 cm. Kunsthaus, Zurich: cat. 191

Jean Peyrissac
● *Cone*, 1930–32. Wood, bone, string, lead and iron, 110 × 11 × 21.5 cm. Musée de Grenoble. RA only: cat. 110

Francis Picabia
- *Adoration of the Calf*, 1941–42. Oil on board, 106.5 × 76.2 cm. Private collection, New York: cat. 162
- *La Feuille de vigne (The Fig Leaf)*, 1922. Ripolin on canvas, 200 × 160 cm. Tate. Purchased 1984. RA only: cat. 57
- *Le Lierre unique eunuque*, 1920. Ripolin on cardboard, 75 × 105 cm. Kunsthaus Zurich: cat. 55
- *L'Oeil, caméra*, c. 1919. Oil and mixed media on cardboard panel, 68 × 50.5 cm. Private collection: cat. 56
- *Physical Culture*, 1913. Oil on canvas, 89.5 × 117 cm. Philadelphia Museum of Art: The Louise and Walter Arensberg Collection, 1950: cat. 42
- *Tahiti*, 1930. Oil on canvas, 194.3 × 129.5 cm. Barry Flanagan: cat. 119

Pablo Picasso
- *Death's Head, Leeks and Pitcher Before a Window*, 1945. Oil on canvas, 73 × 116 cm. Private collection: cat. 161
- Study for *Les Demoiselles d'Avignon*, 1907. Oil on canvas, 54 × 41 cm. Moderna Museet, Stockholm: cat. 16
- Study for *Les Demoiselles d'Avignon*, 1907. Oil on cardboard, 53.5 × 36.2 cm. Musée Picasso, Paris. RA only: cat. 17
- Study for *Les Demoiselles d'Avignon*, 1907. Oil on canvas, 93 × 43 cm. Civico Museo d'Arte Contemporanea, Milan: cat. 18
- *Le Divan japonais*, 1901. Oil on board laid down on panel, 69.85 × 53.34 cm. Mugrabi Collection: cat. 2
- *Figure de femme inspirée par la guerre d'Espagne*, 1937. Oil on canvas, 38 × 46 cm. Private collection. Courtesy Jan Krugier, Ditesheim & Cie, Geneva. RA only: cat. 155
- *The Fool*, 1905. Bronze, 41.5 × 36.5 × 22 cm. Musée d'Art Moderne de la Ville de Paris. RA only: cat. 14
- *Painter and Model, Paris*, 1928. Oil on canvas, 129.8 × 163 cm. The Museum of Modern Art, New York. The Sidney and Harriet Janis Collection, 1967. RA only: cat. 83
- *Portrait of Olga*, 1923. Oil on canvas, 130 × 97 cm. Private collection: cat. 67
- *Sacré-Coeur*, 1910. Oil on canvas, 92.5 × 65 cm. Musée Picasso, Paris: cat. 22
- *Still-life with Skull and Pitcher*, 1943. Oil on canvas, 45.9 × 55 cm. Collection Musée d'Art Moderne de Céret: cat. 160
- *Woman with a Mandolin (Madame Léoni Seated)*, 1911. Oil on canvas, 100 × 81 cm. Marina Picasso Collection. Courtesy Galerie Jan Krugier, Ditesheim & Cie, Geneva. RA only: cat. 26

Serge Poliakoff
- *Abstract Composition*, 1959. Oil on canvas, 130 × 162 cm. Alexis Poliakoff Collection: cat. 205

Anton Prinner
- *Construction in Brass*, 1935. Brass and copper, 50 × 50 × 135 cm. Musée de Grenoble. RA only: cat. 103

Bernard Rancillac
- *Mai 68*, 1968. Paint on wood, Altuglas, 45 × 40 × 2.4 cm. Private collection: cat. 276

Jean Pierre Raynaud
- *Psycho-object, Age 27*, 1967. Metal and plastic, 253 × 76 × 84 cm. Collection of the artist: cat. 269
- *Psycho-object with Blind Man's Stick (Portrait of the Art Critic Alain Jouffroy)*, 1964. Mixed media, 150 × 50 cm. Courtesy Galerie Natalie Seroussi: cat. 268

Martial Raysse
- *La France orange*, 1963. Photograph and acrylic on canvas and wood, 83 × 55 cm. Madame Georges Pompidou Collection: cat. 258
- *Suzanna, Suzanna*, 1964. Oil on canvas, collage with wood paint and film projection of 'Arman dans le rôle de Vieillard', 192 × 141 × 10 cm. Courtesy Galerie Natalie Seroussi: cat. 257

Georges Ribemont-Dessaignes
- *Le Grand Musicien*, c. 1920. Oil on masonite, 75 × 56.5 cm. Private collection, Paris. Courtesy Galerie 1900–2000: cat. 54

Germaine Richier
- *The Bat*, 1946. Bronze, 91 × 91 × 52 cm. Tate. Lent from a private collection, 2000: cat. 192
- *La Tauromachie*, 1953. Gilded bronze, 116 × 54 × 101 cm. Suzanne and Fred Mella Collection: cat. 207

Jean-Paul Riopelle
- *Composition*, 1951. Oil on canvas, 97 × 131 cm. Private collection. Courtesy Galerie Daniel Malingue: cat. 198

Diego Rivera
- *Portrait of Adolfo Best Maugard*, 1913. Oil on canvas, 227.5 × 161.5 cm. Museo Nacional de Arte, CNCA, INBA, Mexico City: cat. 63
- *Portrait of Martín Luis Guzmán*, 1915. Oil on canvas, 72.3 × 59.3 cm. Fundación Televisa Collection, Mexico City. Bilbao only: cat. 38

Georges Rouault
- *Clown with Rose*, 1908. Gouache and watercolour on paper laid down on canvas, 100 × 65 cm. Private collection: cat. 13

Morgan Russell
- *Four-part Synchromy, no. 7*, 1914–15. Oil on canvas, 40 × 29.2 cm. Whitney Museum of American Art, New York. Gift of the artist in memory of Gertrude V. Whitney: cat. 39

Roland Sabatier
- *Hyperthéâtrie (de Zola à Mao)*, 1967. Oil and collage on canvas, 80.7 × 65 cm. Collection of the artist: cat. 264
- *Peinture déambulatoire*, 1966. Ink and collage on a plan of Paris, 56.2 × 75.7 cm. Private collection, Venice: cat. 263

Niki de Saint Phalle
- *Exploded Woman (The Birth of the Bull)*, 1963. Mixed media, 190 × 131 × 32 cm. Sprengel Museum, Hanover: cat. 249
- *Kennedy-Khrushchev*, 1963. Mixed media, 202 × 122.5 × 40 cm. Sprengel Museum, Hanover: cat. 248
- *OAS*, 1962. Bronze, 252 × 241 × 41 cm. Galerie de France, Paris: cat. 250
- *Tir de Robert Rauschenberg*, 1961. Mixed media, 188 × 55 × 56 cm. Sprengel Museum, Hanover: cat. 247

Nicolas Schöffer
- *Spatiodynamic 13*, 1952. Aluminium with polychrome moving circular elements, 223 × 56 × 57 cm. E. de L. Schöffer: cat. 226

Gino Severini
- *Dancer no. 5*, c. 1913–16. Oil on canvas, 93.3 × 74 cm. Pallant House Gallery, Chichester (Kearley Bequest), through the National Art Collections Fund, 1989: cat. 49
- *The Nord–Sud (Speed and Sound)*, 1912. Oil on canvas, 49 × 64 cm. Pinacoteca di Brera, Milan. Emilio and Maria Jesi donation: cat. 29

Walter Sickert
- *Théâtre de Montmartre*, 1906. Oil on canvas, 50.8 × 61.6 cm. King's College, Cambridge (Keynes Collection). On loan to The Fitzwilliam Museum, Cambridge: cat. 10

Francisco Sobrino
- *Permutational Structure HG, no. 1/3*, 1966/70. Stainless steel, 187 × 56 × 56 cm. Galerie Denise René: cat. 232

Jesús Rafaël Soto
- *Penetrable Curtain*, 1967/2002. Wood and plastic, 123 × 70 × 48 cm. Museo Municipal d'Arte Contemporáneo, Madrid: cat. 242

Pierre Soulages
- *Painting, 9 May*, 1968. Oil on canvas, 202 × 336 cm. Collection of the artist: cat. 223

Chaïm Soutine
- *Carcass of Beef*, 1923. Oil on canvas, 81 × 50.5 cm. Petit Palais, Musée d'Art Moderne, Geneva: cat. 131
- *Carcass of Beef*, c. 1925. Oil on canvas, 140.3 × 107.6 cm. Collection Albright-Knox Art Gallery, Buffalo, New York. Room of Contemporary Art Fund, 1939. RA only: cat. 130

Daniel Spoerri
- *Old Kitchen Utensils from the Galerie J*, 1962. Mixed media, 109 × 135 × 33 cm. Private collection, Milan: cat. 259

Nicolas de Staël
- *Parc des Princes (Les Grands Footballers)*, 1952. Oil on canvas, 200 × 350 cm. Private collection: cat. 203

Alina Szapocznikow
- *Self-portrait 1*, 1966. Marble, polyester and resin, 41 × 30 × 20 cm. Collection of the artist's family, Paris: cat. 266

Takis
- *Signal*, 1954–55. Bronze, 238 × 90 × 33 cm. Simon Spierer Collection, Geneva: cat. 230
- *Signal*, 1959. Iron, 254 × 216 × 32 cm. Musée National d'Art Moderne, Centre Georges Pompidou, Paris. Gift of Daniel Cordier (Juan-les-Pins), 1982. Illustrated but not exhibited: cat. 231

Yves Tanguy
- *Blue Bed*, 1929. Oil on canvas, 60 × 49 cm. Private collection: cat. 143
- *Tomorrow*, 1938. Oil on canvas, 54.5 × 46 cm. Kunsthaus, Zurich: cat. 142

Boris Taslitzky
- *The Delegate*, 1947. Oil on canvas, 195 × 114 cm. Collection B. Taslitzky: cat. 181

Sophie Täuber-Arp
- *Composition Vertical-Horizontal*, 1927. Oil on canvas, 100 × 65 cm. City of Locarno Collection. Jean and Marguerite Arp donation: cat. 96

Jean Tinguely
- *Blue, White, Black*, 1955. Black wooden base with eleven differently shaped, blue-and-white, painted metal elements. In the back of the base, wooden pulley wheels, rubber belts, metal fixings and an electric motor, 105 × 59 × 20 cm. Private collection: cat. 229
- *Meta-Malevich*, 1954. Black wooden box, metal elements, wheels, rubber belt and electric motor, 61 × 50 × 20 cm. Museum Jean Tinguely, Basle: cat. 228
- *Miramar (Ballet of the Poor)*, 1961. Metal, different materials, electric motor and eight suspension points, 380 × 350 × 220 cm. Museum Jean Tinguely, Basle: cat. 246

Joaquín Torres-García
- *Construction in White and Black*, 1930. Mixed media, 48.9 × 35.6 cm. Carmen Thyssen-Bornemisza Collection: cat. 85
- *Cosmic Composition with Abstract Figure*, 1933. Tempera on cardboard, 75 × 53 cm. Alejandro, Aurelio and Claudio Torres Collection. Courtesy Galerie Jan Krugier, Ditesheim & Cie, Geneva. RA only: cat. 84

Leon Tutundjián
- *Untitled*, 1929. Metal and wood, 60 cm (diameter). Courtesy Galerie Alain Le Gaillard: cat. 102

Maurice Utrillo
- *L'Impasse Cottin*, 1910–11. Oil on cardboard, 62 × 46 cm. Musée National d'Art Moderne, Centre Georges Pompidou, Paris: cat. 20

Suzanne Valadon
- *The Fortune Teller*, 1912. Oil on canvas, 130 × 163 cm. Petit Palais, Musée d'Art Moderne, Geneva: cat. 19

Georges Vantongerloo
- *Groupe y*, 1931. Oil on canvas, 114 × 129 cm. Collection Jakob Bill: cat. 99

Victor Vasarely
- *Bora II*, 1964. Acrylic on canvas, 186 × 160 cm. Galerie Denise René: cat. 239
- *Tlinko C*, 1955–64. Two engraved glass plaques on metal, 74 × 62 cm. Galerie Denise René: cat. 240

Bram van Velde
- *Boulevard de la Gare*, 1958. Oil on canvas, 162.3 × 130.3 cm. Musée d'Art et d'Histoire, Geneva: cat. 212

Paule Vézelay
- *Five Forms*, 1935. Plaster, 28 × 38 × 25 cm. Tate. Presented by the Patrons of British Art through the Tate Gallery Foundation, 2000. Illustrated but not exhibited: cat. 111

Maria Elena Vieira da Silva
- *Le Souterrain*, 1948. Oil on canvas, 81 × 100 cm. Private collection. Courtesy Jeanne-Bucher, Paris. RA only: cat. 197

Jacques de la Villeglé
- *Boulevard de la Bastille*, 1969. Torn posters on canvas, 84 × 145 cm. Galerie Patrice Trigano, Paris: cat. 274
- *Gare Montparnasse, Rue de Départ, 12 juillet*, 1968. Torn posters on canvas, 109 × 158 cm. Courtesy Galerie Georges-Philippe and Nathalie Vallois: cat. 273

Jacques Villon
- *L'Espace*, 1932. Oil on canvas, 116 × 89 cm. Galerie Louis Carré & Cie, Paris: cat. 104

Maurice de Vlaminck
- *Dancer at the 'Rat Mort'*, 1905–06. Oil on board, 62.2 × 25.4 cm. Joseph Hackmey: cat. 4

Edouard Vuillard
- *Le Boulevard des Batignolles*, c. 1910. Oil on paper, 78 × 96 cm. Niedersächsisches Landesmuseum, Hanover: cat. 9

Wols
- *Champigny Composition*, 1951. Oil on canvas, 68 × 57 cm. Collection Welle: cat. 170
- *Composition*, 1946–47. Oil on canvas, 41 × 37 cm. Private collection: cat. 169
- *(The Last) Composition*, 1951. Oil on canvas, 73 × 60 cm. Collection Welle: cat. 168

Ossip Zadkine
- *Female Torso*, c. 1925. Wood, 61.6 × 16.4 × 16 cm. Hirshhorn Museum and Sculpture Garden, Smithsonian Institution, Washington DC. Gift of Joseph H. Hirshhorn, 1966: cat. 122
- *Female Torso*, 1935. Ebony, 138 × 34 × 29 cm. Fonds National d'Art Contemporain – Ministère de la Culture, Paris. On deposit at the Musée Réattu, Arles: cat. 123

Zao Wou-Ki
- *Homage to Chu-Yun*, 1955. Oil on canvas, 195 × 130 cm. Françoise Marquet Collection: cat. 206

List of Lenders

Y. Agam. Courtesy Artlife Gallery, New York
Stanley J. Allen, New York
Amsterdam, Fridart Foundation
Amsterdam, Stedelijk Museum
Antibes, Fondation Hans Hartung and Anna-
 Eva Bergman
Autun, Musée Rolin

Barcelona, Collecció MACBA, Fundació
 Museu d'Art Contemporani de Barcelona
Basle, Lilja Art Fund Foundation
Basle, Museum Jean Tinguely, Basle
Kunsthalle Bielefeld
Collection Jakob Bill
Gilles and Nadege Blanckaert
Boston, Museum of Fine Arts
Bougival, Pierre and Micky Alechinsky
 Collection
Boulogne-Billancourt, Collection Musée des
 Années 30
Buffalo, Collection Albright-Knox Art Gallery
Daniel Buren

Cambridge, King's College (Keynes
 Collection). On loan to The Fitzwilliam
 Museum, Cambridge
Céret, Musée d'Art Moderne
Chichester, Pallant House Gallery (Kearley
 Bequest), through the National Art
 Collections Fund, 1989
Christo and Jeanne-Claude
Geneviève Claisse
Clamart, Fondation Arp
Cologne, Galerie Limmer
Cologne and New York, Galerie Michael
 Werner
Copenhagen, Statens Museum for Kunst
Henri Cueco

Darmstadt, Hessisches Landesmuseum
Des Moines Art Center
Collection Ginette Dufrêne

Edinburgh, Scottish National Gallery of
 Modern Art

Frankfurt am Main, Städelsches
 Kunstinstitut und Städtische Galerie
The French Communist Party
Gérard Fromanger

Pierre Gallien
Ida and Maurice Garnier
Geneva, Musée d'Art et d'Histoire
Geneva, Petit Palais, Musée d'Art Moderne
Grenoble, Musée de Grenoble
Collection Madame Francis Gruber

Joseph Hackmey
The Hague, Gemeentemuseum
Hanover, Niedersächsisches
 Landesmuseum
Hanover, Sprengel Museum
Houston, The Menil Collection

Collection Wolfgang Joop

Collection Marin Karmitz

Le Cateau-Cambrésis, Musée Matisse,
 Musée Départemental
Marie-José Lefort Collection
Julio Le Parc
City of Locarno Collection
Locarno, Fondazione Marguerite Arp
London, Courtesy Helly Nahmad Gallery
London, Tate
Lyons, Musée des Beaux-Arts

Madrid, Museo Municipal de Arte
 Contemporáneo
Madrid, Museo Nacional Centro de Arte
 Reina Sofía
Madrid, Museo Thyssen-Bornemisza
Mannheim, Städtische Kunsthalle
Marl, Skulpturenmuseum Glaskasten
Françoise Marquet Collection
Marseilles, Collection du MAC, Galeries
 Contemporaines des Musées de Marseille
Raymond Mason
Georges Mathieu
Suzanne and Fred Mella Collection
Mexico City, Fundación Televisa Collection
Mexico City, Museo Nacional de Arte, CNCA,
 INBA
Milan, Civico Museo d'Arte Contemporanea
Milan, Pinacoteca di Brera
François Morellet
Mugrabi Collection

Nantes, Musée des Beaux-Arts
New York, The Museum of Modern Art
New York, Solomon R. Guggenheim
 Museum
New York, Whitney Museum of American Art

Orléans, Musée des Beaux-Arts

Paris, Fondation Le Corbusier
Paris, Fonds National d'Art Contemporain –
 Ministère de la Culture
Paris, Collection Anne and Jean-Claude
 Lahumière
Paris, Courtesy Galerie Alain Le Gaillard
Paris, Galerie Denise René
Paris, Galerie de France
Paris, Courtesy Galerie Georges-Philippe
 and Nathalie Vallois
Paris, Galerie Louis Carré & Cie
Paris, Galerie Marion Meyer
Paris, Courtesy Galerie Natalie Seroussi
Paris, Galerie Patrice Trigano
Paris, Larock-Granoff Collection
Paris, Paule and Adrien Maeght Collection
Paris, Musée d'Art Moderne de la Ville de
 Paris
Paris, Musée Maillol
Paris, Musée National d'Art Moderne, Centre
 Georges Pompidou
Paris, Musée Picasso
Madame Bénédicte Petit
Philadelphia Museum of Art
Marina Picasso Collection. Courtesy Galerie
 Jan Krugier, Ditesheim & Cie, Geneva
Alexis Poliakoff Collection
Madame Georges Pompidou Collection
Private collection. Courtesy of Christie's,
 London
Private collection. Courtesy Jean Albou
 Conseil, Paris
Private collection. Courtesy Jeanne-Bucher,
 Paris
Private collection, Paris. Courtesy Galerie
 1900–2000
Private collection. Courtesy Galerie Beyeler
Private collection. Courtesy Galerie Daniel
 Malingue, Paris
Private collection. Courtesy Galerie Jan
 Krugier, Ditesheim & Cie, Geneva
Private collection. Courtesy Galerie
 Odermatt-Vedovi, Paris

Jean Pierre Raynaud
Rotterdam, Museum Boijmans Van
 Beuningen

Roland Sabatier
Gunter Sachs Collection
Saint-Etienne, Musée d'Art Moderne
Saint-Paul-de-Vence, Fondation Marguerite
 et Aimé Maeght
Salvador Dalí Museum, Inc., St Petersburg,
 Florida
E. de L. Schöffer
Sintra, Museum of Modern Art, The Berardo
 Collection
Pierre Soulages
Simon Spierer Collection
Stockholm, Moderna Museet

Collection B. Taslitzky
Carmen Thyssen-Bornemisza Collection
Alejandra, Aurelio and Claudio Torres
 Collection. Courtesy Galerie Jan Krugier,
 Ditesheim & Cie, Geneva
Troyes, Musée d'Art Moderne de Troyes

Valencia, IVAM, Instituto Valenciano de Arte
 Moderno, Generalitat Valenciana
Venice, Peggy Guggenheim Collection
 (Solomon R. Guggenheim Foundation,
 New York)
Vienna, Museum of Modern Art Ludwig
 Foundation, Vienna

Washington DC, Hirshhorn Museum and
 Sculpture Garden, Smithsonian
 Institution
Collection Welle
Zorrilla de Lequerica Collection
Zurich, Kunsthaus
Zurich, Dr Peter Nathan Collection

*and other lenders who wish to
remain anonymous*

439

Photographic Acknowledgements

All works of art are reproduced by kind permission of the owners. Specific acknowledgements for providing photographs are as follows:

Introduction and Essays

Austin: Carlton Lake Collection, Harry Ransome Humanities Research Centre, The University of Texas at Austin, fig. 57
Basel: Galerie Beyeler/Peter Schibli, fig. 112
Basel: Yves Klein Archives, fig. 16
Basel: Museum Jean Tinguely/John R. van Rolleghem, fig. 100
Bernard Boyer, fig. 105
Dijon: Granville Collection Musée des Beaux-Arts, fig. 8
Eindhoven: Stedelijk van Abbemuseum, fig. 30
Florence: Scala, fig. 70
Kraków: © Gallery Starmach, figs 81, 82
Kraków: Muzeum Narodowe, fig. 83
Jean-Dominique Lajoux, fig. 102
Łódź: Muzeum Sztuki, figs 42, 43
Łódź: Muzeum Stzuki/Pitor Tomczk, figs 89, 94
London: AKG, figs 23, 52
London: Bridgeman Art Library, figs 2, 3, 56, 97
London: © 2001 Tate, figs 29, 110
Merion: The Barnes Foundation. Photograph © reproduced with the permission of the Barnes Foundation. All Rights Reserved, fig. 5
New Haven: Yale University Art Gallery, New Haven. Bequest of Katherine S. Dreier to the Collection Société Anonyme, fig. 48
New York: Art Resource, fig. 11
New York: The Museum of Modern Art, New York. Acquired through the Lillie P. Bliss Bequest/photo © 2001 The Museum of Modern Art, New York, figs 1, 111
New York: The Museum of Modern Art, Mrs Sam A. Lewisohn Bequest (by exchange) and Mrs Marya Bernard Fund in memory of her husband Dr Bernard Bernard and anonymous funds/photo © 2002 The Museum of Modern Art, New York, fig. 74
New York: The Museum of Modern Art. Gift of William Rubin/photo © 2001 The Museum of Modern Art, New York, fig. 62
New York: Morton J. Neumann Collection/Tom Powell, fig. 13
New York: Solomon R. Guggenheim Museum/David Heald © Solomon R. Guggenheim Foundation, fig. 9
New York: Solomon R. Guggenheim Museum. Thannhauser Collection, Gift, Justin K. Thannhauser 1978/David Heald © The Solomon R. Guggenheim Foundation, New York, fig. 26

Nice: Musée d'Art Moderne et d'Art Contemporain, fig. 65
Nîmes: Carré d'Art, Musée d'Art Contemporian/photo © 2000 Pierre Schwartz, fig. 118
Paris: Agence Enguerand/Bernand, fig. 93
Paris: Archives G. Fabre, figs 32, 33, 34, 35, 37, 38, 39, 40, 41
Paris: Bibliothèque nationale, fig. 47
Paris: © Thérèse Bonney/Bibliothèque historique de la Ville de Paris, fig. 46
Paris: Bob Calle Collection, fig. 98
Paris: © CAP-Viollet, fig. 55
Paris: © Collection Harlingue-Viollet, fig. 49
Paris: © Collection Martinie-Viollet, fig. 25
Paris: © Collection Roger-Viollet, figs 19, 21, 22, 24, 44
Paris: Editions Albert Lévy, Fonds photographique conservé au Musée des Arts Décoratifs. All Rights Reserved, fig. 45
Paris: courtesy Erró, fig. 117
Paris: Fonds National d'Art Contemporain, fig. 116
Paris: © Galerie Denise René, fig. 80
Paris: courtesy Georges Mathieu, fig. 14
Paris: © Photo CNAC/MNAM/Dist. RMN, figs 6, 4, 61, 68, 75, 109, 113
Paris: © Photo RMN, figs 20, 60
Paris: © Photo RMN/K. Ignatiadis, fig. 58, J. G. Berizzi, fig. 59, Béatrice Hatala, fig. 63, H. del Olmo, fig. 64
Paris: Photothèque des Musées de la Ville de Paris/Joffre, figs 31, 50
Paris: © Piotr Stanislawski/photo Antoni Miralda, fig. 96; photo J. Sabara, fig. 95
Paris: courtesy Boris Taslitzky, fig. 69
Paris: Telimage-1999, fig. 51
Philadelphia: Philadelphia Museum of Art: The Louise and Walter Arensberg Collection, figs 7, 10
Philadelphia: Philadelphia Museum of Art: The A. E. Gallatin Collection, 1952, fig. 27
Georges Pierre, fig. 12
Poznań: Muzeum Narodowe/photo Adam Cieślawski, fig. 92
J. P. Rey, fig. 108
Harry Shunk, figs 17, 115
Villeneuve d'Ascq: Musée d'Art Moderne de Lille Métropole, Donation Geneviève and Jean Masurel, 1979, fig. 28
Warsaw: Muzeum Narodowe, fig. 91
Warsaw: Muzeum Naradowe/G. Policewice, fig. 85; Henryk Romanowski, fig. 87
Warsaw: Muzeum Plakatu, Wilanów, fig. 88

Exhibition plates

Arles: Musée d'Arles, cat. 123
Autun: © Musée Rolin/S. Prost, cat. 200
Basel: Lilja Art Fund Foundation/Eeva-Inkeri, cat. 254
© Christian Baur, cats 228, 229, 246, 256
Stefania Beretta, cat. 96
Olaf Bergmann, cat. 150
© Gérard Bonnet, cat. 211
Boston: courtesy Museum of Fine Arts. Reproduced with permission, cat. 6
Cambridge: © Fitzwilliam Museum, University of Cambridge, cat. 10
Serge Carrié, cat. 5
Céret: Musée d'Art Moderne de Céret/ Gibernau, cat. 160
Laurent Condominas, cat. 250
Copenhagen: SMK, cat. 3
Darmstadt: Hessisches Landesmuseum/ W. Kumpf, cat. 44
Edinburgh: © Scottish National Gallery of Modern Art, cats 90, 151; Antonia Reeve, cat. 139
Julien Fileyssant, cat. 222
Frankfurt am Main: Städelsches Kunstinstitut/© Ursula Edelmann, cat. 7
© Fabrizio Garghetti, cat. 259
Claude Gaspari, cat. 224
Geneva: © Musée d'Art et d'Histoire, Ville de Genève/ Bettina Jacot-Descombes, cat. 212
Geneva: Studio Monique Bernaz, cats 8, 11, 19, 114, 115, 116, 131
Claude Germain, cats 196, 209, 267
Patrick Goetelen, cats 92, 126, 204
Grenoble: © Musée de Grenoble, cats 100, 103, 108, 110
André Grossman, cat. 255
The Hague: Collection Gemeentemuseum, 2001 c/o Beeldrecht, Hoofddorp, cat. 93
Hanover: Niedersächsisches Landesmuseum, Landesgalerie, cat. 9
Th. Hennocque, cat. 253
Houston: The Menil Collection/ Paul Hester, cats 14, 138; Hickey-Robertson, cat. 149; Janet Woodard, cat. 134
Jacques L'Hoir, cats 60, 61, 71, 157, 164, 179, 180, 226, 233, 258
London: Bridgeman Art Library/ Giraudon cat. 4
London: © Christie's Images Ltd, cat. 140
London: © 2001 Tate, cats 47, 57, 111, 120, 154,192; © Tate/ John Webb, cat. 12
Jean-Louis Losi, cat. 281
Lyon: © Studio Basset, cats 32, 213
Madrid: © Museo Thyssen-Bornemisza, cats 35, 36
Mannheim: Städtische Kunsthalle/Margita Wickenhäuser, cat. 129
© George Meister, cat. 167
Milan: su concessione del Ministero per i Beni e le Attività Culturali/Laboratorio Fotoradiografico, cat. 29
Milan: Foto Saporetti, cat. 18

Nantes: © Musée des Beaux-Arts, cats 195, 199
Thierry Nava, cat. 105
New York: © 1994 The Metropolitan Museum of Art, cat. 75
New York: © 2001 The Museum of Modern Art, cats 41, 113, 171; © The Museum of Modern Art, cat. 83
New York: © The Solomon R. Guggenheim Foundation/David Heald, cats 25, 27, 28, 33, 34, 112, 174, 186; Sally Ritts, cat. 30
New York: © 1996 Whitney Museum of American Art, cat. 39
Paris: © Centre Georges Pompidou, cat. 244; Jacques Faujour, cat. 275; Béatrice Hatala, cat. 187
Paris: © FLC, cats 79, 82
Paris: FNAC/ © Christian Larrieu, cat. 236
Paris: © Galerie Denise René/Thierry Nava, cats 232, 234, 235, 238, 239, 240
Paris: © Galerie Maeght, cats 58, 189, 193
Paris: © Photothèque des Musées de la Ville de Paris/H. Delepelaire, cats 51, 74, 125, 128; Pierrain, cat. 14; L. Degraces, cat. 117
Paris: Photothèque du Musée des Années 30, cat. 153
Paris: © CNAC/MNAM Dist. RMN, cats 43, 159, 182, 278; Jacqueline Hyde, cat. 225; Jacques Faujour, cats 21, 59, 81, 133; Jean-François Tomasian, cats 72, 176, 177, 231; Peter Migeat, cats 72, 176, 177, 231; Philippe Migeat, cats 72, 176, 177, 231; Peter Willi, cat. 277; © RMN/J.G Berizzi, cat. 22; G. Ojeda, cat. 17
© Bénédicte Petit, cat. 148
Philadelphia: Museum of Art/Graydon Wood, cat. 31
Rennes: © Musée des Beaux-Arts de Rennes/Adélaide Beaudoin, cat. 218
Riehen: courtesy Galerie Beyeler, cat. 94
Friedrich Rosenstiel, cat. 170
Rotterdam: Museum Boijmans Van Beuningen, cat. 147
© Adam Rzepka, cat. 104
Saint-Etienne: Musée d'Art Moderne/Yves Bresson, cats 109, 201, 260
St Petersburgh (Florida): © 1990 Schank Photography, cat. 145
© Giuseppe Schiavinotto, cats 52, 64
Pascal Simonet, cat. 152
Stockholm: Moderna Museet/© Asa Lundén, cat. 49
Stockholm: SKM/Anders Allsten, cat. 16
Michael Tropea, cat. 173
Valencia: © IVAM. Institut Valencià d'Art Modern Generalitat Valenciana, cat. 107
Serge Veignant, cats 197, 273
Venice: © 2001 The Solomon R. Guggenheim Foundation/David Heald, cats 78, 101
Vienna: © MUMOK, Museum of Modern Art Ludwig Foundation, cat. 245
A. Voliotis, cat. 202
Washington: Hirshhorn Museum and Sculpture Garden, Smithsonian Institution/Lee Stalsworth, cats 15, 77, 122, 175

Index

All references are to page numbers.
Those in **bold** type indicate works in the exhibition, and those in *italic* type indicate essay illustrations.

Abbaye de Créteil 40–42, *40*, 41, 43, 50
Abbott, Berenice 113
Abstract Expressionism 250, 344, 346, 348
Abstraction-Création 51, 237, 253
Académie de la Grande-Chaumière 17
Académie des Beaux-Arts 239, 240–41
Académie Julian 17
Académie Moderne 51
Action Française 44
'action painting' 350
Adam, Paul 41, 43
Adler, Yankl 44
Aesthetic Society 43
'affiches lacérées' 21, 335
Africa 109, 114–15, 119, 123
Agam, Yaacov 246
 Three Movements **357**
Aguihon, Maurice 38
'Aide amicale aux artistes' 46
Aillaud, Gilles
 To Live or Let Die, or The Tragic End of Marcel Duchamp 337–38, 349, **402**
Albers, Joseph 246
Albert-Birot, Pierre 37
Alechinsky, Pierre 244, 340
 Les Grands Transparents **319**
Alex, Joe
 'La Danse Sauvage' *109*
Algeria 21, 122, 334–35, 336, 337
Aliboron, alias 'Boronali'
 Sunset over the Adriatic 32, *32*
Allais, Alphonse 28
Allard, Roger 41
Alleg, Henri 334
Allendy, Colette 282
'Alliance internationale: les Grandes Conférences' 43
Alliance Israélite 43
Alma, Peter 50
Althusser, Louis 333
American Center, Boulevard Raspail 337
L'Amicale des Israélites Saloniciens 46
Amiens 334
Les Amis de Passy 42
Analytical Cubism 35
Anglada Camarasa, Hermenegildo
 The White Peacock **56**
Antibes 118, 120, 125, 126
anti-Semitism 44, 46, 113, 240
Apollinaire, Guillaume 15, 34, 35, 37, 38, 41, 42, 76, 110
Appel, Karel 245
 Stéphane Lupasco and Michel Tapié **318**
'a.r.' group 51, *51*, 52
Aragon, Louis 20, 48, 110, 236, 237, 238, 242, 254, 256, 335, 344
Arc de Triomphe 38
Archibras 332
Archipenko, Alexander 112
Arcos, René 40, 41, *41*, 47
Arman 22, 126, 127, 332, 337, 348, 349
 Accumulation Renault no. 106 **379**
 Colères 335
 Ulysses' Armchair **380**
Arp, Jean (Hans) 51, 110
 Configuration with Two Dangerous Points **165**
 Un Grand et deux petits **164**
Arroyo, Eduardo 337
 To Live or Let Die, or The Tragic End of Marcel Duchamp 337–38, 349, **402**
Art Brut 20, 245
Art Concret 51, 52, 245
L'Art contemporain 50, 51
Art Deco 18, 108–09, 113, 114
Art Nouveau 252
Artaud, Antonin 20, 24, 243, 245, 252, 337, 341, 388
 Portrait of Colette Allendy **282**
 Portrait of Roger Blin **282**
 Self-portrait **283**
Artificialism 252
Asch, Schalom 46
L'Assiette au beurre 29
Association des Ecrivains et Artistes Révolutionnaires (AEAR) 237
Association Française d'Action Artistique 250
Assy 246

Astruc, Aristide 43
Astruc, Gabriel 43–44
Atelier d'Art Abstrait 246
Atelier Populaire *339*, 340, 341
Atlan, Jean-Michel 246
Auricoste, Emanuel 255
Avignon 37
Aymé, Marcel 38

Bachelard, Gaston 247
Baj, Enrico 337, *337*, 340
 The Great Antifascist Collective Painting 336, *337*, 339
Baker, Josephine 109, 110
 'La Danse Sauvage' *109*
Bakst, Léon 43
'Bal des Quat'z'Arts' (1892) 29
Le Bal Nègre 110
Balfour Declaration (1917) 45
Ballet Suedois 109
Ballets Russes 15–16, 43–44, 108, 109
Balmont, Constantin 46
Balthus (Count Balthazar Klossowski de Rola) 246
 Portrait of Pierre Matisse **146**
 Sleeping Nude **284**
Balzagette, Léon 41, 47
Band, Max 46
Baranoff-Rossiné 45
Barbusse, Henri 47, 48–50
Barcelona 42
Bard, Serge 341
Barlach, Ernst 240
Barnes, Alfred 113
Rarrès, Maurice 48
Barthes, Roland 23, 330, 331
Barzun (Henri Martin) 40, 41, *41*, 42
Basch, Victor 46
Basler, Adolphe 46
Bataille, Georges 242, 341
Bateau-Lavoir 31
Bat-Yosef, Myriam
 Eryximaque **22**
Baudelaire, Charles 12, 118, 332
Bauhaus 51
Baumeister, Willi
 Sport et machine 48
Bazaine, Jean 14, 21, 238, 246, 344
 Earth and Sky **299**
 La Messe de l'Homme Armé **296**
 Windows at the Church of Saint-Séverin, Paris 14
Baziotes, William 344
Beach, Sylvia 113
Beaubourg 341
Beauduin, Nicolas 42
Beaulieu 124
Beauvoir, Simone de 113, 244, 245, 337
Beaux-Arts 240
Beckett, Samuel 20, *20*, 243
Beckmann, Max 18, 240
 Paris Society **18**
 Woman with Snake (or Snake Charmer) **148**
Belgium 113, 245
Bellmer, Hans 110, 240
 The Top **225**
Ben (Vautier) 126
Benda, Julien 44
Bendern, Caroline de *340*, 341
Benjamin, Walter 12, 24, 110, 237
Benois, Alexandre 40, 43
Bernheim-Jeune, Alexandre 31
Bernier, Jean 47
Biélinky, Jacques 47
Biély, Andreï 40
Biennale de Paris 335
Bierut, Bolesław 255
Bing, Henry 111
Biot 126
Blake, William 20, 245
Blanchard, Maria 38
 Cubist Composition **101**
Blériot, Louis 35
Blin, Roger 282
Bloch, Jean-Richard 41, 44, 46
Bloom, Harold 350
Blue Rose 43
BMPT (Buren, Mosset, Parmentier, Toroni) group *338*, 339, 349
Bolivia 338
Bonnard, Pierre 21, 256, 344
 Nude with Red Slippers **200**
Bordier, Roger 246
Botticelli, Sandro 48

Boudin, Eugène 21
Bourdelle, Emile-Antoine 42, 44, 246
 La France 17
Brancusi, Constantin 45, 108–09, 112
 Bird in Space **152**
 Naiad 43
 Nancy Cunard **151**
 Princess X 18, *18*
 Prometheus **153**
Braque, Georges 15, 19, 20–21, 33, 34–36, 37, 45, 126, 330, 331
 Bird **308**
 Cards and Dice **79**
 Montmartre with the Sacré-Coeur 35, *35*
 Still-life: Playing Card, Bottle, Newspaper, and Tobacco (Le Courier) 34
 Poésie des mots inconnus 243
 Seated Woman **202**
 Still-life with Violin **78**
 Studio IX 346, *347*
 Vanitas **266**
Brassaï 19
Brauner, Victor 20, 332
 Ceremony **293**
La Brèche 332
Breker, Arno 240
 The Comrades **241**
Brendlé, Henri 46
Breton, André 20, 28, 48, 50, 110, 124, 240, 245, 252
Broderzon, Moyshe 44
Brooks, Romaine
 Jean Cocteau in the Era of the Big Wheel **140**
Bruant, Aristide 28, 31
Bruce, Patrick Henry 45, 52
Bryen, Camille 243–44, 345
 L'Hypérile éclatée 335
Brzekowski, Jan *50*, 51
Bucher, Jeanne 14, 111
Budapest 252
Buffet, Bernard 19, 241
 Man with Skull **265**
Buñuel, Luis 110
Buraglio, Pierre 14, 350
 Mondrian Camouflaged 339, **404**
Buren, Daniel *338*, 339, 341, 349
 Painting with Variable Forms **405**
Burroughs, William 12
Bury, Pol 246
 Mobile Relief 5 **363**

Cabaret des Assassins *31*
Cabaret Voltaire, Zurich 47
Café Caméléon 43, 46
Café Certa 110
Café Cyrano 38
Café Flore 19
Café Guerbois 31
Café de Notre Dame 245
Cage, John 336
Cagnes 119
Les Cahiers de la Quinzaine 44
Cahun, Claude 18
Calder, Alexander 18, 110, 243, 246
 Spider **168**
 Untitled **168**
Camus, Albert 247
Canada 23
Cannes 119, 123–24
Canudo, Ricciotto 41, 42, 51
Cap d'Ail 126
Cap d'Antibes 119
Caran d'Ache 28
Carco, Francis 31
Cassis 119
Cassou, Jean 43, 250, 252–53, 254, 260, 331
Castiaux, Paul 41
Castro, Fidel 24, 338, 339
Catholic Church 246–47
Cattaui, Georges 46
Cavalcanti, Emiliano di *48*
Céline, Louis-Ferdinand 38
Cendrars, Blaise
 La Prose du Transsibérien de la petite Jehanne de France 37, *37*
Centre Georges Pompidou 341, 350
Centre National d'Art Contemporain (CNAC) 341
Cercle et Carré 51
César (César Baldaccini) 13, 260, 332, 335
 The Grand Duchess **314**
 Plaque **315**
 Sunbeam **378**

Cézanne, Paul 34–35, 41, 42, 120, 241, 243, 257
Chabaud, Auguste 33–34
 Au Salon **63**
 Hotel Corridor **62**
Chagall, Marc 12, 19, 44, 45, 46, 47, 52, 112, 113, 125, 126, 243, 245, 246
 Ceiling of the Paris Opéra *330*, 331
 Paris Through the Window **89**
Chaissac, Gaston 243
Chalupecký, Jindřich 251, 252
Channel coast 119
Chardin, Jean-Baptiste-Siméon 17, 21
Chassériau, Théodore 122
Le Chat Noir 28, *29*, 30, 35
 Le Chat Noir 29
Chatou 33
Chennevière, Georges 41
China 24, 338, 349
Christo 22, 251, 336, 348
 Package on Luggage Rack **381**
 Wall of Oil Barrels – Iron Curtain 337
 Wrapped Portrait of Jeanne-Claude **383**
 Wrapped Vespa Motorcycle **382**
Churchill, Winston 250
Cieślewicz, Roman 260
Cirque Fernando/Médrano 30, 33
Citroën, André 109
Clair, Jean 348, 349
Claisse, Geneviève
 Jazz **364**
Clark, T. J. 13
Clarté 47, 48
Clarté group 47
Claudel, Camille 42
Clement, René *256*
Clert, Iris 14, 246, 332
Cobra group 20, 245, 337
Cockroft, Eva 259
Cocteau, Jean 118, *119*, 122, 125, 126, 140
Cohen, Albert 44
Cohn-Bendit, Daniel 340
Cold War 245–46, 250, 336, 344
Collioure 15
Cologne 50
Combat 339–40
Comité d'Action Révolutionnaire 341
Communist Party 20, 47, 114, 238, 239, 240, 242–43, 245–46, 250, 253, 254, 333, 344, 348
Conceptual art 347
Concrete art 51, 52, 245
Conti, Lydia 14
Cook, Thomas 121
Corot, Jean-Baptiste Camille 15
Côte d'Azur 33, 118–27
Coubine, Othon 46
Council of Europe 331
La Coupole 111, *111*
Courbet, Gustave 21, 238, 257
Courbevoie 40, 41
Le Courrier français 29
Crémieux, Adolphe 43
Cricot 2 theatre 253, 258, *259*
Crippa, Roberto 337
 The Great Antifascist Collective Painting 336, *337*, 339
Cros, Charles 28
Cross, Henri-Edmond 118
Crotti, Jean
 O + T + T = O **132**
Csaky, Joseph 45
Cuba 24, 338, 339, 344
Cueco, Henri 339
 La Barricade, Viet Nam 68, **398**
Cunard, Nancy 109, 151
Ćwik, Tadeusz 255
Le Cyrano 110
Czechoslovakia 42, 251, 258

Dada 18, 37, 110, 126, 244, 331
Daix, Pierre 348
Dali, Salvador 19, 110, 237, 240, 340
 Landscape with Telephone in a Dish **223**
 Paranonia **222**
 Partial Hallucination: Six Apparitions of Lenin on a Grand Piano 236, *237*
 Sleep **220**
 Venus de Milo with Drawers **224**, 332
Dalmau Gallery, Barcelona 42
Daumier, Honoré 238, 250, 340

David, Jacques-Louis 239
 Death of Marat 238
d'Axa, Zo 31
Debord, Guy 332
 Fin de Copenhague 333
 Howlings in Favour of Sade 245
 Psychogéographique de Paris *333*
 La Société du spectacle 339
Debussy, Claude 15
de Chirico, Giorgio 110
 Madame Gartzen **142**
 Portrait of Guillaume Apollinaire 15
Degand, Léon 246
Degas, Edgar 30, 42, 242
de Gaulle, Charles 16, 242–43, 330, 333, 335, 336, 338, 339, 341, 348, 349
de Kooning, Willem 345
Delacroix, Eugène 122
 Liberty Leading the People 339
De La Fresnaye, Roger 45
Delaunay, Robert 15, 35, 45, 115, 245
 L'Equipe de Cardiff 35, 36, *36*
 La Fenêtre sur la ville no. 3 38, **83**
 Tour Eiffel 38, **85**
 Tour Eiffel aux arbres **82**
 La Ville **80**
Delaunay-Terk, Sonia 14, 15, 37, 45
 Le Bal Bullier **95**
 Dubonnet **92**
 La Prose du Transsibérien et de la petite Jehanne de France 37
de Lempicka, Tamara 14, 18, 108, *108*
 Portrait of 'La Duchesse de la Salle' **144**
Deleuze, Gilles 22
Del Marle, Félix 50–51
Demain 47
Denis, Maurice 44
Denmark 113
Depaquit, Jules 31
Derain, André 15, 33, 42, 45, 112
 Henri Matisse **67**
 Two Nudes with Fruit **203**
 Woman in a Chemise **58**
Dermé, Paul 51
Derrida, Jacques 23, 24
Deschamps, Gérard
 Bâche de signalisation **372**
Desnos, Robert 48
Les Deux Magots 19
Devambez, André 341
Dewasne, Jean 246
 The Tomb of Anton Webern (Anti-sculpture) **355**
Diaghilev, Sergei 15, 43, 54
Direction des Musées Nationaux 240
Le Divan Japonais 28
Dobrinsky, Isaac 46
Doesburg, Theo van 51
 Counter-Composition V **172**
Le Dôme 111
Domela, César 108
 Relief no. 12A **184**
Donati, Enrico 244
Dongen, Kees van 18, 29, 31, 33, 42, 47, 123
 Anna de Noailles **147**
 Daniel-Henry Kahnweiler **66**
 Portrait of Fernande 33, **60**
 Self-portrait as King Neptune 123–24, *123*
Dorgelès, Roland 31, 32
Dorival, Bernard 344
d'Otémar, Jacques *41*
Dotremont, Christian
 Je lève, tu lèves, nous rêvons **318**
Dova, Gianni 337
 The Great Antifascist Collective Painting 336, *337*, 339
Doyen, Albert 41
Drancy 240
Dreyfus Affair 40, 44
Dubuffet, Jean 13, 20, 21, 243, 245, 337, 340, 345
 Berthollet, with a Crayfish Up His Nose **279**
 Building Façades from the 'Mirobolus, Macadam et Cie' series **278**
 'Mirobolus' series 243
 Miss Cholera **281**
 Les Murs 335
 Portrait of Artaud 21
 The Villager with Close-cropped Hair **280**
Duccio 247